MIRROR OF EMPIRE

DUTCH MARINE ART
OF THE SEVENTEENTH CENTURY

Cat. 127, detail.

MIRROR OF EMPIRE

DUTCH MARINE ART
OF THE SEVENTEENTH CENTURY

GEORGE S. KEYES

with essays by

George S. Keyes, Dirk de Vries,
James A. Welu, and Charles K. Wilson

THE MINNEAPOLIS INSTITUTE OF ARTS

IN ASSOCIATION WITH

CAMBRIDGE UNIVERSITY PRESS

CAMBRIDGE NEW YORK PORT CHESTER MELBOURNE SYDNEY

Published by the Press Syndicate of the University of Cambridge
The Pitt Building, Trumpington Street, Cambridge CB2 1RP
40 West 20th Street, New York, NY 10011, USA
10 Stamford Road, Oakleigh, Melbourne 3166, Australia

First published 1990

Printed in the United States of America

Library of Congress Cataloging-in-Publication Data
Keyes, George S.
Mirror of empire : Dutch marine art of the seventeenth century
George S. Keyes ; with essays by George S. Keyes ... [et al.].
p. cm.
ISBN 0-521-39328-0
1. Marine art, Dutch – Exhibitions. 2. Marine art – 17th century–
Netherlands – Exhibitions. I. Minneapolis Institute of Arts.
II. Title.
N8230.K49 1990
760'.04437'0949207473 – dc20
DLC
for Library of Congress 90–1492
 CIP

British Library Cataloguing in Publication Data
Keyes, George S.
Mirror of empire : Dutch marine art of the seventeenth
century.
1. Graphic arts. Dutch marine. Catalogues, indexes
I. Title II. Minneapolis Institute of Arts
760.04437074

ISBN 0-521-39328-0 hardback

EXHIBITION SCHEDULE

The Minneapolis Institute of Arts: 23 September to 31 December 1990

The Toledo Museum of Art: 27 January to 21 April 1991

Los Angeles County Museum of Art: 23 May to 11 August 1991

CONTENTS

LENDERS TO THE EXHIBITION

AUSTRIA
Vienna, Gemäldegalerie der Akademie der bildenden Künste, Cat. 19
Vienna, Graphische Sammlung Albertina, Cat. 66, 73, 107

BELGIUM
Antwerp, Museum Ridder Smidt van Gelder, Cat. 22
Brussels, Musées Royaux des Beaux-Arts de Belgique, Collection de Grez, Cat. 58, 65, 75

CANADA
Montreal, Collection of Mr. and Mrs. Michael Hornstein, Cat. 47

DENMARK
Copenhagen, Statens Museum for Kunst, Cat. 7, 14

FEDERAL REPUBLIC OF GERMANY
Berlin, Staatliche Museen Preussischer Kulturbesitz, Kupferstichkabinett, Cat. 57, 68, 76
Darmstadt, Hessisches Landesmuseum, Cat. 69
Düsseldorf, Kunstmuseum, Cat. 91

FRANCE
Paris, Institut Néerlandais, Fondation Custodia (Collection F. Lugt), Cat. 43
Paris, Musée du Louvre, Cat. 5

GERMAN DEMOCRATIC REPUBLIC
Schwerin, Staatliches Museum, Cat. 15

GREAT BRITAIN
Cambridge, The Syndics of the Fitzwilliam Museum, Cat. 60, 64, 74, 95
Edinburgh, National Galleries of Scotland, Cat. 70
London, The National Maritime Museum, Cat. 20, 29, 30, 36, 39, 48

London, Trafalgar Galleries, Cat. 1
London, The Trustees of the National Gallery, Cat. 6, 37
Manchester, City Art Galleries, Cat. 26

HUNGARY
Budapest, Szépmüvészeti Múzeum (Museum of Fine Arts), Cat. 17

ITALY
Florence, Palazzo Pitti, Galleria Palatina, Cat. 32

NETHERLANDS
Amsterdam, Historisch Museum (on permanent loan from the Rijksmuseum), Cat. 50
Amsterdam, Municipal Archives, Cat. 101, 102
Amsterdam, Rijksmuseum, Cat. 8, 21, 33, 49
Rijksprentenkabinett, Cat. 89, 93
Amsterdam, Rijksmuseum "Nederlands Scheepvaart Museum," Cat. 3, 51, 106, 109, 114, 116, 117, 119, 120, 125
Delft, Stedelijk Museum "Het Prinsenhof," Cat. 45
Dordrecht, Museum Mr. Simon van Gijn, Cat. 103, 105, 121
Haarlem, Frans Halsmuseum, Cat. 53
Haarlem, Teylers Museum, Cat. 59, 61, 63, 71
The Hague, Koninklijk Kabinet van Schilderijen, Mauritshuis, Cat. 10, 23, 35
The Hague, Rijksdienst Beeldende Kunst, Cat. 16
Hoorn, Westfries Museum, Cat. 52
Leiden, Bibliotheek der Rijksuniversiteit, Collectie Bodel Nijenhuis, Cat. 99, 100, 122, 128, 132, 133, 134, 135, 136, 137, 138, 139, 140, 141, 142
Leiden, Museum "De Lakenhal," Cat. 24

Leiden, Prentenkabinet der Rijksuniversiteit, Cat. 67, 94

Rotterdam, Historisch Museum Rotterdam, Atlas van Stolk, Cat. 118, 123, 124, 126

Rotterdam, Maritime Museum "Prins Hendrik," Cat. 129

Rotterdam, Municipal Archives, Cat. 104

Rotterdam, Museum Boymans–van Beuningen, Cat. 27, 62, 72, 77, 78, 79, 80, 81, 82, 83, 84, 85, 86, 87, 88, 90, 108

UNITED STATES

Baltimore, The Walters Art Gallery, Cat. 3

Bloomfield Hills, Michigan, Mr. and Mrs. Ben M. Snyder, Cat. 41

Boston, Museum of Fine Arts, Cat. 25

Huntington, New York, The Heckscher Museum, Cat. 42

Milwaukee, American Geographical Society Collection, University of Wisconsin–Milwaukee, Cat. 130

Minneapolis, The Minneapolis Institute of Arts, Cat. 2, 31, 96, 97, 98, 110, 111, 112, 113

New Haven, Yale University Art Gallery, Cat. 92

New York, The Pierpont Morgan Library, Cat. 56

Saint Louis, The Saint Louis Art Museum, Cat. 115

San Francisco, Fine Arts Museum, Cat. 131

San Francisco, San Francisco State College, Sutro Library, Cat. 127

Sharon, Massachusetts, The Kendall Whaling Museum, Cat. 28

Springfield, Massachusetts, Museum of Fine Arts, Cat. 34

Toledo, The Toledo Museum of Art, Cat. 11, 38

Washington, National Gallery of Art, Cat. 4

and the following owners who wish to remain anonymous: Cat. 9, 12, 18, 40, 43, 44, 46, 54, 55

FOREWORD

The history and life of Holland have always been intimately intertwined with the sea. Coastal waters have for centuries provided its people with a great variety of food that is an important element of their diet as well as their economy. Holland's fine ports and the skilled seamen who made their livelihood in her ships were a vital element of her continuing economic development. In fact, the sea offered the new Dutch Republic of the seventeenth century a strategic development to secure its political survival and develop its economic potential not only in the trade of northern Europe but through intrepid voyages to the Americas, India, and the Orient. The Dutch were blessed with good natural ports and a long marine tradition, but, as the eminent marine historian Samuel Eliot Morison has noted, the main reason for the success of Dutch marine ventures was the character and seafaring experience of her sailors. "By 1600 they were already noted for clean, taut ships, and for economy of operation: more blocks and tackle, shortening of the main and top sail yard, and cutting sails into smaller units, saved many men and much money" (Samuel Eliot Morison, *The Eu-*

ropean Discovery of America: The Southern Voyages A.D. 1492–1616, p. 727). Morison's recognition of the sailor as the vital element in Dutch marine success underlines the importance of people and their individual skills as an essential element of the realization of progress in the new Dutch republic. In his well-known study of Dutch landscape painting in the seventeenth century, Wolfgang Stechow recognized this phenomenon in the large corpus of Dutch marine paintings of the seventeenth century that have come down to us. Stechow noted that Dutch sea paintings always have ships and the implied presence of the men who run them as integral elements of any depiction of the great seas. The implication here is clear: Dutch artists and public were not interested in the sublime values that the landscape or seascape alone could symbolically convey to their audiences – this was really an invention of the nineteenth century. To seventeenth-century Holland the sea was a natural resource that afforded its people a unique opportunity for independence and expansion. Given the extreme importance of the sea and the sailing industry to Holland, it is unusual that there are relatively few studies of the subject in

general literature, especially when we consider that the finest Dutch landscape artists also included marine paintings in their repertoire.

We are therefore proud to present this exhibition and its catalogue as the first museum-organized exhibition to examine the broad range of Dutch marine art and its fascinating relationship to the development of the life and history of the Dutch nation. The present publication, the first source available in the English language, should provide a standard reference for students and admirers of Dutch painting for years to come.

Given this unique opportunity, we felt it important to not limit ourselves to the extraordinary representations of ships at sea in the paintings of the period but also to include a broad representation of visual images that have expanded and enriched our understanding. For this reason the exhibition includes the fascinating and enlightening series of drawings, prints, maps, and other documents that record the variety and strength of Dutch economic and mercantile life that propelled this young republic into the ranks of the great powers of seventeenth-century Europe. The images that range from fishing to exploration and war are rendered with the extraordinary ability of the Dutch artist to capture a sense of delight in detail as well as in the power of natural forces. They are eloquent evocations of nature in all of its beauty and power, yet always a nature in which man lives and through hard work and indomitable spirit survives and even prospers.

This project is the result of many years of diligent research and work by our curator of paintings, George S. Keyes. We are grateful for his devotion to the subject, which has resulted in this finely balanced exhibition and important catalogue. We would also like to thank Jane Satkowski, curatorial assistant in the Department of Paintings, for her constant support of the project, as well as the registrarial staff of the Minneapolis Institute of Arts, headed by Catherine Davis, who have arranged the logistics of international travel and transportation. The Minneapolis Institute of Arts is also deeply indebted to its former registrar, Gwen Bitz, who oversaw the art indemnification application, and for her many other critical contributions to the success of this exhibition. The exhibition would not have been possible without the strong support of KLM Royal Dutch Airlines, who provided the overseas travel and shipment for couriers and works of art, or the generous grants from the National Endowment for the Arts and the National Endowment for the Humanities. I would also like to express my sincerest thanks to the staffs and boards of trustees of the Toledo Museum of Art and the Los Angeles County Museum of Art, who supported this project and with whom we have the honor of sharing it.

Evan M. Maurer
Director
The Minneapolis Institute of Arts

ACKNOWLEDGMENTS

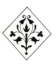

In organizing an exhibition of this magnitude the Minneapolis Institute of Arts has relied on the generous support of many persons and institutions on both sides of the Atlantic. Our greatest debt is to the many lenders who have made this exhibition possible. We wish to thank them one and all for their extraordinary generosity. The contributors to the catalogue, Dirk de Vries, James A. Welu, and Charles K. Wilson, have enriched the project in many substantial ways. In particular I am much obliged to Dirk de Vries for his invaluable input in selecting the cartographical material for the exhibition and preparing catalogue entries for these items. I am also greatly indebted to Robert Vorstman, who provided the preliminary list of prints to be included in the show.

Research for such an ambitious undertaking would have been impossible without the unstinting support of the staffs of the following great facilities. First, I wish to express my thanks to Joop Nieuwstraten and the staff of the Rijksbureau voor Kunsthistorische Documentatie in The Hague. I am also greatly indebted to the libraries of the Rijksmuseum, the Rijksmuseum "Neder-lands Scheepvaart Museum," the University of Leiden, the Koninklijke Bibliotheek, and the Atlas van Stolk in The Netherlands. Likewise, I wish to acknowledge the invaluable assistance of the staffs of the British Library, the Witt Library, and the library of the National Maritime Museum in the United Kingdom; and in the United States, the Frick Art Reference Library, the Library of Congress, the New York Public Library, the Newberry Library, the American Geographical Society, and the Wilson and James Ford Bell Libraries of the University of Minnesota.

Of the many individuals who have provided valuable assistance in innumerable ways, the following deserve special thanks: George and Maida Abrams, Cliff Ackley, Robin Adèr, Alfred and Isobel Bader, Baudewijn Bakker, Robert Baldwin, Maria van Berge-Gerbaud, Laurens Bol, Thomas Brod, Ben Broos, Christopher Brown, Laura Camins, Marco Chiarini, Philip Conisbee, David Cordingly, Hans Cramer, R. Deelen, Cara Denison, Diethelm Doll, Evert Douwes, Roman Drazniowsky, S.A.C. Dudok van Heel, Frits Duparc, E. Ebbinge, Ildikó Ember, Jeroen Giltaij, Larry Goedde, J. Grunfeld, Jane Hancock, Carlos van Hasselt, Egbert

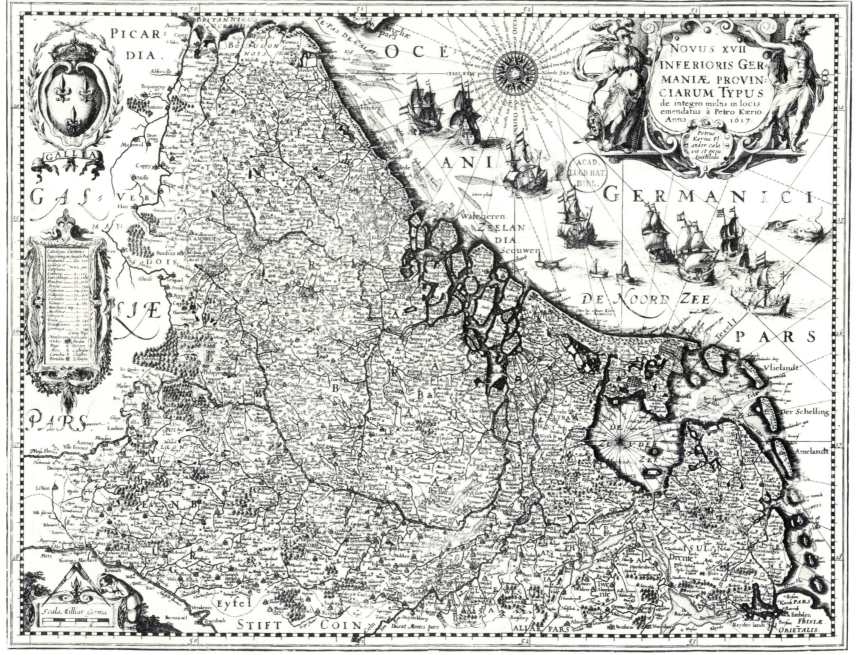

Figure 1 Map of the Netherlands *Engraving from P. van der Keere,* Germania
Inferior, *1617. Leiden, University Library (Bodel Nijenhuis Collection).*

ACKNOWLEDGMENTS

In organizing an exhibition of this magnitude the Minneapolis Institute of Arts has relied on the generous support of many persons and institutions on both sides of the Atlantic. Our greatest debt is to the many lenders who have made this exhibition possible. We wish to thank them one and all for their extraordinary generosity. The contributors to the catalogue, Dirk de Vries, James A. Welu, and Charles K. Wilson, have enriched the project in many substantial ways. In particular I am much obliged to Dirk de Vries for his invaluable input in selecting the cartographical material for the exhibition and preparing catalogue entries for these items. I am also greatly indebted to Robert Vorstman, who provided the preliminary list of prints to be included in the show.

Research for such an ambitious undertaking would have been impossible without the unstinting support of the staffs of the following great facilities. First, I wish to express my thanks to Joop Nieuwstraten and the staff of the Rijksbureau voor Kunsthistorische Documentatie in The Hague. I am also greatly indebted to the libraries of the Rijksmuseum, the Rijksmuseum "Neder-

lands Scheepvaart Museum," the University of Leiden, the Koninklijke Bibliotheek, and the Atlas van Stolk in The Netherlands. Likewise, I wish to acknowledge the invaluable assistance of the staffs of the British Library, the Witt Library, and the library of the National Maritime Museum in the United Kingdom; and in the United States, the Frick Art Reference Library, the Library of Congress, the New York Public Library, the Newberry Library, the American Geographical Society, and the Wilson and James Ford Bell Libraries of the University of Minnesota.

Of the many individuals who have provided valuable assistance in innumerable ways, the following deserve special thanks: George and Maida Abrams, Cliff Ackley, Robin Adèr, Alfred and Isobel Bader, Baudewijn Bakker, Robert Baldwin, Maria van Berge-Gerbaud, Laurens Bol, Thomas Brod, Ben Broos, Christopher Brown, Laura Camins, Marco Chiarini, Philip Conisbee, David Cordingly, Hans Cramer, R. Deelen, Cara Denison, Diethelm Doll, Evert Douwes, Roman Drazniowsky, S.A.C. Dudok van Heel, Frits Duparc, E. Ebbinge, Ildikó Ember, Jeroen Giltaij, Larry Goedde, J. Grunfeld, Jane Hancock, Carlos van Hasselt, Egbert

Haverkamp Begemann, Hans Hoetink, Jan Willem Hoogsteder, John Hoogsteder, Michael Hoyle, Bill Hutton, Paul Huvenne, Guido Jansen, Rob Kattenburg, Gerbrand Kotting, Gary Kurtz, Cynthia Lawrence, Walter Liedtke, Ger Luijten, Roger Mandle, Bram Meij, Hans Mielke, Otto Naumann, Carl Nix, Jack Parker, Konrad Oberhuber, Richard Ormond, Jovanka Ristić, William Robinson, Yvette Rosenberg, Pieter Schatborn, C.O.A. Baron Schimmelpenninck van der Oije, David Scrase, Seymour Slive, Willem Smid, Derk Snoep, Joaneath Spicer, Peter Sutton, Renate Trnek, Carel van Tuyll, Richard Unger, Susan Urbach, John Walsh, Jr., Helen Wallis, Arthur Wheelock, Eliane de Wilde, Eric Zafran, and An Zwollo. I am also most grateful to Robert and Elizabeth Druce and Nan and Bart Oldemans for their generous hospitality during my many sojourns in The Netherlands.

I wish to thank Beatrice Rehl and the staff at Cambridge University Press for producing a magnificent catalogue. Their sustained enthusiasm for this project has been a great inspiration in our race against time to meet critical deadlines.

At the Minneapolis Institute of Arts, the staff has unstintingly supported this project. My special thanks go to my assistant, Jane Satkowski, whose unflagging support has been of inestimable importance. I also wish especially to acknowledge the contributions of Roxanne Ballard, Richard Campbell, Beth Desnick, John Easley, Rosamond Hurrell, Louise Lincoln, Sandra Lipschultz, Gary Mortensen, and Elizabeth Søvik. Gwen Bitz and Cathy Davis, our former and current registrars, have shouldered an immense share of the burden of realizing this exhibition.

The Minneapolis Institute of Arts also gratefully acknowledges the generous financial support of KLM Royal Dutch Airlines. In particular we wish to thank Jack Kempton, Don Palmer, and Mike Rader, who enthusiastically supported the exhibition from the beginning. I am also much obliged to members of the Dutch Consulate in Chicago, in particular J.F.C. Boissevain, and Madeleine Mirani. Lyle Delwich, the Dutch Honorary Consul in the Twin Cities, has provided invaluable assistance. The National Endowment for the Humanities provided a planning grant for the exhibition, which also received generous funding from the National Endowment for the Arts. The Minneapolis Institute of Arts is deeply indebted to both federal agencies for their crucial support of this exhibition.

George S. Keyes

HISTORICAL SURVEY

utch marine art of the seventeenth century has remained the stepchild of the Dutch "golden age." Until now it has never been the subject of a major exhibition surveying the full scope of the theme. Only recently have certain major masters of marine painting been the subject of special exhibitions[1] and independent scholarly studies.[2] These provide a healthy basis for the present exhibition, in which we wish to encompass the range, quality, and importance of Dutch marine art and the way it mirrored the prosperity, aspirations, and values of seventeenth-century Holland.

The maritime activities of the Dutch Republic provided the crucial element that ensured the economic prosperity and well-being of the country. So much of the wealth and energy of the Dutch were generated through their maritime and related trades that general neglect of this aspect of Dutch art seems singularly ironic and anomalous. This exhibition aims to redress this situation. One of the factors governing the traditional assessment of Dutch marine art is the link drawn between it and Dutch landscape painting.[3] The reason this has occurred is not hard to find; the actual dividing line between the two categories of painting is not as clear cut as one might initially suppose. The riverview, for example, is one of the most significant themes within the repertory of Dutch landscape subjects, but thematically it is also linked intimately to marine painting. The estuaries, rivers, inland seas, and lakes of the provinces of Holland, Friesland, and Zeeland provided vital shipping arteries that permitted the easy flow of goods from the hinterlands to the Dutch seaports. A map of the Low Countries (Fig. 1) reveals to what degree the rivers flowing into the Dutch Republic provided a vast network allowing for the easy transport of cargo along the great rivers Rhine, Maas, and Scheldt to the ports of Holland and Zeeland.

Many of the most celebrated Dutch landscape painters also represented coastal scenes. These, more than the riverviews, tended to be incorporated somewhat uneasily into the repertory of Dutch landscape, which once again demonstrates that the line of demarcation between landscape and marine subject matter is

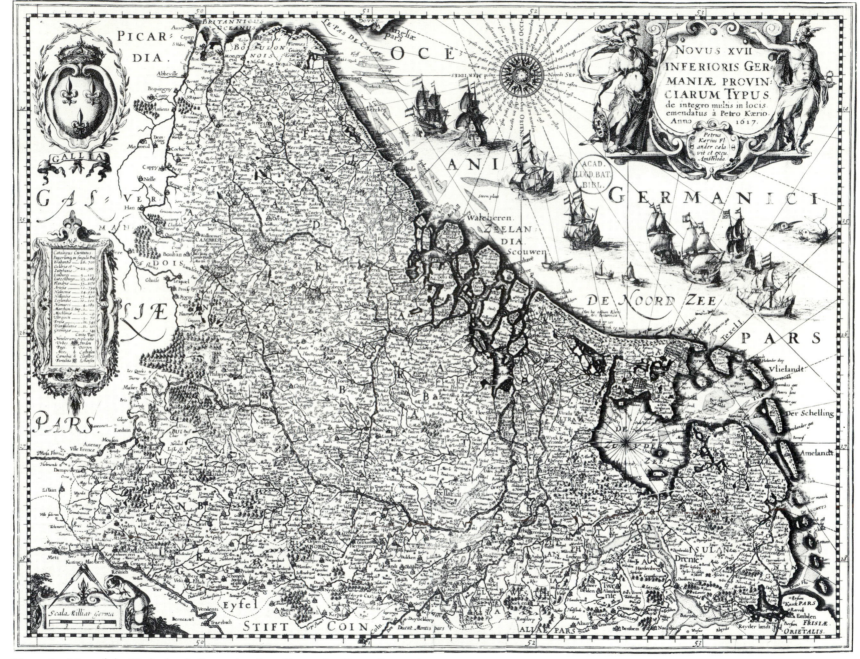

Figure 1 Map of the Netherlands *Engraving from P. van der Keere,* Germania
Inferior, *1617. Leiden, University Library (Bodel Nijenhuis Collection).*

not absolutely clear. Seventeenth-century marine and landscape artists did not perceive this as an issue, and the conventional tendency to compartmentalize such material into clearly differentiated categories must be reappraised. We must remain pragmatic in recognizing the degree of overlap and common interest. By the same token, we have chosen not to stress riverviews but, in trying to highlight the most salient aspects of Dutch marine art, to concentrate on the native maritime environment of the Dutch Republic rather than include a full complement of representations of Baltic and Mediterranean subjects as well as foreign scenes.

This essay's seven subdivisions trace the development of Dutch marine art from its origins to the end of the seventeenth century.[4] In selecting the works included in the exhibition, the organizers decided to concentrate on a limited number of the most representative and outstanding marine artists of the century. An encyclopedic inclusion of all the practitioners of this genre would lessen the impact of the material without noticeably enriching the viewer's understanding of the scope and vitality of Dutch marine art.[5] By concentrating on slightly fewer than twenty of the preeminent Dutch painters of the sea we hope to provide a clear sense of the challenges these artists faced, the ingenuity of their solutions, and the degree to which they influenced their contemporaries and determined the development of Dutch marine art.

HISTORICAL BACKGROUND: THE SIXTEENTH-CENTURY ORIGINS

No category of Dutch art is more closely linked to the historical developments that shaped the existence, character, and aspirations of the Dutch Republic than marine painting. It is a mirror of the unfolding of history and offers a unique means of bringing the past vividly into focus.

Events in the Low Countries following the abdication of the emperor, Charles V, in 1555 led to violent and sustained religious strife and bitter opposition to the ambitions of his son, Philip II, successor to the Spanish and Spanish-controlled dominions. Philip strove to centralize the government of the Low Countries with the goal of maintaining a universal Roman Catholic order. Certain hereditary nobles and municipalities, jealous of their medieval feudal rights, resisted the shift toward centralization, while various Protestant sects, well entrenched in the large cities of the populous southern provinces of Flanders and Brabant, reacted violently to the policy aimed at their suppression. These two related and equally intractable issues were the basis for the origins of the Eighty Years War (1568–1648), otherwise known as the Revolt of The Netherlands.

Certain personalities were crucially important in this protracted struggle. Among the nobles in opposition to Philip II, the young William of Orange, Prince of Nassau (1533–1584), better known as William the Silent, played the most important role. A humanist by instinct and training, he became a seasoned tactician and highly skilled diplomat capable of coalescing the loosely knit federation of groups opposed to Hapsburg ambitions to restructure government and abrogate medieval rights and charters. William became the natural leader of the opposition. His pragmatism and belief in religious toleration attracted a wide range of support. This remarkable man, having guided the opposition through the worst vicissitudes of the struggle for independence from Spain, was assassinated in 1584 by order of Philip II. William the Silent's death caused universal mourning among his followers; understandably, he became recognized as the father of his country, a man who, through his convictions, laid the groundwork for the first great national republic of Europe since that of ancient Rome.[6]

At the time of the outbreak of the Eighty Years War, the southern provinces of the Low Countries – Flanders and Brabant – were the wealthiest in The Netherlands. Antwerp, with a population exceeding 100,000, was the economic, mercantile, and financial hub of the Low Countries and served as the banking center of the Spanish empire. The cities in the province of Holland were

considerably smaller, but even in the course of the fifteenth century, Amsterdam became the center for the carrying trade: Indeed, it was the fulcrum of a transport network extending between the Low Countries and the Baltic and Mediterranean seas. The smaller seaports of Holland had established extensive herring fisheries that provided the basis for their carrying trade. Salted herring was shipped to the Baltic and traded for grain and lumber, which the Dutch transported back to Holland. They utilized the lumber for shipbuilding and shipped much of the grain to France, Iberia, and the Mediterranean. They marketed the grain for the purchase of salt, an indispensable ingredient for Dutch herring fisheries. River traffic along the Rhine and Maas brought goods from the hinterlands that were used in the carrying trade. Dutch cities became centers for the production of linen and other woven goods and beer, all readily marketable.

To maintain authority in The Netherlands the Spanish crown resorted to measures that were vulnerable to criticism and attack. Its use of mercenary armies not only antagonized the local populace but was costly to maintain. Its frequent inability to pay these hired soldiers caused much justifiable dissatisfaction, which on occasion led to outbreaks of uncontrolled violence by the occupying army, culminating in the pillaging and sack of Antwerp, known as the "Spanish Fury," in 1576.

Spain's link to the Low Countries was by sea and involved passage through zones governed by countries hostile to Philip II. Moreover, Spanish vessels were ill adapted to the treacherous shallows of the Scheldt estuary, whereas the ship designers of the Low Countries had developed ship types suitable to these waters, which were easily capable of outmaneuvering the Spanish. The vulnerability of the Spanish lines of communication soon became apparent when the heterogeneous group of disenfranchised nobles known as the "Sea Beggars" (*Watergeuzen*) banded together under the command of Willem Lumeij, Count van der Marck, and freely attacked Spanish ships. These unruly brigands were eventually able to seize control of the islands in the Scheldt estuary.

By disrupting the flow of sea traffic to Antwerp, and ultimately stopping it altogether, they dealt a mortal blow to this great center of trade.

Subsequently, Antwerp shifted its allegiance to William the Silent, but Spain, in a countermove directed by its brilliant military commander Alexander Farnese, Duke of Parma, assumed the initiative and mounted an attack against the city. After a protracted siege, Antwerp fell to Spain in 1585, and by imperial edict, those of its citizens who chose to emigrate were given a three-year period of grace in which to do so. There followed an extraordinary departure of talent and capital, much of which found its way to the provinces of Holland and Zeeland, where the influx of wealth and expertise was of inestimable importance to the emergence of the fledgling Dutch Republic.[7]

In the years following the assassination of William the Silent, the struggle for independence was led by Johan van Oldenbarnevelt, the grand pensionary of Holland, together with Prince Maurice, the son of William the Silent. Maurice, a brilliant military tactician who completely restructured the Dutch army, developed the art of siege warfare with marked success; as a result, the military campaign on land in the Low Countries evolved into a protracted stalemate. Out of this were formed two broadly defined confederacies initially outlined by the treaties of Utrecht (1579) and Arras (1579), which led to the de facto independence of the northern provinces of the ancient Burgundian Hapsburg dominions of the Low Countries. The Dutch, by force of arms, had become independent from Spain but remained politically unrecognized by the great Roman Catholic monarchs of Europe.

The repertory of marine subjects developed by the Dutch painters of the seventeenth century evolved from modest origins. Traditional maritime themes fall into three basic categories: biblical, mythological, and moralizing subjects; historical events; and ships' portraits.[8]

Biblical subjects were drawn from both Old and New Testa-

ments (Fig. 2). The story of Jonah, Christ preaching on the Sea of Galilee or Genasarret, and Saint Paul shipwrecked on Malta (Cat. 55, fig. a) were the most popular religious subjects; representations of the destruction of Sodom and Gomorrah, the Tower of Babel, and depictions of Hell during the Last Judgment frequently contain vignettes of harbors and ships as well. Scenes from mythology, such as the stories of Odysseus and Aeneas, also permitted the inclusion of maritime details and references. Moralizing subjects such as the series of the *Four Seasons*, the *Twelve Months*, the *Virtues and Vices*, as well as the *Allegory of Fortune* contain maritime references and motifs. Many artists — above all Pieter Bruegel the Elder (ca. 1528/1530–1569) — included seaports and shipwrecks in their paintings and designs for reproductive engravings.[9] Series of the months include similar references. Oc-

casionally, tapestries such as the important *Triumph of Hope* (Fig. 3), woven in Brussels and now in Pittsburgh, contain lively vignettes of ships in distress.

The link to representations of historical events is even closer. During the first half of the sixteenth century certain Netherlandish artists were commissioned to represent recent events of significant historical importance. Among the earliest are two paintings now at Hampton Court Palace representing scenes of the famous meeting between Henry VIII of England and Francis I of France known as the Field of the Cloth of Gold.[10] Henry VIII's departure from Dover is a remarkable early marine painting on a large scale. These pictures have been associated with the Netherlandish artists Cornelis Anthonisz. Theunissen (ca. 1499–1553) and Jan Vermeyen (1500–1559). Vermeyen provides a crucial link to one

Figure 2 Joachim Beuckelaer, The Miraculous Draught of Fishes, *1563, panel. Malibu, J. Paul Getty Museum.*

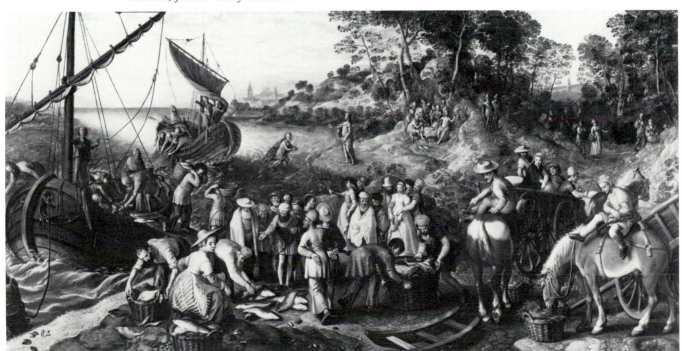

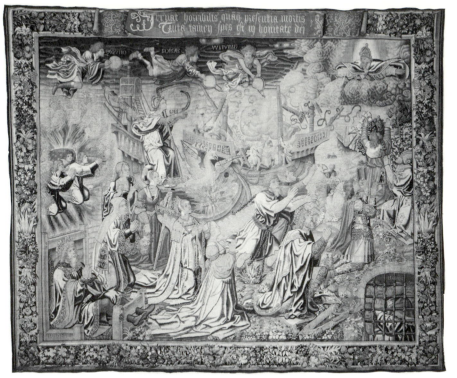

Figure 3 Triumph of Hope, *tapestry. Brussels, ca. 1530. Pittsburgh, Museum of Art, Carnegie Institute.*

category of artistic activity in the Netherlands intimately associated with maritime subject matter – tapestry design. By 1546 he had completed a series of cartoons or full-scale drawings, now in the Kunsthistorisches Museum in Vienna, for a series of tapestries representing the *Capture of Tunis by Charles V.*[11] Between 1548 and 1554 these celebrated tapestries were woven in Brussels by Willem de Pannemaker. Commemorating a major military campaign, they established a lively precedent. Later in the sixteenth century other tapestry series commemorating *The Battle of Lepanto* (1572) (Fig. 4)[12] and *The Defeat of the Spanish Armada* (1588)[13] provide the crucial link to the origins of Dutch marine art because the last series, commissioned for Lord Howard of Effingham, commander of the English fleet that scattered the

Armada in 1588, were designed by Hendrick Vroom, the father of Dutch marine painting. Vroom subsequently designed the Zeeland tapestries commemorating the victories of the Sea Beggars at the commencement of the Eighty Years War. Fortunately these survive and, following their recent restoration, are a vivid and magnificent record of Renaissance tapestry weaving in the Low Countries.[14]

Ships' portraits, the third category of marines, were rare in the sixteenth century. A series of engravings by Frans Huys after the designs of Pieter Bruegel the Elder[15] records Bruegel's careful and spirited delineation of specific types of ships. These form an invaluable document revealing another aspect of Bruegel's critical and sympathetic interest in his human and natural environment. Huys's engravings find parallels in certain paintings by Bruegel, including his *View of Naples* in the Doria Pamphili Gallery in

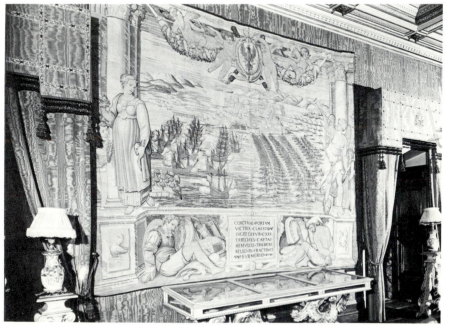

Figure 4 The Battle of Lepanto, *tapestry. Brussels, late sixteenth century. Rome, Palazzo Doria Pamphili.*

Rome, or his now lost *Battle in the Straits of Messina* recorded in a large engraving after Bruegel's design.[16]

HENDRICK VROOM AND THE BEGINNINGS OF DUTCH MARINE ART

Shortly before 1600, marine art emerged as a separate category of artistic endeavor within the repertory of Dutch painting. Hendrick Vroom of Haarlem played a seminal role in its genesis. His importance was noted as early as 1604 by Carel van Mander, who discusses Vroom at great length in *Het Schilder-boeck*.[17] Van Mander may have considered himself on somewhat unfamiliar ground in discussing marine painting, but he recognized the potential importance of its subject matter as it related to the general theme of history painting. A humanist poet and historian like van Mander, following well-established academic precepts, consid-

ered history painting (principally subjects drawn from the Bible and from ancient history) the highest category of artistic endeavor. In his discussion of Hendrick Vroom, van Mander had a presentiment that the subjects treated by this marine artist potentially constituted a significant new category of history painting because they represented recent and contemporary events.

Although conceding that he was no expert on such matters, van Mander marveled at Vroom's astonishingly accurate rendering of ships. Thus, by 1604 two hallmarks of Vroom's style, his interest in history subjects and his penchant for precise description, were already recognized as distinguishing characteristics of his marine paintings. Ironically, much of the work on which Carel van Mander based his discussion of Vroom has been lost. Vroom's earliest surviving documented painting dates from after 1600[18] and represents *The Battle of the Armada* (Fig. 5). Its metallic coloring recalls the palette of Jan Bruegel the Elder, whose work

Figure 5 Hendrick Vroom, The Battle of the Armada, *160(?), canvas. Innsbruck, Ferdinandeum.*

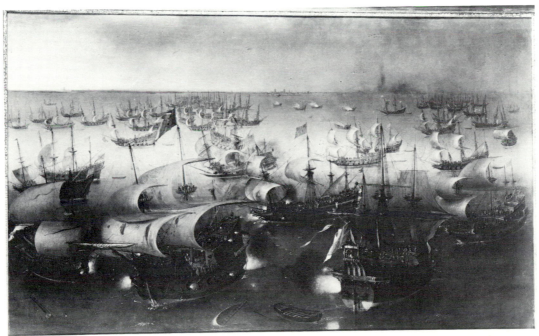

Vroom could have seen perhaps in Italy, but certainly in Antwerp. Although born in Haarlem, Vroom traveled extensively as a youth to Iberia, Italy, France, and even the Baltic.[19] His actual training remains obscure, but his contacts in Italy included Paul Bril and other Netherlandish artists active in Rome.

Vroom specialized in representing large-scale depictions of recent historical events. Initially he became involved in designing suites of tapestries – *The Defeat of the Spanish Armada* and the Zeeland tapestries – both of which were cited by Carel van Mander. The Armada tapestries, commissioned by Lord Howard of Effingham, admiral of the English fleet opposing the Armada, hung in the House of Lords and were destroyed by fire in 1834.[20] These tapestries represent different actions in the protracted campaign as the Spanish fleet approached England and followed its

south coast toward the English Channel. Each subject (Fig. 6) is represented as seen from a bird's-eye view at considerable distance from the actual theater of events. Compositionally they have the effect of offering a quasi-cartographical charting of the battle formations of the opposing enemy fleets. Dramatic detail is downplayed for the sake of tactical clarity. The later series, commissioned by the Admiralty of Zeeland to decorate its council chamber in Middelburg, survives (Figs. 7, 8). Known familiarly as the "Zeeland tapestries," the five hangings depict significant events in the early phase of the Eighty Years War in which the "Sea Beggars" played such a prominent part. The first of these tapestries were woven in Delft, but the series was completed in Middelburg.[21] The Zeeland tapestries have a more arresting visual impact than the more pictographic Armada series. Hendrick

Figure 6 J. Pine, after Hendrick Vroom, The Battle of the Armada, The Action off Portland, *engraving.*

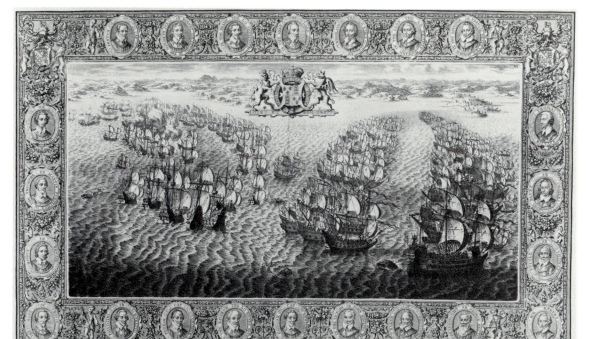

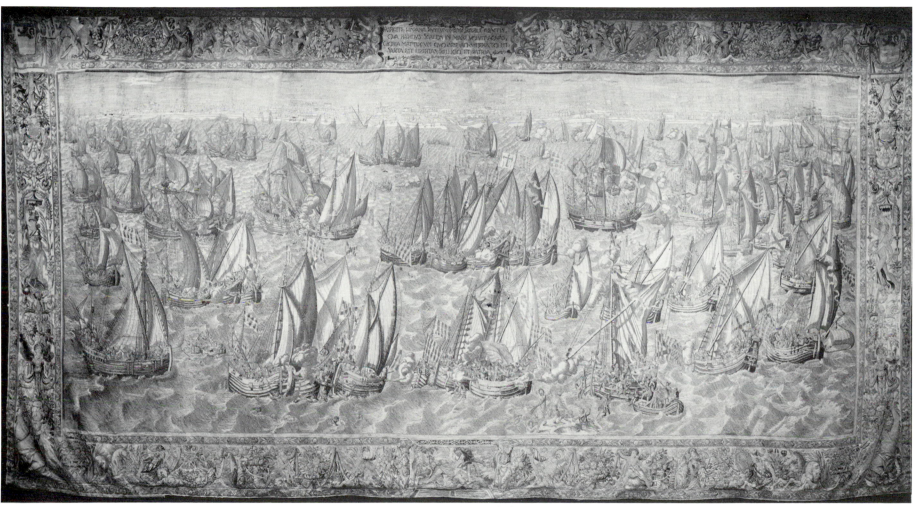

Figure 7 Hendrick Vroom, designer, The Battle by Bergen op Zoom, *tapestry. Middelburg, Abdij, Zeeuws Museum.*

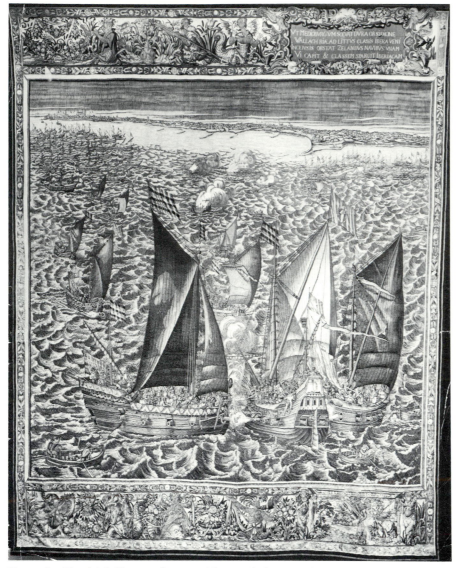

Figure 8 Hendrick Vroom, designer, The Battle by Fort de Haak, *tapestry. Middelburg, Abdij, Zeeuws Museum.*

Vroom envisages the subject from a much closer vantage point and transforms the narrative treatment of the battles to heighten the viewer's involvement in the subject matter. This approach culminates in Vroom's preparatory design (Fig. 9) for the large

engraving of 1600, *The Landing at Philippine,* an early documented work, for which he received payment of 150 florins from the States General of the Dutch Republic.[22] By dropping the vantage point Vroom evokes the sense of a large flotilla sailing in unison before the coast of Flanders launching Prince Maurice's campaign against the Spanish. The artist's remarkable powers of observation are vividly apparent in the superb depiction of the craft sailing across the foreground of the theater of action.

Subsequently, Vroom painted an impressive series of significant maritime events: naval battles (Cat. 49); the return of Dutch East India fleets (Cat. 50); and the arrival of dignitaries at Dutch seaports. An early example is his *Return of the Second Dutch Expedition to the East Indies* (Cat. 50). The artist not only represents the fanfare associated with such a notable event but also stresses the vital relationship between the ships and the city of Amsterdam. This bond between fleet and city culminates in Vroom's masterpiece, *The Arrival of Frederick V of the Palatinate in Vlissingen* (Cat. 52, fig. a) of 1623, in which the English fleet appears before the ramparts of the seaport. The artist's attention to detail in this picture is astonishing. The ships' portraits remain unsurpassed and are indisputably the chief object of our interest, but Hendrick Vroom also accurately represents the profile view of Flushing. Such topographical depictions became independent subjects for marine painters including Vroom, whose representations of the roads of Hoorn (Cat. 52), Veere, and other cities provided lucrative commissions for the painter. The high prices commanded by Vroom indicate the importance that corporate patrons placed on certain commissioned marine paintings.[23]

Hendrick Vroom's success encouraged emulators and competitors. During the early seventeenth century most of this activity was centered in Haarlem and Utrecht; in Haarlem, Vroom's most noteworthy rival was Cornelis Claesz. van Wieringen, whose repertory closely approximates that of Vroom.[24] Van Wieringen received notable commissions from various public institutions in Haarlem. His version of *The Arrival of Frederick V of the Pa-*

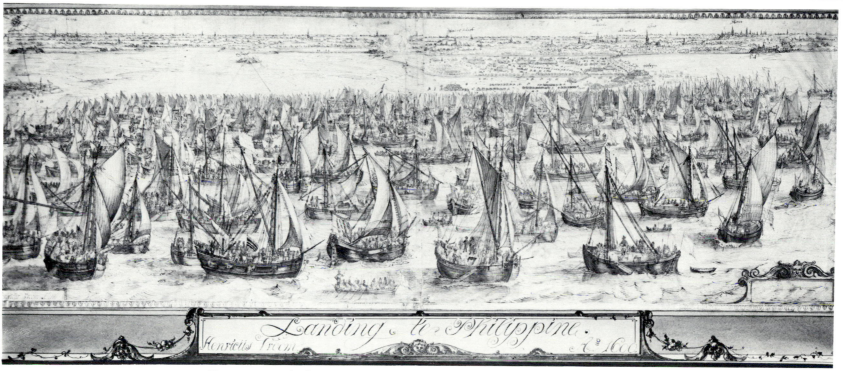

Figure 9 Hendrick Vroom, The Landing at Philippine, 1600, *pen and gray wash.*
Rotterdam, Museum Boymans–van Beuningen

latinate in Vlissingen on May 5, 1613 (Cat. 53) was executed for the old men's almshouse in the city, whereas *The Capture of Damiate* (Cat. 42, fig. a) was commissioned by the *Cloveniers-doelen* (Militia Company of Saint Adriaen – harquebusiers) to hang over the mantelpiece of their quarters. Van Wieringen also designed tapestries including the immense *Capture of Damiate,* commissioned by the city magistrates of Haarlem, which still hangs in the town hall.[25] In tracing the roots of its strong sense of civic pride, Haarlem traditionally claims to have provided the ship that led the Crusaders to Damiate and that successfully broke the chain guarding its harbor from invaders, thus laying it open to successful attack. Understandably, this subject was popular in Haarlem and was featured in paintings, tapestries, stained glass, and engravings. Van Wieringen's most celebrated painting, *The*

Battle of Gibraltar (Fig. 10) of 1622, was commissioned by the Admiralty of Amsterdam to present to Prince Maurice as a token of its esteem. For this painting the artist received the staggering sum of 2,400 florins, a clear indication of the importance the admiralty placed on this intended gift.[26]

One artist, Adam Willaerts, dominated marine painting in Utrecht. While representing subjects similar to those of Vroom and van Wieringen, Willaerts introduced distinctive features inspired by certain landscape painters active in Utrecht. His contact with Roelandt Savery (ca. 1576/78–1639)[27] spurred Willaerts's interest in savage mountainous coastlines as a backdrop to some of his marines. Moreover, Willaerts incorporated lively genre elements into his scenes, ranging from hunters to fisherfolk who pursue their livelihood on the shore. Frequently they interact

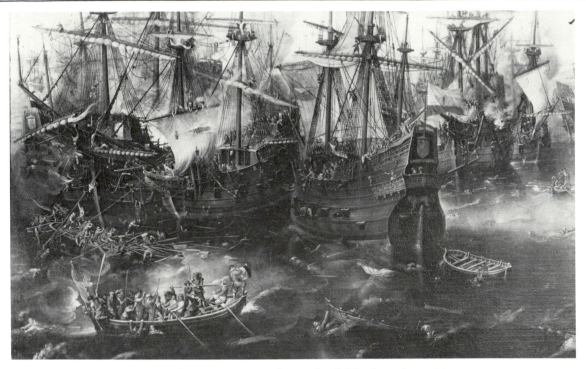

Figure 10 C. Cl. van Wieringen, The Battle of Gibraltar, *det. 1622, canvas.*
Amsterdam, Rijksmuseum, "Nederlands Scheepvaart Museum."

with disembarking or embarking dignitaries and provide eye-catching incidents. Willaerts's oeuvre is also distinguished by the fact that he retained religious subjects within his repertory. Among his favorite themes is *Christ Preaching from the Boat* (Cat. 55). In his vivid characterization of the fisherfolk pursuing their many activities, Willaerts continues the sixteenth-century Netherlandish tradition of Pieter Bruegel the Elder that was perpetuated by his son, Jan Bruegel the Elder.[28]

These three artists – Vroom, van Wieringen, and Willaerts – dominated the first phase of seventeenth-century Dutch marine painting. Their work shares common characteristics: All three pay great attention to detail. Careful description, particularly evident in the work of Hendrick Vroom, indicates that each artist expected his patrons to admire the precision and accuracy so

evident in these pictures. Their palette tends to be bright and somewhat metallic in color. This stress on the cool greens of the sea and the clear bluish-green light of the skies complements the descriptive clarity in the delineation of ships and city skylines. The three artists' major commissions constitute a restricted repertory of subjects conforming to the needs of their patrons. With few exceptions, these illustrate significant events pertaining to the Dutch struggle for independence or to recent developments in Dutch overseas trade. Although certain subjects, particularly the tapestry commissions, occasionally hark back to events in the more remote past, most themes represent momentous recent events in the continuing Dutch struggle for independence from Spain.

Despite the central role played by the history piece in early-

Figure 11 Adam Willaerts, Naval Battle, *pen and wash. Leiden, University Library.*

seventeenth-century Dutch marine art, the major marine painters also explored subjects distinctly nonhistorical in character. For example, Hendrick Vroom painted several modestly scaled beach scenes often anecdotal in flavor. He also produced finished pen drawings of ships, including one notable study of *Ships in a Storm* (Cat. 90).[29] That these subjects had considerable appeal is borne out by the fact that certain printmakers produced reproductive engravings after his designs (e.g., Cat. 107).[30] Apparently Vroom was not a prolific draftsman. The opposite applies to his Haarlem compatriot, Cornelis Claesz. van Wieringen, who produced many spirited small pen, and pen and wash, studies (Cat. 93–95). With few exceptions they are nonhistorical in subject and cover a wide range of interests including landscape.[31] The themes explored in these drawings bear little relationship to van Wieringen's large

paintings. Like Vroom, he painted small-scale beach scenes and views of shipping in estuaries that evidently filled a market demand separate from the large public commissions.

Willaerts's activities as a draftsman remain less clearly defined, but the occasional monogrammed drawings from his hand indicate a parallel development (Fig. 11).[32] Conversely, Willaerts broadened his painting repertory to include storms at sea, shipwrecks, and more placid beach scenes, replete with anecdotal detail. This aspect of their work indicates that these three pioneering marine artists, Vroom, van Wieringen, and Willaerts, explored subjects that heralded change; their art mirrors a considerable range of interests, and anticipates a major shift in the orientation of Dutch marine art.

What Vroom and van Wieringen intimated principally in their

drawings found a unique counterpart in the few documented paintings of the intriguing but little-known artist Cornelis Verbeeck.[33] His surviving corpus of paintings is notable in two respects: Verbeeck's pictures are small, and most of his subjects are nonhistorical. His most memorable paintings represent ships close to rocky shores in rough seas. These diminutive cabinet pieces are emotionally gripping representations of dramatic subjects of shipwrecks, ships in distress, or ships clawing off a forbidding rocky coast. Whatever their actual content or intended message,[34] these arresting images must have appealed to a broad market. Verbeeck's modestly scaled panel paintings further indicate the potential for change that would reorientate the direction of Dutch marine art.

JAN PORCELLIS AND THE EMERGING TONAL PHASE OF DUTCH MARINE PAINTING

Jan Porcellis, born in Flanders about 1584, settled at a young age in Holland, where he allegedly was the pupil of Hendrick Vroom in Haarlem. Porcellis was peripatetic, and until he finally attained recognition in the mid–1620s, he was plagued by poverty.[35] Late in his career Porcellis settled in Zoeterwoude, a village near Leiden. For more than three hundred years the name of Porcellis was shrouded in obscurity, but recent research enables us to reassess his contribution and trace his origins. Two panel paintings (Fig. 12) at Hampton Court Palace, which bear the royal brand of Henry, Prince of Wales (1594–1612), were identified by J. G. van

Figure 12　Jan Porcellis, Ships in a Storm, *panel. Hampton Court Palace, The Royal Collection.*

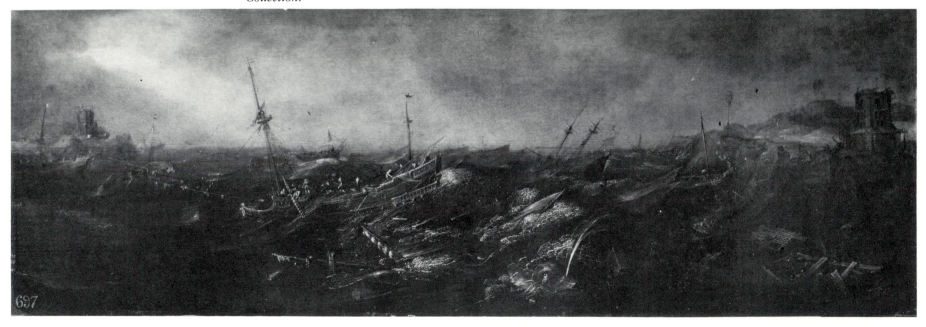

Gelder as being part of the Dutch Gift of 1610 to the prince.[36] These pictures, *Sea Battle by Night* and *Ships in a Storm* (Fig. 12), demonstrate how markedly Porcellis differed from Hendrick Vroom, even at an early date. In both paintings Porcellis rejects specific historical events as a focus of his interest; instead, he concentrates on nature's impact on human activities and ambitions. He focuses on the eerie effects of moonlight, the restless energy and destructive capacity of the sea, and the changing, turbulent skies that inexorably alter the character of the subject. The unusual format of these two panels, their expressive tone and experimental nature, are the products of a personality capable of radically redefining the character of Dutch marine art.

During the 1620s, Porcellis refined his concept of the Dutch marine by placing progressively more stress on the unique impact of the elemental forces of nature that define the subject. He was fascinated by the interaction of the light filtered by clouds, the wind, and the restless sea. His ability to synthesize the subject was appreciated by Samuel van Hoogstraeten, who discusses the artist's discriminating naturalness in his *Inleyding tot de Hooge Schoole der Schilderkunst,* published in 1678. Hoogstraeten employed this term in describing a contest between three painters: François Knibbergen, Jan van Goyen, and Jan Porcellis. In a single day each was to paint a picture that would then be judged by connoisseurs. Porcellis was the winner because he allowed his imagination to dominate his conception of the subject. His judicious selection of detail resulted in a more thought-provoking concept of nature than that achieved by his competitors.[37] Porcellis was a skilled sailor who explored the estuaries and inland waters of Holland. Not surprisingly, many of his mature paintings contain small sailboats with only incidental reference to the larger oceangoing flute ships, the chief cargo vessels used in the Dutch carrying trade.

Porcellis rejected the large-scale history piece as the prime focus of Dutch marine art. Instead, he painted small works on oak panel intended as cabinet pictures for discerning collectors.[38]

What Porcellis achieved in marine painting had tremendous impact on Dutch landscape art. His interest in atmospheric effects and his characterization of the sky as a vast foil to the sea caught the imagination of certain landscape painters whose interest in recording the blustery weather conditions of Holland led to the so-called monochrome phase that dominated Dutch landscape painting during the years 1630–1645. In this phase the palette in these landscapes became a muted, homogenous mix of ochres, greens, and grays. Artists such as Jan van Goyen, Pieter Molyn, and Salomon van Ruysdael owed a tremendous debt to Porcellis and demonstrate that Dutch landscape and marine art shared significant common aspirations, and that these two categories of painting mutually reinforced each other.

What Porcellis formulated was influential; indeed, it would prove as consequential to this phase of Dutch marine art as Vroom's impact had been on his contemporaries. Porcellis had many emulators. His son Julius (Rotterdam? ca. 1609 – Leiden 1645) perpetuated Jan's style closely, although Julius's later marines become progressively harder in style. Conversely, Hendrick van Anthonissen,[39] a pupil and brother-in-law of Jan Porcellis, developed a refined tonal marine idiom in which he specialized in representing small craft under sail in a strong breeze (Cat. 1). Another Leiden painter with close connections to Porcellis, Cornelis Lambertsz. Stooter (Leiden ca. 1595/1600–1655),[40] painted several representations of ships sailing through choppy seas that are deeply under the impress of his more illustrious compatriot.

Porcellis's influence extended beyond Leiden. Among other emulators, Hans Goderis (active in Haarlem from 1622 to ca. 1640) and Pieter Mulier the Elder (Cat. 18)[41] evolved variations on the Porcellis prototype. Both artists were reasonably prolific and indicate that the innovations of Porcellis found a ready audience elsewhere in Holland. Along with the continuation of Porcellis's idiom in Haarlem, Willem van Diest (Cat. 13) in The Hague practiced a similar tonal manner, producing small-scaled pictures as close in style to Porcellis as those of Pieter Mulier the Elder.

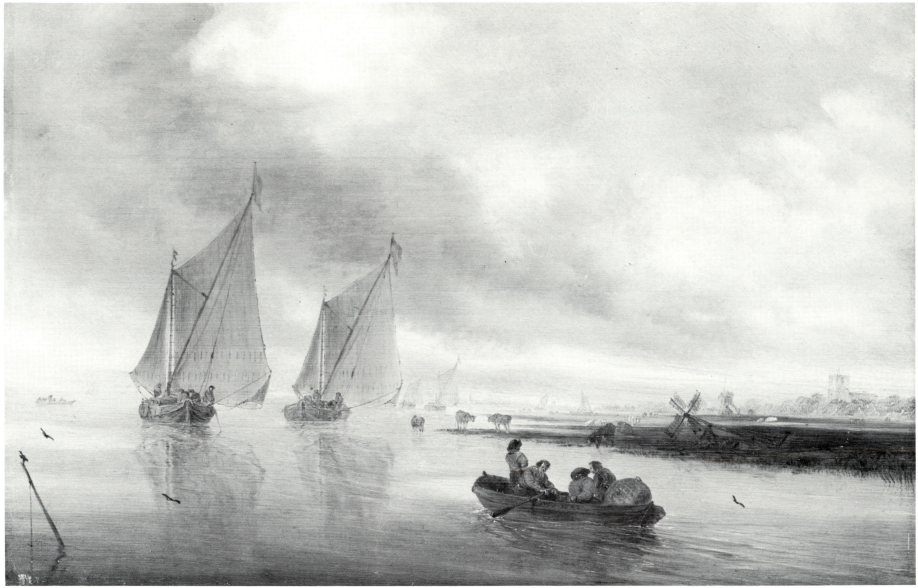

Figure 13 Salomon van Ruysdael, River Landscape, 1643, panel. Copenhagen, Statens Museum for Kunst.

The type of monochrome marine painting developed by Jan Porcellis had great impact on the marines and riverviews of Jan van Goyen – the greatest Dutch landscape painter of the tonal phase. Starting in the early 1630s, van Goyen began representing the inland seas of Holland. Like Porcellis, he owned a sailboat in which he traversed much of the Dutch Republic. During his journeys van Goyen produced sketchbooks filled with hundreds of rapid black-chalk drawings, impetuous studies of rivers, river towns, and villages, and the myriad human activities associated with them.[42]

Van Goyen's subject matter illustrates the difficulty of trying to establish a clear-cut dividing line between landscape and marine art. His numerous river scenes, including views of many celebrated Dutch river towns,[43] contain spirited representations of sailboats, ferries, and passenger barges, ubiquitous features that played an important role in everyday Dutch life.[44] The river landscapes, together with van Goyen's representations of the estuaries and inland seas of Holland (Cat. 17), constitute a sizeable percentage of his total oeuvre.

Abraham van Beyeren was attracted to the distinctive traits of van Goyen's later paintings. Although principally noted as a painter of fish, *pronk* (ostentatious) still lifes, and breakfast still lifes, van Beyeren also produced a handful of marines (Cat. 9) that are robust in character and exhibit his great love for the sea.

Van Goyen set an influential example for Salomon van Ruysdael, his almost exact contemporary. Ruysdael painted many riverviews and late in his career also turned to marine themes.[45] The latter constitute an appealing aspect of his output and complement his much larger series of riverviews – his best-known subjects. The finest of these river landscapes conform to the double diagonal composition favored by so many Dutch landscape painters of the tonal phase. In Ruysdael's case these range from the truly monochrome works of the early 1630s to his much more stately versions from the mid-1640s and the 1650s (Cat. 27). Ruysdael produced exceptions to this type, including two remarkable pic-

tures in Copenhagen and Mainz (Fig. 13), in which he emphasizes the sailboats reflected in the mirroring water, as smooth as glass. Ruysdael's late marines are small panel paintings, evidently intended to appeal to the connoisseur. Like van Goyen's comparable late marines, these must have been tremendously successful because the artist produced many such exquisite and spirited subjects. With few exceptions Salomon van Ruysdael depicted his river landscapes and inland seas in relatively calm weather. As a result, his pictures attain a refinement and poetic serenity in contrast to the more vibrant and robust concept of van Goyen. Late in his career van Goyen also painted marines in calm weather. In their serenity these panoramic marine subjects express a breadth of vision that is one of the supreme achievements of the Dutch school (Fig. 14).

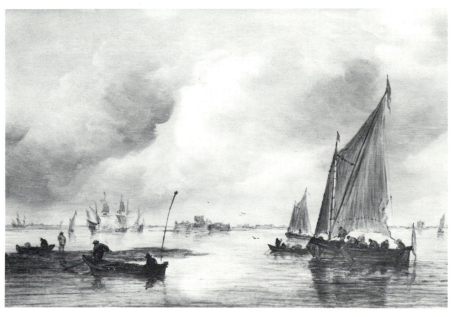

Figure 14 Jan van Goyen, Marine, *panel. Vienna, Akademie der bildenden Künste.*

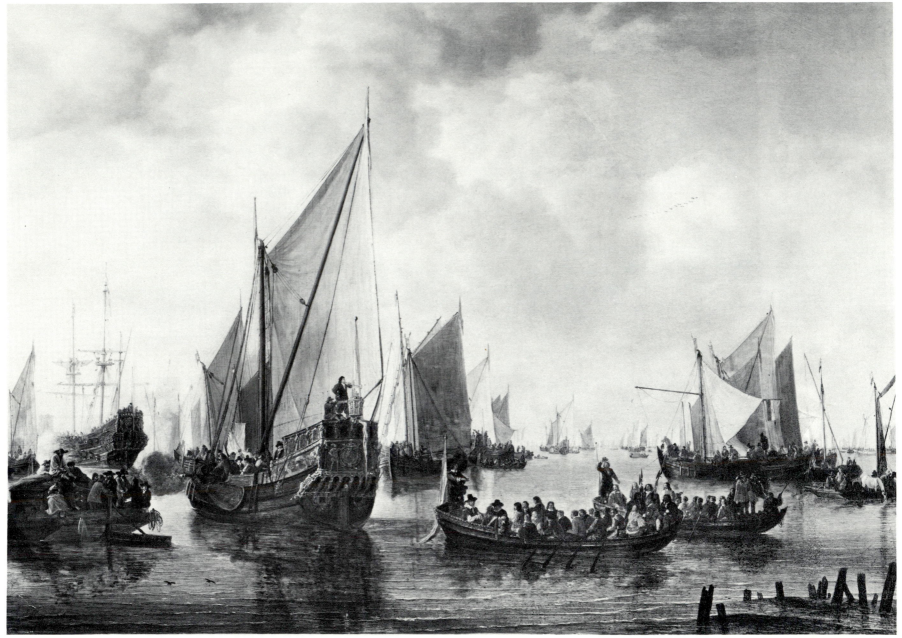

Figure 15 *Simon de Vlieger,* Parade, *panel. Vienna, Kunsthistorisches Museum.*

SIMON DE VLIEGER AND HIS TRANSFORMATION OF THE LEGACY OF JAN PORCELLIS

Dutch marine art developed significantly in the art of Simon de Vlieger, who adapted Porcellis's accomplishments and monochrome palette and applied them to a broader range of subject matter, including themes not treated by Porcellis. De Vlieger represented harbor views and shipping in estuaries, and is intimately associated with the theme of the *parade* (Fig. 15),[46] in which the artist depicts a large assemblage of ships in close but stationary formation. These subjects involve the embarkation or disembarkation of dignitaries from a fleet, an action that invariably involves the firing of salutes and other appropriate fanfare. By developing this theme de Vlieger is able to include details, such as firing cannons and figures in barges and yachts approaching the fleet,

that enliven these subjects enormously. The *parade* constitutes a drastic rethinking of one of the major themes painted by Hendrick Vroom, van Wieringen, and Willaerts: the arrival of a dignitary at a Dutch port (Cat. 53, 54).

De Vlieger seems to have been particularly cognizant of certain pictures by Willaerts.[47] De Vlieger's interest in the human dimension finds a striking parallel in his beach scenes, which rank among the artist's most notable and admired subjects (Fig. 16).[48] His skill in evoking silvery atmospheric effects is perfectly mirrored in his beach scenes and in numerous representations of the Dutch estuaries under cloudy skies. The finest of these date from the mid-1630s through the mid-1640s. De Vlieger refined the monochrome palette of Porcellis in a wide range of subjects. In embracing a broad repertory of maritime themes, de Vlieger up-

Figure 16 Simon de Vlieger, Beach Scene, *panel. Greenwich, National Maritime Museum.*

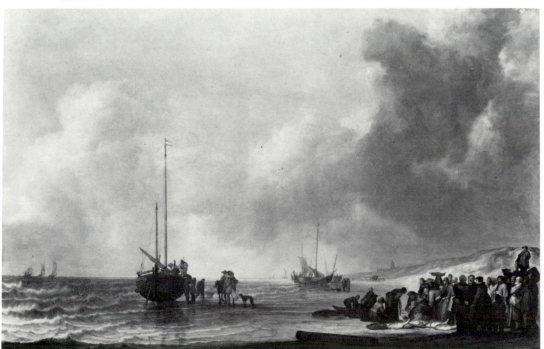

dated the subject matter of Hendrick Vroom and his contemporaries. He contributed as readily to history painting as to the shipwreck and beach themes, and was equally comfortable working on a large scale or producing small works on panel recalling the manner of Porcellis.

In certain fundamental respects Simon de Vlieger anticipated the direction Dutch marine art would assume for the remainder of the seventeenth century. He avoided narrow specialization in his repertory of maritime subjects. De Vlieger also made a distinguished contribution to landscape. He paid considerable attention to designing complex compositions which manifest an increasing sense of visual elegance.

The artist brought to his subjects a degree of conscious aesthetic consideration which is a significant new ingredient in marine painting. However, de Vlieger's primary interest, evident in all of his paintings, remains the sea and the climatic conditions that define the character of the Dutch coast and its inland waterways. Like Porcellis, de Vlieger was fascinated by the interaction of the elemental forces of nature manifested in the changing outward appearance of the marine subject. He was an accomplished draftsman whose rare marines (Cat. 89), wooded landscapes, and studies of animals reveal his profound love for nature.[49]

To what degree de Vlieger had pupils remains uncertain, but his impact on Dutch marine art was considerable, not only on painters who perpetuated the monochrome tradition of Porcellis[50] but also on those of the younger generation whose art superseded the limited scope of the purely tonal phase of Dutch marine painting.

The artist whose name is most closely associated with Simon de Vlieger is the self-taught painter Jan van de Cappelle, son of a wealthy dyeworks owner. A member of the patrician class of Amsterdam, he moved in the most prominent social circles and collected an enormous amount of art including an illustrious group of six thousand drawings. Among these were more than thirteen hundred drawings by Simon de Vlieger,[51] whom van de Cappelle admired greatly. Unlike de Vlieger, Jan van de Cappelle restricted his choice of subject matter to three themes: shipping in a calm, seascapes in breezy weather, and winter landscapes. Furthermore, van de Cappelle never represented the open ocean but focused on the coast and estuaries of the Dutch Republic. This artist's paintings of scenes in calm weather are his most ambitious and celebrated pictures. The silvery, transparent atmosphere he captures in these works is a marvel of close observation of the Dutch climate. These "calms" are the culmination of the tradition of tonality in Dutch marine painting. Van de Cappelle infuses his scenes with poetic grandeur. The interaction between shimmering sea and the elegantly patterned drifting cloud formations, the luminous effect of sails caught in raking light and reflected in the calm water, achieved a stately dignity that found widespread appeal.

The refined pictorial structure evident in van de Cappelle's works became an integral feature of Dutch marine painting during the second half of the seventeenth century.[52] Although Simon de Vlieger foreshadowed this quality in some of his most important mature pictures, it was Jan van de Cappelle who first fully orchestrated the effects of light, filtered light, and atmosphere in perfectly controlled compositions.

Jan van de Cappelle's impact is effectively demonstrated by the oeuvre of his little-known, almost exact contemporary, Hendrick Dubbels. Although Dubbels remains a shadowy figure, his few documented paintings reveal him to have been an artist of great ability.[53] His marines are compositionally sophisticated. In his range of subjects Dubbels parallels Simon de Vlieger, to whom he was also deeply indebted. Conversely, his pictorial syntax displays an elegance and concern for aesthetic considerations that ally him closely to Jan van de Cappelle. In adapting the styles of his more illustrious compatriots, Dubbels became something of a chameleon. He strove for the august effect, and certain of his marines attain a grandeur that parallels that of the rare marines of Jacob van Ruisdael.

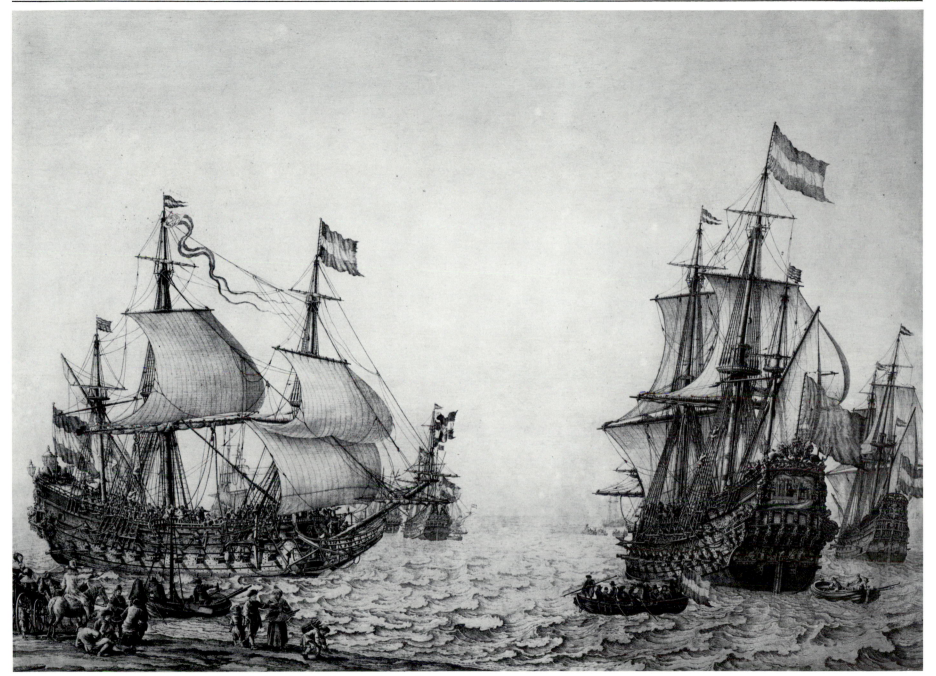

Figure 17 Willem van de Velde the Elder, The Dutch Ship Oosterwijk, *panel.*
Greenwich, National Maritime Museum.

Figure 18 Willem van de Velde the Elder, A Man of War, *black chalk, gray wash. Haarlem, Teylers Museum.*

WILLEM VAN DE VELDE THE ELDER AND THE RETURN TO THE HISTORY PIECE

For the general public Dutch marine art is synonymous with the two Willem van de Veldes, father and son. Despite their common interests, Willem van de Velde the Elder specialized in pen paintings (*pinseel schilderijen*) executed on canvas or oak panels coated with a specially prepared white ground (Fig. 17). These exactly rendered subjects record minute detail in a linear style that recalls the hatching patterns of reproductive engraving. Whether van de Velde was the inventor of pen painting of this type remains uncertain, but he brought it to perfection.[54] He was also a prolific draftsman; literally thousands of his drawings survive (Cat. 77–88) and constitute a uniquely valuable document re-creating the appearance of momentous naval events.[55] These drawings range from rapid overall sketches of naval battles to huge friezes re-

cording the same events. He also executed hundreds of precise, large-scale ships' portraits, usually in black chalk heightened with gray wash (Fig. 18). Willem van de Velde the Elder accompanied the Dutch fleet on several occasions in a small galliot, and sketched events as they occurred.[56] Later, after his permanent move to England in the winter of 1672–1673, he accompanied the English king on state occasions to sketch the royal progress. No Dutch marine artist was a more patient and astute observer of ships. In this respect Willem van de Velde the Elder harked back to the tradition of Hendrick Vroom and, like Vroom, was principally interested in recording significant maritime events. Van de Velde interpreted marine subject matter in terms of ships and naval maneuvers to the virtual exclusion of natural surroundings.

The most distinguished patron of the two Willem van de Veldes, the reigning English monarch, Charles II, recognized the complementary role of Willem van de Velde the Younger. In their contract, dated January 12, 1674, Charles II agreed to give each artist an annuity of £100 for the following:

> the Salary of One hundred pounds p. Annm unto William Van de Velde the Elder for taking and making Draughts of seafights, and the like Salary of One hundred pounds p. Annm unto William van de Velde the Younger for putting the said Draughts into Colours for our particular use.[57]

Willem van de Velde the Younger utilized his father's drawings to produce fully colored paintings. Even at a young age he followed a course independent of his father's influence. The son is thought to have studied with Simon de Vlieger for a possible duration of three years.[58] His contact with the subtle tonalism of de Vlieger's mature paintings inspired Willem van de Velde the Younger to concentrate on the unique light and atmosphere of the sea and coastal sandy reaches of Holland. Unlike Jan van de Cappelle, who chose to explore atmospheric effects, Willem van de Velde stressed the resonance of local color, and his palette enabled him to record maritime features in great detail while

simultaneously enveloping ships in a delicate, pervading atmosphere that, to a unique degree, captures the special climate of the sea. Clouds vaulting above the ships blend imperceptibly with the pale blue of the sky; the partially cloudy sky creates a penumbra that filters the sunlight and illuminates the ships and their surroundings in an almost magical light. Although ultimately moving away from the tradition of monochrome tonality, Willem van de Velde the Younger did retain subtle atmospheric effects in his pictures from the mid-1650s and onward, before his move to England.

Willem van de Velde the Younger's insistent respect for the integrity of local color and his evocation of a less atmospherically-laden sky find a parallel in contemporary developments in Dutch landscape painting. Shortly before 1650 certain landscape artists, including the young Jacob van Ruisdael, formulated an idiom in which colors became more resonant and light more limpid. These landscapes are more stately in composition and august in mood, and reflect a concern for a sense of aesthetic resolution. This same quality is encountered in Jan van de Cappelle's finest marines of the 1650s.

Visual artifice progressively plays a more important role in Dutch painting during the second half of the seventeenth century. The early marines of Willem van de Velde the Younger address these issues in the context of marine painting. Early in his career he produced a handful of diminutive beach scenes and a larger number of calms that are among the most refined marine subjects of the seventeenth-century Dutch school. These are a synthesis of the tonal achievements of Simon de Vlieger and Jan van de Cappelle, yet strike out in a new direction. Light is clearer and the atmosphere more transparent. Van de Velde the Younger captures the effects of objects shimmering, reflecting, and glowing in pervading light. In these pictures Willem may have been inspired by the exquisite beach scenes painted by his younger brother, the landscape painter Adriaen van de Velde (Amsterdam 1636–1672).[59]

Conforming to his father's ambitions, Willem van de Velde the Younger also painted large-scale history pieces, his most celebrated achievements, including naval battles (Cat. 40), *parade* subjects (Cat. 35), the ceremonial arrival of dignitaries joining the fleet (Cat. 36), and harbor views filled with shipping. These bring Dutch marine art full circle back to the repertory of its founders, Vroom, van Wieringen, and Willaerts, yet the subjects have been stylistically updated within the conventions developed during the second half of the seventeenth century. Van de Velde the Younger also returns to other themes initially developed by Hendrick Vroom: ships isolated on the high seas and ships in storms. These vibrant images complement van de Velde's serene calms and indicate his interest in the full range of North Sea weather conditions.

During the winter of 1672–1673 Willem van de Velde the Elder moved to London, and with the exception of occasional journeys back to Amsterdam, remained there until his death in 1693. His son may have moved to London slightly earlier. In any case, the two continued to collaborate, principally fulfilling commissions for Charles II and his brother James, Duke of York. They laid the foundation for the nascent British school of marine painting. Willem van de Velde the Younger had a number of pupils and emulators who perpetuated his style. Artists such as Peter Monamy (1670–1749) and Charles Brooking (1723–1759) show his influence, but in their conformity to established convention their art lacks the pictorial range and subtlety of Willem van de Velde the Younger at his best. It remained for J.M.W. Turner in the early nineteenth century to transform and revitalize British marine painting. Turner's romantic, often turbulent marines indicate that he sought inspiration from a wide selection of Dutch old masters, but Cuyp and Jacob van Ruisdael captured his most intense admiration, tempering his interest in the Willem van de Veldes and opening up vast new horizons for his own work and ultimately the entire British school.

OVERLAP WITH LANDSCAPE, CA. 1650–1670

About 1650 a fundamental shift in Dutch landscape painting had far-reaching impact and began to affect marine painting. In a number of works painted shortly before 1655 a younger generation of artists challenged the dominance of the monochrome tradition they had supplanted. Chief among these was Jacob van Ruisdael, who was initially active in Haarlem but who had settled in Amsterdam by the mid-1650s. Ruisdael redefined the character of landscape art: His early landscapes show a return to more intense local coloring. The contrast between light and shadow in his pictures is more extreme, yet the light is clearer and the shadows become more transparent. As a result, colors are resonant and even those passages of landscape in deep shadow contain areas of residual light. Ruisdael also creates compositions with greater stress on verticality, introducing a stateliness and grandeur to his subjects absent in the monochrome landscape tradition of the preceding generation. These qualities appealed to marine painters such as Willem van de Velde the Younger, Reinier Nooms, and Ludolph Backhuysen, all of whom were Ruisdael's almost exact contemporaries. The very nature of the subject matter they addressed in their paintings was ideally suited to Ruisdael's investigations in his landscapes of the early 1650s and later.

Ruisdael rarely turned his attention to marines and beach scenes, but his few excursions into these subjects are memorable and influential. His *Rough Sea* (Cat. 25) in Boston, for example, exemplifies the artist's magnificent rendering of light and shadow that play across the choppy water, forcefully highlighting the agitated seas in the foreground and the white sail of the boat at right center. The procession of clouds set off by patches of blue sky complements the restless, rhythmic motion of the whitecaps and creates a complex fugue of motion that is an essential feature of Ruisdael's best works. The exhilaration evident in *A Rough Sea* is replaced by a brooding quality in Ruisdael's stormy scenes, in which the artist depicts a pier and fire tower projecting into tossing seas below inky, scudding clouds (Fig. 19). These windswept subjects are further animated by the artist's masterful recording of occasional shafts of intense light piercing the gloom. Ruisdael also painted beach scenes that are among the most magisterial contributions to the subject. Unlike the serene beaches painted by Adriaen and Willem van de Velde, Ruisdael's are charged by dramatic light effects filtered by shifting clouds above vast stretches of shore and sand dunes.

The style of marine painting formulated by Ruisdael finds a parallel in the pictures of Allaert van Everdingen and Johannes Blanckerhoeff (Alkmaar 1628 – 1669 Amsterdam). L. J. Bol argues for Everdingen's primacy over Ruisdael in painting choppy seas in blustery weather.[60] Everdingen influenced Ruisdael in the representations of Scandinavian waterfalls, and his rare marines

Figure 19 Jacob van Ruisdael, Pier in a Storm, *canvas. Fort Worth, Kimbell Art Museum.*

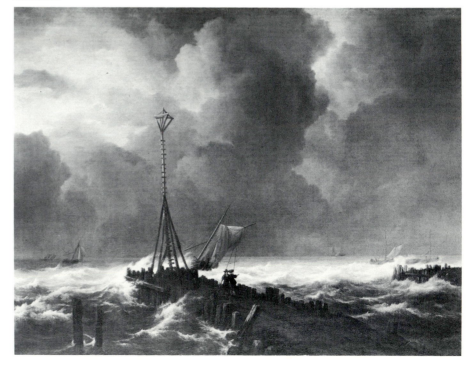

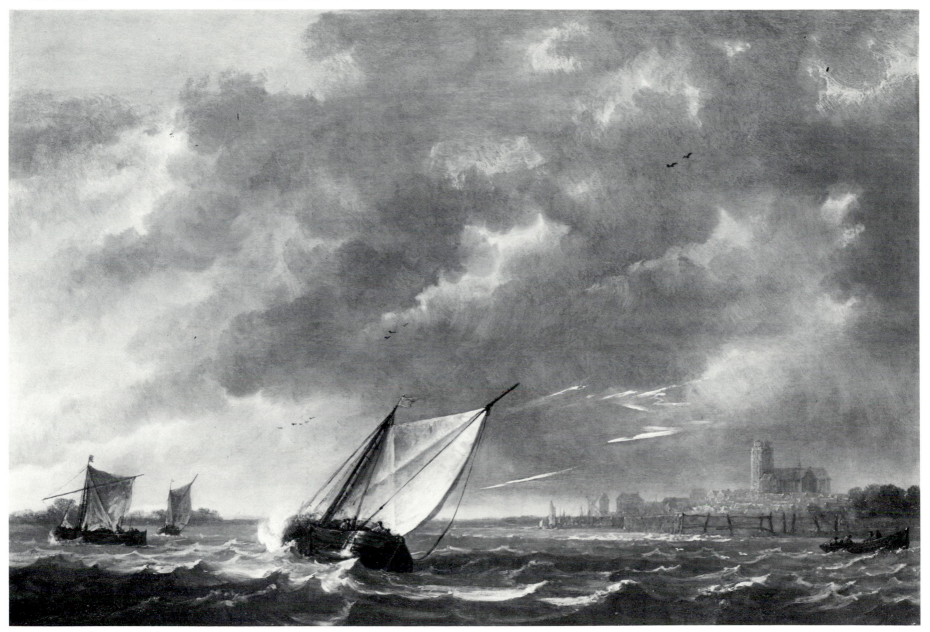

Figure 20 Aelbert Cuyp, The Maas at Dordrecht in a Storm, *panel. London, The National Gallery.*

possibly assumed a similar role.[61] Almost invariably Everdingen chose to represent turbulent weather conditions. In composition and mood most of Everdingen's later marines seem to emulate the more assured and subtle concept realized by Ruisdael. In one spectacular painting Everdingen made a unique contribution to the subject by representing a violent winter storm with a channel marker tossing amid waves in snowy weather.[62]

Another Dutch landscape painter whose riverviews and marines had great impact was Aelbert Cuyp (Dordrecht 1620–1691).[63] His many views of the River Maas at Dordrecht concentrate on shipping in placid weather. Cuyp evokes a tranquil image of river traffic, bathing the subject in warm golden light reflected by the glassy surface of the unruffled water. He also occasionally represents ceremonial events,[64] but his finest marine (Fig. 20), possibly inspired by the example of Jan van Goyen, depicts an inland sea with a sailboat at the onset of a thunderstorm; a lightning bolt threatens the beleaguered vessel. Cuyp captures the effect of light gleaming through the quilted canopy of lowering clouds. This unique masterpiece further indicates the artist's brilliance in representing unusual and visually evocative weather conditions.

The Dutch Italianate landscape painters were one source of inspiration for Aelbert Cuyp's golden light. About 1640 many of these Italianate artists contributed to the tradition of Dutch marine art introducing new themes to the standard repertory. Painters such as Jan Asselyn, Jan Baptist Weenix, Thomas Wyck, Adam Pynacker, Nicolas Berchem, and Johannes Lingelbach produced Mediterranean harbor views and coastal landscapes that greatly appealed to contemporary Dutch collectors. The subjects represented by these artists are usually replete with genre details and reflect the active trade that existed between the Dutch Republic and the Mediterranean.

Early in their careers, Asselyn and Weenix adopted this strain of Italianate subject matter and in at least one notable instance collaborated.[65] They concentrated on depicting the luminous clear light of Italy and its effect on distinctive architectural monuments.

Both were fine painters of staffage. Weenix often included modishly attired figures, peasants, sailors, and a variety of domesticated animals that occupy the foreground in his imaginary harbor views.[66] Berchem elaborated on this tradition in lively Mediterranean seaport subjects.[67] The German-born painter Johannes Lingelbach (Frankfurt-am-Main 1622 or 1624–1674 Amsterdam) contributed to this theme, but he also painted views of the Dam in Amsterdam that capture the bustle of the leading metropolis of Holland (Fig. 21).[68]

Adam Pynacker's (Pynacker 1621–1673 Amsterdam) representations of loaded boats off mountainous coasts count among his most subtle and distinctive subjects. He usually depicts boats moored in the foreground in beautifully modulated hazy afternoon light. The intense raking light and the atmosphere it generates cast a poetic mood over these scenes. To what degree these subjects represent a real coastline remains uncertain, for the open boats depicted are hardly seaworthy, oceangoing vessels. Possibly Pynacker evokes the setting of certain Italian lakes in these unusual pictures.[69]

Figure 21 Johannes Lingelbach, The Dam, Amsterdam. *Amsterdam, Rijksmuseum.*

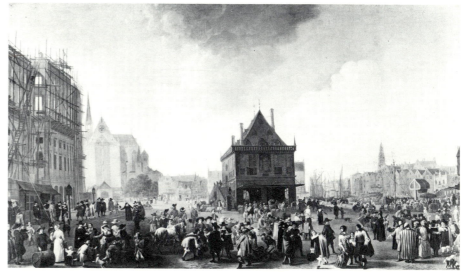

Like the painters of the native Dutch scene, the Italianate land-scapists explored new methods of composition that contributed to the development of a more refined and stately image of nature. In addition, they skillfully captured the glowing light of Italy. Reinier Nooms was one of a number of artists of the mid-seventeenth century who appreciated the significance of their art. His contributions were central to the further development of marine art in Amsterdam.

REINIER NOOMS, LUDOLPH BACKHUYSEN, AND OTHER CONTEMPORARIES OF WILLEM VAN DE VELDE THE YOUNGER

Reinier Nooms, nicknamed "Zeeman" (the Seaman), is one of the most distinguished Dutch marine artists of the mid-seventeenth century. He was a gifted draftsman whose brush and wash drawings (Cat. 68–72) are among the supreme achievements of the Dutch school. Many of these drawings served as studies for etchings of superb quality, and some of these prints (Cat. 108–115) rank among the glories of the Dutch tradition of the *peintre-graveur*. Nooms's drawings strongly affected the character of virtually all subsequent Dutch marine draftsmen. Following the example of Porcellis, he often serialized the subject; many of his drawings and the prints made from them document specific types of sailing vessels and their maneuvers, providing accurate images that have been invaluable in identifying ships in other artists' paintings. Nooms had the rare gift of combining veracity with vivaciousness. His graphic output is both informative and spirited, his technique elegant.

As a painter Nooms is less consistent in quality, but his pictures are visually appealing and valuable as documents recording various aspects of shipbuilding and ship maintenance, which fascinated the artist. Frequently he represents ships by harbor palisades and ships being careened or caulked (Fig. 22 and Cat. 19). Nooms favored a silvery-gray tonality in many of his Dutch views. His

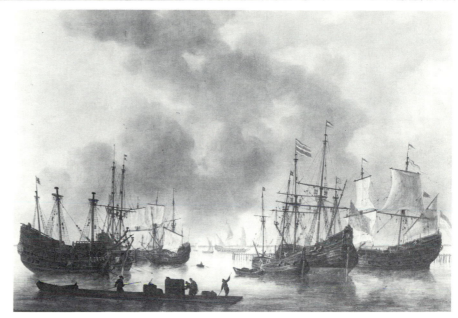

Figure 22 Reinier Nooms, Ships at Anchor, *canvas. Formerly London, The Leger Galleries.*

palette and evocation of a moisture-laden but still transparent atmosphere is kindred to the mature oeuvre of Simon de Vlieger, with whom he may have studied.[70] Nooms also painted Mediterranean subjects (Fig. 23) and topographical views of Moorish citadels along the coast of North Africa. Occasionally he represented large-scale naval battles (Cat. 20, 21), but his finest paintings are his small cabinet pictures of shipping in Dutch harbors.

Ludolph Backhuysen, almost ten years younger than Nooms, became a leading marine painter in Amsterdam during the second half of the seventeenth century. Influential and far more versatile than is generally realized, Backhuysen has recently received long overdue recognition,[71] but a certain histrionic quality in many of his pictures still obscures full awareness of his achievement.

Backhuysen was a gifted draftsman whose approach differs markedly from that of the Willem van de Veldes. Although he executed rapid pen and wash studies, Backhuysen's most notable

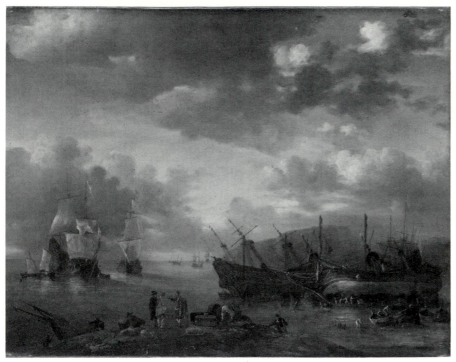

Figure 23 Reinier Nooms, A Mediterranean Harbor, *canvas. Copenhagen, Statens Museum for Kunst.*

miralty now in the Rijksmuseum in Amsterdam.[73] Even at a young age Backhuysen wished to demonstrate his versatility and virtuosity as an artist.

Backhuysen developed a sizable repertory of marine subjects. He also produced several portraits, a number of allegorical representations, and the occasional religious subject.[74] This artist was ambitious and produced large-scale pictures ranging from naval battles to harbor views bustling with shipping, ships in stormy weather (Fig. 24), and shipwrecks in treacherous waters off rugged mountainous coasts. Only occasionally did he paint calms. Backhuysen preferred brisk breezes and the full range of blustery to tempestuous weather conditions.

Samuel van Hoogstraeten uses the term "selective naturalism" to describe Porcellis's visual discrimination. The same concept applies equally to Backhuysen, evident in the attention the artist pays to the gleaming surface and strong colors of the tossing sea, and his equally great interest in contrasting deeply colored cloud banks to patches of clear blue sky.[75] Porcellis and Backhuysen are separated by an immense gulf in terms of their visual focus. The period between 1632, the year of Porcellis's death, and the mature years of Backhuysen saw an extraordinary evolution of Dutch marine painting. There was a return to a brighter color range employed in compositions, which are both stately and dynamic. Backhuysen infused an evident sense of drama into pictures frequently tinged with hyperbole; this grandiloquent element must have appealed to collectors, for it is a quality frequently encountered in Backhuysen's paintings and a recurring ingredient in the pictures of his imitators.

When the two Willem van de Veldes moved to England, Backhuysen became the undisputed leading marine painter of the Dutch Republic, and his style was widely emulated. As Bol points out, Backhuysen was the only Dutch marine artist of the second half of the seventeenth century to have a sizable number of followers.[76] Backhuysen's own art, increasingly conventional, eventually declined into brittle recapitulations of subjects that he had

drawings are highly finished (Cat. 56, 61) and were intended for the discerning connoisseur. His finest drawings are precisely detailed: The artist used the brush as if it were a pen to attain sharp linear clarity. He then applied delicately modulated gray washes that record subtle atmospheric effects, particularly evident in the definition of the clouds and in the rendering of light and shadow on the water. His love of gray ink could have been inspired by Nooms's robust brush and gray ink drawings. Backhuysen's well-known series of etchings[72] relate to certain of Nooms's print series and may possibly have been conceived in emulation and as an updating of the elder artist's achievement. Backhuysen's interest in drawing also expressed itself at an early date in pen paintings close in style to those produced by Willem van de Velde the Elder. The most novel of these is his *Shipyards of the Amsterdam Ad-*

Figure 24 Ludolph Backhuysen, View of Amsterdam, *canvas. Formerly New York,*
French & Company.

explored with much greater fervor and authority earlier in his career. A younger generation – including artists such as Pieter Coopse (active in Amsterdam 1668–1677); Gerrit Pompe (active in Rotterdam during the last third of the seventeenth century); Jan Claes Rietscheoff (Hoorn 1652–1719); Arnout Smit (Amsterdam 1641/1642–1710); and Wigerus Vitringa (Leeuwarden 1657–1721) – perpetuated Backhuysen's idiom without adding significantly to it. Certain of these artists, particularly Hendrick Rietschoeff, Pieter Coopse, and Wigerus Vitringa, produced highly finished drawings reminiscent of Backhuysen but lacking the energy, vibrancy, and range of his finest pen and wash studies.

A similar sense of gradual decline is evident in the oeuvre of Abraham Storck. He was the third son of the little-known painter Jan Jansz. Sturck of Wesel, who settled in Amsterdam. Abraham's elder brothers, Johannes and Jacob (Amsterdam 1641 – before 1688), were also marine painters. Although little survives by Johannes, Jacob's oeuvre is more substantial and clearly defined.[77] Jacob's activity had considerable impact on his younger brother, Abraham, both in terms of style and in his chosen repertory of marine subjects. Jacob painted many versions of imaginary Mediterranean seaports, some of which have been associated with Genoa, Naples, Venice, and certain Iberian and North African coastal cities. These paintings have a largely imaginary flavor, like a number of pictures by Jan Abrahamsz. Beerstraten,[78] and contribute to the early evolution of the *capricci* so highly developed in Roman and Venetian painting of the eighteenth century.[79] Paralleling these foreign subjects, Jacob also painted familiar views of the canals and harbor of Amsterdam. His favorite theme was the sedate canal in Overtoom lined with gabled residences and teahouses that catered to the leisured upper classes.

Abraham Storck exploited a wider repertory of subjects than his older brothers did. Early in his career he painted a series of battle subjects from the Second Anglo-Dutch War (1665–1666) including representations of the *Four Days' Battle* (Cat. 29, 31), the great Dutch naval victory that helped bring hostilities to a close on terms favorable to the Dutch Republic. These spirited pictures recall the full-scale paintings of Willem van de Velde the Younger, Backhuysen, and Beerstraten, but even in these early battle subjects Storck tends to shift attention from the sea to details of the vessels involved. Storck apparently had no firsthand experience of the event; instead, he seems to have reconstructed the battle from secondary sources and from his imagination.[80]

Ultimately, Storck's interests shifted from this type of historical representation. He followed his brother Jacob's example and painted richly detailed Mediterranean seaports, Dutch canal scenes, and harbor views. Late in his career Abraham added two novel subjects to his repertory: mock battles and whaling scenes. The mock battles were staged on the River Ij before the harbor of Amsterdam. One notable occasion – to honor the Russian ambassadors of Czar Peter the Great on September 1, 1697 – involved an elaborate mock battle and is immortalized in prints.[81] This ceremony was doubtless inspired by Peter the Great's visit in 1697 to Holland, where he resided for two months. He wished to learn as much as he could about Dutch shipbuilding (centered in the Zaanstreek) in his determination to build a Russian naval fleet on the Baltic; in preparation for this endeavor he spent his time in the Dutch Republic fruitfully assimilating the great tradition of shipbuilding in Holland. A large etching by Adriaen Schoonebeek (ca. 1658–1714) represents a man-of-war, *The Praying Peter* (Fig. 25), designed by the czar in 1698 and launched in 1700.[82]

Although whaling had been an important commercial industry in the Dutch Republic throughout the seventeenth century, artists rarely represented it until late in the 1600s.[83] Like his contemporaries Backhuysen, Abraham van Salm (Cat. 28), and Vitringa, Abraham Storck represented scenes of whale hunting in the Arctic, which often include striking vignettes showing sailors disembarked on the ice floes, in mortal combat with polar bears (Fig. 26).

Storck's late pictures dwell on the recreational aspects of sail-

Figure 25 Adriaen Schoonebeek, The Praying Peter, *etching.*

By the late 1600s the innovative force of Dutch marine art was spent. Nonetheless, its legacy was spectacular, particularly in England and France but also in Holland itself. One remarkable feature of Dutch marine painting of the seventeenth century was the degree to which it monopolized the field. When the seventeenth-century monarchs of England, France, Denmark, and Tuscany wished to commission marine paintings, they almost invariably turned to Dutch artists. As a result, no indigenous schools of marine art evolved in France and Scandinavia, and even England's native school of marine painting did not materialize until the Willem van de Veldes settled in London and fostered sufficient interest in the subject. The English school of marine painting of the eighteenth century evolved largely along the lines established by Willem van de Velde the Younger. His

Figure 26 Abraham Storck, Whaling in an Arctic Ice Sea, *canvas. Amsterdam, Rijksmuseum.*

ing – inevitably in optimum weather conditions. In general, his later output illustrates the fundamental shift evident in late-seventeenth-century Dutch art from innovation to a complacent consolidation of tradition. Storck's paintings reveal society content with its condition, unable and unwilling to initiate changes.

Following the Glorious Revolution of 1688, when William and Mary assumed the English throne, the deposed monarch, James II, fled to France. The new king of England radically redefined the role of the Dutch navy in his developing struggle against Louis XIV. Ultimately, William III chose to phase out the Dutch navy as an independent presence and merge it with a larger Anglo-Dutch fleet, which he pitted against the territorial ambitions of France. The last great action of the Dutch navy was the battle in the Bay of Vigos (1702).

English followers and emulators focused on van de Velde's calms and concentrated on representations of ships' portraits. This type of marine became immensely popular throughout Europe and the United States during the nineteenth century, and still remains an active genre of twentieth-century decorative painting.

English marine painting underwent a radical transformation with the exhilarating contribution of J.M.W. Turner, whose revitalization of the subject had lasting influence on nineteenth-century romantic marine art. Turner, familiar with many of the works of the greatest Dutch landscape and marine painters of the seventeenth century, particularly admired Aelbert Cuyp and Jacob van Ruisdael, and traveled to Holland on more than one occasion to familiarize himself with the country that inspired these masters.[84] Turner paid homage to these and other Dutch painters in his exuberant and often turbulent marines in which he stresses the sublime in nature. The immeasurable and often destructive power of the sea dwarfs human endeavor in many of Turner's paintings, whereas in other pictures, such as *Peace: Burial at Sea* and *The Fighting Temeraire*,[85] the artist makes reference to the industrial revolution and the degree to which it transformed traditional subject matter. Turner's repertory of marine subjects was vast. He represented not only paradigmatic romantic subjects brimming with explosive energy but also seaports and calms that are serene and visionary in mood.

During the romantic period a number of marine painters in Holland revitalized the great tradition of their seventeenth-century predecessors. Painters such as Martinus Schouman, Johannes Christiaan Schotel, J.H.L. Meyer, Hermanus Koekkoek, and others produced vibrant, wave-tossed subjects that have recently come back into vogue.[86] Their themes owe a debt to Turner, whose lofty and sublime vision of the sea surpassed their more limited ambitions. In certain respects – for example, in their interest in cool, clear light and their penchant for sharply rendered detail – these Dutch marine painters of the nineteenth century pay homage to their seventeenth-century forebears and demonstrate the deep sense of tradition that spanned more than two centuries.

GEORGE S. KEYES

NOTES

1. Greenwich, National Maritime Museum, *The Art of the Van de Veldes*, 1982 (catalogue by D. Cordingly); Amsterdam, Rijksmuseum "Nederlands Scheepvaart Museum," *Ludolf Backhuizen 1631–1708 schryfmeester-teyckenaer-schilder*, 1985 (catalogue by B. Broos, R. Vorstman, and W. L. van de Watering).

2. J. Walsh, Jr., "The Dutch Marine Painters Jan and Julius Porcellis – I: Jan's Early Career," *Burlington Magazine* 116 (1974), pp. 653–662; Walsh, "The Dutch Marine Painters Jan and Julius Porcellis – II: Jan's Maturity and de Jonge Porcellis," *Burlington Magazine* 116 (1974), pp. 734–745; G. S. Keyes, *Cornelis Vroom: Marine and Landscape Artist*, Alphen aan den Rijn, 1975; M. Russell, *Jan van de Cappelle*, Leigh-on-Sea, 1975; M. Russell, *Visions of the Sea: Hendrick C. Vroom and the Origins of Dutch Marine Painting*, Leiden, 1983; J. Kelch, "Studien zu Simon de Vlieger" (diss.), Berlin, 1975.

3. This relationship is significant but must not be used as a means of imposing an external value system onto marine art designed to be applicable to landscape. For discussion of this issue, see W. Stechow, *Dutch Landscape Painting of the Seventeenth*

Century, London, Phaidon, 1966, p. 110. A more recent examination of this relationship at the beginning of the 1600s is M. Russell's essay "Seascape into Landscape," in London, National Gallery, *Dutch Landscape: The Early Years. Haarlem and Amsterdam 1590–1650*, 1986 (catalogue by C. Brown), pp. 63–71.

4. My assessment of this broad subject, although differing in structure from that of previous broad surveys of Dutch marine painting, nevertheless is tempered by the general surveys of Willis, Preston, and Bol: F. C. Willis, *Die Niederländische Marinemalerei*, Munich, 1911; L. R. Preston, *Sea and River Painters of the Netherlands in the Seventeenth Century*, London, 1937; L. J. Bol, *Die Holländische Marinemalerei des 17. Jahrhunderts*, Braunschweig, 1973 (hereafter cited as L. J. Bol, 1973).

5. For a more comprehensive inclusion of lesser-known marine artists, see L. J. Bol, 1973.

6. This political entity came into being despite the sustained efforts of William the Silent to find a suitable monarch to head the Dutch state. His overtures to the Valois house of France and to Queen Elizabeth I of England both came to naught.

7. The impact of this Flemish immigration is treated in depth in J.G.C.A. Briels, "De Zuidnederlandse immigratie in Amsterdam en Haarlem omstreeks 1572–1630" (diss.), Utrecht, 1976.

8. As recently defined by L. O. Goedde, "Tempest and Shipwreck in the Art of the Sixteenth and Seventeenth Centuries: Dramas of Peril, Disaster and Salvation" (diss.), Columbia University, 1984, and Goedde, *Tempest and Shipwreck in Dutch and Flemish Art: Convention, Rhetoric, and Interpretation*, University Park, Pa., 1989.

9. For example, the turbulent vista in Bruegel's *Stormy Day* of 1565 in Vienna representing the advent of spring in its most bleak manifestation (repr. W. Stechow, *Pieter Bruegel the Elder*, New York, 1969, p. 101, pl. 25) or his preparatory drawing for *SPES* in Berlin (see Berlin, Staatliche Museen Preussischer Kulturbesitz, Kupferstichkabinett, *Pieter Bruegel der Alterer als Zeichner*, 1975, pp. 66–67, cat. 70, pl. 100).

10. Published by N. Beets, "Cornelis Anthonisz.," *Oud Holland* 56 (1939), pp. 160–184, pls. 6, 12, as by Cornelis Anthonisz. In its representations of ships and seaports, *The Departure of Henry VIII from Dover to Calais on May 31, 1520* (pl. 12) is the most relevant to our discussion.

11. E. Ritter von Engerth, "Nachtrag zu der Abhandlung über die im Kaiserlichen Besitze befindlichen Cartone darstellend Kaiser Karls V Kriegzug nach Tunis von Jan Vermeyen," *Jahrbuch der Kunsthistorischen Sammlungen des allerhöchsten Kaiserhauses* 9 (1889), pp. 419ff. Also see H. J. Horn, *Jan Vermeyen*, Doornspijk, 1989.

12. At least five tapestries survive from a set and are now in the Palazzo Doria Pamphili in Rome. These were woven in the Low Countries. Although little known, they constitute an important contribution to this type of serialized narrative documenting a recent historical event.

13. C. van Mander, *Het Schilder-Boeck*, Haarlem, 1604, fol. 288r, cites these ten tapestries and stated that François Spierincx of Delft wove them after Hendrick Vroom's designs.

14. For a discussion of these tapestries, see C. de Waard, "De Middelburgsche Tapijten," *Oud Holland* 15 (1897), pp. 65–93, and Keyes, *Cornelis Vroom*, pp. 20–24.

15. R. van Bastelaer, *Les estampes de Peter Bruegel l'ancien*, Brussels, 1908, pp. 39–41, nos. 98–108, repr.; F.W.H. Hollstein, *Dutch and Flemish Etchings, Engravings and Woodcuts 1450–1700*, vol 9, Amsterdam, 1949– , F. Huys nos. 16–26.

16. Van Bastelaer, p. 39, no. 96, repr.

17. Van Mander, *Het Schilder-Boeck*, fols. 287r–288v.

18. L. J. Bol, 1973, p. 13, pl. 6 (in color). This may be the painting cited by van Mander, thus placing it no later than 1604, the year *Het Schilder-Boeck* was published. Russell, *Visions of the Sea*, fig. 122, reproduces a painting, formerly in Schwerin but destroyed during World War II, that she claims is dated 1594. Although impossible to verify, a considerably later date of origin is suggested by the style of this work.

19. As discussed with such animation by C. van Mander in *Het Schilder-Boeck*.

20. See footnote 13. For further discussion of these Armada tapestries, see Keyes, *Cornelis Vroom*, p. 20, and Russell, *Visions of the Sea*, pp. 116–137.

21. See note 14.

22. *Resolutiën der Staten-Generaal*, vol. 11, ed. N. Japikse (R.G.P. Grote Serie 85), The Hague, 1941, p. 358: "9 November werd aan Hendrick Vroom f 150 toegezegd als vereering voor de opdracht van een kaart, die hij had laten snyden van de descente ofte landinge van het leger te philippine."

23. The extraordinarily high price of 2,400 guilders that the Admiralty of Amsterdam paid van Wieringen for his version of the *Battle of Gibraltar* is a clear measure of the importance marine painting held for certain patrons.

24. Like Hendrick Vroom, van Wieringen painted a full range of maritime history subjects including naval battles, the return of merchant fleets, the arrival of dignitaries at Dutch seaports, and scenes of shipping before harbors.

25. Discussed by G. S. Keyes, "Cornelis Claesz. van Wieringen," *Oud Holland* 93, 1979, p. 7; and P. Biesboer, *Schilderijen voor het Stadhuis Haarlem*, Haarlem, 1983, pp. 43–44.

26. Keyes, "Cornelis Claesz. van Wieringen," pp. 3–4.

27. See the forthcoming study by J. Spicer, "Conventions of the Extra-ordinary: Savery, the Willaerts and the Attractions of *Variety*," in which she examines this issue closely, particularly in terms of Savery's impact as a draftsman. I am much obliged to Dr. Spicer for sharing her manuscript with me.

28. For Jan Bruegel the Elder's activities as a painter, see the profusely illustrated monograph by K. Ertz, *Jan Bruegel der Altere Die Gemälde*, Cologne, 1979.

29. See Keyes, *Cornelis Vroom*, pp. 25–26, pl. VII.

30. G. S. Keyes, "Hendrick and Cornelis Vroom: Addenda," *Master Drawings* 20 (1982), p. 117, fig. 2; Russell, "Seascape into Landscape," p. 69, fig. 7, *Shipping Before Middelburg*, engraving by Robert de Baudous after H. Vroom.

31. For van Wieringen as a draftsman, see Keyes, "Cornelis Claesz. van Wieringen," pp. 1–46.

32. Among Willaerts's most notable drawings are the two he contributed to the *Album Amicorum Arnold van Buchell*, Leiden, University Library, Letterkunde 902, fols. 94v, 95r.

33. For Verbeeck, see L. J. Bol, 1973, pp. 45–52.

34. For an illuminating iconographical reading of this theme, see Goedde, "Tempest," 1984; Goedde, "Convention, Realism, and the Interpretation of Dutch and Flemish Tempest Painting," *Simiolus* 16 (1986), pp. 139–149; and Goedde, *Tempest*, 1989.

35. Walsh, "Porcellis – I," pp. 654, 657–659; Walsh, "Porcellis – II," pp. 734, 741.

36. J. G. van Gelder, "Notes on the Royal Collection IV: The Dutch Gift of 1610 to Henry Prince of *Whalis* and Some Other Presents," *Burlington Magazine* 105 (1963), pp. 541–544. These are discussed further by Walsh, "Porcellis – I," pp. 654, 657.

37. The Hoogstraeten text is discussed in detail in Walsh, "Porcellis – II," pp. 737–738.

38. A remarkable gauge of this shift in patronage is the contract signed between

Porcellis and a cooper in Antwerp in 1615. It stipulated that Porcellis, during a period of twenty consecutive weeks, would produce two pictures per week in return for an advance of 32 guilders plus weekly increments of 15 guilders. In turn, the cooper supplied the artist with materials and an assistant and assumed responsibility for trying to sell the pictures on the Antwerp market or elsewhere – see Walsh, "Porcellis – I," p. 657.

39. L. J. Bol, 1973, pp. 105–111.

40. Ibid., pp. 111–113; Leiden, Stedelijk Museum, *De Lakenhal, Geschildert tot Leyden Anno 1626*, 1976/1977, p. 108.

41. For Mulier, see G. S. Keyes, "Pieter Mulier the Elder," *Oud Holland* 90 (1976), pp. 230–261.

42. For a comprehensive illustrated overview of van Goyen's oeuvre, see H.-U. Beck, *Jan van Goyen. Leben und Werk*, 2 vols., Amsterdam, 1972–1973.

43. Ibid., vol. 2, with numerous illustrations. For a recent discussion of the possible meaning of these topographically orientated paintings, see G. S. Keyes, "Jan van Goyen's *River Landscape (Pellekussenpoort near Utrecht)*," *Minneapolis Institute of Arts Bulletin* 66, pp. 48–65.

44. See the fascinating study by J. de Vries, *Barges and Capitalism: Passenger Transportation in the Dutch Economy 1632–1839*, Utrecht, 1981.

45. For Ruysdael, see W. Stechow, *Salomon van Ruysdael Eine Einführung in seine Kunst*, Berlin, 1938 (rev. ed. Berlin, 1975), pp. 110–116, nos. 280–319A.

46. Russell, *Jan van de Cappelle*, pp. 21–22, argues for Jan van de Cappelle's primacy in developing this specific theme and bases this on her reading of the date on van de Cappelle's *Parade* in the Robarts Collection (Russell, pls. 1, 1a) as 1645. Debate on this subject has focused specifically on this painting and a closely related composition by Simon de Vlieger of 1649, *The Visit of Frederick Henry to the Dutch Fleet at Dordrecht* (event 1646), now in the Kunsthistorisches Museum, Vienna (Fig. 15), to the exclusion of a broader assessment of de Vlieger's contribution to and interpretation of the calm as a theme in Dutch marine painting. Representations such as the *View of Amsterdam Seen from the River Ij* (Cat. 120) after De Vlieger contain many of the ingredients of the *parade* theme.

47. Certain pictures by de Vlieger feature rugged mountainous shorelines totally antithetical in character to the expansive sandy beaches constituting the Dutch coast. These are reminiscent of certain paintings by Adam Willaerts including his oval *Shipwreck* in Amsterdam and his many versions of the *Arrival of the Winter King in Prague*, in which the imperial palace, the Hradcany, is perched high above vast slopes dotted with conifers and strewn with boulders leading down to the water. These curious approximations of a quasi-alpine terrain were in all probability inspired by the remarkable large-scale colored-chalk drawings that Roelandt Savery executed in the Tyrol while at the court of Rudolph II but brought back to Holland with him. Certain of these were copied by Lambert Doomer – see W. Schulz, "Doomer and Savery," *Master Drawings* 9 (1971), pp. 253–259 – before being incorporated into the famous *Atlas Blaeu–van der Hem* now in the Osterreichisches Nationalbibliothek in Vienna – see J. Spicer, "The Drawings of Roelandt Savery" (diss.), Yale University, 1979.

48. Although largely falling beyond the parameters of this exhibition, the beach subject and de Vlieger's seminal role in its development remain to be written. It first evolved in terms of the Mannerist representation of stranded whales often interpreted as a foreboding of God's wrath vented against the wayward ways of the Dutch people – see W. Timm, "Der gestrandete Wal. Eine motivkundige Studie," Staatliche Museen zu Berlin, *Forschungen und Berichte*, vols. 3–4, 1961, pp. 76–93; E. Haverkamp Begemann, *Willem Buytewech*, Amsterdam, 1959, pp. 29–30; and E.K.J. Reznicek, *Die Zeichnungen von Hendrick Goltzius*, Utrecht, 1961, pp. 112, 442–443.

Jan Porcellis transformed this subject in his celebrated picture in the Mauritshuis (Cat. 23) representing a shipwreck off a beach with witnesses gathered on the foreground dunes. De Vlieger produced variants of the subject but also harked back to certain pictures by Hendrick Vroom and Adam Willaerts in which the quotidian activities of fisherfolk manning vessels and peddling fish feature prominently. What de Vlieger developed found a host of emulators, such as Jacob Esselens, Hendrick Dubbels, Egbert van der Poel, and others. For a succinct discussion of the beach scene, see Stechow, *Dutch Landscape Painting of the Seventeenth Century*, pp. 101–109.

49. Although few securely documented drawings by de Vlieger survive, he must have been a prolific draftsman – see footnote 51, below. His most notable landscape paintings are two *Forest Scenes* in Budapest and Rotterdam.

50. L. J. Bol, 1973, p. 181.

51. M. Russell, *Jan van de Cappelle*, appendix 1, item 2, pp. 49–57, the inventory of the collection of the late Jan van de Cappelle. This is an English translation of this extraordinary document first published in Dutch by Abraham Bredius, "De Schilder Johannes van de Cappelle," *Oud Holland*, 10 (1892), pp. 26–40.

52. This is part of a much broader development that finds significant parallels in Dutch landscape (e.g., Jacob van Ruisdael and his emulators), genre (Gabriel Metsu, Gerard Terborch, Frans van Mieris), and the architectural painters of Delft.

53. See L. J. Bol, 1973, pp. 211–218.

54. Other early practitioners of this technique include Heerman Witmont, Cornelis Pietersz. de Mooy, and Experiens Sillemans. During the 1660s, Ludolph Backhuysen produced pen paintings that were a natural outgrowth from his initial training as a calligrapher. Later in the century Abraham van Salm ca. 1660–1720 executed a sizable number of such works. Ultimately this entire style may trace its origins to the immensely popular grisaille paintings of Adriaen van de Venne. Another source for this virtuoso display of penwork is the Mannerist tradition of Hendrick Goltzius and artists such as Jacques de Gheyn II and Jacob Matham working in his manner. These masters produced large-scale, highly finished pen presentation drawings that simulate the burinwork of reproductive engraving – see E.K.J. Reznicek, *Die Zeichnungen von Hendrick Goltzius*, Utrecht, 1961, pp. 101–105, 128–130; Washington, National Gallery of Art – New York, Morgan Library, *The Age of Bruegel: Netherlandish Drawings in the Sixteenth Century*, 1986/1987, p. 155, cat. 54, repr.

55. To a unique degree, the two Willem van de Veldes document the shipbuilding achievements and naval victories of the Dutch admiralties; in particular, the working methods of Willem the Elder inform us about the engineering and carpentry skills that went into Dutch and English shipbuilding during much of the seventeenth century. The

majority of these drawings are in two repositories: the National Maritime Museum in Greenwich – see M. S. Robinson, *Van de Velde Drawings: A Catalogue of Drawings in the National Maritime Museum Made by the Elder and the Younger van de Velde*, 2 vols., Cambridge, 1958 and 1974, and the Museum Boymans–van Beuningen in Rotterdam – see R.E.J. Weber and M. S. Robinson, *The Willem van de Velde Drawings in the Boymans–van Beuningen Museum, Rotterdam*, 3 vols., Rotterdam, 1979. Other important collections include the Rijksmuseum and the Rijksmuseum "Nederlands Scheepvaart Museum" in Amsterdam, the Fitzwilliam Museum, Cambridge, and the British Museum, London.

56. A notable instance in which the artist represents himself seated on deck sketching is found in the large grisaille pen painting *The Battle of Scheveningen or Ter Heide* (event August 10, 1653), dated 1655, in Greenwich, National Maritime Museum (D. Cordingly), 1982, pp. 58–59, cat. 11, repr. Willem van de Velde the Elder was on hand during the Four Days' Battle (June 11–14, 1666), as indicated by the order issued by Admiral de Ruyter: "Captain Govert Pietersz is hereby ordered to receive and take on board the galliot under his command Willem van de Velde, ship's draughtsman, and to go with him ahead or astern or with the fleet, or in such manner as he may judge serviceable for the drawings to be made without failing in any way whatsoever under penalty of severe punishment." Quoted from Greenwich, National Maritime Museum (D. Cordingly), p. 12.

57. Quoted from Greenwich, National Maritime Museum (D. Cordingly), p. 15.

58. His earliest dated painting, *A Dutch Merchant Ship Running Between Rocks in Rough Weather*, of 1651, painted when the artist was eighteen, dates from the last year of Simon de Vlieger's life. It displays close affinities to de Vlieger's silvery monochrome paintings of the 1640s.

59. W. Stechow, *Dutch Landscape Painting*, pp. 107–109; L. J. Bol, 1973, pp. 233–234, 244–247.

60. L. J. Bol, 1973, p. 205.

61. Ibid. A. Davies, *Allart van Everdingen*, New York, 1978, pp. 61–98, esp. pp. 94–95.

62. Chantilly, Musée Condé, repr. L. J. Bol, 1973, pl. 210.

63. S. Reiss, *Aelbert Cuyp*, London 1975; Dordrecht, Dordrechts Museum, "Aelbert Cuyp en zijn familie schilders te Dordrecht," 1977/1978 (catalogue by J. Giltay); L. J. Bol, 1973, pp. 265–269.

64. Reiss, *Cuyp*, cat. 93, 95, 99, 103–106, all repr.

65. Vienna, Academy of Fine Arts. For the most recent discussion of this picture, see Salzburg and Vienna, *Niederländer in Italien*, 1987 (catalogue by R. Trnek), pp. 39–41, cat. 10, repr. Also see A. Blankert, *Nederlandse 17e Eeuwse Italianiserende Landschapschilders*, Soest, 1978, pp. 141–142, cat. 69, repr.

66. An outstanding example is the *Harborview* of 1649 in the Centraal Museum, Utrecht – Blankert, *Italianiserende Landschapschilders*, pp. 179–180, cat. 100, repr.

67. One of the finest of these is *A Moor Presenting a Parrot to a Lady*, in the Wadsworth Atheneum, Hartford, Connecticut – Philadelphia – Berlin – London, "Masters of Seventeenth-century Dutch Genre Painting," 1984, p. 137, cat. 5, repr. As Christopher Brown, author of their catalogue entry, notes, Berchem was inspired by analogous pictures by his cousin Jan Baptist Weenix.

68. Including a splendid example in the Amsterdams Historisch Museum – see A. Blankert, *Amsterdams Historisch Museum Schilderijen daterend van voor 1800*, Amsterdam 1975/1979, p. 191, cat. 246. For a selection of Lingelbach's Italianate subjects, see Blankert, *Italianiserende Landschapschilders*, pp. 214–217, cat. nos. 135–137, repr.

69. For discussion and illustration of these subjects by Pynacker, see L. B. Harwood, *Adam Pynacker*, Doornspijk, 1988, pls. IV, IX–XI.

70. L. J. Bol, 1973, p. 291.

71. Amsterdam 1985, Rijksmuseum, "Nederlands Scheepvaart Museum," "Ludolf Backhuizen."

72. A. von Bartsch, *Le Peintre Graveur*, Vienna, 1803–1821, vol. 4, Backhuysen nos. 1–10: Hollstein, vol. 1, Backhuysen nos. 1–10, repr.

73. Inv. A 1428, Amsterdam 1985, p. 26, cat. S2, repr.

74. See Amsterdam 1985, for selected examples.

75. See discussion of Jan Porcellis, above, and and footnote 37.

76. L. J. Bol, 1973, p. 307.

77. For further biographical details of the Storck family, see L. J. Bol, 1973, pp. 315, 317–318, and I. H. van Eeghen, "De Schildersfamilie Sturck, Storck of Sturckenburch," *Oud Holland* 68 (1953), pp. 216–223.

78. For Beerstraaten, see L. J. Bol, 1973, pp. 286–287, pl. 291.

79. For a general discussion of this subject, see Ch. Skeeles-Schloss, *Travel, Trade and Temptation: The Dutch Italianate Harbor Scene 1640–1680*, Ann Arbor, Mich., 1982.

80. I take issue with L. J. Bol's negative assessment of these pictures (Bol, 1973 p. 318). Not only are they demonstrably the artist's most ambitious paintings, but the unusual type of signature on certain of these – e.g., *STVRCK* on the Minneapolis version – suggests that they fall early in Storck's career and indicate that he is emulating the example of Willem van de Velde the Younger and Ludolph Backhuysen on an ambitious scale.

81. F. Muller, *Beredeneerde Beschrijving van Nederlandse Historieplaten, Zinneprenten en Historische Kaarten*, Amsterdam, 1970, vol. 1, no. 2986, suppl. no. 2985A.

82. Ibid., suppl. no. 2989 Fa; F.W.H. Hollstein, 1949– vol. 26, A. Schoonebeek no. 17. For further discussion of Peter the Great and his sojourn in the Dutch Republic, see J. J. Driessen, in Amsterdam, Rijksmuseum, *Russen en Nederlanders*, 1989, pp. 75–84.

83. A notable exception is the large painting *Bay Whaling in the Arctic* by Cornelis Claesz. van Wieringen in the Kendall Whaling Museum, Sharon, Massachusetts.

84. In fact, Turner named one of his important early marines *Port Ruisdael* as an act of homage to this seventeenth-century Dutch master. Recently, A.G.H. Bachrach has

made a close study of Turner's journeys to Holland in pursuit of the landscape that inspired Aelbert Cuyp, another Dutch old master who appealed to Turner.

85. M. Butlin and E. Joll, *The Paintings of J.M.W. Turner*, New York, 1984, 2 vols., cat. nos. 377; 391, pls. 381, 402.

86. Schotel is the recent subject of a long-overdue retrospective exhibition – Dordrecht, Dordrechts Museum, *Een onsterfelijk zeeschilder J. C. Schotel 1787–1838*, 1989. As early as 1936, W. Martin, *De Hollandsche Schilderkunst in de Zeventiende Eeuw*, Amsterdam, vol. 2, p. 381, recognized the great influence of Willem van de Velde the Younger on Dutch marine painters of the romantic epoch.

A NEW REPUBLIC

The eighty-year struggle of the Netherlands against Spain ended in 1648. Among the peace arrangements for Europe, referred to comprehensively as the Peace of Westphalia, was the formal recognition of an independent Netherlandish republic. It was known variously as the "United Provinces," the "Seven Provinces," the "Dutch Republic," "Holland" – incorrectly because, strictly speaking, Holland was the name of one of the provinces, not of the whole group – and, today, as "The Netherlands" (*Nederland*).

This truncated northern Netherlandish state was, in almost every respect one can think of, peculiar in the eyes of contemporaries. It remains even today a country marked by strong and curious characteristics found in no other part of Europe or the world.

Politically, it was peculiar because it had emerged, by means of a revolution against established authority, in the form of a "republic." In its republican and mercantile aspects, it was often compared to Venice; but its historical evolution was quite different.

Its frontiers were partly formed by natural geographical features – sea and rivers – but partly bore the mark of the strategy and tactics of the long war of which it was the practical result. Thus, the southern boundary with the Spanish (later Austrian) Netherlands had been pushed well south of the great rivers running east and west to form a territorial bridgehead that had survived as Dutch under the treaties of 1648.

The constitution of the Dutch state was another oddity. It was not unitary but federal. Its slow, cumbersome workings were in practice dominated by the state, or province, of Holland, which controlled the greatest part of its trade and contributed some half of the "federal" income. Nothing like it existed anywhere else in the seventeenth-century world. (In the eighteenth century it was to exercise considerable influence as a model for the Founding Fathers of the United States of America.)

Geographically (or topographically) it was again unique. This truncated section of the old Burgundian, more recently Hapsburgian, empire, stretched across the delta formed by the three great European rivers – Rhine, Maas, Scheldt – as they debouched

into the North Sea. This was a prime conditioning influence on its scenery, with which this chapter is much concerned. The area's most critical boundary was its line of defense against inundation by the sea: a line of sand dunes built by man and nature over many centuries, high and broad enough to protect its landward side and to make it dry and fertile for agriculture.

Even so, about half of the entire area lay below sea level, in some places as much as twenty feet below. Nowhere, except in a small section of the southeast, on the present Belgian and German borders, did the land rise to a height of a thousand feet. Consequently, there really was "water, water, everywhere"; in some areas of Holland and Zeeland, nothing else. The enclosing dykes could be (and were) used in warfare, against Spain and later against France, as powerful weapons of strategy and tactics; but even in peace, flooding was a problem. Andrew Marvell was quick to comment:

> Yet still his claim the injured ocean laid,
> And often leap-frog o'er their steeples played,
> The fish oft times the burger dispossessed,
> And sat, not as a meat but as a guest.

Demographically, The Netherlands in the sixteenth century, and even more in the seventeenth century, bore strong individual features. The central area especially was densely populated compared with contemporary European states. It was also highly urbanized, with growing cities, towns, and villages, many of them fortified during the wars with Spain, all of them engaged in trade. In spite of the wars there was a marked increase in population during the sixteenth century, and in spite of war – indeed, in some respects because of war – trade and employment increased. The towns, trade, and industry all grew as people moved from country to town.

That the economy was able to sustain a growing population was due to the increasingly complicated structure of the Dutch economy. Although most of Europe was basically an agrarian, rural society and economy, and much of it remained self-sufficient with only tenuous links with the outside world, the Dutch were busily developing an economy based on exchange. A high proportion of the Dutch people were engaged in trade, international as well as national. They were the first to take the risks, and secure the benefits, of living by trade, by exporting goods that sold at high profits and by importing goods that could be bought cheaply abroad.

These goods included food. By 1600 much of the supply of basic foods – corn especially – was imported from the Baltic. This was possible because the Dutch commanded a mercantile marine that had grown, by the seventeenth century, to be the largest in the world. The availability of cheap foreign corn enabled the Dutch farmer to turn his hand and resources – including a soil easy to work and with a high yield of produce – to more specialized and profitable crops. Already farming was as much horticulture as agriculture. Fruit, vegetables, flowers were widely grown and sent to town, even for export. Growing for bulbs was especially popular in the country between Rotterdam and Amsterdam. Haarlem was famous for its *bollenvelden* (bulb fields): In the seventeenth century this was to be the land of "Tulip Mania." In the north, peat cutting provided not only fuel but employment and profits.

Increasingly in the seventeenth century a strong, commercially oriented middle class came to occupy the leading role in the Dutch Republic. This was truly a race of shopkeepers, large, small, and middling. The faces that gaze down from the great group portraits of Frans Hals are those of the important merchants of Haarlem who ruled its business life, bleached the linens that made many a fortune, and supervised the charities that looked after the old, the poor, and the orphans of the town.

The largest merchants of all gradually became part of a land- and property-owning elite, the *vroedschap,* which organized public affairs yet still retained one foot probably in trade or finance.

At the other end of society were the petty shopkeepers, whose numbers included some of those who were to rank among the greatest of the artists. Van de Velde sold linens, van Goyen traded in tulips, Jan Steen was an innkeeper. At Amsterdam (as earlier at Antwerp) painters were as plentiful as butchers and bakers. This was a consumer society. When he visited Rotterdam in 1641, John Evelyn the diarist was amazed to see the annual fair "so furnished with pictures ... tis an ordinary thing to find a common farmer lay out two or three pounds on them. Their houses are full of them."

The people of the republic came to live largely by trade, a contrast to almost the whole of the rest of Europe, where a land-locked society often divided very simply into lords and peasants. In the republic there were relatively few lords, and a great many

peasants had at least a finger in the pie of commerce. The secret of all Dutch material progress was their use of the water that surrounded them on all sides (Fig. 27). They built barges to navigate these great inland lakes like the Haarlem Meer and the Zuyder Zee, the great rivers like the Rhine and Maas, and the intricate network of canals that lengthened annually in the golden age between 1600 and the last quarter of the century. These carried cargoes of goods from country to town, from city to city, and from city to the ports for foreign destinations overseas. They also acted as forerunners of buses, trams, and trains, carrying thousands of passengers every year according to orderly and punctual timetables. The Dutch men and women of the seventeenth century knew where they were going, and when and how; they traveled as often by barge as by road. Foreign visitors like Thurloe, Evelyn, Matthew Prior, and James Boswell found the *trekschuiten* (towed barges, Fig. 28) convenient but sluggish.

Thomas Nugent, writing his advice to gentlemen travelers on the Grand Tour, still had this to say in 1778:

> The usual way of travelling in ... most parts of the United Provinces ... is in trekschuits or draw-boats, which are large covered boats, not unlike the barges of the livery companies of London, drawn by horse at the rate of three miles an hour. Boswell's recollections bore him out. It took him nine hours to get from Leiden to Utrecht by *trekschuit* in 1763. (T. Nugent. *The Grand Tour*, 1778, vol. 1, p. 48)

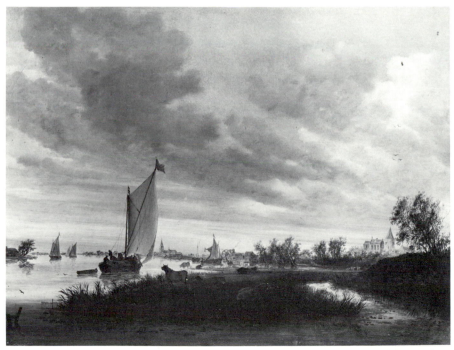

Figure 27 Salomon van Ruysdael, River Landscape, *panel. Mainz, Mittelrheinisches Landesmuseum.*

A unique degree of physical mobility was matched in this dynamic society by a degree of tolerance unknown elsewhere in Europe. In a long satirical poem, *The Character of Holland,* the English poet Andrew Marvell essayed the ultimate in rudeness toward a people once a partner in a Protestant alliance but at that time (1653) eclipsed by a bitter naval war over trade and maritime sovereignty. It was to be reprinted whenever English governments felt themselves in need of propaganda (1665 for the Second Dutch War; 1672 for the Third); yet somehow the con-

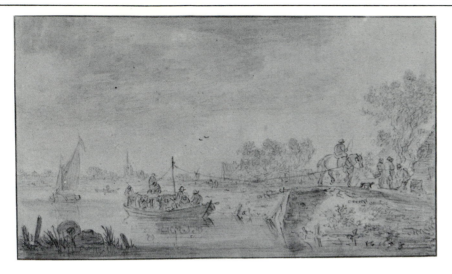

Figure 28 Jan van Goyen, River Landscape with a Trekschuit, *1656, black chalk, gray wash. New York, Metropolitan Museum of Art.*

trived bitterness kept fizzling out. A kind of reluctant admiration keeps on showing through the jaundiced network of metaphor. Thus:

> Hence Amsterdam, Turk–Christian–Pagan–Jew,
> Staple of sects and mint of schism grew,
> That bank of conscience where not one so strange
> Opinion but finds credit, and exchange.

One of the grandest temples of Amsterdam was the Sephardic Jewish synagogue. Its members – refugees from persecution by the Inquisition in Portugal and Spain – added greatly to the variety of trades, industries, crafts, skills, and learning of the city. Rembrandt lived in their midst. So did the great philosopher Baruch Spinoza. Vondel, the greatest of the seventeenth-century Dutch poets, was a Roman Catholic. Hugo Grotius, the great polymath and father of modern international law, was a non-Calvinist Protestant, like many – and probably most – of the ruling class of merchant families. Between them and the influential Calvinist clergy (who exercised great influence among the lower classes) little political quarter was asked or given. The two factions played Box and Cox, roughly counterbalancing each other; so that, by and large, this "middle-class dictatorship" (as a Dutch historian has characterized it) exercised a rule that was at least comparatively tolerant. Put at its least idealistic: intolerance, persecution, and witch-hunting did not pay. For a merchant class that increasingly did business on a world scale and had assets at stake in countries of many faiths, types of government, and ways of life, such behavior was apt to return like a boomerang. As the Dutch dynamo of trade and finance enlarged its sphere of power, Dutch foreign policy became more neutral, cautious, and defensive.

Daniel Defoe, most famous as author of *Robinson Crusoe,* wrote with equal verve and point on many economic issues. Here, in miniature, is his masterly microcosm of the Dutch economy:

> The Dutch must be understood as they really are, the *Carryers* of the World, the Middle Persons in Trade, the factors and brokers of Europe...that *buy* and *sell* again, *take in* to *send out;* and the greatest part of their vast commerce consists in being supplied from All Parts of the World that they may supply all the World again.

Defoe wrote (in the early eighteenth century) when the golden age of the republic was in fact fading, but his is a perfect encapsulation of its functions in international trade at the height of its power. In 1650 and for long after, the republic dominated world trade and finance. How had it achieved this?

THE DUTCH MIRACLE

When Guicciardini described his European travels in 1561, he had found Amsterdam still to be a place of modest wealth. Sir Thomas Gresham, a great merchant, expert in continental trade and exchange, mentions the city only once in his correspondence in the thirty years from 1540 to 1570. The citizens were prosperous; they were not millionaires. Dealers in corn, wood, and

cloth predominated. When a capital levy was raised in 1585, the highest contribution came from a dealer in iron: he paid just over 200 guilders – not a very large sum even at that time.

Mostly, the Amsterdam traders dealt with the area lying between the Baltic and the ports of western France. This was the skeletal beginning of what developed into the republic's main trading route overseas between 1585 and 1610; the "spine," or "mother trade," as it came to be known. But in 1585 much of the capital and shipping in Dutch long-distance trade still came from Antwerp. It was the fall of Antwerp, the hinge of the old, "great" Netherlands, to the brilliant tactics of Alexander Farnese, Spain's great general, that threw the Dutch on their own resources, and projected the republic into a steep economic climb to the pinnacle of European trade.

Swiftly the Dutch sought out new trades and routes. The "classical" system ran from Bergen in the north to Gibraltar in the south, from the Gulf of Finland on the east, and the British Isles in the west. This central system expanded rapidly as shipping based in Amsterdam and the ports to the south, around the estuaries of the Rhine, Maas, and Scheldt, pushed ever farther outward: north into the Atlantic fishing and around to Archangel, through and beyond the Straits of Gibraltar to Italy, and on into the Levant, south and west to the Azores, Madeira, and the Cape Verde Islands; 1593 saw the first voyage to Guinea. By 1600 this system had developed into regular trade to the gold and slave coasts of Africa. War and competition combined to drive Dutch traders on, around the Cape of Good Hope to India. Houtman's voyage of 1595 became an annual event, and 1602 saw the foundation of the Dutch East India Company trading to Java and the other East Indian islands for spices.

The first voyage to Brazil to open a market in slaves and sugar came in 1600. In 1621 the Dutch West India Company was founded – it was the most aggressive of all the Dutch enterprises with a strong element of dedicated Calvinists on its directorate. The company itself was the least successful of the republic's business ventures; but, in general, wherever the Dutch impinged on the old empires of Spain and Portugal, those tight monopolies toppled before their thrusting enterprise.

What lay behind the Dutch story of business success? Two certain factors may be identified beyond doubt: one technological, the other social and human.

First, in shipbuilding, operating, and technology the Dutch were without rivals between 1590 and 1600. Their greatest coup was not the great ships of the line that they slowly evolved for naval warfare, but the modest, practical, and businesslike seagoing barge they called the *fluit* or *fluitschip* (in English parlance, "flute" or "flyboat") (Fig. 29; Cat. 110, 119). It first appeared at Hoorn, on the Zuyder Zee, in the 1590s. The design was conditioned by the northern trades, Baltic especially, the stuff of which consisted of bulky cargoes – corn, timber, iron, metals, hemp, flax, tar, rope, and general naval stores. And in spite of the spectacular growth of the exotic trades to the Americas, West and East Indies, and Africa already described, it should be stressed that in bulk

Figure 29 Reinier Nooms, The Geele Fortuin, a Baltic Merchantman, and the Liefde, a Norwegian Merchantman, *etching. Minneapolis, Minneapolis Institute of Arts.*

and value, the trades of the "spine," from the Baltic and the north down to the Netherlands and on to France and the Mediterranean, remained the most important of Dutch overseas trades.

The flute, round in the stern, broad in the bottom, narrow in the deck, was cheap to build and economical to operate. It called for a crew only a fraction of the size necessary in merchant ships of traditional design. Its services were much in demand in an age when, all over Europe, population growth was outstripping local food resources (corn especially) and continuous wars were creating a demand for naval stores and munitions. This cheap freighter, usually a three-master (Fig. 30), gave the Dutch an apparently unshakable hold on the bulk trades of Europe – but it was not entirely limited to them. It was to be found operating country-to-country coastal trades in the East and West Indies. Hundreds, probably thousands, were in operation by the second quarter of the seventeenth century. The flute had the advantage in peacetime of being unarmed; its cargoes were not – like spices or precious metals – in need of the protection the "rich cargoes" demanded. In war, however, this became a problem. In the Anglo-Dutch wars (1652, 1663, 1672), for example, it was necessary to provide strong warship protection for the large flocks of flutes that had to be shepherded through the narrow seas between Britain and the Continent. Highly skilled as was the Dutch seamanship, war, in this as in every other respect, created intractable and serious problems for the republic.

The second indispensably creative contribution to the almost magical growth of the maritime economy of the republic came from a large influx of skilled and enterprising immigrants from the southern Netherlands. Even before the final capitulation in 1585 of Antwerp to Farnese, the Spanish commander, the melancholy tide of emigration from the towns and villages of the old south (now mostly Belgium) had begun. After 1585 it was a flood. Many immigrants were Protestants – mainly Calvinists and Anabaptists – of different varieties of artisan skills, seeking either to worship as their faith required or simply to find a secure livelihood

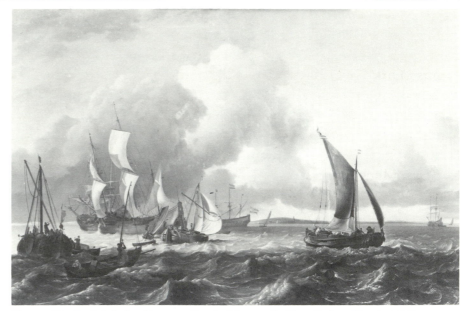

Figure 30 Ludolph Backhuysen, Dutch Mercantile Fleet Before Texel, 1665, canvas. Greenwich, National Maritime Museum.

across the rivers in the northern redoubt of the republic. Some were much bigger fish: bankers, merchants, shipowners, entrepreneurs in the cloth, linen, silk, and carpet industries. They saw little future for their business investment or enterprise in a country that would henceforth be a satellite of Spain, ruled by governments whose relentless extravagance in continual war offered only a future of bankruptcy and ever increasing taxation.

So they sailed or trudged to Amsterdam, Haarlem, Leiden, and other cities. From Lille, Ypres, Hondschoote, Ghent, Bruges, Poperinghe, they brought their capital, tools, and skills. Soon they were participating in overseas trade, textile industries, and metal industries, and were investing in banking or speculating in stocks and shares of the growing joint stock companies that sprang up from 1600 on. When the Exchange Bank was set up (1609–1611), more than half its original clients were southern Netherlanders.

Men, like plants, often seem to benefit from being transplanted to fresh soil. Certainly it is difficult not to be impressed by the

evidence of vigor, intelligence, and enterprise shown by the immigrants from the south. For example, two of the largest stockholders in the new East India Company were southern immigrants: Dirk van Os and Isaac le Maire. The largest trader in Swedish iron and copper, Louis de Geer, was the son of a Liège merchant who fled north in 1596, taking his fortune with him to found a large business and virtually a commercial dynasty. As mentioned earlier, Sephardic Jews from Spain and Portugal — Pereiras, Machados, Macattas, Capadoses, da Costas — penetrated the trades in silk, sugar, diamonds, tobacco, precious metals, and much else. Toleration bred enterprise.

The nerve center of the international system of trade and shipping that has been sketched so far consisted of three institutions, all of which were set up between 1609 and 1620. They were the Beurs (Bourse, stock exchange) of Amsterdam; the Amsterdam Loan Bank; and the Exchange Bank of Amsterdam.

The Bourse (Fig. 31), an elegant exercise in classical architecture in the Italian style by the distinguished architect Hendrik de Keyser, replaced the old informal meetings in the open air, come rain or come shine, that had begun in the second half of the sixteenth century. Gradually, the institution came to include representatives of the whole commercial, manufacturing, and financial community of Amsterdam. Bolswert's print (Fig. 31) illustrates the organized shelter the new building gave the different trades.

The edifice consisted of a square, two storys high, with covered cloisters along each side that were supported on pillars. The whole effect was reminiscent of the large piazza facing the Cathedral of San Marco in Venice or Neville's Court, Trinity College, Cambridge. In the Bourse, however, the thirty or so pillars had a specific function: Each pillar was the recognized meeting place of merchants engaged in a particular trade — Baltic, Spanish, Levant, South American, East Indian, and so on. Only one group — the stockjobbers — was unprovided for. They continued to gather in the open air; this particular activity was the special preserve of the Jewish Sephardim, who were not, in these early days of the

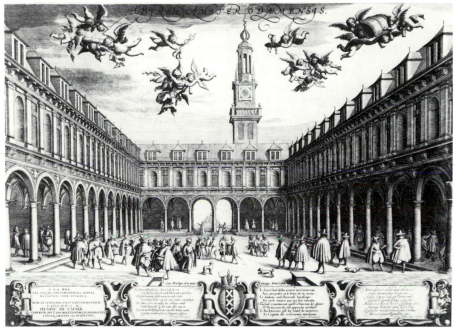

Figure 31 Boethius A. Bolswert, Interior of the Stock Exchange in Amsterdam, 1609, *engraving. Amsterdam, Gemeente Archief.*

great expansion, a particularly wealthy group. Later, however, they would include some very successful and prosperous members: stockbrokers, contractors to the government for victualling armies and navies, and so on. It was through them that the Amsterdam Bourse fostered a highly sophisticated modern system of speculation in stocks and shares, replete with *rescontre* — or contango — days, puts and calls, options, and all facilities of dealing "on the margin." The Bourse was the center where thousands of transactions in domestic and overseas trade and shipping charters were made, each to be registered with the notary specializing in the particular brand of business concerned. (Many such contracts still exist in the Amsterdam archives.)

The second great mechanism was the Wissel Bank (Exchange Bank) opened in 1609. It was the greatest public bank in seventeenth-century Europe. Like many other features of this nascent economy — marine insurance, double-entry bookkeeping, and

the like — it was based on an Italian model: the Bank of Venice. The Exchange Bank was not a bank of note-issue, as the later Bank of England was to be, nor (strictly speaking, at least) did merchants borrow from it — although as time passed it did some lending, none too successfully. It functioned as a clearing bank: Each merchant with an account could settle his debts and credits with other merchant clients by a simple book transfer. The merchant put his money on deposit and drew on his account as necessary, but no overdrafts. Nor did the bank itself discount bills of exchange, although these proliferated from the 1580s on.

The bank's other function was to remedy, or at least reduce, the existing monetary confusion that hindered trade. The republic itself had fourteen mints, and the processes of international trade involved the import and export of large quantities of foreign coin and bullion. The bank bought gold and silver both at home and abroad for minting. It also played an active role in buying bullion from merchants whose operations yielded a surplus of silver or gold (e.g., those trading with Spain), and selling it to those whose import business could only be transacted by paying their suppliers in coin or bullion (e.g., much of the Baltic and East India trade, which drained away silver and gold).

Like other branches of the economy, the Exchange Bank's business grew. In its first full year of operations (1611), it had 708 clients, whose deposits totaled just under one million guilders; by 1700, it had 2,700 clients, whose deposits totaled 16 million guilders. They included all the principal merchants of the city and a number of foreigners looking for somewhere to deposit their money securely; the earls of Danby and Shrewsbury and several European princes kept sizable nest eggs there in 1688, the year of the English revolution.

The Bank van Leening (Loan Bank) did what the Exchange Bank had been prohibited from doing. It provided funds, against suitable collateral security, for merchants needing working capital for business ventures. Here, and in private borrowing transactions, it was both a consequence of the buoyancy of the Dutch economy and a cause for further buoyancy that the rate of interest in the republic — around 3 percent — was markedly lower than it was in other national economies. In the least stable, the going rate for government borrowings was upward of 10 percent; in England the going rate was in these days tending — but with many interruptions — to decline from about 10 percent to about 5 percent or 6 percent. But most foreign observers (especially the English, who watched the economic rise of Holland with keen interest and not a little envy) put the low rate of interest among the benefits that more rational economic order bestowed on the investor of enterprise. It was ranked, along with cheap sea transport by flyboat, as a major cause of Dutch prosperity.

Another was the skilled buying that capital aplenty brought within the Dutch grasp. The Dutch motto was "Buy most when and where prices are lowest and wait for a sellers' market." Thus, the herring fishing catch in the North Sea was contracted before it was caught. Norwegian timber was purchased by the shipload for both house- and shipbuilding in the ports of Holland and Zeeland, and for export. Whole forests were bought up in Germany; grain and cattle were bought in gross on Danish markets; grain and wine were contracted for before harvest in France. English cloth, tin, and coal, Danzig corn, West Indian sugar, Brazilian sugar and (later) coffee, East Indian spices and tobacco, Swedish copper, Spanish wool, Portuguese salt, Russian fur and honey, Spitzbergen whale oil . . . all went, on a Dutch merchant's own account or on commission, to the quays and warehouses of Amsterdam (Fig. 32), "to await the tide" (of good prices). "Amsterdam," wrote an English observer in 1641, "is continually stored with 100,000 quarters of wheat, besides what is by trade daily sold away and vented." The same was true of tobacco, timber, brandy, sugar, and cloth.

The golden age of the Dutch economy lay between 1620 and the 1680s — roughly the same period as the golden age of Dutch art. The most eloquent witness to the wealth, prosperity, and vigor of the republic was its great fleet of oceangoing cargo ship-

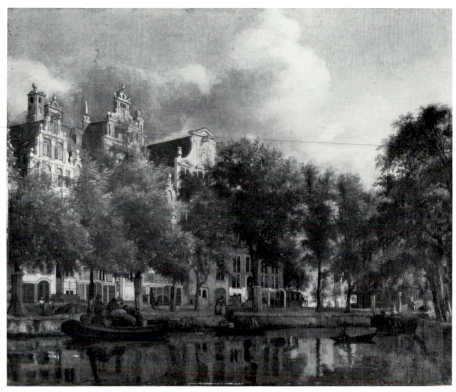

Figure 32 Jan van der Heyden, The Herengracht, Amsterdam, *panel. Paris, Musée du Louvre.*

ping, its thousands of river barges, and its bustling quays equipped with drays and mechanical cranes that handled thousands of tons of cargo in the busy ports. The English statistician and economist Sir William Petty (1623–1687) calculated that of some two million tons of European shipping in the 1670s, the Dutch owned just under half, their merchant fleet being twice that of England. This was probably an exaggeration, but they may have had about three thousand ships of an average tonnage of two hundred tons.

As already discussed, Dutch shipping could be seen operating all over the known world. The Baltic trade supplied the Dutch with much of their food (bread, corn, and barley for brewing and distilling) as well as the timber and other needs of the mighty shipbuilding industry at Zaandam and elsewhere. The trade with

Spain and Germany supplied the wool with which the largest cloth manufacturing center in the world – Leiden – made its famous broadcloths as well as, by the late sixteenth century, the "New Draperies" brought by the refugees from the southern Netherlands. Imported sugar, tobacco, canvas, rough linens, and rags formed the raw material for the *trafieken* (finishing industries, such as sugar boiling, tobacco cutting and packing, papermaking) that grew up along the banks of the stream of goods flowing into the republic from the outside world, for the republic's maritime economy nourished manufacture as well as trade.

Dutch ships were built in many ports, small ones everywhere by river, canal, or sea; the great ships, especially for the "rich trades," up to a thousand tons apiece, tended more and more to be built at Zaandam, the "village of carpenters" near Amsterdam. Peter the Great was to make his celebrated pilgrimage there later in the century to see the world-famous technology in action; it included some features of later mass production – interchangeable parts, for example. Samuel Pepys recorded in his diary a fascinating glimpse of the inside of a big East Indiaman taken as a prize in the Second Dutch War, in 1665. Walking around her at Erith, he saw "the greatest wealth . . . in confusion that a man can see the world. Pepper scattered through every chink. You trod upon it, and in cloves and nutmegs I walked above the knees, whole rooms full. And silk in bales, and boxes of copper plate . . ."

Important as colonial trades were, a Dutchman-in-the-street, if asked what was the most valuable of all Dutch seafaring occupations, would probably have given the same answer as the States General of the republic in 1624:

> The great Fishing and Catching of Herrings is the cheafest trade and principal Gold Mine of the United Provinces, whereby many thousands of Households, Families, Handicrafts, Trades and Occupations are set on work, well-maintained and prosper, especially the sailing and navigation, as well within as without these Countreys, is kept in great estimation; Moreover many returns of money, with the increase of the means. Convoys and Customs and revenues . . . are augmented and prosper.

Since the late fourteenth century, pickling in salt had been the method of converting highly perishable fish meat into a durable article of trade. The best fishing grounds (unfortunately) lay off the British coasts. Dutch exploration was carried out annually with all the precision of a military exercise (Fig. 33). The fishing fleet sailed to the Shetlands about mid-June. Fishing began on St. John's Day (June 24). From then until St. Catherine's Day (September 25) they fished herrings off the Scottish and English coasts, south to the Thames estuary. Operations ended on January 31, while smaller operations in whitefish areas continued in the middle of the North Sea.

The whole exercise – the type of salt used, the design and marking of the barrels, the timing of arrivals at different points by the "*busses*" to convey the barreled catch back home, and so on – was minutely controlled by the College of the Great Fishery (Groote Visschery) comprising deputies from Delft, Rotterdam, Enkhuizen, the Brill, and Schiedam. Statistics are not reliable, but if one of the more careful is anywhere near correct, the fishing "busses" made up a third or so of the republic's seagoing fleet. In modern jargon, the Groote Visschery was an economic "multiplier." It *created* a demand not only for herrings but for nets, rope, timber, ships, boats, barrels, salt, and ships' stores – and not least for labor, on the wharves, at sea, and in stalls and shops. A famous account of the Dutch economy by a Leiden merchant, Pieter de la Court (a southerner, incidentally), written in the 1660s but published much later, declares that the fishing industry employed directly and indirectly nearly half a million people, or nearly one-fifth of the Dutch population.

The herring supplied an equally significant proportion of the Dutch diet. It was eaten everywhere, in the great town houses that multiplied along the banks of the city canals – the Heerengracht and the Prinzengracht of Amsterdam, for example – or in the streets of the big towns and villages. The herring was the diet of the rich and poor alike; the *nieuwe haring* (fresh herring) was (and remains) one of the greatest delicacies for the Dutch. Her-

rings were also an exceedingly valuable export trade. In the Baltic trade, for example, there was always a problem of balancing the plentiful supply of corn, timber, and so on, which came out of that area with corresponding exports that the Baltic countries would buy. The gap was partially filled by the Dutch by payment in silver, coin, or bullion. But silver could only be won by exporting to Spain or other countries with whom the Dutch had a favorable balance of trade (see Christensen 1941, p. 428). Herrings were welcome in the Baltic: They helped conserve silver for export to the Indies, where the Dutch also had problems in balancing imports and exports of commodities.

PEACE AND WAR

English (and Scottish) troops and commanders had made a considerable contribution to the Dutch liberation from Spain; but it had not been a particularly cordial alliance. Elizabeth detested

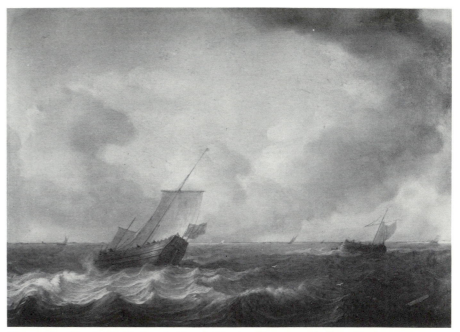

Figure 33 Hendrick M. Sorgh, Dutch Herring Fleet, *panel. New York, private collection.*

Calvinism and made no secret of her contempt for tradesmen; William the Silent had every reason to resent bitterly her repeated failure to live up to her promises. Under the Stuarts and the Interregnum (1604–1660) relations deteriorated further. There were three major causes of friction: first, rivalry in the East between the English and Dutch trading companies; second, the Dutch insistence on their right to full discretion in trading, not only with neutrals in war but with the declared enemies of England *and* the republic. Not the least remarkable feature of the economic rise of the Dutch was that it was achieved by highly skilled, audacious trade with their mortal enemy, Spain. Third, the Dutch claimed their right to regard as *mare liberum* (free seas) not only those areas where Spain and Portugal claimed sovereignty but the seas around Britain that England insisted (especially in the more nationalistic phase of history that developed from the accession of James I onward) were subject to English sovereignty.

It was, not least, the Dutch claim to the right to fish in what the English regarded as the "British seas" – a virtually limitless area – that led to the naval wars between the two former allies. Broadly speaking, the Dutch were vulnerable to attack by England in much the same way as Britain was vulnerable to attack by Germany in 1914–1918 and 1939–1945. Dutch sea-lanes of trade were wide open to assault by English warships, especially in the English Channel, through which a high proportion of Dutch seaborne trade passed.

In the three Anglo-Dutch naval wars, the Dutch were compelled to move from their pacific, neutral stance to meet the English strategy of attack. Their basic problem was to decide whether this was a case where the best defense was attack. The merchant owners of the flock of flutes that carried Dutch seaborne trade strongly favored a policy of armed convoy by warships – or merchant ships adapted to war purposes, as they were at the start. The task included the supremely important one of guarding the "Silver Fleet" – the ships bringing to the home ports in Holland the bullion and coin paid to the Dutch merchants by the Spaniards

out of their Central American resources for goods and services supplied by the Dutch.

In the course of the first war (1652–1654) the Dutch naval commanders achieved some remarkable feats of seamanship – none more remarkable than Admiral Tromp's astonishing maneuvers at Cape Gris-Nez in February 1653. Retreating after being trounced by Admiral Blake off Portland and again off Beachy Head, Tromp backed toward the coast of France. He then accomplished what the English believed impossible. Under cover of darkness he rounded the cape with a convoy of two to three hundred flutes. The next morning by ten o'clock he lay in comparative safety off Gravelines.

This kind of defensive warfare was all very well; but to the Dutch commanders it was tame, boring, and inconclusive. Their object was not to defend convoys but to destroy the English fleet that constituted the threat. Destroy that and it would be the end of the war. "I could wish to be so fortunate," wrote Tromp to his masters of the States General on December 6, "to seek out and destroy the enemy or to give convoy; for to do both is attended by great difficulties." The English were more fortunate: The Dutch seaborne trade lay wide open to attack. They could launch it when and where they chose.

The shipyards of Zaandam had by now half a century of experience of building great ships for the far flung, rich trades. They adapted this to the needs of the navy. The Dutch were equipped, as time went on, with fine large warships (Fig. 34), heavily gunned and manned by good sailors. But the Dutch never succeeded in totally destroying their enemy. Naval warfare was not like that – total victory was never achieved. Fog, bad weather, a change of wind, the death of a commander, or a fire could thwart the best of intentions. So the wars dragged on. All that happened was that the Dutch steadily improved their chances; the English, as steadily, failed to seize theirs. The end was the great reconciliation of 1688, and a heritage of great marine paintings. They include the splendid ceremonial portrait (of 1667) by Ferdinand Bol of

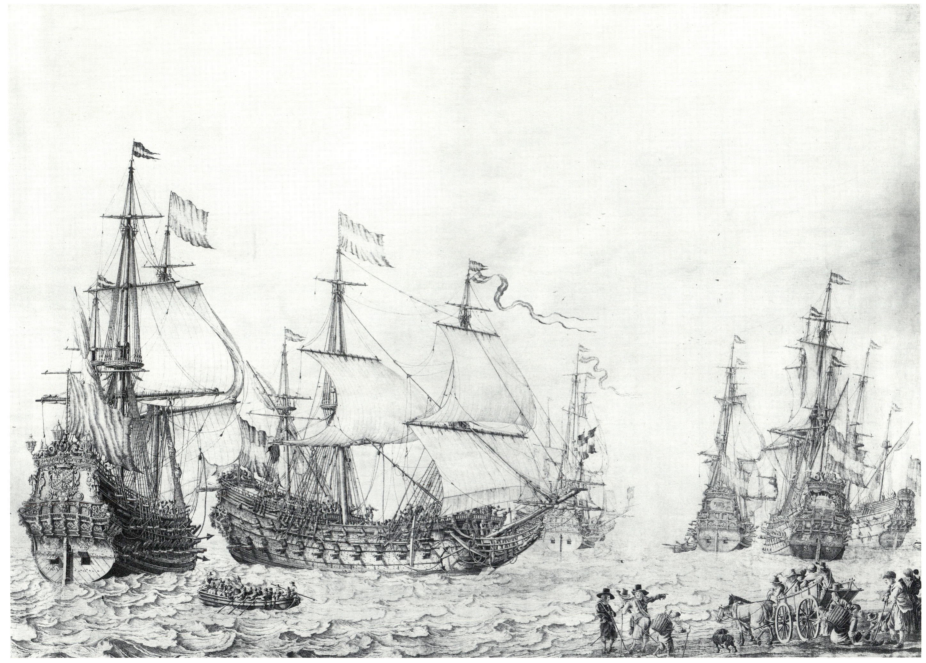

Figure 34 Willem van de Velde the Elder, Dutch Ships Coming to Anchor, *1654,
pen painting on panel. Greenwich, National Maritime Museum.*

the incomparable Dutch admiral Michiel de Ruyter (Fig. 48); the sitter originally donated it to the Admiralty of Middelburg, in whose service he had fought. After the admiralties were phased out, it went to the Rijksmuseum in Amsterdam, where it still hangs.

The far-flung trade of the Dutch was not merely transitory. Wherever they did business, they left their mark. In France, Richelieu used the Dutch firm of Hoeufft as agents for ships and munitions. They were still lending money to France in the eighteenth century. In England, Burlamachi and Calandrini acted as moneylenders to the early Stuarts; they were originally southern Netherlanders of Italian origin who had become Amsterdammers. Dutch capital was raised to drain the English fens (1625–1660). In the eighteenth century the Dutch still owned a large stake in the Bank of England and the English national debt. In Sweden the firm of Trip and de Geer controlled monopolies of mining and farming. The de Geers ended as Swedish nobles. Allaert van Everdingen in the seventeenth century was only one of the Dutch painters who visited Sweden (Fig. 35) and Norway and put coniferous forests and waterfalls into his landscapes, just as his "Italianate" colleagues who took cheap passages to Leghorn depicted Tuscan villages and ruins. In Denmark, the Marselis brothers were to the monarchy what the Trips and de Geers were to the Vasas. In Austria, the House of Deutz lent money to the emperor in return for a monopoly of quicksilver and copper mining. In Russia, too, they operated concessions for mining and export monopolies granted by the czar in return for financial help.

Everywhere the Dutch accumulated guilder balances from trade. Then, as the commercial expansion slackened pace in the eighteenth century, these balances became permanent investments. They were husbanded skillfully until the owners became bankers and moneylenders throughout Europe. (When the newly independent United States found themselves short of capital, it was to the Dutch that they turned for help.)

The evolution of their maritime economy bears out the contention that the Dutch were a "saving" people. "Their common

Figure 35 Allaert van Everdingen, Mountainous Landscape with a River Valley, 1647, canvas. Copenhagen, Statens Museum for Kunst.

riches" wrote Sir William Temple, English ambassador to the Hague in 1672 "lye in every Man's having more than he spends: or, to say it properly, in every Man's spending less than he has coming in, be that what it will." Whatever they saved on, it does not seem to have been on paintings: As we have seen, these were popular with everybody. Temple, it may be noted, made no comment whatever on Dutch art, even though it was at this very time at its apogée. The average middle-class Dutch home was well furnished with glass, pewter, silver, tapestries, carpets; and the paintings of domestic interiors by Johannes Vermeer, Pieter de Hooch, Jan Steen, Ferdinand Bol, Emmanuel de Witte, Nicolaes Maes, and many others not infrequently depict at least one painting hanging in the background.

The Dutch school consists of many genres; of these, marine paintings are only one. The geography, economy, and social cir-

cumstances of the country encouraged, and reflected, variety of representation. The growth of urban living suggested the urban exteriors we find, for instance, in Vermeer or Berckheyde, the domestic interiors of de Hooch or de Witte, the still lifes of Heda or Claesz. The development of horticulture partly explains the popularity of the meticulous realism of flower paintings, such as those of Jan van Huysum or Bosschaert. The social life of the town was the natural stimulus for the group paintings of Hals or de Bray — clubs, governors of hospitals and orphanages, Rembrandt's "Night Watch." The spare religion of Calvin was the origin of the bare expanses of stone, the plain lines, and almost "abstract" quality of Saenredam's churches, unadorned by people, images, or decoration. Perhaps the individual portrait came into fashion because there were more painters to paint or more money to pay them, or because people in towns live in closer proximity and observe each other more closely.

On the origins of all these, as of marine painting, we may speculate endlessly. This chapter will end merely by hazarding a guess: that of all the influences working, consciously or unconsciously, to suggest subjects to the Dutch painters, few were as strong and omnipresent as water. Wherever the countryman went, he saw dikes, ditches, rivers, canals, seas, seashores, lakes, locks. The townsman spent his days crossing bridges, walking by the side of canals, visiting the harbor; if he was a merchant, he waited anxiously for news of his cargoes going or coming by ship to or from London or Brazil or Batavia. If he was a banker or investor or speculator, the arrival of the packet boat from Harwich at Helvoetsluys might herald news of world prices, booms or bankruptcies that could make or break him. In wartime the people of Holland held their breath — was it victory or defeat for Tromp, de Witte, or de Ruyter?

Water to the Dutch was as important as land. They, and they alone, had so far escaped from the universal prison of isolation, poverty, and famine that enclosed the rest of landlocked humanity. They alone commanded a seaborne empire: their acquired skills in navigation, hydrography, cartography, and ship management in peace and war were basic to their history and their art. A "landscape" by Jan van Goyen or Jacob van Ruisdael is likely to turn out to be a waterscape or seascape. The humdrum functions of the fishing fleet were poetry to Abraham van Salm, just as the great sea battles were symphonies of action and color to the van de Veldes, Elder and Younger. There is terror as well as the beauty of motion in the sea pictures of Ludolph Backhuysen. And while Hendrick Cornelisz. Vroom and Lieve Pietersz. Verschuier were recording the comings and goings of European VIPs in the republic, Rumphius, "Pliny of the Indies," arrived in the Moluccas to execute his commission from the East India Company. The result was several hundreds of the most exquisite botanical drawings of the century.

CHARLES K. WILSON

SEVENTEENTH-CENTURY DUTCH SEASCAPES

AN INSIDE VIEW

Considering the number of seascapes produced during The Netherlands' golden age, it is not surprising to find a fair number of them represented in paintings from this period. Contemporary inventories indicate that marine paintings could be found in almost every type of interior setting, from narrow hallways in private homes to grand salons in public buildings. Paintings and drawings show that seascapes were often combined with landscapes, portraits, and other subjects to enhance the plain, off-white walls of Dutch interiors. A study of these "pictures within pictures" indicates that maritime imagery had numerous meanings for the seventeenth-century viewer.

Marine paintings often appear in the elaborate Renaissance interior scenes that were a specialty of several of Holland's early-seventeenth-century artists. Although mainly fanciful, paintings like Bartholomeus van Bassen's *Interior with Tric-trac Players* (Fig. 36) suggest the types of pictures to be found in the more elegant Dutch interiors. In another of van Bassen's paintings (Fig.

37), from the 1620s, a framed marine picture occupies a prominent position, this time not on the wall but on a bench at the right. Here a heavy black frame heightens the illusion of a view onto the open sea. These representations, with their often dramatic portrayals of sea and sky, were a strong contrast to the controlled and peaceful ambience of such interior settings. Views of the open sea were also a regular item in simpler interiors, as seen in *Musical Company* of 1645 by Joost Cornelisz. Droochsloot (Fig. 38). Here all three paintings on the walls are in narrow black frames. The shapes and sizes of the seascapes in these paintings, including their frames, varied greatly, as did the height at which they were hung. Sometimes they were placed at eye level, but just as often they were displayed high on the wall, well out of reach of both youngsters and adults.

It is almost impossible to document the specific source of any of the seascapes found in seventeenth-century Dutch paintings. The same is true of landscapes because of the large number of similar compositions.[1] At best, art historians have only been able

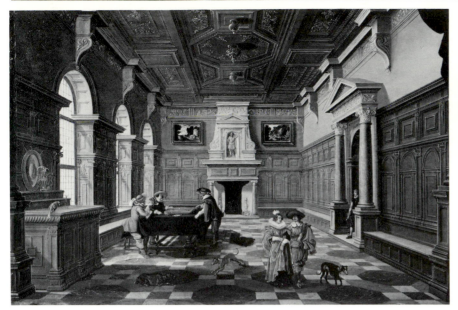

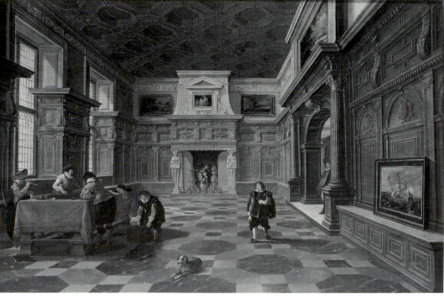

Figure 36 *Bartolomeus van Bassen,* Interior with Tric-trac Players, *oil on panel.*
Copenhagen, Statens Museum for Kunst.

Figure 37 *Bartolomeus van Bassen,* Interior with Tric-trac Players, *162(?), oil on*
panel. The Netherlands, private collection.

to associate certain works with major artists or schools based on the overall style of the picture in question.[2] Our inability to confirm specific sources should not lead us to conclude, however, that the seascapes and landscapes in these interior scenes were not taken from original works. In fact, a good number of other types of paintings – especially figurative compositions – and many of the wall maps found in interior scenes from this period have been identified with specific sources.[3]

Seascapes were a common element in the so-called merry company pictures that were painted in great numbers in the second quarter of the seventeenth century by artists like Dirck Hals, Pieter Codde, and Anthonie Palamedesz.[4] One of Hals's merry company paintings (Fig. 39) includes both a large seascape and a large wall map.[5] Although the source of the seascape remains unknown, the map has been identified. First published in 1602 by Jodocus Hondius, it represents the Seventeen Provinces of the Netherlands.[6]

This particular map is an appropriate accompaniment to the seascape because it includes representations of twenty-six different types of sailing vessels, each of which on the original map is identified by its name and size. Both map and seascape serve to link this crowded interior scene to the much larger world beyond. Like the ornate Dutch costumes, they add to the national identity of these wealthy inhabitants of one of Europe's most powerful seafaring nations.

As Hals's painting demonstrates, wall maps, like seascapes and other framed pictures, are important compositional elements in the scenes in which they appear. Their simple rectangular shapes made them an easy addition to most interior scenes. Like maps and landscapes, seascapes also offer a contrast to the confined interior by suggesting the much larger world outside.

The maritime pictures appearing in these interior scenes reflect first and foremost the strong seafaring interest of the Dutch na-

Figure 38 *Joost Cornelisz. Droochsloot, Musical Company, 1645, oil on canvas. Utrecht, Centraal Museum.*

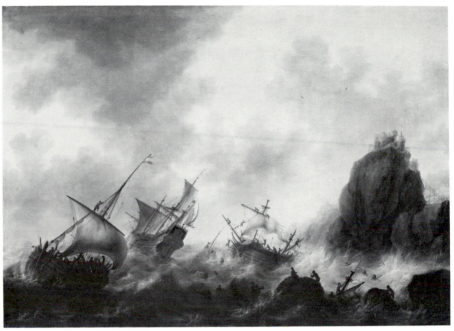

Figure 40 *Jacob Adriaensz. Bellevois, Sea Storm on a Rocky Coast, 1664, oil on canvas. Braunschweig, Herzog Anton Ulrich-Museum.*

Figure 39 *Dirck Hals,* Merry Company, *ca. 1630, oil on panel. Nottingham Art Gallery.*

tion. To appreciate any further significance of the seascapes within these interior settings, one must first consider the general symbolic associations marine pictures had for the seventeenth-century viewer. Since ancient times, the ship on the sea had been a common symbol of man's life (*navigatio vitae*), which was seen as being at the mercy of outside forces. From early Christian times the church was often compared to a ship by which the faithful reached salvation. Such symbolism was reinforced by biblical accounts like Christ and his disciples on the stormy sea (Matt. 8:25–27). By the sixteenth century the depiction of ships on stormy seas had become a standard symbol of the fragility of life, the precariousness of human institutions, and the necessity of having faith in God. Jacob Adriaensz. Bellevois's seventeenth-century painting *Sea Storm on a Rocky Coast* (Fig. 40) dramatically con-

veys the kinds of dangers one faced in traveling by sea. Here men struggle for their lives as they flee the ships that have crashed against the rocks. The two figures silhouetted in the foreground, shown praying for their salvation, are vivid reminders of man's dependence on God.

Considering that by the seventeenth century the relationship between man and the sea formed the basis for marine iconography, it is not surprising to find that seascapes from this period almost without exception include some form of human activity. A recent study by Lawrence Goedde indicates that in the majority of Dutch tempest paintings of the seventeenth century, man takes a more active role in his struggle against the elements.[7] These tempest paintings, which rely heavily on convention, are still in effect memento mori, reminders of man's helplessness in the face of certain elemental forces. On the other hand, a depiction of a calm sea could reflect man's livelihood or, in general, his being in harmony with God.

In a country dominated by Calvinism, seascapes were convenient reminders of not only the fragility but also the transitoriness of man's life. The seascapes that appear in the merry company pictures, therefore, may well have further meaning. As a background to the well-dressed men and women who are often shown indulging in worldly pleasures, they may serve to call attention to both the moral dangers and the transience of man's earthly environment.

The ship at sea as a metaphor for man's life is hinted at in Gabriel Metsu's *Visit to the Nursery* (Fig. 41), painted in 1661. In this scene, which focuses on a newborn child, the overmantel painting, formerly more visible than it is today, represents a storm at sea. As John Walsh has observed, the prominently displayed painting probably serves as a reminder of the fragility of human life or, as Shakespeare called it, "life's uncertain voyage."[8]

As with many Dutch paintings, it is often difficult to determine the specific intentions of the artist because much of the symbolism

Figure 41 Gabriel Metsu, The Visit to the Nursery, *1661, oil on canvas. New York, The Metropolitan Museum of Art.*

is represented in realistic terms. Although marine imagery has had a rich iconographic tradition, the inclusion of a seascape within an interior scene is no guarantee of further meaning. One must consider other factors, in particular the specific context in which the seascape appears. For example, in Jan Steen's *Easy Come, Easy Go* (Fig. 42), painted the same year as Metsu's *Visit to the Nursery*, there is little question about the significance of the marine painting that appears over the fireplace. Here the ornately framed seascape serves as the background to a sculpture of Fortuna and echoes the capricious role of the goddess by showing

Figure 42 Jan Steen, Easy Come, Easy Go, *1661, oil on canvas. Rotterdam,
Museum Boymans–van Beuningen.*

Figure 43 Emblem from Jan Harmensz. Krul, Minne-beelden...Amsterdam, 1640.

century description of de Vlieger's marine painting in its original setting referred to it as "a shipwreck and thus as the origin of the poverty encountered in this house."[11] Such an account enables us to appreciate further the special significance seascapes could have for an earlier audience.

In the seventeenth century, seascapes were often incorporated into genre paintings that have amorous connotations. E. de Jongh was the first to point to an emblem of Jan Harmensz. Krul (Fig. 43) to show the connections that were made at the time between love and the sea. This emblem, the title of which can be roughly translated "Out of sight, but not out of mind," shows a man on a bow of a ship being piloted by Cupid. The text that accompanies the emblem points out the tenuous nature of love: "Love may rightly be

one ship safely under sail and another shipwrecked on the rocks. Together, the seascape and Fortuna suggest the eventual floundering of the man seated at the table, who is shown indulging in worldly pleasures. This interpretation is confirmed by the inscription on the fireplace, translated "Easy come, easy go," which warns about the dangers of luxurious living. Steen, who used the same motif of Fortuna and a seascape over a fireplace in a painting dated 1660, appears to have borrowed the motif from a 1633 engraving by Abraham Bosse.[9]

It appears that seascapes were often placed over the fireplace.[10] Simon de Vlieger's *Shipwreck,* now in the Amsterdam Historical Museum, for example, once hung in Amsterdam over the fireplace in the Oudezijds Huiszittenhuis, a charitable institution whose purpose was to provide relief for the poor, many of whom were disabled sailors and families of men lost at sea. An eighteenth-

Figure 44 Dirck Hals, Woman Tearing Up a Letter, *1631, oil on panel. Mainz, Landesmuseum.*

Figure 45 Gabriel Metsu, The Letter Reader, *oil on panel. Blessington, Ireland, Sir Alfred Beit Collection.*

Figure 46 Jan Vermeer, The Love Letter, *ca. 1670, oil on canvas. Amsterdam, Rijksmuseum.*

Figure 47 Pieter Codde, Portrait of a Young Man Standing, *1625, oil on panel. Oxford, Ashmolean Museum.*

compared with the sea / from the viewpoint of her changes / which one hour cause hope / the next fear: So too goes it with a lover / who like the skipper / who journeys to sea / one day encounters good weather / the next storm and roaring wind."[12]

A number of paintings depicting a woman and a letter next to a seascape also convey the theme of love. Two by Dirck Hals are among the earliest. In the one dated 1631 (Fig. 44), which shows an enraged woman tearing up a letter, the only picture on the back wall is a stormy marine showing ships combating treacherous conditions. The combination of the letter and the marine painting suggests that the woman has just received word of a lover lost at sea, in effect the end of a love affair. In the other

work by Hals, in the Philadelphia Museum of Art, the artist incorporates a calm seascape to reflect the positive reaction of a woman with a letter who is shown seated.[13]

The seascape and letter motif was continued by the next generation of Dutch artists, including Gabriel Metsu, whose painting in the Beit Collection (Fig. 45) incorporates two figures to carry out the theme. Here the one woman reads a letter while her maid raises the curtain on a painting to provide a glimpse of several ships on a choppy sea. The curtain that covers the framed marine painting not only was a protective device – to limit the exposure to light and dust – but also added a certain preciousness to the work. The raising of the curtain to view the painting must have

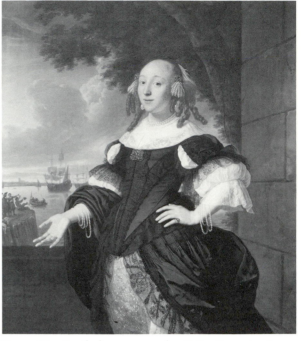

Figure 48 Ferdinand Bol, Michiel Adriaensz. de Ruyter, *1667, oil on canvas. Amsterdam, Rijksmuseum.*

Figure 49 Bartholomeus van der Helst, Portrait of Aert van Nes, *oil on canvas. Amsterdam, Rijksmuseum.*

Figure 50 Bartholomeus van der Helst, Portrait of Geertruide den Dubbelde, *oil on canvas. Amsterdam, Rijksmuseum.*

heightened the illusion of looking into a world far removed from the interior setting. In Metsu's painting, the seascape combined with the letter again serves to suggest the absent lover.

Knowing the seventeenth-century associations between love and the sea, one can better appreciate Jan Vermeer's painting *The Love Letter* (Fig. 46), the only work by the master to include a seascape. The woman seated next to her maid holds a letter that in connection with the lute has amorous connotations. In this context, the depiction of boats on a calm sea serves as a good omen regarding the unopened letter.[14]

Seascapes were often incorporated into portraits, such as Pieter Codde's *Portrait of a Young Man Standing* (Fig. 47), dated 1625. Because the man's identity is unknown, it is impossible to determine if the artist intended any particular significance with the framed seascape that hangs on the back wall. In other portraits

one can be more certain that the seascape was included to suggest specific interests of the person portrayed. For example, Lodewijk van der Helst's portrait of the marine painter Willem van de Velde the Younger shows the artist holding a large drawing of a seascape.[15] Much more common, however, than a "picture within a picture" was the practice of including behind the sitter an actual scene of ships on the water. One of the best examples is Ferdinand Bol's portrait of Vice Admiral Michiel Adriaensz. de Ruyter (Fig. 48). The background of this portrait, which includes a view of the Dutch fleet and, most prominently, de Ruyter's flagship, *Zeven Provincien,* is thought to have been painted by the marine specialist Willem van de Velde the Younger. Such maritime vistas became part of the standard iconography of Dutch naval portraiture. They also appear in pendant portraits, as in the pair by Bartholomeus van der Helst of Vice Admiral Aert van Nes (Fig.

49) and his wife, Geertruida den Dubbelde (Fig. 50). In these two paintings, the scene in the background, added by the marine painter Ludolph Backhuysen, serves to visually connect the two separate canvases.[16]

Whether an actual scene or a framed painting, seascapes were a natural addition to Dutch portraits and genre scenes. As "windows" to the sea, they point to the maritime world that was so much a part of The Netherlands. As with many of the details in Dutch painting, they also provide further insight into the beliefs and customs of this small but important seafaring nation.

JAMES A. WELU

NOTES

1. See W. Stechow, "Landscape Paintings in Dutch Seventeenth Century Interiors," *Nederlands Kunsthistorisch Jaarboek* 2 (1960), p. 166.

2. One attempt to associate a seascape with a specific artist was made by J. Walsh, Jr., "The Dutch Marine Painters Jan and Julius Porcellis – I:" *Burlington Magazine* 1 (December 1974), p. 653. Walsh connected the seascape in Thomas de Keyser's portrait of Constantijn Huygens with Jan Porcellis, who was a favorite of Huygens.

3. See J. A. Welu, "Vermeer and Cartography" (diss.), Boston University, 1977.

4. Philadelphia, Philadelphia Museum of Art, *Masters of Seventeenth-Century Dutch Genre Painting*, 1984, p. 293 (catalogue by P. Sutton), suggests that the stormy seascape in several paintings by Anthonie Palamedesz. may have been a studio prop.

5. Another, larger, version of this same composition (panel, 42 × 78.3 cm) is currently with Charles Roelofsz, Amsterdam.

6. The same map appears in another composition by Dirck Hals; see Welu, "Vermeer," pp. 11–12.

7. L. O. Goedde, "Convention, Realism and the Interpretation of Dutch and Flemish Tempest Painting," *Simiolus* 16 (1986), p. 142, points out, however, that seventeenth-century tempest paintings emphasize man's control and perseverance, whereas actual accounts often describe man's helplessness in the face of the open sea.

8. The Flemish artist Hieronymous Janssens (1624–1693) incorporated a series of three seascapes on the back wall of a painting whose subject is similar to that of Metsu. See Worcester, Worcester Art Museum, *The Collector's Cabinet: Flemish Paintings from New England Private Collections*, 1983, p. 73, fig. 18d (catalogue by J. A. Welu).

9. For an illustration of the other Steen painting and the Bosse print, see Philadelphia, *Masters*, 1984, pp. 309–310, figs. 1, 2.

10. Catalogue entry on file at the Metropolitan Museum of Art. The overmantel painting in Metsu's *Musical Company* in the Mauritshuis also represents a ship on a stormy sea, which in this case serves as a contrast to a scene of harmony and moderation.

11. See T. Krielaart, "Symboliek in zeegezichten," *Antiek* 8 (1973–1974), pp. 568–569.

12. De Jongh, *Zinne- en minnebeelden in de schilderkunst van de zeventiende eeuw*, Amsterdam, 1967, p. 52; Krul, *Minnenbilden: Toe-gepast de lievende jonckheyt*, Amsterdam, 1640, pp. 2–3; "Wel te recht mach Liefde by de Zee veergeleecken werden / aenghesien haer veranderinge / die d'eene uyr hoop / d'ander uyr vreese doet veroorsaecken: even gaet het met een Minnaer / als het een schippen doet / de welcke sich op Zee beghevende / d'eene dagh goedt we'er / d'ander dagh Storm en bulderende wint gewaer wort." Susan Kuretsky refers to this association between love and the sea in commenting on the presence of what appears to be a seascape in Jacob Ochtervelt's *The Betrothal* (ca. 1671–1673) – see *The Paintings of Jacob Ochtervelt (1634–1682)*, Oxford, 1979, pp. 72–73.

13. A similar seascape appears in the background of *The Soloist*, another work by Hals from about the same time. The significance, if any, of the seascape in this painting is unclear; see Renate Trnek's discussion in Minneapolis, The Minneapolis Institute of Arts – Houston Museum of Fine Arts – San Diego, San Diego Museum of Art, *Dutch and Flemish Masters: Paintings from the Vienna Academy of Fine Arts*, 1985, pp. 50–51, 101.

14. Vermeer's painting has been associated with the engraving in Jan Krul's *Pampiere Wereld*, in which Cupid delivers a letter to a woman seated before a picture of a boat on a calm sea. See A. K. Wheelock, Jr., *Vermeer*, New York, 1981, pp. 42–43.

15. Rijksmuseum, Amsterdam, A2236.

16. Rijksmuseum, Amsterdam, A140, A141. For discussion of the background in these two paintings, see D. R. Smith, *Masks of Wedlock: Seventeenth-Century Dutch Marriage Portraiture*, Ann Arbor, Mich., 1982, p. 46.

"Chartmaking is the Power and Glory of the Country"

DUTCH MARINE CARTOGRAPHY IN THE SEVENTEENTH CENTURY

INTRODUCTION

"Chartmaking is the nation's power and glory." These words, written by engraver and chartmaker Johannes van Loon in the foreword to his marine atlas *De Klaer Lichtende Noort-Star* (1666), sum up the vital importance of nautical cartography in the Dutch golden age.[1] Van Loon was well aware that the young Republic of the Seven United Provinces owed its prosperity, and indeed its very existence, to the powerful mercantile empire it had established. The nation's interests abroad, which had been the source of its strength in the eighty-year struggle for independence from Spain, could be served only as long as it had access to these lands overseas, and a safe voyage depended on reliable charts. Without them, as van Loon pointed out, "het kost niet alleenlick 't Lijf, maar oock Schip en goedt" (it costs not only lives but ship and cargo too).

Many inhabitants of the Low Countries had long depended on the sea for their livelihood, and by the late Middle Ages both shipping and fishing were important occupations in the North Sea and the Baltic. When the Low Countries were incorporated into the empire that Charles V had built up around the globe, and links were established with the Spanish and Portuguese realms, commerce increased dramatically and within a few decades had created unprecedented prosperity. Antwerp became an international center of shipping from which trade routes radiated to the four corners of the earth. After Antwerp fell to the Spanish in 1585, its access to the sea permanently cut off by the northern provinces, Amsterdam rose to prominence as a leading maritime center. The conditions were ideal: Amsterdam had everything to offer — competent seamen who were skilled and experienced at sailing the coasts of Europe, numerous ships, an influx of wealthy merchants from Flanders and Antwerp, and a liberal trading climate.

This surge of activity was accompanied by a growing demand for navigational aids such as instruments, pilot books, and charts, particularly toward the end of the century, when explorers in

search of new routes to the riches of the Far East took to the open sea. The seventeenth century ushered in a period of unprecedented growth in which Amsterdam became the world's leading center of cartography.

WAGHENAER, PLANCIUS, AND CLAESZ.

Strictly speaking, the year 1600 was not the true watershed in the history of Dutch hydrography of the period, as the last two decades of the sixteenth century had been of decisive importance in the development of pilot guides and charts.

From the late Middle Ages, Dutch seafarers were content to rely on information passed down from father to son, both orally and in writing. Then, toward the middle of the sixteenth century, descriptions of routes and coastlines as well as sea charts began appearing in print for the first time. On the basis of this material, and drawing on his own knowledge and experience, Lucas Jansz. Waghenaer (1533/34–1606) published in 1584 the *Spieghel der Zeevaert,* which was the first true pilot guide and consequently a milestone in the history of navigation (Fig. 51).[2] Translated into French, Latin, and German, and reprinted several times, it comprised a general introduction to the art of navigation, charts, and sailing directions complete with coastal profiles. A volume on the German Bight and the Baltic Sea, the "eastern" navigation, was followed a year later by one on the "western" navigation with sailing directions for the coasts of Western Europe as far as the Canary Islands. Waghenaer published a new pilot in 1592, the *Thresoor der Zeevaert,* which contained a substantially more detailed text and a larger number of charts. Its oblong format, moreover, was better suited to the needs of seamen.[3]

Waghenaer was from Enkhuizen in the north of Holland, where between 1580 and 1610 a number of chartmakers were specializing in portolan charts, magnificently colored works depicting the seven seas and their adjacent coastlines, either drawn on vellum or in some cases printed. Distinct similarities in design and

drawing style, and the fact that these *caert-schrijvers* (chartmakers) lived and worked in close proximity to one another, suggest that there was a certain tradition of maritime cartography that warrants the description "school": the North Holland school of cartographers.[4] On the whole, they were not particularly original, relying heavily on Spanish and Portuguese examples. This is apparent in the work of Cornelisz Doedsz., for instance, in a *Chart of the Atlantic Ocean* (Cat. 133). Some, however, succeeded in producing original work by drawing on material they had themselves collected. Waghenaer was in fact alluding to this element of personal experience when he called himself a "navigator" in his monumental *Generale pascaerte van gantsch Europa,* which was published in four sheets in 1589.[5]

Figure 51. Johannes van Doetecum, frontispiece to Lucas Jansz. Waghenaer, Spieghel der Zeevaerdt., 1584. Leiden, University Library. The first printed pilot guide with charts.

Petrus Plancius (1552–1622) geographer, mathematician, and theologian, is rightly regarded as the father of Dutch cartography (Fig. 52).[6] A devout Protestant, he fled the Catholic south in 1585 to make his home in Amsterdam. There was a growing interest at the time in voyages beyond the confines of Europe, in particular to Southeast Asia. Plancius laid the scientific groundwork for the first Dutch expeditions to the East Indies, both through the northeast passage via Nova Zembla (1594, 1595, and 1596) and around the Cape of Good Hope (1595–1597 and 1598–1599). It was primarily through his efforts that crucial source material could be obtained from Portugal. Plancius used this material as a basis for a number of "special" charts that he compiled in 1592 of coastlines in regions beyond Europe, as well as for his renowned world chart in eighteen sheets, the *Nova et exacta terrarum orbis tabula geographica ac hydrographica,* which summarizes the entire body of geographical knowledge of the day.[7] Plancius's charts, which were based on the work of the Portuguese, therefore mark the end of an era. At the same time, however, they were the first in a long series of original Dutch charts that recorded with meticulous care the explorers' progress and discoveries. The year 1592 was thus crucial in the history of Dutch cartography: Its golden age was dawning.

The unique contribution made by Amsterdam's printers and publishers represented a major breakthrough. Whereas chartmakers elsewhere in Europe were still drawing maps by hand, their counterparts in Amsterdam had begun publishing maps in printed editions by the end of the sixteenth century. For more than a hundred years, Amsterdam was to dominate the world market in printed ocean cartography. Were it not for this transition from handmade work to typography and the prospects it opened up for large-scale commercial production, the overwhelming demand for navigational charts could never have been met.[8] Between 1580 and 1609, the Amsterdam publisher Cornelis Claesz. published a beautiful series of travel journals, charts, and atlases, setting a precedent that few could surpass.[9] Besides the

Figure 52. W. J. Delff, Petrus Plancius (1552–1622), *engraving, 1623. Amsterdam, Rijksprentenkabinet. Plancius was the father of Dutch cartography.*

later editions of Waghenaer's pilot guide, for example, he also published the Mediterranean sequel, the *Nieuwe beschrijvinghe ende caertboeck vande Midlandtsche Zee* (1595), originally a collection of hand-drawn portolan charts that the famous explorer Willem Barentsz. had annotated and prepared for publication.[10]

Waghenaer's competence and experience as a seaman, the ingenuity of the scientist Plancius, and the spirit of enterprise shown by the publisher Claesz. paved the way for the unparalleled development of Dutch hydrography during the following century.[11] In this essay, I have chosen to highlight two of the oldest forms of marine cartographic publication – pilot books and charts. In each case the pioneer was Willem Jansz. Blaeu (1571–1638).

PILOT BOOKS

By the time he published his first pilot book in 1608, Blaeu had acquired a formidable reputation as a scientific cartographer. Born near Alkmaar, he mastered the principles of mathematics and astronomy at an early age. He spent several months in the winter of 1595–1596 studying under the distinguished astronomer Tycho Brahe on the Danish island of Ven in the Sound. This sojourn afforded him a unique opportunity to advance in his field and to learn how to make and use astronomical instruments in Brahe's observatory, Uranienborg. Blaeu's son Joan Blaeu was later to include eleven drawings of Brahe's observatory in his *Atlas Maior* as a tribute to his father's tutor.[12]

At the beginning of 1599, Willem Jansz., as Blaeu was then known, settled in Amsterdam as a dealer in nautical instruments, globes, and charts. His first terrestrial globe dates from that same year. No sooner had he completed two of his most outstanding works in the field of cartography – the wall charts of the world dating from 1605 and 1607 – than his first pilot guide, *Het Licht der Zeevaert*, was published (Cat. 129).[13] The structure, layout, and format were based on the example of Waghenaer's *Thresoor der Zeevaert*. Blaeu's book appeared in the same oblong format, likewise in two volumes covering the Western and Eastern seas, describing the coastal waters in separate sections by means of a combination of text, coastal views, and charts. In 1618 he completed a volume on the Mediterranean, but the hope he had cherished of completing the work with a volume on Guinea, Brazil, and the East and West Indies was never fulfilled.

Blaeu's pilot guide, translated into English and French and reprinted twenty times by 1637, was a definitive work and remained without parallel for a quarter of a century. Throughout that period nothing in it needed to be changed. The introduction on the art of navigation reveals the debt Blaeu owed to his teacher, Brahe. It is a lesson in applied astronomy, a manual to enable navigators to identify stars and calculate latitude by the declination of the sun and stars. As far as longitude was concerned, Blaeu was critical of the theory espoused by Plancius and the mathematician Simon Stevin, who maintained that longitude could be calculated from the compass deviation. Finally, Blaeu rejected the popular notion that printed charts, unlike hand-drawn ones, could not be revised and updated at regular intervals.

In 1620, after carefully copying the text and charts, Blaeu's rival Johannes Janssonius published a pirate edition under the same title. At this point, Willem Jansz, who also used the Latinized version of his name – Guilielmus Janssonius – assumed the surname Blaeu in order to avoid confusion. For the same reason, he decided in 1623 to publish a completely revised edition of the pilot under the title *Zeespiegel*, which contained one hundred eleven charts instead of the original forty-two. Printed in folio format, *Zeespiegel* became the prototype for the innumerable atlases and pilots published throughout the century.[14]

Amsterdam was now poised on the threshold of its own golden age as a metropolis of international trade and maritime power. The demand for nautical instruments, pilot guides, sea atlases, and charts was growing daily, and not surprisingly, Blaeu's monopolistic position was gradually undermined as competitors vied for a slice of the market.

Jacob Colom (1600–1673), a printer and seller of books and charts who, like Blaeu and Janssonius, had a business "on the Water" in the heart of Amsterdam (now the Damrak boulevard), was Blaeu's first serious competitor.[15] In 1632 he published a brand-new pilot guide entitled *De Vyerighe Colom*. The title, which means "the fiery column," was both a pun on his name and an allusion to the pillar of fire that served to guide the people of Israel on their journey through the desert (Fig. 53). There was a large demand for the new manual, in which, according to Colom, "de feylen en misslagen van 't voorgaende Licht of Spiegel der Zee naectelijck verthoont en verbetert werden" (the shortcomings and errors in the earlier *Licht of Spiegel der Zee* [Blaeu's work] were frankly exposed and rectified). The fact that thirteen

Figure 53.　Frontispiece to the French edition of Jacob Aertsz. Colom's pilot guide, Colomne de la Mer, 1633. Leiden, University Library. This frontispiece shows instruction in the art of navigation.

editions were published between 1632 and 1671 is evidence of its extraordinary success. Blaeu was ultimately unable to equal it and finally abandoned his efforts to recover the ground he had lost. The production of pilot guides was left to the other publishing houses that sprang up to fill the gap in the market.

Following Blaeu and Colom, Anthonie Jacobsz. (1606/7–1650) was the third in a succession of Amsterdam publishers to have an innovative impact on Dutch nautical cartography.[16] His *Lichtende Columne ofte Zeespiegel* (1643) – whose title was a bold challenge to Colom – contained substantially more charts than Colom's atlas and was a work of outstanding quality. The same is true of the coastal descriptions and sailing directions, which are presumably attributable to the same Johannes van Loon from whom the opening sentence of this essay has been cited.

The following years, until about 1680, saw few changes of any importance, and most of what was produced was copied from earlier examples. The bookseller Pieter Goos (1615/16–1675) was the least original. He bought Jacobsz.'s copperplates, which he then reduced, printed, and issued in a reduced format under the original title, *Zeespiegel*. He also copied the charts of Hendrick Doncker (1625/26–1699), which he published in an edition entitled *Zee-atlas*.[17] "Bunglers," van Loon called these plagiarists, who "reap where they have not sown, and take bread from the mouths of others." A distinctive and rather singular feature of Goos's sea atlases was that they were often beautifully colored. Doncker took a different approach and was more concerned to ensure that his charts were revised at regular intervals. The fact that his *Zee-atlas ofte Water-Waereld* (1659) was the first atlas to include coastal charts of non-European waters is a further mark of his originality.[18] A new course had been set, to be followed by the first publication ever of a pilot guide devoted exclusively to coastal waters outside Europe. In 1675, Pieter Goos published Arent Roggeveen's *Het Brandende Veen* (Cat. 130), a compilation of charts and sailing directions for the territories in which the West India Company was operating, covering the eastern coast of America from Guyana to the mouth of the St. Lawrence.

This period in the development of pilot guides culminated in the publication of an atlas in five volumes, *De Nieuwe Groote Lichtende Zee-fakkel*, by Johannes van Keulen (1654–1715). It was the first marine world atlas to cover navigation along the

European coasts and in the Mediterranean as well as West Africa and the West Indies (Fig. 54).[19] Although van Keulen was neither the author nor the compiler of the atlas, it was published under his name and rightly so, because it was he, as the editor of this ambitious project, who had the courage and energy to bring it to fruition. It is clear from the speed with which one volume followed another over a period of four years, from 1681 to 1684, that the groundwork for the enterprise as a whole had been carefully laid long before the first volume was published. The huge overnight success of the project proved so intimidating to other publishing houses that several were forced to close down.

Figure 54. Jan Luyken, frontispiece to Johannes van Keulen, Zee-fakkel, engraving, 1682. Leiden, University Library. The burning torch of the largest Dutch pilot guide lights the globe and the seas, with a grateful Mercury in the foreground.

The actual selection and compilation of the material had been in the hands of Claas Jansz. Vooght, a mathematician and instructor in the art of navigation. He was assisted by Johannes van Loon in preparing the second volume, covering the Western Sea. His main accomplishment lay in the acquisition and systematic recording of vast amounts of up-to-date information. Van Keulen's preface to the atlas draws attention to the improvements that had been made: "Coastal strips occupy a smaller area on the maps; latitude is indicated more accurately; the positions of several places have been corrected so that directions and distances are more reliable; chart data are on the whole more accurate; the coastal maps have been designed to link up with each other as much as possible, and in volume four (the West Indies) errors in the charts as well as in Arent Roggeveen's sailing instructions have been corrected."

The *Zee-fakkel* was destined for a long life. Parts of it were revised and amplified, and the work was published far into the eighteenth century. Finally, in 1753, the sixth volume appeared, with charts of the Indian Ocean and the Far East – the empire of the Dutch East India Company.

From about 1660, as French and Dutch publishers began issuing French books in the Netherlands, cartographic material from France also became available, and was sold either as original work or as copies made locally in the Republic. Here the key figure in the field of cartography was Pieter Mortier (1661–1711), a third-generation refugee.[20] The signboard reading *De Stad Parijs* (The City of Paris), which he displayed outside his premises on the Dam, proclaimed that he specialized in French books. On September 15, 1690, the States General of Holland granted him the right to publish Sanson and Jaillot maps.

In 1693 the first official French sea atlas, *Le Neptune François*, came off the presses of the royal printing office in Paris. It was indeed fit for a king. The twenty-nine charts covering the coastline from Norway to Gibraltar were superbly engraved and printed on heavy paper in a large-folio format. In the same year, Mortier

managed to surpass even this achievement by marketing in Amsterdam a pirate edition that was identically engraved and printed. The original French edition stood no chance of success because Mortier had flooded the European market with his own version in Dutch and English as well as French. Two important supplements followed in 1693 and 1700. The first, *Cartes Marines à l'usage du Roy de la Grande Bretagne* (William III of Orange), contains nine sea charts collected and engraved by Romeyn de Hooghe, which are the loveliest examples of the art of Dutch hydrographic etching produced in the seventeenth century (Fig. 55). The second supplement contains sketch charts of the coasts of Africa and of the oceans, which Mortier had based on copies

Figure 55. Romeyn de Hooghe, frontispiece to Pieter Mortier, Cartes Marines à l'usage du Roy de la Grande Bretagne, 1693. *Leiden, University Library. The pillars of Hercules with the coat of arms of William III of Orange adorn this frontispiece.*

of "secret" Portuguese charts. However, this decorative French flourish at the close of the seventeenth century had little impact on the further development of Dutch pilot guides; the popularity of van Keulen's *Zee-fakkel* saw to that.

SEA CHARTS

In days gone by, Dutch seafarers used charts only sporadically as they sailed the coastline of Europe, where they regularly came in sight of land. They relied predominantly on their own experience for fixing their position at sea and for entering estuaries and harbors. In the course of the sixteenth century, they started to compile pilot guides, initially by hand and later in print, to record the information they had accumulated. Estuaries along the coasts and the approaches to large ports were sometimes charted as well, although not in any systematic fashion (Cat. 129).

After about 1600, with the growth of the deep-sea trade to both the East and West, charts suddenly became indispensable for laying off routes, plotting courses, and establishing a ship's position by dead reckoning, out of sight of land. As previously noted, the chartmakers working in North Holland toward the end of the sixteenth century produced charts, largely copied from the examples of Portuguese and Spanish portolans, that introduced ocean cartography in the Netherlands. The earliest and best known is the *Generale Paschaerte van Europa*, dating from 1583, which opened Waghenaer's *Spieghel der Zeevaerdt*.[21] These charts, most of them beautifully colored, show a growing global interest in cartography. At this stage, however, they were not used for navigation but were prized mainly for their decorative and informative value. Petrus Plancius was the first to recognize their potential as navigational aids, and he accordingly started to produce them in print. Right from the start, they were welcomed as an indispensable component of the navigator's equipment for voyages on the high seas.

The charts dating from this period fall into three categories.

First, there were the small-scale printed or manuscript charts covering entire oceans or parts of them. They were often produced on vellum, which was relatively resistant to wear and tear and the ravaging effects of climatic conditions at sea. The second category consisted of *paskaarten,* or compass charts, which had preprinted grids of compass roses, usually sixteen in number, and were used for plotting courses. The coastline was often only roughly indicated, or was sketched in en route. The third category comprises charts on a larger scale for the navigation of estuaries, straits, and coastlines (Cat. 138, 139).

As far as the first group is concerned, it was again Willem Jansz. Blaeu who set the standard for the rest of the seventeenth century with his publication in 1605 of the *Generale Pascaerte vande gheheele Oostersche Westersche ende een groot deel van de Mid-delantsche Zeevaart* by Cornelis Doedsz. of Edam. Three years previously, Cornelis Claesz. had published a magnificent chart of the coasts of Europe by Doedsz., but it was Blaeu who issued all the subsequent editions, including a revised version (ca. 1610) and two completely new engravings (1606 and ca. 1625). The same chart was even republished in 1677, by this time under the imprint of Willem, Pieter, and Joan Blaeu.[22]

The *West Indische Paskaert,* which represented the whole of the Atlantic Ocean and the adjacent coastlines, was greatly admired for both its accuracy and its artistic excellence, and has been described by Destombes and Gernez as "one of the most important contributions to the history of nautical cartography, made by the Dutch in the seventeenth century."[23] It was also published by Willem Blaeu between 1626 and 1630 and was the first Dutch chart to use the projection of increasing degrees devised by Mercator in 1569. This monument of Dutch cartography was based on two of Blaeu's charts of the West Indies – the *Paskaarte van de Westersche Zee* (1622) and the *Paskaart van Guinea, Brasilien en Westindien* (1625). The latter was especially important for its depiction of New Netherland, showing the latest discoveries made by Dutch explorers.[24] The *West Indische Paskaert*

remained in use for many years, partly because publishers such as Colom, Jacobsz., Doncker, and Goos produced a long series of copies (Fig. 56).

The most prolific producer of ocean charts in the seventeenth century was undoubtedly the Dutch East India Company (VOC), established in 1602 to trade with Asia.[25] The company's chart-making division had two main centers, in Amsterdam and Batavia, which were responsible for collecting data and compiling the basic charts, and it was they who produced the thousands of charts, mostly on vellum, with which the company equipped its vessels. It is estimated that between 1602 and 1699 some twenty thousand charts were produced at the VOC chart office in Amsterdam alone.

Figure 56. Joannes Loots, West Indische paskaert (sea chart of the Atlantic ocean), c. 1700. Leiden, University Library. The West Indische paskaert *on Mercator projection is one of the greatest achievements of Dutch hydrography of the seventeenth century.*

Hessel Gerritsz. (1580/81–1632) played an invaluable role in organizing this chart division and systematizing the task of charting the oceans. Keuning praised him in the highest possible terms, referring to him as "unquestionably the leading Dutch cartographer of the seventeenth century."[26] After studying graphic art under the Antwerp-born genre painter David Vinckboons, and cartography under Willem Jansz. Blaeu, the versatile Gerritsz. embarked on what was to be a highly varied career. From 1610 on he printed his own charts and published them as well. He had already established a reputation for several outstanding products, including maps of Lithuania, Russia, Italy, and Spain (Cat. 141), when he was appointed cartographer at the VOC's Amsterdam office in 1617.[27] During his first five years in this post, he designed several basic charts of the oceans, which continued to serve as models until the company was dissolved in 1799.

The strict pledge of confidentiality that the company demanded of its employees was less rigidly observed as time went by. This is apparent from the large number of geographic and ethnological publications that appeared in the seventeenth century, with illustrations taken from the VOC archives. They included work by Laet, Nieuhof, Dapper, Montanus, Baldaeus, and Bidloo. There are examples, too, of charts that were "released" at a surprisingly early stage and were printed in Amsterdam. The best known is the *Oost Indische Pas-caart* in four sheets, which Colom brought onto the market shortly after 1628, with Jacobsz., Doncker, Goos, and Allard in hot pursuit (Cat. 135). The charts showing the latest discoveries on the west coast of Australia, which Hessel Gerritsz. published under patent from the States General, can hardly be regarded as classified material (Fig. 57).[28] In the course of time, these *overzeilers* (sea crossings), or ocean charts, also appeared in the atlases published by Doncker, Goos, and van Keulen, albeit reduced in scale. By simply knowing the right people, even collectors apparently could obtain copies of charts from the VOC archives. With the help of the VOC's official cartographer, Joan Blaeu (1598–1673), the Amsterdam patrician Laurens van der

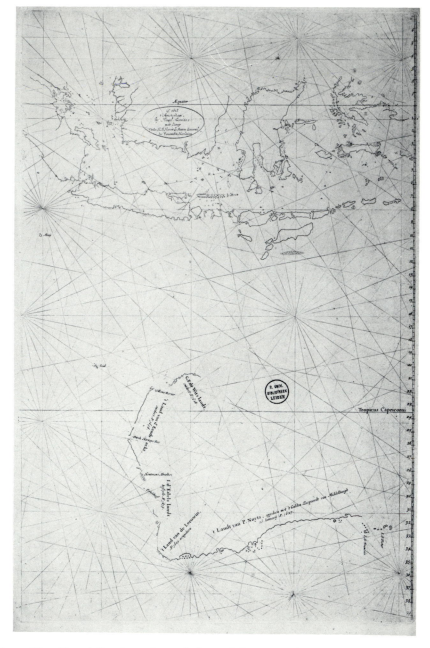

Figure 57. Hessel Gerritsz., General chart of the East Indian Archipelago, *engraving, 1618. Leiden, University Library. Hessel Gerritsz. designed and engraved this chart in 1618, but the Dutch discoveries made in the years 1616 to 1628 determining the west coast of Australia were added at a later date.*

Hem managed to expand his eleven volumes of Blaeu's Latin *Atlas Maior* into a collection of more than two thousand sheets in fifty volumes, including the four volumes on Asia comprising some 180 charts of the territories in which the VOC held patents.[29] Beautifully colored by the master in this genre, Dirck Jansz. van Santen,[30] and luxuriously bound in white vellum, it is the most expensive atlas in the world and is now a treasured possession of the Austrian National Library.

Hessel Gerritsz. was followed at the VOC by three generations of the Blaeu family, who supervised the company's charting operations with verve and enthusiasm for over seventy years. By about 1655, sufficient material had been accumulated for the company to contemplate compiling a book of charts of the East Indian waters. Joan Blaeu was deeply involved in the project, and not only in his capacity as VOC cartographer. He was a publisher, too, and therefore alert to the opportunity to add a volume on Southeast Asia to his monumental series of geographic works and atlases, and to expand his life's work, the *Atlas Maior,* with an ocean atlas of the western and eastern hemispheres.[31] Nothing came of these plans in the end, although a great deal of the preparatory work had been done. Blaeu had commissioned draftsman and engraver Johannes Vingboons (1616/17–1670), for instance, to copy numerous items from the archives of the East and West India Companies for this purpose. In many cases he made more than one copy. Thanks to Blaeu's grand scheme, four important collections of Vingboons's drawings have survived – one each in The Hague, Rome, and Florence, and one over various parts of the world – whereas the majority of the originals have been lost.[32] The pomp and splendor of the two Dutch maritime empires in the East and West Indies have been captured for posterity in the incomparably beautiful illustrations of the van der Hem atlas and the Vingboons collections. An atlas of the East Indian waters, which Blaeu never managed to compile, nevertheless appeared toward the end of the century. Based on the most up-to-date charts – some of them from Batavia – it was the work of Isaak de Graaf and represents the culmination of a century of Dutch exploration in the East.

The West India Company (WIC) was founded as a counterpart to the VOC in 1621 to pursue mercantile interests on the Guinea coast and in America. Its combined chart office and hydrographic institute was in many respects similar to that of the VOC. The West India Company likewise appointed an official chartmaker to supervise the general administration of the office. Moreover, it also maintained a chart archive and attempted, at least initially, to adopt a systematic approach to hydrography. In a certain sense, it tried to keep its activities confidential. The company was not as well organized as the VOC, however, and the scarcity of source material makes it difficult to trace the development of the organization. A few general remarks will therefore have to suffice.

The individuals were the same as those prominent in the VOC. Hessel Gerritsz., for instance, broke new ground for the West India Company by making a series of oceanic navigation charts for the entire region under patent, of which *De eylanden ende vastelanden van Westindien* (the Caribbean) and various others appeared in print (Cat. 136).[33] Members of the Blaeu family were also closely involved in the cartographic work undertaken by the WIC, as we know from the *West Indische Paskaert* and Caspar Barlaeus's *Rerum per octennium in Brasilia* (1647).[34] The latter contains not only an account of the rule of Johan Maurits van Nassau as governor of Dutch Brazil (1637–1644) and a description of the country and its people, but also Georg Markgraf's famous wall chart *Brasiliae Geographica & Hydrographica tabula nova*, a combined land and sea chart, as the title indicates (Fig. 58). Philips Vingboons and his brother Johannes, finally, were responsible for the *Brasylische paskaert,* which the former drew and the latter engraved in 1637, incorporating the coastal surveys that the Dutch had conducted from Recife a short while previously.

In a relatively brief space of time, the hydrographic institutes of these two powerful mercantile companies accomplished vast

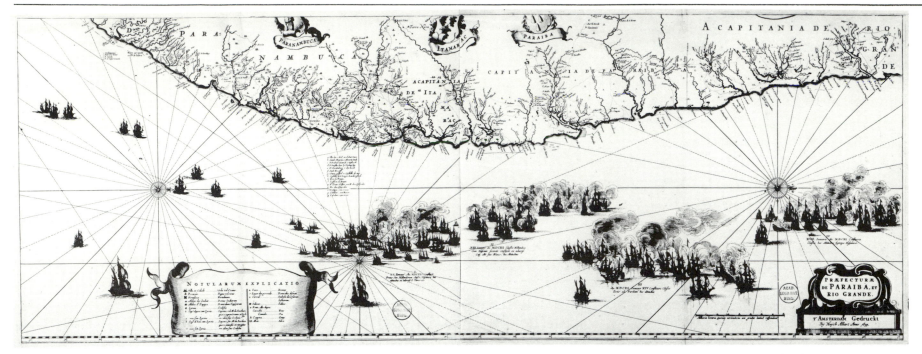

Figure 58. Georg Markgraf, Map of Dutch Brazil, *published by H. Allard, 1659. Leiden, University Library. This detail shows the four-day sea battle in January 1640 between the Portuguese and Dutch fleets.*

amounts of work. Their achievements enabled the oceans and the coastlines of the continents to be charted far more comprehensively and with a substantially greater degree of accuracy. Most important of all, the ocean chart had come to be viewed as a standard part of the navigator's equipment for the long voyage east or west.

As for the "commercial" side of the field, ocean cartography proved highly lucrative for the Amsterdam publishers, not only in view of the growing demand in the Republic itself but also because of the preference for Dutch pilot guides and charts in other countries. English, French, Italian, and Spanish editions were exported from Amsterdam – the international center of printed ocean cartography – to the whole of Western Europe.[35] Although this trend continued into the following century, with the enterprising van Keulen and his publishing house in the van-

guard, shortly after 1670 other countries gradually began to shake off their dependence. In 1693 the first French sea atlas, *Le Neptune François,* was published in Paris;[36] in London, where the chartmakers of the Thames school had been producing manuscript charts for more than a century, Seller (1669), Thornton (ca. 1685), and Collins (1689) produced the earliest printed sea atlases in England,[37] while a Swede, Peter Gedda, compiled an atlas of the Baltic in 1695 that contained more accurate charts than those van Keulen was publishing.[38]

THE MAP OF THE WORLD

The expansion of trade brought the Dutch into contact with other parts of the globe. In theory, there were four routes to the spices and other riches of the East – around the north of Asia, around

the north of America, through the Straits of Magellan, or via the Cape. Dutch seamen tried all four, which meant that their geographical horizon ultimately extended far beyond the shores of Europe. These distant lands exercised a tremendous fascination, creating an unprecedented demand for information in both word and, above all, image. Publishers were hard put to keep up with the demand for travel journals, descriptions of foreign lands and their peoples, maps and atlases.

The large multi-sheet wall maps of the world (Cat. 127), as graphic representations of the synthesis of geographic knowledge, are an ideal means of following the course of this dramatic process of reorientation. Not only is the figuration of the continents of interest, but certainly no less informative are the decorations both on the maps themselves and in the margins surrounding them, which often show quite explicitly how people conceptualized the earth. These decorative elements have a significance of their own and were not merely intended to adorn what might otherwise have been a slightly dull map.[39] They represent a journey into the realm of allegory, depicting personifications of basic concepts in classical and Christian cosmology (the elements, seasons, months, continents, and planets), and illustrating biblical and mythical legends passed down through the ages. The princes of the earth mounted on their steeds, pictures of towns, and figures in costume conjure up an image of the world as a procession of the human drama; in this way the picture of the world developed, framed by a chronicle of man's experience. In this respect, Dutch maps were not unlike the medieval *mappae mundi,* which recorded history as a pictorial narrative.

The decoration on the maps themselves serves a different purpose altogether. The new discoveries are generally of central importance; richly decorated panels and ovals contain written descriptions of particular voyages, portraits of the explorers of the New World — Columbus and Vespucci — and of Magellan and other circumnavigators and, finally, the geographers and astronomers with their instruments, without whom these maps

could not have been made (Fig. 59). The oceans are no longer depicted as blank expanses of water separating the continents but have been enlivened by allegorical figures and fantastic sea monsters, while innumerable vignettes of ships create symbolic links between the various parts of the world.

Concerning the manner in which the continents were charted, Wieder once pointed out that these monuments of Dutch cartographic art represented only "the outlines of the continents and islands, the frontiers between land and sea," as they provided little new information about the hinterland.[40] Indeed, these large world maps are really marine charts and may therefore serve here as a worthy conclusion to this survey.

There is no need to discuss individually all of the multi-sheet world maps that appeared in the Republic between 1600 and 1700.[41] Some forty are known, ten of which deserve special mention, as their scientific value and artistic merit have earned them a place in the highest ranks of Dutch cartographic art. In most cases only a single specimen has survived, but nearly all of them have been reproduced and made available to a wide public.

In this case, too, the foundation was laid in the first decade of the century, and it was again Willem Jansz. Blaeu who played the principal role. The twelve-year patent that Plancius had been granted for his planisphere in 1592 expired in 1604 and, with this in mind, Willem Jansz. (as Blaeu was still known at the time) commissioned Josua van den Enden to engrave a somewhat reduced version of it, likewise in cylindrical projection.[42] It included a representation of the results of the three Dutch journeys to the Arctic. A year later, in 1605, Blaeu published a world map in hemispheres in twenty sheets, entitled the *Nova universi terrarum orbis mappa.*[43] Some of the place names on the coast of South Africa and the island of Mauritius, named after Prince Maurits, recall the "first" and "second" voyages to the Indonesian archipelago in 1595–1597 and 1598–1599 respectively. A dotted line also indicates the route followed by Olivier van Noort — honored as *vera Neptunia proles,* or true son of Neptune — in his journey

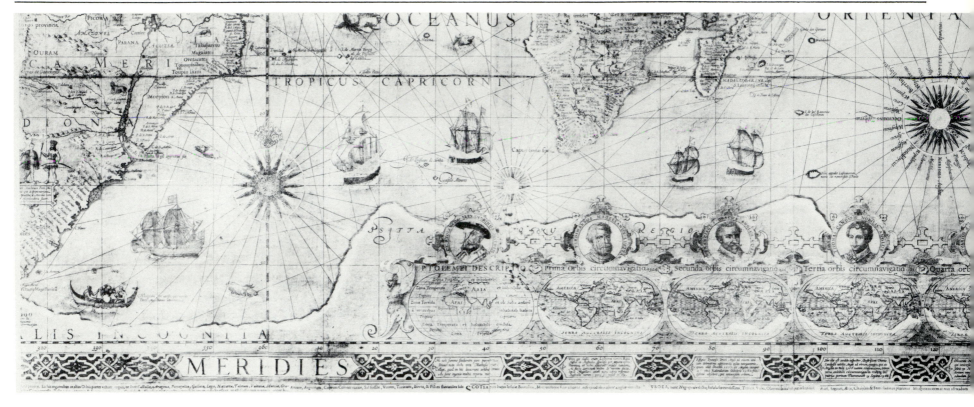

Figure 59. Jodocus Hondius, World Map, detail, engraving, 1608. From the facsimile edition, Leiden, University Library. This detail shows portraits of Ptolemy and the circumnavigators Magellan, Drake, Cavendish, and van Noort, linked together in a series of Renaissance-style cartouches.

around the world (1600). In 1624, Jodocus Hondius the Younger supplied a new edition of the map, adding to it Le Maire's discoveries (1616) to the south of the Straits of Magellan. Blaeu completed the series of three wall maps of the world in 1607 with the four-sheet *Nova orbis terrarum geographica ac hydrogr. tabula* in Mercator projection, to which he added two maps of the poles.[44] In 1604, prior to the edition of his world map in four sheets published in 1607, he had already issued a smaller version in two sheets (cf. cat. 128) and on one sheet. The map was to serve for an unusually long period of time. The four-sheet version was copied by Pieter van den Keere, who published it under his own name in 1609 and 1619, as he also did with the single-sheet edition. Van den Hoeye and Allard (Cat. 128) later reprinted the

two-sheet edition from the original plates.[45] In Japan, painted versions of Blaeu and van den Keere's Mercator maps were used to adorn household screens.

Two Amsterdam publishers of Flemish origin successfully followed in Blaeu's bold footsteps. In 1608, a year after the completion of Blaeu's series, Jodocus Hondius the Elder (1563–1612) produced another Mercator map, the *Nova et exacta totius orbis terrarum descriptio geographica et hydrographica*, which combines utility and decoration in perfect harmony.[46] For this reason, and because of its beautifully balanced artistic design and delicate but clear engraving, the work is a unique masterpiece. Moreover, it contains a wealth of geographic information and, along the bottom edge in the Antarctic, a superb portrait gallery of the

was amply compensated by his superlative talent for enhancing them with a wealth of decoration. His wall map of the world in two hemispheres, the *Novis totius orbis mappa ex optimis auctoribus desumta* (1611), is so elaborately decorated that the map as such is virtually subordinated to the richness of the illustrations surrounding it (Cat. 127).[49]

The new information offered in these world maps as a result of the discoveries made by Dutch explorers (mainly the Arctic and the East Indian archipelago) did not change the face of the world as radically as the gradual disappearance of the large land mass of the Antarctic in the following thirty years. In 1619, Willem Jansz. Blaeu published a large new wall map of the world in two hemispheres, showing the results of Isaac le Maire's voyage around the south of Tierra del Fuego and through the Pacific Ocean (1615–1617).[50] Blaeu eliminated the coastline of "Terra Australis incognita" from this area. The North American discoveries made by Henry Hudson on his fourth voyage (1610–1611) are also shown on this map. In 1645–1646, Willem's son Joan Blaeu produced a revised version, from which the coastline of the Antarctic has disappeared completely. This was a result of Abel Tasman's journey (1642–1643) along the south coast of Tasmania and the eastern side of Australia. This map was also the first to show Maarten Vries's discoveries near Hokkaido and Sakhalin in the northern Pacific (1643).[51]

The voyages undertaken by Tasman and Vries opened up the Pacific for further exploration, although it was over a century before any new discoveries were made. For the time being, an end had come to the series of discoveries made by Dutch navigators. They had thoroughly changed the appearance of the world, particularly in the far north and south, and the process had been visually recorded in a number of impressive examples of cartographic art, the Dutch *mappae mundi* of the first half of the seventeenth century.

In the year in which the Treaty of Westphalia was signed (1648), enabling the Republic to join the forum of independent European

explorers (see Fig. 59). Shortly before his death, Hondius completed his 1612 world map in hemispheres, the *Novissima ac exactissima totius orbis terrarum descriptio magna*, printed from twenty copperplates.[47] The map was reprinted four times up to 1669, the names of Hondius's sons and of Nicolaas Visscher being associated with the later editions. The most important changes introduced over a timespan of fifty years concerned California, which was now represented as an island; Tierra del Fuego with the Le Maire Straits; and Hollandia Nova – present-day Australia.[48]

The engraver Pieter van den Keere, a brother-in-law of Hondius, worked chiefly on commission but also published maps under his own name. His heavy reliance on the examples produced by others

states as a fully fledged partner, Joan Blaeu published a new wall map of the world in two hemispheres, the *Nova totius terrarum orbis tabula,* in twenty-one sheets, which rounds off the period of the Netherlands' most important contributions to cartography.[52] There was no comparison between Plancius's planisphere (1592), based entirely on Portuguese sources, and this represen-

tation. This was the world that the Dutch themselves had discovered. It was their seasoned view of the world, and it was to remain virtually unchanged far into the eighteenth century.

DIRK DE VRIES
(TRANSLATED BY YVETTE ROSENBERG)

NOTES

1. C. Koeman, *Atlantes Neerlandici,* vol. 4, (1970) Amsterdam, 1967–1971, pp. 403–408, refers to ten editions of this atlas, printed between 1661 and 1706. The quotation is taken from the preface, "Aen de Liefhebbers van de Zeevaert," which appeared in the atlas from 1666 on.

2. For Waghenaer, see C. Koeman, *The History of Lucas Jansz. Waghenaer and His "Spieghel der Zeevaerrdt,"* Lausanne, 1964, and E. Bos-Rietdijk, *Het Werk van Lucas Jansz. Waghenaer,* Enkhuizen, Zuiderzeemuseum, 1984. His pilot guides are described in Koeman, *Atlantes,* pp. 465–516, and special attention is given to the *Spieghel* on pp. 469–501.

3. Koeman, *Atlantes,* vol. 4, pp. 502–512, describes nine editions of the *Thresoor.*

4. Besides Doedsz., the principal representatives of this group of *caert-schrijvers* were Evert Gijsbertsz., Joris Carolus, and the brothers Harmen and Marten Jansz. G. Schilder, *De Noordhollandse Cartografenschool,* Enkhuizen, Zuiderzeemuseum, 1984, gives an overview of the charts they produced.

5. This chart was recently acquired by the University Library in Amsterdam: Amsterdam, Amsterdams Historisch Museum, *Gesneden en gedrukt in de Kalverstraat. De kaarten- en atlassendrukkerij in Amsterdam tot in de 19e eeuw* (ed. P. van den Brink and J. Werner), Utrecht, 1989c, p. 76. no. 1.22.

6. On the life of Plancius and his work as a cartographer, see F. C. Wieder, *Monumenta Cartographica,* The Hague, 1925–1933, pp. 37–46; J. Keuning, *Petrus Plancius, theoloog en geograaf 1550–1622,* Amsterdam, 1946; Rotterdam, Maritime Museum "Prins Hendrik," *Plancius 1552–1622,* 1973.

7. R. W. Shirley, *The Mapping of the World. Early Printed World Maps 1472–1700,* London, 1983, no. 183; published in facsimile in Wieder, *Monumenta Cartographica,* pp. 27–36 and pls. 26–38.

8. C. Koeman, "The Chart Trade in Europe from Its Origin to Modern Times," *Terrae incognitae* 12 (1980), pp. 49–64.

9. On Cornelis Claesz., see E. W. Moes and C. P. Burger, *De Amsterdamse boekdrukkers en uitgevers in de zestiende eeuw,* Amsterdam, 1907, pp. 27–209; R. van Selm, *Een menighte treffelijcke Boecken: Nederlandse boekhandelscatalogi in het begin van de zeventiende eeuw,* Utrecht, 1987, pp. 174–319.

10. Koeman, *Atlantes,* vol. 4, pp. 21–26.

11. Earlier reviews of Dutch hydrography in the sixteenth and seventeenth centuries can be found in G. Schilder and W. F. J. Mörzer Bruyns, *Navigatie in Maritieme Geschiedenis der Nederlanden,* vol. 2, Bussum, 1977, pp. 159–199; C. Koeman, *Geschiedenis van de kartografie van Nederland. Zes eeuwen land- en zeekaarten en stadsplattegronden,* Alphen aan den Rijn, 1983, pp. 203–224; G. Schilder, *The Netherland Nautical Cartography from 1550 to 1650,* Lisbon, 1984. See also C. A. Davids, *Zeewezen en wetenschap. De wetenschap en de ontwikkeling van de navigatietechniek in Nederland tussen 1585 en 1815,* Amsterdam, 1986.

12. On Willem Jansz. Blaeu, see P.J.H. Baudet, *Leven en werken van Willem Jansz. Blaeu,* Utrecht, 1871; Wieder, *Monumenta Cartographica,* pp. 67–76; J. Keuning, *Willem Jansz. Blaeu. A Biography and History of His Work as a Cartographer and Publisher* (revised and edited by M. Donkersloot-de Vrij), Amsterdam, 1973.

13. Blaeu's *Licht der Zeevaert* is described in Koeman, *Atlantes,* vol. 4, pp. 27–53; the editions by Johannes Janssonius in ibid., pp. 54–75; see also R. A. Skelton, Introduction to *Willem Jansz. Blaeu (William Johnson), The Light of Navigation, Amsterdam, 1612,* facsimile edition, Amsterdam, 1964.

14. For Blaeu's *Zeespiegel,* see Koeman *Atlantes,* vol. 4, pp. 78–112.

15. For J. S. Colom, see ibid., pp. 119–151.

16. For Anthonie Jacobsz. and his sons Jacob and Casparus Lootsman, see ibid., pp. 223–265.

17. For Pieter Goos, see ibid., pp. 192–217.

18. For Doncker, see ibid., pp. 152–189.

19. On the history of van Keulen's publishing house, see G. D. Bom, *Bijdragen tot eene geschiedenis van het geslacht "Van Keulen," Eene biblio-cartographische studie,* Amsterdam, 1885; Koeman, *Atlantes,* vol. 4, pp. 276–401; C. Koeman, *The Sea on Paper: The Story of the Van Keulens and Their "Sea-torch,"* Amsterdam, 1972; C. Koeman and G. Schilder, "Ein neuer Beitrag zur Kenntnis der niederländischen Seekartografie im 18. Jahrhundert," *Festschrift für Erik Arnberger. Beiträge zur theoretischen Kartographie,* Vienna, 1977; M. Kok, "Cartografie van de firma Van Keulen 1674–1880," in Amsterdam, Rijksmuseum "Nederlands Scheepvaart Museum," *In de*

Gekroonde Lootsman. Het kaarten-, boekuitgevers- en instrumentenmakershuis Van Keulen te Amsterdam 1680–1885, Utrecht, 1989, pp. 15–43.

20. Koeman, *Atlantes*, vol. 4 pp. 423–432; D. de Vries, "Dutch Cartography," in Williamsburg, Colonial Williamsburg, *The Age of William & Mary II: Power, Politics and Patronage 1688–1702*, 1989, pp. 107–108.

21. Replaced in 1591 by a corrected version; both charts are reproduced in Bos-Rietdijk, *History*, pp. 27 and 31 respectively.

22. For the various editions and variants of Blaeu's chart of the European coasts, see Brussels, Koninklijke Bibliotheek, *De Hollandse kartografie*, 1971 (catalogue by A. de Smet), p. 57 (no. 37); Keuning, *Willem Jansz. Blaeu*, pp. 68–71; G. Schilder, "Willem Janszoon Blaeu's Map of Europe (1606), a Recent Discovery in England," *Imago Mundi* 28 (1976) pp. 9–20; Schilder, "Noordhollandse Cartografenschool," pp. 50–55; Leiden, Rijksmuseum van Oudheden, *Goed gezien. Tien eeuwen wetenschap in handschrift en druk*, 1987, pp. 88–89 (no. 50).

23. The only two known copies of the *West Indische Paskaert* are at the Bibliothèque Royale Albert Ier, Brussels, and the Badische Landesbibliothek, Karlsruhe; see also M. Destombes and D. Gernez, "La *West Indische Paskaart de Willem Jansz. Blaeu* de la Bibliothèque Royale," in *Communications de l'Académie de Marine de Belgique*, vol. 4, Antwerp, 1947–1949, pp. 35–50. Reprinted in M. Detombes, *Contributions sélectionnées à l'histoire de la cartographie et des instruments scientifiques* (ed. G. Schilder), Utrecht, 1987, pp. 23–40; Brussels, Koninklijke Bibliotheek, *De Hollandse kartografie*, pp. 49–51 (no. 29); Keuning, *Willem Jansz. Blaeu*, pp. 72–76; M. Destombes, "Quelques rares cartes nautiques Néerlandaises du XVIIe siècle," *Imago Mundi* 30 (1978), pp. 64–70; T. Campbell, "One Map, Two Purposes: Willem Blaeu's Second *West Indische Paskaart* of 1630," *The Map Collector* 30 (1985), pp. 36–38.

24. C. Koeman, "17e eeuwse Hollandse bijdragen in de kartering van de Amerikaanse kusten," *Caert-Thresoor* 1 (1982), pp. 50–53.

25. For the history of the cartography of the Dutch East India Company, see G. Schilder, "Organization and Evolution of the Dutch East India Company's Hydrographic Office of the Seventeenth Century," *Imago Mundi* 28 (1976a); K. Zandvliet, *De groote wereld in 't Geschildert. Nederlandse kartografie tussen de middeleeuwen en de industriële revolutie*, Alphen aan den Rijn, 1985, pp. 107–121; G. Schilder, "Het cartografisch bedrijf van de VOC," in Enkhuizen, Zuiderzeemuseum, *De VOC in de kaart gekeken, Cartografie en navigatie van de Verenigde Oostindische Compagnie 1602–1799*, The Hague, 1988; T. Vermeulen, "Onvermoeid in actie: verkenningen in die Oost," in Enkhuizen, Zuiderzeemuseum, *De VOC in de kaart gekeken, Cartografie en navigatie van de Verenigde Oostindische Compagnie 1602–1799*, The Hague, 1988.

26. J. Keuning, "Hessel Gerritsz.," *Imago Mundi* 6 (1949), pp. 56–61.

27. Unique copies of the first editions of the charts of Spain (1605) and Italy (1617) are at the Niedersächsisches Staats- und Universitätsbibliothek, Göttingen; see Amsterdam, *Gesneden en gedrukt in de Kalverstraat*, 1989, p. 94 (nos. 4.36 and 4.41).

28. G. Schilder, *Australia Unveiled: The Share of the Dutch Navigators in the Discovery of Australia*, Amsterdam, 1976, pp. 302–305.

29. K. Ausserer, "Der Atlas Blaeu der Wiener National-Bibliothek," *Beiträge zur historischen Geographie, Kulturgeographie, Ethnographie und Kartographie*, Vienna, 1929 (reprinted in *Acta Cartographica*, vol. 27, Amsterdam, 1981, pp. 15–59), gives a broad description of the contents of the van der Hem atlas; see also Wieder, *Monumenta Cartographica*, pp. 145–196; F. Wawrik, *Berühmte Atlanten. Kartographische Künst aus fünf Jahrhunderten*, Dortmund, 1982, pp. 132–136; G. Schilder, "The *Van der Hem Atlas*, A Monument of Dutch culture in Vienna," *The Map Collector*, no. 25 (1983), pp. 22–26. An integral facsimile edition is being prepared by SDU/Gary Schwartz Publishers, The Hague.

30. For D. J. van Santen, see H. de la Fontaine Verwey, "The Glory of the Blaeu Atlas and the *Master Colourist*," *Quarendo* 9 (1981), pp. 197–229.

31. C. Koeman, *Joan Blaeu and His Grand Atlas*, London, 1970; H. de la Fontaine Verwey, "Dr. Johan Blaeu and His Sons," *Quaerendo* 9 (1981), pp. 2–23.

32. Wieder, *Monumenta Cartographica*, pp. 9–26, 58, 59, 89–143; J.T.W. van Bragt, *Ten geleide Atlas van kaarten en aanzichten van de VOC en WIC, genoemd Vingboons-Atlas*, Haarlem, 1982; K. Zandvliet, "Joan Blaeu's Boeck vol kaerten en beschrijvingen van de Oostindische Compagnie," in Amsterdam, Koninklijk Paleis, *Het kunstbedrijf van de familie Vingboons*, 1989, pp. 58–95.

33. Keuning, "Hessel Gerritsz.," pp. 61–66; Zandvliet, *De groote wereld*, pp. 123–133.

34. On the Dutch contribution to Brazilian cartography, see K. Zandvliet, "Johan Maurits and the Cartography of Dutch Brazil," in *Johan Maurits van Nassau-Siegen, a Humanist Prince in Europe and Brazil*, The Hague, 1979, pp. 494–518; and Zandvliet, "Die cartografie van Nederlands Braziliën," in The Hague, Mauritshuis, *Zo wijd de wereld strekt*, 1979, pp. 151–167.

35. Koeman, "Chart Trade."

36. M. Pastoureau, *Les atlas français, XVIe–XVIIe siècles: repertoire bibliographique et étude*, Paris, 1984, pp. 351–356, specifically Neptune François Ba and Bb; de Vries, "Dutch Cartography," p. 108.

37. C. Verner, Introduction to *The English Pilot: The Fourth Book*, London, 1689, facsimile edition, Amsterdam, 1967; C. Verner and R. A. Skelton, Introduction to *John Thornton, The English Pilot: The Third Book, London, 1703*, facsimile edition, Amsterdam, 1970; T. R. Smith, "Manuscript and Printed Sea Charts in Seventeenth Century London: The Case of the Thames School," in *The Compleat Plattmaker. Essays on Chart, Map and Globemaking in England in the Seventeenth and Eighteenth Centuries*, Berkeley and Los Angeles, 1978, pp. 45–100.

38. For Gedda's atlas, see Koeman, *Atlantes*, vol. 4, p. 411; Koeman and Schilder, "Ein neuer Beitrag," p. 276.

39. J. A. Welu, "The Sources and Development of Cartographic Ornamentation in the Netherlands," in *Art and Cartography: Six Historical Essays*, Chicago, 1987, pp. 147–173, 233–238; Amsterdam, Rijksprentenkabinet, *Kunst in kaart*, Utrecht, 1989.

40. Wieder, *Monumenta Cartographica*, p. 64.

41. R. W. Shirley, *The Mapping of the World*, gives a bibliography of printed world maps up to 1700.

42. Ibid., no. 243, published in facsimile in M. Destombes, *La mappe-monde de Petrus Plancius gravée par Josua van den Ende, 1604 d'après l'unique exemplaire de la Bibliothèque Nationale Paris*, Hanoi, 1944.

43. Shirley, *Mapping*, no. 253, published in facsimile in E. L. Stevenson, *Willem Janszoon Blaeu 1571–1638. A Sketch of His Life and Work with a Special Reference to His Large World Map of 1605*, New York, 1914. There is a recent reproduction of the 1624 reprint by Hondius (Shirley, *Mapping*, 310) in G. Schilder, *World Map of 1624*.

44. Shirley, *Mapping*, no. 258, published in facsimile in G. Schilder, *Three World Maps by Francois van den Hoeve of 1661, Willem Janszoon (Blaeu) of 1607 (and) Claes Janszoon Visscher of 1650*, Amsterdam, 1981; see also Schilder, "Willem Jansz. Blaeu's Wallmap of the World on Mercator's Projection 1606–07 and Its Influence," *Imago Mundi* 31 (1979), pp. 36–54.

45. Reductions by Blaeu in one sheet: Shirley, *Mapping*, no. 255, and in two sheets: ibid., no. 265. Reduction by van den Keere in one sheet: ibid, no. 264. Copy in four sheets by van den Keere: ibid., no. 266.

46. Ibid., no. 263, published in facsimile in E. Heawood, *The Map of the World on Mercator's Projection by Jodocus Hondius, Amsterdam 1608 from the Unique Copy in the Collection of the Royal Geographical Society, London*, 1927.

47. Shirley, *Mapping*, no. 273, published in facsimile in E. L. Stevenson and J. Fischer, *Map of the World by Jodocus Hondius, 1611*, New York, 1907.

48. For the reprint by Nicolaas Visscher, see G. Schilder, *The World Map of 1669 by Jodocus Hondius the Elder and Nicolaas Visscher*, Amsterdam, 1978.

49. Shirley, *Mapping*, no. 274, published in facsimile in G. Schilder and J. A. Welu, *The World Map of 1611 by Pieter van den Keere*, Amsterdam, 1980.

50. Shirley, *Mapping*, no. 300, published in facsimile in G. Schilder, *Monumenta Cartographica Neerlandica III*, Alphen aan den Rijn, 1989.

51. Shirley, *Mapping*, no. 366; Rotterdam, Maritiem Museum, *"Prins Hendrik,"* De wereld volgens Blaeu, Blaeu's wereldkaart op groot formaat uit 1646, 1986.

52. M. Debergh, "A Comparative Study of Two Dutch Maps, Preserved in the Tokyo National Museum. Joan Blaeu's Wall Map of the World in Two Hemispheres, 1648 and Its Revision ca. 1678 by N. Visscher," *Imago Mundi* 35 (1983), pp. 20–36, published in facsimile in Wieder, *Monumenta Cartographica*, pp. 61–66, pls. 51–71; Shirley, *Mapping*, no. 371.

CATALOGUE

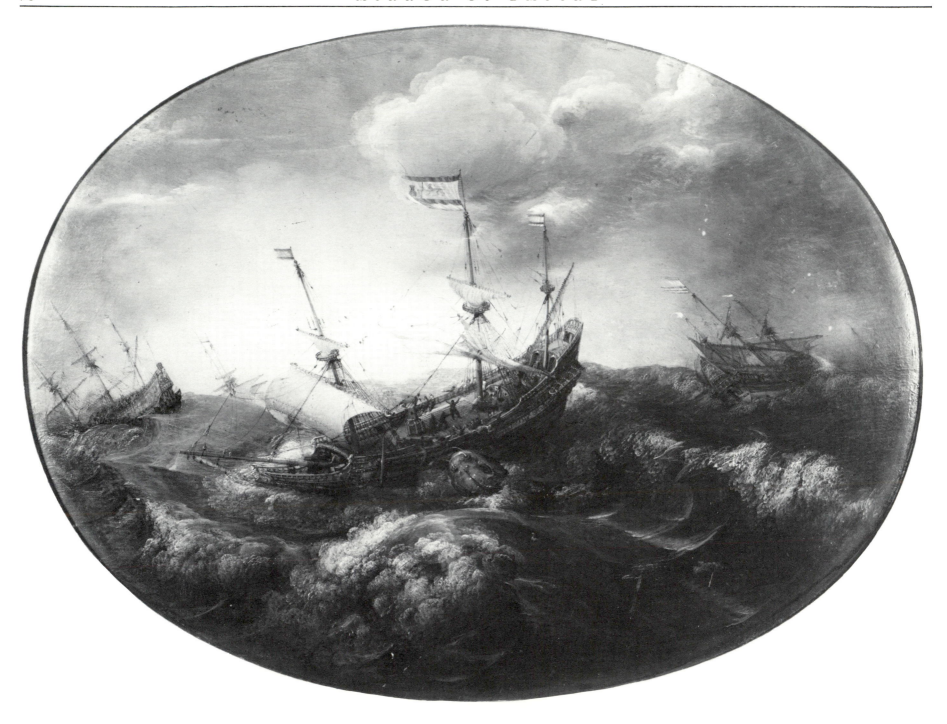

PAINTINGS

1

HENDRICK VAN ANTHONISSEN
Shipping Scene

Oil on panel, 35 × 48 cm
Signed: *ANTs*
Private collection, courtesy Trafalgar Galleries, London

LITERATURE: London, Trafalgar Galleries, *Trafalgar Galleries at the Royal Academy IV*, 1985, pp. 32–33, repr.

This deep, silvery gray monochrome marine is directly inspired by the artist's teacher and brother-in-law, Jan Porcellis. Like Porcellis, Anthonissen captures the various moods of the North Sea climate and his subjects range from calms to rough seas.[1] Cloudy sky is an important component of these mood paintings, and Anthonissen is among the first marine painters of the Dutch school to investigate the expressive potential of expansive skies and the interaction of filtered light playing on the water. Van Anthonissen produced two outstanding beach scenes, now in Cambridge and Schwerin,[2] in which atmospheric effects are of paramount importance. During the same period, the mid-1630s, Anthonissen also produced monochrome marines with turbulent skies and rain squalls above choppy water. These count among his most successful paintings because of the effective integration of the sailboats into the restless motion of the sea and sky. The artist captures a great tonal range and evokes a tremendous sense of distance through the silvery atmosphere.

Despite its small size, this *Shipping Scene* is a monument to the unique character of the estuaries and inland seas of the Dutch Republic as well as to the skilled seamanship of the Dutch, whose small sailboats ply these shallow and unpredictable waters. The Trafalgar marine dates from the mid-1630s and is similar to *Sailboats in a Breeze* in the Spaendonck Collection, Tilburg,[3] where a similar boat under full sail cruises in the left foreground. The ship's buoyant movement perfectly complements the cloud configuration framing it.

NOTES

1. L. J. Bol, 1973, pls. 106, 107, 110.
2. Ibid., pls. 108, 109.
3. Ibid., pp. 105–107, pl. 105.

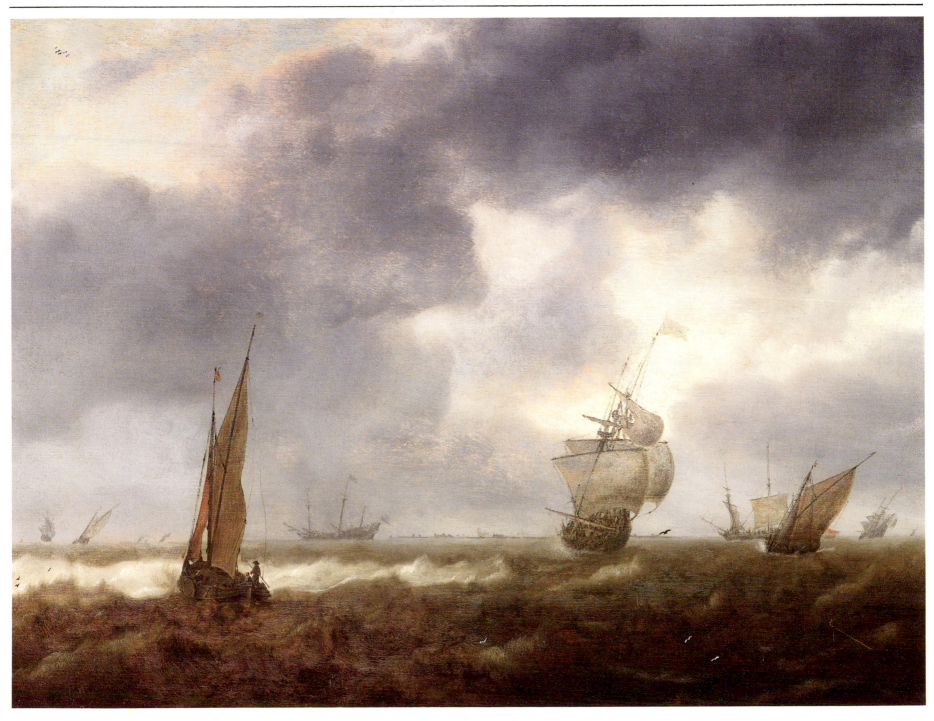

2

LUDOLPH BACKHUYSEN
Fishing Vessels Offshore in a Heavy Sea

Oil on canvas, 64.6 × 97.7 cm
Signed and dated on barrel at left: *L Backh. 1684*
Minneapolis, Minneapolis Institute of Arts, Gift of John Hawley, by exchange, inv. 82.84

PROVENANCE: London, auction Barnard (Christie) June 12, 1925, lot 32, bought by Collings
London, auction (Christie) July 10, 1981, lot 17, repr.
London, Douwes Fine Arts, from whom bought by the Minneapolis Institute of Arts

LITERATURE: Minneapolis Institute of Arts, *The Art of Collecting*, 1986, p. 60, repr.

In this picture Backhuysen focuses attention onto two open single-masted sailboats. One comes to the aid of the other, which has lost its mainsail. Grappled together, the two boats rise on a swell with white water foaming beneath their prows.

Backhuysen infuses tremendous energy into the composition, principally by means of the restless action of the waves but also by the dramatic cloud bank that vaults over the sea below. The distant sand dunes at the left may be near Den Helder across from the island of Texel, which forms one flank of the main entrance to the Zuider Zee. A similar backdrop appears in Backhuysen's *Return of the "Hollandia" in the Landsdiep in 1665* in the Rijksmuseum "Nederlands Scheepvaart Museum" in Amsterdam,[1] painted in 1666–1667.

Backhuysen frequently treated sailboats as the subject of his marine compositions. More often than not he depicted them sailing close to shore beyond a foreground beach. A notable example of this type is his *Beach Scene* (fig. a) in the National Gallery in London.[2] On other occasions he represents sailboats in more open water with land appearing solely in the distance. Pictures in Karlsruhe,[3] Leipzig,[4] Schwerin,[5] and formerly in the collection of Lord Barnard at Raby Castle[6] are excellent examples of this

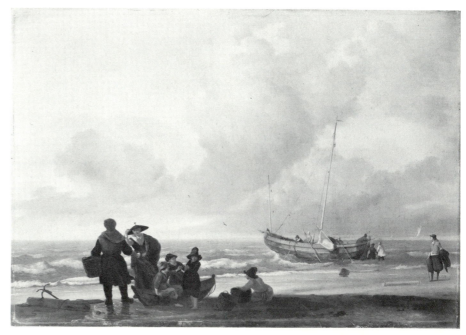

Cat. 2, fig. a Ludolph Backhuysen, Beach Scene, *oil on canvas. London, The National Gallery.*

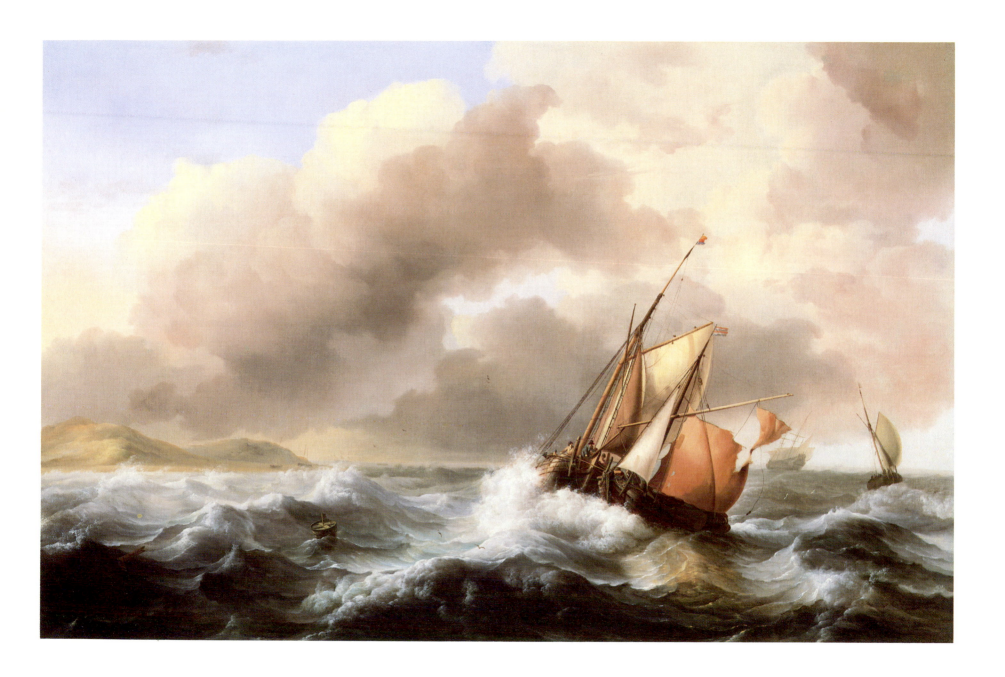

type. The ex-Barnard picture offers close parallels to the Minneapolis marine, particularly in the artist's rendering of the tossing waves and the sailboat in the right foreground, whose bow breaks through a wave.

The setting of another painting, *Boats Before Distant Dunes,*[7] is similar to that in the Minneapolis marine. The mainsail of the two-masted sailboat is loose, while a wave strikes this boat, casting spray before its bow. Seen in conjunction with each other, these features introduce an element of suspense comparable to that expressed in *Fishing Vessels Offshore in a Heavy Sea.*

Backhuysen's *Sailboat to the Left of a Pier* (fig. b) in Edinburgh[8] is stylistically close to the marine in Minneapolis and must date from the same period. Although similar in spirit, it differs by the inclusion of a jetty that offers shelter from the sea, thereby changing the tone of the subject. Another picture with analogies to the *Fishing Vessels Offshore in a Heavy Sea* is *Sailboats and a Merchantman Beyond a Pier,* now in Bremen.[9] Here Backhuysen's representation of the waves and clouds and his modulation of light are similar in both works.

In its dynamism *Fishing Vessels Offshore in a Heavy Sea* reveals Back-huysen's admiration for Willem van de Velde the Younger, for example, the latter's great *Kaag Close-hauled in a Fresh Breeze* (Cat. 38) now in Toledo. In turn, Backhuysen's painting was greatly admired, as at least two surviving copies attest.[10]

NOTES

1. Amsterdam, 1985, cat. S9, repr.

2. Inv. 818, HdG 230.

3. *Choppy Sea,* inv. 342, HdG 221, J. Lauts, Staatliche Kunsthalle, Karlsruhe, *Katalog Alte Meister,* 1966, p. 35, repr.

4. *Dory on the Crest of a Wave,* inv. 1587, HdG 246.

5. *Ships Before the Roads of Enkhuizen,* 1980, cat. 23, Amsterdam, 1985, cat. S22, repr.

6. *Sailboats and Ships in a Choppy Sea,* canvas. 49.4 × 64.1 cm., HdG 265.

7. Last recorded in an auction in Brussels (Fievez), May 26, 1930, lot 4, repr.

8. National Gallery of Scotland, 1900, cat. 122, HdG 199.

9. Kunsthalle, 1939, cat. 134, HdG 189.

10. (a) Oil on canvas, 62.2 × 78.8 cm, composition cropped at top and drastically along the left side – London, auction (Christie) July 7, 1978, lot 121, repr. (b) Oil on canvas, 65.5 × 81.5 cm, lacking the distant shoreline at the left – Amsterdam, K. & V. Waterman Gallery (1983–1984).

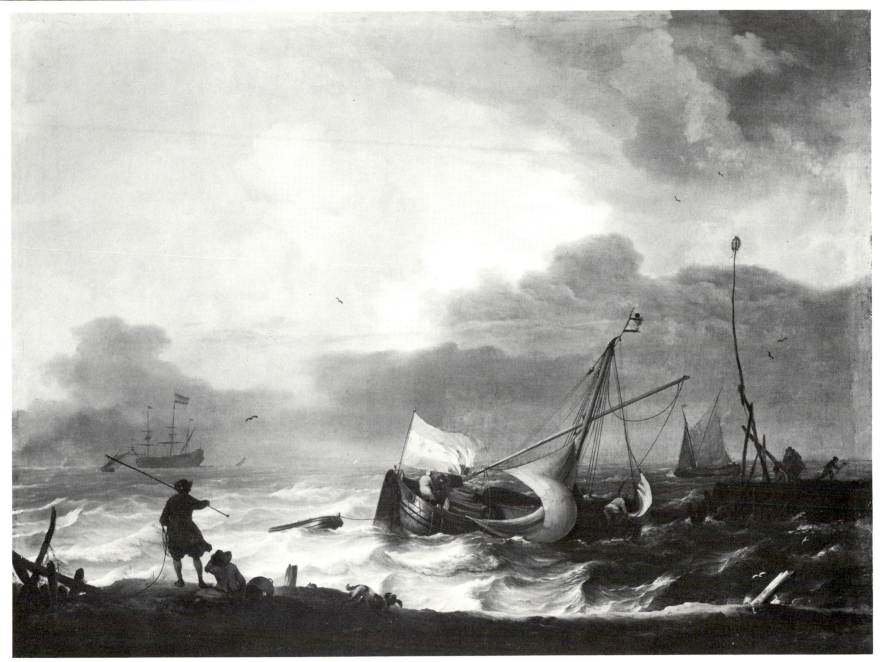

Cat. 2, fig. b Ludolph Backhuysen, Sailboat to the Left of a Pier, *oil on canvas.*
Edinburgh, National Gallery of Scotland.

3

LUDOLPH BACKHUYSEN
Shipping

Pen painting on panel, 60 × 83.5 cm
Signed on the leeboard of the *kaag: Lud Backhuysen*
Amsterdam, Rijksmuseum "Nederlands Scheepvaart Museum," inv. A33

PROVENANCE: Acquired by 1916
LITERATURE: 't Hooft and de Balbian Verster, 1916–1917a, p. 36. Nannen, 1985, p. 107
EXHIBITION: Amsterdam, 1985, cat. S4, repr.

This picture is one of Backhuysen's rare pen paintings, datable to about 1665.[1] Relatively early in his career Backhuysen tried his hand in a medium exploited with such great success by Willem van de Velde the Elder. Backhuysen displays his proficiency in this taxing manner of painting, but chose to abandon it in favor of conventional painting.

In *Shipping*, the artist represents various ships and sailboats before a still unidentified Dutch seaport, which appears in the left distance. A large warship under sail at the left has a lion rampant clasping a sword and arrows, the symbolic attribute of the province of Holland, carved on its tafferel. A second warship in port profile lies at anchor at the right. In the center distance are two anchored flute ships, the mainstay of the Dutch merchant marine and its carrying trade.[2] Backhuysen attempts to evoke atmospheric conditions in this grisaille. The contrasting light and shadow playing on the ships and across the water enliven the subject to a marked degree not usually found in pen paintings of this type.

NOTES

1. According to R. Vorstman, two other pen paintings, *The Shipyards of the Amsterdam Admiralty* in the Rijksmuseum (Amsterdam, 1985, cat. S2, repr.), and *Ships Before Amsterdam* (ibid., cat. S3, repr.) in the collection of the Royal Naval Academy in Amsterdam, date from the same time as *Shipping*.

2. For further description of the various types of vessels in this picture, see R. Vorstman in Amsterdam 1985, p. 29, cat. S4.

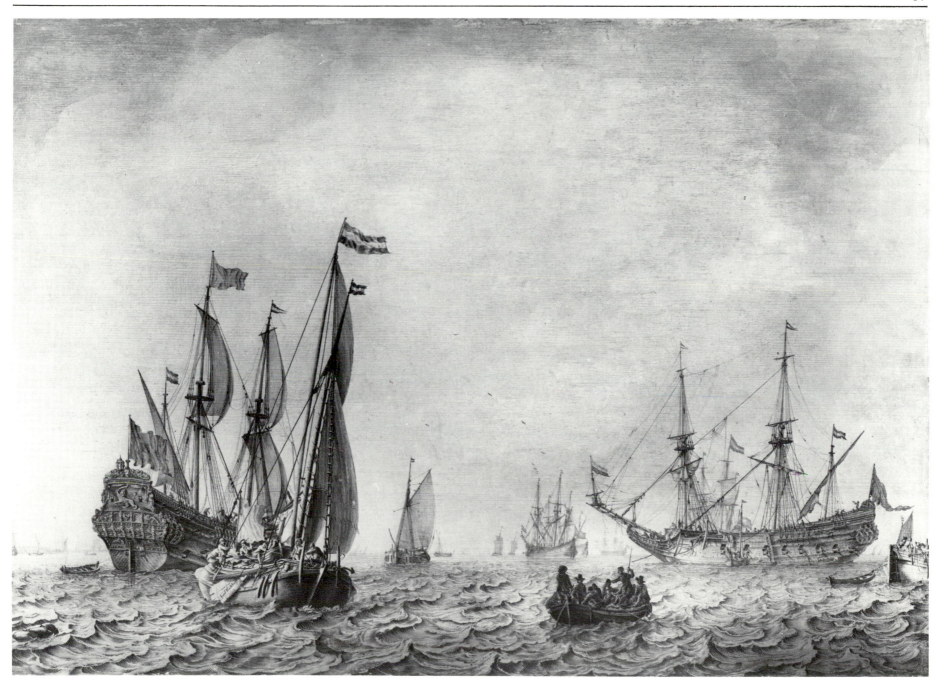

4

LUDOLPH BACKHUYSEN
Ships in Distress off a Rocky Coast

Oil on canvas, 114 × 168 cm
Signed and dated on rock at center: *1667 LBackh*
Washington, National Gallery of Art, Ailsa Mellon Bruce Fund, 1985.29.1

PROVENANCE: Clandon Park, Collection 3rd Earl of Onslow
London, auction Earl of Onslow (Christie) July 22, 1893, lot 24, bought by Vokins
Brussels, Del Monte Collection
London, Colnaghi (1959–1960)
London, auction (Christie) April 19, 1985, lot 111, repr.

LITERATURE: Goedde, 1989, fig. 161

This recently rediscovered masterpiece is one of Backhuysen's most compelling representations of ships in distress. The potential for imminent destruction is great, yet the sailors heroically attempt to claw the ship off from the treacherous coast. Despite its proximity to the pinnacle rocks, the large ship at center appears to be under control, with its foresheet reefed. By contrast, the ship at the right is in still greater danger, having suffered terrible damage to its masts. It flounders helplessly toward the savage rocks and becomes an insidious obstruction to the ship at the center.

This picture is an early example of Backhuysen's theatrical powers, in which the awesome force and scale of nature become larger than life. Evidently such a subject was very appealing to collectors, because Backhuysen continued to represent such themes throughout his career. In fact, one late example (now in Brussels), *Ships off a Mountainous Coast in a Storm,* measuring 173.5 × 341 cm, is the artist's largest surviving picture.[1] A closely related painting, *The Warships "Ridderschap" and "Hollandia" in the Straits of Gibraltar During a Storm in March 1694,* is similar in mood.[2] Although the melodramatic tenor of these pictures is already anticipated in *Ships in Distress off a Rocky Coast,* in the earlier painting Backhuysen's attention to detail and his more refined coloration of the clouds, rocks, water, and foam create a more compelling image because the seeming verisimilitude heightens the viewer's involvement.

To a seventeenth-century beholder, the theme of ships in distress could have held many levels of meaning. Backhuysen's penchant for theatrical effects no doubt encouraged the viewer to vicarious enjoyment of gripping drama. However, such subjects also had moralizing overtones: Ships threatened by destruction could symbolize the dangers of pride or the human soul on its journey through life fraught with dangers.[3] Equally, ships were metaphors for the ship of state. Their precarious circumstances became a commentary on the dangers to government. Whatever one may be inclined to read into such subjects, Backhuysen's *Ships in Distress off a Rocky Coast* was clearly intended for a discerning connoisseur. Today, after more than three centuries, it remains in excellent condition and attests to Backhuysen's superb technical mastery.

NOTES

1. Koninklijke Musea voor Schone Kunsten, *Catalogue inventaire de la peinture ancienne,* 1984, p. 12, inv. 6, HdG 194; Bol, 1973, pl. 307.

2. Amsterdam, 1985, cat. S33, repr. The Rijksmuseum in Amsterdam recently acquired this picture, inv. A4856 – *Bulletin van het Rijksmuseum* 36, 1988, p. 257, pl. 2. Also see Kattenburg 1989, pp. 42–43, repr.

3. This idea again became popular in the nineteenth century, as indicated by the enormous appeal of Thomas Cole's *Voyage of Life* suite in which the individual human soul follows its journey through life on a continuous stream of water – see Boston, Museum of Fine Arts – Washington, Corcoran Gallery of Art – Paris, Grand Palais, *A New World: Masterpieces of American Painting 1760–1910,* 1983/1984, pp. 225–228, cat. 25–28, repr.

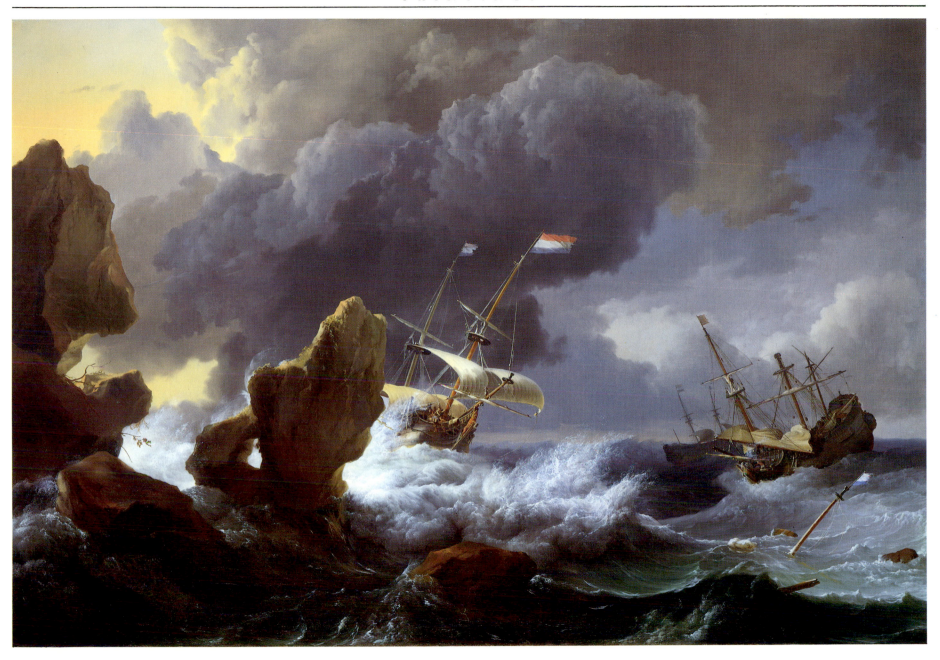

5

LUDOLPH BACKHUYSEN
Shipping Before Amsterdam

Oil on canvas, 128 × 221 cm
Signed on stern of the warship, *De Spiegel: Ano 1666 Ludolff Back fecit*
Paris, Musée du Louvre, inv. 988

PROVENANCE: Paris, Collection Hughes de Lionne, Marquis de Berny
 Paris, Collection E. Bouchardon, presented by his heirs to Louis XV in 1762
LITERATURE: Mentioned by Christian Huygens in a letter of November 26, 1666, to his brother-in-
 law, Philips Doublet – *Oeuvres Completes*, vol. 6
 E. W. Moes, "Een Geschenk van de Stad Amsterdam aan den Marquis de Lionne," *Oud
 Holland* 11 (1893), pp. 30–33
 Willis, 1911, p. 108. Hofstede de Groot, 1907–1928, vol. 7, no. 80
 Haak, 1984, p. 47, pl. 42
EXHIBITIONS: Paris, 1970/1971, cat. 6. Amsterdam, 1985, cat. S8, repr.

This important painting is Backhuysen's best-documented commission. The city magistrates of Amsterdam formally resolved to commission this work on November 3, 1665, as a gift to Hugues de Lionne, the minister of foreign affairs of Louis XIV of France. The Marquis de Lionne collected views of the major cities of Europe, but Coenraad van Beuningen, the Dutch ambassador to France, noted that this collection lacked a view of Amsterdam. Backhuysen's painting filled this lacuna. The artist secured this commission largely through the efforts of the burgomaster, Gerard Hasselaer, who broached the issue well before November 1665. In July of that year the magistrates of Amsterdam had already voted to pay Ludolph Backhuysen 400 ducats plus one gold ducat to the artist's wife for his painting of Amsterdam commissioned by Hasselaer. The artist received payment for this work on July 13, 1666.

Backhuysen views the city from the northeast, partially screening its profile beyond various ships. The large ship at the left seen from the stern is the *Spiegel* (the *Mirror*, as denoted by the convex mirror carved on its

tafferel). Built in 1663, this was the most heavily armed man-of-war constructed by the Admiralty of Amsterdam. To either side of the *Spiegel* appear the East India Company Magazine, built in 1664, and the Magazine of the Admiralty of Amsterdam.[1] The heart of the city appears at the center and is dominated by the spire of the Oude Kerk and the bulky profiles of the new Town Hall and the Nieuwe Kerk adjacent to it.

Backhuysen's *Shipping Before Amsterdam* is one of the most important contributions to the theme of the Dutch seaport seen in profile view. It is animated by the dynamic cloud bank that creates strong contrasts of light and shadow playing across the choppy sea. Hendrick Vroom was the first marine painter to produce profile views of Dutch seaports in which the interaction between the city and its shipping are indelibly bonded. His stress on shipping as the chief source of prosperity was not lost on the viewer. Backhuysen brings this idea up-to-date in an exuberant baroque idiom in which man's world harmonizes with the vast theater of nature. The dynamic interplay between ships, sea, distant city, and sky is exhila-

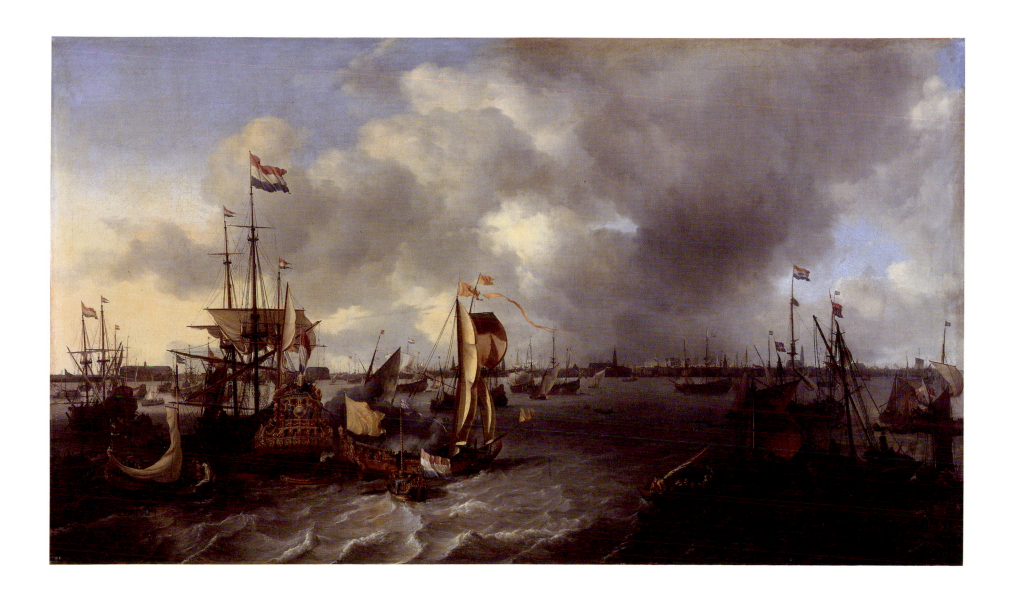

rating and uniquely embodies the energy that made Amsterdam the dynamo of the Dutch Republic.

Backhuysen often represented the harbor of Amsterdam, but rarely with the sense of drama displayed in *Shipping Before Amsterdam* in Paris. In one instance (Fig. 24, p. 29) he represents the city beyond a forest of masts under inky black clouds. Although lacking the sweep of the larger panorama in Paris, this work shares a concentration and dramatic intensity rarely encountered in views of this type.

Backhuysen's *Shipping Before Amsterdam* is deservedly recognized as one of the great portrayals of Amsterdam at the zenith of its prosperity. Despite its illustrious history, this picture remains less known than Willem van de Velde the Younger's celebrated *The River Ij Before Amsterdam* of 1686, now in the Rijksmuseum.[2] Van de Velde's image of the city is more

stately and serene than Backhuysen's earlier version of the theme. Van de Velde drops the viewer's vantage point, thereby reducing the scale of the city profile relative to the ships before it. His poetic rendering of light and the less threatening clouds above the city evoke a mood different from that expressed by Backhuysen. Fittingly, both painters, in representing a subject so central to their own livelihood, produced masterpieces that express their differing temperaments. No comparison more fittingly manifests the differences between these two greatest Dutch marine painters of the second half of the seventeenth century.

NOTES

1. This information derives from R. Vorstman's entry on this painting in Amsterdam, 1985, p. 33.

2. Reproduced in L. J. Bol, 1973, pls. 246–248.

6

LUDOLPH BACKHUYSEN
The "Eendracht" and a Dutch Fleet of Men-of-War Before the Wind

Oil on canvas, 75.5 × 105 cm
London, the Trustees, National Gallery, inv. 223

PROVENANCE: Cranbury near Winchester, Collection Lady Holland
London, auction Lady Holland (Christie) April 22, 1826, lot 85, bought by Woodin
Collection Charles A. Bredel by whom bequeathed to the National Gallery in 1851
LITERATURE: J. Smith, 1829–1837, vol. 6 (1835), no. 76
Waagen, 1854, vol. 2, p. 292
Hofstede de Groot, 1907–1928, vol. 7, no. 229 (with references)
Maclaren, 1960, pp. 7–8, inv. 223
Amsterdam, 1985, p. 17, repr.
Nannen, 1985, p. 125

This picture represents the Dutch fleet with its flagship, the *Eendracht* (the *Unity*), at the left center. As Maclaren points out, Backhuysen's representation of the ship's stern with the lion in left profile is not entirely accurate.[1] The lion should be rampant and set within a fence symbolizing the bound-

aries of the Dutch Republic, which it defends. The *Eendracht*, a seventy-six-gun ship built in 1653, flies a prince's flag on its mainmast and a second on its sternpost. A long, tricolored wimple flies below the mainmast flag, indicating the presence of the admiral on board. It was the flagship of

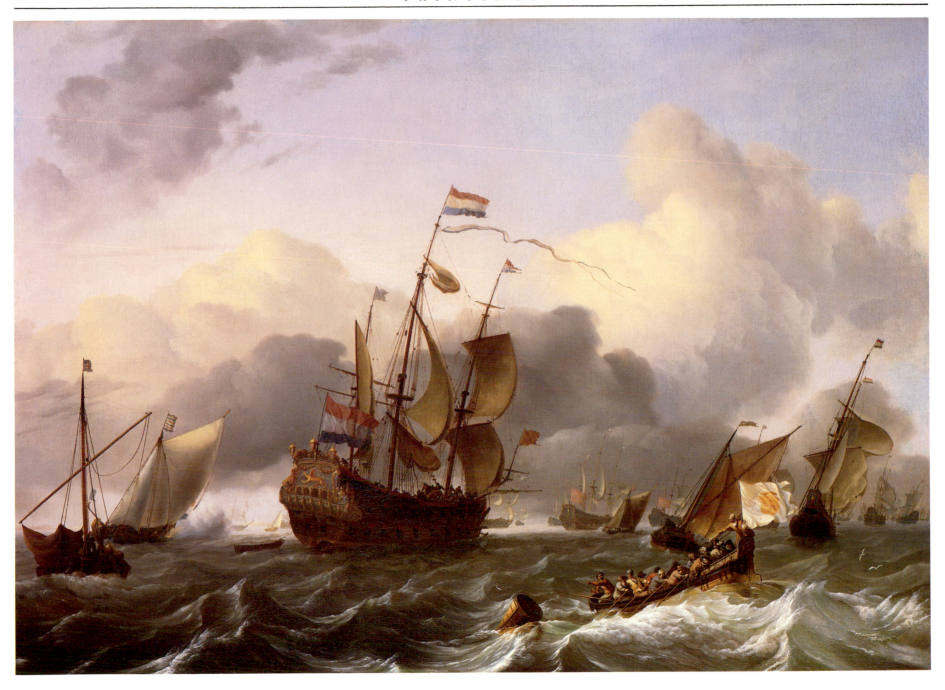

Admiral Jacob van Wassenaer van Obdam during the Dutch campaign against the Swedes in 1658–1659, and also at the Battle of Lowestoft on June 3, 1665. It blew up during this battle, creating disarray among the Dutch and contributing in no small measure to the English victory.[2]

Other representations of the *Eendracht* make clear Backhuysen's license in depicting this ship of the line. His inaccuracies lead Maclaren to believe that Backhuysen painted this work several years after the destruction of the *Eendracht,* probably in the early 1670s.

In style and spirit this painting is reminiscent of Backhuysen's *Return of the "Hollandia" in the Landsdiep on November 3, 1665,* in the Scheepvaart Museum in Amsterdam,[3] but differs in one significant respect. Back-

huysen omits the beach or any other reference to land in the foreground. Instead, he focuses on the lively rhythmic action of the sea. His rendering of the whitecaps and gleaming surface of the waves is a hallmark that he exploits with equal success in Cat. 2 and 4. Maclaren cites at least two known copies of this painting,[4] a significant measure of its popularity.

NOTES

1. Maclaren, 1960, p. 7.
2. Ibid.
3. Amsterdam, 1985, cat. S9, repr.
4. Maclaren, 1960, pp. 7–8.

7

LUDOLPH BACKHUYSEN
The Four Days' Battle (June 11–14, 1666)

Oil on canvas, 141 × 234.5 cm
Signed on a barrel: *L. Backh.*
Copenhagen, Den kongelige Maleri – og Skabtursamling, Statens Museum for Kunst,
 1951, cat. 20., inv. no. Sp. 543

PROVENANCE: Amsterdam, auction, September 16, 1739, lot 29
 Copenhagen, Royal Gallery, acquired in Hamburg in 1755
LITERATURE: Hoet, 1752, vol. 1, 600
 Willis, 1911, p. 108
 Hofstede de Groot, 1907–1928, vol. 7, no. 21 (erroneously as in Stockholm)
 Copenhagen, Royal Museum of Fine Arts, *Catalogue of Old Foreign Paintings*, 1952,
 p. 10, no. 20, repr.
 Nannen, 1985, pp. 118–119
EXHIBITION: Amsterdam, 1985, cat. S10, repr.

This canvas, one of Backhuysen's largest paintings, represents the first day of the Four Days' Battle. The previous year the English had been victorious over the Dutch at the Battle of Lowestoft (June 3, 1665), leaving the Dutch vulnerable to coastal depredation and to the potentially harmful disruption of their trade. The Dutch Republic moved quickly to build up a more formidable navy. By early June 1666 they had assembled near the island of Texel a fleet of seventy-two large warships plus thirteen frigates and other smaller vessels. Under the command of Lieutenant Admiral Michiel de Ruyter, this fleet set sail down the English Channel in search of the English fleet, under the Duke of Albemarle, which was assembled near Duins. On June 8 an English squadron of twenty ships set sail to intercept a French fleet to prevent it from joining forces with the Dutch. This temporary weakening of the English navy had disastrous consequences. Reduced to fifty-six ships, the main English fleet set sail for the coast of Flanders, when it sighted the Dutch fleet sailing southward from Texel.

Within four miles of the English, de Ruyter established the Dutch battle

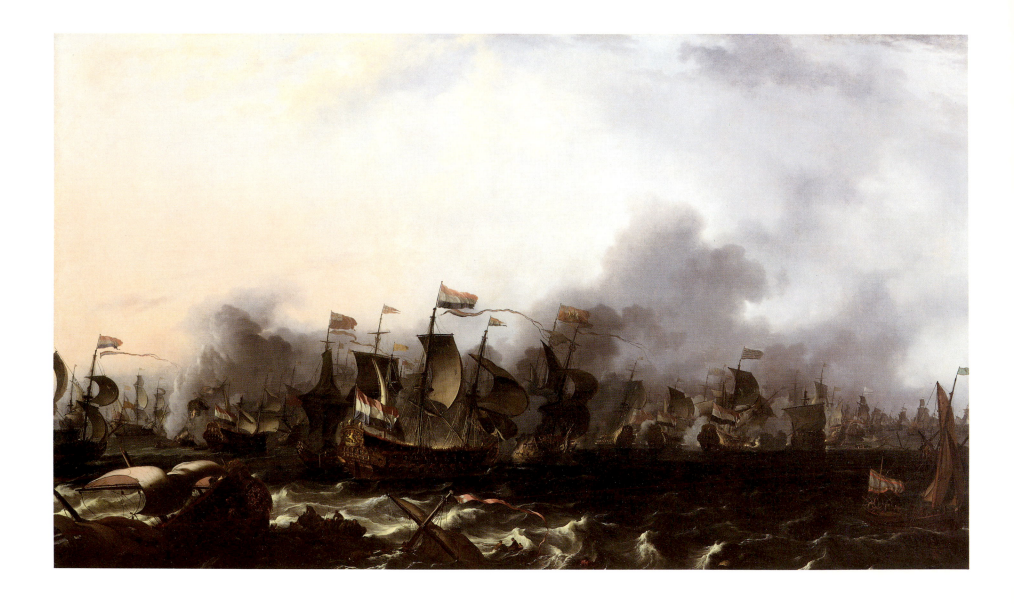

formation: Cornelis Tromp commanded the lead squadron, de Ruyter was at the center, and Cornelis Evertson commanded the third squadron. The enemy fleets, moving in a south-southeast course, encountered each other. The English were forced to change course to avoid the treacherous shallows off the coast of Flanders. Only at 10:00 p.m. did the action cease during this first day of the Four Days' Battle.

The *Seven Provinces* appears at the center of Backhuysen's composition, flying a prince's flag and a forked wimple. The *Royal Charles*, under the Duke of Albemarle, sails before the bow of the *Seven Provinces*, whereas the *Royal Oak*, the flagship of Joseph Jordan, vice admiral of the English red squadron, appears just beyond the *Seven Provinces*. The ship at the left with the large prince's flag and wimple flying from its foremast is probably the *Walcheren*, the flagship of Cornelis Evertson. Tromp's ship, the *Hollandia*, appears in the right center distance, distinguished by its fallen foremast shot away in action.[1]

Backhuysen rarely depicted naval battles. The *Four Days' Battle* in Copenhagen is by far his most important contribution to this category of marine painting, equal in its ambitions to the large battle subjects of Willem van de Velde the Younger.[2] Possibly Backhuysen felt ill equipped to compete with the Willem van de Veldes in this specialty. Instead, he shifted his interest to representations of shipping or of fleets assembled in formation. His most notable representation of commercial fleets is *Shipping Before the Island of Texel* of 1665, in Greenwich.[3] Subjects involving the navy of the Dutch Republic include *The Return of the "Hollandia" in the Landsdiep on November 3, 1665* of 1666–1667 in the Rijksmuseum, "Nederlands Scheepvaart Museum" in Amsterdam;[4] *The Dutch Fleet with the "Delfland" off the Dutch Coast on August 18, 1665*, of 1671, in Emden;[5] *The Return of the Dutch East India Fleet in 1676*, in the Louvre, Paris;[6] and *The Landing of William III* of 1694.[7]

<div align="center">NOTES</div>

1. Robert Vorstman first identified this subject and the ships involved in Backhuysen's painting – Amsterdam, 1985, p. 35, cat. S10.

2. Only late in his career did Backhuysen represent another naval battle, *The Battle of La Hogue*, now in Dresden. The study for this painting is in Brussels (Cat. 58).

3. Amsterdam, 1985, cat. S6, repr.

4. Ibid., cat. S9, repr. A closely related composition is *The "Gouden Leeuw" and other Ships at Texel* of 1671, in the Rijksmuseum, Amsterdam, inv. A8.

5. Ibid., cat. S12, repr.

6. Ibid., cat. S17, repr.

7. Eindhoven, Philips Collection, exhibited Paris, 1967, cat. 382.

8

JAN ABRAHAMSZ. BEERSTRATEN
The Battle of Terheide (August 10, 1653)

Oil on canvas, 176 × 281.5 cm
Signed on a spar at lower left: *I. BEER-STRAATEN*
Amsterdam, Rijksmuseum, inv. A22

PROVENANCE: Rotterdam, auction G. van der Pot van Groeneveld, June 6, 1808, lot 6
LITERATURE: Moes and van Biema, 1909, pp. 112, 156, 184
 Willis, 1911, p. 100
 C. G. 't Hooft, "Onze Vloot in de Schilderkunst," *Feestbundel Bredius,* 1915, p. 106
 Martin, 1936, vol. 2, p. 398
 Diekerhoff, 1970, vol. 5, p. 22, fig. 1
 Bol, 1973, p. 286, pls. 289, 290
 Maritieme Geschiedenis der Nederlanden, 1977, vol. 2, p. 326, repr.
 Haak, 1984, p. 480, pl. 1062

The Battle of Terheide was the decisive naval engagement of the First Anglo-Dutch War.[1] Shortly after the battle began, the Dutch commander, Marten Harpertsz. Tromp, was killed by a cannonball. The Dutch repressed news of this disaster, and the battle continued furiously with heavy losses on both sides. Later, about twenty Dutch warships sailed away from the main theater of battle, with the apparent intention of withdrawing. As a result, the entire Dutch fleet was forced to sail to the island of Texel. Although the English navy had been ceded victory, it was so battered that it could no longer maintain its blockade of the Dutch Republic and was forced to return to England for refitting. This, combined with van Galen's victory at Leghorn (see Cat. 20 and 21), made both countries anxious to end hostilities. Although the final treaty was favorable to England, its terms were not onerous for the Dutch. They were forced to accept Oliver Cromwell's Navigation Acts and to guarantee that the Prince of Orange would not be declared stadholder of the United Provinces.

Beerstraten represents the Battle of Terheide at its height with Tromp's flagship, the *Brederode,* seen at left center with its broken mainmast. It is locked in deadly combat with the English flagship, the *Resolution,* commanded by Admiral Monk. The two ships furiously deliver cannon broadsides.[2] This focus on the duel between the ships of Tromp and Monk is likely intended to commemorate the universally lamented loss of Marten Harpertsz. Tromp in this culminating battle of the First Anglo-Dutch War.

NOTES

1. The English traditionally refer to this event as the Battle of Scheveningen.

2. Hieronymus van Diest also represented the *Battle of Terheide* in two large, closely related canvases: (a) 112 × 171 cm; (b) 112 × 179 cm, Amsterdam, auction (F. Muller), April 25, 1911, lots 179, 180. Version (b) represents the duel between the flagships of Tromp and Monk.

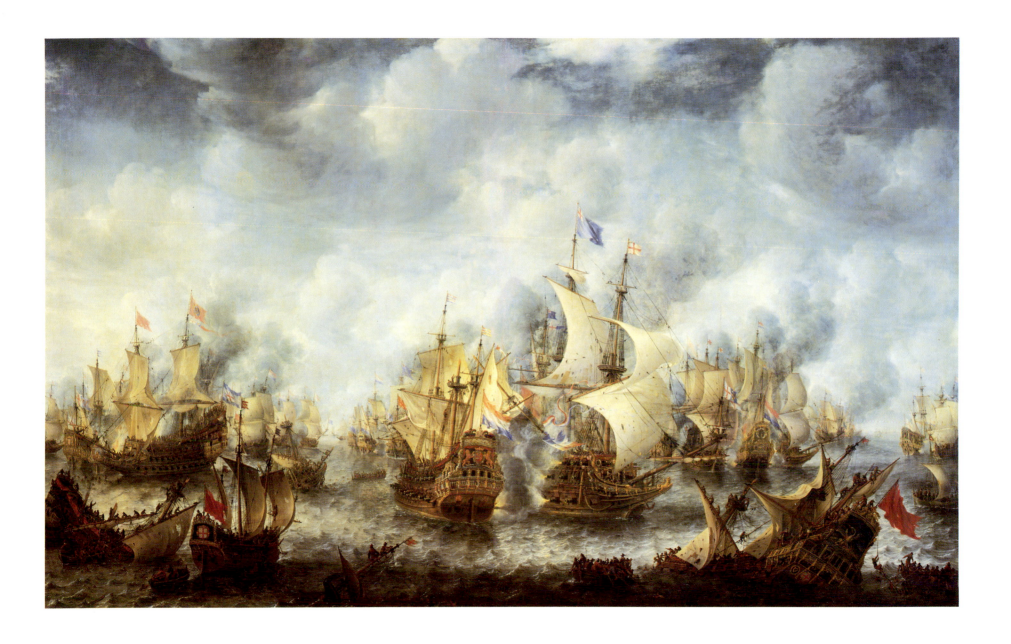

9

ABRAHAM VAN BEYEREN
Sailboats on a Choppy Sea

Oil on panel, 33 × 43 cm
Monogrammed on leeboard of sailboat: *A.V.B.*
Bahamas, private collection

PROVENANCE: The Hague, Galerie Hoogsteder (1974)
EXHIBITION: The Hague, Mauritshuis, *A Collectors' Choice*, 1982, pp. 60–61, cat. 12, repr.

Abraham van Beyeren's marines are rare, numbering hardly more than a dozen, not including the seven scenes that embellish his fishery plaque of 1649 in the Groote Kerk in Maassluis.[1] An early marine by van Beyeren in the Hannema–de Stuers Foundation in Heino[2] reveals the influence of Simon de Vlieger, but even in this work the artist shows an equal interest in the marines of Jan van Goyen, particularly evident in his rendering of the sea and clouds. In his more characteristic, slightly later works van Beyeren brightens his palette and develops more robust brushwork, particularly in his representation of choppy water. Like van Goyen, he depicts the estuaries and lakes of Holland rather than the open ocean. Large ships appear in his paintings, but usually as background motifs. Van Beyeren focuses on small sailboats and dories, which dominate the foregrounds of his marines. The broadly defined clouds in *Sailboats on a Choppy Sea* are reminiscent of those found in Salomon van Ruysdael's paintings of the 1640s and 1650s, suggesting that this picture dates from the mid-1650s.

NOTES

1. Sullivan, 1987, pp. 115–125, repr.

2. D. Hannema, *Beschrijvende catalogus van de schilderijen, beeldhouwwerken, aquarellen en tekeningen*, Verzameling Stichting Hannema-de Stuers, 1967, cat. 13, pl. 21.

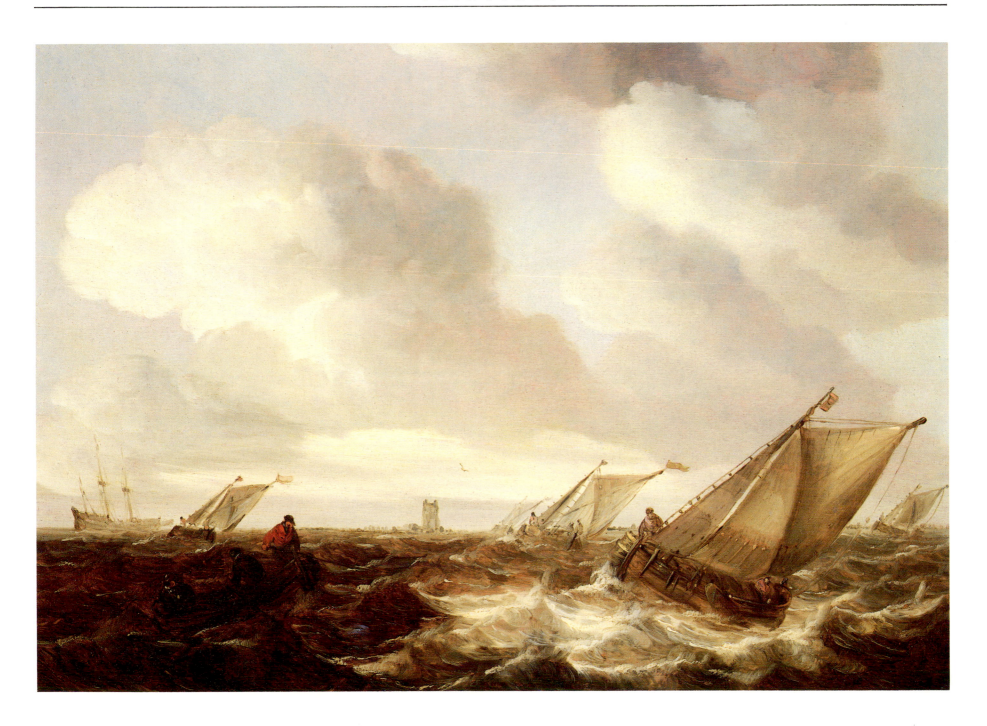

10

JAN VAN DE CAPPELLE

Ships off the Coast

Oil on canvas, 72.5 × 87 cm
Signed and dated at bottom center: *I V CAPelle 1651*
The Hague, Mauritshuis, Koninklijke Kabinet van Schilderijen, inv. 820

PROVENANCE: London, Collection R. G. Wilberforce
London, Collection Charles T. D. Crews
London, auction Crews (Christie) July 1, 1915, lot 13, repr., bought by Colnaghi
London, Colnaghi
Breukelen, Collection Onnes van Nijenrode
Amsterdam, Gallery J. Goudstikker
Almelo, Collection H. E. ten Cate
London, Collection Sir Henry Detterding by whom presented to the Mauritshuis

LITERATURE: Hofstede de Groot, 1907–1928, 1918, vol. 7, p. 214, no. 133
Martin, 1936, vol. 2, p. 387, pl. 206
G. Knuttel, *De Nederlandsche Schilderkunst van Van Eyck tot Van Gogh*, Amsterdam, 1950, p. 385, repr.
W. Martin, *De schilderkunst in de tweede helft de 17de eeuw*, Amsterdam, 1950, p. 62, no. 166
Stechow, 1966, pp. 106–107, pl. 212
L. J. Bol, 1973, p. 227, pl. 232
Russell, 1975, pp. 22, 28, 80, pl. 19
The Hague, Mauritshuis, *Hollandse Schilderkunst Landschappen 17de Eeuw*, 1980, pp. 19–20, repr.
 (with complete exhibition history and bibliography)
Hoetink, 1985, pp. 162–163, repr.
Broos, 1987, pp. 97–100, repr.

EXHIBITIONS: London, Royal Academy, *Dutch Painting*, 1929, cat. 289
New York–Toledo–Toronto, 1954/1955, Cat. 18, repr.

The organizers of this exhibition have opted not to include a survey of beach scenes, particularly of a type developed by Jan van Goyen in which genre details play a significant role. Nonetheless, it is appropriate to include this celebrated picture by van de Cappelle. His painting stems from the celebrated *Shipwreck on a Beach* (Cat. 23) by Jan Porcellis that spawned a host of emulators including Hendrick van Anthonissen and Simon de Vlieger.

Unlike the more characteristic beaches of van Goyen, Jan van de Cappelle includes the sea in the right foreground and devotes as much space to it as to the beach and dunes at the left. The daily activities of the figures on the beach are secondary to the vessels at the center and right.[1] Like Porcellis, van de Cappelle includes in the foreground aristocratic figures who survey goods being unloaded from the boats at the center. The chief difference between van de Cappelle and his immediate predecessors is his greater

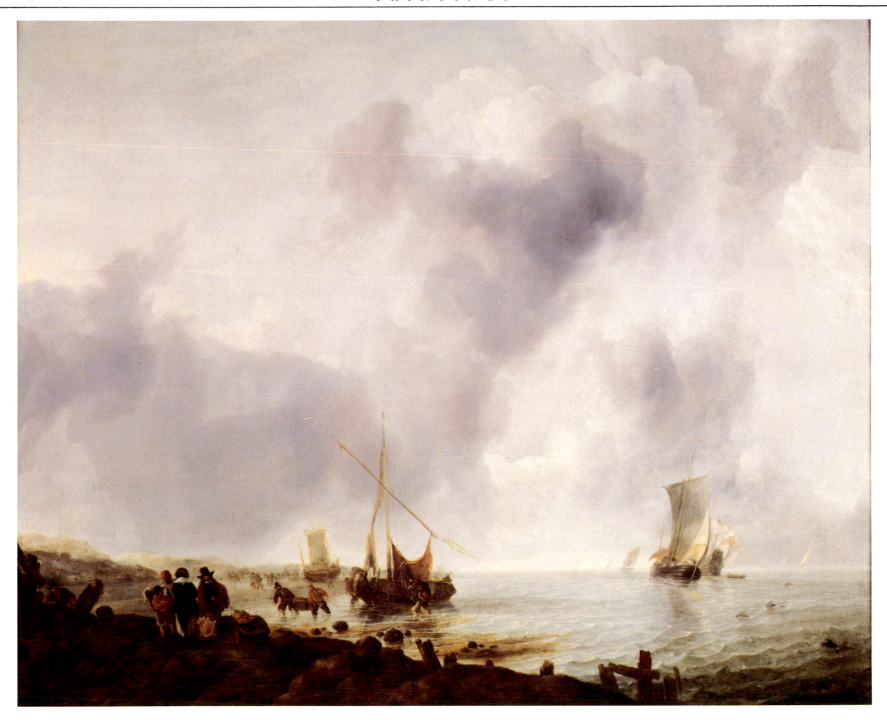

focus on the cloudy sky. He emphasizes the clouds that rise up as a magnificent canopy above the coast. Sky comprises almost four-fifths of the composition, and the way it filters light reflecting off the sea is a marvel of observation. Jan van de Cappelle observes the tremendous cloud banks that form above the North Sea along the coast of Holland, and transforms a common phenomenon into poetry.

Stechow rightly stresses the unique degree to which van de Cappelle has developed aerial perspective in his concept of landscape. Light effects convey a sense of moisture that imparts a silken sheen to the subject.[2] The

stateliness of this picture precedes the marines of Jacob van Ruisdael (Cat. 25 and 26) by many years and sets a standard that would inspire the greatest marine painters of the second half of the seventeenth century.

NOTES

1. Broos calls attention to the genre component in this picture and links it to the *Calm*, also dated 1651, in Chicago. In particular he cites the distinctive motif of two wading men carrying a chest to shore–Broos, 1987, p. 99.

2. Stechow, 1966, pp. 106–107.

11

JAN VAN DE CAPPELLE
Shipping off the Coast

Oil on canvas, 61.9 × 84 cm
Signed on second ship from the left: *J.V.C.*
Toledo, Toledo Museum of Art, Gift of Edward Drummond Libbey, inv. 56.56

PROVENANCE: Brussels, Collection Dukes of Arenberg (from the early eighteenth century until 1955)
 London, Edward Speelman
LITERATURE: W. Burger, *Galerie d'Arenberg à Bruxelles*, 1859, no. 10
 Hofstede de Groot, 1907–1928, vol. 7, no. 24
 Stechow, 1965, pp. 115–116
 Stechow, 1966, p. 118, pls. 232, 233
 Russell, 1975, pp. 20, 24, 64–65, pl. 9
 Haak, 1984, pp. 476–477, pl. 1051
EXHIBITION: The Hague, 1966, cat. 26

Shipping off the Coast is one of Jan van de Cappelle's finest and best preserved paintings, a perfect example of this artist's type of centralized composition. It is closely linked to dated pictures from 1650 and 1651 in Amsterdam, London, and Zurich,[1] all notable for the clarity of the ships' reflections in the glowing water and for the fuguelike patterning of clouds vaulting above and behind the ships. Van de Cappelle modulates the light and shadow defining these clouds with unrivaled subtlety. Not only do these pictures evoke vast space, but the artist attains atmospheric effects

that charge them with the potential for change. The very stillness of the subjects almost anticipates change and heightens the viewer's interest in them. Ships, with the play of light on their hulls and sails, become yet another vehicle to record the complex weather conditions that so attracted the painter's attention.

Shipping off the Coast distinguishes itself from van de Cappelle's well-known *parade* subjects in that it contains fewer boats. Only one of these, the yacht beyond at the center, is the obvious type of vessel to participate

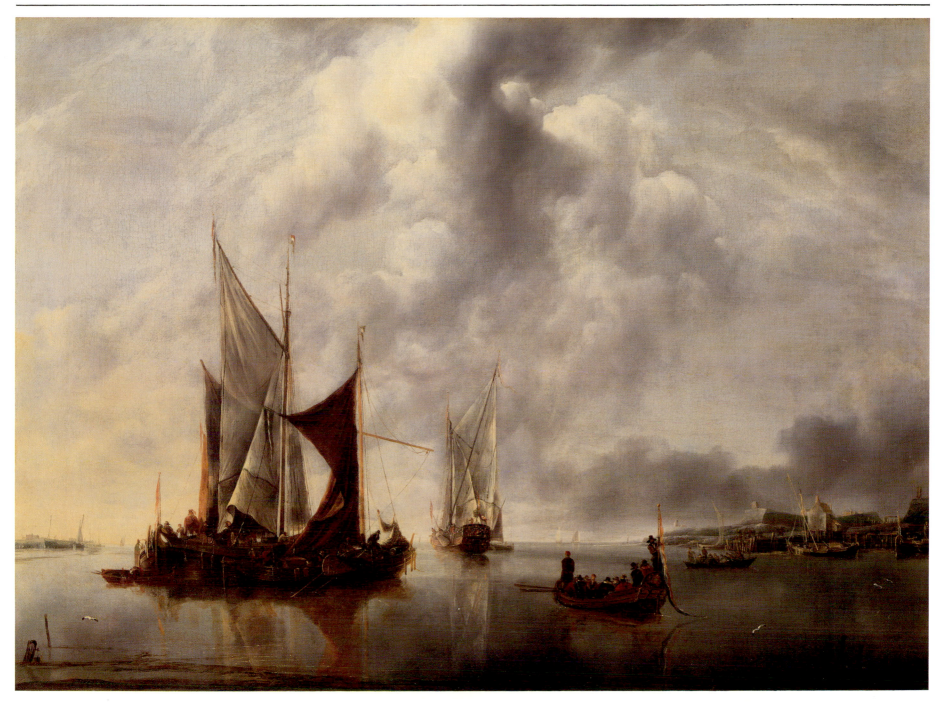

in such an occasion, but it seems to bear little relationship to the three sailboats clustered together at the left. Van de Cappelle represents this group of boats on an estuary with shallows in the foreground and land in the left and right distance. He provides ample space around the sailboats and offers the viewer glimpses into the center distance. He creates analogous settings in a number of closely related paintings including his *Riverview* of 1651 (fig. a) in Zurich, *Shipping Becalmed* of 1654 in the collection of the Marquess of Zetland,[2] as well as pictures in Capetown, Los Angeles, and Rochester, New York.[3]

During the early 1650s, Jan van de Cappelle experimented with his palette. Many of his estuary subjects and particularly *Shipping off the Coast* display a range of silvery-gray tones that perfectly realized the artist's need to refine atmospheric effects. Although not constituting an outright break with the warm brownish palette of his *parade* subjects of 1650 and earlier, they indicate a shift that parallels the tonality formulated by Simon de Vlieger in his greatest paintings from the mid to late 1640s. Van de Cappelle's admiration for de Vlieger may be gauged by the number of paintings (8) and drawings (more than 1,300) by this artist in van de Cappelle's own collection. His earlier marines may reveal awareness of the warm, monochrome beach scenes and marines by Jan van Goyen, but after 1650 one notes a shift to a greater depth of color and a love for the silvery palette so noticeable in the cloudy skies in van de Cappelle's marines of the 1650s. This refinement of his palette and his progressive striving for greater stateliness finds a parallel development in landscape painting during the same period. Although change was "in the air" about 1650, there is no question that van de Cappelle produced refined atmospheric effects in his marines well in advance of similar developments in landscape. That spectacular moisture-laden skies only later entered the repertory of Jacob van Ruisdael and Meindert Hobbema demonstrates the precocity of van de Cappelle's achievement.

NOTES

1. Russell, 1975, pls. 6, 5, 10.

2. Ibid., pl. 14.

3. Ibid., pls. 86, 90, 91.

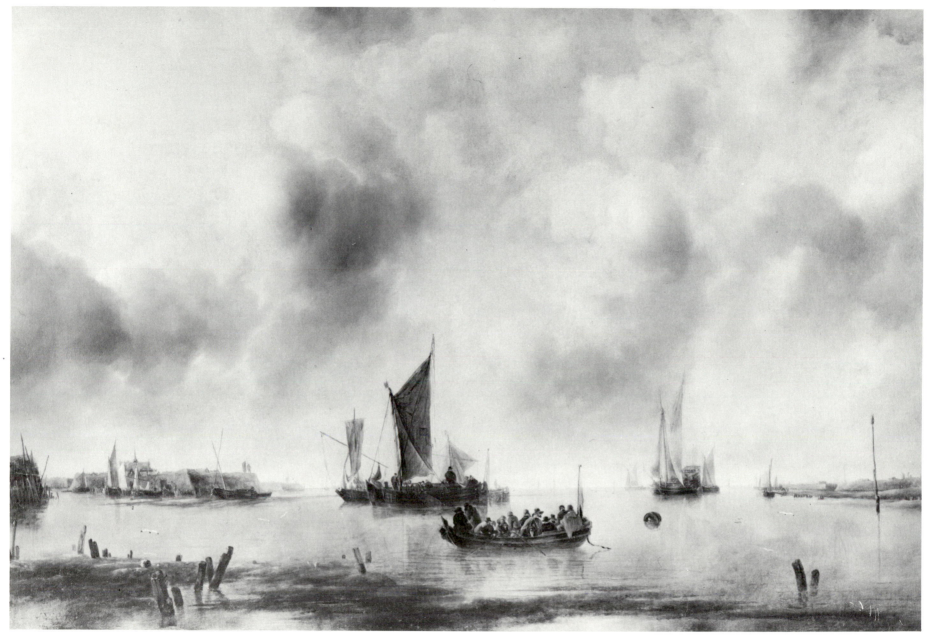

Cat. 11, fig. a Jan van de Cappelle, Riverview, *1651, oil on canvas. Zürich, Kunsthaus, Ruzicka Stiftung.*

12

JAN VAN DE CAPPELLE

Ships on a Calm Sea

Oil on panel, 62.2 × 83.2 cm
Signed on the side of the large boat: *I V C*
New York, private collection

PROVENANCE: Probably Amsterdam, auction August 14, 1793, lot 23, bought by De Vry for fl. 121
(?) Amsterdam, auction M. Feitama, April 2, 1794, bought by Jan Spaan for fl. 110
Paris, Galerie J. Depret (1912)
Essen, Villa Hugel, Collection Krupp von Bohlen und Halbrach
Palm Beach, Collection Arndt Krupp von Bohlen and Halbrach
New York, auction (Christie) January 13, 1987, lot 135, repr.

LITERATURE: Hofstede de Groot, 1907–1928, vol. 7, p. 192, no. 59
Russell, 1975, p. 69, no. 59, and probably p. 72, no. 79

EXHIBITIONS: Essen, Folkwang Museum, *Holländische Landschaftsmalerei des 17. Jahrhunderts*, 1938, cat. 3
New York, 1988, p. 43, cat. 11, repr.

This painting, which has only recently resurfaced, is a major early work by Jan van de Cappelle. In 1941, Valentiner pointed out that van de Cappelle painted virtually his entire oeuvre in a very compressed period ranging from the later 1640s until the mid-1650s.[1] Subsequent discoveries have done little to alter this notion.[2] Despite Adams's proposed dating of this picture to the early 1650s,[3] two features of *Ships on a Calm Sea* suggest that it probably dates from the 1640s. The first is the unusual representation of the sun's rays playing across the water in the left center foreground. This device indicates the artist's abiding interest in the subtle effects of diffused atmospheric light, which he would refine to a progressively greater degree in his most celebrated pictures of the 1650s (see Cat. 10 and 11). However, this display of sunbeams serves to divide the composition into two unequal halves, with a smaller grouping of boats by a jetty at the left and a larger cluster of sailboats by a ship to the right. Second, clouds form an elaborate patchwork with a distinctive contrast between those across

the horizon and the clouds gathering high above the foreground. In his later pictures Jan van de Cappelle would modulate the entire cloud canopy more subtly and evoke a palpable atmosphere to a greater degree.

Valentiner analyzes van de Cappelle's evolution from a different angle, in terms of his principles of composition. He focuses on the artist's shedding of coulisse devices, which he associates with Simon de Vlieger, whom van de Cappelle admired and with whom he may have studied.[4] Valentiner stresses that Van de Cappelle tends to centralize his subjects, massing ships and sailboats in such a way that he offers uninterrupted visual vistas to either side of them without recourse to coulisses. This idiom is not yet fully realized in *Ships in a Calm Sea*, characterized by its single vista just to the right of the jetty. This work, with its warm brown, monochrome tonality, belongs to an early phase in the artist's career. It is also a remarkable premonition of his larger *parade* subjects in London and Rotterdam,[5] which retain a similar palette but develop the artist's incomparable ability to

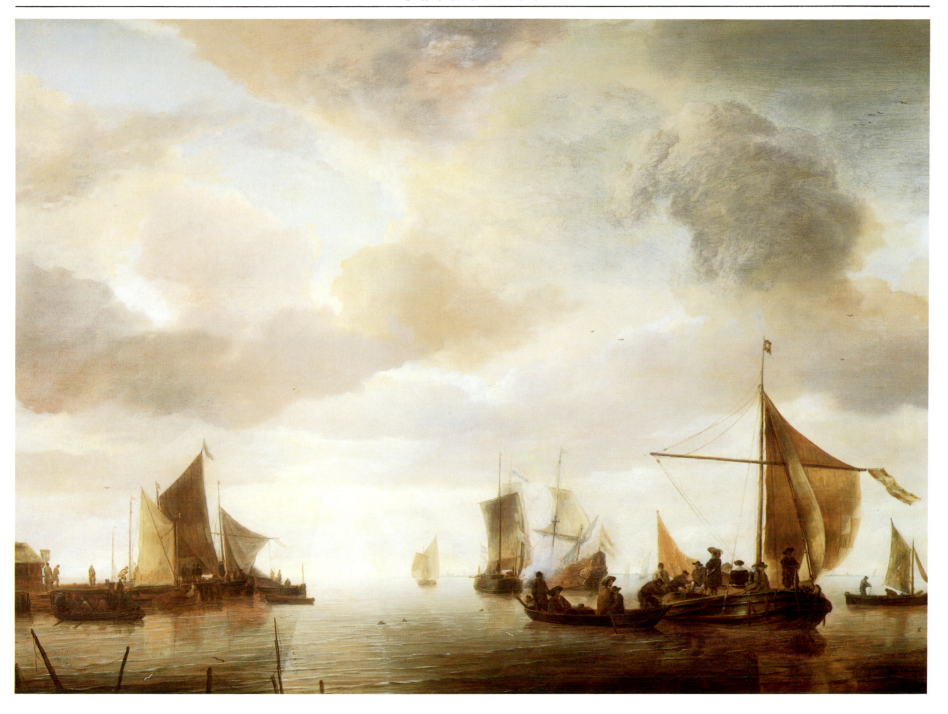

represent reflecting ships on unruffled water. They also display van de Cappelle's refined method of clustering ships within a continuous expanse of water whose shimmering surface mirrors subtle atmospheric effects.

<div align="center">NOTES</div>

1. Valentiner, 1941, p. 276.

2. See Cat. 10 for the recently discovered date of *Ships off the Coast* in the Mauritshuis. For the most recent discussion of Jan van de Cappelle's marine paintings, see Russell, 1975. Of crucial importance in Russell's study, deriving in part from Stechow's 1966 assessment of Jan van de Cappelle, is the dating of the artist's *Parade* in the Robarts Collection. Russell reads the date as 1645, although Stechow remains more noncommittal.

3. A. Adams, in New York, 1988, p. 43.

4. Valentiner, 1941, pp. 272, 275.

5. Russell, 1975, pls. 5, 7.

<div align="center">

13

WILLEM HERMANSZ. VAN DIEST
Shipwreck on a Beach

</div>

Oil on panel, 48.9 × 71.5 cm
Signed and dated: *W. v. Diest 1629*
Baltimore, Walters Art Gallery, inv. 37.877

PROVENANCE: Rome, Palazzo Accoramboni, Collection Massarenti

This turbulent scene is Willem van Diest's finest contribution to a theme first perfected by Jan Porcellis (Cat. 23) and later popularized by Simon de Vlieger, Hendrick van Anthonissen, and others.[1] Van Diest heightens the dramatic impact of the subject by including large rocks scattered across the sand, indicating the non-Dutch character of the coastal terrain. The three gesturing figures in the foreground and the sailors struggling for shore are dwarfed by the magnitude of the storm and fury of the sea. In the left distance several merchantmen struggle to steer free of the treacherous coast.

Van Diest's dated pictures are from the 1640s and 1650s, after which he came under the influence of Hendrick Dubbels.[2] In general, however, his mature style reveals the pervasive impact of Simon de Vlieger. The *Shipwreck on a Beach* in the Walters Art Gallery is van Diest's earliest known dated work. The strong contrast between light and shade and the inky sky indicate to what degree van Diest was inspired by the late works of Jan Porcellis.

Despite the gripping drama, this painting is a product of the artist's imagination and conveys a symbolic or moralizing message. Most recently Goedde has elucidated the symbolism of the sea storm in Dutch marine art.[3] Shipwrecks and ships in distress become metaphors for the human soul, its earthly vicissitudes and yearning for salvation. Such marine subjects can also refer to the precariousness of human pride. Interpreted metaphorically, these shipwreck subjects contain moralizing messages that, although evident to the seventeenth-century owners of such pictures, have only recently been reinterpreted as such by students of Dutch iconography and emblemata literature.[4]

<div align="center">NOTES</div>

1. For example, Simon de Vlieger's picture in the exhibition (Cat. 46) and Hendrick van Anthonissen's well-known painting in Schwerin – L. J. Bol, 1973, pl. 109.

2. Bol, 1973, p. 165.

3. Goedde, 1984, and Goedde, 1986, pp. 139–149.

4. Amsterdam, 1976, pp. 121, 165; Braunschweig, 1978, pp. 44–47; Goedde (see note 3).

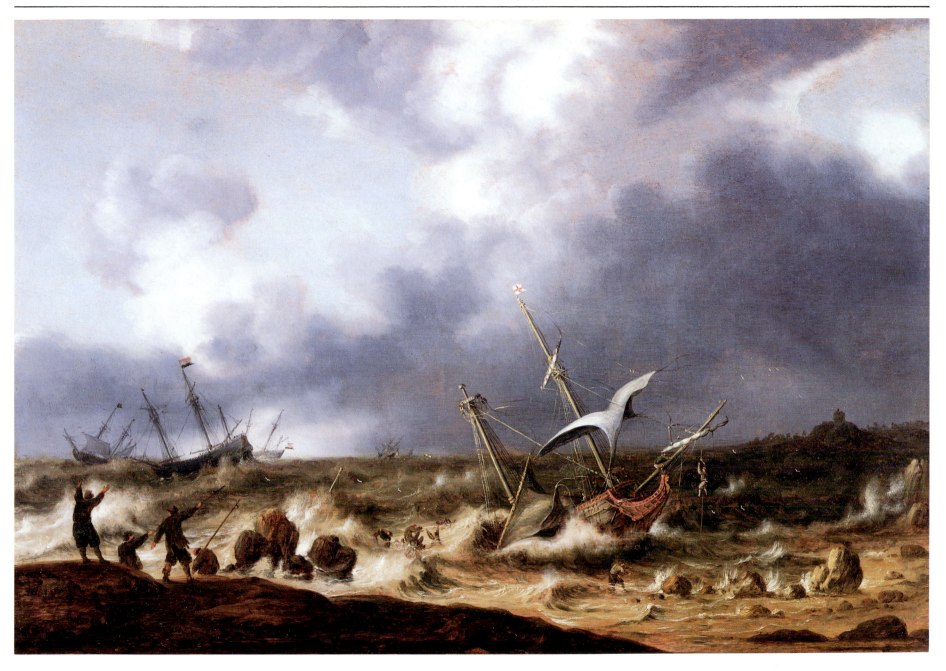

14

HENDRICK DUBBELS
Ships Beyond a Beach

Oil on canvas, 136 × 193 cm
Signed on barrel at bottom left: *Dubbels*
Copenhagen, Den kongelige Maleri-og Skulptursamling, Statens Museum for Kunst,
 1951, cat. 191

PROVENANCE: Danish Royal Collection by 1761
LITERATURE: Royal Museum of Fine Arts, *Catalogue of Old Foreign Paintings*, 1951, p. 81, no. 191, repr.

This marine, one of Dubbels's most innovative compositions, is a key work in defining his style. Dubbels is something of a chameleon whose pictures often recall the style of Jan van de Cappelle, Simon de Vlieger, or Willem van de Velde the Younger. Because they so closely resemble the oeuvre of these distinguished painters, Dubbels's original signatures have frequently been altered or effaced to enable his pictures to masquerade under more illustrious, albeit erroneous, attributions.

A small group of paintings including *Ships Beyond a Beach,* plus related beach scenes in the Rijksmuseum, Amsterdam,[1] and the Palazzo Pitti in Florence,[2] display an intensity of vision and clarity of design that reveal Dubbels at his best. In these works he concentrates on the restless action of waves breaking on the shore. The white water seems to catch the light although the sea is largely in shadow. Dubbels represents overlapping clouds in complex configurations. His depiction of clouds reveals Dubbels's interest in Jan van de Cappelle, but his subjects are darker and more brooding in mood, paralleling the more overtly dramatic marines of Jacob van Ruisdael or Backhuysen.

Cat. 14, fig. a Hendrick Vroom, Beach by Scheveningen, *163(?), oil on panel. Formerly Amsterdam, Gallery de Boer.*

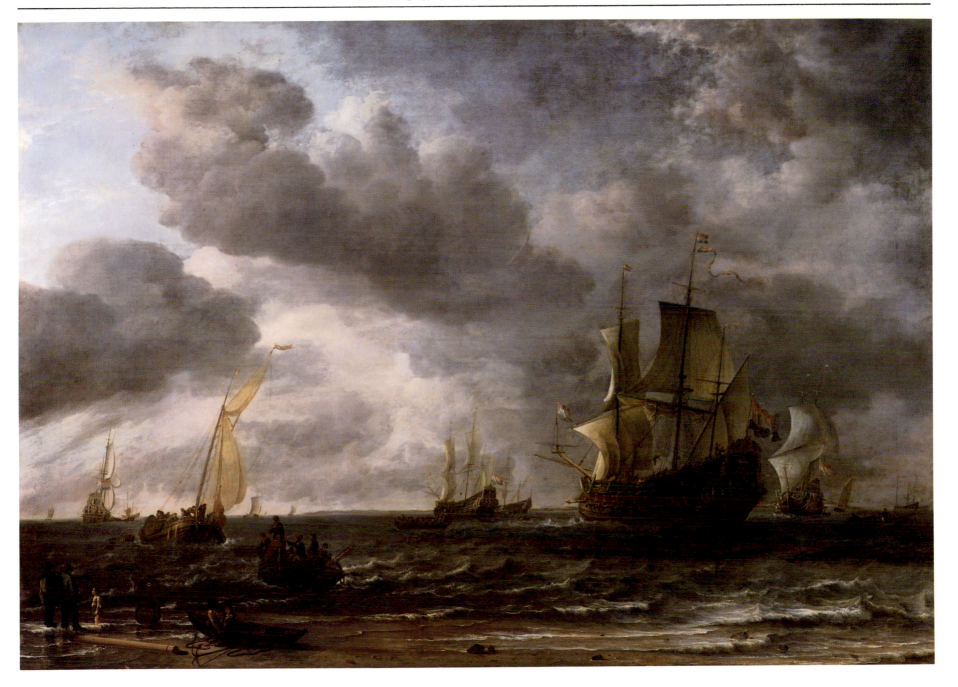

Dubbels's *Ships Beyond a Beach* is one of his most distinctive and felicitous inventions. He places warships beyond a beach that extends across the entire foreground. Backhuysen develops this composition in certain of his marines (see Cat. 2, fig. a). Although Hendrick Vroom first introduced this theme into Dutch marine art fifty years earlier (fig. a), Dubbels derives his ideas directly from Jan van de Cappelle, but with one notable difference. Van de Cappelle's beach scenes, which often include figures wading in the foreground, are represented in calm weather. By contrast, Dubbels prefers to represent more variable weather conditions, with wind as an important component of his marines. The suggestion of somewhat blustery weather quickens the tempo and introduces a dramatic note into the subject. This tendency becomes more fully orchestrated later in the seventeenth century in the marines of Backhuysen and Ruisdael, and in Willem van de Velde the Younger's works of the early 1670s (Cat. 2, 25, 26, 38).

NOTES

1. Inv. 813, *The Fleet of Admiral Van Wassenaar Obdam by Texel in 1665*, canvas, 140 × 196 cm, signed at lower right: *Dubbels*, repr. Amsterdam, *All the Paintings in the Rijksmuseum*, 1976, p. 200.

2. Inv. 464, 1937 cat. 457, panel, 69 × 86 cm, signed on spar at lower right: *DVBBELS*. The setting in this painting is virtually identical to that in the marine in the Rijksmuseum cited in footnote 1. Dubbels employs a similar setting in his signed *Beach Scene near Den Helder*, in Leipzig-Museum der bildenden Künste, Katalog der Gemälde, 1979, p. 51, inv. 1002, repr., canvas, 51.7 × 67.5 cm, and in a variant of this composition, canvas, 48 × 64 cm, signed on a spar on the beach: *Dubbels*, New York, auction (Sotheby) June 5, 1986, lot 46, repr.

15

HENDRICK DUBBELS

Sailboats in a Breeze

Oil on canvas, 49.9 × 49.5 cm
Signed on spar at lower left: *Dubbels*
Schwerin, Staatliches Museum, inv. 42

PROVENANCE: Old collection, acquired before 1836
LITERATURE: Schlie, 1882, pp. 168–169, no. 333
 Bode, 1891, pp. 112–113, repr.
 Willis, 1911, p. 73, pl. XIX
 L. J. Bol, 1973, p. 211, fig. 215
 Russell, 1975, p. 43, pl. 51
 Schwerin, Staatliches Museum, *Holländische und flämische Malerei des 17. Jahrhunderts*, p. 9, pl. 86
 Haak, 1984, p. 474, pl. 1047

This painting is one of Dubbels's most audacious and memorable works. In it he formulates an exuberant baroque idiom in which the painter magnifies the relationship between sea and cloudy sky. Dubbels stresses the immense sweep of sky by the square format of the painting. By assuming a somewhat high vantage point and by reducing the size of the sailboats and distant ships, Dubbels infuses a greater monumentality into the magnificent cloud bank that seems to hold the vessels below it in thrall. This vigorously defined interaction between sea, clouds, and ships became the fundamental composing principle of such painters as Backhuysen and Ruisdael (Cat. 2, 25, 26).

Dubbels rarely dated his pictures.[1] The exuberant tenor of the picture in Schwerin, matched with the sophisticated counterpoint between sea and sky, suggests a date of about 1660.

NOTE

1. His earliest dated marine is from 1651, *Frozen Harbor with Pier*, panel, 58 × 78 cm, Vienna, auction (Kende), March 2, 1921, lot 23, repr.

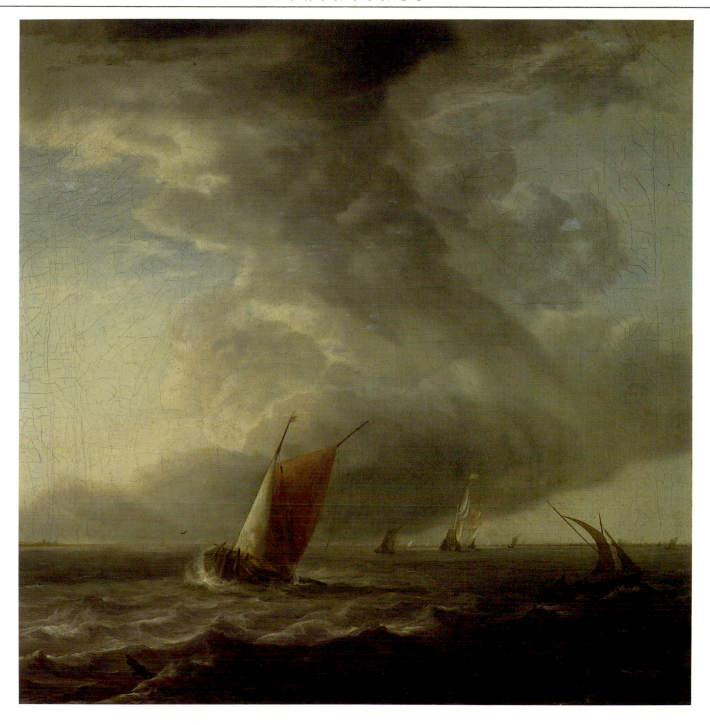

16

JAN VAN GOYEN
Sailboats in a Thunderstorm

Oil on panel, 40 × 60.5 cm
Signed and dated on the rowboat at the right: *VG 1643*
The Hague, Rijksdienst beeldende Kunst, inv. NK 2831

PROVENANCE: Paris, Galerie C. Sedelmeyer
Amsterdam, auction (Fr. Muller) May 26, 1914, lot 311, repr.
London, Gallery Max Rothschild (1920–1925)
Amsterdam, Gallery Goudstikker
Brussels, auction (Fievez) May 8, 1929, lot 52, repr., bought by Goudstikker
Amsterdam, Gallery Goudstikker
Linz, Museum (inv. 3815)

LITERATURE: Hofstede de Groot, 1907–1928, vol. 8, no. 1111
Beck, 1972–1973, vol. 2, p. 362, no. 807, repr. (with early exhibition history)

During the late 1630s, van Goyen began producing marines. Certain of these are stormy subjects in which gray lowering clouds herald a coming storm. This type of charged atmosphere appealed to the artist, who developed its potential further when he represented the storm itself. The most dramatic of these representations include bolts of lightning flickering across murky skies. In these pictures van Goyen brings the monochrome landscape to its logical extreme. He painted relatively few thunderstorms; Beck lists only 8 from a total of slightly more than 150 marine paintings.[1]

Van Goyen's paintings are strikingly modern in comparison with the sea storms of Vroom, Willaerts, and even Porcellis. These earlier proponents of this theme impart a moralizing tenor into their sea storms and depict rugged coastlines that are distinctly non-Dutch in character. By contrast, Jan van Goyen bases his subjects on direct meteorological observation. His marines seem specific and actual. The topography is quintessentially Dutch and more often than not represents the lakes and estuaries of Holland and Zeeland.

Van Goyen seems to have been the inventor of this strain of marine painting. His work did not go unnoticed. Simon de Vlieger, in his *Sailboats in a Thunderstorm* at Petworth (fig. a), expounds a similar idea, and Albert Cuyp's *The Maas at Dordrecht in a Storm* (Fig. 20, p. 25), now in the National Gallery in London, is a unique contribution to the subject, in which the awesome power of nature is heightened to dramatic pitch.

NOTE

1. Beck, 1972–1973, vol. 2, nos. 803, 804, 807, 811, 827, 833, 863, and vol. 3, no. 807A.

Cat. 16, fig. a Simon de Vlieger, Sailboats in a Thunderstorm, *oil on panel. Petworth House (The National Trust).*

17

JAN VAN GOYEN
A Calm

Oil on panel, 36.1 × 32.1 cm
Monogrammed on gunwale of rowboat at left: *VG*
Budapest, Szépmüvészeti Múzeum, inv. 4305

PROVENANCE: Vienna, Galerie Plach (1869)
Pressburg, Collection Count Johann Palffy by whom bequeathed to the Szépmüvészeti
 Múzeum

LITERATURE: Hofstede de Groot, 1907–1928, vol. 8, no. 1023
A. Dobrzycka, *Jan van Goyen*, Posen, 1966, no. 270
A. Pigler, Budapest, Museum der bildenden Künste, *Katalog der Galerie Alter Meister*,
 Tübingen, 1968, p. 281, inv. 4305, repr.
Beck, 1972–1973, vol. 2, p. 99, no. 207, repr. (with previous literature)

Jan van Goyen was an indefatigable observer of landscape and topography. He often studied the Dutch landscape from a small sailboat in which he plied the rivers, lakes, and estuaries of the Dutch Republic. Several surviving sketchbooks attest to his sharp eye and his deft characterization of familiar monuments. He imparts the same spirited quality to his mature panoramas and marines.

By the late 1630s, van Goyen began to experiment with landscape compositions in which sky played a progressively more important role. One solution the artist developed is the upright format for certain landscape and marine compositions. In these pictures sky constitutes more than four-fifths of the subject. A *Calm* in London from 1638[1] is the earliest dated marine where the painter utilizes the vertical format. Its tremendous success led the artist to develop the idea further. Although he produced fewer than twenty upright marines, they remain among his most popular and innovative paintings. None is large, but each seems monumental because van Goyen conveys a vast sense of scale through his judicious contrast between the flat expanse of water below a vast cloudy sky. The *Calm* of 1638 is characterized by a sultry atmosphere, whereas later marines, including this *Calm* in Budapest, are brighter in color. The light is much clearer in these later pictures, and the artist no longer emphasizes blurring atmospheric effects.

Most of these small marine paintings are undated. The majority, in-

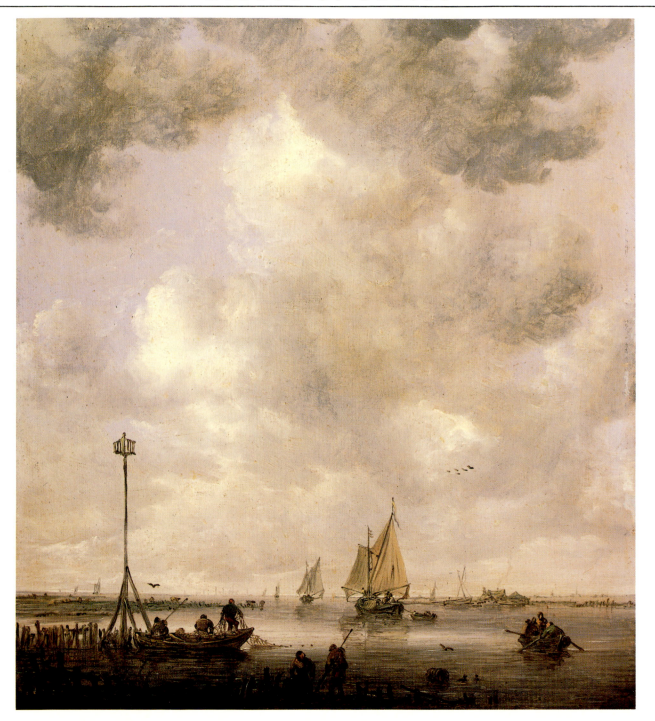

cluding the pair of marines in the National Gallery in London,[2] date from the early 1650s. However, the pale green and silvery-gray palette of the *Calm* in Budapest suggests a date from the mid 1640s. It closely parallels the artist's *Marine,* dated 1646, in The Hague,[3] particularly in the treatment of the clouds. They are thinly painted with alternating zones of modulated grays, in contrast to luminous white areas. It is also very close in style to a *Panorama with a Herd of Cows,* dated 1645,[4] in which the artist silhouettes objects against the gleaming water or the luminous horizon.

In certain marines van Goyen includes familiar landmarks such as the Huis te Merwede near Dordrecht, and the Batsentoren.[5] The same applies to the *Calm* in Budapest. Van Goyen includes the city profile of Leiden in the left center distance. He resided in Leiden early in his career, but moved to The Hague. The two cities are close to each other, and van Goyen returned to the region around Leiden frequently. He loved to sail on the Haarlemer – or Leidsemeer, the large inland lake that extended between the cities of Haarlem and Leiden. This lake offered him vast, uninterrupted panoramic views of Leiden, such as the one represented in this calm.

NOTES

1. Beck, 1972–1973, vol. 2, no. 168, repr.

2. Ibid., nos. 208, 209, repr.

3. Rijksdienst beeldende Kunst, Beck, 1972–1973, no. 181, repr.

4. Beck, 1987, vol. 3, no. 859A, repr.

5. For example Beck, vol. 2, nos. 181, 183, 197, 205, repr.

18

PIETER MULIER THE ELDER
Sailboats in a Stiff Breeze

Oil on panel, 38 × 59.3 cm
Monogrammed at lower right on a spar: *PML* (in ligature)
Baltimore, private collection

PROVENANCE: London, Johnny van Haeften Gallery (1983)

Pieter Mulier, active in Haarlem, was one of the marine painters most deeply influenced by Jan Porcellis. In his mature works, Mulier develops a distinctive style in which he contrasts tossing seas with cloud banks partially caught in light. He often includes evidence of a distant squall. His foreground seas almost invariably contain waves with whitecaps and white water alternating with deep troughs. A further leitmotif of his art is the skiff caught on the crest of one of these waves. This adds a human dimension to the subject. *Sailboats in a Stiff Breeze* is a characteristic mature work with a particularly boldly differentiated cloudy backdrop. It is similar to Mulier's *Sailboats in a Squall* in the Mauritshuis,[1] which represents small craft on one of the inland seas or lakes of Holland. By contrast, *Sailboats in a Stiff Breeze* contains a three-master in the right distance, implying that this body of water lay along a major shipping route with access to one of the great ports of the Dutch Republic. Mulier often represents the open ocean and includes the motif of three-masters sailing close to purely imaginary rocky coasts.

NOTE

1. Inv. 549 – Mauritshuis, 1980, p. 60, repr. as ca. 1640.

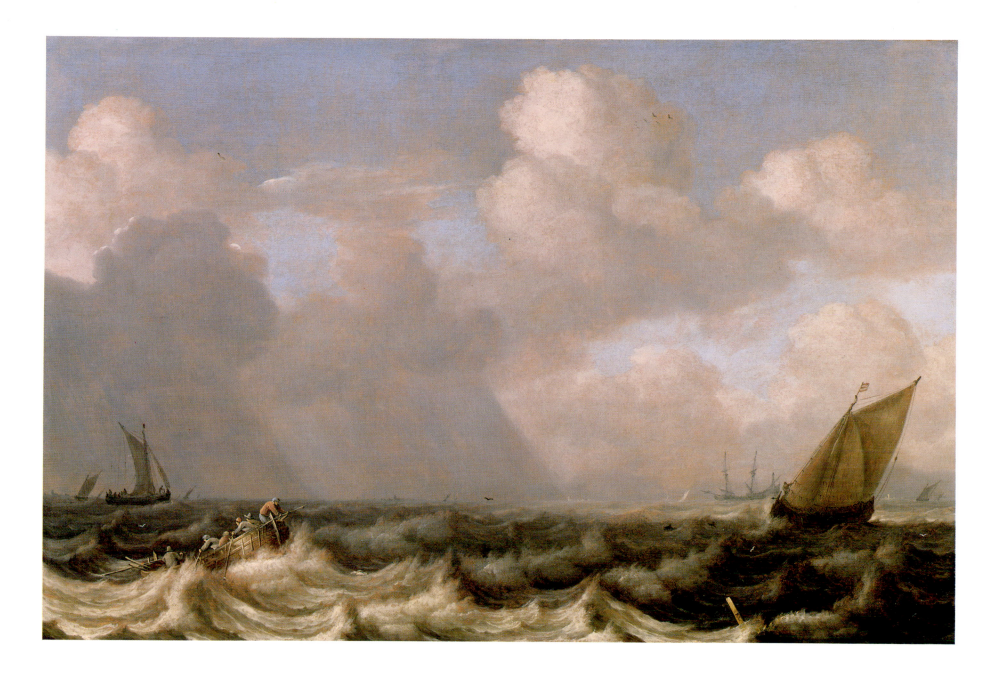

19

REINIER NOOMS ("ZEEMAN")
Ships at Anchor

Oil on canvas, 47.5 × 56.8 cm
Signed and dated on side of sailboat at center: *R. zeeman 1658*
Vienna, Gemäldegalerie der Akademie der bildenden Künste, inv. 1397, Dr. Wolfgang
 Wurzbach-Tannenberg Bequest

PROVENANCE: Collection Josef R. von Lippmann-Sissingen
By descent to W. von Wurzbach-Tannenberg by whom bequeathed to the Akademie der
bildenden Künste in 1954

LITERATURE: E. Schaffran, 1957, vol. 72, pp. 41–50, pl. 4
Haak, 1984, p. 477, pl. 1053

Nooms preferred painting small, cabinet-sized pictures for which he found a ready market. These fall into several distinct groups, including topographical views of Amsterdam, views of its harbor and palisades, Mediterranean subjects, and more generalized Dutch harbor views, usually containing ships being refitted and careened. *Ships at Anchor* belongs to this last category and dates from the artist's best period. It represents lightly armed merchantmen lying at anchor before a distant seaport. Nooms represents the subject beneath lowering gray skies. One almost senses a lull before the outbreak of a squall.

Nooms rarely represented such threatening weather conditions. His more characteristic calms are more analogous to those of the young Willem van de Velde, although Nooms's contribution precedes that of his younger colleague. A *Calm* of 1657[1] offers many points of similarity to the *Ships at Anchor* in Vienna, despite the fact that the sky is less brooding.

Ships at Anchor contains small sailboats anchored before distant dunes

and is an important work because Nooms, in selecting the theme of a calm and in his representation of the cloud canopy, reveals the influence of Jan van de Cappelle. He also stresses atmospheric effects. Although not attaining the subtlety of van de Cappelle, Nooms nonetheless emulates this master to a unique degree. Not only did his study of van de Cappelle enable Nooms to capture the variable weather conditions of Holland, it served him equally successfully in his representations of Mediterranean subjects, although these are demonstrably quite Italianate in mood.[2]

NOTES

1. Oil on canvas, 46 × 60 cm, signed and dated on cargo of sailboat at left: *R. zeeman Ao 1657*, present location unknown, provenance: Amsterdam, auction (Fr. Muller) December 4/5, 1912, lot 238, repr.; Dieren, Ksth. D. Katz; London, Agnew's (1957).

2. Nooms's interest in Italianate subject matter is far more apparent in his several suites of etchings representing Mediterranean subjects – e.g., Bartsch, 1803–1821, nos. 23–30.

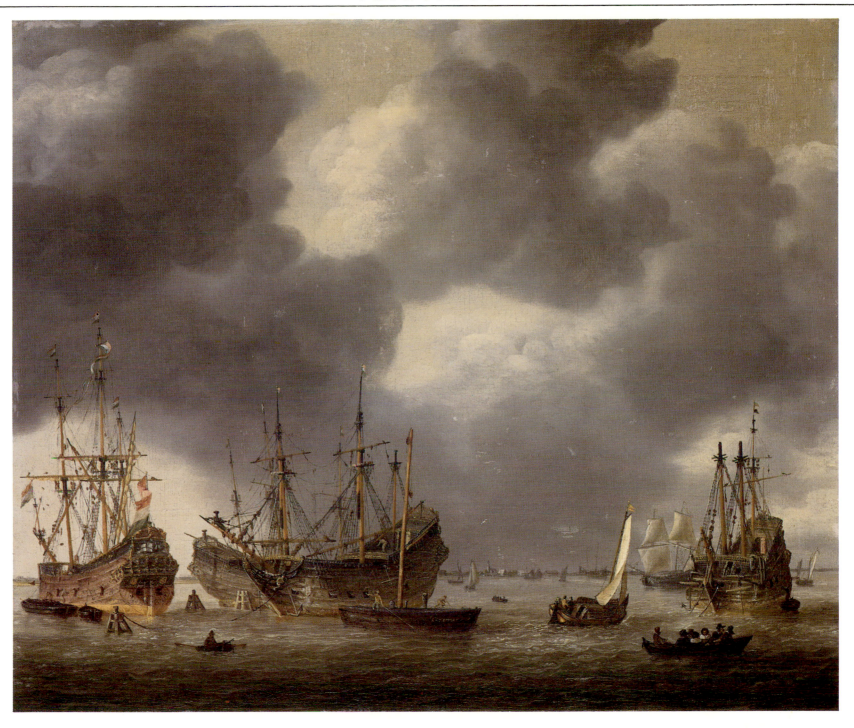

20

REINIER NOOMS ("ZEEMAN")
Battle of Leghorn (March 14, 1653)

Oil on canvas, 66 × 117 cm
Signed on stern flag of Dutch ship at left: *R zeeman*
Greenwich, National Maritime Museum, Caird Collection, 1937 cat. 12

PROVENANCE: Collection Sir James Caird (by whom bequeathed to the National Maritime Museum)
LITERATURE: J.F.L. de Balbian Verster, "De Slag bij Livorno (14 Maart 1653)," *Elsevier's
 Geillustreerd Maandschrift* 24, no. 48 (1914), pp. 340–354

The Battle of Leghorn was the major Mediterranean action during the First Anglo-Dutch War (1652–1654). The two navies had been skirmishing inconclusively in the Mediterranean during the autumn of 1652 until they fought a major battle between Elba and Montecristo on September 26–27, 1652. The English, under the command of Richard Badiley, escaped to Elba and were blockaded by the Dutch. An English merchant fleet under Captain Appleton arrived in Leghorn from Smyrna to seek refuge from the Dutch, only to be blockaded by them there. Under the command of Joris Catz, the Dutch attempted to attack the English in Leghorn but were dissuaded by the protests of the ambassador of the Grand Duke of Tuscany. Catz was recalled and replaced by Admiral Jan van Galen. The Dutch blockade of Leghorn disrupted commerce so seriously that the grand duke commanded the English to leave Tuscany. In response, the English devised a simple strategy. Appleton and Badiley planned to leave Leghorn and Elba simultaneously and close in on the Dutch. Contrary to instructions, Appleton left Leghorn too early, with the result that the Dutch set upon the English fleet on March 14 and inflicted heavy losses. Only the ship *Mary* escaped and joined Badiley's fleet. The Dutch captured the *Leopard*, the *Pilgrim*, and the *Merchant of Levant*. Two English ships, the *Samson* and the *Bonaventure*, were burned along with Badiley's fireship. In turn, the Dutch lost two ships including the *Sun*, but their greatest casualty was Admiral van Galen, who was mortally wounded in the battle.[1] The Admiralty of Amsterdam commissioned van Galen's tomb in the city's Nieuwe Kerk.

Psychologically, the Battle of Leghorn was a significant counterweight to the English victories in the North Sea theater of action. Moreover, the English had to abandon their commercial interests in the Mediterranean, which forced many British merchants into bankruptcy. The considerable discontent this caused in London added pressure on Cromwell's government to seek peace.

In Nooms's painting in Greenwich, van Galen's flagship dominates the center and fires on the *Leopard*, seen from the stern at the left. A second Dutch ship, *De Zon* (the Sun), also attacks the *Leopard*, but it suffered severe damage and sank. Nooms's beautiful alternating dark and silvery-gray effects on the foreground waves are enhanced by the added reflecting colors of the burning English ship.[2] He painted naval battles only occasionally, and his two finest paintings in this vein are the two surviving versions of the *Battle of Leghorn* in Greenwich and Amsterdam (Cat. 21).[3]

NOTES

1. The above information is drawn principally from J.F.L. de Balbian Verster's authoritative study of this battle, 1914, vol. 24, no. 48, pp. 340–354.

2. Nooms was intrigued by representing ships on fire. His most unusual contribution to this theme is a nocturne containing a burning hull – repr. L. J. Bol, 1973, p. 294, pl. 295 – which was inspired partly by Aert van der Neer, whose paintings of cities burning at night popularized such subjects.

3. He also represented *The Battles of the Sound* (1658), canvas, 82.5 × 133 cm, London, auction (Sotheby) April 8, 1981, lot 193, repr.; and a *Battle Between Galleys and Dutch Warships*, canvas, 49.5 × 64 cm, London, auction (Sotheby) February 7, 1979, lot 95, repr., present location unknown.

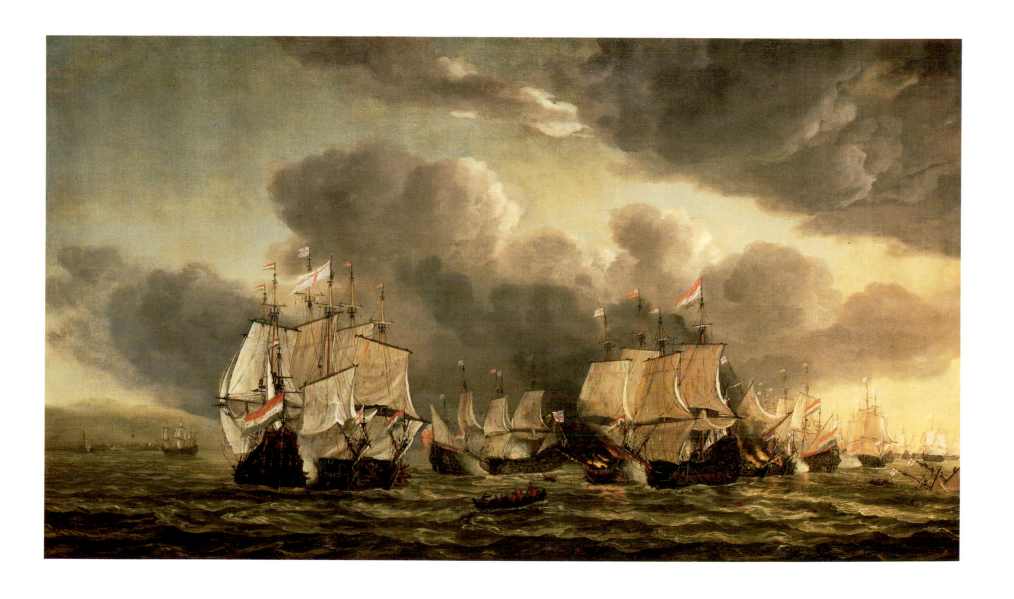

21

REINIER NOOMS ("ZEEMAN")
Battle of Leghorn (March 14, 1653)

Oil on canvas, 142 × 225 cm
Signed on a flag: *R. zeeman*
Amsterdam, Rijksmuseum, inv. A 294

PROVENANCE: Amsterdam, Gallery C. S. Roos (1800)
LITERATURE: Haverkorn van Rijsewijk, 1899, vol. 17, p. 38
 Willis, 1911, p. 103
 de Balbian Verster, 1914, vol. 24, no. 48, pp. 340–354
 Martin, 1936, vol. 2, p. 381
 Stechow, 1966, pp. 122–123, pl. 249
 L. J. Bol, 1973, p. 293
 Amsterdam, *All the Paintings,* 1976, p. 418, inv. A 294

This version of the *Battle of Leghorn* is Nooms's largest representation of a naval battle. Unlike the version at Greenwich (Cat. 20), Nooms sets the battle before the distant hilly coastline of Tuscany, clearly visible in the left distance, with the lighthouse and mole of Livorno appearing above the text.

Nooms stresses the fury of battle by the billowy smoke that all but eclipses the clouds. He includes a lengthy text at the left in which he identifies the ships and their commanders. This use of a vignette with identifying captions occurs regularly in Dutch history prints of the period (e.g., Cat. 105 and 125) and suggests that this large picture may have been a public commission.[1]

Although Nooms preferred painting on a smaller scale, his large naval battles attest to his ability to capture the fury of combat. Of these, his two versions of the Battle of Leghorn are the most important and are of a scale more readily associated with Backhuysen or Willem van de Velde the Younger. These early efforts where reutilized later when Nooms produced his suite of eight etchings entitled *Nieuwe Scheeps Batalien,* representing naval battles, datable to the period of the First Anglo-Dutch War. In all likelihood these prints were inspired by his rare paintings of the same theme.

NOTE

1. Yet, as Haverkorn van Rijsewijk, 1899, p. 38, pointed out, Nooms, along with Willem van de Velde the Elder and Johannes Lingelbach, tended to pay homage to the victors without producing particularly accurate representations of the Battle of Leghorn.

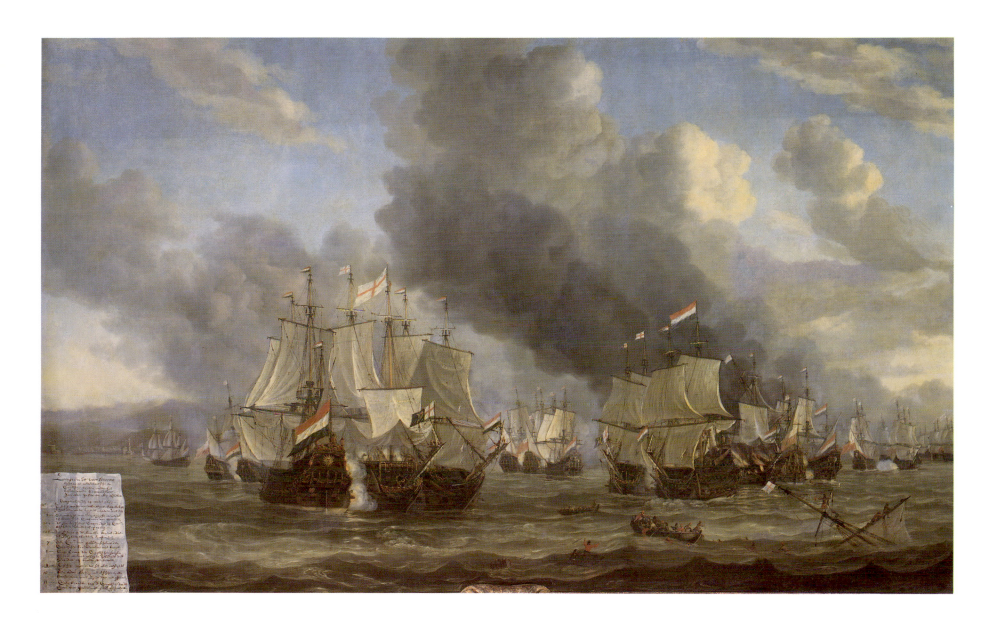

22

JAN PORCELLIS
Sailboats in a Tossing Sea

Oil on panel, 39.5 cm ⌀
Signed on a spar in the left foreground: *IP*
Antwerp, Museum Ridder Smidt van Gelder, inv. Sm. 866

PROVENANCE: Amsterdam, Gallery M. Wolff (before 1940)
Antwerp, Collection Pieter Smidt van Gelder by whom given to the museum in 1949
LITERATURE: Walsh, 1974b, vol. 116, p. 737, pl. 24
Antwerp, Museum Ridder Smidt van Gelder, *Catalogus I Schilderijen tot 1800,* Antwerp,
1980, p. 88, repr.

Sailboats on a Tossing Sea is one of Porcellis's most notable inventions. Its tondo format is innovative, but Porcellis was not the first marine painter to experiment with unusually shaped panel supports. Several years earlier the Utrecht marine painter Adam Willaerts produced marines in an oval format. Two of the three surviving oval panels by Willaerts that survive represent ships in storms. The panel in the Rijksmuseum in Amsterdam represents ships wrecked or floundering along a foreign rocky coast.[1] The marine in the National Maritime Museum in Greenwich (reproduced on p. 78) depicts ships on the high seas in a violent storm. Huge sea monsters in both pictures add a further note of terror and are a timely reminder of the awesome power of the sea.[2]

Porcellis may well have been cognizant of these unusual ovals by Willaerts. In *Sailboats on a Tossing Sea* Porcellis employs the tondo format to great advantage. The circular shape reinforces the restless movement of the sea, enabling the artist to stress the powerful relationship between the tossing waves, the distant horizon, and the magnificent tracery of clouds that vault above the open water. The entire subject is held in momentary equilibrium, yet is perfectly balanced. This is a fine example of the selective naturalism that Samuel van Hoogstraeten extolled in Porcellis's work.[3]

This picture is closely related to a second tondo by Porcellis in the Museum Boymans–van Beuningen in Rotterdam,[4] which contains an even more pronounced contrast between light and shadow. The Antwerp picture exhibits a more refined modulation of light and shadow, and probably dates slightly later. Walsh dates it between 1625 and 1629, to Porcellis's mature, more monochrome phase.

NOTES

1. Reproduced in L. J. Bol, 1973, pl. 61. This picture is signed and dated 1614.

2. The third documented oval represents *Dutch Ships to the Left of a Rocky Coast*, panel, 64.5 × 84 cm, signed and dated 1614, formerly London, Slatter Gallery (1949).

3. For Hoogstraten's assessment of Porcellis, see Walsh, 1974b, pp. 737–738.

4. Bol, 1973, p. 97, pl. 93.

23

JAN PORCELLIS
Shipwreck on a Beach

Oil on panel, 36.5 × 66.5 cm
Monogrammed and dated at bottom left: IP 1631
The Hague, Mauritshuis, Koninklijke Kabinet van Schilderijen, inv. 969

PROVENANCE: London, Collection Bruce Ingram
London, auction B. Ingram (Sotheby) March 11, 1964, lot 27
The Hague, Galerie Cramer from whom acquired by the Johan Maurits van Nassau
 Foundation

LITERATURE: H. Gerson, *Van Geertgen tot Frans Hals*, 1950, p. 51, pl. 137
Stechow, 1966, p. 104
De Vries, 1968a, pp. 5a, 5b
De Vries, 1968b, pp. 14–15, repr.
Walsh, 1974b, p. 741, pl. 31
L. J. Bol, 1973, p. 102, pl. 99
Mauritshuis, 1980, pp. 71–72, repr. (with complete bibliography and exhibition history).
Haak, 1984, p. 268, pl. 570
Goedde, 1989, fig. 1

EXHIBITIONS: Greenwich, National Maritime Museum – Southampton, Art Gallery, *Paintings from
 Holland*, 1947, cat. 33
Rotterdam, 1950, cat. 34
London, Royal Academy, *Dutch Pictures 1450–1750*, 1952/1953, cat. 295
Breda-Ghent, *Het Landschap in de Nederlanden van Bruegel tot Rubens*, 1960/1961, cat.
 52
Dordrecht, 1964, cat. 61, repr.
The Hague, Mauritshuis, *A Collectors' Choice*, 1982, pp. 170–171, cat. 65, repr.

Dated 1631, this work, one of Porcellis's last paintings, reveals that his powers had not abated, although he was to die only one year later. In it the artist demonstrates his inventiveness by adding a new theme to the repertory of Dutch marine painting. While other artists before him had represented beach scenes,[1] Porcellis transformed the beach subject from a busy forum of commercial fishing activity to a vast amphitheater from which one witnesses disaster. As in his *Ships off a Rocky Coast* in the Hallwylska Museet in Stockholm (fig. a), Porcellis does not exaggerate the latent force of nature in theatrical terms. He does focus attention onto the wind as gauged by the rollers, the grandiose sweep of clouds, and the cape

Cat. 23, fig. a Jan Porcellis, Ships off a Rocky Coast, *oil on panel. Stockholm, Hall-wylska Museet.*

of the man standing in the right foreground. He also exploits light effects to great advantage through the use of shafts of sunlight that pierce the atmosphere and illuminate strips of sand and sea. The almost palpably audible sound of wind and wave action intensifies the viewer's response. Porcellis contrasts the flat-keeled fishing boats safely beached in the left foreground with the much larger three-masters in distress. One is foundering, masts and all, whereas a second with main and mizzen masts

snapped off is veering toward the same fate. The birds gliding effortlessly above this scene of human disaster heighten the irony of the juxtaposition.

Shipwrecks were a suitable metaphor for human failings, excessive pride,[2] for unrequited or unhappy love, and for the affairs of state.[3] Those small vessels safely drawn up on shore may symbolize men of moderate ambitions who know their limits, versus the large ships embodying far greater ambition, fated to meet with disaster. Porcellis may well have intended such a meaning to this picture, but as in his *Ships off a Rocky Coast,* he also stresses the gripping realism that contributed substantially to the appeal such paintings held for his contemporaries. His emphasis on the magnitude of nature and the degree to which it governs human affairs is an integral component of Porcellis's concept of realism.

NOTES

1. For example, Hendrick Vroom represented the beach in paintings and drawings—see L. J. Bol, 1973, pl. 7, and Keyes, 1975, pl. XXVI. He was emulated by Van Wieringen—Bol, pl. 31—and Adam Willaerts—Bol, pl. 60.

2. A. B. de Vries points out that shipwrecks were not an everyday occurrence in seventeenth-century Holland. This motif held a symbolic meaning in which life itself is each person's most costly possession. Life is unpredictable and subject to vicissitudes as embodied metaphorically by the violence of the sea. According to this interpretation, only through faith in God can one perceive that life has a value far above normal material concerns.

3. For discussion of the possible multiple meanings associated with shipwrecks and ships in storms, see Goedde, 1986, pp. 139–149; Goedde, 1989, and Chapter 3 by J. Welu in this catalogue.

24

JAN PORCELLIS
Sailboats in a Breeze

Oil on panel, 28 × 35.7 cm
Signed at bottom left: *IPORCEL 1629*
Leiden, Stedelijk Museum De Lakenhal, inv. 877

PROVENANCE: Amsterdam, Gallery Paul Cassirer from whom acquired in 1951
LITERATURE: Stechow, 1966, pl. 221
L. J. Bol, 1973, p. 98, pl. 97
Walsh, 1974b, p. 738, fig. 29
Preston, 1974, p. 37
Leiden, 1976/1977, p. 93, repr.
Leiden, Stedelijk Museum De Lakenhal, *Catalogus van de schilderijen en tekeningen*,
 1983, p. 264, cat. 359, repr.
Haak, 1984, p. 149, pl. 312
EXHIBITIONS: Warsaw, National Museum, *Krajobraz holenderski XVII wieku*, 1958, illus. 71
Krefeld, Kaiser Wilhelm Museum, *Niederländische Barockmalerei*, 1975, cat. 24, repr.

This is one of Porcellis's rare dated pictures and a yardstick of his late style. By this point in his career Porcellis had become the leading master of monochrome atmospheric effects. His achievement in this direction had not only far-reaching effects on marine painting but also notable implications for landscape painting. Not only did he spawn a number of gifted followers (see Cat. 1 and 18), but he attracted the interest of landscape artists such as Jan van Goyen, who also contributed notably to monochrome marine painting (Cat. 16).

Two features of *Sailboats in a Breeze* are particularly noteworthy. The artist assumes a low vantage point, which enables him to silhouette the sailboats against the sky.[1] Second, he devotes three-quarters of the subject to the sky, anticipating developments that had great implications for the representation of the flat Dutch panorama so celebrated by Jan van Goyen, Jacob van Ruisdael, and others later in the century.[2] Porcellis also develops a system of alternating patches of light and shadow playing across the water. He modulates this with great finesse to evoke general atmospheric effects that unify the subject.

Porcellis was an enthusiastic sailor and during his last years lived close

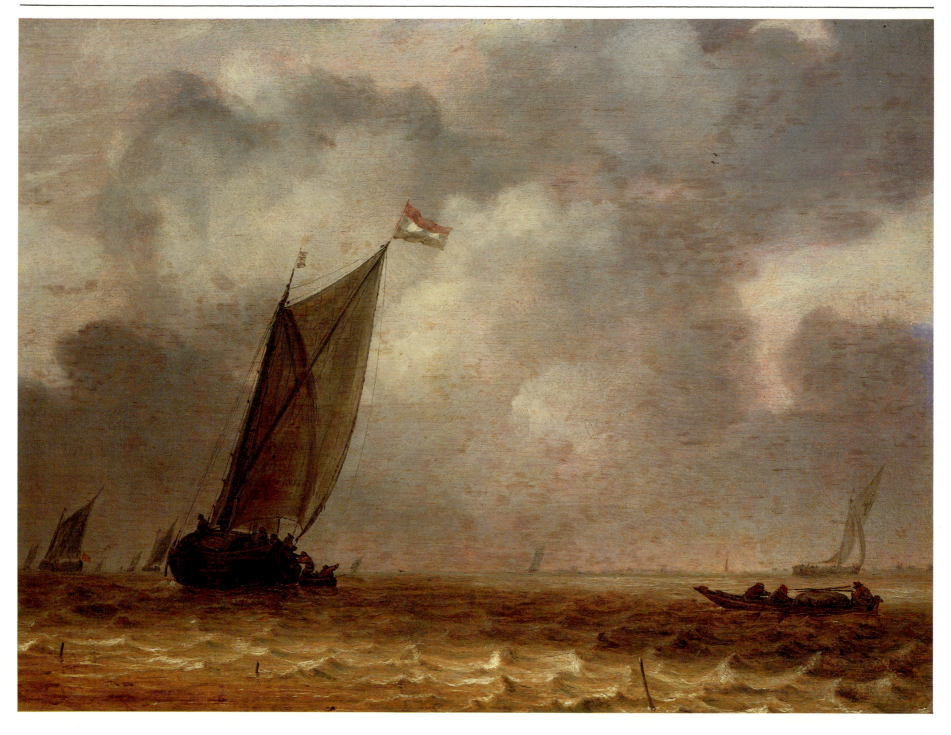

Cat. 24, fig. a Jan Porcellis, Sailboats in a Breeze, *oil on panel. Berlin-Dahlem, Staatliche Museen Preussischer Kulturbesitz, Gemäldegalerie.*

to the Leidsemeer, the large inland lake extending east of the coastal dunes from Leiden north to Haarlem. This picture immortalizes the small sailboats that plied the lakes, rivers, and estuaries of the Dutch Republic. One can imagine that Porcellis identified readily with the protagonists of this painting. For this reason it is a particularly spirited representation of everyday life on the inland waterways of Holland.

NOTES

1. Other paintings in which this effect is pronounced are in Oxford (Bol, 1973, pl. 100) and Los Angeles, Collection Mr. and Mrs. Edward Carter (Bol, 1973, pl. 98); J. Walsh, Jr., and C. Schneider, in Los Angeles–Boston–New York, 1981/1982, cat. 18, repr.

2. Another painting by Porcellis in which this effect is equally pronounced is his *Sailboats in a Breeze* (fig. a) in West Berlin – repr. Stechow, 1966, pl. 220. In this late picture Porcellis utilizes the vertical format that would prove to be a precocious realization of the vast potential the upright format could offer to marine and landscape painting.

25

JACOB VAN RUISDAEL
A Rough Sea

Oil on canvas, 107 × 124.5 cm
Signed at lower left: *JvRuisdael* (JvR in ligature)
Boston, Museum of Fine Arts, William Francis Warden Fund, inv. 57.4

PROVENANCE: Holstein, discovered by Harzen (according to Waagen)
Collection Edmund Forster
Clewer Park, Collection Richard Forster
London, auction R. Forster (Christie) July 13, 1895, lot 70, bought by Colnaghi
London, Collection Sir Alfred Beit
New York, Rudolf Heinemann Gallery

LITERATURE: Hofstede de Groot, 1907–1928, vol. 4. no. 957 (with previous literature)
Rosenberg, 1928a, no. 591
Rosenberg, 1958, pp. 144–146
Haak, 1984, p. 463, pl. 1019

EXHIBITION: The Hague–Cambridge, 1981/1982, pp. 138–139, cat. 48, repr.

The *Rough Sea* in Boston is one of Ruisdael's stateliest paintings. Its almost square format is reinforced by the refined balance between the restless sea and the magnificent cloud formations above. The artist's subtle modulation of light and shadow enhances the degree to which the clearing skies, with substantial patches of blue, filter the light. As in his celebrated panoramic views of Haarlem, known as his *Haarlempjes*, Ruisdael pierces the flat horizon with shapes that catch the eye. In this case ships serve this function. Their masts and sails are either caught in strong light or form dark silhouettes against the distant clouds.

Although described as a rough sea, the weather conditions are considerably less extreme than in other contemporaneous marines by Ruisdael, including his picture in Manchester (Cat. 26). The wind is constant and blows from the left, forming whitecaps across the shallow foreground waters. Despite the dramatic visual effects of the breaking waves, the many sailboats indicate that the hardy seafaring Dutch found these weather conditions optimal. The saluting three-master in the right distance sails before the wind with only its foresheet unfurled.

Slive dates this picture about 1670. Its refined palette and the artist's subtle modulation of the colors defining the clouds find close parallels in Ruisdael's upright panoramic views of Haarlem[1] and Alkmaar,[2] his beach scenes,[3] and certain of his waterfall compositions.

The transparent atmosphere and the artist's refined representation of light playing across agitated or flowing water are hallmarks of his greatest pictures from this period. In them he evokes an august mood that manifests the progressive refinement of Ruisdael's concept of nature. This led to a shift in style that superseded the robustness characterizing Ruisdael's land-

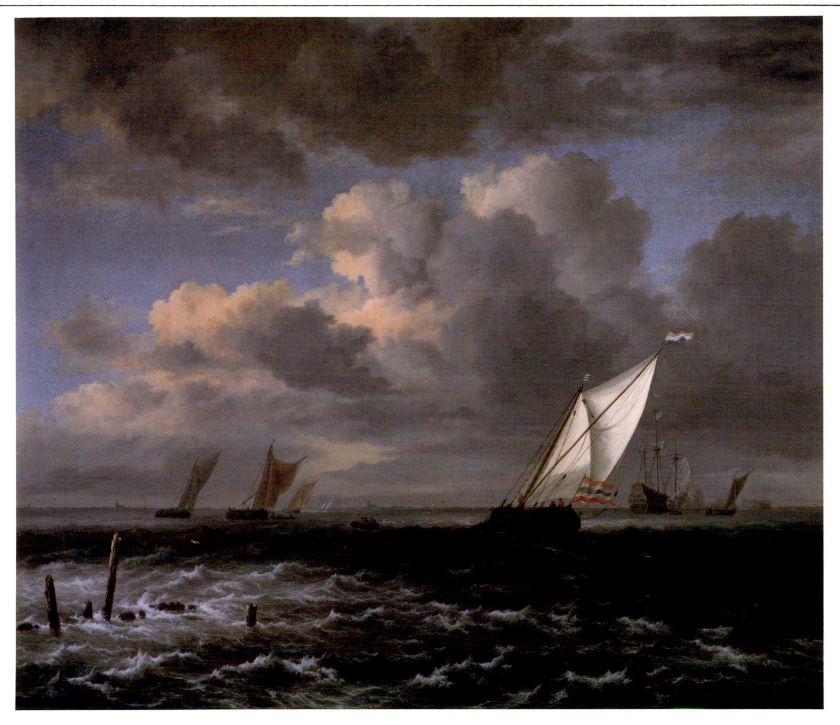

scapes of the 1650s, painted during his first years in Amsterdam. His mature marines and beach scenes are among the most felicitous works dating to the period around 1670. Fittingly, his finest paintings in this refined mode are quintessential Dutch subjects that eulogize the distinctive character of that unique terrain crisscrossed with lakes and inland waterways and flanked on its western rim by high coastal dunes.

NOTES

1. For example, the paintings in Amsterdam, Berlin, The Hague, and Zurich. For discussion of the *Haarlempjes*, see The Hague–Cambridge, 1981/1982, cat. nos. 44, 45, repr., and Amsterdam–Boston–Philadelphia, 1987/1988, pp. 463–465.

2. Ruisdael's *View of Alkmaar*, also in Boston and recently featured in Amsterdam–Boston–Philadelphia, 1987/1988, cat. 89, repr.

3. Ruisdael's two finest beach scenes are in the National Gallery, London, and at Polesdon Lacey – see The Hague–Cambridge, 1981/1982, pp. 140–141, cat. 49, repr. Slive dates these pictures to the late 1660s and 1670s.

26

JACOB VAN RUISDAEL
A Storm off the Dutch Coast

Oil on canvas, 86.4 × 101.6 cm
Signed at the bottom right: *JvRuisdael* (JvR in ligature)
Manchester, City Art Gallery, inv. 1955/124, presented by the National Art-Collections Fund[1]

PROVENANCE: London, auction Count de Morny of Paris (Phillips) June 20–21, 1848, lot 74 (bought in?)
Paris, auction Comte de Morny (Drouot) May 24, 1852, lot 23
Possibly New York, auction William Schaus (American Art Association) February 28, 1896, lot 22
London, Colnaghi (1936)
London, auction Leonard Gow (Christie) May 28, 1937, lot 113, bought by Gooden & Fox
New York, Knoedler & Co. (before 1946)
Collection E. E. Cook by whom presented to the National Art-Collections Fund[1]

LITERATURE: *52nd Annual Report of the National Art-Collections Fund*, 1956, p. 28
Guide to the Manchester Art Galleries, 1956, pl. XIX
Manchester, City Art Gallery, *Concise Catalogue of Foreign Paintings*, 1980, p. 88, repr.

EXHIBITIONS: Amsterdam, Rijksmuseum, *Oude Kunst uit het bezit van den internationalen kunsthandel*, 1936, no. 189
London, Tate Gallery, *The Romantic Movement*, 1959, cat. 6

This relatively unknown picture is one of Ruisdael's most important marines. Its unique qualities are best gauged when considered next to Ruisdael's *Rough Sea*, recently acquired by the Kimbell Art Museum (Fig. 19, p. 24)[2] and the artist's most celebrated marine, *A Rough Sea* (Cat. 25), in Boston. Although smaller than the other two, the Manchester painting combines features of both in a synthesis that differs sufficiently from either. Ruisdael retains the pier and fire tower from the Kimbell picture and even approximates the pounding surf driven by the lashing wind. Although threatening, the sky in *A Storm off the Dutch Coast* is less inky than that which engulfs the tossing sea in the Kimbell painting. By shifting the pier

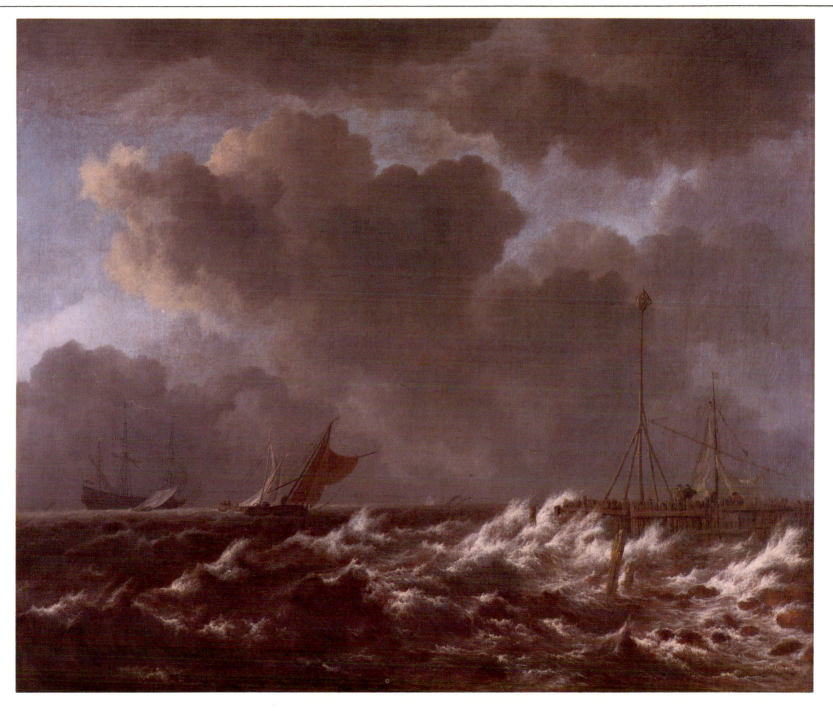

to the right, Ruisdael fills the foreground with water, a compositional element also found in the *Rough Sea* in Boston. Moreover, Ruisdael's employment of light, particularly that playing on the foreground waves, is analogous. Ruisdael includes a three-master in the distance in both paintings. Its scale, matched with the refined tracery of clouds, lends a stateliness to both compositions that contrasts with the more turbulent mood of the *Rough Sea* in Fort Worth. The open foreground with the waves pounding to the right and caught in light creates an expansiveness largely denied in the more brooding mood expressed in the Kimbell marine. However, unlike the picture in Boston, that in Manchester represents a much greater wind velocity, with whitecaps breaking over the jetty as they do in the Fort Worth marine. By contrast, the weather conditions in the painting in Boston seem calm.[3]

NOTES

1. I am much obliged to Seymour Slive, who kindly provided me with his up-to-date documentation on this painting.

2. The Hague–Cambridge, 1981/1982, cat. 27. repr.

3. Ruisdael develops one other type of marine in which he represents rugged, rocky coastlines and heavy surf pounding on rocks across the foreground. Examples of this type include Rosenberg nos. 593 and 598 and the picture formerly in the Hans Wetzlar Collection – Amsterdam, auction Wetzlar (Sotheby–Mak) June 9, 1977, lot 76, repr.

27

SALOMON VAN RUYSDAEL
Sailboats on an Inland Sea

Oil on panel, 36 × 31.7 cm
Signed on leeboard of nearest sailboat: *SvR*
Rotterdam, Museum Boymans–van Beuningen, inv. 1750

PROVENANCE: Rotterdam, Collection H. L. Bekker and bequeathed by Mrs. J. A. Bekker–la Bastide to the museum in 1961

LITERATURE: Rotterdam, Museum Boymans–van Beuningen, *Catalogus schilderijen tot 1800*, 1962, pp. 123–124
Ibid., *Old Paintings*, 1972, p. 221, repr.
W. Stechow, *Salomon van Ruysdael*, Berlin, 1975 (2nd ed.), p. 76, no. 47

Stechow dates this picture about 1650.[1] It is a particularly felicitous example of Ruysdael's upright marine composition. Relatively late in his career, Salomon van Ruysdael developed a category of pure marine subjects in contradistinction to his far more numerous river landscapes. These marines form an interesting parallel to his even rarer still lifes because the artist handles both with great verve and originality, whereas his late river landscapes tend to become repetitious and uninspired.

Ruysdael was influenced by Jan van Goyen, whose diminutive and lively marines from the 1640s (e.g., Cat. 17) convey a similar sense of spirited optimism. Ruysdael's marines tend to be calmer and more stately than those of van Goyen. The upright format reinforces these qualities. A slight breeze ruffles the water. By casting the foreground largely in shadow, the painter enhances the presence of the nearest sailboat, whose bulk is stressed by its strong silhouette against the sky and luminous horizon. Ruysdael offers vistas to the far distance and creates a vast, flat panorama analogous to that in van Goyen's *A Calm* (Cat. 17) in Budapest. The silvery water in the distance seems to blend imperceptibly with the sky. The artist creates a contrapuntal effect between the slow and stately movement of the sailboats in contrast to the drifting motion of the clouds.

Sailboats on an Inland Sea is related closely to an analogous upright

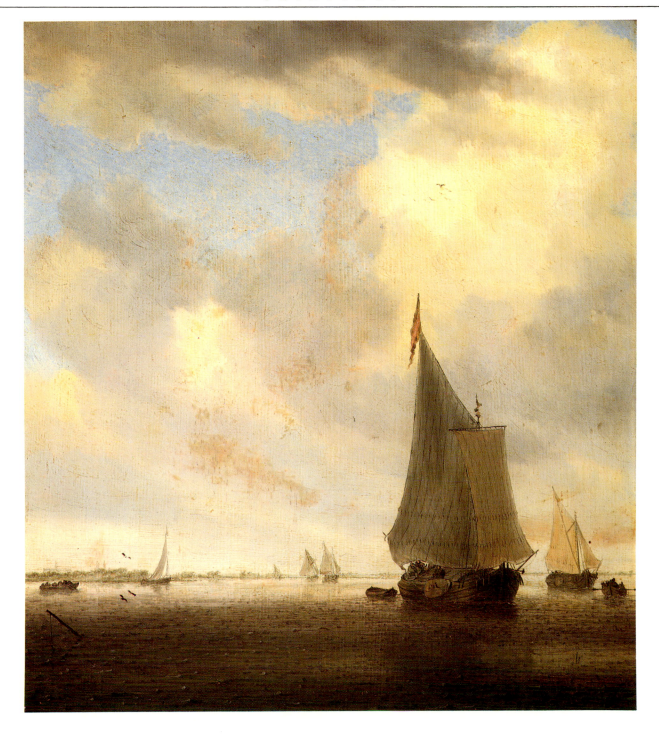

marine recently bequeathed to the Mauritshuis by Mrs. C. Th. F. Thurkow,[2] and to a pair of marines in Salzburg.[3] The marines in Salzburg, particularly inv. 552, contain cloudy skies with greater contrasting values than that in *Sailboats on an Inland Sea*. By inferring the potential for more turbulent weather, the painter creates a somewhat different mood from the stately atmosphere that pervades the Rotterdam painting. In two other marines by the artist,[4] a similar boat sails forward in roughly the same position and with sails trimmed in an analogous manner.

Ruysdael occasionally produced marines in pairs, such as the examples now in Salzburg cited in footnote 3. Another well-known pair is in the collection of Sir Edmond Bacon.[5] *Sailboats on an Inland Sea* may once have had a companion painting. At least three surviving pictures with virtually identical measurements to the marine in Rotterdam might be considered possible pendants to it.[6]

NOTES

1. Stechow, 1975, p. 47.
2. Mauritshuis, 1980, p. 98, repr.
3. Residenzgalerie, *Katalog*, 1980, p. 98, inv. nos. 552, 553, pl. 23 (Stechow nos. 51, 52).
4. *Marine*, panel. 21 × 31 cm, Stechow 302, and *Sailboats Before distant Land*, Stechow 301, plus a larger variant of this composition formerly with Gallery Müllenmeister in Solingen – repr. K. J. Müllenmeister, 1973, vol. 1, no. 1. The sailboat in the ex-Müllenmeister painting is particularly close to that in the Boymans picture, but is in even closer proximity to the viewer.
5. Stechow nos. 297, 298.
6. (a) *Sailboats in a Breeze*, Stechow 49, panel, 36 × 32 cm, Denmark, private collection. This picture contains a sailboat in shadow at the right center that bears down towards the viewer. (b) *Sailboats in an Estuary*, panel, 36 × 32 cm, Paris, private collection – exhibited Paris, Musée Carnavalet, *Chefs d'oeuvre des collection Parisiennes*, November–December, 1950, cat. 68. (c) *Sailboats Before distant Land*, monogrammed, panel, 36.1 × 32.3 cm, provenance: Collection Gilbert Colville; Collection Edwin Cohen; London, A. Brod Gallery (1959); exhibited London, Royal Academy, 1952/1953, cat. 264. This picture offers the most striking comparison to the marine in Rotterdam. A sailboat at the center tows a dinghy and sails into the right distance. Like its counterpart in *Sailboats on an Inland Sea*, it is in half shadow. Water and sky in both pictures are represented in an analogous manner. If, indeed, it is the companion painting to that in Rotterdam, this picture would logically be the right-hand pendant.

28

ABRAHAM VAN SALM
Whaling in a Northern Ice Sea

Oil on canvas, 60 × 76 cm
Signed at bottom: *Abram Salm*
Sharon, Massachusetts, The Kendall Whaling Museum, inv. 0–112

LITERATURE: Brewington, 1965, p. 3, Cat. 1, repr. as frontispiece

The whaling industry, first developed by Basque fishermen in the Middle Ages, expanded into the region of Iceland and northern Norway by the fifteenth century. Subsequently the English, under the Muscovy Company, began to dominate the whaling industry in the later sixteenth century. They fostered a demand for seal, walrus, and whale oil, which became indispensable for the production of soap, candles, and oil for lamps.

The Dutch explored the northern polar seas and in 1596, Willem Barentsz. and Jan Cornelis Rijp discovered Spitsbergen, the future center of the Dutch whaling industry.[1] In 1613 and 1614 this industry was established in Amsterdam, Rotterdam, Delft, Hoorn, and Enkhuizen, which, by fiat of the States General, led to the creation of the Northern or Greenland Company. This chartered company prospered. Whales were hunted close to the shores of Spitsbergen and Jan Mayen Island, and were hauled to shore to be cut up and refined. These operations took place in summer settlements constructed expressly for the purpose.

By the mid-seventeenth century the traditional harvesting method was superseded because of the relative scarcity of whales close to shore. Instead, they were harpooned and partially processed on board ship, packed and

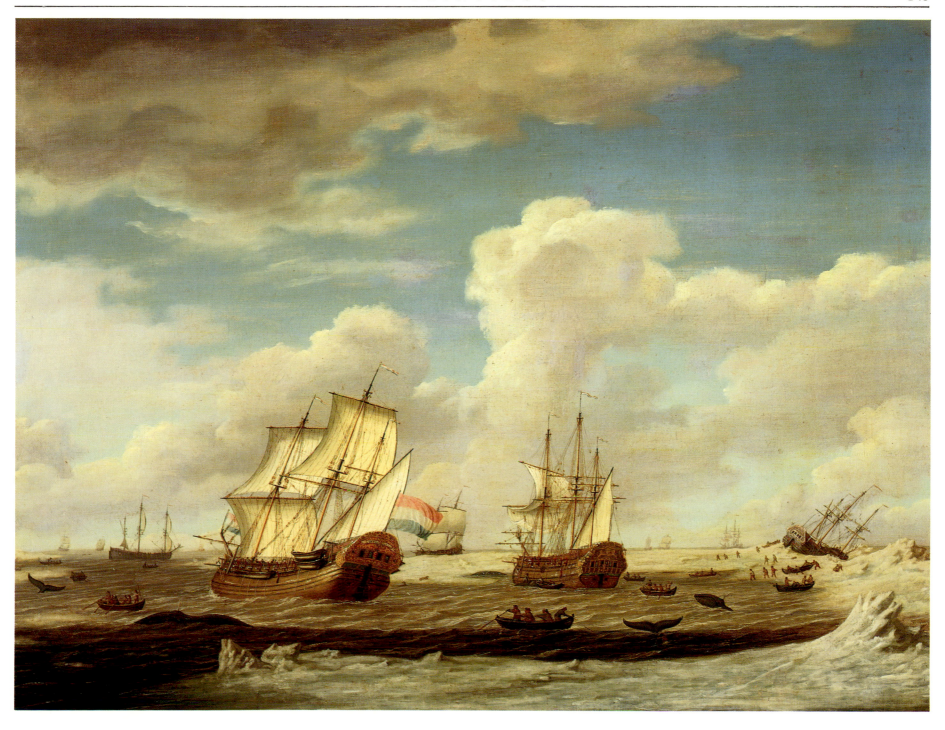

stored in barrels, and subsequently refined back in the Netherlands (see Cat. 44 for the unloading of a Dutch whaler at a refinery near Rotterdam). This was known as the *zeevisserij* (sea fishery). As the whales became more scarce the fishery evolved one stage further. Ships had to sail farther north in search of walrus and whales and found themselves amid the ice floes. This is the situation represented in Salm's picture. In this form the industry was known as the *ijsvisserij*.[2] Salm represents a fleet of whalers including one in the right stranded in the ice. The whaler at the left bears the carved crest of Amsterdam flanked by lions on its rail with the ship's name below: (?) *DE TRINADAD*.

Salm is principally noted for his pen paintings. This fully signed and fully colored picture is exceptional in his oeuvre, and is a valuable document in terms of its subject and its status as one of this artist's finest achievements. A certain confusion exists concerning Salm, whose first name is often miscited or simply referred to as "A. van Salm."[3]

Despite the importance of the whaling industry, seventeenth-century representations of it are not all that common, and many tend toward the anecdotal, often containing the obviously popular detail of sailors fighting off polar bears.[4] A notable exception is the series of sixteen etchings by Adolf van der Laan after Sieuwart van der Meulen, published by Pieter

Schenck, which make up the first section of a suite entitled *De Groote Vissery*. The series concludes with representations documenting the herring fishery.[5] These prints were intended for an international audience, as indicated by the captions in Dutch, German, and English in the bottom margin of each.[6]

NOTES

1. The industry expanded following the discovery of Jan Mayen Island, which, like Spitsbergen, was strategically located within the whale migration – C. de Jong, *Maritieme Geschiedenis der Nederlanden*, 1977, vol. 2, p. 312. For further discussion of the Dutch whaling industry, see the recent publication, Amsterdam, Rijksmuseum, *Walvisvaart* (ed. L. Hacquebord and W. Vroom), 1988.

2. *Maritieme Geschiedenis*, pp. 313–314.

3. However, Preston, 1937, fig. 105, reproduces a *Dutch Herring Fleet* in the collection of the National Maritime Museum in Greenwich, and correctly cites the painter as Abraham Salm.

4. Abraham Storck popularized the subject in paintings that contain polar bears and walruses in the foreground. A prime example is *Whaling in a Northern Ice Sea* in the Rijksmuseum in Amsterdam, inv. A 4102 – *All the Paintings*, 1976, p. 527, repr. This artist produced at least six other versions of this subject, each with minor variations.

5. For selected prints illustrating the herring fishery, see de Groot and Vorstman, 1980, cat. 161–163, repr.

6. The subject was popular in the eighteenth century. Painters such as Adam Silo (1674–1766) represented whaling scenes in northern ice seas frequently. They constitute the principal portion of his repertory.

29

ABRAHAM STORCK
The Four Days' Battle

Oil on canvas, 76.2 × 107.8 cm
Signed on a spar at the right: *A STORCK FECIT*
Greenwich, National Maritime Museum, inv. 48–719

LITERATURE: Haak, 1984, p. 481, pl. 1063

In this version of the *Four Days' Battle*, Storck represents the Dutch flagship *The Seven Provinces* at left center. It is under the command of a lieutenant admiral, Michiel de Ruyter, whose squadron flies its pendants from the mainmast under the Dutch standard. Seen from the stern, *The Seven Provinces* has carved crests of each province clustered around a larger central crowned crest containing the lion emblem of the Dutch Republic. Two

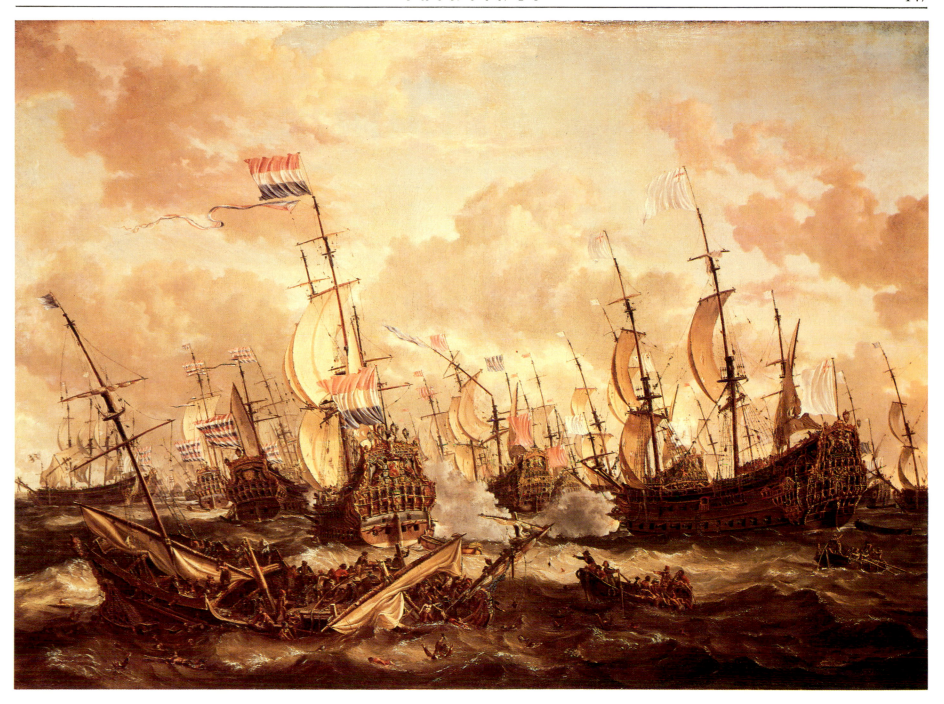

large supporting lions flank these crests. On the rail above is the inscription: *ANNO 1665*.[1] At the right is the English flagship, the *Royal Prince,* which ran aground on the Galloper Shoals – see Cat. 40. In their representations of the *Royal Prince,* Willem van de Velde the Elder and Younger portray

Cat. 29, fig. a Abraham Storck, The Four Days Battle, *oil on canvas. Cambridge, Fitzwilliam Museum.*

its stern far more accurately than Storck does. Between these two ships is the *Royal James,* the flagship of Prince Rupert, whose squadron was only able to rejoin the main English fleet on June 13, the third day of the battle. It has just lost its top mainmast, which topples.

Storck seems to represent a conflation of events to evoke the intensity of battle. Compositionally the Greenwich painting differs considerably from that in Minneapolis (Cat. 31), but both include an English ship sinking in the foreground. The sea is quite calm in the Minneapolis picture, whereas it runs higher in the Greenwich version. The artist also suggests a stronger breeze by the clouds that swirl to the left.

A closely related painting is in the Fitzwilliam Museum in Cambridge (fig. a). Compositionally it is virtually the same as *The Four Days' Battle* in Greenwich, but it extends farther to the left and includes a burning ship.[2]

NOTES

1. Willem van de Velde the Elder provides a vivid representation of *The Seven Provinces* in his large pen painting *The Council of War on Board the Seven Provinces Prior to the Four Days' Battle* in the Rijksmuseum in Amsterdam – H. P. Baard, 1942, pp. 23, 25, 30–31, repr.

2. Fitzwilliam Museum, *Catalogue of Paintings I: Dutch, Flemish, French, German, Spanish,* 1960, p. 124, inv. 106, repr.

30

ABRAHAM STORCK
A Dutch Ship Passing a Mediterranean Port

Oil on canvas, 83.8 × 66.1 cm
Signed on stone at right center: *A Storck/fecit*
Greenwich, National Maritime Museum, inv. 34–85

PROVENANCE: Collection Loeb Caldendorf
Düsseldorf, Galerie Stern (1934)

Abraham Storck restricted his repertory to a modest range of themes. His representations of naval battles and beach scenes are rare, compared with his many views of Amsterdam and Mediterranean seaports. His depictions of Amsterdam often focus on recreational sailing activities or mock battles on the River Ij, such as the one staged in honor of Czar Peter the Great in 1697.[1] Storck's views of Lisbon, Rhodes, Smyrna, and Venice tend to be imaginary in character and conform in spirit to antecedents by Nooms (Fig. 23, p. 28), and Jan Beerstraten who produced such Mediterranean subjects frequently.[2] Like these two artists, Storck focused his greatest attention onto the Dutch ships dominating the foreground. At the right, seen stern-on, is the *Spiegel* (the *Mirror*), a Dutch warship that also appears in Storck's version of the *Four Days' Battle* in Minneapolis (Cat. 31). Possibly it was assigned to the Mediterranean to escort a Dutch convoy.

The Dutch maintained a brisk trade with Iberia and the Mediterranean, which formed an important component of the "mother trade." Specifically, the Dutch bought in France and Iberia the salt used to preserve the cod and herring that were key staples for this same great trade network. The great importance of the Mediterranean trade routes to the Dutch is borne out by the *Battle of Leghorn* (Cat. 20 and 21) fought during the First Anglo-Dutch War.

Cat. 30, fig. a Abraham Storck, A Mediterranean Port, oil on canvas. Greenwich, National Maritime Museum.

Most of Storck's dated imaginary harbor views were painted in the 1670s and 1680s. The Greenwich picture probably dates from this period. The artist pays great attention to detail in representing the *Spiegel*. This precision is analogous to that found in his naval battles (Cat. 29 and 31), which date from early in Storck's career. The upright format enabled Storck to include ships that loom large in the foreground. A second upright in Greenwich (fig. a) represents a large armed Dutch ship before a seaport, with mountains partially veiled in clouds rising up in the left distance. Storck's imaginary subjects tend to show a progressive loosening up in terms of less precise detail and a general tendency toward anecdotal subjects so apparent in his late whaling scenes and his depictions of mock battles and other recreational subjects.

NOTES

1. Amsterdam, Rijkmuseum "Nederlands Scheepvaart Museum," canvas, 66 × 92 cm, signed at bottom center: *Abr Storck fecit,* reproduced in Preston, 1937, pl. 107.

2. Storck may also have been influenced by the Mediterranean harbor scenes of Johannes Lingelbach, who placed great stress on the genre activities that take place in the foregrounds of his views of seaports.

31

ABRAHAM STORCK
The Four Days' Battle

Canvas, 92 × 127 cm
Signed on spar at bottom left: *A STVRCK*
Minneapolis, Minneapolis Institute of Arts, inv. 84.31, Gift of John B. Hawley, by
 exchange, the Walter H. and Valborg P. Ude Memorial Fund, the Christina N. and
 Swan J. Turnblad Memorial Fund, and the Ethel Morrison van Derlip Fund

PROVENANCE: England, Collection G. Glee
London, auction G. Glee (Christie) May 3, 1872, lot 355
Collection Joseph Gillot (1877)
London, Collection H. L. Bischoffsheim (to 1926)
London, auction Bischoffsheim (Christie), May 7, 1926, lot 93, bought by F. Partridge
 for gns. 700
Hoevelaken, Collection C.J.K. van Aalst, by descent to N. J. van Aalst
Hilversum, Collection A.B.C. Dudok de Wit
The Hague, Galerie J. Hoogsteder

LITERATURE: W. Valentiner and J. W. von Moltke, *Catalogue of the Collection of Mr. C. J. K. van
 Aalst*, Hoevelaken, 1939, p. 292
Minneapolis, Minneapolis Institute of Arts, *The Art of Collecting*, 1986, p. 63, repr.

EXHIBITIONS: Utrecht, Centraal Museum, *Kunstbezit der Reunisten*, 1956, cat. 28
Delft, Museum "Het Prinsenhof," *Nederlandse Meesters uit particulier Bezit*, 1952–1953,
 p. 35, cat. 73
Breda, De Beyerd, *Vrede van Breda*, 1967, cat. 39

This picture represents a later phase of the *Four Days' Battle* than the version in Greenwich (Cat. 29). At the center two Dutch ships, the *Gouda* and the *Spiegel* (the *Mirror*), deliver broadsides against an English warship that has lost its mainmast. The *Spiegel*, its convex mirror flanked by angels carved on its tafferel, was under the command of Vice Admiral A. van der Hulst.[1] The *Gouda*,[2] bearing the carved crest of the city on its tafferel, had been under the command of Rear Admiral I. Sweers, but when Cornelis Tromp's *Hollandia* was knocked out of action, Tromp assumed command of the *Gouda*. Both of these Dutch ships fly pendants from their mizzenmasts, denoting that they were part of Tromp's lead squadron, the *van*.

An English ship sinks in the left foreground. In the left center distance a ship explodes, and at the right, a ship has burst into flames.

This painting relates to two others representing the *Four Days' Battle,* in Cambridge and Greenwich (Cat. 29). Storck produced only two other battle subjects on a comparable scale. Both represent the *Battle of the Texel* (or, in Dutch usage, the *Battle of Kijkduin*), which took place on August 21, 1673.[3]

NOTES

1. The *Spiegel* was built in 1663 for the Amsterdam admiralty, and carried 68 to 70 guns. Weber suggests that it was perhaps named in honor of Hendrick Dircssen Spiegel, a councilor in the Admiralty of Amsterdam – Weber and Robinson, 1979, vol. I, p. 104.

2. Built in 1665 for the Amsterdam admiralty, she carried 72 guns. This ship was last mentioned in 1677 – see Weber, 1979, vol. I, p. 96. Storck's representation of the stern of the *Gouda* is only fairly accurate. A highly finished chalk drawing in the National Maritime Museum in Greenwich by Willem van de Velde the Elder of the stern of the *Gouda* gives a far more accurate idea of the elaborate carving – Robinson, 1958–1974, vol. 1, 1973, p. 149, no. 349, pl. 74.

3. The first is in the National Maritime Museum in Greenwich, whereas the second was recently acquired by the Amsterdam dealer Rob Kattenburg – (1989, pp. 52–53, repr.).

32

WILLEM VAN DE VELDE THE ELDER
The Dutch Fleet Under Sail

Oil on canvas, 112 × 203 cm
Signed at bottom right: *W. v. velde 1672*
Added above the signature: *H. Payer Restauro 1898*
Old inventory numbers at bottom right: *139 74*
Florence, Palazzo Pitti, inv. 328

PROVENANCE: Florence, Collection Cardinal Leopold de Medici (acquired in 1674)
LITERATURE: Haverkorn van Rijsewijk, 1902, vol. 20, p. 175
 't Hooft, 1915, p. 106
 Geisenheimer, 1911, vol. 32, pp. 47–50

In 1667 and 1669, Cardinal Leopold de Medici accompanied his nephew, Cosimo III, the crown prince of Tuscany, to Holland where they were hosted by the Florentine merchant Francesco Ferroni, residing in Amsterdam at the time. The cardinal's guide was Pieter Blaeu, the son of the famous Amsterdam publisher Joan Blaeu. Pieter Blaeu arranged visits to a number of artists' studios, including that of Willem van de Velde the Elder. Cardinal Leopold and his nephew were captivated by Van de Velde's grisaille pen paintings. Subsequently both acquired several superb examples of Van de Velde's work, including the present canvas.

Pieter Blaeu maintained a correspondence with Cardinal Leopold. Blaeu informed him in a letter of June 1, 1674, that Willem van de Velde the Elder had moved to England a year and a half earlier because of the disastrous political and economic circumstances of the Dutch Republic following the French invasion of the United Provinces in May 1672.[1] In a subsequent letter of June 20, 1674, Blaeu indicated that the artist was back in Amsterdam on a visit to collect his wife and return to England, where he had received generous royal patronage. The painter met Pieter Blaeu on the street and the two caught up on each other's affairs, all of which Blaeu communicated to the cardinal.[2]

Blaeu cites *The Dutch Fleet Under Sail* in his letters of June 1 and July 27, 1674, to the cardinal. He was able to acquire this picture for Cardinal Leopold for 325 guilders. Blaeu specifically points out that this painting is

not a battle subject but represents eighteen ships, including many of the largest warships of the Dutch fleet.[3] Haverkorn van Rijsewijk believes that this painting represents the Dutch fleet prepared in readiness to set sail for the Medway and Sheerness in 1667.[4]

In June 1667 the Dutch fleet under Michiel de Ruyter launched an attack along the River Medway and reached Chatham. They were able to destroy much of the English fleet. Their skillful deployment of fireships wreaked havoc within the English fleet and the greatest casualties were the destruction by fire of the *Royal Oak,* the *Royal James,* and the *Loyal London.*

Many of the most impressive Dutch warships of the time are represented in *The Dutch Fleet Under Sail.* At the right is the *Witte Olifant* (the *White Elephant*), with the prominent elephant on its tafferel. To the right of it is the *Vrijheid* (*Freedom*), and the ship beyond it at the left is probably the *Zeelandia.*[5] The *Gouden Leeuw* (*Golden Lion*) appears at the center.[6] The ship in the left foreground seen stern-on is the *Huis Tijdverdrijf.*[7] Beyond at the left is the *Zeven Provincien* (the *Seven Provinces*), recognizable by its tafferel with the crests of the seven provinces of the Dutch Republic clustered around the Dutch lion at the center.

NOTES

1. Baard, 1942, p. 16.

2. D. Cordingly, in Greenwich, 1982, p. 14. For more detailed discussion of this correspondence, see Geisenheimer, 1911, vol. 32, pp. 34–61.

3. Geisenheimer, 1911, p. 47.

4. Haverkorn van Rijsewijk, 1902, vol. 20, p. 175.

5. Willem van de Velde the Elder produced detailed portrait drawings of these ships, which are now part of the large collection in the Museum Boymans–van Beuningen in Rotterdam: *Witte Olifant* (built 1666), inv. MB 1866/T300 (Weber, p. 109, III 182); *Vrijheid* (built 1651, blown up in action in 1676), inv. MB 1866/T290 (Weber, p. 108, III 177); *Zeelandia* inv. MB 1866/T261 (Weber, p. 110, III 186). Little is known about the *Zeelandia*, which was last mentioned in 1659 (?). Nonetheless, the details of the carved stern of the *Zeelandia* in the drawing correspond closely to those of the ship in the painting in Florence. Moreover, the drawing is an offset that reverses this detail. The original drawing from which it was taken would have appeared facing in the same direction as it does in the painting.

6. Willem van de Velde the Elder produced a detailed portrait drawing of this ship in which the stern is carefully worked up. This is also in the Museum Boymans–van Beuningen in Rotterdam, inv. MB 1866/T299 (Weber p. 96, III 120).

7. A fine portrait drawing by Willem van de Velde the Elder is also in the Museum Boymans–van Beuningen in Rotterdam, inv. MB 1866/T266 (Weber, p. 106, III 167). This ship was first mentioned in 1655 and was wrecked in 1683. 't Hooft first identified it in van de Velde's painting (1915, p. 106).

33

WILLEM VAN DE VELDE THE ELDER
Battle of the Downs (October 21, 1639)

Oil on canvas, 124 × 190 cm
Signed and dated at lower right: *W. v. Velde f 1659*
Amsterdam, Rijksmuseum, inv. A 1363

PROVENANCE: Collection, Tromp Family
Auction van Kinschot 1788, bought by Caspar van Kinschot
Amsterdam, C. S. Roos (1811)
Acquired by the Rijksarchief (1863)
N.M.G.K., 1887

LITERATURE: P. Haverkorn van Rijsewijk, 1898, vol. 16, p. 75
Willis, 1911, pp. 30–31
Martin, 1936, vol. 2, p. 374
Baard, 1942, pp. 24, 26
B. N. Teensma, 1968, vol. 3, p. 222, fig. 6
Amsterdam, *All the Paintings*, 1976, p. 560, inv. A 1363

EXHIBITION: Delft, Stedelijk Museum "Het Prinsenhof," *Vrede van Munster*, 1948, p. 144, cat. 380

The fledgling Dutch Republic sought *de jure* recognition of its independence from Spain, and hostilities between the two countries continued up to the Treaty of Munster in 1648, when Spain formally recognized the United Provinces as independent. The Dutch, in their ongoing struggle against Spain, constantly sought to undermine the power of their traditional enemy. Following the Twelve Years Truce (1609–1621) hostilities recommenced, Spain hoping to send an armada to the Spanish Netherlands and launch a decisive invasion of the Dutch Republic.

In 1639 this plan began to be realized and a large polyglot Spanish fleet transporting thousands of soldiers arrived in the English Channel with the intention of reaching safe haven in Flanders. The Dutch fleet under Maarten Harpertsz. Tromp on his flagship, the *Aemilia*,[1] monitored the movement of the Spanish fleet with the express intention of destroying it.[2] The Spanish admiral, Antonio De Oquendo, who commanded the Spanish flagship, the

Santiago, saw that the Dutch were the superior force and sought to avoid battle by delaying tactics. One of these was to seek protection in English territorial waters along the coast of Kent. Finally, on October 21, 1639, Tromp launched his fleet in battle in a region called the Downs, off Deal, north of Dover between North and South Foreland in Kent. The large and vulnerable Spanish galleons became easy targets for the smaller, more deft Dutch ships. Van de Velde depicts the *Santiago* in the left middle distance and the *Santa Tereza* under heavy attack at the left. The battle was a decisive Dutch victory that all but destroyed this second Spanish armada and decimated the troops transported on board. The great victory enormously enhanced the prestige of the Dutch Republic and demonstrated to all Europe the degree to which Spanish military might had waned. From this date on, it was only a matter of time before Spain had to accept the inevitable – its formal recognition of Dutch independence.

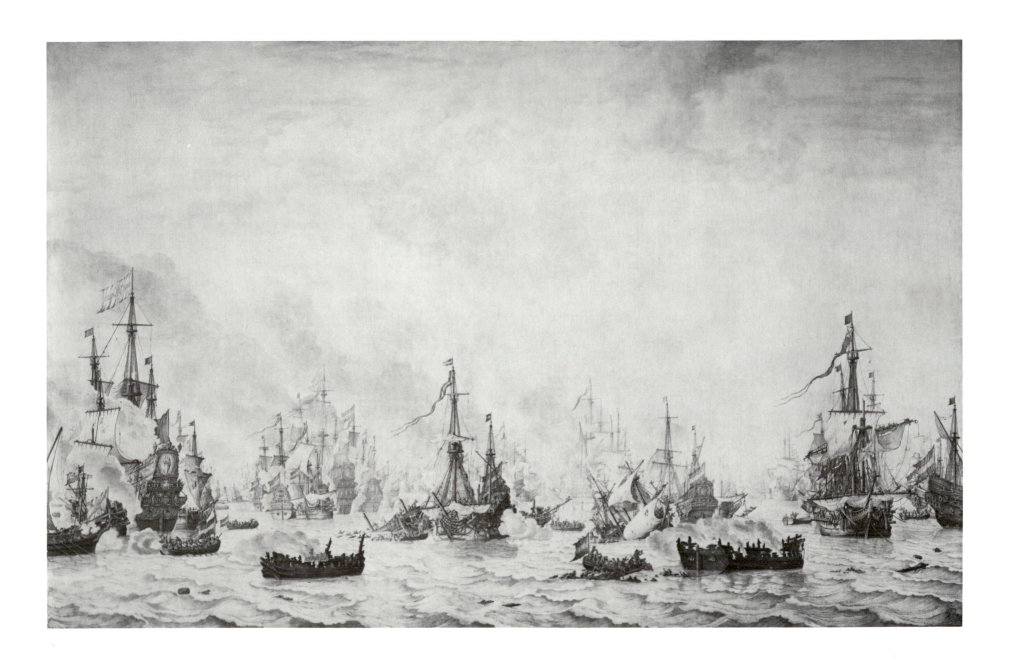

For this great victory the French monarch Louis XIII ennobled Tromp, whose family commissioned five pen paintings from Willem van de Velde the Elder. Each was set into a custom-made ebony frame that contains Admiral Maarten Tromp's family crest carved on a cartouche at the top center.

NOTES

1. For a portrait of this ship, see Cat. 121.

2. Tromp maintained a diary describing the movements of the Dutch fleet during the summer and autumn of 1639 as it maintained its surveillance of the Spanish fleet – see Boxer, 1930.

34

WILLEM VAN DE VELDE THE YOUNGER
Fishing Boats Offshore in a Calm

Oil on canvas, 65.8 × 78.5 cm
Signed on plank at lower left: *W.V.V.*
Springfield, Massachusetts, Springfield Museum of Fine Arts, The James Philip Gray
 Collection, inv. 50.02

PROVENANCE:	Collection Viscount Sackville, 5th Duke of Dorset
	By descent to Lady Elizabeth Sackville, wife of George John, 5th Earl de la Warr, Withyam, Surrey
	Esher Place, Surrey Collection, Sir Edgar Vincent, Lord D'Abernon
	New York, Duveen Brothers
	Sewickley Heights, Pa., Collection Mrs. B. F. Jones, Jr.
	New York, auction Mrs. B. F. Jones, Jr. (Parke-Bernet), December 4, 1941, lot 27
	New York, Collection D. Birnbaum
LITERATURE:	Hofstede de Groot, 1907–1928, vol. 7, no. 321
EXHIBITIONS:	London, Burlington House, *Old Masters Exhibition*, 1871, cat. 55
	London, Burlington Fine Arts Club, 1900, cat. 55
	Montreal, Museum of Fine Arts, *Five Centuries of Dutch Art*, 1944, cat. 81

During the first phase of his career Willem van de Velde the Younger concentrated principally on calms. These tend to be small and attain a degree of formal compositional refinement matched by truly astonishing optical effects. Despite their small scale, these paintings are stately and serene.

Fishing Boats Offshore in a Calm is a mature work within this group. Most of van de Velde's finest calms date between 1653 and the early 1660s. These tend to fall into three distinct categories, in which certain motifs unique to each play a central compositional role. A number contain piers or jetties, others include beaches in the foreground, and a third group contains no land at all. These three general categories afforded the artist inexhaustible variations and possibilities.

The earliest calms from 1653, including well-known pictures in Budapest, Kassel, and Leningrad,[1] are still somewhat monochrome in character and tend to contain relatively undifferentiated reflections of the ships. Relative to his somewhat later paintings, the artist also defines clouds in a

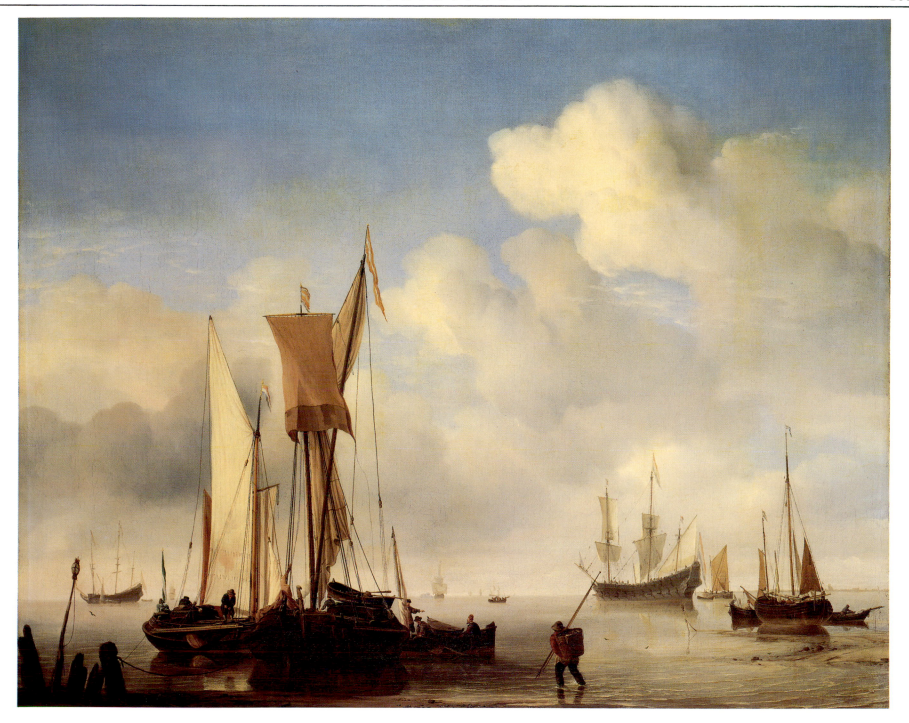

summary manner. By the late 1650s, van de Velde's representation of the effects of light is more subtle. Hues have become more intense, light is less atmospheric in effect, and the contrast between light and shadow is more pronounced. Moreover, van de Velde represents reflections in greater detail than in his earliest calms.

Fishing Boats Offshore in a Calm is one of a small group of pictures from the early 1660s to which van de Velde brings his concept of the calm to perfection. His *Calm* of 1661 in the National Gallery in London (fig. a)[2] is justly recognized as one of the finest examples from this group. The shallow water reflecting the sky and the sense of pervading light are both rendered with consummate skill and sensitivity. The sailboats in the foreground, a *kaag* and a *wijdschip*, are similar to the boats in the Springfield marine.

The Springfield painting is so similar in style, subject, and effect to the *Calm* in London that it must date from the same period, about 1661 or slightly later.[3] The piles driven into the sand and silhouetted against the water are analogous in both pictures. Both works also represent subtle atmospheric effects of the clouds, which seem to extend as far as the eye can see. The reflecting water enhances this optical effect. However, the *Fishing Boats Offshore in a Calm* in Springfield differs from the *Calm* in London in two fundamental respects. In it the artist omits the pier and also transforms the sky by the continuous sweep of ultramarine blue across the top. This vibrant color enhances the clarity of the light. By eliminating the pier, van de Velde allows the transition from foreground to distant horizon to flow without interruption. This ingredient provides an inexhaustibly satisfying visual resolution to a number of pictorial issues that preoccupied the artist in this series of calms. The sense of continuous space in which sea and sky echo each other supplies the perfect setting for ships of all sizes and types, each occupying its perfectly allotted spot in the composition. The harmony attained by van de Velde is indelibly linked to the serenity of these subjects. Willem van de Velde the Younger continued to produce calms later in his career, but they never approach the matchless resolution of these earlier works dating to about 1660.

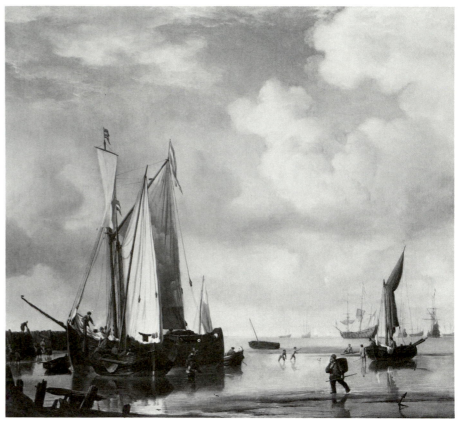

Cat. 34, fig. a Willem van de Velde the Younger, Pier: A Calm, oil on canvas. London, The National Gallery.

NOTES

1. Stechow, 1966, pls. 238, 239.

2. Greenwich, 1982, cat. 23, repr.

3. In its treatment of the clouds, reflecting water, and contrasting light and shadow playing on the ships this painting offers close parallels to the *Calm: Dutch Ships coming to Anchor* in the Wallace Collection, which Cordingly, in Greenwich 1982, p. 72, cat. 26, dates to about 1665.

35

WILLEM VAN DE VELDE THE YOUNGER
Calm: A Prince's Yacht Surrounded by Other Vessels

Oil on canvas, 66.6 × 77.2 cm
Monogrammed on the barrel: *W. V. V.*
The Hague, Mauritshuis, Koninklijke Kabinet van Schilderijen, inv. 201

PROVENANCE: Amsterdam, auction Pieter Leendert de Neufville (Cok) June 19, 1765, lot 106
The Hague, Stadholder William V (removed to Paris during the Napoleonic era, *inventaire et etat* 1795, no. 173 or 174)

LITERATURE: 't Hooft, 1915, pp. 97–108
Hofstede de Groot, 1907–1928, vol. 7, no. 19
Preston, 1937, fig. 54
L. J. Bol, 1973, pp. 235–236, pl. 240
Mauritshuis, 1980, pp. 112–114 (with comprehensive bibliography), repr.

This is an important *parade* subject, in which many small craft gather about a prince's yacht. This yacht, originally built for Stadholder Frederick Henry in 1645–1647, was completed only after his death. As a result, its stern contains the coat-of-arms of his son and successor, William II. The carving on the stern was executed by the father of the marine painter Lieve Verschuier (see Cat. 44), and the polychromy, by Jacobus de Vileers.[1]

Traditionally the subject has been considered the ceremonial greeting of King Charles II of England near Dordrecht on May 24, 1660, when he accompanied the fleet from Moerdijk *en route* to Delft.[2] Charles was journeying from France to England via the Dutch Republic, where he resided from May 25 to June 2. He departed from Breda on May 24 and arrived at Moervaert near Dordrecht, where the procession stopped for lunch. Here Charles learned that the English fleet, commanded by Montague, had anchored off Scheveningen and awaited his arrival. Charles and his entourage sailed past Dordrecht, but because of unfavorable winds, they were delayed in reaching Rotterdam until late afternoon. After spending the night in Overschie, Charles II reached Delft at five the next morning. From there he traveled overland by carriage to The Hague, where he resided in

the house of Maurice of Nassau until June 2, when he boarded the *Royal Charles* and set sail to assume the throne of England.[3] Recently this identification has been queried because evidence indicates that the prince's yacht of William II was, in all likelihood, not present at this juncture of Charles's journey through the republic. Moreover, as the recent catalogue of the Mauritshuis indicates, such an event would have attracted a far greater number of ships than those present in van de Velde's picture.[4] Until further evidence is forthcoming, the historical event represented in this picture remains a matter of conjecture.

Stylistically the picture fits perfectly with events of 1660. The types of ships represented confirm that the greeting occurred on a river or estuary rather than on the North Sea. Three-masted oceangoing vessels are conspicuously absent.

In one sense the Mauritshuis painting conforms readily to Willem van de Velde the Younger's typical calms, such as Cat. 34, but actually belongs to a cohesive subgroup that stems from the parade subjects of Jan van de Cappelle and Simon de Vlieger. He makes no reference to land or to piers or harbor jetties. This *Calm* is similar to a number of closely related paint-

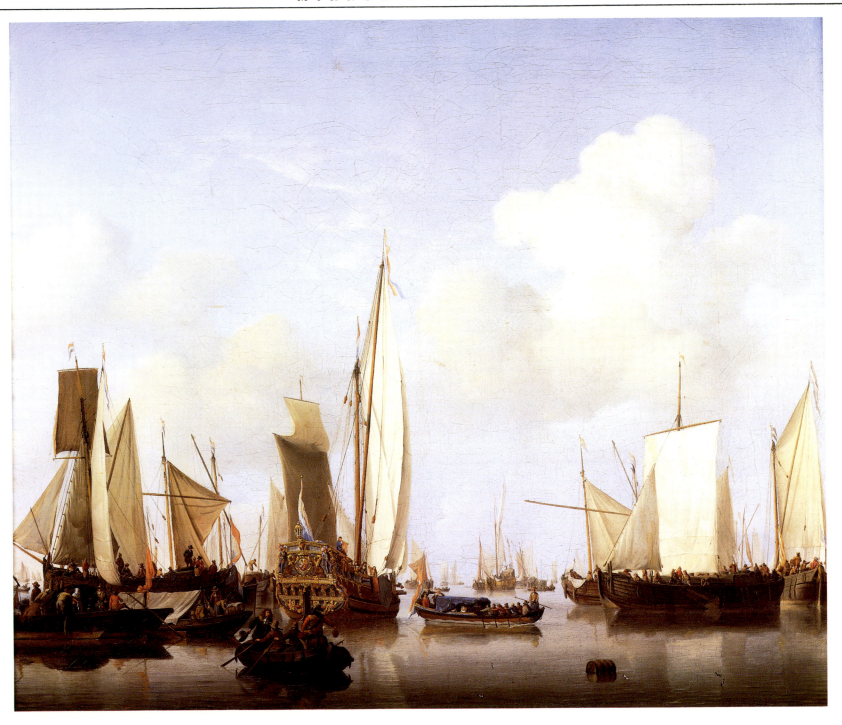

ings, including works in the British royal collection[5] and a *Calm: A States Yacht and Many Other Vessels in a Very Light Air*.[6] The latter picture may even derive from the *Calm* in the Mauritshuis. Not only does it contain the same prince's yacht, but a number of the other vessels clustered at the left and right appear to be a reshuffling of the same or analogous boats in the Mauritshuis picture. The repositioning of the prince's yacht and the inclusion of the skiff in the left center foreground in the *Calm* tend to create a more concentrated effect, also enhanced by the almost square format of the canvas.[7]

Cordingly points out in connection with the *Calm: A States Yacht and Many Other Vessels in a Very Light Air* that Willem van de Velde the Younger based many of his compositions on his father's pen paintings.[8] In turn, he may have referred to certain of his own earlier pictures. For example, Willem van de Velde the Younger represents the same prince's yacht in his *Calm: A Dutch Flagship Coming to Anchor* (Cat. 39) of 1658, albeit with a slight repositioning of its sails. Enough similarities exist to suggest that the artist often chose to rethink a motif while transferring it into a new context.

NOTES

1. Mauritshuis, 1980, p. 113.

2. Willem van de Velde the Elder represented this event in his pen painting in grisaille in the Rijksmuseum in Amsterdam, inv. A 1589.

3. 't Hooft, 1915, pp. 98–102, provides a detailed analysis of this event based on Abraham de Vicquefort's *Verhael in forme van Journaal van de reys ende 't vertoeven van Carel II*, The Hague, by Adriaen Vlack, a contemporary account of the king's journey through the Dutch Republic in 1660.

4. Mauritshuis, 1980, pp. 112–114, citing the history of the identification of the subject and the more recent dissenting opinion of Michael Robinson.

5. For example, the *Calm* reproduced in Greenwich, 1982, cat. 25.

6. Ibid., cat. 22, repr.

7. Mauritshuis, 1980, pp. 112–114, surmises that the picture may have been cut down along the left side and bottom. Its relationship to the *Calm: A States Yacht and Many Other Vessels in a Very Light Air* needs to be considered in ascertaining to what degree the Mauritshuis picture has been cut down.

8. In Greenwich, 1982, p. 69.

36

WILLEM VAN DE VELDE THE YOUNGER
A States Yacht Running Down to Some Dutch Ships in a Breeze

Oil on canvas, 75 × 108 cm
Signed: *W. V. Velde* (1673)
Greenwich, National Maritime Museum, inv. 60–16

PROVENANCE:	Ashbourne, Okeover Hall, Collection H. C. Okeover
	London, auction Captain N. E. Okeover (Christie) June 26, 1936, lot 66, repr.
	London, auction Eckstein (Sotheby) December 8, 1948, lot 27, bought by Spink
LITERATURE:	Waagen, 1854, vol. 3, p. 390
	Hofstede de Groot, 1907–1928, vol. 7, no. 568
	Preston, 1937, fig. 57
EXHIBITIONS:	London, Royal Academy, *Winter Exhibition*, 1879, cat. 10
	Greenwich, 1982, cat. 108, repr.

This painting, although produced after Willem van de Velde the Younger had moved to England, represents Dutch ships. A states yacht in the right center foreground sails toward the *Seven Provincien*, the flagship of Michiel de Ruyter. It can be identified by the lion emblem carved on the stern. The

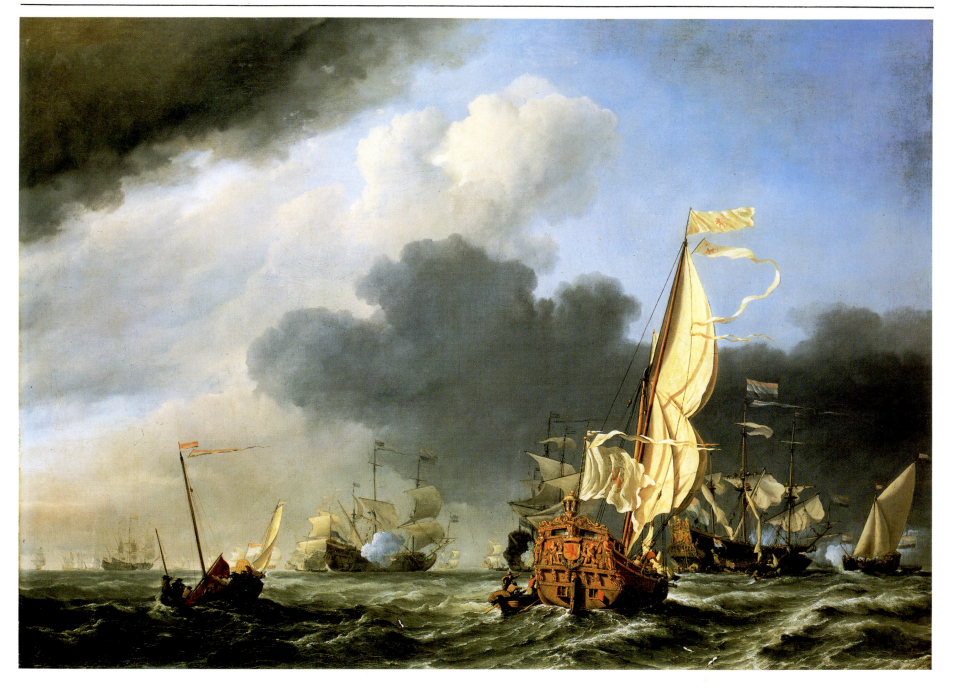

Seven Provincien flies a large prince's flag and wimple atop its mainmast. A second yacht to the right salutes. This picture is traditionally dated 1673, which leads Cordingly to believe that the subject represents the Dutch fleet assembling off the island of Texel in 1672. He supports this claim by pointing out that van de Velde places a fishing pink prominently in the left foreground. Its conspicuous presence can be explained by the fact that de Ruyter removed all the permanent channel markers and buoys to hinder a possible English naval invasion and replaced them with small vessels with the same, albeit temporary, function.[1]

Stylistically this painting is similar to the *Kaag Close-hauled in a Fresh Breeze* (Cat. 38), with the artist's focus on the restless action of the waves and the sweeping clouds across the distance. Ships sail in optimum weather conditions. The artist imparts an exuberance to the subject that may have been inspired by Backhuysen. Like the Toledo painting, this subject was renowned. At least two other surviving versions exist in Greenwich and in Glasgow.[2]

NOTES

1. D. Cordingly, in Greenwich, 1982, p. 106.
2. Ibid.

37

WILLEM VAN DE VELDE THE YOUNGER
A Dutch Man-of-War and Small Vessels off a Coast in a Strong Breeze

Oil on canvas, 55 × 70 cm
Signed and dated on flag of the Kaag at left: *W V Velde 1658*
London, the Trustees, National Gallery, inv. 2573

PROVENANCE: Brussels, auction Corneille-Louis Reynders, August 6, 1821, lot 102, bought by Verbelen for Nieuwenhuys
London, Collection Sir Robert Peel, 2nd Bart. (by 1835), by descent to Sir Robert Peel 4th Bart.
London, Thomas Agnew & Sons
London, Collection Sir George Salting by whom bequeathed to the National Gallery in 1910

LITERATURE: J. Smith, 1829–1842, vol. 6, no. 107
Hofstede de Groot, 1907–1928, vol. 7, no. 485
Maclaren, 1960, p. 432
Stechow, 1966, p. 120, pl. 241
L. J. Bol, 1973, pp. 234–235, pl. 238

Although the majority of Willem van de Velde's earlier paintings are calms, he also represented ships in breezier weather. Although numerically smaller, the artist's breeze subjects are an important component of his activity and reveal van de Velde's versatility. In fact, his earliest surviving picture of 1651 represents *A Dutch Merchantman in a Storm,*[1] possibly painted while he was studying with Simon de Vlieger. His earliest breeze subject appears

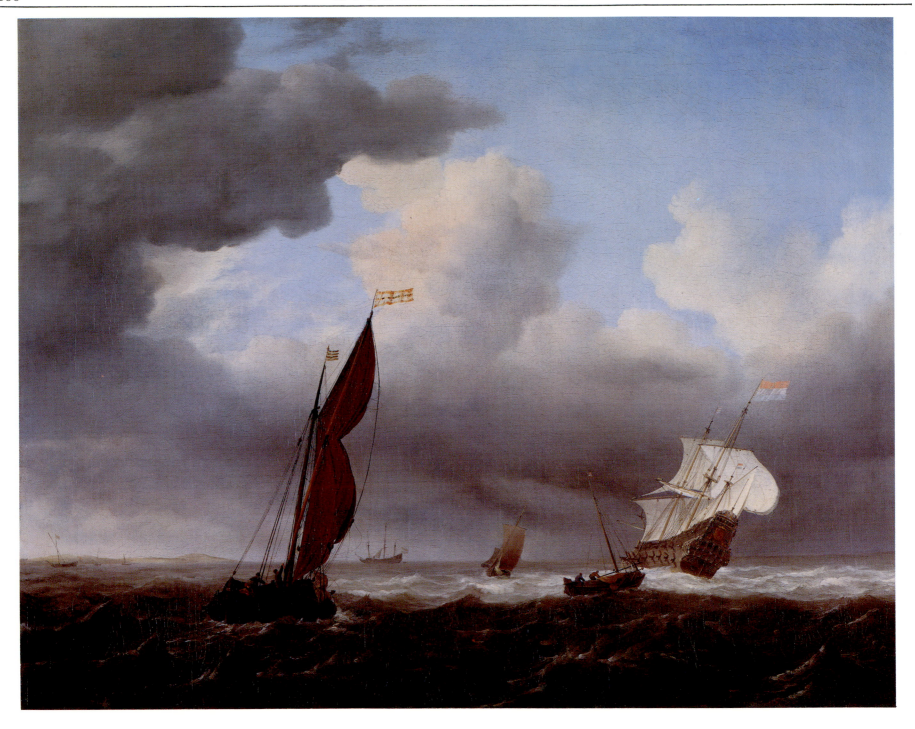

to be *A States Yacht Meeting a Dutch Two-decker* of 1654, produced when the artist was twenty-one.[2] This painting conforms closely to the artist's calms, particularly evident in his treatment of the sky.

By 1658, the date of the *Dutch Man-of-War and Small Vessels off a Coast in a Strong Breeze*, Willem van de Velde had moved in a different direction. He stresses the pervasiveness of the cloudy atmosphere and modulates the range of grays in the clouds to an extraordinary degree. A single shaft of light plays across the water in the mid-distance striking the man-of-war. All else, including the distant dunes, remains in shadow. Despite the suggestion of heavy atmospheric conditions, the light remains clear. One experiences a tremendous sense of depth and can easily distinguish the ships in the distance. This evocation of the sea as a vast stage parallels van de Velde's achievements in the calms (Cat. 34 and 39), but interpreted with greater, albeit restrained, dramatic force. Stechow and Bol stress the potent energy of this composition, with the strong diagonal accents of the ships responding to the sea swell. The *kaag* in the left foreground has her mainsail brailed. The warship beyond at the right has the arms of the Province of Holland carved on its stern.

NOTES

1. Greenwich, National Maritime Museum, inv. 65–19, repr. in Greenwich, 1982, cat. 18.

2. Ibid., cat. 19, repr.

38

WILLEM VAN DE VELDE THE YOUNGER
A Kaag Close-hauled in a Fresh Breeze

Oil on canvas, 129.5 × 189 cm
Signed on spar at lower left: *W v Velde*
Toledo, Toledo Museum of Art, Gift of Edward Drummond Libbey, inv. 77.62

PROVENANCE: Leiden, auction Catharina Backer, September 8–9, 1766
Amsterdam, auction Pieter Locquet, September 22–24, 1783, lot 370, bought for fl. 2800
England, Collection Hope
London, Collection Lord Francis Egerton
London, Collection Marquess of Stafford (1818 cat. 125)
London, Bridgewater House, Collection of Earl of Ellesmere (1892 and 1907 cat. no. 196)
London, auction (Christie) July 2, 1976, lot 92, repr.

LITERATURE: J. Smith, 1829–1842, vol. 6, no. 1
Waagen, vol. 2, 1854, p. 50, no. 1
Hofstede de Groot, 1907–1928, vol. 7, no. 488
J. G. van Gelder, 1953, p. 34 (as Backhuysen)

EXHIBITION: London, Royal Academy, *Dutch Pictures*, 1952/1953, cat. 587

In 1671, at the point when Willem van de Velde the Younger seriously considered moving to England, he drew inspiration from the dramatically conceived marines of Ludolph Backhuysen. The *Kaag Close-hauled in a* *Fresh Breeze*, traditionally dated 1672, is one of the artist's masterpieces from this transitional period. The strong spotlighting, rolling seas, and magnificent cloudy backdrop coalesce to form an exhilarating image. The

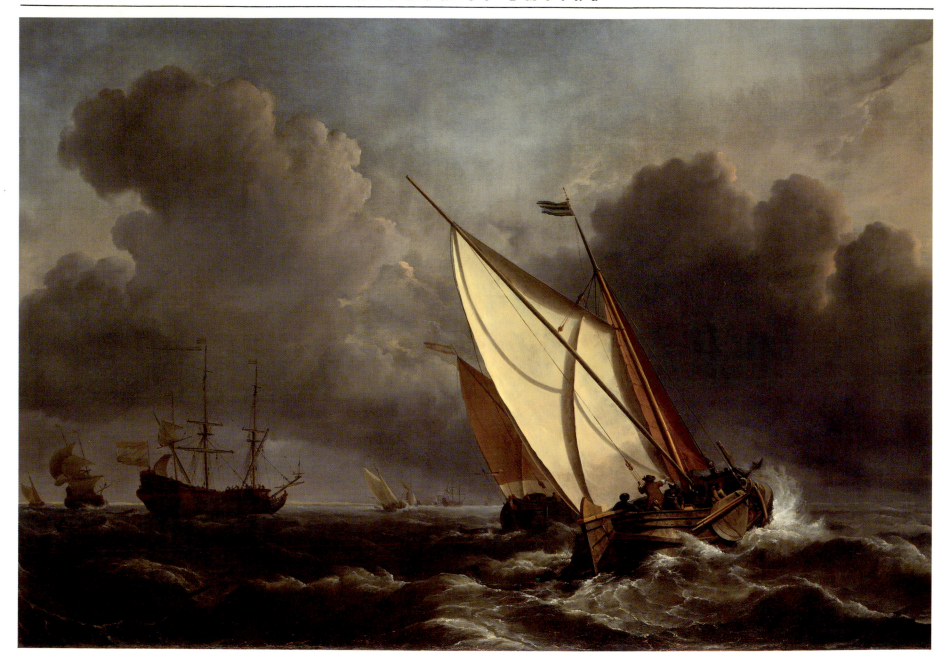

constant wind velocity is measured in the taut sails of the *kaag* and the spray breaking on its hull. By his bold shift in scale from immediate foreground to far distance, van de Velde creates a heroic image in which the open *kaag,* in a burst of light, seems to dwarf the three-master in shadow beyond at the left. Despite the nature of the subject matter, the large size of the painting lends to its monumental air. This is not a depiction of a significant historical event. Instead, it becomes an embodiment of the thrill of being at sea in optimum sailing conditions. The magnitude of the weather conditions of the North Sea climate are manifest, yet man by his ingenuity masters the awesome energy of nature, harnessing it for his own commercial or recreational ends.[1]

Van de Velde's dynamic image was influential. This picture appealed to Turner, who was commissioned by Francis Egerton to paint a companion piece to this great van de Velde. In his work, known as the "*Bridgewater Sea Piece,*" Turner responded to Willem van de Velde's poetic evocation of the restless power of the sea. In his own exuberant painting (fig. a) the fury of the sea becomes yet more apparent.[2] Turner continued to develop the powerful spirit inherent to this theme and so compatible with early-nineteenth-century romanticism. In his later marine paintings, such as his celebrated *Calais Pier, with French Poissards Preparing for Sea: An English Packet Arriving* of 1803 in the National Gallery, London,[3] Turner continued to develop this theme, which so appealed to his romantic temperament.

The *Kaag Close-hauled in a Fresh Breeze* was one of van de Velde's most celebrated paintings. At least two copies of it survive.[4]

Cat. 38, fig. a J. M. W. Turner, Bridgewater Sea Piece, *oil on canvas. Present whereabouts unknown.*

NOTES

1. A closely related painting, *Sailboats and Ships in a Strong Breeze* (HdG 526), signed and dated 1672, in the collection of Sir Alfred Beit, Blessington, Ireland, is similar in mood, including a restless sea, a dramatic cloudy sky, and analogous strong spotlighting. Like the picture in Toledo, this work was also popular. Copies attributed to Backhuysen and Dubbels exist.

2. Turner's "*Bridgewater Sea Piece*" was sold from the Ellesmere Collection in London, auction (Christie) June 18, 1976, lot 121, repr. – see Butlin and Joll, 1984, pp. 12–13, cat. 14, repr.

3. Ibid., pp. 37–38, cat. 48, repr.

4. (a) Canvas, 76 × 95 cm, monogrammed. Brussels, auction (Galerie Thermis) November 13, 1954, lot 223, repr.; Brussels, auction (Thermis) October 4, 1958, lot 271, repr.; Brussels, auction (Giroux) December 18, 1959, lot 447, repr. (b) Canvas, Italian art trade (1988), acquired in England. Same dimensions as the Toledo painting but lacking the spar in the left foreground.

39

WILLEM VAN DE VELDE THE YOUNGER
Calm: A Dutch Flagship Coming to Anchor with a States Yacht Before a Light Air

Oil on canvas, 85 × 104 cm
Signed at the bottom right in the water: *W. v. Velde*
Dated on the cartouche above the rudder head of the yacht: *1658*
Greenwich, National Maritime Museum, Ingram Collection, inv. 64.23

PROVENANCE: Zurich, Henneberg Collection (1902, cat. 60)
Munich, auction Henneberg (Helbing) October 26, 1903, lot 78
Paris, Galerie C. Sedelmeyer (catalogue of 100 paintings, 1906, cat. 42)
Paris, auction (Sedelmeyer) May 25, 1907, lot 191
Amsterdam, auction (Fr. Muller) May 6, 1913, lot 107, repr.
Amsterdam, auction (Fr. Muller) May 28, 1918, lot 191
London, Collection Bruce Ingram

LITERATURE: Hofstede de Groot, 1907–1928, vol. 7, no. 80

EXHIBITIONS: London, Royal Academy, *Exhibition of 17th Century Art in Europe*, 1938, cat. 200
New York–Toledo–Toronto, 1954/1955, cat. 85, repr.
Greenwich, 1982, Cat. 21, repr.

This painting is one of a handful of calms more ambitious in scale than the artist's smaller coastal subjects. Van de Velde focuses as much attention on his rendering of the ships as on the atmosphere enveloping them. In this case, a states yacht at the left bearing the arms of the House of Orange on its tafferel sails toward a warship tentatively identified as the *Huis te Zwieten*. The large ship in the right foreground is the *Eendracht* (the *Unity*), built in 1653, which also appears in Backhuysen's picture in the National Gallery, London (Cat. 6). Willem van de Velde the Elder produced an extremely accurate portrait drawing of the *Eendracht,* detailing its stern with the lion rampant protecting the Dutch garden, symbolizing the Dutch Republic.[1]

Willem van de Velde the Younger focuses attention onto the light that plays on the sails of the *Eendracht*. At the same time he makes a close study of the seamen furling the top mainsail. A skiff in the foreground contains dignitaries who may have disembarked. The slightest suggestion of a breeze denoted by the ripples in the water and the barely fluttering flags adds to the palpable atmosphere. Clouds seems to blend imperceptibly with the pale blue haze of the sky above.

In this picture van de Velde still reveals his debt to Simon de Vlieger, but despite the similar treatment of atmosphere, light does not blur detail. Instead, it seems to envelop the ships in a subtle glow. As Cordingly points out, van de Velde's somewhat later *Calm: Dutch Ships Coming to Anchor* of about 1665 in the Wallace Collection[2] is the painter's masterpiece in this vein. Nonetheless, the *Calm: A Dutch Flagship Coming to Anchor*

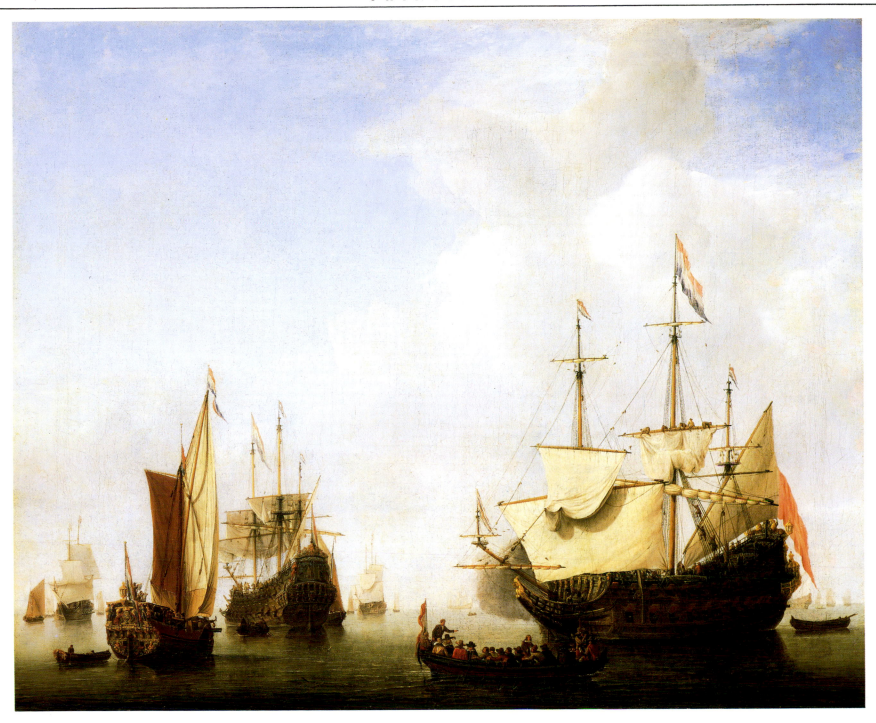

with a States Yacht Before a Light Air is a compelling premonition of this larger and more stately masterpiece from the following decade. What it intimates in terms of the artist's study of reflections, light, and atmosphere finds its ultimate fruition in the later *Calm: Dutch Ships Coming to Anchor,* which is one of van de Velde's most magisterial and best-preserved large pictures.[3]

NOTES

1. Reproduced by R. Vorstman in Amsterdam, 1985, p. 16, illus. 2, cited in conjunction with his analysis of Backhuysen's painting in the National Gallery.

2. D. Cordingly, in Greenwich, 1982, cat. 26, repr.

3. A copy of the right half of this composition, canvas, 73.5 × 78 cm, was formerly in the European art trade – Berlin, Galerie P. Cassirer (1926–1927); Berlin, auction, February 26, 1932, lot 32a; The Hague, Galerie Kees Hermsen (1932).

40

WILLEM VAN DE VELDE THE YOUNGER
The Surrender of the "Royal Prince"

Oil on canvas, 75.5 × 106 cm
Signed: *WvVJ*
West Germany, private collection

PROVENANCE:	Amsterdam, auction Johan Verkolje, October 24, 1763, lot 21, bought by Zwart for fl. 600
	The Hague, auction Van Zaanen, November 16, 1767, lot 2, bought for fl. 600
	Amsterdam, auction Jan Gildemeester, June 11–13, 1810, lot 235, bought by Westerwoud for fl. 3425
	London, Collection Lord Francis Egerton
	London, Collection Marquis of Stafford (1818 cat. 128)
	London, Bridgewater House, Collection Earl of Ellesmere (1892 and 1907 cat. no. 134)
	London, auction (Christie) July 2, 1976, lot 93, repr.
LITERATURE:	J. Smith, 1829–1842, vol. 6, pp. 381–382, no. 219
	Waagen, 1854, vol. 2, p. 51
	Hofstede de Groot, 1907–1928, vol. 7, no. 27
EXHIBITION:	London, British Institution, 1838, no. 43

This picture, one of the master's supreme achievements, represents the most significant episode occurring on the third day of the Four Days' Battle of June 11–14, 1666. The English flagship, the *Royal Prince,* commanded by Sir George Ayscue, admiral of the white squadron, ran aground on the Galloper, one of the many sandbars off the coast of Flanders. Van de Velde represents the moment when its white flags are being hauled down to be replaced by the Dutch prince's flags, which are being brought by sailors on dories to the *Royal Prince.* The *Gouda,* commanded by Captain Sweers, is standing to the right seen stern-on. Two carved lions hold the crest of the city of Gouda, identified by the upright sword flanked by six gold stars, on the tafferel. Before this event Cornelis Tromp had transferred his flag to the *Gouda.* Storck represents the same event in his painting now in Minneapolis (Cat. 31).

Willem van de Velde the Younger isolates this key event in the course of the third day of the battle by highlighting the *Royal Prince* and *Gouda* in strong light. Its play on the water and sails of these two ships forms a powerful accent, isolating them from the battle beyond. He also includes the motif of Willem van de Velde the Elder's galliot sailing close to the

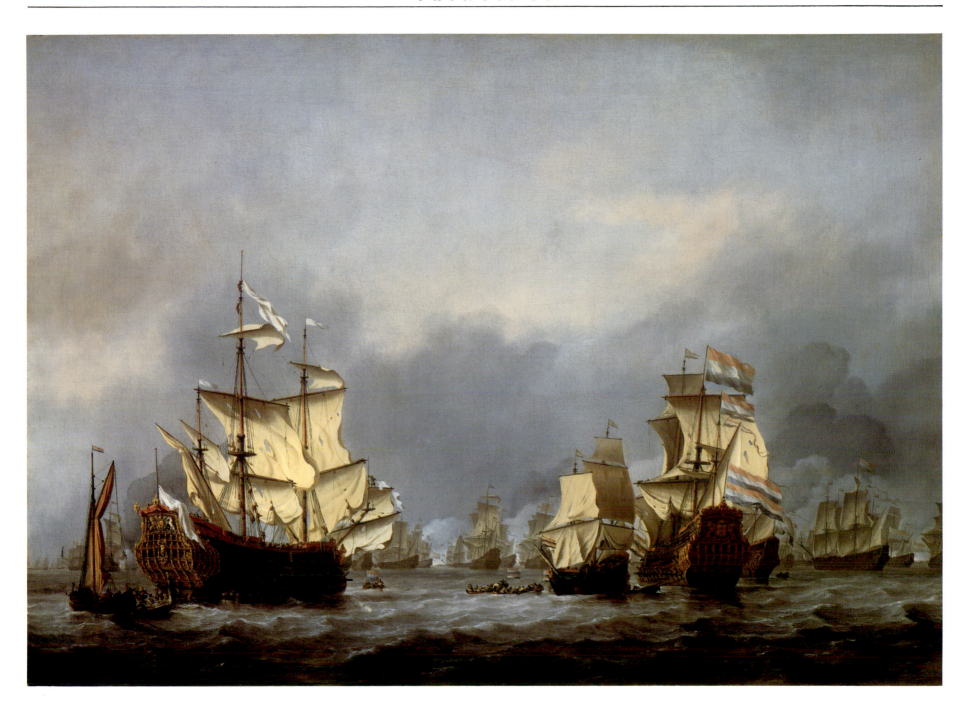

stern of the *Royal Prince*. In fact, the standing figure in the galliot may possibly be the artist sketching.

This episode of the Four Days' Battle caught the Dutch imagination and was represented frequently by painters. Willem van de Velde the Younger himself produced at least four versions of this event,[1] but all lack the supreme quality and narrative force of the present picture. Certain of these appear to have involved the participation of studio assistants.[2]

NOTES

1. Cited in Mauritshuis, 1980, p. 115.

2. Willem van de Velde the Younger may well have consulted certain drawings by his father, including the fully worked-up portrait study of the *Royal Prince* (Cat. 88) in the Museum Boymans–van Beuningen in Rotterdam. A substantially reworked compositional study by Willem van de Velde the Younger in Greenwich is closely related to his painting in the Lugt Collection rather than the ex-Ellesmere picture – Robinson, 1973, p. 66, no. 288, pl. 59. This drawing also contains the motif of van de Velde's galliot sailing close to the stranded *Royal Prince*.

41

CORNELIS VERBEECK
Four Ships in High Seas

Oil on panel, 35 × 55.5 cm
Signed in monogram: *CVB*
United States, private collection

PROVENANCE: London, Collection Sir Bruce Ingram
 The Hague, Gallery Cramer (1964)
LITERATURE: L. J. Bol, 1973, p. 49, pl. 46
EXHIBITIONS: London, Colnaghi, *Masters of Maritime Art from the Collection Bruce Ingram*, 1938,
 cat. 1
 Dordrecht, 1964, cat. 90, pl. 7

Although deeply influenced by Hendrick Vroom, Cornelis Verbeeck developed a distinctive concept of marine painting that had important ramifications for the future. He produced pictures modest in scale, and he often represented subjects nonhistorical in character. *Four Ships in High Seas* is a typical example in which the artist focuses on two themes. Two ships skirmish. A large Dutch three-master seen in starboard beam fires at a ship at the right seen from the stern. These ships are caught in large waves that add further drama to the subject.

Four Ships in High Seas is close in mood to Verbeeck's representations of ships sailing dangerously close to rocky shores in rough seas.[1] Although these draw inspiration from Hendrick Vroom – for example, his large painting *The Great Sea Storm*,[2] – Verbeeck interprets the subject on a more modest scale. This evidently appealed to collectors, who sought marines more intimate in character than the large public commissions one associates with Vroom. Verbeeck's oeuvre consists primarily of these smaller-scale pictures in which he represents beaches, coastal scenes, and naval battles as well as ships in storms. All of these depictions derive in some manner from Hendrick Vroom, but Verbeeck modifies Vroom's idiom in his quest for works charged by a different appeal.[3]

NOTES

1. For example, his two well-known examples in Amsterdam, Rijksmuseum "Nederlands Scheepvaart Museum," and in the National Maritime Museum in Greenwich – see L. J. Bol, 1973, pls. 47, 48.

2. Bol, 1973, pl. 9.

3. An excellent example of this transcription is Verbeeck's signed *Ships Beyond a Beach* in the Frans Hals Museum in Haarlem, which derives from Hendrick Vroom's larger marines of similar subjects including the two well-known examples in the Rijksmuseum, Amsterdam. Russell, 1983, figs. 162, 140a, 140b.

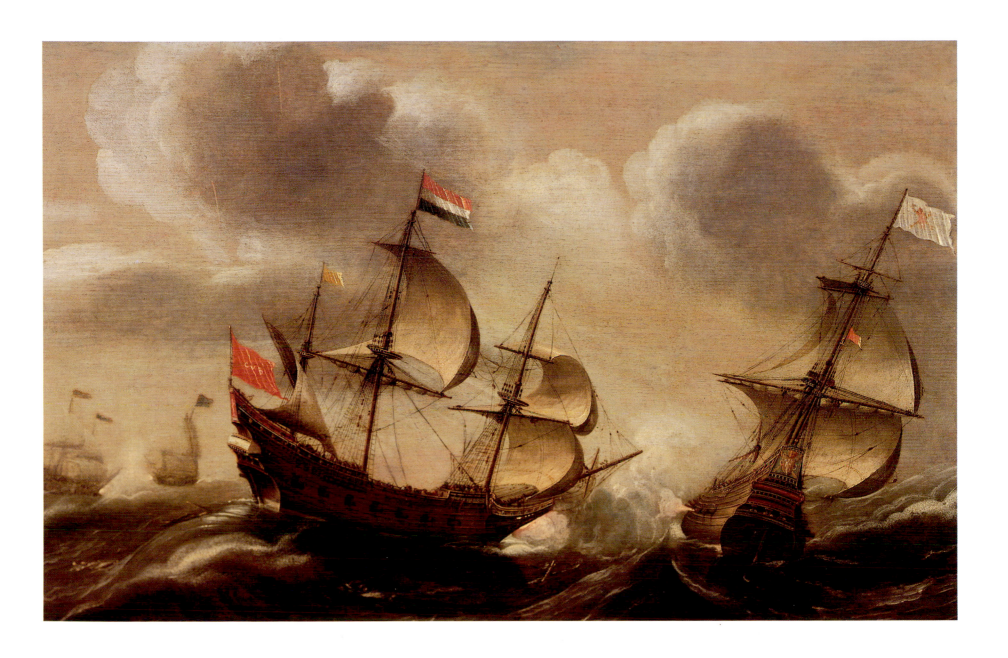

42

CORNELIS VERBEECK
The Capture of Damiate

Oil on panel, 52.7 × 84.45 cm
Signed on mainmast flag of the largest three master: *CVB H*
Heckscher Museum, inv. 59.133 (Gift of August Heckscher)
Huntington, New York,

PROVENANCE: New York, Collection August Heckscher (acquired by 1920)
LITERATURE: L. J. Bol, 1973, pp. 51–52, pl. 53
 Huntington, New York, The Heckscher Museum, *Catalogue of the Collection Paintings*
 and Sculpture, 1979, p. 140, repr.

This is one of a small number of paintings by Verbeeck in which he represents significant historical events,[1] in this instance, a scene from the Middle Ages. Dutch and Frisian soldiers accompanied Count William I of Holland on the crusade of 1218–1219. As part of the Crusaders' strategy to capture the Holy Land via Egypt, they captured the port city of Damiate at the mouth of the Nile. This feat was putatively achieved with the crucial participation of a ship from Haarlem. The Saracens had closed the harbor of Damiate by suspending a chain from the two moles that controlled the harbor entrance to the city; but by audaciously sailing over and snapping this chain, the Crusaders were able to capture Damiate, whose port was now vulnerable to attack. The Saracens fought furiously and used catapults at the top of the towers guarding the moles to hurl firebrands and other lethal projectiles at the attacking Christian ships.

Haarlem, proud of its medieval origins and achievements, exploited this largely mythical event, which became part of the heritage and lore of the city. As a means of honoring the city for its critical contribution to this victory over the Saracens, the emperor Frederick II and the Patriarch of Jerusalem awarded Haarlem the privilege of adding the upraised sword of Damiate and the Greek cross to its crest.[2]

The capture of Damiate became a popular subject in Haarlem, and was represented by an engraving of 1595 by Nicolas Clock as well as in paint-

ings, a tapestry, and stained-glass windows commissioned for Haarlem and elsewhere. These include the great stained-glass window designed by Willem Thibaut of 1597 presented by the city of Haarlem to the St. Janskerk in Gouda and analogous windows for churches in Bloemendaal and Edam, and for the great west window of the Church of St. Bavo in Haarlem.[3] The example most crucial for Verbeeck is the painting by Cornelis Claesz. van Wieringen of the same subject (fig. a), datable to about 1620 and com-

Cat. 42, fig. a C. Cl. van Wieringen, The Capture of Damiate, *oil on canvas. Haarlem, Frans Hals Museum.*

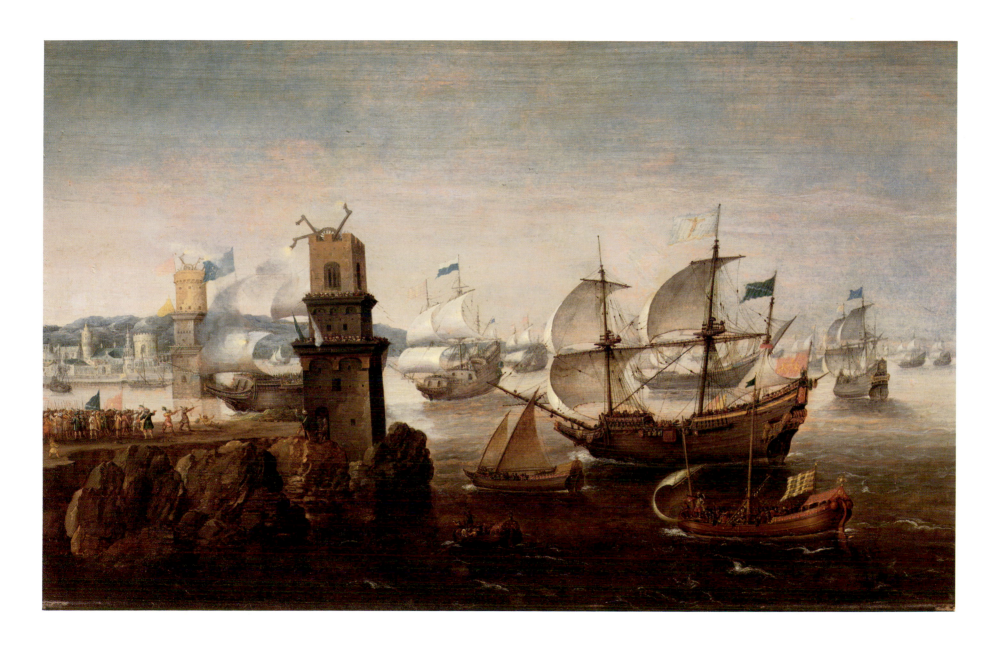

missioned for the Cloveniersdoelen in Haarlem. Several years later van Wieringen also designed a huge tapestry commissioned by the city magistrates for the town hall of Haarlem in 1629.[4]

As van de Waal notes, van Wieringen was the first artist to represent the capture of Damiate from the side looking obliquely across the nearer jetty.[5] Verbeeck assumes a similar vantage point. He follows van Wieringen closely in both composition and in detail. Most notable is that the ships, although of seventeenth-century design, carry no cannon. The artist includes a two-masted yacht in the right foreground analogous to the one in van Wieringen's painting. Verbeeck does not include the detail of projectiles streaming from the guard towers on the jetties.

NOTES

1. Two other notable examples include the *Departure of C. Houtman's Fleet to the East Indies*, dated 1623, in the Art Gallery in Cheltenham, England, and *A Dutch Fleet Anchored Before the Island of St. Helena*, in the Rijksmuseum "Nederlands Scheepvaart Museum" in Amsterdam – L. J. Bol, 1973, pl. 51.

2. For discussion of the capture of Damiate, see van de Waal, 1952, pp. 31, 243–252; Biesboer, 1983, p. 44.

3. See van de Waal, 1952, pp. 245, 246, 248, pl. 92.

4. On April 12, 1629, van Wieringen received 300 pounds flemish from the treasurer of the city of Haarlem. Pieter Holsteyn, a glass engraver, received 225 pounds flemish for producing the cartoon based on van Wieringen's drawing; and Joseph Thienpont (Thybauts) the weaver received 2,300 pounds flemish for executing the tapestry. This brought the total cost to 2,825 pounds flemish plus supplementary beer moneys to the members of Thienpont's atelier – see Keyes, 1979, p. 7, pls. 5a–c, 6a–b; Biesboer, 1983, pp. 43–45, pl. 20.

5. van de Waal, 1952, p. 251.

43

LIEVE PIETERSZ. VERSCHUIER
Ships in a Bay at Sunset

Oil on canvas, 48.3 × 64.3 cm
Signed on a barrel at the right: *L/...schuir*
Paris, Institut Néerlandais, Fondation Custodia (Collection Frits Lugt), inv. 6265

PROVENANCE:　　Probably Leiden, Collection Johan van der Marck Aegidiuszn
Amsterdam, auction J. van der Marck (H. de Winter & Yver) August 25, 1773, lot 348,
　　bought by Pothoven for fl. 62
London, Collection Lady Frances Vyvyan
London, auction (Christie) June 23, 1950, lot 28, bought by F. Lugt

EXHIBITIONS:　　Paris, 1983, pp. 149–150, cat. 90, repr.
Paris, 1989, pp. 16–17, cat. 12, repr.

This marine is a strikingly fine example of Verschuier's unusual light effects, in which he includes the setting sun in the center distance. Its rays color the clouds and also cast a shaft of light across the sea. Verschuier developed a keen interest in these poetically conceived marines so distinctive in coloristic and optical effects. Some represent the end of day, others are moonlit nocturnes.[1]

In mood, pictures such as *Ships in a Bay at Sunset* recall Verschuier's experience of Italy and may reveal knowledge of Claude Lorrain, whose celebrated harbor subjects at sunset could have been a powerful source of inspiration. Nonetheless, Verschuier's marines display a greater interest in ships and shipping activities and find a closer source in the art of Reinier Nooms (Fig. 23, p. 28), whose Mediterranean shipping subjects were well known.

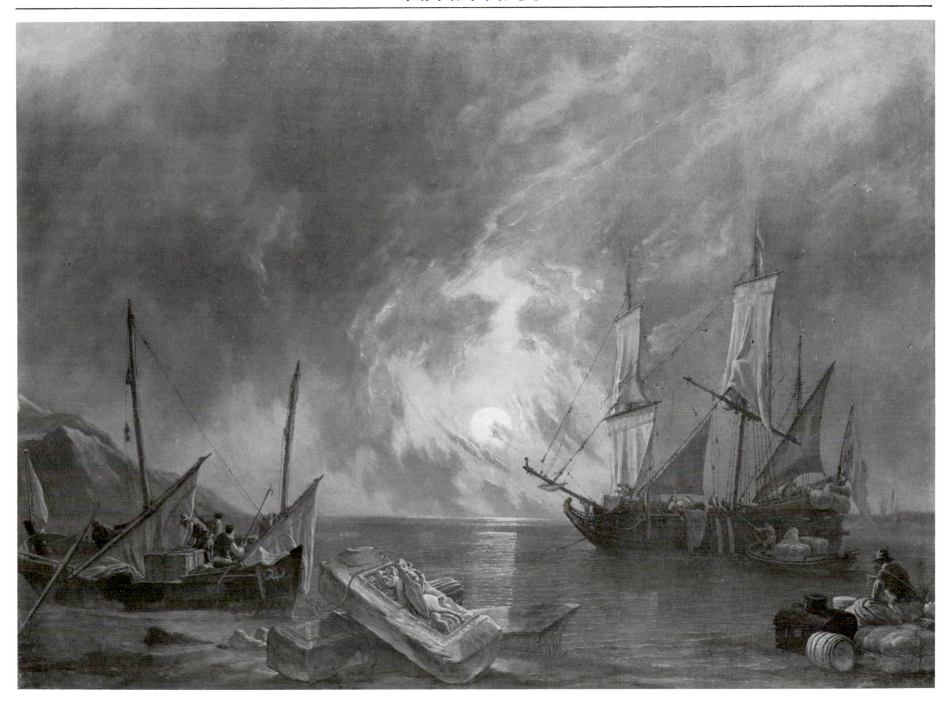

Nystad cites the close relationship between the Lugt painting and a canvas, *Ships in Moonlight,* formerly in the Girardet Collection,[2] that has almost identical measurements – 46 × 66 cm. She also proposes a date of ca. 1660 that accords well with Verschuier's *Shipping* of 1661 in Munich.[3]

NOTES

1. In a parallel vein Verschuier even represented the Fire of London of 1666, in which he depicts the city in flames at night – Budapest, Museum of Fine Arts, inv. 345, repr. W. Bernt, 1962, vol. 3, no. 923. This subject finds parallels in pictures by Aert van der Neer and Egbert van der Poel.

2. Cologne–Rotterdam, *Sammlung Herbert Girardet,* 1970, cat. 61, repr.

3. L. J. Bol, 1973, p. 273, pl. 277.

<div align="center">

44

LIEVE PIETERSZ. VERSCHUIER
The Whaler, "Prince William," on the River Maas, near Rotterdam

</div>

Oil on canvas, 95 × 140 cm
Signed: *L. Verschuier*
United States, private collection

PROVENANCE: London, Collection the Reverend Dr. Jelf, Kings College
London, auction Jelf (Christie) June 1, 1861, lot 21, bought by Graves for 15 gns
Collection William Dickinson (1802–1880)
London, auction Dickinson (Christie) December 5, 1919, lot 149 (withdrawn)
England, private collection
London, auction (Sotheby) April 20, 1988, lot 70, bought by O. Naumann
New York, Gallery O. Naumann

LITERATURE: Dekker and Eggink, 1989.

This important picture represents the return of the whaler *Prince William* from the northern ice seas.[1] By this time whaling had shifted to the form known as ice whaling, in which the whales were killed, brought on board ship on the open ocean, and partially processed. The partially refined blubber was put in barrels and transported to refineries in Holland, where it was refined further into whale oil used for lamps and in the production of soap and candles. The Dutch whaling industry reached its peak in 1680–1725, when as many as 200 to 250 ships participated.[2] The Dutch whaling fleets were accompanied by a warship that protected the whalers from enemy attack. Thus, the admiralties were involved with the Dutch Greenland Fishery Company and its annual harvesting of whales.[3]

The *Prince William* is a modified flute ship with a heavily reinforced, rounded bow to protect it from the danger of icebergs and ice floes. It has a distinctive hoist with two shallops or pinnaces hanging on either side of the stern. The flag on the mainmast has a whale embossed onto the Dutch standard. The vessel flies a prince's flag from the sternpost, Dutch colors on the foremast, and an admiralty flag on the bowsprit. Each ship flying the admiralty flag was under the command and protection of the admiralty placed in charge of the fleet.

The ramparts of Rotterdam appear in the right distance. However, the *Prince William*'s destination was the island of Feijenoort on the opposite shore, where the magistrates of Rotterdam established a whale oil refinery as early as 1649.[4]

Two whaling ships by the name *Prins Willem* are documented. The first

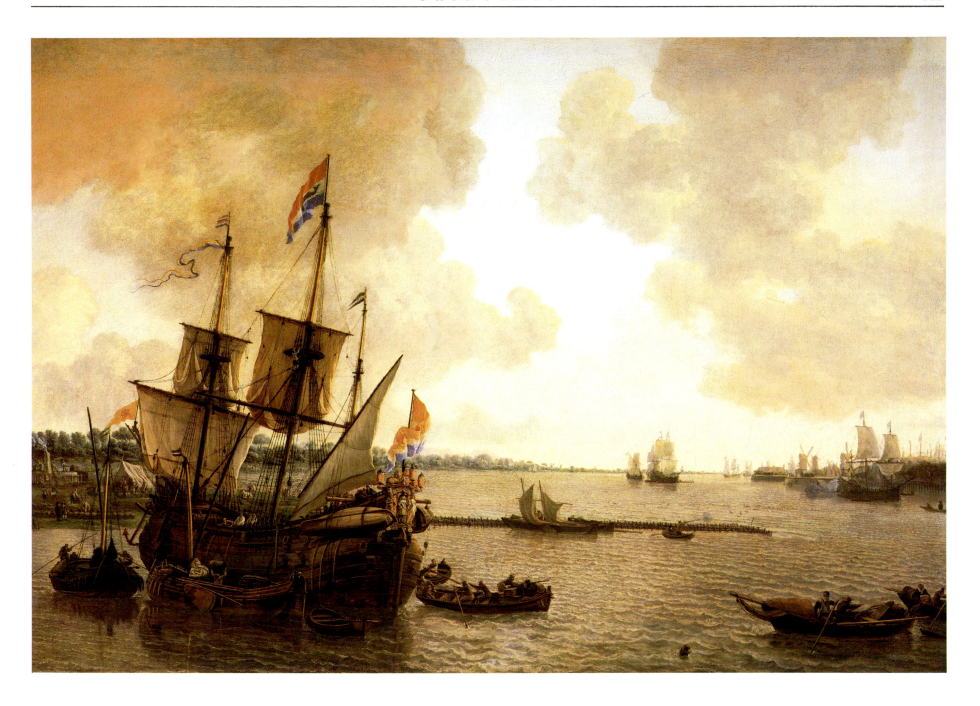

is cited in 1670, and the second is first mentioned in 1682. Each ship originally bore another name but its owner changed it to *Prins Willem*. Dekker and Eggink conjecture that Verschuier probably represented the earlier of these two documented ships and suggest a date of about 1675 for this painting by him.[5]

A closely related picture, also representing a whaler before the island of Feijenoort, is in the Philadelphia Museum of Art.[6] Both paintings represent the subject in warm, late afternoon light. Verschuier represents the slightly ruffled water in a distinctive manner, with each wave highlighted to create a lively linear pattern of rippling waves across the wide expanse of the River Maas.

NOTES

1. This ship has a carved figure on its tafferel. It holds a baton in his left hand and below is the inscription *P WILLEM*.
2. Dekker and Eggink, p. 4.
3. Ibid., p. 7.
4. Dekker and Eggink ascertained that by shortly after 1684 this refinery had disappeared.
5. Ibid., pp. 13–14.
6. Ibid., p. 9, repr.

45

SIMON DE VLIEGER
Admiral van Tromp's Flagship Before Den Brielle

Oil on canvas, 82 × 125 cm
Signed on a spar: *S de Vlieger*
Delft, Stedelijk Museum "Het Prinsenhof," inv. PDS 104

PROVENANCE: Collection Marshall Von Nemes (1927)
Munich, auction Von Nemes (F. Muller) June 1931, lot 63
Amsterdam, auction (F. Muller) November 8–11, 1940, lot 501
Amsterdam, Gallery B. Houthakker (1940–1941)
LITERATURE: L. J. Bol, 1973, p. 186, pl. 189
EXHIBITION: Delft, Stedelijk Museum "Het Prinsenhof," *Hollands Glorie*, 1955, p. 88, cat. 230

This painting represents the Dutch fleet on the River Maas before the town of Den Brielle. The distinctive silhouette of the Grote Kerk (Church of St. Catherine) is visible at the left, between the fore and mainmast of the warship at the left. Marten Harpersz. Tromp's flagship appears at the right. Although the actual event is not documented, this is a mature work by the artist, which Bol dates to the early 1640s.

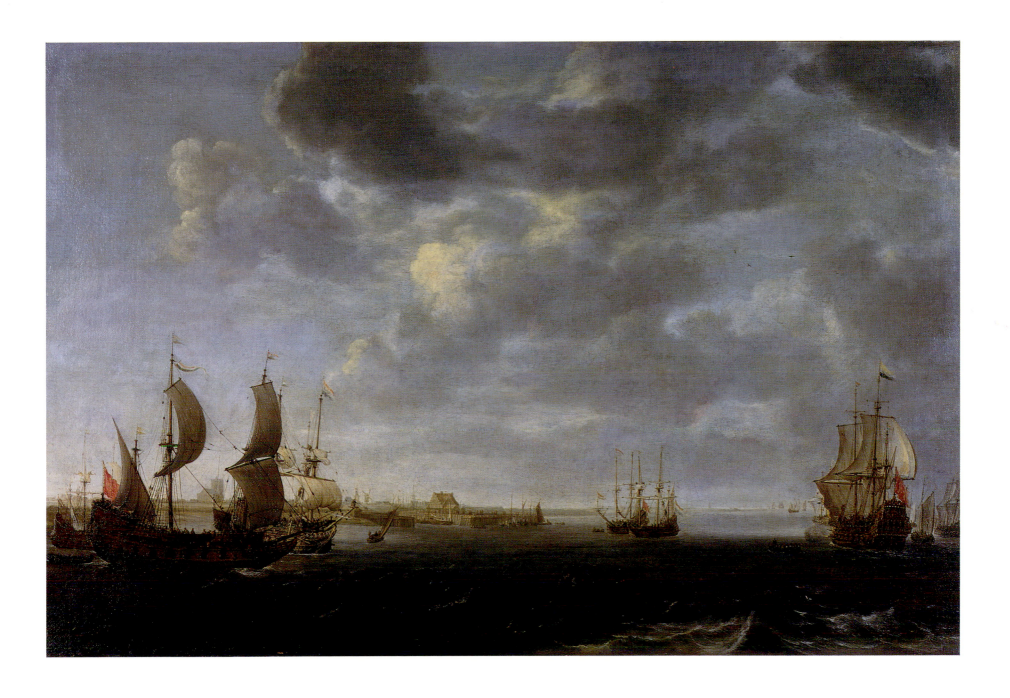

During the 1630s, Simon de Vlieger developed a monochrome style that derived from Jan Porcellis. In works such as his *Marine* in Kassel,[1] de Vlieger stresses the interplay between the choppy sea and expansive gray sky. Following the example set by Porcellis, he devotes more than three-quarters of the composition to the sky. In certain beach scenes such as the celebrated picture of 1633 in Greenwich,[2] de Vlieger refined his monochrome palette to a high key, blond in coloring. He strove for more refined tonal effects in which objects that catch the light seem to glow. During the 1640s, as his palette shifted the artist introduced a greater range of resonant grays, more transparent and silvery in tone. *Admiral van Tromp's Flagship Before Den Brielle* manifests this tendency. Much of the sea is in deep shadow, and the buildup of clouds across the center and right-hand sections of the sky lends further weight to this shift to a deeper gray coloration.

Another unusual feature is the grouping of ships distributed across the scene. The artist breaks up the composition by scattering the ships, which partially screen the distant, low-lying land. De Vlieger has completely re-thought the compositional method of artists like Hendrick Vroom, Cornelis Claesz. van Wieringen, and Adam Willaerts in their representations of fleets arriving at seaports (Cat. 50, 53, 54). Simon de Vlieger opens up the composition by stressing the open foreground with vistas to the far distance framed by ships. Bol notes that the artist introduces piers and jetties as coulisses in a number of paintings from the 1640s.[3] These composing experiments had tremendous impact on younger marine artists including Jan van de Cappelle, Hendrick Dubbels, and Willem van de Velde the Younger.

NOTES

1. L. J. Bol, 1973, p. 181, pl. 180, as from the mid-1630s.
2. National Maritime Museum – L. J. Bol, 1973, pl. 183.
3. Ibid., pp. 184, 186, plates 187, 188.

46

SIMON DE VLIEGER
Ship in Distress off a Rocky Coast

Oil on panel, 55.2 × 78.7 cm
Signed on a rock at lower right: *S. DE VLIEGER*
Milwaukee, Collection of Dr. and Mrs. Alfred Bader

PROVENANCE: Cologne, auction (Lempertz) November 26, 1958, lot 174, repr.
Amsterdam, Collection Hans Wetzlar
Luzern, auction (Fischer) June 26, 1965, lot 2175, bought by A. Bader

LITERATURE: H. Bader, *Selections from the Bader Collection*, Milwaukee, 1974, cat. 29, repr.
Goedde, 1989, fig. 71

EXHIBITIONS: Kalamazoo, Michigan, "Alfred Bader Collection," 1967, p. 17
Kingston, 1984, p. 24, cat. 11, repr.

Simon de Vlieger frequently represented rocky coastlines, but rarely in such tempestuous weather. These are often interpreted as evocations of the rugged coast of Scandinavia, but the presence of monks in the right fore-ground coming to the aid of the sailors struggling through the surf suggests a locale such as Portugal or Spain.[1] Dutch marine painters often represented ships in storms or shipwrecks as metaphors for the human soul subject to

the vicissitudes of life and in need of spiritual salvation. This picture, with its reference to monks, makes the symbolism explicit.

De Vlieger developed a wide repertory of marine subjects and is noted for his calms, beach scenes, *parade* subjects, and storms. Despite the fact that de Vlieger only painted a small number of storms, his contributions to this last category are notable, experimental in their presentation and subject matter. Certain examples represent religious themes, such as *The Storm on the Sea of Galilee*,[2] but his purely secular sea storms are far more successful inventions. These include ships in distress, shipwrecks, ships in gales on the high seas beyond sight of land, and thunderstorms with lightning bolts. *Ship in Distress off a Rocky Coast* includes lightning.[3] Despite the fury of the storm, this picture is filled with light that plays across the whitecaps and the horizon. In subject this picture and Allaert van Everdingen's drawing *A Rocky Coast in Rough Weather,* in Vienna (Cat. 66), have much in common.

Simon de Vlieger was interested in unusual geological phenomenon, such as natural arches emerging from the sea. His painting in Greenwich (fig. a)[4] represents a fleet close to a rugged coastline in calm weather. A much later example, dated 1651, now in a private collection in Montreal,[5] represents a remote and awesome rocky coast that is reminiscent of the landscape drawings of the Tyrolean Alps by Roelandt Savery, which experienced considerable renown in Holland during the seventeenth century.

Jan Kelch proposes a date of about 1645 for *Ships in Distress off a Rocky Coast.*[6] This dating accords well with the silvery-gray tonality and the transparency of the light evident in the work.

Cat. 46, fig. a *Simon de Vlieger,* Dutch Ships off a Rocky Coast, *oil on panel. Greenwich, National Maritime Museum.*

NOTES

1. This subject recalls Carel van Mander's account of Hendrick Vroom's shipwreck off the coast of Portugal – *Het Schilder-Boeck,* 1604, folios 287v–288r.

2. Oakly Park, Collection the Earl of Plymouth – repr. Washington – Detroit – Amsterdam, 1980/1981, pp. 260–261, cat. 74. This catalogue cites two other versions of this theme by de Vlieger including his well-known picture in Göttingen.

3. De Vlieger's storms with lightning include a signed panel at Petworth House (cat. 16, fig. a); *Ships in a Choppy Sea,* panel, 50 × 67.3 cm, signed, formerly Collection Bruce Ingram, Collection Lord Northbrook; *Sailboats in a Storm,* panel, 44.5 × 67.5 cm, signed, formerly Berlin, Gallery Matthiessen (1929), Rotterdam, auction (Van Marle), May 28–30, 1952, lot 76; and *Sailboats in a Thunderstorm,* panel, 41 × 55 cm, formerly The Hague, Collection C. Hofstede de Groot, Luzern, Galerie A. G. (1934), Luzern, auction (Fischer), June 18, 1963, lot 1920, repr. These subjects find a contemporaneous parallel in the oeuvre of Jan van Goyen (e.g., Cat. 16).

4. National Maritime Museum, neg. A 5768, Ingram Collection, oil on panel, 21 ½ × 41 ½ inches, signed and dated: *S DE VLIEGER 1637.*

5. *Landing Party on a Rugged Coast* – see Amsterdam – Boston – Philadelphia, 1987/1988, pp. 514–516, cat. 113, repr.

6. Cited in Kingston, 1984, p. 24.

47

SIMON DE VLIEGER
Sailboats in a Stiff Breeze

Oil on panel, 45.8 × 61 cm
Signed on a spar at bottom right: SVLIEGER
Montreal, Collection of Mr. and Mrs. Michael Hornstein

PROVENANCE: (?) Sir Peter Lely
 Audley End, Collection Lord Braybrook (acquired by 1797)
 London, Thos. Agnew and Son (1980)
LITERATURE: R.J.B. Walker, *Audley End Catalogue*, 1964, p. 18, no. 113

Simon de Vlieger painted this picture during the late 1640s, at the height of his career.[1] The artist creates a forceful counterpoint between the tossing sea and the clouds above, then enlivens the scene by the band of intense light illuminating the mid distance which silhouettes the sailboat at the left and also highlights the jetty and beacon in the right mid distance. De Vlieger evokes strong atmospheric effects, yet these do not obscure detail. The vast expanse of uninterrupted water is enhanced by the distance. Glowing light picks out ships in the distance that further define the extent of the vista. The artist's bold definition of the clouds may indicate an interest in Jan van Goyen's paintings from the 1640s, which offer many points of similarity to de Vlieger's parallel interest in stronger color and clearer light that characterize his marines from the mid-1640s onward.

Stylistically, *Sailboats in a Stiff Breeze* is close to two other marines by de Vlieger. The first, *Shipping Before Rotterdam* (fig. a), in the Royal Museum of Fine Arts in Copenhagen,[2] contains an analogous cloudy sky that fills three-quarters of the composition. The second picture, *A Choppy Sea*,[3] also datable to about 1650, is even more similar in composition to *Sailboats in a Stiff Breeze*. In both marines, overlapping cumulus clouds form a vast canopy across the sky. In *A Choppy Sea* the painter distributes light more evenly throughout the composition and makes no reference to

Cat. 47, fig. a Simon de Vlieger, Shipping before Rotterdam, *oil on canvas. Copenhagen, Statens Museum for Kunst.*

land. The resulting composition differs considerably from that of the Hornstein marine, but there is a similar dynamic counterpoint between the clouds

and the restless motion of the sea. The artist's sensitive interpretation of the interrelationship of wind, wave action, light, and atmosphere in these late marines was a significant source of inspiration for younger painters, such as Willem van de Velde the Younger and Ludolph Backhuysen.

De Vlieger often included jetties in his marines. A fine example from the mid-1640s[4] contains this motif extending from a beach at the left. The entire foreground denotes stability, whereas the jetty in *Sailboats in a Stiff Breeze* is linked to land only by inference. The waves lapping against its wooden pylons and the degree to which the artist isolates this feature in the mid-distance make it more vulnerable to the relentless power of the sea.

NOTES

1. Dr. J. Kelch, in correspondence with Agnew's, proposes a date from the late 1640s – London, Thos. Agnew and Son, *Old Master Paintings and Drawings*, October 21–December 12, 1980, p. 5, cat. 1.

2. Oil on canvas, 107 × 185.5 cm – Royal Museum of Fine Arts, *Catalogue of Old Foreign Paintings*, 1951, cat. 779, repr. This picture is close in style and date to de Vlieger's *Shipping Before Dordrecht* of 1651 in the Fitzwilliam Museum in Cambridge – Fitzwilliam Museum, Cambridge, *Catalogue of Paintings*, vol. 1, 1960, pp. 136–137, inv. 105, pl. 71. The Fitzwilliam painting is closely linked to de Vlieger's late *parade* subjects, but is analogous to *Sailboats in a Stiff Breeze* in its treatment of the cloudy sky.

3. Oil on panel, 58.5 × 82.5 cm, signed on flag of sailboat at the left: *S DE VLIEGER*, exhibited Dordrecht, 1964, p. 34, cat. 97, pl. 50; The Hague, Mauritshuis, "A Collector's Choice", 1982, cat. 92, repr.

4. The Hague, Rijksdienst beeldende Kunst, inv. NK. 2259 – exh. Dordrecht, 1964, p. 34, cat. 98, pl. 54.

48

CORNELIS VROOM
Battle Between Spanish Galleons and Barbary Corsairs

Oil on canvas, 61 × 103 cm
Signed and dated on the mast of the sinking galley: *CVROOM F 1615* (CVR in ligature)
Greenwich, National Maritime Museum, inv. 36–59

PROVENANCE: Collection Sir James Caird by whom bequeathed to the National Maritime Museum
LITERATURE: Archibald, *Sea Fights, Oil Paintings in the National Maritime Museum* 1957, pl. III
Greenwich, National Maritime Museum, *Concise Catalogue of Paintings*, 1958, p. 81
L. J. Bol, 1973, p. 29, pl. 25
Keyes, 1975, vol. 1, pp. 30–32; vol. 2, p. 182, cat. P18, fig. 1
Russell, 1983, p. 187, fig. 169
Haak, 1984, p. 240, fig. 503
EXHIBITION: Rotterdam, 1950, p. 27, cat. 63

This is Cornelis Vroom's earliest surviving dated painting and indicates his origins as a marine painter. Although trained by his father, Hendrick, Cornelis developed a concept of marine painting that differed radically from that propounded by Hendrick Vroom. Hendrick insisted on an absolutely clear narrative presentation to stress the unfolding drama, whereas Cornelis concentrates on its intensity, interpreting the subject as a complex grouping of struggling ships in which each individual combatant is not easily distinguishable from its enemy. While subordinating clarity of detail, Cornelis captures the fury of battle as a phenomenon in and for itself. He projects the narrative directly into the foreground: the struggling sailors aboard the sinking galley seem to spill into the immediate proximity of the viewer. Such turmoil finds an echo in the right distance, where a parallel engagement takes place.

The nature of the subject matter, making no reference to Holland, in-

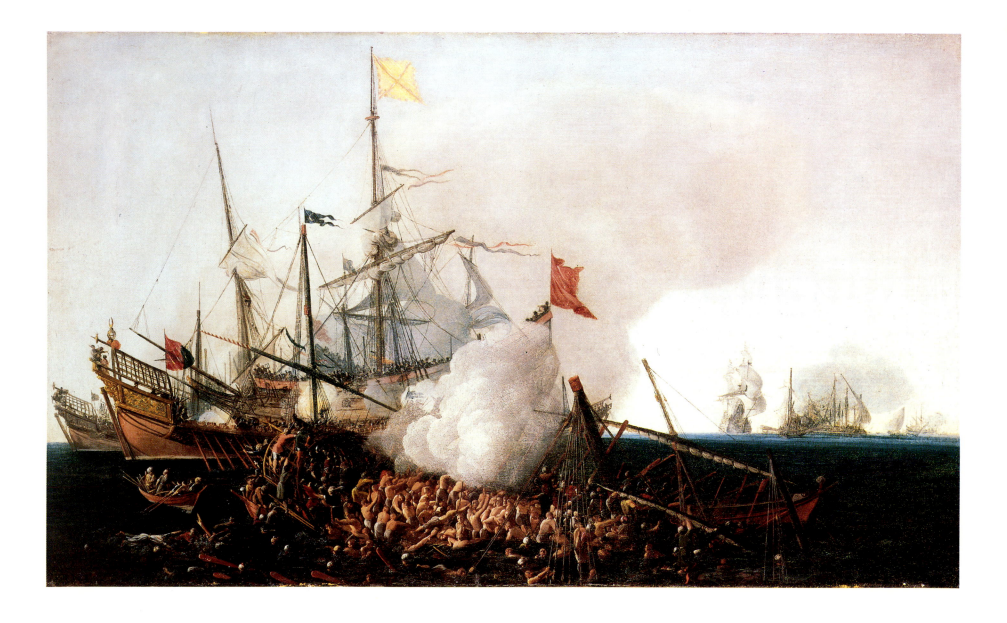

dicates Cornelis's unusual training as an emerging artist. Like his father, he appears to have spent time in Italy, where he came into contact with a different tradition of representing landscape and marine narratives. He became intrigued with subjects such as the *Battle of Lepanto*, which he painted in a large canvas at Ham House (fig. a). Cornelis also produced a large pen drawing of this subject, which is closer in style to his father's characteristic manner yet conforms to the son's narrative instincts.

The *Battle Between Spanish Galleons and Barbary Corsairs* displays an interest in warm light and pervading atmosphere that contrast to Hendrick Vroom's style, in which sharp light and crisp detail predominate. The obscuring effects of smoke are exploited to heighten the sense of battle. In this respect, Cornelis is a precursor of artists like Reinier Nooms, who also attains analogous effects in his marines (for example, Cat. 20).

Cat. 48, fig. a *Cornelis Vroom,* Battle of Lepanto, *oil on canvas. Ham House (The National Trust).*

49

HENDRICK AND CORNELIS VROOM
Battle Between Dutch Ships and Spanish Galleys off the Flemish Coast

Oil on canvas, 117.5 × 146 cm
Signed on foremast flag of the Dutch warship: *VROOM 1617*
Amsterdam, Rijksmuseum, inv. A 460

PROVENANCE: The Hague, National Museum, 1808, transferred to the Rijksmuseum
LITERATURE: Willis, 1911, pl. IV
Martin, vol. 1, 1936, fig. 26
Bernt, 1948, vol. 3, pl. 981
Diekerhoff, 1967, fig. 16
Preston, 1974, pl. 83
Keyes, 1975, vol. 1, pp. 41–42; vol. 2, p. 173, cat. P2, figs. 17–18
Amsterdam, *All the Paintings*, 1976, p. 592, inv. A460, repr.
Maritieme Geschiedenis der Nederlanden, 2, 1977, p. 324, repr.
Russell, 1983, p. 160, fig. 143

This collaborative effort demonstrates the stylistic differences between Hendrick Vroom and his son, Cornelis. Hendrick is responsible for the large Dutch warship and the foreground waves, whereas Cornelis painted the galleys and the distant landscape.

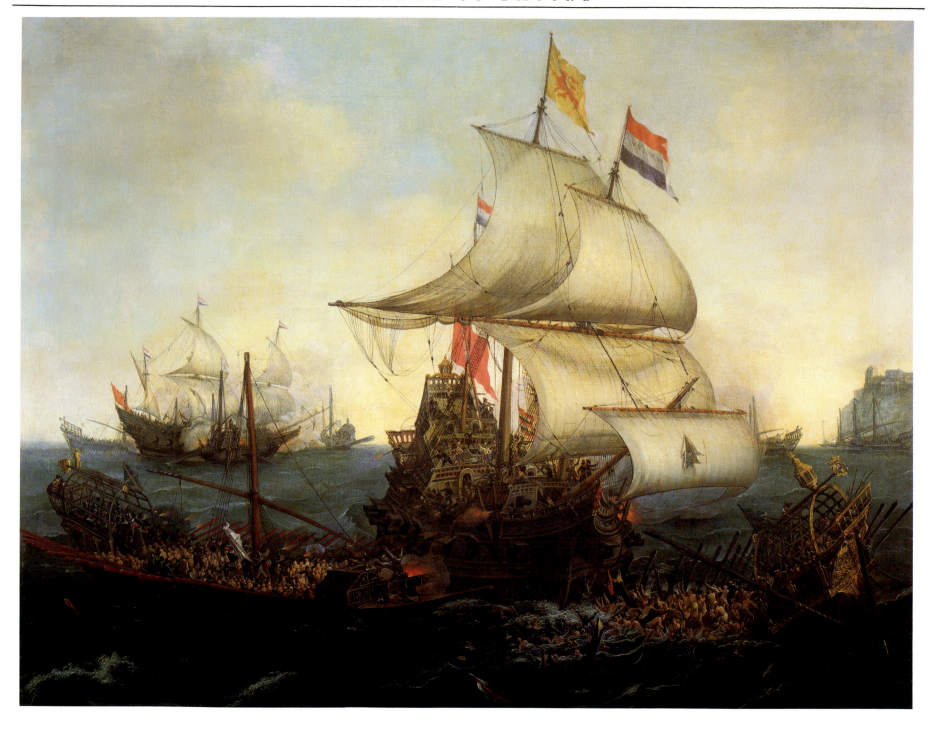

The painting represents an event that occurred off the coast of Flanders on October 3, 1602. Working in concert with the English, a Dutch squadron under the command of Vice Admiral Johan Cant destroyed an attacking fleet of eight Spanish galleys under Frederick Spinola. These galleys were better suited for Mediterranean waters. In this Vroom painting the Dutch warship *Tiger,* commanded by Captain Jacob Pietersz. Mol, has rammed and sunk one of the galleys while repulsing the attack of a second on its starboard flank. This incident typified the hostilities between the United Provinces and the Spanish crown, which continued long after the de facto independence of the Dutch Republic from the authority of the Spanish Hapsburg monarchy.

The southern provinces of the Low Countries remained loyal to Spain and served as a springboard for Spanish military activities against the Dutch. Only in 1609 did the Dutch Republic and Spain agree to a twelve-year truce (1609–1621). Before 1609 both sides pursued military operations against each other. This naval battle was one notable incident, but others of even greater stature included the *Landing at Philippine* (Cat. 122), the *Battle of Nieuwpoort,* and the *Battle of Gibraltar* (Cat. 125).

50

HENDRICK CORNELISZ. VROOM
Return of the Second Dutch Expedition to the East Indies

Oil on canvas, 110 × 220 cm
Signed and dated on shallop at the bottom left: *H Vroom F P Harlem 1599*
Amsterdam, Rijksmuseum, inv. A 2858, on loan to the Amsterdam Historisch Museum

PROVENANCE: Oosterbeek, Collection Kneppelhout
The Hague, Collection Dowager of Jonkheer G. J. Th. Beelaerts van Blokland, née J. M.
 Kneppelhout van Sterkenberg, from whom purchased in 1921

LITERATURE: Baard, 1942, p. 7, repr.
Keyes, 1975, pp. 19, 20, 28, pl. XI
Maritieme Geschiedenis der Nederlanden, 1977, vol. 2, p. 248, repr.
Russell, 1983, pp. 149–152, fig. 134
Haak, 1984, p. 163, pl. 341

This painting represents the return of the second Dutch fleet from the East Indies on July 19, 1599. Under the command of Jacob van Neck, this fleet of eight ships set out in 1598 for east Asia. Four richly laden ships returned with costly spices. The success of the venture inspired the States General of the Dutch Republic in 1602 to establish the Dutch East India Company, a joint stock company heavily underwritten by investors who hoped to realize spectacular returns on their initial investment. Many of these already held shares in existing ventures, such as the Oude Compagnie in Amsterdam, which underwrote Jacob van Neck's fleet.

The goal of Johan van Oldenbarnevelt, the grand pensionary of Holland and political leader of the States General, was to eliminate pointless competition among Dutch joint stock ventures and merge them under a nationally organized East India Company. Thus, the Dutch East India Company (the VOC, or Verenigde Oostindische Compagnie) was organized in six chambers of varying importance contingent on the number of shares invested. These six chambers were established in Amsterdam, Middelburg in the province of Zeeland, Rotterdam, Delft, Hoorn, and Enkhuizen. Amsterdam was allotted 50 percent of the total shares and Zeeland, 25

percent; the remaining four chambers were allotted the balance in equal shares. The VOC was managed by a committee of seventeen – the Heren Zeventien or Heren 17 – who were appointed by each chamber proportional to its percentage of allotted shares. Amsterdam selected eight members, Zeeland four, and the remaining chambers one each. The non-Amsterdam chambers together selected the seventeenth member as a counterbalance to the preponderant role of Amsterdam. Although Amsterdam dominated the enterprise, the return on initial investment assured a tremendous infusion of wealth to all parties involved. The true balance of power reflected the interests of the regent class of the provinces of Holland and Zeeland, whose source of wealth was so symbiotically linked to trade and commerce.[1]

In *The Return of the Second Dutch East India Fleet,* Vroom stresses the fanfare of the citizens of Amsterdam as they welcome the returning fleet and underscores the significant link between the fleet, which personifies overseas commerce, and the city itself. The skyline of Amsterdam appears in the right distance – a reminder that much of the bounty realized from this expedition would enrich the city that had the courage and foresight to invest in this commercial venture.

An inscription on the frame describes the voyage and cites the four ships that returned with their rich cargoes – the *Mauritius,* the *Holland,* the *Overijssel,* and the *Vrieslant.* They ride high in the water, indicating that their cargoes had already been unloaded.

This painting set a standard for the representation of ships before Dutch seaports of the type that Vroom and his emulators produced for years. As Russell notes, it is likely that Vroom painted this picture soon after the event, possibly as a commission from Jacob van Neck or the Oude Compagnie that underwrote this fabulously successful commercial venture.[2]

NOTES

1. This information is drawn from *Maritieme Geschiedenis der Nederlanden,* 1977, vol. 2, pp. 251–253.
2. Russell, 1983, p. 152.

51

HENDRICK CORNELISZ. VROOM
Skirmish Between Dutch and English Warships

Oil on canvas, 155 × 240 cm
Signed and dated on foremast flag of the Dutch warship: *VROOM 1614*
Amsterdam, Rijksmuseum "Nederlands Scheepvaart Museum," inv. A2

PROVENANCE: Amsterdam, auction (F. Muller) 1917
LITERATURE: 't Hooft and de Balbian Verster, 1916/1917b, p. 36; 1919, vol. 3, p. 61
L. J. Bol, 1973, p. 19, pls. 12–14
Russell, 1983, p. 160, fig. 142

Skirmish Between Dutch and English Warships is one of Vroom's most spirited and important pictures. It represents an incident of April 20, 1605, when ships of the Amsterdam admiralty refused to salute an English warship in English territorial waters. The large Dutch man-of-war has a prince's flag on its mainmast and flies the Dutch standard on its foremast. The large red flag on its sternpost indicates its state of readiness to engage the English ship. Its crew is fully galvanized. A drummer and a trumpeter call the men to arms while the ship's commander stands with upraised sword on the poop deck.[1] Musketeers on deck fire on the English ship, and cannons are ablaze. Vroom sets the action on a restless sea with whitecaps. A large fish

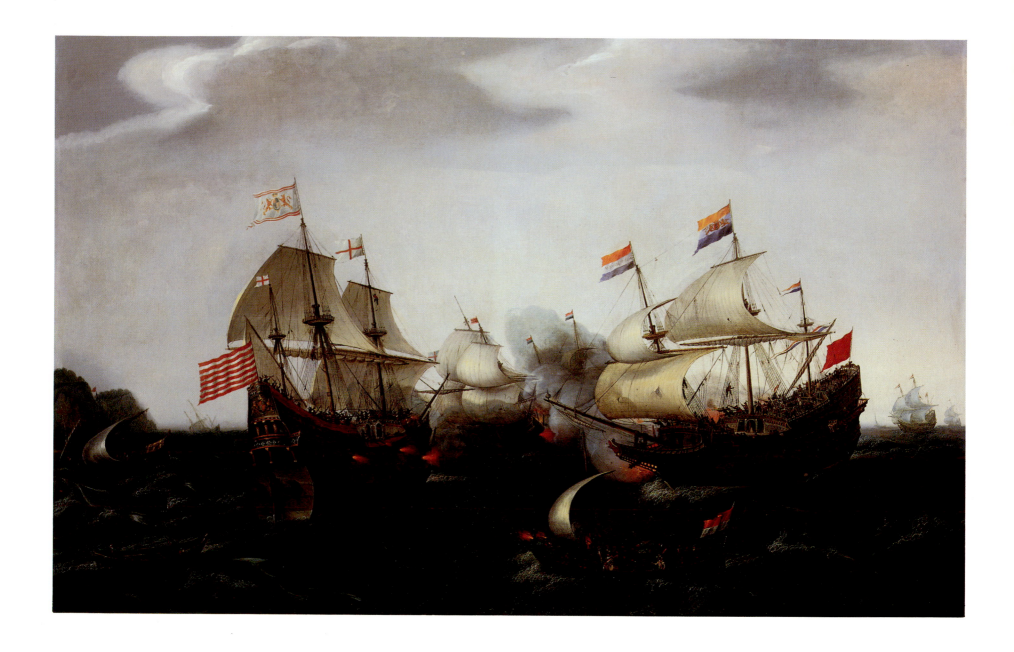

appears in the right foreground, and may embody the mysterious and forbidding character of the sea, which held constant terror for shipwrecked or stranded sailors.

Vroom's painting addresses an issue of great importance to the Dutch – the freedom of the seas. The Dutch operated vast herring fisheries, many along the coast of Scotland. Their presence became a perennial source of irritation to James I of England, who felt that the Dutch should respect English claims for territorial waters along its coast. The English claimed the prerogative of territorial waters, which the Dutch adamantly refused to recognize. One of the most brilliant legal minds of the seventeenth century, the Dutchman Hugo de Groot (Grotius), wrote his famous treatise

Mare Liberum, first published anonymously in 1608, in which he argues for the freedom of the seas. This subject, which lay at the root of Anglo-Dutch rivalry throughout the seventeenth century, is still a topical issue in contemporary international affairs.[2]

NOTES

1. As L. J. Bol notes, this proved to be a particularly dangerous place to stand. The Dutch admirals Marten Harpertsz. Tromp (see Cat. 8) and Michiel de Ruyter were both killed in battle while commanding their ships from the poop deck – L. J. Bol, 1973, p. 19.

2. For example, expanded claims for territorial waters was a major issue sparking the recent Falklands War. Likewise, national sovereignty exercised over vastly expanded territorial waters is principally motivated by an individual country's quest for exclusive control of expanded fishing territories and for oil and mineral deposits lying beneath the sea.

52

HENDRICK CORNELISZ. VROOM
View of Hoorn

Oil on canvas, 105 × 202.5 cm
Signed on flag of ship at left: *VROOM*
Hoorn, Westfries Museum

PROVENANCE: Commissioned by the city magistrates of Hoorn in or before 1622
LITERATURE: Willis, 1911, pp. 19–20
L. J. Bol, 1973, p. 26, pl. 21
Russell, 1983, pp. 172–173, fig. 156
Haak, 1984, p. 179, pl. 367

Hendrick Vroom received payment of 100 guilders for this picture from the magistrates of the city of Hoorn on June 27, 1622. It dates from approximately the same period as Vroom's *Arrival of Frederick V of the Palatinate in Vlissingen* of 1623, now in the Frans Hals Museum in Haarlem (fig. a). Both rank among the artist's supreme representations of seaports in profile view. Although the skyline of Vlissingen is painted in greater detail with a more diverse panoply of ships before it, Vroom's *View of Hoorn* is a particularly felicitous composition.[1]

The painter includes fewer ships on the roads before Hoorn and thus

provides an uninterrupted vista of the city profile along the horizon. Except in the foreground, the sea is in light, which creates a foil for the city profile that pierces the glow of the horizon. The sky shifts to a deeper blue above, the clouds subtly blending into it. Two large ships, almost reverse images of each other, frame the distant city. One, at least partly laden, departs from Hoorn and sails toward the viewer, and a second at anchor has been unloaded and floats high on the water. On its tafferel this ship bears the crest of Hoorn: a shield with a large powder horn carved on it.[2]

Vroom's interest in accurate representations of city profile views in the

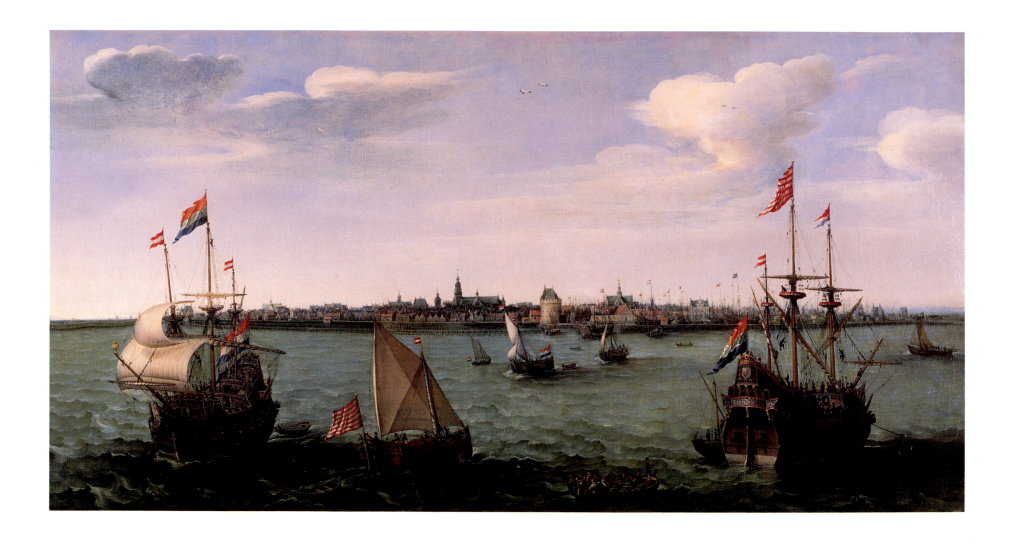

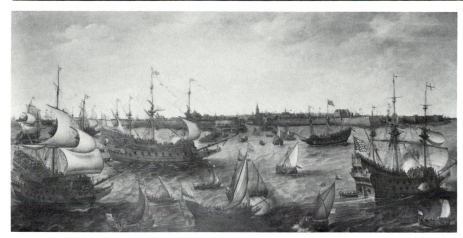

Cat. 52, fig. a Hendrick Vroom, The Arrival of Frederick V of the Palatinate in Vlissingen, *oil on canvas. Haarlem, Frans Hals Museum.*

backgrounds of his marines can be traced back to his early career. Even in his Middelburg tapestries, forts in the Scheldt estuary are carefully represented. In his early marine paintings Vroom includes vistas of Amsterdam

seen from the River Ij.[3] Hendrick Vroom's interest in urban topography continued throughout his career with notable views of Alkmaar, Delft, Veere, and Vianen.[4] His interest found contemporary parallels in the engraved profile views of Dutch and Frisian cities by Pieter Bast (Cat. 100), well-known views by Claes Jansz. Visscher (Cat. 101), and the important anonymous *Profile View of Amsterdam,* dated 1606, published by Willem Jansz. Blaeu.[5] This tradition continued to attract adherents throughout the seventeenth century. Examples in the exhibition include Ludolph Backhuysen's *Shipping Before Amsterdam* (Cat. 5) and Romeyn de Hooghe's *Groundplan and Profile View of Rotterdam* (Cat. 104).

NOTES

1. I am extremely grateful to Rob Kattenburg, who has kindly provided funding to have this picture conserved and cleaned. It is now free from a yellowed and discolored varnish that obscured the beauty of this important work.

2. These features are discussed by L. J. Bol, 1973, p. 26.

3. See Cat. 50 and a second *View of Amsterdam* recently acquired by the Amsterdam Historisch Museum – Russell, 1983, fig. 149, which she dates to about 1605.

4. L. J. Bol, 1973, pls. 20, 22–24.

5. M. Russell, 1983, fig. 177.

53

CORNELIS CLAESZ. VAN WIERINGEN
The Arrival of Frederick V of the Palatinate in Vlissingen on May 5, 1613

Oil on canvas, 110 × 215 cm
Signed on a spar at the lower left: *C C WIERINGEN*
Haarlem, Frans Hals Museum, inv. 308

PROVENANCE: Probably Haarlem, Old Men's Almshouse (commissioned in 1628)
LITERATURE: A. van der Willigen, *Les Artistes de Haarlem,* 1870, p. 334
L. J. Bol, 1973, pp. 31–33, pls. 28, 29
Keyes, 1979, pp. 4–5, pl. 3
Russell, 1983, p. 274, fig. 157
Hoogsteder, 1986, vol. 1, pp. 222, 227, vol. 3, pl. 217

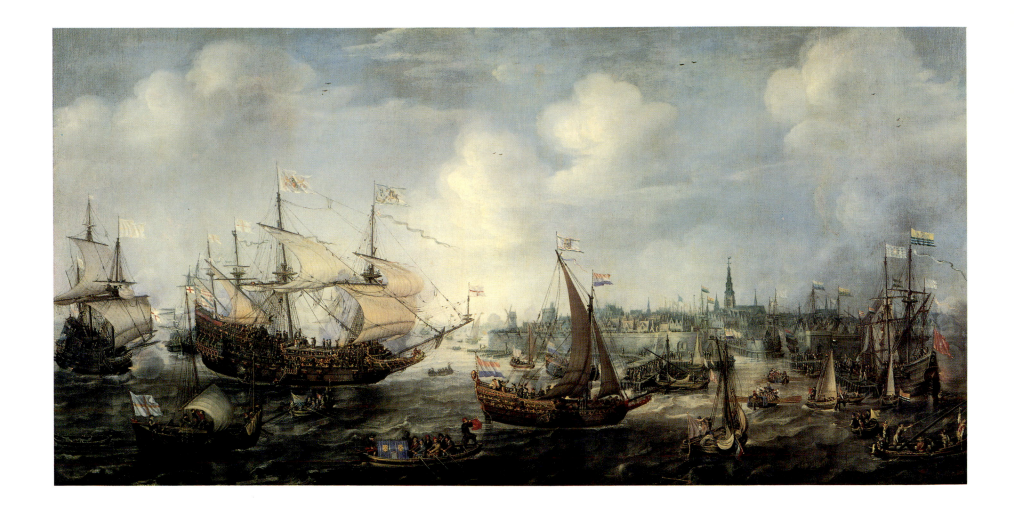

Van Wieringen represents Frederick V of the Rhenish Palatinate (1596–1632), accompanied by his wife, Elizabeth (1596–1662), daughter of James I of England, arriving in the Dutch seaport of Vlissingen (Flushing). The German princes of the Protestant League perceived this marriage as forging an important political alliance assuring English support for the Protestant cause in central Europe. In their eyes, Frederick was their acknowledged leader. Moreover, he was the grandson of William the Silent, thus explaining the strong family ties between him and the Orange Nassau stadholders of the Dutch Republic. After some delay caused by unfavorable weather, Frederick and his consort set sail from Margate with the English fleet and arrived in the roads of Flushing on May 5, 1613, where they were received amid much fanfare by the states of Holland and Zeeland and by Frederick's uncle, Prince Maurice. Following a triumphal tour through the United Provinces, Frederick and Elizabeth arrived in Heidelberg, the seat of Frederick's domain.

In a few years, events in central Europe transformed Frederick's position. Matthias, the Holy Roman Emperor and king of Bohemia, died in 1619. The Bohemian Protestant estates deposed Matthias's designated heir, Archduke Ferdinand — subsequently to become Holy Roman Emperor — and offered the crown of Bohemia to Frederick. He accepted and was crowned in Prague on November 4, 1619. Ferdinand perceived this as an act of provocation and sent an army to challenge Frederick. At the Battle of White Mountain in 1620, Frederick was defeated and was forced to flee from Bohemia. The following year the imperial armies drove him from the Palatinate as well, and he went into exile in the Dutch Republic. There, he and Elizabeth became members of the stadholder's court in The Hague. Frederick and Elizabeth also built a palace in the town of Rhenen, east of Utrecht.[1]

The *Arrival of Frederick V in Vlissingen* was a popular theme for Dutch marine painters including Hendrick Vroom, Adam Willaerts (Cat. 54), van Wieringen, and Jan Pietersz. van de Venne. The subject involved much fanfare, and the impressive display of the English navy with the four-masted *Prince Royal* under the command of the Lord High Admiral provided the principal focus of the occasion. Despite the festive pomp, this subject held deeper meaning for the Dutch. Virtually all of the representations of the subject postdate 1620, the year in which Frederick V was deposed as king of Bohemia. His political demise initiated the phase of the Thirty Years War that evolved into a religious struggle between the Protestants and Roman Catholics of central Europe. As this escalated other major European powers including Sweden, France, and the Dutch Republic became involved. For the Dutch the Thirty Years War merged with their protracted struggle against the oppression of Spain and its Inquisition in the Low Countries. Frederick became an embodiment of the Protestant cause.

Van Wieringen's version of the *Arrival of Frederick V in Vlissingen* is inspired by Hendrick Vroom's huge picture of 1623,[2] also in the Frans Hals Museum (Cat. 52, fig. a).

NOTES

1. I am much obliged to Joaneath Spicer, whose forthcoming study of Adam Willaerts contains an extensive discussion of Frederick's political circumstances. Despite the twist of fate that shunted Frederick from the center of the political stage of Europe, he and his progeny were to be of considerable consequence to the future destiny of more than one European country. His sons Karl Ludwig and Rupert subsequently became prominent figures in Restoration England. Karl Ludwig was instated as Elector of the Palatinate. Prince Rupert, in particular, was a popular and important figure in the court of Charles II. He also followed a distinguished career as an admiral in the British Royal Navy. He participated in the Four Days' Battle and was the commander in chief of the allied fleet at the Battle of the Texel. Frederick and Elizabeth's daughter, Sophie, married Ernst Ludwig of Braunschweig-Luneburg, Duke of Hannover, in 1658. Their son became George I of England following the death of Queen Anne, whose children all predeceased her.

2. L. J. Bol, 1973, pls. 15–18.

54

ADAM WILLAERTS

The Arrival of Frederick V, Elector of the Palatinate, in Vlissingen on May 5, 1613

Oil on canvas, 123.5 × 236.5 cm
Signed and dated on flag of sailboat second from right: *A Willarts f/162(3)*
Europe, private collection

LITERATURE: Hoogsteder, 1986, vol. 1, p. 223

For discussion of the *Arrival of Frederick V, Elector of the Palatinate, in Vlissingen* and his subsequent residence in the Dutch Republic, see Cat. 53. This picture is one of three large-scale depictions of this subject by Adam Willaerts,[1] which, in turn, are linked to closely related representations of the *Departure of Frederick V and his Wife, Elizabeth Stuart, from Margate*.[2] W. J. Hoogsteder, in his discussion of Frederick V and Elizabeth of Bohemia as art collectors, conjectures that the *Departure from Margate* in the Royal Collection and the exhibited version of the *Arrival in Vlissingen* may be companion paintings.[3] In *The Arrival of Frederick V, Elector of the Palatinate, in Vlissingen,* the English fleet hovers several miles offshore. The largest ship, the *Prince Royal*, was built by Phineas Pett in honor of Henry, Prince of Wales, whose personal coat of arms decorates the stern. The ship's sides are decorated with crowns surmounted by three plumes alternating with the lettering *H. P.* (Henricus Princeps).[4] A gangplank has been lowered from its port side, and three manned galleys row the dignitaries ashore to Vlissingen, which appears in the left distance. The English fleet consisted of seven ships, but many Dutch ships and sailboats cluster around it.

The most impressive single representation of the *Arrival of Frederick V, Elector of the Palatinate, in Vlissingen* is Hendrick Vroom's huge canvas of 1623 (Cat. 52, fig. a), now in the Frans Hals Museum in Haarlem.

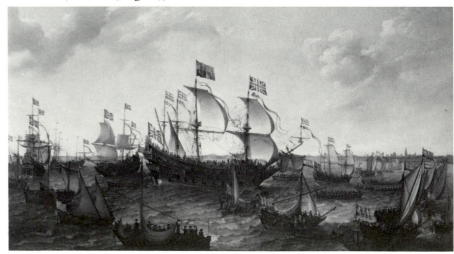

Cat. 54, fig. a Adam Willaerts, *Arrival of Frederick V, Elector of Palatinate, in Vlissingen*, oil on canvas. Greenwich, National Maritime Museum.

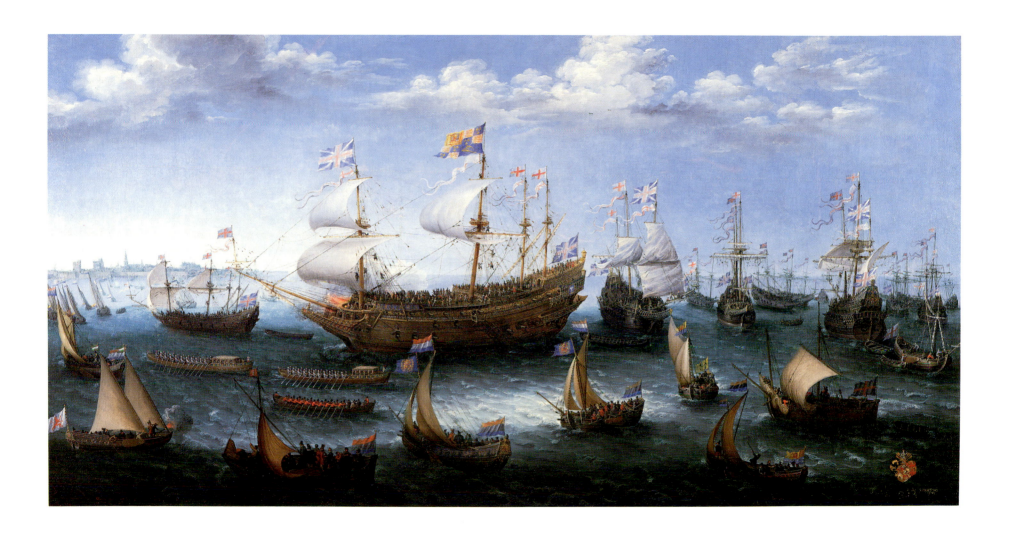

Curiously, many treatments of this subject date from 1623, and Hoogsteder believes that many were commissions to commemorate the tenth wedding anniversary of Frederick and Elizabeth.[5] Van Wieringen's painting (Cat. 53) is clearly indebted to Hendrick Vroom. Willaerts has formulated a different interpretation of his own invention: In it, the English fleet remains farther from the port of Vlissingen, which he relegates to the distant horizon. In arriving at his solution, Willaerts relies on his own related compositions. With this *Arrival of Frederick V, Elector of the Palatinate, in Vlissingen,* he recapitulates the same central triad of English ships that appear in his *Departure of Frederick and Elizabeth from Margate* (fig. b) in the National Maritime Museum in Greenwich. The number of unfurled sails of the *Prince Royal* and the ship to its stern are virtually identical. Only the smaller four-masted ship off the bow of the *Prince Royal* has its sails trimmed differently.

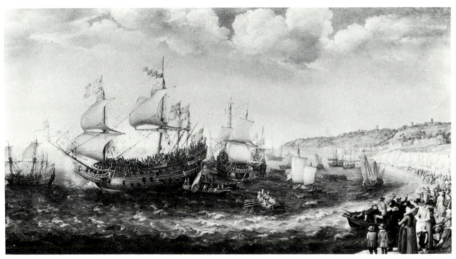

Cat. 54, fig. b Adam Willaerts, Departure of Frederick V of the Palatinate and his Wife, Elisabeth Stuart, from Margate, *oil on panel. Greenwich, National Maritime Museum.*

NOTES

1. The other two paintings are in the National Maritime Museum in Greenwich (ex. Lords Craven, heirs of Elizabeth of Bohemia – fig. a) and in Lisbon.

2. Paintings of this subject are in the National Maritime Museum in Greenwich, the Royal Collection in London, canvas, 122 × 197 cm, and a panel, 78 × 138 cm, London, auction (Christie) March 31, 1933, lot 119.

3. W. J. Hoogsteder, 1986, vol. 1, pp. 223, 227, 228.

4. The *Prince Royal* was launched in 1610 and carried fifty-four guns on its three decks. This was the largest four-masted ship of its time, but proved to be a poor sailor and rarely participated in major actions. For further discussion of the *Prince Royal* and the confusion evident in the various representations of this ship by Dutch artists in terms of the colors it flies in their paintings, see the forthcoming study by J. Spicer, "Conventions of the Extra-ordinary: Savery, the Willaerts and the Attractions of *Variety.*"

5. Hoogsteder, 1986, pp. 219, 226–228. These could have been commissioned by certain cities of the Dutch Republic that had close associations with Frederick and his consort.

55

ADAM WILLAERTS
Christ Preaching from the Boat

Oil on panel, 57 × 87.5 cm
Signed on the ground at bottom left: *A Willarts 1621*
Turin, Italy, private collection

PROVENANCE: Collection Rawdon St. John Jackson
London, auction St. John Jackson (Sotheby) December 10, 1975, lot 106, repr.
London, Richard Green Gallery (1976)
Zurich, Gallery Bruno Meissner

LITERATURE: A. Zwollo, 1983, Vol. 31, p. 408

This picture by Willaerts is one of several depicting religious subjects painted by the artist. They provide a crucial link to the religious origins of marine painting as practiced by Netherlandish artists of the sixteenth century, including Pieter Aertsen, Joachim Beukelaer, Maerten van Heemskerck, and others. Willaerts follows their lead by placing the religious theme in a secular context. He has reduced the detail of Christ preaching to a small component within a large and diverse composition. Although a large crowd has gathered on the shore to listen to Christ, many other peasant figures in the foreground ignore this event and continue their workday activities. This interpretation of Christ preaching is inspired by Pieter Bruegel the Elder, whose *Preaching of the Baptist* in Budapest, although it contains larger-scale figures relative to the landscape, also includes many spectators who seem uninterested in the Baptist's message.

Willaerts based his New Testament narrative on Matthew 13:2 and Mark 4:1 but set the subject into a purely imaginary setting with pinnacle rocks, wooden buildings, and other structures in stone that are patently not Dutch in style (although the sailboats and ships are). Moreover, these buildings do not attempt to evoke the type of architecture associated with the Holy Land. In creating exotic buildings Willaerts relied on the art of Roelandt Savery, who produced many drawings representing the Tyrolean Alps and scenes in and near Prague, where he worked for Emperor Rudolph II. Savery brought much of this material back with him to Utrecht, where he permanently settled in 1619, and must have shared it with his confreres in the city.[1]

Christ Preaching from the Boat was Willaerts's preferred religious subject. In one version, now in the Centraal Museum in Utrecht, the artist represents the religious narrative in much closer proximity to the viewer than in the exhibited picture.[2] *Christ Preaching on the Sea of Galilee* (fig. a),[3] in the Bowes Museum in Barnard Castle, is similar in composition to the Utrecht painting with Christ's boat in a bay at the center and crowds gathered at the right before jutting pinnacle rocks.

A second painting in the Centraal Museum represents *The Apostle Paul Shipwrecked on Malta* (fig. b) and is dated 1621.[4] Willaerts divides the composition into two compartments. The left foreground contains figures

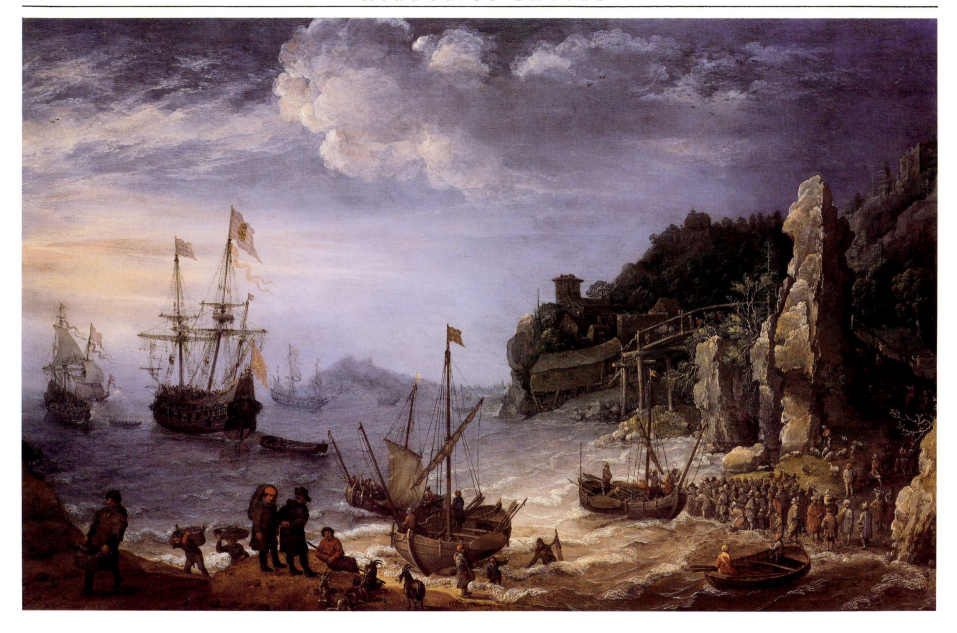

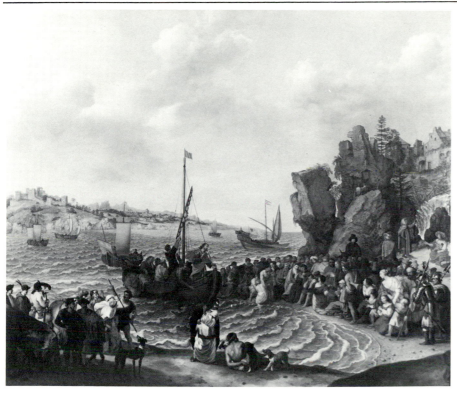

Cat. 55, fig. a Adam Willaerts, Christ Preaching on the Sea of Galilee, *oil on canvas.*
Barnard Castle, Bowes Museum.

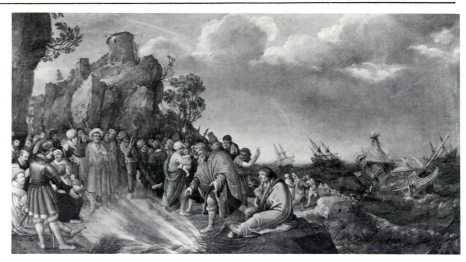

Cat. 55, fig. b Adam Willaerts, The Apostle Paul Shipwrecked on Malta, *oil on canvas.*
Utrecht, Centraal Museum.

gathered around a fire on the shore. Beyond at the right he depicts ships in distress in a tumultuous sea.[5] Willaerts often relied on this two-pronged compositional structure when producing marines with a religious or historical narrative. Although most noted for this type of marine theme, Willaerts also painted subjects such as beach scenes, ships in storms, and fleets off foreign shores. These were free from the compositional restraints imposed by the religious or historical subjects, and conform more closely to the images of painters such as Hendrick Vroom.[6]

NOTES

1. For further discussion of Willaerts's relationship to Roelandt Savery, see the forthcoming article by J. Spicer, "Conventions of the Extra-ordinary: Savery, the Willaerts and the Attractions of *Variety.*" I am much obliged to Dr. Spicer for sharing her manuscript with me.

2. This work dates later than the picture in Turin, and the figures appear to be by a collaborator.

3. Oil on canvas, 140 × 168 cm.

4. Centraal Museum, *Catalogus der Schilderijen*, 1952, no. 343, canvas, 141 × 258 cm.

5. In producing this type of religious painting, Willaerts may have been influenced by the German painter Adam Elsheimer, who represents the narrative in a similar manner, albeit as a nocturne, in his painting in the National Gallery in London – Andrews, 1977, cat. 10, pl. 30. Hendrick Goudt of Utrecht, a friend and patron of Elsheimer in Rome, owned several of Elsheimer's paintings and also produced several reproductive engravings after certain of Elsheimer's most celebrated subjects.

6. The most wonderful of these are two purely secular sea storms, both in an oval format, now in the Rijksmuseum in Amsterdam and in the National Maritime Museum in Greenwich (reproduced on p. 78). Both are painted on panel but, unfortunately, are so fragile that neither could be included in the current exhibition.

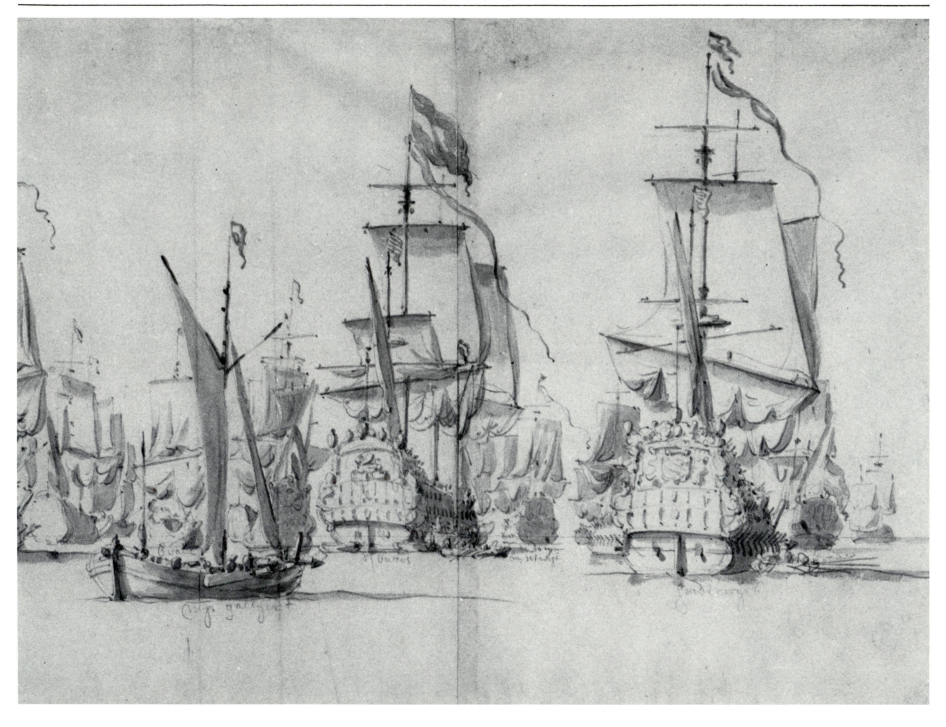

DRAWINGS

56

LUDOLPH BACKHUYSEN
The "Amsterdam" Under Sail by a Harbor

Brush, black ink, and gray washes over faint indications in graphite, 268 × 362 mm
Signed on barrel at left: *L.B.* and dated on mainmast flag of the *Amsterdam: 1688*
New York, The Pierpont Morgan Library, inv. III. 220

PROVENANCE: Amsterdam, Collection Cornelis Ploos van Amstel (L. 2034, 3003–3004)
Amsterdam, auction C. Ploos van Amstel, March 3, 1800, album P, no. 1, bought by Yver for fl. 305
Collection Robert Stayner Holford (L. 2343)
London, auction Holford (Christie) July 11–14, 1893, lot 616, bought by Davis for £10
London, Collection Charles Fairfax Murray
New York, Collection J. Pierpont Morgan
LITERATURE: Fairfax Murray, 1905–1912, vol. 3, no. 220, repr.
EXHIBITION: Paris–Antwerp–London–New York, 1979/1980, pp. 158–159, cat. 119, repr.

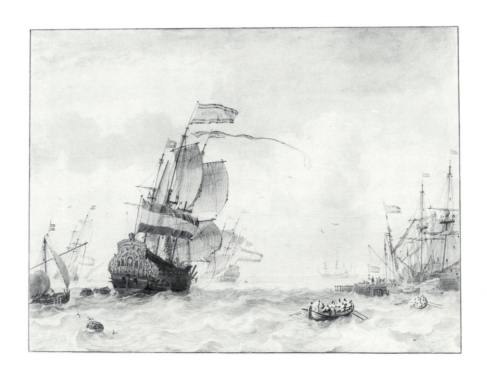

This drawing is an outstanding example of Backhuysen's highly finished brush and wash technique. The attention to detail, the subtle modulation of light and shadow playing across the choppy water, and the range of clouds lend great character to what the artist conceived as a finished art work in its own right. Such drawings were eagerly sought after by discerning collectors and sustained their popularity as collectors' items well into the nineteenth century.

Backhuysen produced many such large, highly finished drawings, including several notable examples from the 1680s. A closely related sheet from 1684 in the Rijksmuseum "Nederlands Scheepvaart Museum" in Amsterdam[1] contains a warship in virtually the same position as that in the Morgan Library drawing.

As Stampfle points out, the ship *Amsterdam* in the Morgan Library drawing differs from that in Backhuysen's etching of 1701 (Cat. 97). The most obvious difference is the sculpted figure of Hercules standing in a niche below the crest of Amsterdam in place of the figure of Atlas on the tafferel of the *Amsterdam* that appears in the etching.[2] Whether Backhuysen modified the ship's ornamental stern design for his etching or truly represented a different ship *Amsterdam,* remains to be established, but Backhuysen, unlike the Willem van de Veldes, did not always strive for the same degree of accuracy, but allowed his imagination greater play.[3]

NOTES

1. Amsterdam, 1985, cat. T14, repr.

2. Paris – Antwerp – London – New York, 1979–80, p. 158, based on information kindly provided by M. S. Robinson.

3. See R. Vorstman, in Amsterdam, 1985, pp. 17–20, 35.

57

LUDOLPH BACKHUYSEN
Ships Before a Hilly Coast

Brush, brown ink, and wash over graphite, 150 × 273 mm
Signed at bottom right: *LB* and on hull of sailboat at right center: *LB*
Berlin-Dahlem, Kupferstichkabinett, Staatliche Museen, Preussischer Kulturbesitz, inv. Z105

LITERATURE: Bock and Rosenberg, 1930, p. 74, pl. 61
Amsterdam, 1985, p. 94, repr.
Nannan, *Ludolf Backhuysen,* Emden, 1985, p. 142
EXHIBITION: Berlin, 1974, p. 4, cat. 9, pl. 112

This highly finished pen drawing is closely related to several works dating from about 1680 that represent the English coast near Plymouth. A drawing dated 1679 in the British Museum[1] is a study for a picture of 1680 now in Munich, which M. S. Robinson has identified as representing the arrival in Plymouth of Charles II in his royal yacht in August 1677. The king was the guest of Sir Richard Edgcumbe, whose family house dominates the bluff

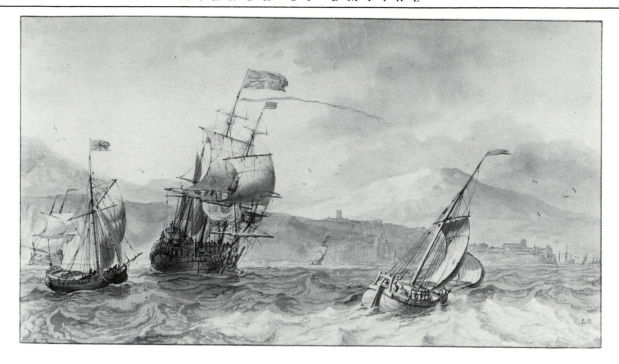

of Mount Edgcumbe before Plymouth.[2] In the Berlin drawing Backhuysen
has created a more summary mountainous backdrop reminiscent of that
beyond the Roads of Plymouth. He has also replaced the yacht with a large
English warship.[3]

A second drawing, dated 1679, in Darmstadt, represents *Ships Before
a Mountainous Coast* (fig. a) and is closely related in style and subject to
these representations of the rugged coast of Devon. Backhuysen rarely
represented foreign scenes and, unlike Storck or Nooms, who frequently
depicted Mediterranean subjects, Backhuysen restricted his field to Eng-
land, with the exception of drawings in which he represents ships before
the harbor of Rhodes.[4]

<center>NOTES</center>

1. Amsterdam, 1985, cat. T9, repr.

2. Backhuysen returned to this theme in his picture of 1693 in Schwerin, inv. 94 – repr. Am-
sterdam, 1985, cat. S31.

3. B. Broos, in ibid., 1985, p. 94, draws similar conclusions in discussing the closely related
drawing in the Historical Museum, Amsterdam, cat. T10, which he dates to ca. 1680.

4. Amsterdam, 1985, cat. T28.

Cat. 57, fig. a Ludolph Backhuysen, Ships before a Mountainous Coast, *brush, gray
ink, and wash. Darmstadt, Hessisches Landesmuseum.*

58

LUDOLPH BACKHUYSEN
Battle of La Hogue, May 29, 1692

Pen, black ink, and gray washes, 204 × 296 mm
Signed and dated at upper left: *Ludolph Bakhuysen ft 1692*
Brussels, Koninklijke Musea voor Schone Kunsten van België, Collection de Grez, no. 132

PROVENANCE: Dordrecht, Collection L. Dupper
Dordrecht, auction Dupper (Roos) June 28–29, 1870, lot 9, bought by J. de Grez
Brussels, Collection Jean de Grez
LITERATURE: *Inventaire des dessins et aquarelles donnés à l'Etat Belge par Mme la douairière de Grez,*
 1913, cat. 132
EXHIBITIONS: Amsterdam, 1985, p. 80, fig. 5
Brussels, 1971, pp. 56–57, cat. 65, repr.

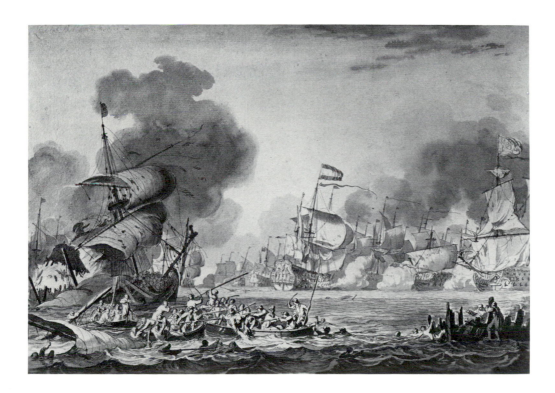

This drawing is a study for Backhuysen's painting in Dresden of the same subject.[1] James II of England, who fled to exile in France in 1688, envisaged invading England and deposing William III, the usurper of his throne. Louis XIV encouraged James's ambitions and provided an invasionary fleet, which sailed from Brest on May 17, 1692. Forty-four French ships under Admiral Tourville encountered the much larger Anglo-Dutch fleet of ninety-nine ships under the command of Admiral Russell. They met off Cape Barfleur to the northeast of Normandy's Cotentin Peninsula. The French were badly mauled during the initial battle, and most of the rest of James II's fleet was destroyed in the Bay of La Hogue on May 23–24. A Dutch warship at the center distance flies a prince's flag above a wimple. A French ship appears at the right, and exploding and sinking ships in the left foreground add to the mayhem.

Following the Glorious Revolution of 1688, William III was able to combine the naval might of England and the Dutch Republic to ward off the threat of France. The decisive Anglo-Dutch victory on May 29, 1692, at La Hogue eliminated the ambitions of Louis XIV to invade England. This battle was one of the last in which the Dutch navy played a major role. William used the Dutch forces to aggrandize English naval power over the French as these two rapidly growing nation states struggled for ascendancy during the late seventeenth century.

NOTE

1. Inv. 1641, HdG 33.

59

LUDOLPH BACKHUYSEN
Amsterdam Harbor: Calm

Pen, brown ink, and wash over graphite, 116 × 188 mm
Haarlem, Teylers Museum, portfolio Q*, no. 78 (L. 2392)

LITERATURE: Scholten, 1904, p. 239

Backhuysen only occasionally represented calms, but these constitute a notable contribution to his oeuvre. In particular he produced a handful of refined drawings representing ships before the distant profile of Amsterdam. These calms include pen and wash studies in the Municipal Archives in Amsterdam,[1] and a·second calm (fig. a) in the Teylers Museum.[2] In *Amsterdam Harbor: Calm*, Backhuysen includes only the western half of the city profile. At the far left one can detect the Haringpakkerstoren and the

dome of the Lutheran Church. The tower of the Westerkerk is visible between the man-of-war and the sailboat at the center, and the squat profile of the Noorderkerk is further to the right.

These drawings may have inspired Backhuysen in his two vibrant etchings (B 4, 5) representing shipping before Amsterdam and Rotterdam from the series *D 'Y Stroom en Zeegezichten* of 1701, but, in turn, seem to be a response to the remarkable calms of Willem van de Velde the Younger.[3]

Cat. 59, fig. a Ludolph Backhuysen, Calm, *pen, brown ink, and wash. Haarlem, Teylers Museum.*

Although most of these date from early in van de Velde's career, Backhuysen would have felt compelled to assess this subject anew following Willem van de Velde's monumental *View of the Ij before Amsterdam* of 1686, probably painted for the city harbor commission of Amsterdam.[4] Van de Velde animates the subject by a varied cloudy backdrop. Backhuysen employs a similar pictorial program to his calms, which are so notable for the lively interplay between clouds and reflecting water.

NOTES

1. Amsterdam, 1985, cat. T29, repr.

2. *Ships Before a Distant City* (possibly Rotterdam), portfolio Q*, no. 77.

3. B. Broos, in Amsterdam, 1985, p. 113, cat. T29, dates the *Calm* in the Municipal Archives in Amsterdam to the years 1690–1700.

4. L. J. Bol, 1973, pp. 240–243, repr.

60

LUDOLPH BACKHUYSEN

Warehouses of the Dutch East India Company, Amsterdam

Brush, black ink, and gray washes, 117 × 192 mm
Inscribed on verso in pencil: *het O: Ind: Compp: Buitenhuis een scheepstimmerwerf.*
 L. Bakhuizen delt
Cambridge, Fitzwilliam Museum, inv. PD 92–1963 (Ingram Bequest)

PROVENANCE: Berlin, Collection A. von Beckerath
 Berlin, Kupferstichkabinett (inv. Z 5906, L. 2482)
 London, Collection Bruce Ingram (L. 1405a)
LITERATURE: Bock and Rosenberg, 1930, p. 74, Z 5906

Backhuysen represents one of the familiar monuments of the harbor of Amsterdam, the huge warehouses (*buitenhuis*) of the Dutch East India Company. The Dutch East India Company built this vast complex on the Oostenburg between 1662 and 1664. It included shipyards and lumbermills, and also provided space for the ropewalks and smiths as well as other specialized trades involved in shipbuilding. The focal point of this complex was the *zeemagazijn* – a large four-story structure 180 meters long and 20 meters wide – which serves as the backdrop to shipyards where several large hulls are under construction. Two are already afloat. Backhuysen includes a pavilion yacht under sail in the left foreground and a *trekjacht* at the right. This small boat was propelled by oarsmen, unlike its counterpart at the left.[1]

Backhuysen painted this subject in 1696.[2] In the foreground of this picture he includes several retourships of the Dutch East India Company. In style *Warehouses of the Dutch East India Company, Amsterdam* is close to Backhuysen's drawings of calms (see Cat. 59) and is probably close in date to the related painting of 1696.

NOTES

1. R. Vorstman discusses this building complex in Amsterdam, 1985, p. 60.

2. The Hague, Rijksdienst beeldende Kunst, *Ludolf Bakhuizen*, 1985, cat. S34, repr. He also includes this complex at the far left in his celebrated *Shipping before Amsterdam* (Cat. 5) of 1666 in the Louvre.

61

LUDOLPH BACKHUYSEN
Ships in a Storm

Brush, black ink, and gray washes, 306 × 425 mm
Signed on barrel at lower right: *LB* and dated on spar at left: *1697*
Haarlem, Teylers Museum, Portfolio Q*, no. 79 (L. 2392)

LITERATURE: Scholten, 1904, p. 240
Amsterdam, 1985, p. 105, cat. T21, repr.
Nannen, 1985, p. 129

This large and highly finished drawing is one of the artist's supreme contributions to the theme of the storm at sea. Its forceful drama manifests Backhuysen's tendency toward theatricality. Broos discusses this drawing in detail, links it to a closely related sheet in Vienna, and cites how the artist incorporates features from each in his painting formerly with Dean Cevat (1964).[1] The Teylers Museum also possesses Backhuysen's prepa-

ratory study for *Ships in a Storm*.[2] This impetuous sketch reveals another facet of this artist's activity but also demonstrates that Backhuysen conceived of the signed and dated drawing as an independent art work comparable in finish to a painting. Backhuysen represented storms throughout his career, but his interest in this subject reached a new level of theatricality in several huge canvases from the 1690s. These include his largest surviving

painting, *Storm off the Norwegian Coast* in Brussels,[3] and *The Dutch Warships "Ridderschap" and "Hollandia" in a Hurricane in the Straits of Gibraltar* (event March 1–3, 1694), recently acquired by the Rijksmuseum in Amsterdam.[4]

The carved crest on the tafferel of this ship bears the crest of Amsterdam flanked by rampant lions. Although similar in design to the stern of the *Amsterdam* represented by Backhuysen in his drawing in the Morgan Library (Cat. 56), it remains sufficiently indeterminate to confirm its iden-

tification with this ship or the one dominating Backhuysen's etched frontispiece to his series *D 'Y Stroom en Zeegezichten* (Cat. 96).

NOTES

1. Amsterdam, 1985, p. 105.

2. Ibid., p. 104, cat. T20.

3. L. J. Bol, 1973, pl. 307.

4. Amsterdam, 1985, p. 59, cat. S33, repr.

62

LUDOLPH BACKHUYSEN
Ship in Distress in a Thunderstorm

Pen, brown ink, brown and gray washes, 245 × 184 mm
Rotterdam, Museum Boymans–van Beuningen, inv. H 209

PROVENANCE: Munich, J. Bohler
Haarlem, Collection Frans Koenigs (acquired in 1929)
Given by D. G. van Beuningen to the Stichting Museum Boymans in 1940

EXHIBITIONS: Göteborg, 1954, cat. 38
Rotterdam, 1954/1955, cat. 40

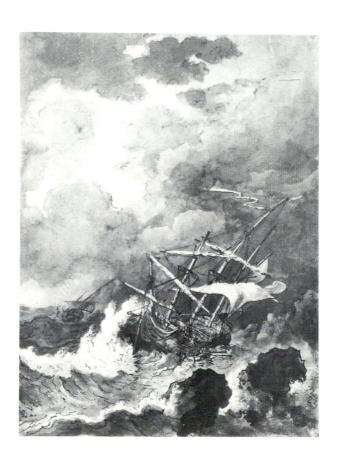

A three-master shudders under the impact of a huge wave that breaks upon its bow. Backhuysen heightens the sense of impending doom by the eerie lighting cast by a lightning bolt. It intensifies the white water that silhouettes the jagged rocks in the right foreground. This drawing is impetuously executed in pen and wash. The rapid, broken pen lines enhance the drama, and the artist's deep washes complement the penwork. The upright format compresses the subject and adds to its dramatic intensity. Despite the hope-less plight of this doomed vessel, one cannot help but admire the discipline displayed by the sailors who disembark in a dingy. They tried to keep their ship under control, as evidenced by the trimmed sails, but were unable to claw off this treacherous coast. In subject and spirit this drawing is close to *Ships in Distress off a Rocky Coast* of 1667 (Cat. 4) in the National Gallery of Art in Washington.

63

PIETER COOPSE
Ships in a Strong Breeze

Brush, black ink, and gray washes, 170 × 279 mm
Signed at upper right: *P. Coops: fe*
Haarlem, Teylers Museum, portfolio R, no. 63 (L. 2392)

LITERATURE: Scholten, 1904, p. 262

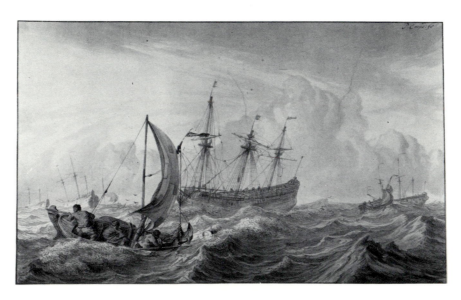

This finished drawing is a particularly fine example by one of Backhuysen's most talented emulators. Coopse places great emphasis on the waves, the whitecaps, and the way the ships and sailboats respond to the restless motion of the sea. The artist contrasts the waves with a cloud bank in a manner reminiscent of the pictorial principles of Backhuysen.

64

PIETER COOPSE
Yacht and Other Ships Beyond a Beach

Brush, black ink, and gray washes, 177 × 277 mm
Signed at bottom right: *P Coops. fe* and dated on a spar: *1674*
Cambridge, Fitzwilliam Museum, inv. PD 245–1963 (Ingram Bequest)

PROVENANCE: Amsterdam, Collection A. W. Mensing
London, Colnaghi (1937)
London, Sir Bruce Ingram (L. 1405a)

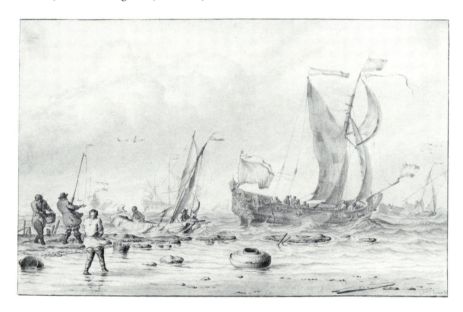

In this spirited drawing Coopse represents an armed pavilion yacht coming about close to a beach. To its bow and stern, small fishing boats ply the shallow water. The subject of boats sailing in the shallows beyond a beach appealed to several Dutch marine painters during the second half of the seventeenth century, including Willem van de Velde the Younger[1] and Ludolph Backhuysen. Backhuysen loved this theme and produced many versions of it, with notable examples in the Rijksmuseum, Amsterdam,[2] Edinburgh (Cat. 2, fig. b),[3] Emden,[4] Oldenburg,[5] and Schwerin.[6]

NOTES

1. Van de Velde shows a marked preference for representing this subject in calm weather.
2. Amsterdam, 1985, cat. S30, repr.
3. National Gallery of Scotland, HdG 199.
4. Amsterdam, 1985, cat. S 20, repr.
5. HdG 251; H. W. Keiser, *Gemäldegalerie Oldenburg*, Munich, 1967, p. 100, repr.
6. HdG 162, inv. 2354, canvas, 38.5 × 52 cm.

65

ALLAERT VAN EVERDINGEN
Sailboat in a Stiff Breeze Before a Harbor

Brush, brown ink, and washes over traces of black chalk, 123 × 190 mm
Signed on leeboard of sailboat: *AVE*
Brussels, Koninklijke Musea voor Schone Kunsten van België, Collection de Grez, no. 1265

PROVENANCE: Brussels, Collection Jean de Grez
LITERATURE: *Inventaire des dessins et aquarelles donnés à l'Etat Belge par Mme la douairière de Grez,*
 1913, cat. 1265
EXHIBITION: Brussels, 1967, p. 32, cat. 81

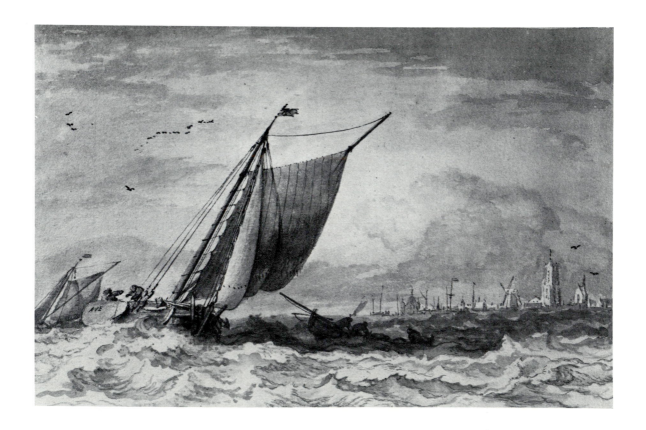

Cat. 65, fig. a Allaert van Everdingen, Sailboats in a Breeze, *brush, brown ink, and wash over graphite. Cambridge, Harvard University Art Museums.*

Cat. 65, fig. b Allaert van Everdingen, Ships in a Storm, *oil on canvas. Frankfurt, Städelsches Kunstinstitut.*

Allaert van Everdingen frequently included maritime motifs in drawings that belong to suites of landscapes, but he produced few marine drawings per se. This example in Brussels is one of his most imposing marines and is closely related compositionally to his painting in Leningrad.[1] It is also similar to a fine marine sketch in the Harvard University Art Museums (fig. a), which represents somewhat less turbulent weather conditions. Everdingen employs strong contrasts between alternating patches of light and shadow. The large sailboat is caught in both, whereas the distant city skyline rises in light beyond a broad zone of sea lying in shadow. Jacob van Ruisdael

brought this lighting system to perfection in such celebrated marines as *A Rough Sea* in Boston (Cat. 25). In developing this pictorial manner, Ruisdael was influenced by Allaert van Everdingen, whose rare marines (see fig. b) appear to date from the 1640s and 1650s, whereas the majority of Ruisdael's marines date closer to about 1670.

NOTE

1. Allaert van Everdingen, *Rough Sea at Vlissingen* (*Ships in a Gale Before a Seaport*), oil on canvas, 67 × 77.5 cm, monogrammed at lower right A.V.E. Leningrad, Staatliche Ermitage.

66

ALLAERT VAN EVERDINGEN
A Rocky Coast in Rough Weather

Brush, black ink, gray and brown washes, and white highlights on gray tinted paper,
225 × 416 mm
Signed at lower right: *AVE*
Vienna, Graphische Sammlung Albertina, inv. Z9590 (L. 174)

Allaert van Everdingen is most noted for his representations of Scandinavian waterfall subjects. Only a few of these date close to the period of his journey to Sweden. Most date much later and constitute a stereotyped reminiscence of his experience of the rocky and often savage terrain of Scandinavia. *A Rocky Coast in Rough Weather* parallels these waterfall subjects but is a unique representation by this artist of a forbidding coastline in tempestuous weather. Its refined technique and the stress on coloristic values demonstrate that this is a highly finished work in its own right and not a spontaneous sketch recording immediate, firsthand experience.

Three ships in the distance are dwarfed by the scale of the rough sea breaking on the jagged pinnacle rocks of a foreign shore. The artist represents this remote coast under weather conditions that manifest the awesome splendor of nature.

Everdingen's representation of the remote majesty of nature finds antecedents in the rare etchings of Hercules Seghers, the large chalk landscape drawings by Roelandt Savery representing the Tyrolean Alps, and the paintings of Adam Willaerts (Cat. 55)[1] and Simon de Vlieger in which they represent fleets sailing by or anchored before similar rocky terrain.[2] Unlike Simon de Vlieger, who represents these savage rocky coasts in calm weather, Everdingen dramatizes the subject by the restless action of the sea. In this regard he is more kindred to Pieter Mulier the Elder, who also included analogous rocky coastlines in certain of his marine paintings and drawings (Cat. 67). *A Rocky Coast in Rough Weather* is a remarkable premonition of the nineteenth-century evocation of the sublime grandeur of nature.

NOTES

1. Notable examples by Simon de Vlieger include his painting in the National Maritime Museum in Greenwich, neg. A 5768 (Cat. 46, fig. a), or the large panel painting recently acquired by a private collector in Montreal; Amsterdam–Boston–Philadelphia, 1987/1988, cat. 113, pl. 89.

2. Willaerts and de Vlieger drew inspiration from the drawings of Savery. Certain of Simon de Vlieger's rare marine drawings are reminiscent of Savery's chalk studies of the Alps. For discussion of these drawings, see Cat. 89. Allaert van Everdingen may also have been influenced by Roelandt Savery. Whether he had access to Savery's drawings remains uncertain, but he would have been familiar with prints after Savery's drawings.

67

PIETER MULIER THE ELDER
Ships off a Rocky Coast

Pen, brown ink, and gray wash over black chalk, 123 × 196 mm
Leiden, Prentenkabinet der Rijksuniversiteit, inv. AW 90

PROVENANCE: Amsterdam, R.W.P. de Vries, November, 1929 (as H. Vroom)
 Amsterdam, Collection Dr. A. Welcker (L. 2793c)
LITERATURE: Keyes, 1976, p. 260, cat. 6, pl. 12

This drawing is one of Mulier's most characteristic sheets in which he represents various types of vessels sailing close to a treacherous rocky coastline. The two-masted sailboat in the right foreground is a pink and is similar to the one-masted type represented by Nooms in his etching, B 95 (Cat. 114). In Mulier's drawing a pinnacle rock surmounted by a commemorative cross juts up in the left foreground.[1]

Mulier represents this subject in several paintings. Two monogrammed pictures[2] contain similar rough seas across the foreground, a three-master in the distance, and cloud banks across the entire sky. This study belongs to a series of drawings that have traditionally borne attributions to artists such as Hendrick Vroom, Jan Porcellis, Cornelis Claesz. van Wieringen and Bonaventura Peeters. These ascriptions demonstrate to what degree Mulier's origins can be traced back to the earliest phase of marine painting in Haarlem.[3]

NOTES

1. This motif is the principle subject in two other drawings by Mulier – Keyes, 1976, cat. nos. 7, 8, pls. 23, 24.

2. Ibid., pls. 4, 5.

3. Recently two hitherto unrecorded drawings belonging to the same group were bequeathed by Mr. H. Teding van Berkhout to the Teylers Museum in Haarlem: (a) *Two Ships Skirmishing,* pen and brown ink, 123 × 196 mm, verso: *House with a gabled Chimney.* (b) *Ships in a Calm,* pen and brown ink, 125 × 197 mm.

68

REINIER NOOMS ("ZEEMAN")
Dutch Fleet After a Battle with Captured English Warships

Brush, black ink, and gray washes, 203 × 331 mm
Signed on stern flag of the skiff in the left foreground: *zeeman*
Berlin-Dahlem, Kupferstichkabinett, Staatliche Museen, Preussischer Kulturbesitz, inv.
 Z5490

LITERATURE: Bock and Rosenberg, 1930, p. 329, Z 5490
Lugt, 1931, vol. 52, p. 78

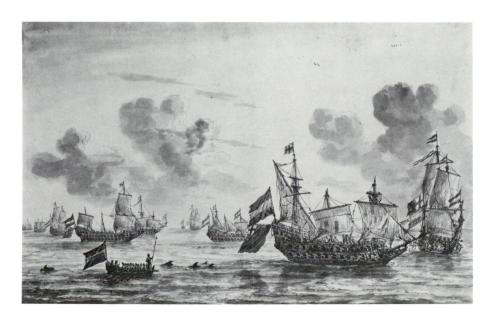

This drawing, although closely related to Nooms's etching B. 106, was not used as a preparatory study for a print. The subject is dominated by the English prize in the right foreground with its severed fore- and mainmasts. It still flies an English vane on its mizzenmast, but its English ensign hangs below a large Dutch standard on the sternpost. Other battered warships sail beyond and behind it. Nooms contrasts the uninhibited motion of the leaping porpoises to the labored struggle of the severely crippled ships. The clouds rising up beyond the fleet find no echo from the smoke of battle. In fact, the gleaming water lends an almost eerie serenity to this scene depicting the battle's aftermath. This subject is probably from the time of the First Anglo-Dutch War. The Berlin drawing may belong to a series of studies intended as preparatory designs for an unrealized suite of prints. For further discussion of this issue, see Cat. 70.

69

REINIER NOOMS ("ZEEMAN")
Fishing Fleet Before Mountains

Brush, black ink, and gray washes with white highlights, 126 × 244 mm
Darmstadt, Hessisches Landesmuseum, inv. AE 767

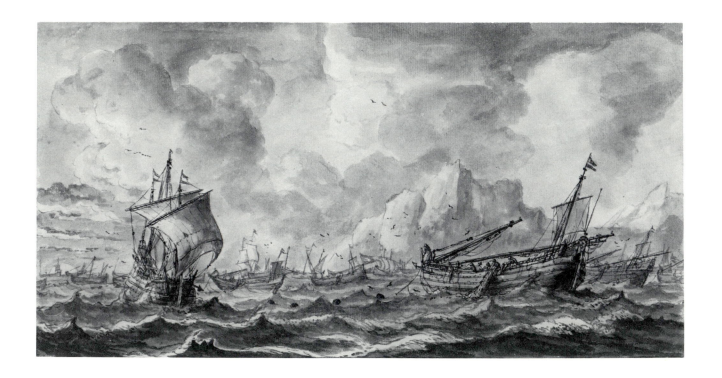

This drawing is a preparatory study for Nooms's etching *Herring Busses* (B. 69) in reverse. The etching, which bears the caption *Harinck-Buysen* in the bottom margin, belongs to Nooms's largest print series, *Verscheyde Schepen en Gesichten van Amsterdam* (Various Ships and Views of Amsterdam), made up of three parts totaling thirty-six items. The Darmstadt drawing is a particularly important image because it represents Dutch herring *busses* fishing off a foreign coast, possibly Scotland. The artist accurately represents these broad, stalwart boats with masts that can be lowered to allow for the stability needed when setting out and hauling in the herring nets during rough weather with heavy swells. Nooms evokes the remote setting for this trade and captures the grandeur of the intrepid sailors who journeyed so far from Holland to harvest the herring. This fishery formed the mainstay of the Dutch maritime economy.

The herring fleets fished at night to prevent the fish from recognizing the nets. They hauled them in early in the day, a fact noted by Nooms, who indicates the sun just rising above the horizon at the left. The herring nets, once set in the water, were denoted by a long rope attached to a string of floating barrels. When the fishermen hauled in the net, they also had to haul in this rope with barrels attached. The earliest *busses* had a flat stern, but evolved a rounded one with a small tafferel. An armed warship escorted these fleets to protect them from marauders. In Nooms's print, this three-masted escort ship appears in the left distance.[1]

The Dutch herring industry became a source of friction between the Dutch Republic and the English crown. Even during the reign of James I of England the issue came to a head, and continued to aggravate the English to a progressively greater degree as the century unfolded. In fact, it was the chief pretext triggering the First Anglo-Dutch War of 1652–1654 (see Cat. 108).

NOTE

1. For further discussion of this operation, see de Groot and Vorstman, 1980, cat. 77, who describe Nooms's etching.

70

REINIER NOOMS ("ZEEMAN")
A Naval Engagement Between a Dutch and an English Ship

Brush, black ink, and gray washes, 226 × 353 mm
Signed on flag of the Dutch ship: *zeeman*
Edinburgh, National Gallery of Scotland (transferred from the Royal Scottish Academy
 in 1910), inv. D616

PROVENANCE: Edinburgh, Collection David Laing
 Edinburgh, Royal Scottish Academy
LITERATURE: Andrews, 1985, p. 57, inv. D616, fig. 389

A lengthy inscription in Dutch on the back of this drawing identifies the subject as the capture of two armed English prizes by the Dutch. Although the specific action has not been identified, the event seems to be associated with the First Anglo-Dutch War of 1652–1654.[1]

This drawing, Nooms's largest surviving sheet, is a characteristic example of his refined brush and wash technique. In subject it relates closely to his series of eight etchings representing naval battles from the First Anglo-Dutch War (B. 99–106, Cat. 115). It may also be linked to several analogous

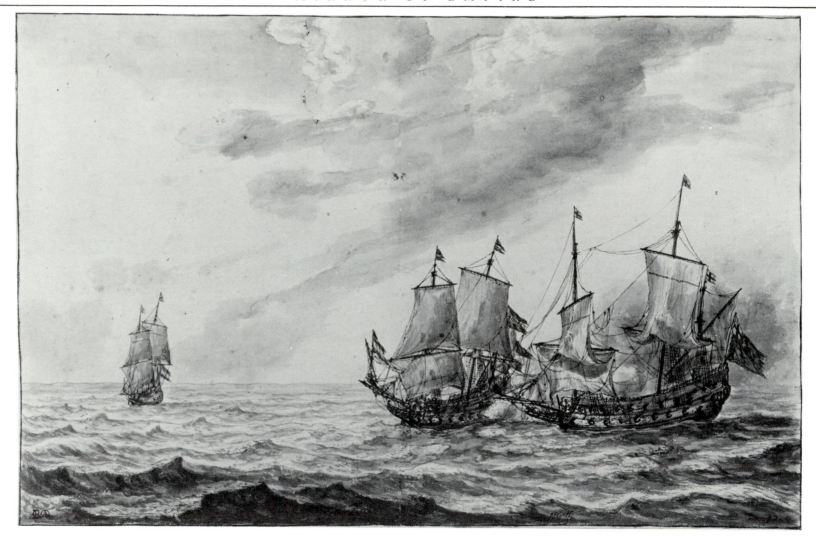

drawings, none of which served as a preparatory study for a Nooms etching. These include *Dutch Fleet After a Battle with Captured English Warships* (Cat. 68) in West Berlin; *A Dutch Fleet* in the Dutuit Collection in Paris;[2] and *A Battle Between Dutch and English Ships* in the British Museum.[3] These highly finished studies capture subtle atmospheric effects. The artist represents the smoke of battle and contrasts it to the clouds that filter the sunlight and create a general haze.

NOTES

1. Andrews, 1985, p. 57, citing information provided by M. S. Robinson.

2. 205 × 330 mm, Lugt, 1927, p. 39, no. 94, repr.

3. 196 × 311 mm, A. M. Hind, 1931, cat. vol. 4, Nooms no. 4. Nooms also produced several drawings representing battles between Dutch warships and enemy galleys. These were also probably intended as a suite and include two sheets in the British Museum, *Battle with Galleys*, 166 × 271 mm (Hind, 1931, cat. vol. 4, Nooms no. 6), and *Battle with Galleys*, 170 × 275 mm (Hind, 1931, cat. vol. 4, Nooms no. 7). A third drawing, *A Battle with Dutch Ships and Galleys*, 175 × 275 mm, provenance, Collection Werneck, W. P. Knowles, P. Langerhuizen, Amsterdam, R.W.P. de Vries, 1924, cat. 727, present location unknown, probably belongs to this same presumed project.

71

REINIER NOOMS ("ZEEMAN")
Calm: Ship Being Careened

Brush, black ink, and gray washes, 162 × 266 mm
Signed on a floating spar in left foreground: *zeeman*
Haarlem, Teylers Museum, inv. Portfolio Q*, no. 1 (L. 2392)

LITERATURE: Scholten, 1904, p. 214
Maritieme Geschiedenis der Nederlanden, vol. 2, 1977, p. 74, repr.
Illustrated Bartsch, vol. 6 (commentary), 1986, p. 158, repr.

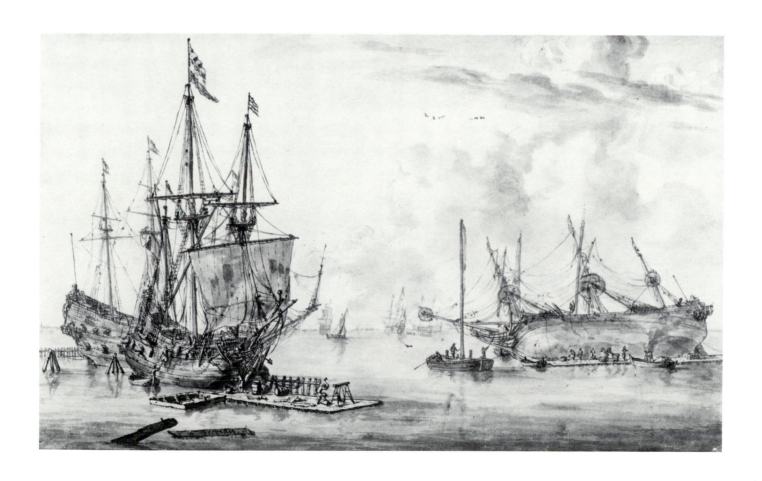

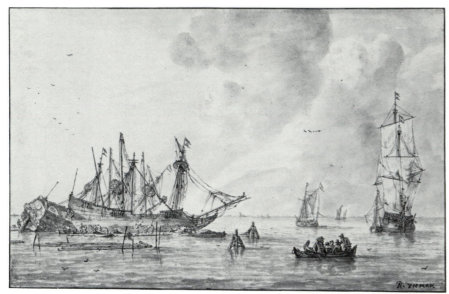

Cat. 71, fig. a Reinier Nooms ("Zeeman"), Calm: Ships being Careened, brush, black ink, and gray washes. Vienna, Graphische Sammlung Albertina.

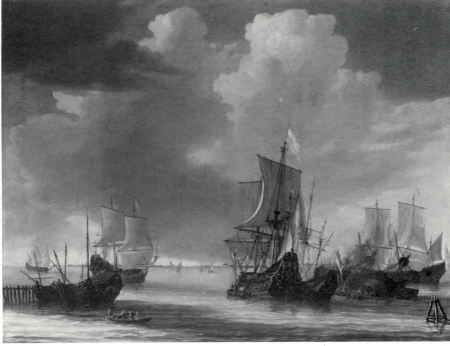

Cat. 71, fig. b Reinier Nooms ("Zeeman"), Ships Being Careened, oil on canvas. Copenhagen, Statens Museum for Kunst.

In this drawing Nooms represents a favorite subject, ships being refitted. At the right, a three-masted ship rests on its starboard side while workmen on a floating platform caulk its hull. The removal of barnacles from its hull and the retarring were arduous tasks required of all vessels, particularly those involved in the long voyages across the tropics to the Far East and Brazil.

Nooms depicted these activities in several drawings, including distinguished examples in Brussels,[1] Vienna (fig. a),[2] and Windsor Castle.[3] He also occasionally included the motif of refitting ships in his paintings such as the fine picture in Copenhagen (fig. b), but popularized it in his etchings.[4]

Nooms transposes these activities into an evocative realm in which the stillness of the sea and the delicate cloud tracery establish a tranquil mood that underscores the purposefulness of these unglamorous but essential shipbuilding tasks.

NOTES

1. Koninklijke Musea voor Schone Kunsten van België, Collection de Grez, 1913, cat. 4231, signed and dated 1659, brush, black ink, and gray washes, 120 × 278 mm.

2. Albertina, inv. 9403.

3. Inv. 6277, Puyvelde no. 761.

4. For example, B. 44, 46, 49, 113, 117–119, 130.

72

REINIER NOOMS ("ZEEMAN")
Ships Anchored

Brush, black ink, and gray washes, 149 × 278 mm
Rotterdam, Museum Boymans–van Beuningen, inv. R. Nooms 3 (L. 1857)

PROVENANCE: Collection F. J. O. Boymans by whom bequeathed to the Museum Boymans in 1847
LITERATURE: Corpus Gernsheim 37204
 Maritieme Geschiedenis der Nederlanden, 1977, vol. 2, p. 86, repr.
EXHIBITIONS: Göteborg, 1954, cat. 58
 Rotterdam, 1954/1955, cat. 60
 Brussels, 1961, pp. 113–114, cat. 114, pl. XLIV

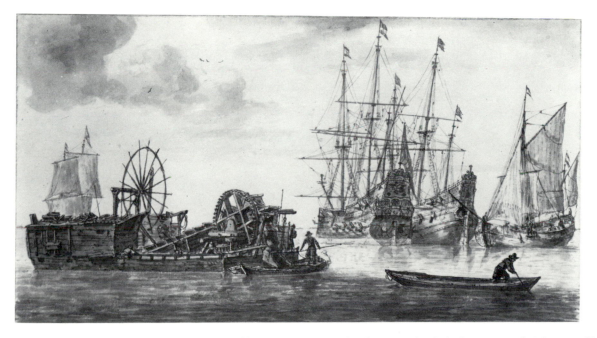

This drawing is one of Nooms's most beautiful calms, similar in effect to *Calm: Ship Being Careened* in Haarlem (Cat. 71). By contrast, the artist represents the entire foreground in shadow. He also evokes a greater sense of atmospheric pall. This sketch is a particularly fine example of Nooms's great ability to portray different types of ships. Most notable in this sheet is the dredger in the left foreground. The small dorylike boat just to the right of the dredger is a mud hopper that the dredger fills with the muck brought up from the sea bottom on a conveyer belt. Four men or a horse operating a treadmill activated the conveyor belt. These dredgers usually removed mud or silt, but with especially designed equipment certain were

capable of removing harder, more resistant material.[1] The type of dredger depicted by Nooms was used principally in Amsterdam but also operated in Rotterdam and Dordrecht. In Nooms's drawing a *boeier* under sail appears to the right of a flute, and a warship appears beyond the dredger at the center.

Although of wooden construction, the basic principle of these seventeenth-century dredgers remains essentially the same as its modern counterpart. Dredging served an important function in The Netherlands because the vast system of canals, harbor basins, rivers, and estuaries constantly silted up to such a degree that it was necessary to maintain channels of a proper depth to allow larger vessels to ply the waterways of the Dutch Republic. Nooms etched a similar dredger with its attendant mud hoppers as part of his great series *Various Ships and Views of Amsterdam* (B. 96).

NOTE

1. J. P. Sigmond, in *Maritieme Geschiedenis der Nederlanden*, 1977, vol. 2, pp. 86–87.

73

JAN PORCELLIS
A Zeeland Koch

Brush, gray ink, and wash, 165 × 275 mm
Monogrammed at bottom left: *I.P.*
Vienna, Graphische Sammlung Albertina, inv. Z8580 (L.174)

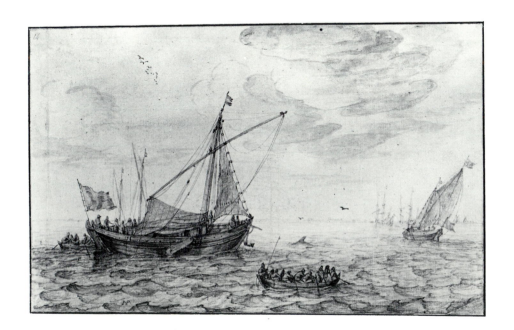

This drawing is Porcellis's preparatory design for the eighth print in the series *Icones Variarum Navium Hollandicarum* (see Cat. 116 and 117), which bears in the bottom margin the caption *Een zeeusche Koch groot omtrent 11 Last.*

Few drawings by Porcellis survive, and the two known studies for this series, in Vienna and in the Lugt Collection[1] in Paris, are a yardstick of his mature style. They set the standard for determining this artist's style as a draftsman. Here Porcellis introduces pronounced tonal effects, particularly apparent in his representation of the clouds. But the anonymous printmaker who engraved the designs for the Amsterdam publisher Claes Jansz. Visscher was unable to reproduce these tonal effects and created somewhat schematic images that lack the vitality and subtlety of Porcellis's drawings.

NOTE

1. Inv. 3441, *Damloopers in a Procession*, brush, gray ink, and washes, 165 × 271 mm, traced for transfer.

74

HENDRICK RIETSCHOEFF
Dutch Warship, Yacht and Other Ships in a Breeze

Pen, brush, black ink, and gray washes over graphite, 203 × 307 mm
Signed on spar at bottom left: *HR-schoof*
Cambridge, Fitzwilliam Museum, inv. PD 635–1963 (Ingram Bequest)

PROVENANCE: Unidentified collector (L. 1481b)
London, Sir Bruce Ingram (L. 1405a)

Rietschoeff represents a variety of ships sailing close to shore in a breeze. A pavilion yacht at the right center filled with passengers bears down to the right. A flute at the left center seen in port profile has a rounded stern and a lateen sail on its mizzen mast. At the far left two sailboats partially screen a distant warship. Stylistically this drawing is similar to Ludolph Backhuysen's finished brush and wash drawings. The tall trees beyond a house at the right indicate that this scene represents a stretch of shoreline along the Zuider Zee rather than the more exposed coast of the North Sea.

75

HENDRICK RIETSCHOEFF
Estuary at Sunset

Brush, gray ink, and washes, 149 × 189 mm
Brussels, Koninklijke Musea voor Schone Kunsten van België, Collection de Grez, no.
　　3044 (as Jan Rietschoeff)

PROVENANCE:　　Brussels, Collection Jean de Grez
LITERATURE:　　*Inventaire des dessins et aquarelles donnés à l'Etat Belge par Mme la douairière de Grez,*
　　　　　　　　1913, cat. 3044

Rietschoeff's drawing of sailboats by a pier at sunset is a romantically charged image that manifests a shift in the tenor of Dutch marine art. This change was already evident in the late works of Backhuysen and the purely recreational subjects of Abraham Storck that date from the last years of

the seventeenth century. Rietschoeff's unusual treatment of the rays of the setting sun finds a precedent in Backhuysen's drawing representing *A Ship Being Careened* in the Fitzwilliam Museum, Cambridge.[1] Lieve Verschuier previously explored such visual effects in his marines with sunsets or his moonlit nocturnes (Cat. 43).

NOTE

1. Amsterdam, 1985, p. 101, T16a, repr.

76

ABRAHAM STORCK
A Mediterranean Harbor

Pen, brown ink, and gray washes, 195 × 159 mm
Berlin-Dahlem, Kupferstichkabinett, Staatliche Museen, Preussischer Kulturbesitz, inv. Z 2627

PROVENANCE: Frankfurt-am-Main, Collection Johann Städel
Hannover, Collection D. B. Hausmann (L. 377)
LITERATURE: Bock and Rosenberg, 1930, p. 278, Z 2627

Cat. 76, fig. a *Abraham Storck*, An Italian Harbor, *pen, brown ink, and wash. Brussels, Koninklijke Musea voor Schone Kunsten van België, Collection de Grez.*

Cat. 76, fig. b *Abraham Storck*, A Southern Port Scene, *oil on canvas. Formerly London, Richard Green Gallery.*

This drawing is a particularly fine and characteristic sketch by the artist. Storck produced a large number of these imaginary Mediterranean harbor views. This example is unusual because it places considerable emphasis on the large three-masted merchantman moored at the pier. His more typical drawings of this theme often include elaborate fountains or monumental sculptures on plinths that attract crowds. Such subjects focus principal attention on the genre activities of the figures gathered at the harbor and reveal a kinship with the idiom of artists such as Johannes Lingelbach.

A Mediterranean Harbor is similar in style and format to a second drawing in West Berlin, *A Mediterranean Harbor with an Equestrian Monument on a Jetty,* which may even be a companion sheet.[1] A similar drawing in Brussels, *An Italian Harbor,* signed and dated: *A: Storck/Fecit Ao/1674* (fig. a),[2] would suggest approximately the same date for the pair of drawings in West Berlin. Drawings like these may have served as models for the artist when he painted analogous themes. *A Southern Port Scene* (fig. b), recently on the London art market, is a particularly fine example of Storck's contribution to this theme, and one with many points of similarity to the Berlin drawing.

NOTES

1. Inv. Z 3903, signed: *A. STORCK.*
2. Koninklijke Musea voor Schone Kunsten van België, Collection de Grez, cat. 3481.

77

WILLEM VAN DE VELDE THE ELDER
Dutch Ships at Anchor off Land

Pencil, 232 × 391 mm
Rotterdam, Museum Boymans–van Beuningen, inv. MB 1866/T480 (L. 1857)

PROVENANCE: Amsterdam, Collection Gerard Leembruggen Jz.
Amsterdam, auction Leembruggen (Brakke Grond) March 5 and days following, 1866,
bought by the Museum Boymans

LITERATURE: Weber and Robinson, 1979, vol. 1, p. 85; vol. 3, pl. 36

With great economy Willem van de Velde the Elder sketches a segment of the Dutch fleet offshore in calm weather. He summarily indicates a beach extending across the foreground with a breakwater indicated at the left. Several skiffs cluster around a large three-masted ship at left center, which

flies a standard from its mainmast and a pendant from its mizzenmast. A spit of land extends across the right distance beyond the warship at the right.

Van de Velde, by his incisive and energetic use of the pencil, creates a

strong sense of pervading light. In a closely related drawing, also in Rotterdam,[1] the artist represents the same or a similar scene but defines the foreground in greater detail, with men standing on the beach by a breakwater and with sailboats moored on the sands or in the shallows beyond. Weber and Robinson tentatively date both these sheets about 1665.[2]

NOTES

1. Weber and Robinson, 1979, vol. 1, p. 85, inv. MB 1866/T481; vol. 3, pl. 37.
2. Ibid.

78

WILLEM VAN DE VELDE THE ELDER
Ships at Anchor with a States Yacht Approaching

Pencil and gray washes, 230 × 540 mm
Rotterdam, Museum Boymans–van Beuningen, inv. MB 1866/T486 (L. 1857)

PROVENANCE: Same as Cat. 77
LITERATURE: Weber and Robinson, 1979, vol. 1, p. 85; vol. 3, pl. 40

This drawing forms an interesting comparison to Cat. 77. Weber dates it to the same time, ca. 1665.[1] By the judicious addition of wash, the artist enhances the monumentality of the subject without diminishing the overall atmospheric effects that play such a central role in defining the character of the drawing. The balance between light and shadow and the interplay between foreground and distance reveal an instinctive composing flair that transforms this careful recording of actuality into an imposing image. A states yacht seen in starboard quarter view at the left salutes and runs down toward ships in the distance. The warship at the right beyond the breakwater flies a Dutch standard from its mainmast and a pendant from its mizzen.

NOTE

1. Weber and Robinson, 1979, vol. 1, p. 85.

79

WILLEM VAN DE VELDE THE ELDER
The English Fleet at Anchor off Den Helder (August 1653)

Pencil and gray washes, 205 × 905 mm
Inscribed at top: *hoe de engelse armade haer voort tlant laet zien & verthoont buijten de*
Haeckx (How the English fleet appears as it lies off the land outside the Haaks)
Rotterdam, Museum Boymans–van Beuningen, inv. MB 1866/T8 (L. 1857)

PROVENANCE: Same as Cat. 77
LITERATURE: Weber and Robinson, 1979, vol. 1, p. 20; vol. 2, pls. 12, 13

After the Dutch defeat at the Battle of Nieuwpoort on June 12–13, 1653, the Dutch fleet withdrew in two parts, with Marten Tromp's force to Vlissingen in Zeeland, and Witte de With's to the roads off Texel and Goeree. The English blockaded the Dutch coast off Den Helder. Van de Velde's panoramic drawing conveys the awesome scale of this blockade. The work relates to a large number in Rotterdam in which Willem van de Velde records the relative positions of the Dutch and English fleets. Witte de With's squadron was reassembling in great haste. Until August 5 it lay opposite Den Helder at the southern part of the Texel, but it sailed through the Marsdiep and anchored inside the Haaks sands. Following a council of war with deputies from the States General, de With sailed out to sea to join Tromp. On August 10 the reunited Dutch fleet fought the English at the Battle of Scheveningen (or Terheide – see Cat. 8). Although this battle was also a tactical English victory, its fleet suffered such extensive damage that the English were forced to abandon their blockade and return home to refit.

A second drawing in Rotterdam represents the same subject, but seen from a different angle looking toward a Dutch fort before dunes at the left and with a greater expanse of beach across the foreground.[1]

NOTE

1. Weber and Robinson, 1979, vol. 1, p. 20, inv. MB 1866/T9; vol. 2, pls. 14, 15.

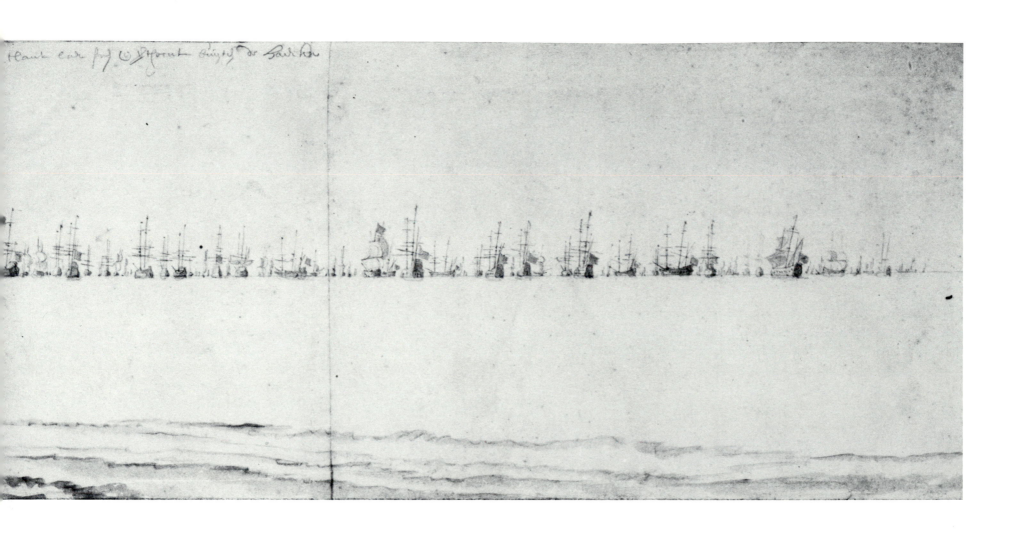

80

WILLEM VAN DE VELDE THE ELDER
The "Jupiter" at Anchor and
the Yacht of the States of Holland in the Fleet

Pencil and gray washes, 405 × 935 mm
Rotterdam, Museum Boymans–van Beuningen, inv. MB 1866/T39b (L. 1857)

PROVENANCE: Same as Cat. 77
LITERATURE: Weber and Robinson, 1979, vol. 1, p. 27; vol. 2, pl. 45

This is the right half of a large composition representing the Dutch fleet assembled by order of the States General of the Dutch Republic. They placed it under the command of Jacob, Baron van Wassenaar van Obdam, during the summer and autumn of 1664 in response to England's belligerent stance. Weber and Robinson explain in great detail how this fleet was divided into three squadrons, which officer was appointed to command each, and the increase in the number of flag officers and the complex nature of their appointments as determined by the states of Holland, Zeeland, and Friesland.[1] This fleet shifted position along the coast of Holland, where it was joined by Willem van de Velde on September 6, 1664. The artist accompanied Jan Evertsen, vice admiral and commander of the second squadron. Having seen no action during these months in 1664, this Dutch fleet was dispersed from the Goeree Roads on December 1, 1664.

In this drawing van de Velde represents, from left to right, the *Wapen van Utrecht* (*Arms of Utrecht*) and a saluting states yacht that flies the flag of the States of Holland. Beyond at the center, seen in port bow view, is the *Eendracht* (*Unity*), Wassenaar van Obdam's flagship. The *Gouden Leeuw* (*Golden Lion*) is seen stern-on at the right center. Beyond it in the distance is *Het Hof van Zeeland*, commanded by Jan Evertsen, which flies a flag at the main- and a pendant from the foremast. At the right is the *Klein Hollandia* with a lion rampant carved on its tafferel. This study is sufficiently large in scale to indicate the great size of these heavily armed warships. Van de velde's broad yet subtle use of washes across the water adds a further note of stability to an impressive assembly of the Dutch fleet.

NOTE

1. Weber and Robinson, 1979, vol. 1, pp. 22–23.

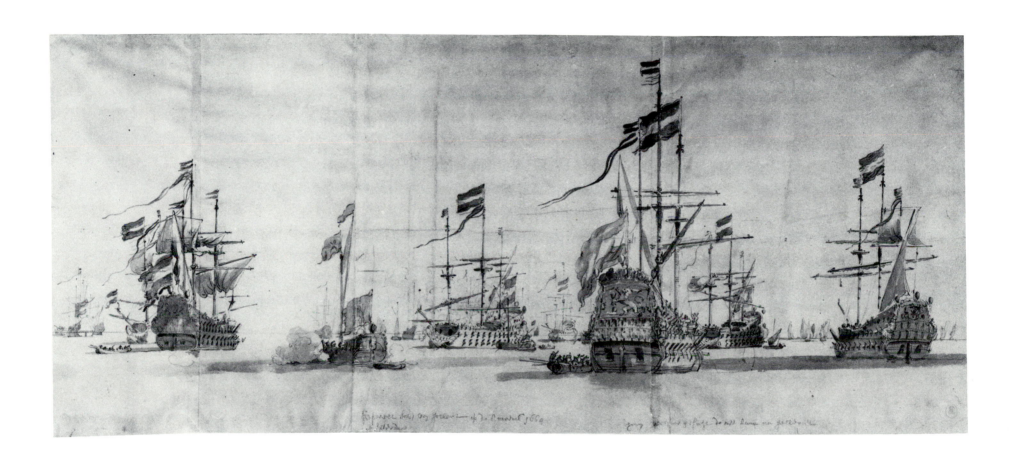

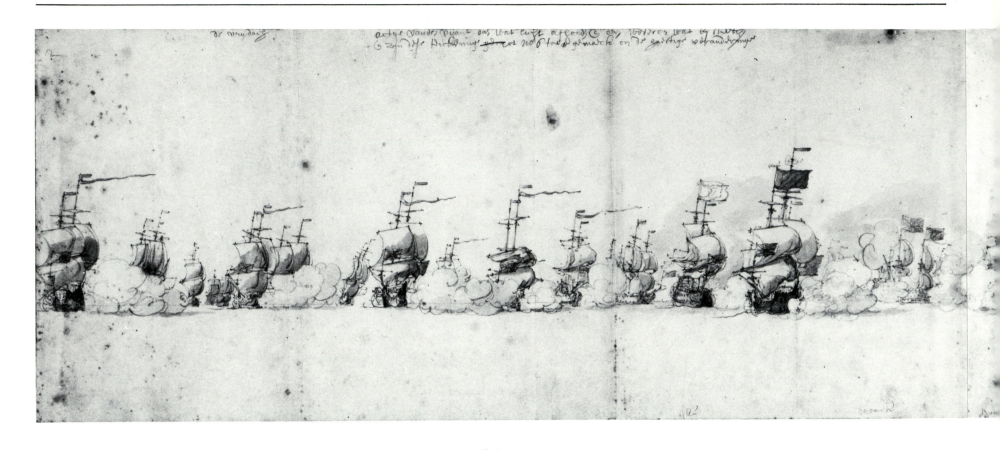

<div align="center">

81

WILLEM VAN DE VELDE THE ELDER
The Four Days' Battle: The English Ships Close-hauled on the Starboard Tack and Tromp Tacking Back

</div>

Pencil and gray washes, 315 × 1,618 mm
Captions throughout
Rotterdam, Museum Boymans–van Beuningen, inv. MB 1866/T82a, T82b (L. 1857)

PROVENANCE: Same as Cat. 77
LITERATURE: Weber and Robinson, 1979, vol. 1, pp. 45–46; vol. 2, pls. 140–141

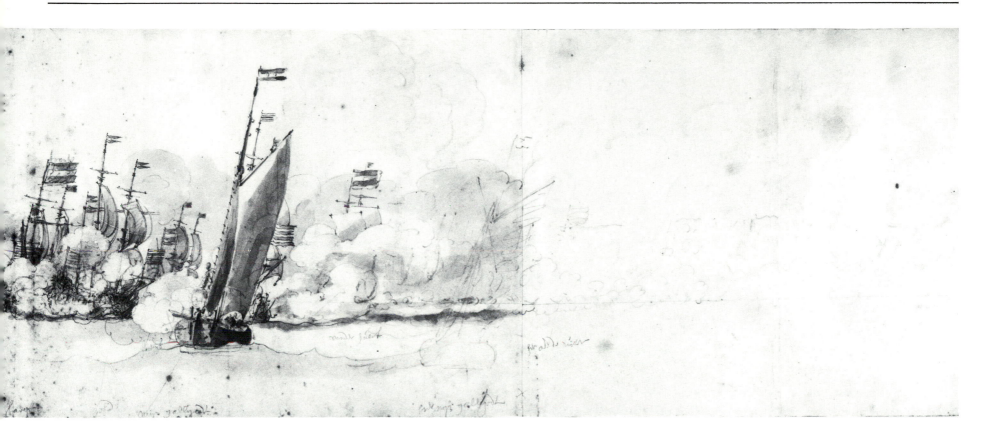

In this study van de Velde represents the first day of the Four Days' Battle. This engagement took the form of a fight on parallel lines, with Cornelis Tromp commanding the Dutch van, Michiel de Ruyter the center, and Evertsen the rear squadrons of the Dutch fleet. This action continued until both fleets had to tack to avoid the hazardous sands off the coast of Flanders. The artist represents the English fleet in the left section of this large frieze. The *Royal Prince,* under the command of Sir George Ayscue, appears at the right. Beyond it, farther in the distance, the *Royal Charles,* commanded by George Monck, Duke of Albemarle, appears sailing before the wind and flying the union flag on its mainmast and a red flag on its foremast. The right-hand section contains Dutch warships. The *Hollandia,* commanded by Cornelis Tromp, is in starboard quarter view next to the *Liefde.* The *Gouda,* commanded by I. Sweers, is in the smoke beyond. The *Zeven Provincien,* commanded by Michiel de Ruyter, is beyond at the right, largely screened by smoke. Appearing before these tacking warships is van de Velde's galliot seen in lee bow view and flying a flag with two balls in the white middle band. The artist's dedication to his task is made evident by the caption across the top of the left-hand section: "Friday, showing the enemy bearing away a little and then hauling their wind again, these drawings numbering six made owing to the rapid changes."[1] He displays his matchless ability to capture the unfolding drama by sketching each ship incisively in pencil and reinforcing it with judiciously applied gray washes.

NOTE

1. "de vrydach actye vanden vyant dan wat licht afhouden & dan wederom wat by steeken & zijn dese teickeninge tot no 6 toe gemaeck om de haestige veranderinge," cited in Weber and Robinson, 1979, p. 45.

82

WILLEM VAN DE VELDE THE ELDER

The Four Days' Battle: Damaged English Ships; "Het Hof van Zeeland" and the "Duivenvoorde" Burning; the "Swiftsure," "Loyal George" and "Seven Oaks" Captured (June 11, 1666)

Pencil and gray washes, 355 × 2,348 mm
Captions throughout
Rotterdam, Museum Boymans–van Beuningen, inv. MB 1866/T87a–c (L. 1857)

PROVENANCE: Same as cat. 77
LITERATURE: Weber and Robinson, 1979, vol. 1, p. 48; vol. 2, pls. 151–153

This great frieze in three sections shows the first day of battle at its height. Damaged English ships appear in the left distance of the left-hand section at the perimeter of the raging battle. In the central section van de Velde represents many Dutch ships seen in lee bow view on a starboard tack. Amid them two Dutch ships burn, the *Hof van Zeeland* beyond the ship of Michiel de Ruyter at the left, and the *Duivenvoorde*, at the center just beyond the *Eendracht,* under the command of Aert van Nes. The right-hand section shows the lee side of the battle with Willem van de Velde in his galliot in the center foreground. In the left foreground a skiff rescues five survivors from a Dutch fireship. To the left center beyond the galliot transporting the artist is the captured English ship the *Loyal George,* seen in stern view. Just to the right of the galliot is the *Swiftsure,* which is surrendering to the *Reiger.* Sailors are in the process of removing the English white squadron flags. Still part of the main action at the right, the *Seven Oaks* has been captured by the Dutch, and in the far distance badly damaged English ships retreat.[1]

Willem van de Velde immortalizes the height of the struggle during the first day of the Four Days' Battle, during which the Dutch captured many

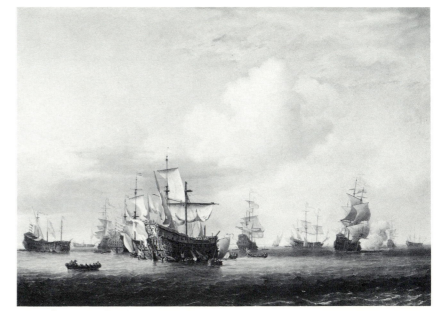

Cat. 82, fig. a *Willem van de Velde II,* The Captured English Ships "Swiftsure," "Seven Oaks," "Loyal George," and "Convertine" being hauled to Goereese Gat following the Four Days Battle, *oil on canvas. Amsterdam, Rijksmuseum.*

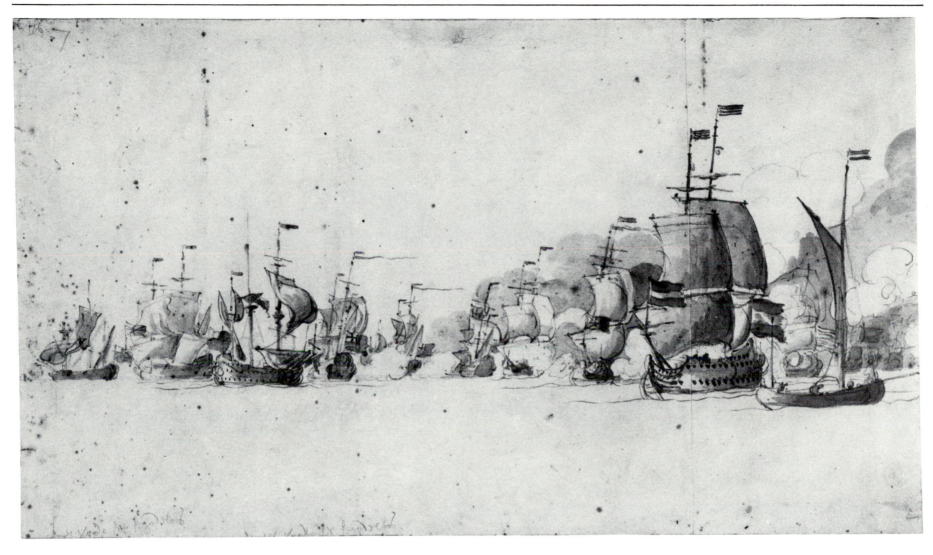

of their greatest prizes.[2] However, the greatest of all, the *Royal Prince,* fell to the Dutch only on June 13, having run aground on the Galloper shoals. Willem van de Velde the Younger painted this subject on several occasions (e.g., Cat. 40).

NOTES

1. For a fuller description of many ships represented in this three-part drawing, see Weber and Robinson, 1979, p. 48.

2. Willem van de Velde the Younger represents *The Captured English Ships "Swiftsure," "Seven-oaks," "Loyal George," and "Convertine" being hauled to the Goereese Gat following the Four Days' Battle* in his painting in the Rijksmuseum, Amsterdam (fig. a), inv. A439.

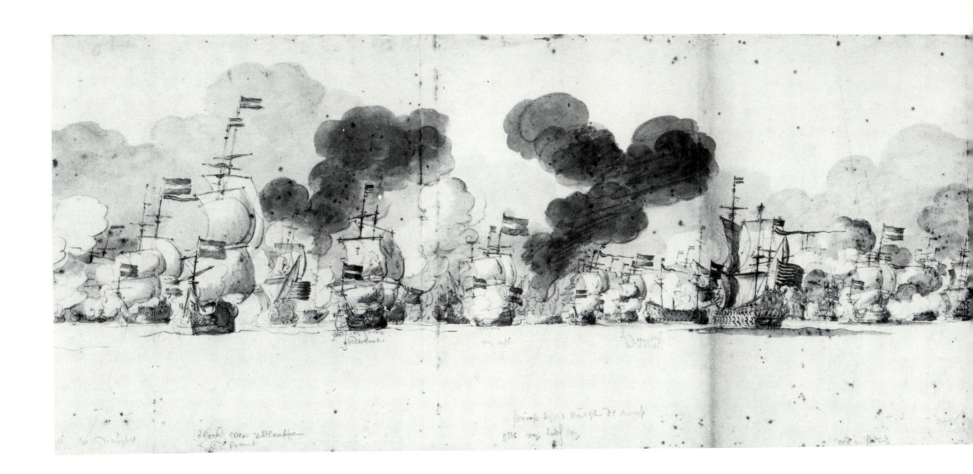

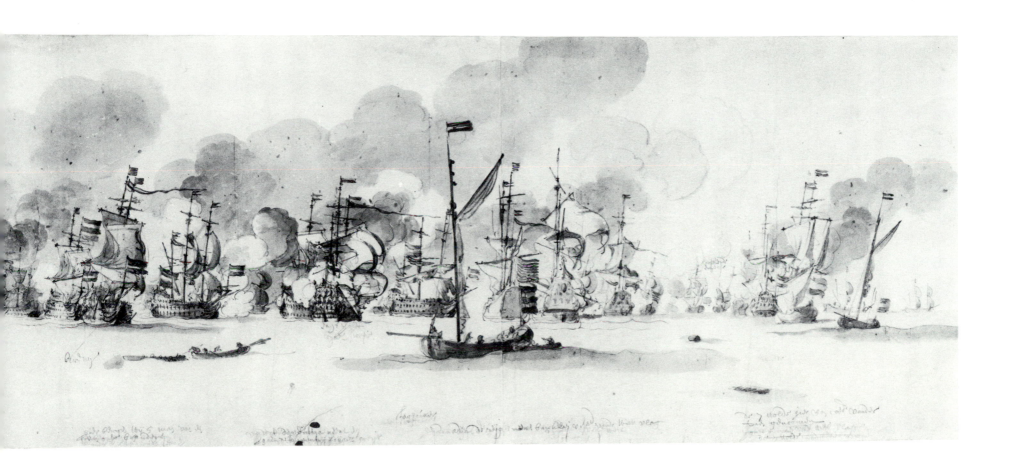

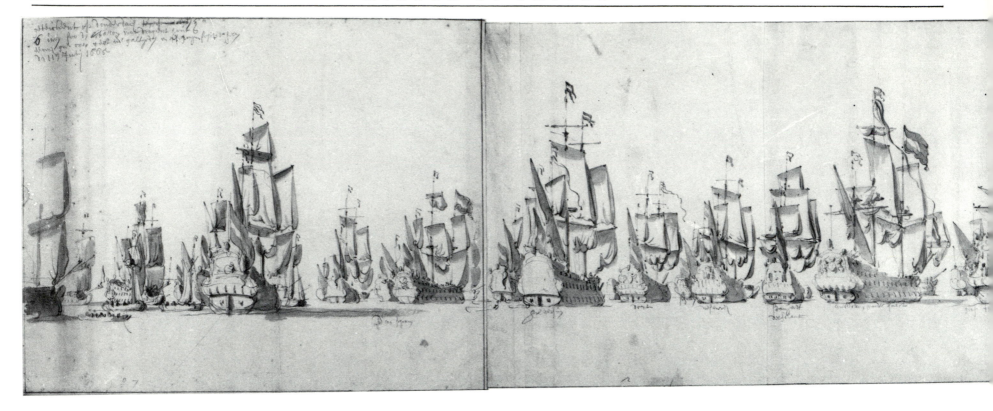

83

WILLEM VAN DE VELDE THE ELDER
The Dutch Fleet in Light Airs Before the Battle of Lowestoft
(June 11, 1665)

Pencil and gray washes, 348 × 1,868 mm
Captions throughout
Rotterdam, Museum Boymans–van Beuningen, inv. MB 1866/T53a, 53b (L. 1857)

PROVENANCE: Same as Cat. 77
LITERATURE: Weber and Robinson, 1979, vol. 1, pp. 34–35; vol. 2, pls. 84–86

Jacob, Baron van Wassenaar van Obdam, was appointed commander-in-chief of the Dutch fleet assembled in the Texel by the States General on April 16, 1665. This fleet set sail to seek out the English and spotted the enemy fleet close to the Suffolk coast near Lowestoft; on the morning of June 13, 1665, the Dutch initiated a passing fight. The English avoided accepting this provocation to join a general melée, which would suit the

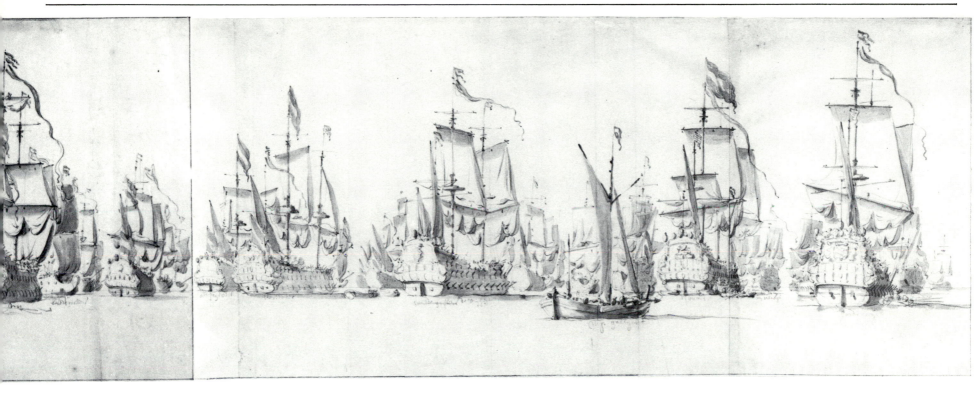

Dutch strategy of boarding the enemy. Instead, the English attempted to divide the Dutch fleet, and Edward Montagu, Earl of Sandwich, commander of the English blue squadron, accomplished this at about one p.m. James, Duke of York, commander-in-chief and admiral of the red squadron, was in battle with the *Eendracht*, the flagship of Wassenaar van Obdam. At about three p.m. the *Eendracht*, with its commander-in-chief and crew, blew up. This threw the Dutch into disarray and their resistance crumbled. Admirals Jan Evertsen and Cornelis Tromp formed a rearguard action to enable as many ships to escape as possible, and the battered Dutch fleet returned to the safety of its own estuaries.[1]

Ironically, Willem van de Velde the Elder produced more drawings of the Dutch fleet in the days preceding the Battle of Lowestoft than for any other single major naval action. Moreover, many of these, including the frieze under discussion, are on a monumental scale that remains unsurpassed in the artist's oeuvre. The ships in this drawing are mostly seen from starboard quarter. Van de Velde's galliot appears in the foreground of the right-hand section before a formidable array of warships. From left to right in the right-hand section are the *Hof van Zeeland*, under the command of Jan Evertsen, the *Groot Hollandia*, under the command of E. M. Kortenaer, the *Vrijheid*, the *Eendracht* just to the right of van de Velde's galliot, and the *Harderwijk*. This stately grouping is enhanced by the artist's sparing use of gray washes that contrast to the sheen of the paper. As a result, the calm sea and luminous sky underscore the majestic procession of ships.

NOTE

1. See Weber and Robinson, 1979, vol. 1, p. 30, who also describe the division of the Dutch fleet into seven squadrons in order to give more flag officers a command. Willem van de Velde the Elder also produced a series of three drawings, now in Greenwich, in which he represents the *Battle of Lowestoft* – see Robinson, 1973, vol. 1, cat. no. 446–448, repr., which he dates to ca. 1674. As Robinson states, p. 85, these three studies, represented in bird's-eye view, were conceived as tapestry designs.

84

WILLEM VAN DE VELDE THE ELDER
The English Ship "Providence"

Pencil and gray washes, 287 × 455 mm
Rotterdam, Museum Boymans–van Beuningen, inv. MB 1866/T412 (L. 1857)

PROVENANCE: Same as Cat. 77
LITERATURE: Weber and Robinson, 1979, vol. 1, pp. 117–118; vol. 3, pl. 243

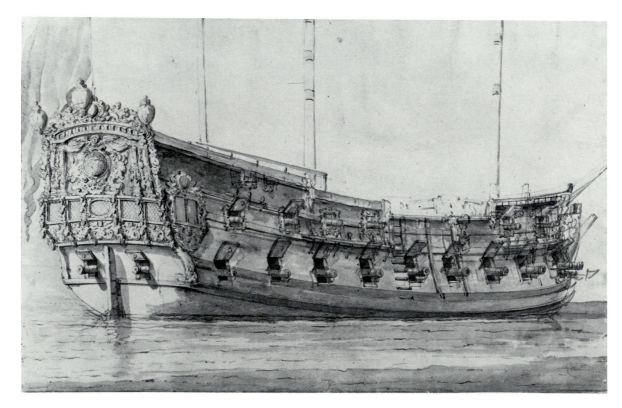

This vessel, seen from starboard quarter view, is a fourth-rate-class ship that carried thirty-four guns. Built as early as 1637, it was converted into a fireship in 1667 and was wrecked in 1668. Weber dates this drawing ca. 1661.[1]

This drawing relates closely to two in Greenwich that Robinson tentatively identifies as the *Providence* or the *Expedition*.[2] The Boymans drawing is rubbed on the back, suggesting that an offset was taken from it. Van de Velde's practice of using drawings in this manner enabled him to work

the same basic prototype up into different ships to suit his needs.[3] In fact, a partially effaced and altered inscription on the Greenwich portrait of the *Expedition* may originally have read: *de providence*. Van de Velde's portrait of the *Providence* in Rotterdam still retains the freshness of his modulated gray washes. His penchant for detail is especially evident in the depiction of the stern with its elaborately carved tafferel.

NOTES

1. Weber and Robinson, 1979, vol. 1, p. 117.
2. Robinson, 1973, vol. 1, p. 164, cat. 68, pl. 23, and p. 168, cat. 74, pl. 25.
3. As noted by Weber and Robinson, 1979, vol. 1, pp. 117–118.

85

WILLEM VAN DE VELDE THE ELDER
The Dutch Ship "Ster" (Star)

Pencil and gray wash, 355 × 500 mm
Rotterdam, Museum Boymans–van Beuningen, inv. MB 1866/T218 (L. 1857)

PROVENANCE: Same as Cat. 77
LITERATURE: Weber and Robinson, 1979, vol. 1, p. 105; vol. 3, pl. 162

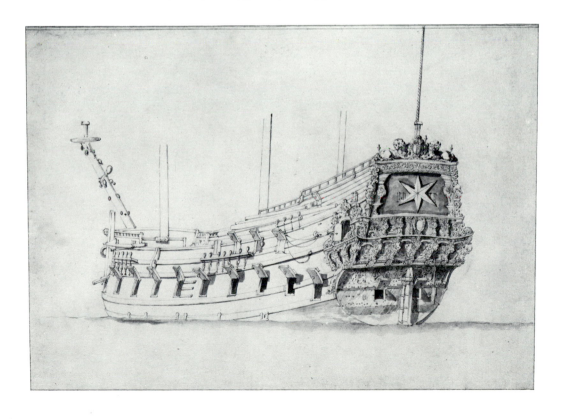

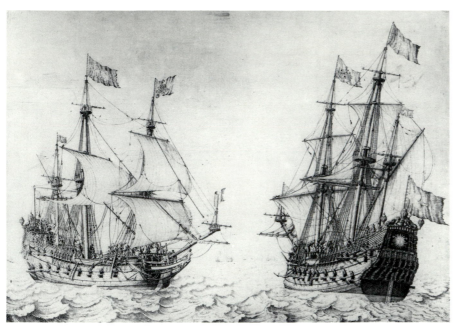

Cat. 85, fig. a Willem van de Velde the Elder, "The Ster," *pen painting on panel. Amsterdam, Rijksmuseum "Nederlands Scheepvaart Museum."*

This Dutch frigate, built in 1644, was burned in action in 1677. It has a large six-pointed star in its tafferel with the arms of Amsterdam flanked by lions. Two shields appear on the counter, the inward-sloping zone of the stern above the waterline. The shield on the port side contains crossed anchors, whereas the one on the starboard side contains a lion rampant. Both denote the Admiralty of Amsterdam. The *Ster* was originally built to carry twenty-eight guns but carried thirty-six at the Battle of Lowestoft.[1] The drawing in Rotterdam is an offset worked up in pencil and wash. Van de Velde produced an offset from this drawing, also in Rotterdam,[2] which lacks wash. At the bottom left it bears the inscription: *t vergadt de goude ster* (the frigate, the *Golden Star*). Weber discusses the complex production of these offsets, which he dates to about 1665. Van de Velde produced a pen painting dated 1653 representing the *Ster*, now in the Rijksmuseum "Nederlands Scheepvaart Museum" in Amsterdam (fig. a). In all probability he produced carefully finished preparatory drawings of the ship related to this project and may have subsequently used one of these for the offsets now in Rotterdam. Weber also suggests that the gray washes and added pencil reinforcement may have been executed by Willem van de Velde the Younger.[3]

NOTES

1. Weber and Robinson, 1979, vol. 1, p. 105.
2. Ibid., vol. 1, p. 105, inv. MB 1866/T454; vol. 3, pl. 163.
3. Ibid., vol. 1, p. 105.

86

WILLEM VAN DE VELDE THE ELDER
The Dutch Ship "Vrijheid" (Freedom)

Pencil, 392 × 515 mm
Caption at bottom left in pencil: *de vryheyt,* and numbered at bottom right: 7
 (altered from a *5*)
Rotterdam, Museum Boymans–van Beuningen, inv. MB 1866/T291 (L. 1857)

PROVENANCE: Same as Cat. 77
LITERATURE: Weber and Robinson, 1979, vol. 1, p. 108; vol. 3, pl. 178

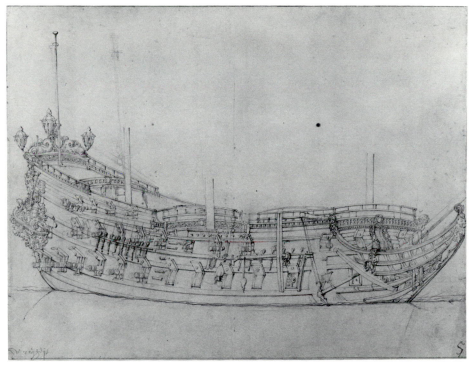

Van de Velde views this ship, which carried forty-six guns (fifty-six subsequent to renovation), from before the starboard beam. The *Vrijheid* was built in Amsterdam in 1651 and blew up in action in 1676. This drawing, dated by Weber to ca. 1665, is an offset strengthened in pencil. A closely related drawing in Greenwich[1] is worked up with gray washes. While depicting sailors on board, it actually includes less ornamental detail. Another portrayal of the same ship, viewed from the starboard quarter, also in Rotterdam,[2] shows the carved stern with the seated personification of

freedom on the tafferel with the arms of Amsterdam carved on the rail above and two crests, crossed shields, and the arms of Holland denoting the Admiralty of Amsterdam on the counter (also see Cat. 32 for similar armorials). The arms of Holland are in reverse, indicating that this drawing is an offset, in mirror image to the original it was taken from. Weber and Robinson note that the original drawing may have served for the corre-sponding detail in van de Velde's large grisaille painting in the Palazzo Pitti (Cat. 32).[3]

NOTES

1. Robinson, 1973, vol. 1, p. 155, cat. 15, pl. 6.
2. Weber and Robinson, 1979, vol. 1, p. 108, inv. MB 1866/T290; vol. 3, pl. 177.
3. Ibid., vol. 1, p. 108.

87

WILLEM VAN DE VELDE THE ELDER
A Dutch Ship of About Eighty Guns

Pencil and gray washes, 377 × 907 mm
Rotterdam, Museum Boymans–van Beuningen, inv. MB 1866/T302 (L. 1857)

PROVENANCE: Same as Cat. 77
LITERATURE: Weber and Robinson, 1979, vol. 1, p. 111, vol. 3, plates 190, 191

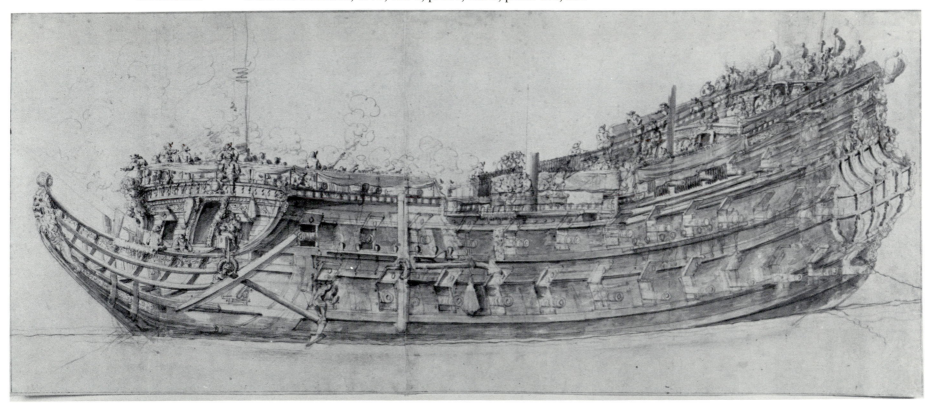

Viewed from before the port beam, this large warship is one of Willem van de Velde's most magisterial portraits of a ship. Its decks are crowded with people and some of its railings are swathed in cloth. Figures on the forecastle fire muskets into the air, possibly indicating a celebratory occasion. Weber and Robinson conjecture that this still unidentified ship was built about 1665, whereas he dates the drawing to about 1672, the year Willem van de Velde moved to England.[1]

NOTE

1. Weber and Robinson, 1979, vol. 1, p. 111.

88

WILLEM VAN DE VELDE THE ELDER
The English Ship, the "Royal Prince"

Pencil, pen, and gray washes, 449 × 739 mm
Caption at upper left: *de prins*
Rotterdam, Museum Boymans–van Beuningen, inv. MB 1866/T352 (L. 1857)

PROVENANCE: Same as Cat. 77
LITERATURE: Weber and Robinson, 1979, vol. 1, p. 119; vol. 3, pl. 257

The *Royal Prince* saw a long and eventful life. Built in 1610, it was rebuilt twice in 1641 and 1663. Its second transformation took more than two years and resulted in creating a heavily armed warship of the first rate that carried ninety-two guns. The *Royal Prince*, as the flagship of the white squadron commanded by Sir George Ayscue, participated in the Four Days' Battle. On the third day, June 13, the *Royal Prince* ran aground on the Galloper shoals and was forced to surrender. It could not be dislodged, so the Dutch admiral, Michiel de Ruyter, commanded that it be set afire and destroyed. Its surrender became a popular subject for Dutch marine painters and was represented in several pictures by Willem van de Velde the Younger (Cat. 40). He may possibly have consulted this or a similar drawing when producing certain of his versions of this subject. That in the Rijksmuseum in Amsterdam represents the *Royal Prince* in virtually the same position.[1] Even the lighting on the hull is similar. By contrast, in the ex-Ellesmere painting (Cat. 40) the stern captures full sunlight and the starboard flank is in deep shadow. In general the same applies to Willem van de Velde the

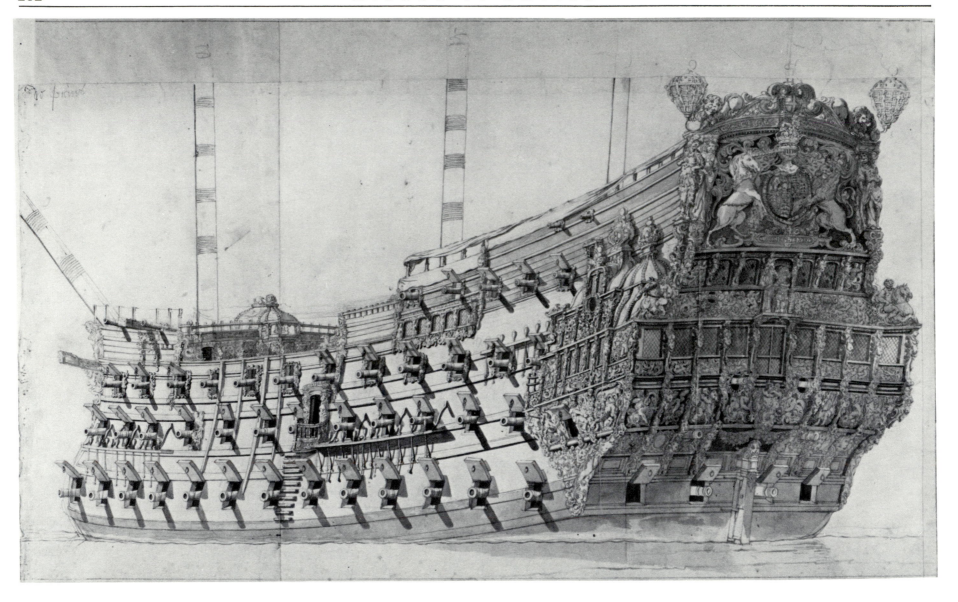

Younger's versions in The Hague[2] and Paris.[3] In the picture in Paris, van de Velde represents the *Royal Prince* in a similar raking light, but in a slight sea swell. In the drawing in Rotterdam, Willem van de Velde the Elder represents the ship in particularly clear light, as evidenced by the sharply defined shadows cast by the gun ports and projecting cannon.

NOTES

1. H. P. Baard, *Willem van de Velde de Oude Willem van de Velde de Yonge* (n.d.), p. 49, repr.

2. Mauritshuis, 1980, p. 115, inv. 471, repr.

3. Institut Néerlandais, inv. 5807, "Reflets du Siècle d'Or," 1983, cat. 87, pp. 143–145, pl. 52.

89

SIMON DE VLIEGER
Ships in a Calm

Black chalk and gray wash, 156 × 273 mm
Signed at bottom left: *S DE VL*
Amsterdam, Rijksprentenkabinet, inv. A 1537 (acquired by the Vereeniging Rembrandt)

PROVENANCE: Amsterdam, Collection Jacob de Vos, Jbzn. (L. 1450)
LITERATURE: Moes, 1904–1906, cat. 91, repr.
EXHIBITION: Amsterdam, 1987, pp. 33–34, repr.

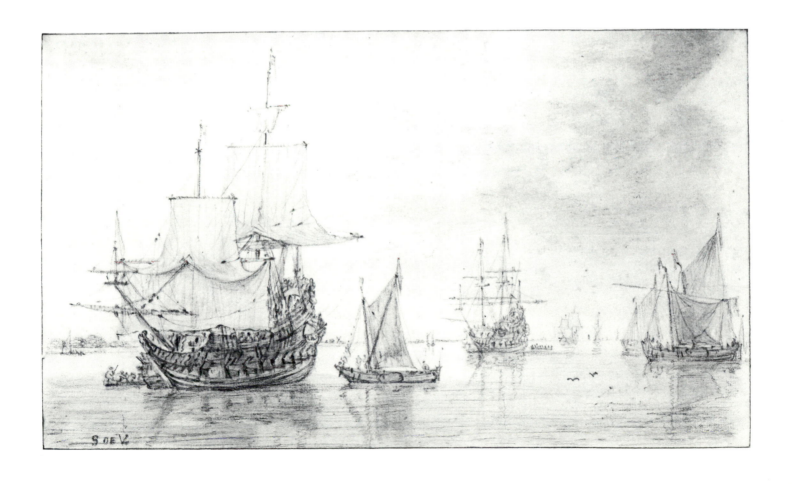

Simon de Vlieger's preferred medium is black chalk reinforced with gray wash. This drawing is a particularly refined example of his late style, in which he represents ships in calm weather. Distant trees and a windmill suggest a locale along the shores of an estuary or inland sea. Late in his life de Vlieger moved to Weesp, a village on the Zuider Zee about fifteen miles east of Amsterdam. In this drawing he possibly represents large ships approaching the River Ij from the Zuider Zee. The artist evokes the stillness of a calm day by the reflecting water and limp sails of the warship. De Vlieger sketches a cloud bank at the right that contrasts to the luminous blank sky at the left.

Jan van de Cappelle owned more than 1,300 drawings by Simon de Vlieger, yet few sketches from his hand survive, and the majority of these are forest views. De Vlieger's marine drawings are extremely rare. A second marine drawing by Simon de Vlieger in the Rijksprentenkabinet, *Ships in a Calm,* is also signed and has the same provenance.[1] His other marines, which represent remote rocky coastlines distinctly non-Dutch in character, are also rare and include well-known examples in Cambridge,[2] London,[3] and Vienna.[4] These drawings reveal de Vlieger's interest in the chalk landscape drawings of Roelandt Savery and may date from the artist's middle period – ca. 1635–1640. The two *Calms* in Amsterdam are later. In mood and style they anticipate the brush and wash drawings of Reinier Nooms, who in all likelihood was cognizant of this aspect of Simon de Vlieger's activity.

NOTES

1. Inv. A 1536.

2. Rotterdam, 1961/1962, pp. 93–94, cat. 112, pl. 50.

3. Courtauld Gallery, Witt Collection, inv. 4639, *Rocky Coastline*, black chalk, gray wash, 83 × 138 mm, signed at lower left: *S DE VL.*

4. Albertina, inv. Z9167, *Rocky Coastline*, black chalk, gray wash, 186 × 297 mm, signed: *S DE VLIEGER.*

90

HENDRICK VROOM
Ships in a Storm

Pen and brown ink, 147 × 195 mm
Rotterdam, Museum Boymans–van Beuningen, inv. H. Savery I.

PROVENANCE: Amsterdam, auction (R.W.P. de Vries) April 5, 1906, lot 230
LITERATURE: L. J. Bol, 1973, pp. 41–42, pl. 41
 Keyes, 1975, vol. 1, pp. 25–26, 123, pl. VII
 Keyes, 1982, p. 119, pl. 3
 Russell, 1983, p. 145, fig. 130b

Ships in a Storm is one of Vroom's most highly finished compositional studies. The theme of ships in tempests was important to him and became popular in the repertory of Dutch marine art. Vroom also produced a large painting, *The Great Sea Storm,*[1] that is closely related in theme to the Rotterdam drawing. This picture and its pendant, *The Battle of Cadiz,* were influential, and served as prototypes that inspired Vroom's emulators.[2] Although *Ships in a Storm* was never engraved, Hendrick Vroom produced similar designs for such purposes. One such example is the rare engraving

by Meynert Jelissen, *Ships by a Rocky Coast in a Storm* (Cat. 107), published in 1612. A second anonymous engraving published by Pieter van den Keere,[3] is even closer to Vroom's drawing in Rotterdam. Like it, the engraving represents ships on the high sea with no reference to land. Despite the threatening tempest, these ships appear to be under control with most of their sails trimmed. Such images may function as metaphors for the ship of state or for the human soul steadfast in its faith in God despite the vicissitudes of destiny.[4]

NOTES

1. Private collection, Great Britain; L. J. Bol, 1973, pl. 9; Russell, 1983, fig. 135. This has as its companion painting *The Battle of Cadiz*.

2. In fact, Aert Anthonisz. produced a faithful replica, dated 1608, of Vroom's *Battle of Cadiz*. This picture is in the Rijksmuseum in Amsterdam – repr. L. J. Bol, 1973, fig. 35.

3. Keyes, 1975, pl. VIII. This print is monogrammed on the barrel at the right: *HCV*. Russell, 1983, fig. 130a, reproduces the same engraving in a later state with the address of Claes Jansz. Visscher.

4. Russell, 1983, p. 154. For a comprehensive discussion of the theme of the storm in Dutch marine painting, see Goedde, 1989.

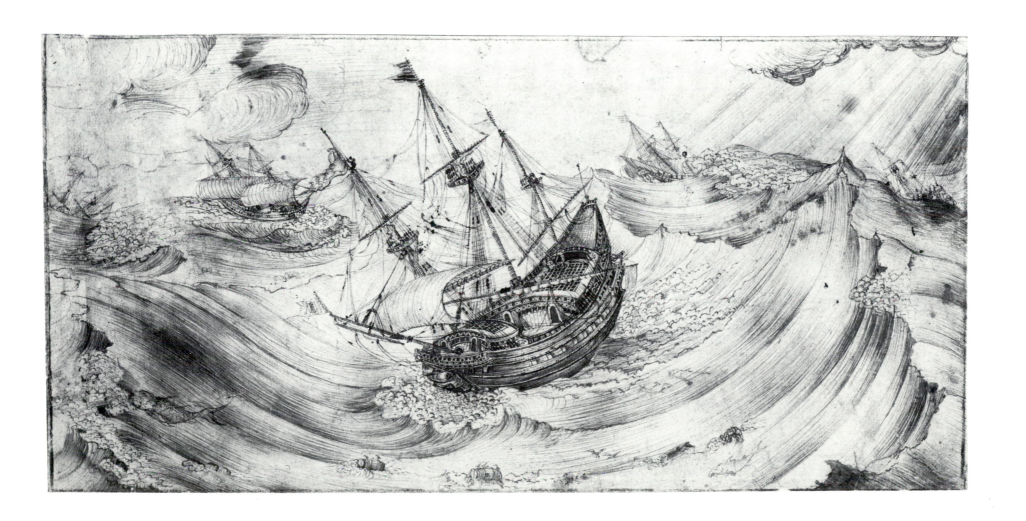

91

HENDRICK VROOM
A Dutch Warship

Pen and brown ink, 411 × 570 mm
Düsseldorf, Kunstmuseum, inv. Z5421

LITERATURE: Keyes, 1982, pp. 115–119, pl. 1

This recently discovered drawing is one of Hendrick Vroom's most notable studies of ships. The large armed vessel under sail is defined with acute attention to detail, evident in the delineation of the hull and the full sails. Vroom's characterization of water with whitecaps is analogous to that found in *Ships in a Storm* (Cat. 90). The warship bears the admiralty flag of war, the Dutch lion holding seven swords on the wimple, symbolizing the seven united provinces of the Dutch Republic. Unfortunately the drawing has been trimmed sufficiently to crop the tops of the fore- and main-masts of this ship. Nonetheless, enough survives to indicate that this is one of Hendrick Vroom's most impressive and spirited drawings. It dates to the period shortly after 1600. Similar vessels with an open gallery around the stern appear in Vroom's *Skirmish Between Dutch and English Ships* (Cat. 51) of 1614 in the Rijksmuseum "Nederlands Scheepvaart Museum" in Amsterdam, and Jelissen's engraving, *Ships by a Rocky Coast in a Storm* (Cat. 107) of 1612.

This portrait of a ship under sail is the earliest surviving example in seventeenth-century Dutch art and is an important antecedent for Willem van de Velde the Elder's earliest experiments in this genre, for example, his *Portrait of the Aemilia* (Cat. 121). Given his penchant for precise characterization of ships in all of his marine paintings, it is logical that Hendrick Vroom should have produced such accurate portrayals of ships in pen.

92

HENDRICK VROOM
Ships in a Storm

Pen and brown ink, 258 × 424 mm
Signed and dated at bottom right: *vroom Ao 1625*
New Haven, Yale University Art Gallery, inv. 1961.66.37

PROVENANCE: Collection John Percival, 1st Earl of Egmont
Collection John T. Graves
Collection Robert Hoe
New York, auction R. Hoe (Anderson) April 15–19, 1912, Port. III, A–K, no. 949,
 acquired by a friend of Yale University, (presented to the Yale University Library in
 1957)
LITERATURE: Haverkamp Begemann and Logan, 1970, vol. 1, p. 242, cat. 443, pl. 193
Keyes, 1975, p. 45, pl. XXV
Russell, 1983, p. 192, fig. 174 (as dated 1629)

This drawing dates late in Hendrick Vroom's career and demonstrates his striving to remain abreast of recent developments in Dutch marine art. He represents a variety of sailing vessels in rough weather. Although Vroom employs his characteristic precise penwork, he nevertheless evokes general atmospheric effects with swirling clouds forming a penumbra of shade behind the ships. The subject is nonhistorical in character and shows

Vroom's awareness of the precepts of Jan Porcellis, who dispensed with representing history subjects in his mature output. Hendrick Vroom developed further in this direction in a second drawing at Yale[1] and in a drawing, *Shipping in a Breeze,* dated 1623.[2] Like *Ships in a Storm,* this drawing contains swirling clouds that create atmospheric effects. The penwork is scratchy, but the artist defines waves with great sensitivity. Vroom also drew a handful of remarkable beach scenes in pen and ink. Although he expressed interest in this subject as early as 1600, his finest beach scenes

date later[3] and are closely related stylistically to his two dated marine drawings of 1623 and 1625.

NOTES

1. *Ships in a Breeze,* Haverkamp Begemann and Logan, 1970, vol. 1, p. 241, cat. 442, pl. 194; Russell, *Visions of the Sea,* 1983, fig. 175.

2. Pen and brown ink, 146 × 214 mm, current whereabouts unknown, provenance: Saint Louis, Collection Dr. Max A. Goldstein; New York, auction (Sotheby Parke-Bernet) January 20, 1982, lot 45, repr.

3. Russell, 1983, p. 155, figs. 137, 138a–b.

93

CORNELIS CLAESZ. VAN WIERINGEN
A Ship Saluting

Pen, brown ink, gray washes, and white highlights, 120 × 180 mm
Amsterdam, Rijksprentenkabinet, inv. A 4637

PROVENANCE: Collections A. van der Willigen and A. van der Willigen Pz.
Amsterdam, auction (A. G. de Visser) June 10–11, 1874, lot 299, bought by Prestel
Rotterdam–Wiesbaden, Collection W. Pitcairn Knowles (L. 2643)
Amsterdam, auction W. Pitcairn Knowles (F. Muller) June 25–26, 1895, lot 725, bought
 by the Rijksprentenkabinet

LITERATURE: Moes, 1904/1906, cat. 92
Boon, 1978, cat. 482, repr. (as H. Vroom)
Keyes, 1979, vol. 93, pp. 25–26, cat. 5, pl. 36
Russell, 1983, pp. 142–143, fig. 125 (as H. Vroom)

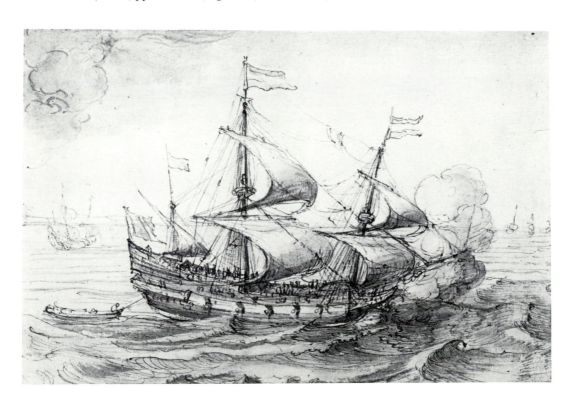

This spirited drawing, representing a saluting three-master viewed just before starboard beam, is a characteristic example of van Wieringen's pen and wash studies. Unlike Hendrick Vroom, from whom only a few carefully finished pen drawings survive, van Wieringen was a prolific draftsman. He tended to sketch quite impetuously and on occasion produced drawings intended as designs for prints. This example is somewhat exceptional in his oeuvre because of the artist's use of white highlights. Combined with the gray wash, they define the smoke generated by the cannon salute. The definition of the waves, distant boats, and clouds finds analogies in two similar drawings by van Wieringen in Brussels[1] and Frankfurt.[2]

NOTES

1. Keyes, 1979, cat. 14, pl. 38.
2. Ibid., cat. 30, pl. 34.

94

CORNELIS CLAESZ. VAN WIERINGEN
Sailboats by a Wooded Shore

Pen, brown ink, and gray wash, 75 × 118 mm
Leiden, Prentenkabinet der Rijksuniversiteit, inv. 73/15

PROVENANCE: London, auction (Christie) November 27, 1973, lot 306, repr. (as. H. Vroom)
LITERATURE: Keyes, 1979, vol. 93, p. 35, cat. 37, pl. 32

This small sketch is an important example of van Wieringen's interest in depicting an everyday subject rather than a significant historical event. It indicates the shift that occurred in Dutch marine art even in the earliest phase of its evolution. This phenomenon was accelerated by the example of Jan Porcellis, but artists such as Hendrick Vroom and Cornelis Claesz. van Wieringen also represented nonhistorical subjects of this type and contributed to the reorientation of Dutch marine art. Van Wieringen accepted this shift with greater ease than Hendrick Vroom and even became involved in designing suites of prints. Printmakers such as Jan van de Velde II and Robert de Baudous utilized marine drawings similar to this sketch in Leiden as designs for etchings and engravings, which became popular collector's items. One example of this is Jan van de Velde's print after van Wieringen's drawing *A Pier* in the Rijksprentenkabinet in Amsterdam.[1] Van Wieringen's contribution to this production of prints was important and deserves greater recognition. His association with the Amsterdam publisher Claes. Jansz. Visscher preceded Visscher's edition of prints after Jan Porcellis (Cat. 116, 117), which brought the idea of producing suites of marine prints to a new level of sophistication.

NOTE

1. Keyes, 1979, p. 27, cat. 7, pls. 50, 46; de Groot and Vorstman, 1980, cat. 49–51.

95

CORNELIS CLAESZ. VAN WIERINGEN
Sailboats by a Pier

Pen, brown ink, and gray wash, 160 × 227 mm
Cambridge, Fitzwilliam Museum, inv. PD 566–1963 (Bruce Ingram Bequest)

PROVENANCE: Berlin, Collection M. A. von Beckerath
Berlin, Kupferstichkabinett
London, Collection Bruce Ingram (L. 1405a)
LITERATURE: Bock and Rosenberg, 1930, p. 210, inv. Z12097 (as Bonaventura Peeters)
Keyes, 1979, vol. 93, pp. 28–29, cat. 17, pl. 29

Sailboats by a Pier is one of van Wieringen's largest and most important marine drawings. His precise representation of the large single-masted sailboat may suggest that the artist intended to use this drawing as a study for a print depicting a specific type of sailing vessel, a *veerschuit*, which provided ferry service across the inland waterways of the Dutch Republic. As noted by de Groot and Vorstman, a hitherto undescribed print by Jan van de Velde II contains an analogous sailboat in reverse, but enough differences exist between this print and the drawing in Cambridge to indicate that van de Velde based his etching on another drawing by van Wieringen, now lost.[1] *Sailboats by a Pier* is similar in finish to a somewhat

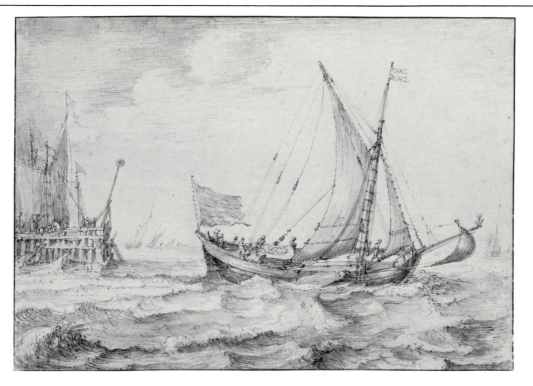

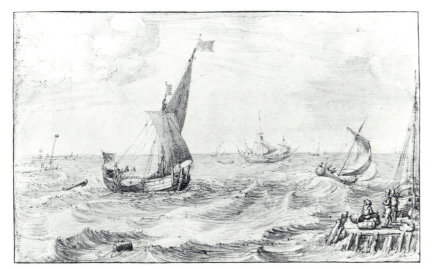

larger drawing in Vienna (fig. a),[2] which may have been intended for a similar purpose. The artist stresses certain picturesque features, such as the rays of sunlight emanating from behind the clouds at the left, that would have appealed to a reproductive printmaker. As far as we know, however, this drawing, like that in Cambridge, was never used as a design for a print.

NOTES

1. de Groot and Vorstman, 1980, cat. 50, repr.
2. Keyes, 1979, vol. 93, pp. 41–42, cat. 61, pl. 28.

Cat. 95, fig. a Cornelis Claesz. van Wieringen, Sailboats by a Pier, *pen, brown ink, and washes. Vienna, Graphische Sammlung Albertina.*

PRINTS

96

LUDOLPH BACKHUYSEN
The Personification of Amsterdam Riding in Neptune's Chariot

Etching, state III, 198 × 259 mm
Signed (in reverse) on the barrel at lower right: *LBF*
Signed in bottom margin: *L. Bakhuizen fecit et exc: cum Privil: ord: Hollandiae et West*
 Frisiae
Minneapolis, Minneapolis Institute of Arts, inv. 825, Ladd Collection, Gift of Hershel
 V. Jones, 1916

LITERATURE: Bartsch 1
Dutuit 1
Hollstein 1
Illustrated Bartsch, 1979, vol. 5, p. 265, repr.
de Groot and Vorstman, *Zeilschepen*, 1980, cat. 110, repr.
Boston–Saint Louis, 1980–81, p. 297, cat. 207, repr.
Paris, 1989, pp. 94–95, cat. 93

This allegorical print represents the tyche of Amsterdam seated on Neptune's chariot on the River Ij before the warehouse of the Dutch East India Company. It is an evocation of the mercantile prosperity and power of Amsterdam, whose naval might is manifested by the stern of the sixty-four-gun warship, *Amsterdam*, built in 1688. The carved crest of the city appears on the tafferel, and the flag on the stern also bears the caption *AMSTER-DAM* flanking the coat-of-arms of the city.[1]

This print served as the frontispiece to a series of ten marine prints entitled *D Y Stroom en Zeegezichten geteekent en geetst door Ludolf Bakhuizen Anno 1701.*[2] Backhuysen included a six-line poem, printed on a separate plate below the image, which glorifies maritime trade as the driving mechanism of Dutch prosperity.[3]

The recent rediscovery of unfinished working-proof impressions of several prints from this series, including the frontispiece, allows us to appreciate Backhuysen's intentions to a much greater degree. These proofs exist prior to the artist's signature and address and prior to the numbering. In the last state of each print the numbers were removed, making it appear like the finished state with signature and address. However, these late impressions appear to be posthumous pulls from the plates and are usually heavily inked and somewhat blotchy, and lack tone. This series of etchings remained popular, ranking with the finest marine prints of the Dutch school.

Backhuysen's preparatory study for this print is in the Dutuit Collection, Petit Palais, Paris.[4]

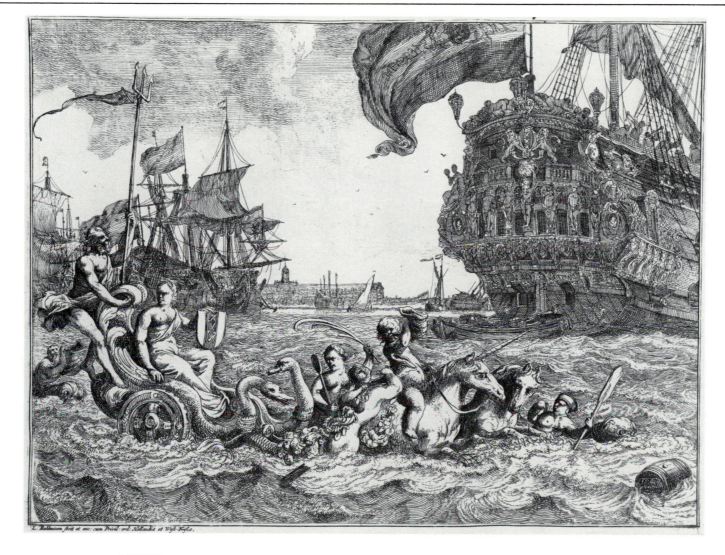

L. Bakhuisen fecit et exc: cum Privil: ord: Hollandiæ et West-Frisiæ.

NOTES

1. This ship fought against the French in the Battle of La Hogue in 1692 – see Cat. 58. Back-huysen represents the *Amsterdam* in his painting *Shipping on the Ij* of 1703, recently on the Amsterdam art market – Amsterdam, Gallery Rob Kattenburg, *Two Centuries of Dutch Marine Paintings and Drawings from the Collection of Rob Kattenburg*, 1989, p. 46, repr.

2. Although these were published in 1701 when Backhuysen was aged seventy-one, it is likely that he designed most if not all of these etchings considerably earlier.

3. Ackley translates Backhuysen's poem as follows: "So one builds here on the Y rich in shipping / The centerbeam of the state and cities / For the benefit of the community and the members / Of the East India Company / So one brings pearls from far-flung lands / There Christ's teaching is learned, established and planted"; in Boston–Saint Louis, 1980/1981, p. 297.

4. See Amsterdam, 1985, cat. T26, repr. B. Broos, who catalogued the drawings for this exhibition, argues that the second version of this subject, in the British Museum, is merely an old copy.

97

LUDOLPH BACKHUYSEN
Shipping on the Ij Before Amsterdam

Etching, state III, 177 × 238 mm
Signed in bottom margin: *L. Bakhuizen fec: et exc: cum Privil: ordin: Holland: et
 West Frisiae*
Minneapolis, Minneapolis Institute of Arts, inv. 828, Ladd Collection, Gift of Hershel V.
 Jones, 1916

LITERATURE: Bartsch 4
 Dutuit 4
 Hollstein 4
 de Groot and R. Vorstman, 1980, cat. 112, repr.
 Illustrated Bartsch, 1979, vol. 5, p. 268, repr.
 Boston–Saint Louis, 1980/1981, p. 297, cat. 208, repr.
 Amsterdam, 1985, p. 113, repr.

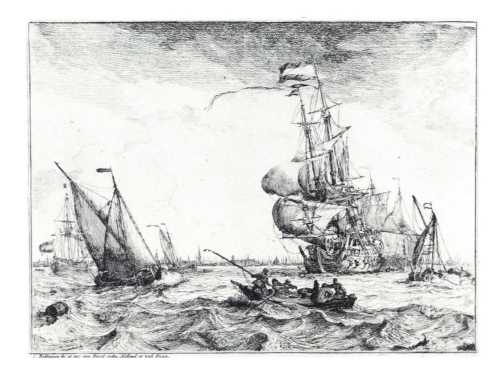

This monumental image of shipping before the distant, low-lying profile of Amsterdam is, as Broos indicates, one of Backhuysen's last versions of a subject that the artist returned to often.[1] His great painting of 1666 (Cat. 5) set a standard that Backhuysen continued to strive for. Not only did he represent the city in calm weather in his drawings in Amsterdam and Haarlem (Cat. 59)[2], but also in a notable painting recently on the art market (fig. 24), in which Backhuysen depicted Amsterdam screened by a forest of masts at the outbreak of a squall. His etching from the series *D Y Stroom en Zeegezichten* returns more to the spirit of his great painting of 1665,

although the artist assumes a lower vantage point. Tossing waves animate the foreground. The ships beyond, from left to right, include a flute, a *kaag* and a large warship with a rowboat and a wide or *smalschip* before it.[3]

NOTES

1. In Amsterdam, 1985, p. 113.
2. For a discussion of these calms, see Cat. 59.
3. As identified by de Groot and Vorstman, 1980, cat. 112.

98

LUDOLPH BACKHUYSEN
Yacht and Other Ships by a Mole

Etching, state III, 176 × 236 mm
Signed on flag at stern of the yacht: *LB*
Signed in bottom margin: *L. Bakhuizen fec: et exc: cum Privil: ord: Holland: et West Frisiae*
Minneapolis, Minneapolis Institute of Arts, inv. 830, Ladd Collection, Gift of Hershel V. Jones, 1916

LITERATURE: Bartsch 6
Dutuit 6
Hollstein 6
de Groot and Vorstman, 1980, cat. 114, repr.
Illustrated Bartsch, 1979, vol. 5, p. 270, repr.
Paris, 1989, p. 96, cat. 95

This subject from Backhuysen's suite of ten marines perfectly embodies the artist's enthusiasm for somewhat blustery weather. Ships respond to the stiff breeze and choppy water as if in optimum sailing conditions. The sailboat in the left foreground is a *boeier* (see Cat. 111) and the larger ship

at the center is a pavilion yacht of the States General. It is under full sail and tows a dingy.[1] Backhuysen's preparatory study for this print is in the British Museum.

Yachts were designed for comfort and were often presented as gifts to

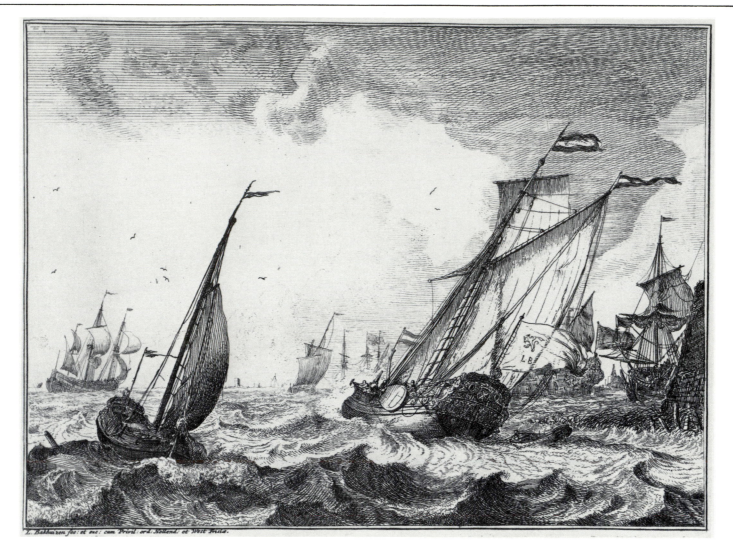

L. Bakhuizen fec: et exc: cum Privil: ord: Holland: et West Frisia.

important dignitaries, who used them for official and recreational purposes. They were a prime means of transporting dignitaries and were commissioned by the admiralties, the Dutch East and West India companies and the States General, the States of Holland, Zeeland, and Friesland, and by the Orange Nassau stadholders (see, for example, Cat. 35, 36, 64, 98).[2]

NOTES

1. These are cited by de Groot and Vorstman, 1980, cat. 114.

2. R. Vorstman, in Amsterdam, 1985, pp. 14–15; and J. van Beylen, in *Maritieme geschiedenis der Nederlanden*, 1977, vol. 2, pp. 54–55.

99

PIETER BAST

Amsterdam: Groundplan Seen from the North

Engraving in four plates, 1606 edition, ca. 929 × 819 mm
Caption across top: *AMSTELODAMVM VRBS HOLLANDIAE PRIMARIA,*
EMPORIVM TOTIVS EVROPAE CELEBERRIMVM
19-line Latin dedication to magistrates of Amsterdam by Herman Allard in cartouche at
upper right: *AMPLISSIMIS, . . . dedicabet Hermanus Alardi ipsis Calendis Octob. Ao.*
CIƆ.IƆ.IC.
Signed below scale in bottom right-hand plate: *Petrus Bastius fecit. CIVisscher excudit*
Amstelod. (CIV in ligature)
Numbered throughout
Crests of Holland and Amsterdam at upper left and right
Leiden, University Library, Bodel Nijenhuis Collection, inv. Portf. 26, no. 20 (1–4)

LITERATURE: Bodel Nijenhuis, 1872, pp. 89–110, no. 2
Burger, 1917 (2nd ed., 1925)
d'Ailly, 1934, cat. 84, 86, 96, 98
Hazelhoff Roelfzema, 1971–1972, pp. 76ff.
Hofman, 1978, cat. 5
Keyes, 1981, pp. 6–9; 32–36, cat. 7

Pieter Bast's *Groundplan of Amsterdam* is this artist's most important engraving and the most significant groundplan of Amsterdam produced between the celebrated woodcut of 1544 by Cornelis Anthonisz. and what still remains the definitive view of the city, the huge groundplan of 1625 by Balthasar Florisz. van Berckenrode (Cat. 102). Bast's engraving in four plates records the city of Amsterdam at a critical juncture in its history and growth. This is particularly evident in the bottom left-hand section, where several islands east of the Amstel River were transformed into the center for shipbuilding and related maritime industries. This region of the city, known as the *Plantage,* grew rapidly in the years around 1600. Bast's *Groundplan* is a unique document recording this growth. He began this printmaking project in the mid-1590s, and the first edition appeared in 1597, signed by Bast alone. The plates were reworked considerably by Bast for the subsequent edition of 1599, but the publisher of this edition, Herman Allard, recognized the commercial potential of the project and transformed the groundplan by adding new crests of Holland and Amsterdam, an ostentatious cartouche containing Allard's dedication, and a bold title across the top.

By 1606 the copperplates were in the possession of the Amsterdam publisher, Claes. Jansz. Visscher, who continued to update the *Groundplan.* In this edition most of the medieval ramparts of the city were removed, and other smaller details were altered to keep the image up to date. How-

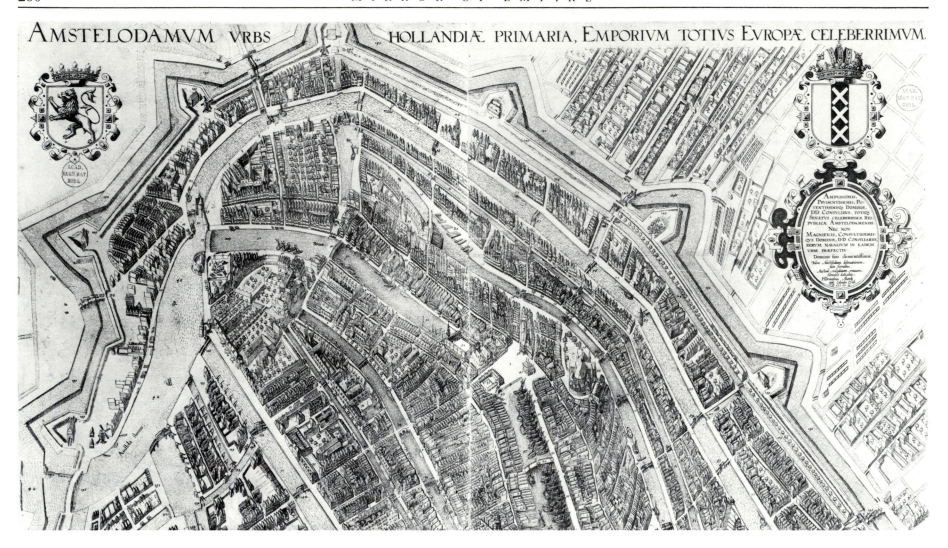

AMSTELODAMVM VRBS HOLLANDIÆ PRIMARIA, EMPORIVM TOTIVS EVROPÆ CELEBERRIMVM.

ever, Bast had died in 1605 and the engraver or engravers responsible for these changes executed them without real sensitivity to Bast's style. Subsequent small changes occurred in a last known edition. The most notable of these is the addition of Hendrick de Keyser's stock exchange building between the Dam and the Rokin.

Allard's renumbering throughout the *Groundplan* and Visscher's modification of it indicate that both publishers must have produced an accompanying printed text with numbers and explanatory captions. Alas, no impression of this *Groundplan of Amsterdam* survives with such a text.

In fact, Burger proposed that Bast may have envisaged producing a large wall map that would have included the groundplan accompanied by his two profile views of the city. Although no documentary evidence confirms this hypothesis, it still remains plausible.[1]

The impression of Bast's *Groundplan of Amsterdam* included in the exhibition is a composite consisting of plates from different editions. All but the lower-left-hand plate reflect the edition of 1606 published by Visscher.

Bast's *Groundplan of Amsterdam* focuses on the immense volume of

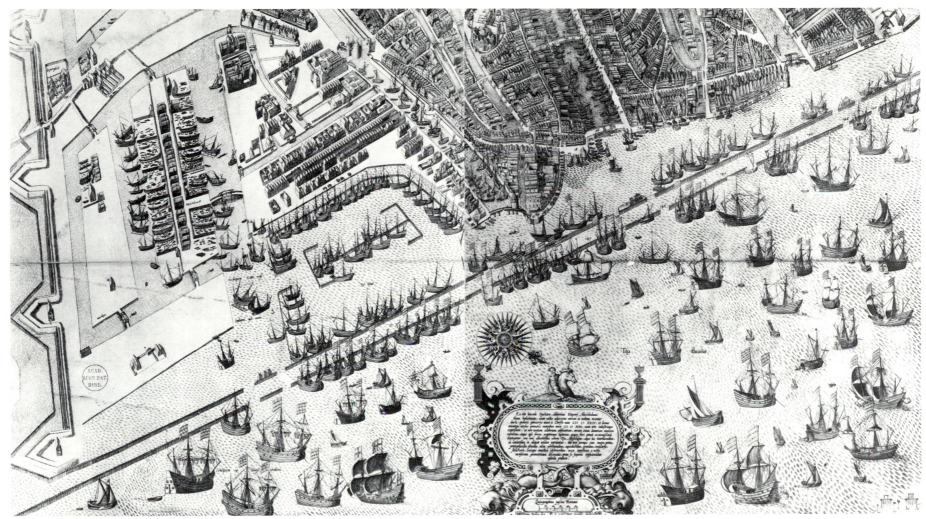

Bottom half of groundplan.

shipping that appears before and within the harbor palisades. The artist also indicates the spectacular growth of the shipyards in the *Plantage* district and how they complement the medieval heart of the city along the Damrak. He also includes the earthwork fortifications along the perimeter of the city.

The spectacular pace of growth of Amsterdam soon required extensive expansion beyond the earthworks. The city initiated the building of the famous Heren-, Keizer-, and Prinsengrachts, the concentric ring canals, which define the character of Amsterdam to this day, and which reflect the fabulous wealth of the city at the height of its glory during the seventeenth century. This physical expansion rendered Bast's engraving obsolete, and the celebrated groundplan of 1625 by Balthasar Florisz. was the first to represent Amsterdam in its recently expanded state.

NOTE

1. For a discussion of this hypothesis, see Keyes, 1981, p. 35.

100

PIETER BAST

Profile View of Amsterdam Seen from the River Ij

Engraving in two plates, 260 × 753 mm
Signed at bottom: *PETR BAST au et Sculp et excudebat 1599 Et excudit*
Leiden, University Library, Bodel Nijenhuis Collection, inv. Portf. 321, no. 147

LITERATURE: Bodel Nijenhuis, 1872, pp. 89–110, no. 3
Burger, 1917, vol. 16, pp. 1ff.
d'Ailly, 1953, cat 6
de Groot and Vorstman, 1980, cat. 19, repr.
Keyes, 1981, pp. 19, 22, 36, cat. 8
Russell, 1983, p. 33, fig. 36

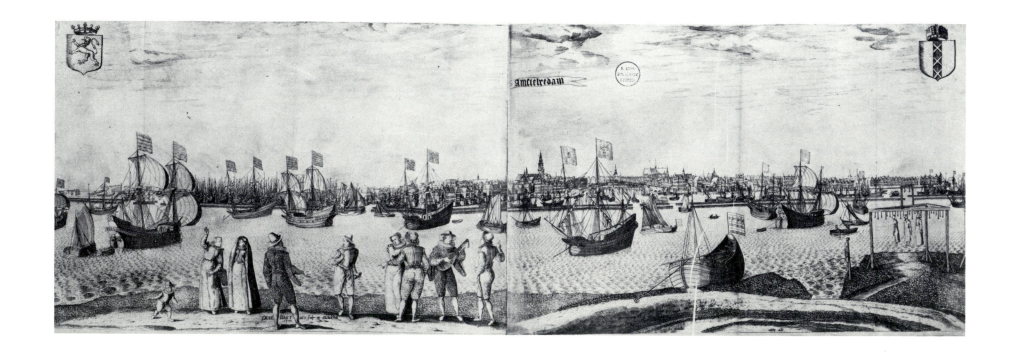

This profile view of Amsterdam seen from the north bank of the River Ij is one of Bast's most influential prints. Elegantly dressed figures in the left foreground contrast to the grim symbol of civic justice, the gallows and gibbet at the right. For health reasons the corpses of criminals executed in the city were transferred to these gallows outside the city walls. They became carrion and reminded the citizenry of the awesome authority of the city magistrates as dispensers of civic justice.

Many ships rest at anchor or approach the city palisades. Far more have entered the harbor, having passed by the blockhouses that regulated the traffic through the palisades. Just to the right of center one sees down the Damrak, which runs on a north-south axis before the two great Gothic churches of Amsterdam, the Oude Kerk, whose profile rises below the banderole containing the name of the city, and to its right, the Nieuwe Kerk.

At the left a veritable forest of masts rise up before the *Plantage,* the zone in the northeast quadrant of the city that was rapidly developing into the chief shipbuilding center within Amsterdam. Gabled warehouses appear in an almost continuous procession across the entire harbor front of the city and indicate to what degree Amsterdam was a mercantile mecca. Even in 1599, the year of this engraving, the city had an enormous volume of trade. Bast represents several different types of ships, including several three-masted flute ships with or without open stern galleries. The ship at anchor at the right center flies the coat of arms of Amsterdam on its foremast. This same crowned crest appears at the upper right, whereas the coat of arms of Holland appears at the upper left of the engraving.

This impression of Bast's *Profile View of Amsterdam Seen from the River Ij* is remarkable for the silvery-gray film of ink that lends a sultry atmosphere to the subject. Later in the seventeenth century Rembrandt experimented frequently with inking his copperplates: Instead of wiping them clean, he intentionally left much surface tone. This residual ink created remarkable atmospheric effects and often lent a greater sense of profound mystery to his subjects. Surviving impressions of Bast's engravings indicate that the copperplates were usually wiped clean, but in this one instance the artist appears to have experimented with tone in a way that is a premonition of Rembrandt. A large vertical printer's crease appears in the right-hand plate.

This *Profile View of Amsterdam* was influential. Profile views of Dutch seaports were popularized by Hendrick Vroom in his paintings, such as his *View of Hoorn* (Cat. 52), and by Adam Willaerts in his several versions of the *Arrival of Frederick V, Elector of the Palatinate, in Vlissingen* on May 5, 1613 (Cat. 54), but these painters were cognizant of Bast's topographical engravings such as this precocious *Profile View of Amsterdam Seen from the River Ij.*

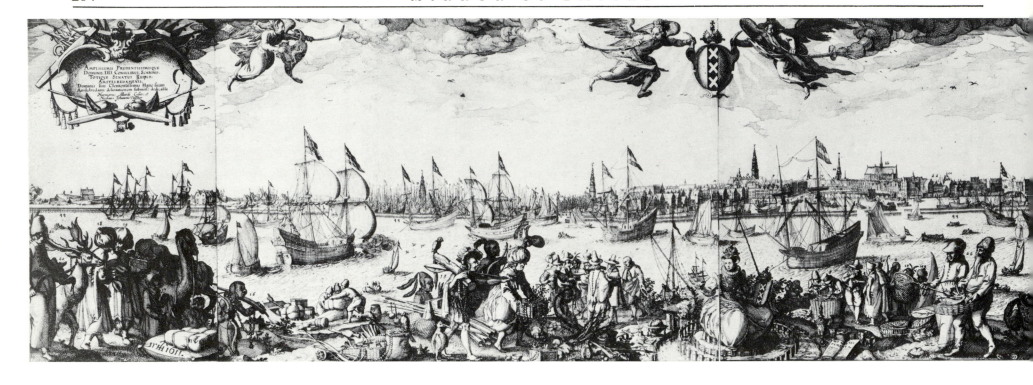

101

PIETER BAST, RE-ENGRAVED AND ENLARGED BY CLAES JANSZ. VISSCHER

Profile View of Amsterdam Seen from the River Ij

Etching and engraving in four plates. 255 × 1,120 mm
Numbered and lettered throughout
8-line Latin dedication to the city magistrates of Amsterdam at the upper left:
 AMPLISSIMIS . . . dedicabat Hermanus Allardi Coster et Nicolaus Johannes Visscher
Signed at bottom left: *CIV in no 1611 HIA* (CIV and HIA in ligature)
Amsterdam, Municipal Archives, inv. Dreesmann II–115

LITERATURE: *Verzameling Amsterdam W. J. R. Dreesmann,* 1942, vol. 1, p. 38
 d'Ailly, 1953, cat. 17
 Simon, 1958, cat. 160
 de Groot and Vorstman, 1980, cat. 20, repr.
 Keyes, 1981, pp. 20–21, 36, cat. 8

Visscher acquired Bast's copperplates for his *Profile View of Amsterdam Seen from the River Ij* (Cat. 100) and transformed them into a radically different image. Not only did Visscher rework Bast's plates, he also expanded the view at both sides. Visscher replaced the foreground figures in Bast's engraving by an allegorical representation of the city of Amsterdam as the center of world trade. The city is personified by a seated maiden who holds a ship's model in her right hand and the coat of arms of the city and a fishing pole in her left hand. To the right of her many figures symbolize the various trades and industries of Holland including agriculture, fishing, and commerce. They move in procession toward the tyche of Amsterdam to offer her the native abundance that the city, in turn, trades throughout the world. Figures personifying the four corners of the world appear at the left, and approach the maiden of the city offering her the wealth of Asia, Africa, and the Americas. At the far left a Laplander leading a reindeer appears behind two turbanned figures deep in conversation by a camel and an elephant. Trumpeting angels across the sky announce the fame of Amsterdam, whose crowned crest is held by two angels at the top center.

The numbers and letters appearing throughout the profile view indicate that Visscher intended to publish this image with an accompanying text. Only two impressions survive with this accompanying text. That in the Atlas van Stolk in Rotterdam contains the text in eight columns and also includes four scenes within the city, the Dam, the stock exchange, and the meat and fish markets.[1] These four vignettes incorporated into the text indicate to what degree the focus on commerce and trade dominates the imagery of this magnificent allegory dedicated to the prosperity of the city.

As de Groot and Vorstman note, Visscher updated the city profile with the addition of several key monuments built since 1599. These include the pepper wharf (C), the Montelbaanstoren (D), the spire of the Zuiderkerk (K) and the enlarged spire of the town hall (aa), and the Haringpakkerstoren (kk).

NOTE

1. Repr. in Keyes, 1981, pp. 20–21.

102

BALTHASAR FLORISZ. VAN BERCKENRODE
Groundplan of Amsterdam, 1647 edition

Scale (1:1.950)
Etching and engraving in ten plates, 144 × 160 cm
Numbers and captions throughout
16-line Latin poem by Petrus Scriverius in cartouche below view of city in upper left
 hand plate: *AMSTELREDAMVM/VENVS ANADYOMENE, Forte...manus*
In upper right-hand and right center plate, register with numbers and accompanying
 explanatory captions
Signature in tablet below register: *Hanc Tabulam...expressit, / BALTHAZAR*
 FLORENTIVS BATAVVS/Sumptibus/PHILIPPI MOLEVLIET /...
 AMSTELREDAMI cIɔ Iɔc XLVII/Cum Privilegio sexennium
16-line Dutch poem by Petrus Scriverius in tablet in bottom left-hand plate: *PETRI*
 SCRIVERII/Aen-spraeck/...O. Wijtberoemde Stadt,...even groot. cIɔ Iɔc XLVII
6-line Latin dedication to the burgomasters of Amsterdam on plinth below figures in
 bottom center plate: *MAGNIFICIS...DEDICANT CONSECRANTQ/Iacobi A*
 Colom
Amsterdam, Municipal Archives, Atlas Splitgerber, no. 17

PROVENANCE: Amsterdam, Collection Louis Splitgerber
LITERATURE: Bodel Nijenhuis, 1845, pp. 32–36
 d'Ailly, 1932, vol. 29, pp. 103–130
 d'Ailly, 1934, nos. 117, 134, 143
 Hollstein, 1949, vol. 2, B. Florisz. no. 4
 Hofman, 1978, p. 28

In 1625 Balthasar Florisz. van Berckenrode produced the first edition of this *Groundplan of Amsterdam.* His father, Floris Balthasar, was a celebrated surveyor, and the son followed in his footsteps. Balthasar Florisz.'s *Groundplan of Amsterdam* is a matchless example of technical and descriptive accuracy. Moreover, it exhibits his extraordinary artistic flair as an etcher, its design imbued with a vitality that places it among the masterpieces of Dutch printmaking.

This *Groundplan of Amsterdam* is a seminal achievement made all the more important because the artist represents the city following its greatest period of expansion early in the seventeenth century. Pieter Bast's *Groundplan of Amsterdam* (Cat. 99) simply could not accommodate the inclusion of this expansion. Balthasar Florisz. produced his *Groundplan of Amsterdam* directly in response to the urban growth that culminated in the addition of the three famous concentric ring canals, the Heren-, Keizers-, and

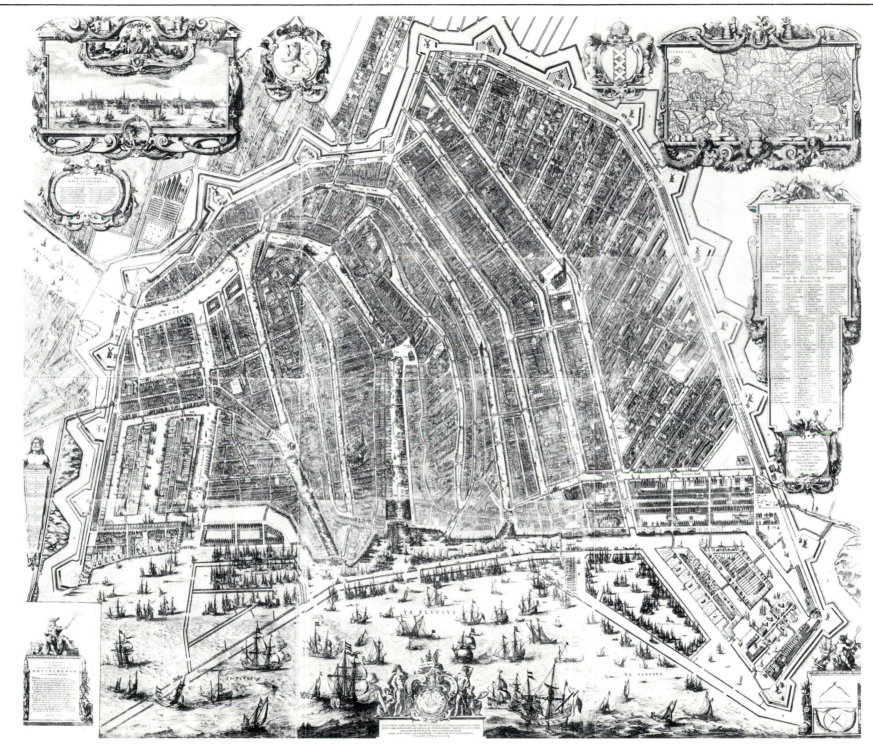

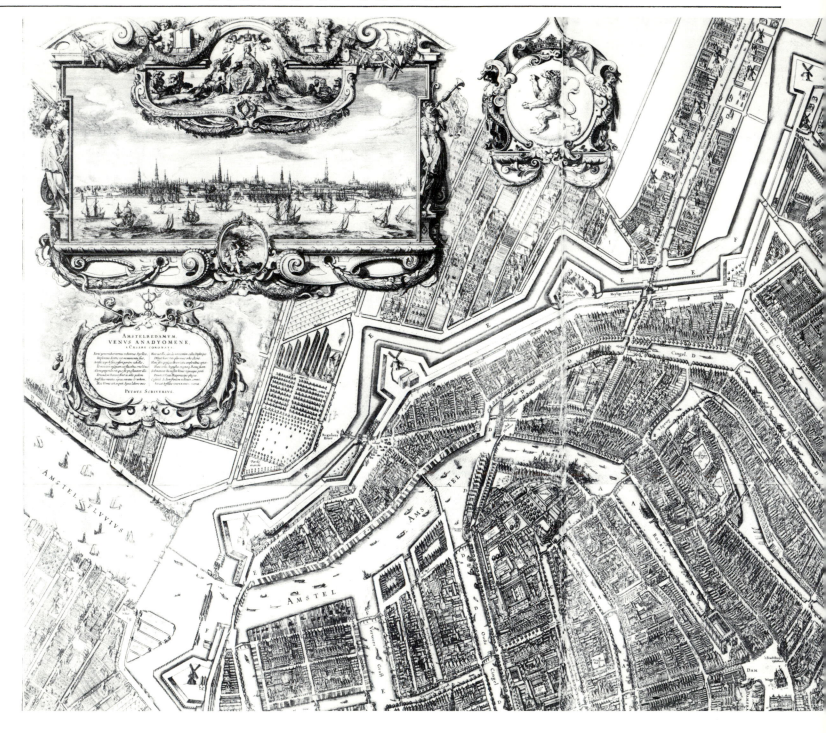

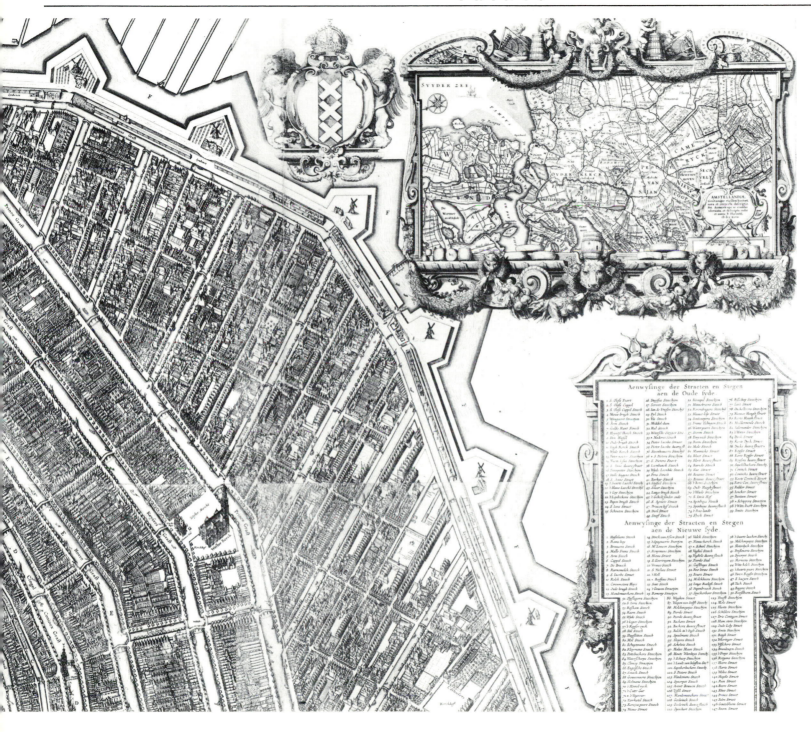

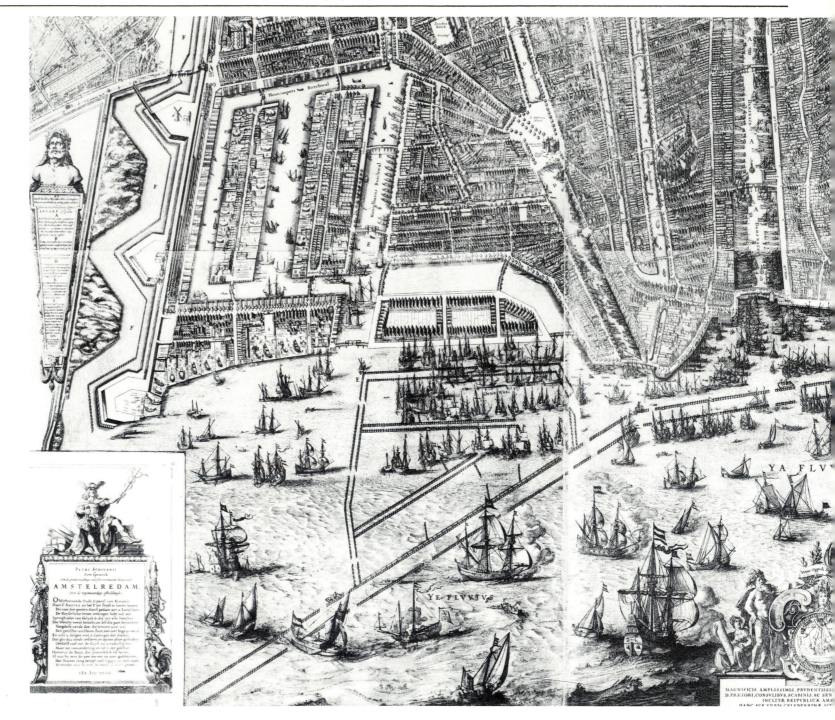

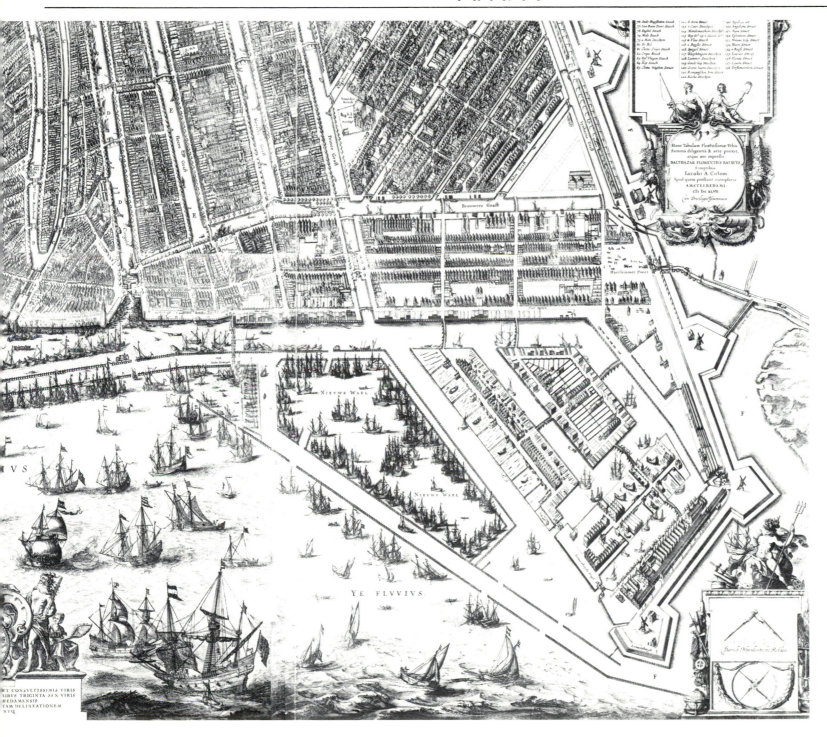

Prinsengrachts. He also records the establishment of the district due west of the Keizersgracht, the *Jordaan,* plus the Western Islands in the area projecting into the harbor north of the Haarlem Gate.

The copperplates for this *Groundplan* were acquired by the Amsterdam publisher Jacob Colom, who issued a second, revised edition in 1647.[1]

The impression included in the exhibition is a hitherto undescribed publisher's proof in which Colom initiated the changes that occurred throughout the image. It conforms to d'Ailly's description of the second edition in all but one notable feature: In standard impressions of the second edition, the segment of the bottom left-hand plate containing the Dutch poem by Scriverius has been cut out of the copperplate and replaced by the addition of Kattenburg Island. In order to include the entire island to scale, it had to project below the bottom margin of the larger plate. Colom solved this problem by adding an ornamental rinceau consisting of dolphins under the entire groundplan to the right or west of Kattenburg Island. However, in the exhibited impression Colom had not yet decided to add Kattenburg Island. Instead, he simply cut out the section of the copperplate containing Scriverius's poem, but burnished out the water surrounding the ornamental tablet. This copperplate, measuring 220 × 143 mm, has been printed separately, bringing the total number of plates used for this proof to ten. Subsequently, Colom decided to discard the detail including the poem and replaced it with Kattenburg Island, also printed on a separate plate. At this time he also added the ornamental border across the bottom.

The *Groundplan of Amsterdam* was updated by Colom, which involved a number of substantial changes and additions to the fabric of the city and its harbor. The most notable changes occurred in the harbor, along the Amstel River, along the earthworks and moats, and in the newly laid-out neighborhoods. The half-round medieval tower, the Rondeel, was torn down and a bridge was built across the Amstel leading to the Regulierspoort at the southeast edge of the city. The floating island on the Amstel south of the *steenhouwerij* was transformed into a city block, and the section of the river east of it extending from the Groene Burgwal to the Blaeuwe Brug was similarly transformed into city blocks, thereby reducing the width of the Amstel River considerably.

The harbor palisades were reconstructed and shifted to a different location extending from the northeast to a point just west of the Harringpakkerstoren. At the bottom left they shift to the northeast. The Nieuwe Waals Island was added between the Oude Waal and the quay leading to the Montelbaanstoren. Four bridges connect this island to the existing city waterfront.

A bastion was constructed at the Rysen-hooft at the northeast where the city moat meets the harbor. To the south of it the old dike from the Sint Anthonispoort has been replaced by a bridge, and a dam was constructed from the bastion just to the north of this bridge. A bastion was built along the southern perimeter of the earthworks, and the city ropewalks (*lijnbanen*) were expanded considerably. Much housing was built throughout the city, but the most substantial transformation occurred in the new areas north and south of the Brouwersgracht toward the Haarlemerpoort and including the Western Islands.

Certain impressions of the second Colom edition of 1647 already show signs of wear; the third edition shows wear to a much greater degree. The most notable change in the third edition is the removal of the medieval town hall and its replacement by Jacob van Campen's splendid neoclassical edifice, then considered the eighth architectural wonder of the world. It still dominates the great square, the Dam, at the head of the Damrak.

NOTE

1. An impression in this edition, now in the Bodel Nijenhuis Collection of the University of Leiden, contains the separately printed caption across the top: *AMSTELREDAMVM EMPORIVM HOLLANDIAE PRIMARIVM TOTIVS EVROPAE CELEBERRIMVM.* No surviving impression from the 1625 edition has this caption across the top, but such a title would have been an expected feature embellishing an ambitious undertaking.

103

HENDRICK HONDIUS II, EXCUDIT
French Man-of-War in Port Profile

Etching, 364 × 524 mm (370 × 530 mm)
Caption across top: *Navire Royale faicte en Hollande Anno 1626*
Address in plaque at bottom left: *A AMSTERDAM / chez Henry Hondius*
Dordrecht, Museum Mr. Simon van Gijn, Atlas Mr. Simon van Gijn, inv. 10.914

LITERATURE: F. Muller, *historie platen*, no. 1555a
Atlas van Stolk 1639
Keyes, 1982, vol. 20, p. 118, fig. 3
de Groot and R. Vorstman, 1980, p. 11, fig. 6

This ship's portrait evolved from a Netherlandish printmaking tradition that finds its origins in the suite of prints by Frans Huys after Pieter Bruegel the Elder. However, this etching differs in one fundamental respect in that it portrays a specific ship, not a general type. Seen in port beam, the heavily armed vessel is an impressive achievement built by the Dutch for the French royal navy. The designer of this print produced an accurate portrayal of this warship, which flies French colors from all three masts and a long pendant from its foremast. The image is spirited as indicated by the full sails, fluttering pendant, and slightly choppy seas. The artist lends a more monumental air to this ship by placing it before low-lying land at the distant horizon.

French Man-of-War in Port Profile is one of the first portrayals of a ship built by the Dutch expressly for foreign clients, and shows that the Dutch shipbuilding industry was not averse to serving prospective buyers outside the Dutch Republic. The ill-fated *Wasa*, built by the Dutch for King Gustav Adolphus of Sweden as his flagship, is compelling testimony to this fact. Later in the century Willem van de Velde the Elder represented six Dutch-built ships commissioned by the French royal navy.[1]

NOTE

1. These were built in 1666–1667 in Amsterdam and probably Zaandam. Weber discusses this commission and lists all the drawings of these six ships by Willem van de Velde the Elder and Younger known to him, including six in the Museum Boymans–van Beuningen in Rotterdam (Weber and Robinson, 1979, vol. 1, pp. 127–129).

104

ROMEYN DE HOOGHE AND JOHANNES DE VOU
Groundplan and Profile View of Rotterdam (1694)

Etching and engraving in 43 plates, groundplan, profile view, twelve accompanying
 scenes with armorials and ornamental borders
166 × 194 cm
Scale (ca. 1:1.850)
Signed in lower right-hand plate of groundplan: *Romanus de Hooghe JVD / et Com P.*
 auctor 1694
Lettered and numbered throughout
Caption across center of profile view: *ROTTERODAMUM*
Register in bottom left-hand plate with nos. 1–46, A–Z and a–z with accompanying
 explanatory captions
12-line Dutch caption at upper right in upper right-hand plate of the groundplan:
 ROTTERDAM / MET AL SYN GEBOUWEN . . . GETEEKENT EN
 GESNEDEN . . . Ao 1694 / Door / JOANNES DE VOU
Rotterdam, Municipal Archives, topographical atlas no. 41

LITERATURE: Scheffer, 1868–1880, nos. 39–41
 van 't Hoff, 1941–1942, vol. 2, pp. 29–68; 97–150
 van 't Hoff, 1949, pp. 43–65
 Hollstein, vol. 9, no. 328b
 van 't Hoff, 1966
 Ratsma, 1984, pp. 55–58, no. 9
 Gordijn and P. Ratsma, 1984, no. 42
EXHIBITIONS: Rotterdam, 1984, cat. nos. 11, 12
 Cologne, 1975, cat. 113

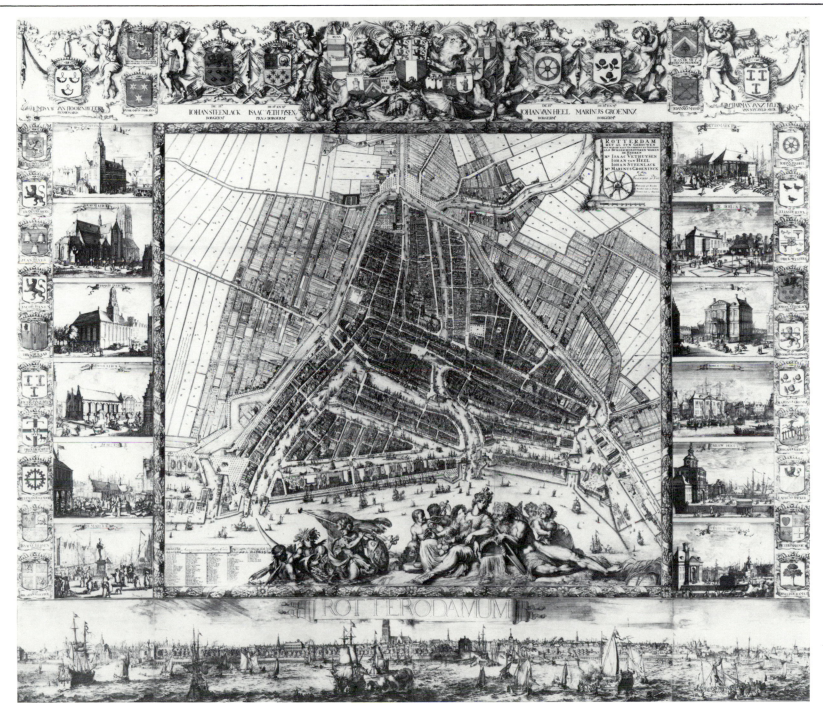

This groundplan is one of the supreme topographical and cartographical achievements of the Dutch school. Romeyn de Hooghe is responsible for the groundplan and profile view of the city seen from the River Maas, whereas his colleague, Johannes de Vou, produced twelve views of the most noteworthy buildings and public spaces in the city. De Vou signed each of these *J De Vou f.* They flank each side of the groundplan in groups of six. A caption in a banderole at the top of each scene identifies each view. The groundplan proper is framed in an ornamental vegetal rinceau, and the entire composition is flanked across the top and sides by crests of the burgomasters of Rotterdam and other members of the city council. At the top center two lions hold the crowned crest of Rotterdam. Clustered to either side of it are five crests of the neighboring towns that came under the authority of Rotterdam.

This huge *Groundplan* is a splendid testimony to the civic pride of a major Dutch seaport. Rotterdam wished to rival the magnificence of Amsterdam and other Dutch cities. The city magistrates commissioned this *Groundplan* in 1690, but issued payment to Romeyn de Hooghe and Johannes de Vou only on May 16, 1695.[1]

Comparison of this *Groundplan* with that of Balthasar Florisz. van Berckenrode representing Amsterdam (Cat. 102) indicates the degree to which Romeyn de Hooghe and Johannes de Vou elaborated on this antecedent.[2] By including detailed views of the city, the elaborate family crests, and the rich ornamental borders, they succeeded in producing a more opulent image. Yet, like Balthasar Florisz., Romeyn de Hooghe also attained startling accuracy. De Hooghe and Vou evoke a metropolis marked by great prosperity and civic pride.

Although dwarfed by Amsterdam during the Dutch "golden age," the modern city of Rotterdam has become the largest seaport of Europe. The horrendous German bombing of the city on May 14, 1940, and the ensuing firestorm all but obliterated the inner city. Romeyn de Hooghe's *Groundplan and Profile View of Rotterdam* becomes all the more meaningful as a poignant reminder of the former glory of this great seaport during its formative years.

NOTES

1. Ratsma, 1984, p. 56.
2. Ibid., p. 56, cites other antecedents.

105

ROMEYN DE HOOGHE
Reception of Mary as Queen of England

Etching, 481 × 583 mm
3-line Dutch caption in banderole at upper left: *RECEPTIE . . . Van gr: Britange*
3-line English caption at upper right: *RECEPTION . . . as queene of great Brittain*
At left center in bottom margin: *R. de Hooge fec. Tot leiden By I. Tangena gedruckt met Privilegi*
Numbered and with captions throughout
Separately printed Dutch, French, and English texts in three columns. Each text followed by nos. 1–23 with accompanying explanatory captions
Address below texts: *Tot Leiden gedrukt, bij Johannes Tangena, . . . Anno. 1689*
Dordrecht, Museum Mr. Simon van Gijn, Atlas Mr. Simon van Gijn, inv. 2239

LITERATURE: F. Muller, *historie platen*, no. 2729
Atlas van Stolk 2773
Hollstein 147

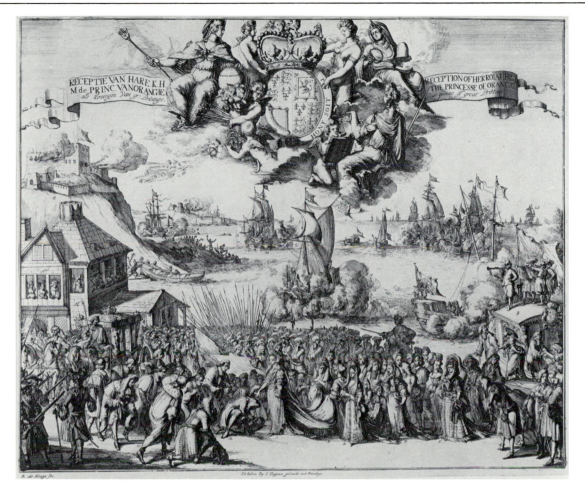

This etching represents Princess Mary, sister of James II of England and wife of William III, Prince of Orange, being received by the English nobility and receiving the crown of England. The Dutch fleet appears beyond the foreground personages. This elaborate allegorical print is a characteristic example of Romeyn de Hooghe's erudite political imagery. His virtuoso etching manner is manifest in the rendering of sumptuous details, such as the elaborate costumes. He also captures the refined social demeanor exhibited on public occasions in which courtly ritual unfolds on the public stage.

The Glorious Revolution in which William and Mary supplanted James II on the English throne marked a new era in European politics. William used his expanded authority to forge an Anglo-Dutch alliance to counter the ambitions of Louis XIV of France. This superseded the Anglo-Dutch enmity of the mid-seventeenth century marked by the three great Anglo-Dutch wars that dominated the naval energies of both countries. However, the growing power of England and the vulnerability of the Dutch Republic resulted in an alliance of unequal parts, in which the shift in power to England was evident. By funneling the Dutch military into the ambitions of England, William recognized that the interests of Holland had become subservient to those of Great Britain. This policy demonstrated that, for all practical purposes, the great naval might of the Dutch Republic had become a thing of the past.

106

ROMEYN DE HOOGHE
Allied Victory over the Swedes, June 11, 1676

Etching, 476 × 706 mm
Captions throughout
5-line caption in shell cartouche at left: *VERBEELDING . . . door de K. Deense en*
 Hollantse Zeemacht dan 11 Juni 1676
Amsterdam, Rijksmuseum "Nederlands Scheepvaart Museum," inv. S847 (6)

LITERATURE: F. Muller, *historie platen*, no. 2590

Frederik Muller ascribed this unsigned etching to Romeyn de Hooghe, and his attribution remains undisputed. The artist represents the naval battle in three friezes, each depicting consecutive stages of the event. On June 11, 1676, an allied Danish and Dutch navy commanded by Cornelis Tromp sought out, attacked, and destroyed the Swedish navy. The upper register represents the allied fleet going after the Swedes. The middle frieze represents the battle, with the Swedish flagship in flames, and the bottom register depicts a later stage of this battle.

The Dutch mother trade was seriously dependent on its Baltic component. Any disruption of the Baltic grain trade had a direct impact on the remaining Dutch trade network throughout continental Europe. As a result, the Dutch were compelled to police the ongoing disputes between Denmark and Sweden. Those that had the greatest effect in disrupting Dutch trade took place in the Sound – the narrow channel between the Danish island of Zeeland and the Swedish mainland – which was the sole shipping channel into the Baltic from the North Sea. Swedish military ambitions posed a constant threat to its weaker neighbor, Denmark. As a result the Dutch were frequently forced to ally themselves with the Danes to check the Swedes. This battle of June 11, 1676, was the last major naval engagement in which the Dutch navy played a decisive role in monitoring control of the Baltic access routes.

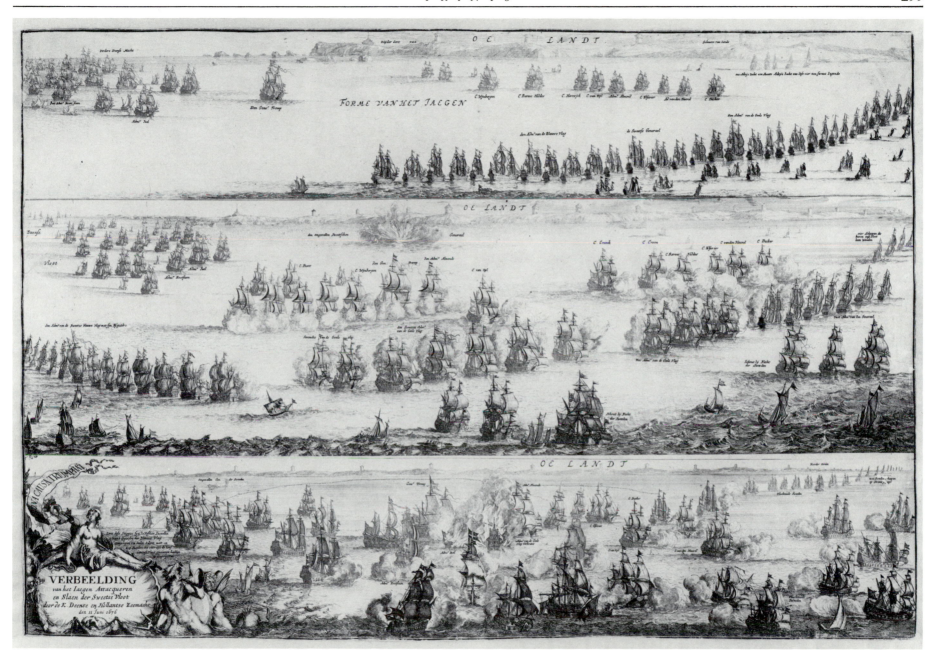

107

MEYNERT JELISSEN AFTER HENDRICK VROOM
Ships in a Rough Sea by a Rocky Coast

Engraving, 265 × 438 mm
In bottom margin: *Henricus Vroom Inventor Meynert Jelissen schulp t'Amsterdam by
kornelis Janssen in d'seylende ys schuyt by d'buers Anno 1612*
Vienna, Graphische Sammlung Albertina, inv. Albertina Band II 15, p. 57

LITERATURE: Hollstein, vol. 9, Jelissen no. 9
Keyes, 1982, p. 117, fig. 2
Russell, 1983, fig. 129

This rare engraving represents two three-masted ships sailing away from a threatening rocky shore in the right distance. A huge dolphin in the left foreground and a porpoise at the center embody the mysteries of the sea. As the large ships sail away from a squall toward clearer weather, they may symbolize safe passage through the vicissitudes of life or embody the ship of state passing through a hazardous moment (for further discussion of these themes see Cat. 4).

The large ship at the center has on its tafferel the Dutch lion on a crest; below is the crest of Amsterdam flanked by lions rampant. Jelissen has captured Hendrick Vroom's great attention to detail. The large Dutch ship is depicted convincingly with its foresail, mainsail, and lateen sail tautly unfurled. This ship responds vigorously to the wind and surges forward in the heavy seas, leaving white water in its wake.

108

REINIER NOOMS ("ZEEMAN")
Struggle Between Dutch and English Fishing Vessels

Etching, state II, 188 × 282 mm
Signed at bottom right: *zeeman*
Rotterdam, Museum Boymans–van Beuningen, inv. D.N. 237/690

PROVENANCE: London, Collection Seymour Haden (L. 1227)
LITERATURE: Bartsch 2
 Dutuit 2
 F. Muller, *historie platen*, no. 2051
 de Groot and Vorstman, 1980, cat. 71, repr.
 Illustrated Bartsch, 1980, vol. 6, p. 114, and vol. 6 (commentary), 1986, p. 11

This print represents an incident of August 9, 1652. A Dutch fishing vessel, a hooker skippered by Jonge Kees, hailed an English sailboat in the hope of buying bait. The English skipper, misunderstanding Kees's intent, flew into a rage and hurled abuses at the Dutch, on whom the English had just declared war. The altercation quickly degenerated into a free-for-all. During the melee the Dutch were able to board and capture the English boat, which they took back to Holland as a prize. The Dutch enthusiastically acclaimed this act of bravery, and the admiralty commemorated Jonge Kees by striking a gold medal with his portrait on it. Nooms reproduces this medal at the upper right.[1]

English resentment caused by Dutch herring fleets fishing in British waters was a constant source of friction and played a major role in precipitating formal hostilities between England and the Dutch Republic in 1652. Events like the one depicted by Nooms fanned Dutch popular sentiment against the English and served as inflammatory pamphlets fueling nationalistic resentment against English acts of aggression.

Nooms's presentation is lively. He depicts the moment when the Dutch struggle to overpower the English crew. By truncating the mast and sail of the Dutch hooker, Nooms visually anchors the composition and projects it into the foreground.

NOTE

1. For lengthy discussion of this incident, see de Groot and Vorstman, 1980, cat. 71.

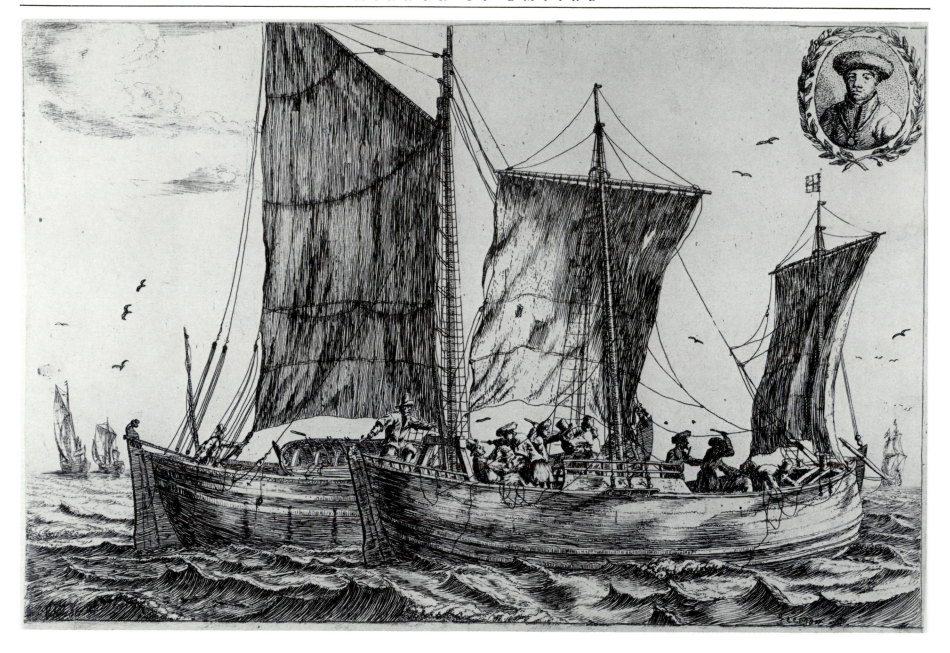

109

REINIER NOOMS ("ZEEMAN")

Ravaged Ships by a Foreign Coast

Etching, state II, 122 × 208 mm
Signed at top center: *zeeman;* and numbered at right in bottom margin: 7
Amsterdam, Rijksmuseum "Nederlands Scheepvaart Museum," inv. A145

LITERATURE: Bartsch 45
Dutuit 45
Illustrated Bartsch, 1980, vol. 6, p. 151, repr., and vol. 6 (commentary), 1986, pp. 128–129
Paris, 1989, p. 124, cat. 138

This print is from a series of eight etchings. Its title print bears the caption: *Quelque navieres desseigner & graver par Remy Seeman Ao 1652.* In the first edition these were published in Paris and bear the following address: *I van Marlin, rue St Jacques a la Ville d'Anvers.* The prints were numbered consecutively 1–8. This spirited series of etchings is notable for the artist's experimental use of hatching patterns that create beautiful contrasts of light and shadow. The subject is particularly poignant as it represents battered ships in a remote setting. The topos derives from harbor views

with ships being loaded or unloaded, but Nooms transforms this prototype into a remote wilderness with great cliffs bare of vegetation. The large merchantman in the foreground has lost virtually all of its masts, and even its hull has lost planking at the bow. The large ship in starboard profile in the distance has hardly fared better. Yet Nooms introduces a sense of resignation and hope by focusing on the industry of the sailors and the light that plays across the foreground and on the cliffs. The weather seems to be clearing, and despite the damage inflicted on these battered ships, they have managed to weather the storm.

Nooms produced another suite of prints published in Paris, a set of thirteen small *Seascapes* (B. 6–18), published in 1650. He also represented views of Paris and its environs, including a series of eight etchings (B. 55–62), plus a handful of paintings representing familiar monuments along the Seine in Paris. Paris became an important center for the publishing of prints by such Dutch artists as Jan Asselyn, Reinier Nooms, and Herman Swanevelt. In certain respects Nooms's use of wiry lines, taut hatching patterns, and flicks imposed on broader areas of parallel hatching may have been inspired by Swanevelt.

The preparatory study in reverse for this print is in the Kunsthalle, Hamburg.[1]

NOTE

1. Inv. 22759, Corpus Gernsheim 17809, *Illustrated Bartsch*, 1986, vol. 6 (commentary), p. 128, repr. The Kunsthalle also possesses the preparatory study for B. 42 from the same series – inv. 22758.

110

REINIER NOOMS ("ZEEMAN")
The "Geele Fortuin," a Baltic Merchantman, and the "Liefde," a Norwegian Merchantman

Etching, state II, 137 × 247 mm
Caption in bottom margin: *t'Geele Fortuyn een Ooster-Vaerder De Liefde een Noorts-Vaerder a4*
Minneapolis, Minneapolis Institute of Arts, inv. P 924, Ladd Collection, Gift of Herschel V. Jones, 1916

PROVENANCE: London, Collection Seymour Haden (L. 1227)
LITERATURE: Bartsch 66
 Dutuit 66
 Illustrated Bartsch, vol. 6, 1980, p. 172, repr., and vol 6 (commentary), 1986, pp. 137–138
 Paris, 1989, pp. 126–127, cat. 143

This print is from Nooms's most famous suite of prints, *Verscheyde Schepen en Gesichten van Amstelredam* (*Various Ships and Views of Amsterdam*), which evolved into a series comprising three parts. Most of these prints depict ships represented in optimum sailing conditions. Interspersed among them are occasional views of Amsterdam that pertain specifically to ship-ping and to its harbor. In a sense these views complement Nooms's important series *Views in Amsterdam* (Bartsch; Dutuit 47–54), which represents scenes along the well-known canals of the city. The relationship between the two series is close.

The main ship involved in the Dutch carrying trade was the flute, often

t'Geele Fortuÿn een Ooster-Vaerder, De Liefde een Noorts-Vaerder,

referred to in English as a flyboat. Traditionally credited to Pieter Jansz. Liorne of Hoorn, the flute evolved in the late sixteenth century to become the most versatile merchant vessel of the seventeenth century. With its lengthened hull relative to its width and its enlarged keel, the flute was able to sail more quickly and with less drift. Because it drew more, the three-masted flute allowed for more sail adding to its efficiency and speed. It also had a considerably larger hull with greater cargo capacity. Flutes were also designed to require a small crew. These lightly armed and lightly manned vessels reduced cost, enabling the Dutch to maintain an edge against all competition. Although principally built for the European trade, flutes were also used for inter-island trade in the Far East and also served as transport vessels for the Dutch admiralties.[1]

The two ships represented by Nooms were the mainstay of the mother trade serving its northern component. The flutes serving the Baltic grain and the Scandinavian lumber trades were smaller than those designed for the trade to Iberia and the Mediterranean. Flutes carrying grain from the Baltic Sea drew about two feet less than the lumber ships sailing to Norway. The latter were especially designed to take on lumber of great length, which included timber for masts. They had ports in the stern to allow the loading of long spars, as well as added ballast ports on the port and starboard sides of the hull for added loading capacity. Timber was vital to the Dutch shipbuilding industry, which lacked local resources. By transporting lumber to Holland, specific centers such as the Zaan, northwest of Amsterdam, were transformed into major shipyards specializing in building ships for the carrying trade.

The preparatory study in reverse for this etching is in Brussels.[2]

NOTES

1. R. Vorstman, in Amsterdam, 1985, p. 15.
2. Koninklijke Musea voor Schone Kunsten van België, Collection de Grez, 1913 cat. 4230 – repr. *Maritieme Geschiedenis der Nederlanden*, vol. 2, 1977, p. 28. A closely related drawing by Nooms is in the Rijksprentenkabinet in Amsterdam – repr. *Illustrated Bartsch*, 1986, vol. 6 (commentary), p. 137. In this sheet Nooms appears to be rethinking the composition of the etching. He extends the foreground and adds a sailboat at the right. He also enlarges the sky across the top to create a more extensive and monumental backdrop to the scene.

111

REINIER NOOMS ("ZEEMAN")
A Boeier and a Galliot

Etching, state II, 122 × 243 mm
Caption in bottom margin: *Een Boeyer. Een Galioot a6*
Minneapolis, Minneapolis Institute of Arts, inv. P 926, Ladd Collection, Gift of Herschel
 V. Jones, 1916

PROVENANCE: London, Collection Seymour Haden (L. 1227)
LITERATURE: Bartsch 68
 Dutuit 68
 Illustrated Bartsch, 1980, vol. 6, p. 174, repr., and vol. 6 (commentary), 1986, pp. 138–139
 Paris, 1989, p. 128, cat. 145

Een Boeÿer, Een Galioot, a6

This print is from the series *Various Ships and Views of Amsterdam*. These two closely related boats were flat-bottomed with a shallow draft and were ideal as small cargo vessels that could traverse coastal waters. Each had a wide hull that provided considerable space below deck. The *boeier* had a more pronounced poop deck known as the *staatsje* or *hek* that had a stateroom below.

Boeiers had been popular in the Low Countries since the Middle Ages. The early-seventeenth-century prototype was single-masted with a bowsprit, and its mainsail was gaff-rigged. These were oceangoing vessels, but their shallow keels and tall masts supporting such extensive sail made them temperamental to maneuver in deep water. Nooms's etching represents a two-masted *boeier* with a short mizzenmast with lateen sail. By the mid-seventeenth century *boeiers* were falling out of favor. Shipbuilders tried to build ever larger *boeiers,* but they ultimately competed unsuccessfully with the ubiquitous flute in terms of inter-European trade.

The galliot that Nooms depicts in the same etching supplanted the *boeier* as the most successful coastal transport vessel. Its greater maneuverability and cargo capacity assured its popularity at the expense of the *boeier,* which became principally a pleasure craft. The galliot also had a higher sternpost than the boeier, and enabled shipbuilders to construct a tiller that passed behind rather than through the tafferel. Like the most advanced mid-seventeenth-century *boeier,* the galliot was two-masted with a lateen sail on its short mizzenmast. Galliots served various functions: as a coastal cargo vessel, a yacht, a ferry, or as a communications vessel accompanying a fleet. Galliots also served as packet boats and ferries between the Dutch Republic and England.[1]

NOTE

1. This information is principally drawn from J. van Beylen, *Maritieme Geschiedenis der Nederlanden,* 1977, vol. 2, pp. 24–26; 36–37. Willem van de Velde the Elder was frequently assigned to a galliot in order to witness the many battles of the Anglo-Dutch wars, which he sketched for the Dutch navy; see Greenwich, 1982, pp. 12, 59.

112

REINIER NOOMS ("ZEEMAN")

Bicker's Island

Etching, state II, 136 × 247 mm
Caption in bottom margin: *Bickers Eylandt. a9*
Minneapolis, Minneapolis Institute of Arts, inv. P 929, Ladd Collection, Gift of
 Herschel V. Jones, 1916

PROVENANCE: London, Collection Seymour Haden (L. 1227)
LITERATURE: Bartsch 71
 Dutuit 71
 de Groot and Vorstman 1980, cat. 79, repr.
 Illustrated Bartsch, vol. 6, 1980, p. 177, repr., and vol. 6 (commentary), 1986, p. 140
 Paris, 1989, p. 129, cat. 147

This etching, from Nooms's series, *Various Ships and Views of Amsterdam,* provides a close-up view of the harbor of Amsterdam and conveys the full range of activity of this great seaport. Bicker's Island was one of three to the west of Amsterdam, known as the Western Islands (*westerse eilanden*),

Bickers Eÿlandt,

that were incorporated into the city at the time of its expansion in 1612. Subsequently the great Amsterdam merchant Jan Bicker acquired it from the city and developed it to serve his far-flung mercantile empire. He built shipyards, warehouses, and a residence for himself. At the left are Bicker's shipyards with two hulls under construction, supported by scaffolding on dry land. A third uncompleted hull in starboard profile floats in the water at the center. A guardhouse at the right, built as part of the harbor palisades, controls the traffic entering and leaving this section of the harbor by the Nieuwe Waal.[1]

NOTE

1. De Groot and Vorstman reproduce an impression of *Bicker's Island* in the first state with lengthy discussion of the locale.

113

REINIER NOOMS ("ZEEMAN")
The "Pearl," A Dutch East Indiaman, and the "Spread Eagle," a Dutch West Indiaman

Etching, state II, 136 × 248 mm
Caption in bottom margin: *De Paerrel een Oostindis Vaerder, Den Dubbelen Arent een Westindis Vaerder b2*
Minneapolis, Minneapolis Institute of Arts, inv. P. 934, Ladd Collection, Gift of Herschel V. Jones, 1916

LITERATURE: Bartsch 76
Dutuit 76
Illustrated Bartsch, 1980, vol. 6, p. 182, repr., and vol. 6 (commentary), 1986, p. 143

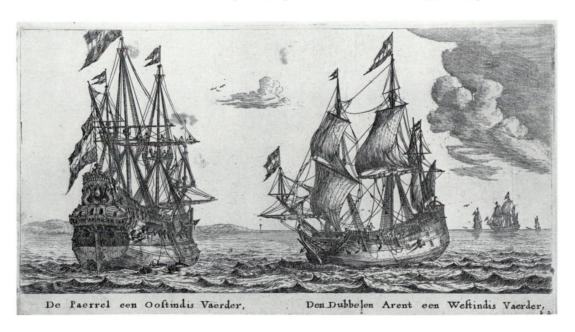

De Paerrel een Oostindis Vaerder, Den Dubbelen Arent een Westindis Vaerder,

This is from part two of the *Various Ships and Views of Amsterdam*. These three-masted ships, known as *retourschepen*, are larger and more heavily armed than the flute ships (see Cat. 110) that were the mainstay of the Dutch mother trade. Because of the need for a cannon deck, these ships were heavier and had two complete decks from stem to stern. Their hulls were also heavier because they had to be constructed of oak, which was more resistant to tropical woodworm. Even so, the oak planking below the waterline was encased in an outer shell of red pine or deal that protected

the oak from woodworm action. Before this outer pine planking was added, the oak hull was coated in tar with an overlay of cow hairs as added protection. Plates of lead or copper sheets were a further sealer.[1]

These large ships had one serious drawback. Their considerable draft did not enable them to sail fully loaded in the shallow coastal waters of Holland. As a result they had to be loaded and unloaded offshore in deeper water. Small boats called *lichters* (lighters) accompanied the outgoing East and West India fleets transporting cargo and ship supplies to be loaded onto the Indiamen in deeper water, or met the returning fleets to reduce their cargo load sufficiently so that the large ships could sail into port.[2] Because the East and West Indiamen were strong and reasonably heavily armed, they were often preempted by the Dutch admiralties and incorporated into the navy in time of war.

NOTES

1. J. van Beylen, in *Maritieme Geschiedenis der Nederlanden*, vol. 2, 1977, pp. 42–43.

2. Ibid., pp. 43–44. See also R. Vorstman, in Amsterdam, 1985, pp. 30–31.

114

REINIER NOOMS ("ZEEMAN")
Fishing Pinks

Etching, state I, 129 × 233 mm
Caption in bottom margin: *Schol. Schuyties of Pinckies 9*
Amsterdam, Rijksmuseum "Nederlands Scheepvaart Museum," inv. A 149

LITERATURE: Bartsch 95
Dutuit 95
Maritieme Geschiedenis der Nederlanden, vol. 2, 1977, p. 50, repr.
de Groot and Vorstman, 1980, cat. 89, repr.
Illustrated Bartsch, 1980, vol. 6, p. 201, repr., and vol. 6 (commentary), 1986, p. 148

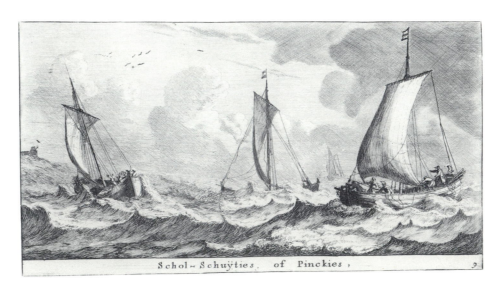

Schol- Schuÿties, of Pinckies, 9

This spirited etching, from the series *Various Ships and Views of Amsterdam,* represents a small flat-bottomed boat used for fishing. These pinks could be sailed directly onto beaches at high tide and served small fishing villages along the coast of Holland and Zeeland that lacked harbor facilities.

The famous late-seventeenth-century Dutch shipbuilder Nicolas Witsen describes pinks as having two or even three masts and leeboards, but Nooms represents a smaller, earlier type that has a single mast and tiller. These smaller fishing boats were ideally suited for the shallow waters off the coastal dunes of the Dutch Republic. Certain large pinks shipped fresh oysters and red herring from Holland to England.[1]

Nooms's preparatory study in reverse for *Fishing Pinks* is in the Fitzwilliam Museum in Cambridge.[2]

NOTES

1. J. van Beylen, in *Maritieme Geschiedenis der Nederlanden,* vol. 2, 1977, pp. 50–52.

2. Inv. PD 948–1963 (B. Ingram Bequest). This drawing is not cited in the commentary volume of *The Illustrated Bartsch,* under Nooms cat. 95.

115

REINIER NOOMS ("ZEEMAN")
Naval Battle

Etching, state II, 180 × 260 mm
Numbered at bottom right: *5*
Saint Louis, Saint Louis Art Museum, inv. 5: 1981: 5

LITERATURE: Bartsch 103
Dutuit 103
Illustrated Bartsch, vol. 6, 1980, p. 209, repr., and vol. 6 (commentary), 1986, p. 156

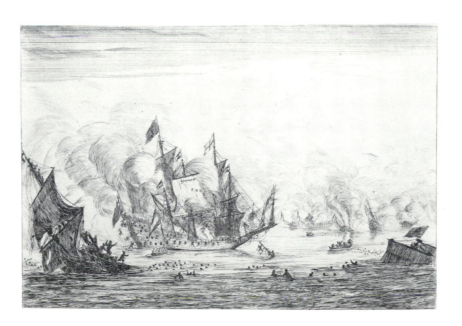

Nooms lavished much attention onto this series of eight naval battles entitled *Nieuwe Scheeps Batalien* (B. 99–106), in which he captures the fury of battle with ships sinking, aflame, and suffering the ravages of cannon fire. Nooms also represents the aftermath of battle with ships, many lacking masts, limping to port (B. 106 and Cat. 68). His preparatory drawings survive for four of these etchings and include his design for the title print plus an alternate proposal that the artist decided against in favor of the more dynamic etched image of a trumpeter standing to the left of a firing cannon.[1] This series, associated with the First Anglo-Dutch War (1652–1654), is closely linked to Nooms's two painted versions of the *Battle of Leghorn* (Cat. 20, 21).

These prints mark a high point in Nooms's career as an etcher, and exhibit a refined use of the etcher's needle and the stopping-out process. Together the two create extraordinary tonal effects in which the smoke of battle lends great force and mystery to the subject. The technical sophistication evident in these prints assures them a special place in Nooms's oeuvre.

Despite their importance and popularity, attested by the fact that the title print exists in six published editions, this series of etchings has never been catalogued adequately. All the prints exist in proof impressions before numbering at the bottom right. More important, at a time when the copperplates were beginning to show signs of wear, particularly in the lightly etched zones of the sky and background, they were cut down across the top by about 13 mm. This radical alteration has passed unnoticed, but it indicates that these prints, even in their reduced format and with substantial reworking, commanded great interest.[2]

Nooms's preparatory study in reverse for the *Naval Battle* was auctioned in London in 1974.[3]

NOTES

1. These drawings are reproduced in *The Illustrated Bartsch*, vol. 6 (commentary), pp. 152–155. Although not cited in the commentary volume of *The Illustrated Bartsch*, Nooms's preparatory drawing for B. 105 survives in the collection of the Yale Art Gallery – see Haverkamp Begemann and Logan, 1970, pp. 245–246, cat. 453, pl. 223.

2. This same situation applies to Nooms's wonderful series *Thirteen Naval Scenes* – B. 107–118a. Their publishing history is even more peculiar because in later states, the entire bottom margin in the copperplates was removed. Enough traces of the tips of letters suggest that in an intermediate state before the point when the London publisher, Arthur Tooker, acquired the already worn copperplates, these prints bore captions in the bottom margin. The blank margins in the existing proof impressions that survive indicate Nooms provided ample space for intended captions. Despite sustained efforts, I have yet to find impressions with these captions produced before the injudicious transformation of this impressive series by Tooker for his edition of 1675.

3. London, auction Eva, Countess of Rosebery (Sotheby) November 22, 1974, lot 12, repr. – *Illustrated Bartsch*, 1986, vol. 6 (commentary) p. 155, repr.

116

JAN PORCELLIS, ANONYMOUS AFTER
Damloopers in a Procession

Engraving, 176 × 250 mm
At bottom left and right: *I.P. in CIV ex.* (CIV in ligature)
Caption in bottom margin: *Damloopers groot omtrent 16 Last 3*
Amsterdam, Rijksmuseum "Nederlands Scheepvaart Museum," inv. A 2017

LITERATURE: Hollstein, vol. 17, Porcellis no. 23
Keyes, 1979, vol. 93, p. 35, fig. 42
de Groot and Vorstman, 1980, cat. 25, repr.
Paris, 1989, p. 111, cat. 118

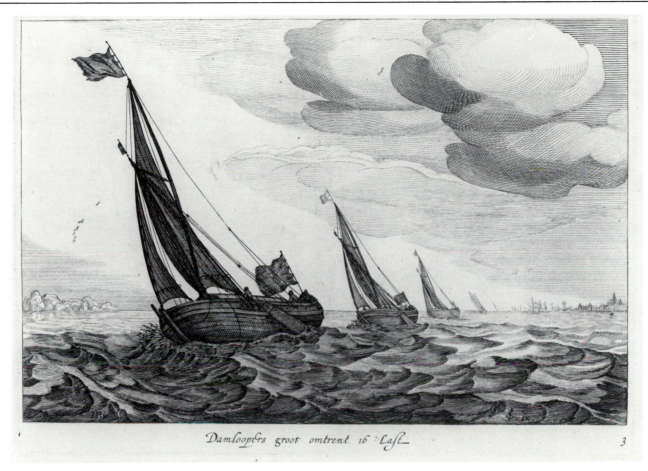

Damloopers groot omtrent 16 : Laft 3

This engraving belongs to a series of eleven prints plus a frontispiece bearing the title *Icones Varium Navium Hollandicarum*. Claes Jansz. Visscher designed the title page, which bears his address and the date 1627. The remaining eleven prints are after drawings by Jan Porcellis. The preparatory study for *Damloopers in a Procession* is in the Lugt Collection in Paris.[1] The *damlooper* was a small sailing vessel used on the lakes and estuaries of the Dutch Republic. Because of its small size it could be transported easily over dams by the use of the *overtoom*, and could continue its travels without serious delay.[2]

 This series of marine prints was the first produced in Holland in which the artist represents specific types of sailing vessels.[3] Porcellis, who was an avid sailor, represented small types of boats, not the warships and large three-masted merchant vessels that interested Hendrick Vroom and his

generation. This shift in focus constituted a radical departure for Dutch marine art and heralded interest in the sailing activities that took place within the country. This example would soon inspire painters such as Jan van Goyen (Cat. 17) and Salomon van Ruysdael (Cat. 27) to depict similar subjects.

NOTES

1. Inv. 3441, brush, gray ink, and washes, 165 × 271 mm, traced for transfer. The second surviving drawing for this series, the design for *Een Zeeuwsche Koch*, is in Vienna (Cat. 73).

2. See de Groot and Vorstman, 1980, cat. 25. For an illustration of an *overtoom* in operation, see ibid., cat. 88, Reinier Nooms's etching B. 92, repr.

3. Ibid. The authors note under cat. 24 that this series was the second ever produced in the Low Countries following the engravings by Frans Huys after the designs of Pieter Bruegel the Elder. The popularity of this series of prints is demonstrated by the number of editions it passed through. Hollstein records three editions, but at least one other exists in which the address on the title page reads: *Amsterodami Impressae apud / Gerardi Valk / Excudit, no. 96.*

117

JAN PORCELLIS, ANONYMOUS AFTER
Herring Busses

Engraving, 178 × 251 mm
Signed at bottom left and right: *I.P. in. CIV ex.* (CIV in ligature)
Caption and number in bottom margin: *Haring Buyssen groot omtrent 40 Last 4*
Amsterdam, Rijksmuseum "Nederlands Scheepvaart Museum," inv. A 2017

LITERATURE: Hollstein, vol. 17, Porcellis no. 24

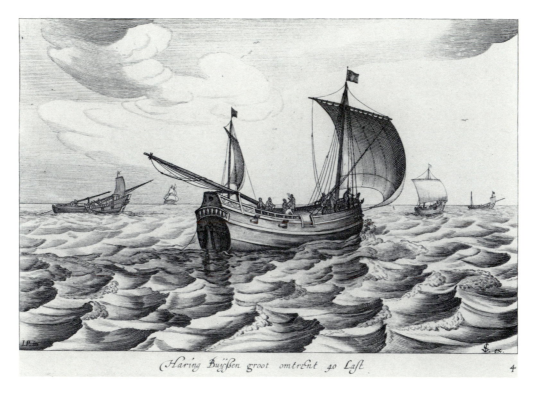

This engraving, also from the *Icones Variarum Navium Hollandicarum*, represents a herring fleet on the open ocean. Early in the seventeenth century, *busses* had a flat stern, whereas in Nooms's drawing (Cat. 69), the more modern *busses* have a rounded stern. Porcellis illustrates how these two-masted ships could lower their masts. These small ships are armed, whereas in Nooms's drawing the *busses* were accompanied by a larger armed ship that escorted the fleet and protected it from marauders.

118

HANS REM, ANONYMOUS AFTER
The Battle of Sluis

Engraving in two plates, 520 × 933 mm
Caption across top: *SOLI DOMINO GLORIA: Viva icon . . . Spinola teryt*
Letters, numbers, and captions in scene
12-line text in six columns in bottom margin: *Coelitus . . . ultor*
7-line dedication to Prince Maurice in tablet at bottom right of right-hand plate:
 Illustmis Nobiliss . . . Heroi Mauritio Nassovio . . . D. D. Johannes Rem
Separately printed 9-column German text accompanies print
Rotterdam, Stichting Atlas van Stolk, inv. 1195 A

LITERATURE: F. Muller, *historie platen*, Supplement 1195A
 Atlas van Stolk
 Hollstein, vol. 17, Rem no. 2

On May 26, 1603, a Dutch fleet, commanded by Joos de Moor, captured eight Spanish galleys under the command of Frederick Spinola in the Scheldt estuary before the town of Sluis. Spinola lost his life in the battle. In their ongoing strategy to retain control of the mouth of the Scheldt and as part of their campaign to recapture Flanders, the Dutch mounted attacks on the Spanish Netherlands from Zeeland. Although the latter effort was to end in failure, the Dutch stranglehold on trade coming into Antwerp had enormous impact in terms of diverting much of this trade to the seaports of the fledgling Dutch Republic. The *Battle of Sluis* reconfirmed this strategy and was a serious naval setback to Spain, which the Dutch continued to perceive as a dire threat to their own sovereignty.

 The impression of *The Battle of Sluis* in the Atlas Muller in the Rijksprentenkabinet in Amsterdam bears the address of the Amsterdam publisher – Willem Jansz.: *Amstelodami / Gulielmus Janssonius excudit* – but lacks the separately printed accompanying text.[1] The impression in the Atlas van Stolk lacks this address and is, in all likelihood, a proof printed before the addition of the publisher's address. On June 28, 1603, the States General of the Dutch Republic granted Hans Rem, resident of Amsterdam, a four-year patent for the creation, printing, and publishing of this print.[2]

NOTES

1. The Rijksmuseum "Nederlands Scheepvaart Museum" in Amsterdam owns this print in the same state (inv. A 1280–6) and with separately printed accompanying four-column texts in Dutch and French. The Dutch text is headed by the caption: *Waerachtige afbeeldinge en Conterfeytsel . . . en gepasseert is* and reads: *Den 26. May 1603, smorgens . . . salichmaker. Jesum Christum. Amen.* The French heading reads: *Vray pourtraict . . . s'est passe* with the text: *Le 26 mois de May l'an 1603 . . . Ainsi soit il.* These conclude with the letters A–F and the numbers 1–4 and their accompanying captions. The French text is followed by the address: *t'Amstelredam by Willem Jansz . . . in de Sonne-wyser.* The Albertina in Vienna also possesses an impression of this rare print, inv. 75717.

2. *Resolutiën der Staten-Generaal*, 1602–1603, vol. 12, ed. H.H.P. Rijperman (R.G.P. 921, Grote Serie), p. 649.

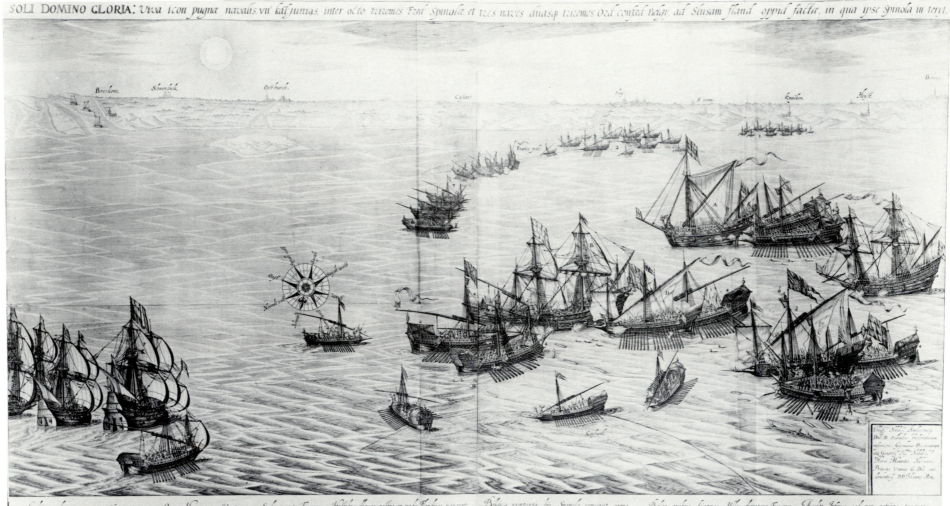

119

SALOMON SAVERY
A Flute Ship in Starboard Profile

Etching, 387 × 516 mm
Address at bottom right: *S. Savery Excut.*
Amsterdam, Rijksmuseum "Nederlands Scheepvaart Museum," inv. A 145 (121).

LITERATURE: Hollstein, vol. 24, S. Savery 103, repr.

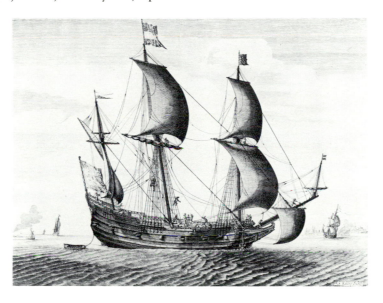

Salomon Savery published several marine prints including one suite of six small etchings.[1] He also produced three considerably larger prints representing, respectively, a warship, a yacht, and a flute ship.[2] These three large-scale ship's portraits are exceedingly rare. To the best of our knowledge each survives in a unique impression, yet, given Savery's ambitions as a publisher, originally these must have been printed in reasonably large editions. Although lacking the originality of Hendrick Hondius's *French Man-of-War* (Cat. 103), Savery's ships portraits are a rare and noteworthy contribution to this category of Dutch marine art, and form a link between the earlier contribution of artists such as Porcellis (Cat. 116, 117) and van Wieringen, and the celebrated suites of etchings by Reinier Nooms (Cat. 110, 111, 113).

A Flute Ship in Starboard Profile makes evident how lightly armed these ships were. It has a lateen sail on its mizzenmast, whereas its fore- and mainmasts have square sails, three of which are unfurled.

NOTES

1. Hollstein, S. Savery nos. 101–109.
2. Ibid., nos. 101–103, all repr.

120

SALOMON SAVERY, AFTER SIMON DE VLIEGER
Festive Procession of Ships Before Amsterdam

Etching, state I, 297 × 649 mm
Amsterdam, Rijksmuseum "Nederlands Scheepvaart Museum," inv. A 145 (193)

LITERATURE: Hollstein, vol. 24, S. Savery, 144 (g)

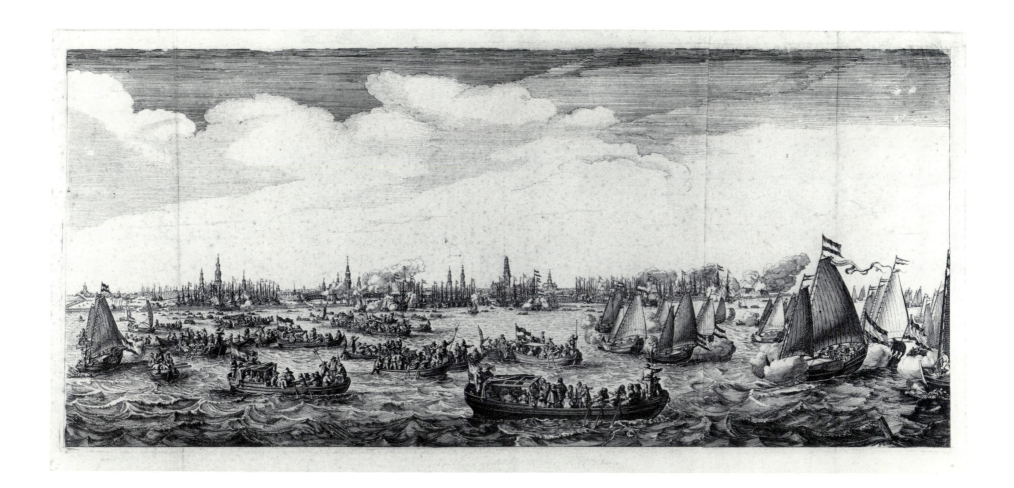

This is one of eight illustrations that Savery contributed to Caspar Barlaeus, *Medicea Hospes,* published by Joan and Cornelis Blaeu in Amsterdam in 1638. The remaining illustrations are by Pieter Nolpe after Claes Moeyaert. This etching and two others by Savery are after the designs of Simon de Vlieger.[1] Savery depicts the festivities surrounding the visit of Marie de Medici to Amsterdam in 1638. The queen mother, although stripped of power by her hated enemy Cardinal Richelieu, still hoped to reestablish her role in the court of her son, Louis XIII of France. This trip to Amsterdam was part of her program to secure foreign recognition of her authority and reassert her position in the French court. The city of Amsterdam lavished considerable attention onto her visit, building triumphal arches at strategic points throughout the city. The magistrates also provided a procession of stately barges accompanied by saluting sailboats on the River Ij before the city. In Savery's print the city profile appears on the horizon partly obscured by smoke from fireworks, a festive image that offers an interesting comparison to Pieter Bast's *Profile View of Amsterdam* (Cat. 100) of 1599. Simon de Vlieger shifts the vantage point to the northeast and omits ref-

erence to the north bank of the River Ij to evoke a vast, uninterrupted expanse of water before the distant harbor.

This image is an important contribution to the well-established theme of a Dutch seaport seen in profile view from the water. It differs from its antecedents, such as Hendrick Vroom's paintings, because of the festive nature of the boating activities in the foreground. Images such as this may prove to be a crucial link between the early-seventeenth-century representations of the arrival of dignitaries at Dutch seaports and the *parade* themes that first appeared in Dutch marine painting shortly before 1650.[2]

NOTES

1. In the second state this print is signed at the right center and right: *S. Saury Sculp. de Vlieger inu.,* and has coats of arms added at the upper left and right.

2. The two chief practitioners of the *parade* theme were Simon de Vlieger and Jan van de Cappelle. Russell, 1975, pp. 21–22, argues for Jan van de Cappelle's primacy in inventing the parade picture based on van de Cappelle's painting in the Robarts Collection (Russell, fig. 1), which many consider to bear the date 1645. Evidently this picture precedes Simon de Vlieger's similar painting of 1649 in the Kunsthistorisches Museum in Vienna (Russell, fig. 2). Nonetheless, the possibility exists that the origin of this theme can be traced back a decade earlier in terms of Simon de Vlieger's designs for prints such as those that appear in the *Medicea Hospes.*

121

WILLEM VAN DE VELDE THE ELDER, ANONYMOUS AFTER
The "Aemilia," Admiralty Ship of Holland

Etching, 391 × 534 mm (396 × 539 mm)
Caption across top: *AEMILIA HET ADMIRAELS SCHIP VAN HOLLANT*
At bottom left and right center: *W. Vande Velde C Dankerts excud*
Dordrecht, Museum Mr. Simon van Gijn, Atlas Mr. Simon van Gijn, inv. 10.913

LITERATURE: F. Muller, *historie platen,* 1555b
Atlas van Stolk 1639 (in a later edition with the address of Joannes Loots)
Maritieme Geschiedenis der Nederlanden, vol. 2, 1977, p. 332, repr.

This heavily armed warship was the flagship of Lieutenant Admiral Marten Harpertsz. Tromp, on which he fought the Battle of the Duins against the Spanish in 1639. The *Aemilia,* built in 1632, was the flagship of the ad-

miralty fleet of the Maas. After years of stalwart duty, the *Aemilia* was sold in 1647.[1] Van de Velde represents the flagship in starboard beam, flying Dutch standards and a long pendant from its foremast. This ship

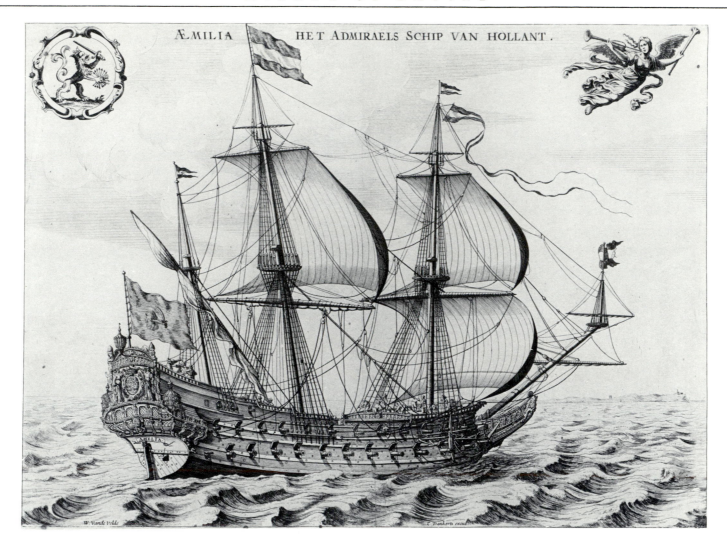

was named in honor of Amalia von Solms, the consort of Frederick Henry, stadholder of Holland and supreme military commander of the Dutch Republic. A crest at the upper left contains the lion symbolizing the Dutch Republic. The lion brandishes a sword in its left paw, and in its right it holds a cluster of seven arrows, signifying the seven united provinces of the Dutch Republic. The personification of fame at the upper right precedes the progress of this celebrated ship.

NOTE

1. Diekerhoff, 1970, vol. 5, p. 23.

122

HENDRICK CORNELISZ. VROOM, ANONYMOUS AFTER
The Landing at Philippine

Engraving in two plates, 380 × 965 mm
Signed on tablet at bottom right: *HENRICVS.VROOM INVEN / Cornelis Claes
 zoon excud*
Captions throughout
Caption across top: *Ectypoma classis bis mille octingentarum navium Ductore
 Illustrissimo Principe MAURITIO NASSOVIO in Flandriam appulsa xxii Juny M.VI*
3-line dedication to Prince Maurice in tablet at bottom left: *Illust.mo Heroi D.
 MAURITIO. Principi Uraniae . . . Henricus Vroom Harlemensis D. D.*
36-line Latin text in twelve columns in bottom margin: *Adspice ut instructas . . . undis*
Leiden, University Library, Bodel Nijenhuis Collection, inv. Portf. 38, no. 85 (1–2)

LITERATURE: F. Muller, *historie platen,* 1132 and Supplement
 Atlas van Stolk 1081
 Keyes, 1975, vol. 1, pp. 24–25
 Russell, 1983, pp. 145–146, figs. 132a–b
EXHIBITION: Leiden, 1987, p. 180, cat. 116, repr.

Hendrick Vroom received 150 guilders from the States General of the United Provinces for his preparatory study for this engraving.[1] His drawing survives (fig. 9) and is preserved in the Museum Boymans–van Beuningen in Rotterdam.[2] Vroom represents the Dutch flotilla, an invasionary fleet numbering approximately 2,800 vessels, which transported the army of Prince Maurice to the coast of Flanders near Ostende in June 1600. A few days later, on July 2, the Battle of Nieuwpoort took place, in which Maurice claimed a victory over the forces of Frederick Spinola, the commander of the Spanish army. This celebrated battle was the high point of the Dutch effort to recapture Flanders as part of the United Provinces. Ultimately the protracted campaign became a bloody and costly stalemate, only resolved with the Twelve Years Truce commencing in 1609. To this day, the Dutch possess land along the southwest flank of the River Scheldt around Sluis, but their larger ambitions to recapture Ostende and Antwerp were never realized.

Vroom's design is a remarkable document of a complex and significant military operation. He stresses the tremendous sense of discipline of these hundreds of small craft sailing in formation before the coast of Flanders. His lively definition of these boats under sail heralds a new vision of maritime reportage that culminated later in the century in the great battle friezes of Willem van de Velde the Elder (Cat. 81–83).

The engraving *The Landing at Philippine* exists in at least three known

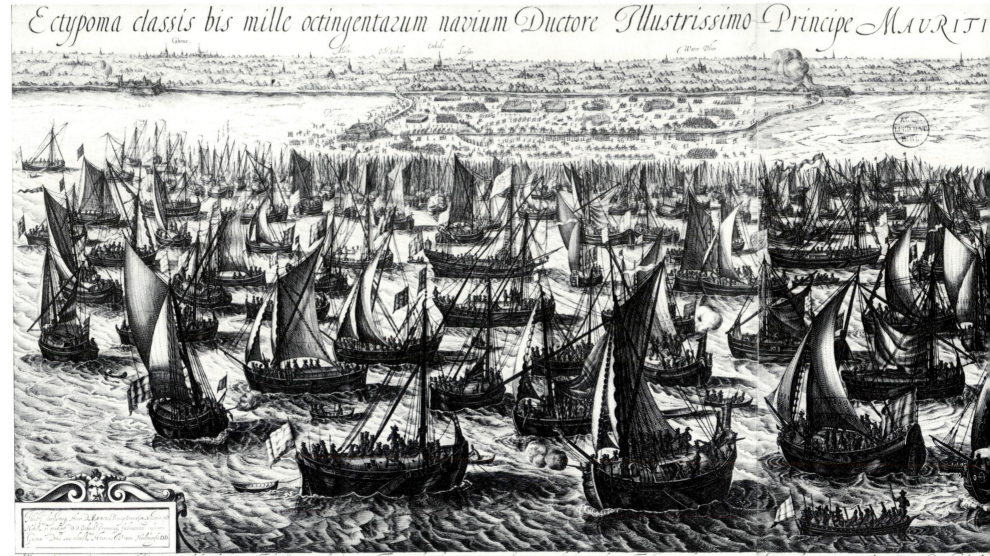

Ectypoma classis bis mille octingentarum navium Ductore Illustrissimo Principe MAURITI

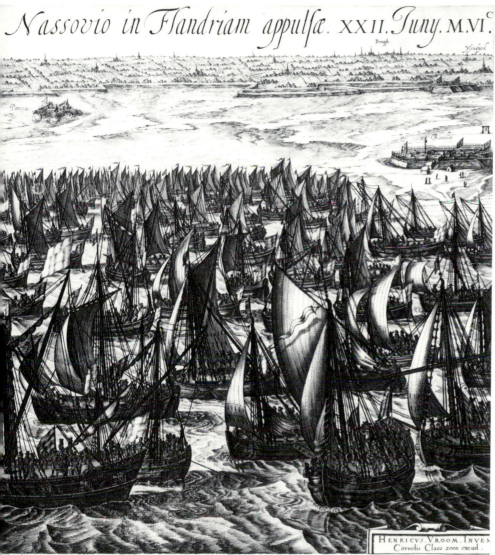

editions. The first was published by Cornelis Claesz. Subsequently, Claes Jansz. Visscher acquired the copperplates, but even at that date they show signs of wear.[3] The impression included here is spectacularly sharp and velvety. Moreover, it is only one of three known impressions containing the dedication to Prince Maurice rather than the more standard dedication to the States General.[4]

NOTES

1. On November 9, 1600, the States General resolved to pay Hendrick Vroom 150 guilders for his preparatory drawing – *Resolutiën*, 1941, vol. 11 (R.G.P. 85), ed. Japikse, p. 358.

2. This commission is the last work by Hendrick Vroom described by Carel van Mander in *Het Schilder-Boeck*, 1604. For the drawing, see Keyes, 1975, vol. 1, pp. 24–25, pl. V–VI; Russell, 1983, fig. 132a.

3. F. Muller, *historie platen*, Supplement, p. 116, no. 1132, describes a third edition.

4. The Rijksmuseum "Nederlands Scheepvaart Museum, inv. A 1280 (5), has a most remarkable impression of *The Landing at Philippine*, which has been included in a much larger broadsheet incorporating the large *Battle of Nieuwpoort* by Lambartus Cornelius, plus five other scenes. The entire assemblage is capped by a two-line block-printed Dutch title that reads: *Afbeeldinghe vande groote Scheeps Armada . . . tweentwintichsten Junij Anno sesthien hondert tot Philippijnen in Vlaenderen ghelandt + zijn*. The following address appears at the bottom right of the broadsheet: *Ghedruct t'Amsterdam by Cornelis Claessz. op't Water in't Schrijf-boeck*. The Albertina in Vienna also possesses an impression in this edition.

123

ANTHONY VAN ZYLVELT, AFTER MICHIEL COMANS
The Four Days' Battle

Etching, 330 × 437 mm
Signed at bottom right: *M. Comans del. / A. v. Zylvelt fe*
Lettered and numbered throughout
With separately printed 3-column Dutch text headed by caption: *Pertinente Afbeeldinge*
 van de Victorieuse Vierdaeghsche Zeeslagh . . . op den 11/12/13 en 14 Junij 1666
This caption followed by letters, numbers, and accompanying explanatory captions
Address below text: *t'Amsterdam, By Pieter Arentsz. . . . 1666*
Rotterdam, Stichting Atlas van Stolk, inv. suppl. (F.M. 2226)

LITERATURE:
 F. Muller, *historie platen* 2226
 Wurzbach, 1910, vol. 1, p. 320
 Thieme Becker, *Künstler Lexikon*, 1947, vol. 36, p. 616
 Hollstein, vol. 4, listed under M. Comans, after

Anthony van Zylvelt, an obscure printmaker, is best known for his reproductive portrait likenesses.[1] This rare history subject by the etcher after the equally obscure artist, Michiel Comans,[2] provides a bird's-eye view of this battle with the sand dunes of the coast of Flanders in the distance. The artist amalgamates features from different days of the battle to create a tapestry of events. This approach differs from the on-the-spot reportage of Willem van de Velde the Elder (Cat. 81, 82), but provided a popular broadsheet commemorating this significant Dutch naval victory.

NOTES

1. For listings of his portraits, see F. Muller, *Beschrijvende Catalogus van 7000 Portretten, van Nederlanders*, Amsterdam 1853, p. 393; Wurzbach, 1910, vol. 2, p. 687.

2. Wurzbach, vol. 1, p. 320, cites Michiel Comans, who was a schoolteacher, instructor in calligraphy, and etcher from Rotterdam. Comans married in Amsterdam on February 31, 1657, and died on December 9, 1687.

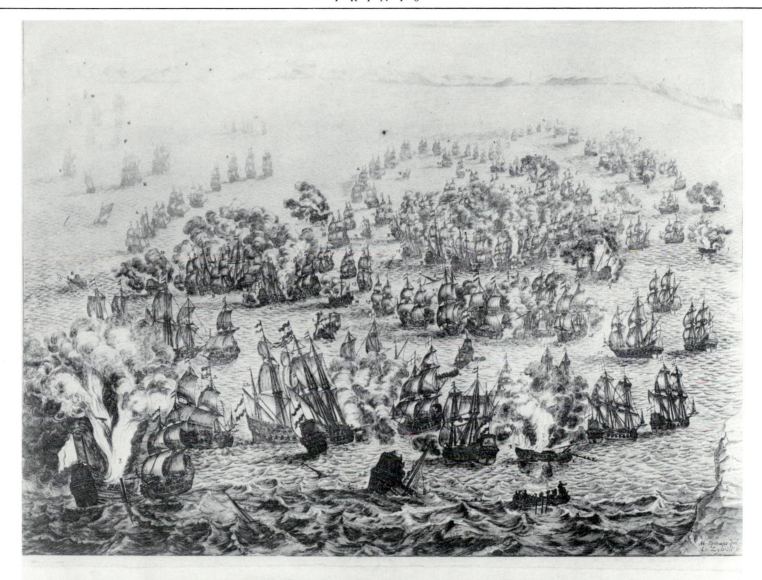

124

ANONYMOUS
The Battle of Bantam

Engraving in three plates, 414 x 846 mm, hand-colored
6-line Latin dedication in tablet at upper left between the crests of Holland and Prince
 Maurice:
 PRVDENTIBVS...HOLLANDIA. ZELANDIA ET WESTFRISIA / Hermanus
 Alaedi et Johannes Everardi Cloppenburgius merito Dedicarunt Ao CIƆ.IƆ.CIII
Address at bottom right of middle plate: *CIVisscher excudebat* (CIV in ligature)·
Rotterdam, Stichting Atlas van Stolk, inv. 1124

LITERATURE: F. Muller, *historie platen* no. 1172
 Atlas van Stolk 1124
 Maritieme Geschiedenis der Nederlanden, vol. 2, 1977, p. 251

Jan Huygen van Linschoten's *Itinerario,* widely published in Holland, indicated the scope, workings, and wealth of the Portuguese trade in the Far East. It was centered at Goa on the Malabar coast of India but also included a network of shipping posts in Southeast Asia and the Indonesian archipelago. The Dutch and the English were determined to break into this monopoly and share the wealth generated by the spice trade. As early as 1595 the Dutch sent fleets to the Far East. The first, led by Cornelis de Houtman, reached Bantam after fifteen months under sail, and three of the four ships originally constituting this fleet returned to Holland in August 1597. A much larger fleet consisting of eight ships set sail from Amsterdam under the command of Jacob van Neck in 1598 (see Cat. 50). This fleet returned with rich cargoes of costly spices on July 19, 1599. The huge financial returns to the backers of the venture spurred the States General of the Dutch Republic to establish the Dutch East India Company[1] on March 20, 1602.

The *Battle of Bantam* occurred on December 30, 1601. Five Dutch ships commanded by Admiral Wolfert Harmensz. were victorious over a Portuguese fleet of thirty ships. This victory demonstrated that the Portuguese

trading empire in India and the Far East was vulnerable. In fact, the Dutch victory at Bantam enabled them to dominate this part of the world, which came under the mercantile domain of the Dutch East India Company.

The city of Bantam, a major seaport on the eastern tip of Java, was strategically located on the Straits of Sunda opposite the island of Sumatra. It was also a major trading center for pepper. Here, Chinese and Indian merchants bought pepper and other spices which they shipped to their homelands for distribution. The Straits of Sunda were the southern east-west shipping channel through the Indonesian archipelago, and Bantam became the center of a vast trading network partly superseding the role of Malakka further to the north on the Straits of Malakka between northern Sumatra and Singapore. Bantam's position was undermined when the Dutch established the nearby community of Batavia (now modern Jakarta), which became the political center of the Dutch East India Company.[2]

A map at the lower left of this engraving indicates the strategic position of the Straits of Sunda between Java and Sumatra. Viewed from north to south, Ceylon and the tip of India appear at the lower right in the map, and the Philippines are represented at the bottom left.

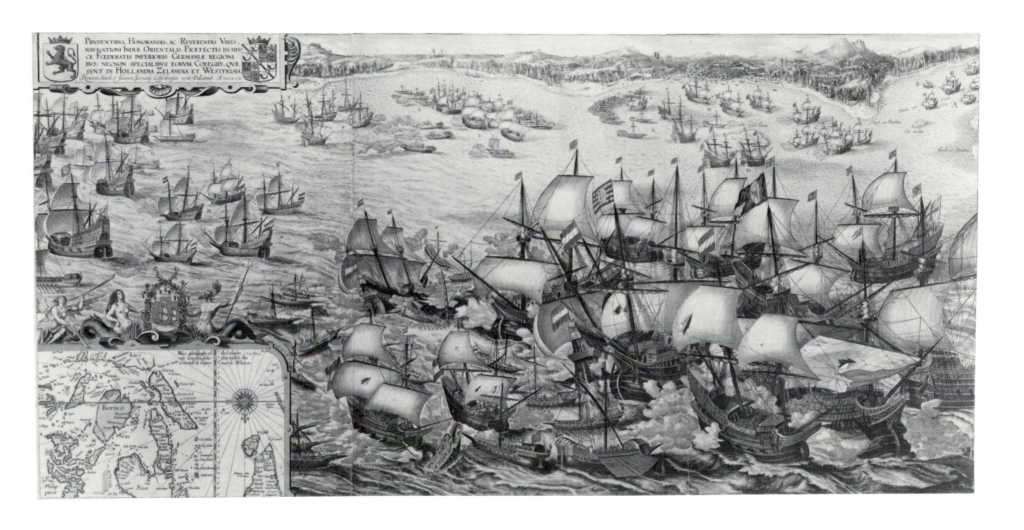

Impressions of this print in the Atlas Muller of the Rijksprentenkabinet in Amsterdam and in the Rijksmuseum "Nederlands Scheepvaart Museum" in Amsterdam contain a separately printed three-line title across the top.[3]

NOTES

1. Verenigde Oostindische Compagnie – known familiarly as the VOC.

2. For further information on Bantam, see *Maritieme Geschiedenis der Nederlanden*, 1977, vol. 2, p. 250, and de Groot and Vorstman, 1980, cat. 21.

3. F. Muller, *historie platen*, no. 1172, also cites a separately printed text, now in the Prentenkabinet in Leiden, which he surmises was intended to be mounted surrounding the image of the *Battle of Bantam*. It bears the address of the Amsterdam publisher, Cornelis Claesz., and the date 1608.

125

ANONYMOUS
Battle of Gibraltar

Etching and engraving in three plates, 429 × 844 mm
Captions in scene and with letters and numbers in vignettes
13-line Latin text between scenes A and B at upper left: *Vera ... IACOBI*
 HEEMSKERCKII ... Civitatis Gibraltar, 25 Aprilis Anno 1607
2-line title under portrait of Admiral Jacob van Heemskerck at top center:
 EFFIGIES ... IACOBI HEEMSKERCKII AMSTELODAMENSIS
Amsterdam, Rijksmuseum "Nederlands Scheepvaart Museum," inv. A 2980

LITERATURE: F. Muller, *historie platen*, 1241 and Supplement
 Atlas van Stolk 1197
 Maritieme Geschiedenis der Nederlanden, 1977, vol. 2, p. 346

Under the command of Admiral Jacob van Heemskerck, a Dutch fleet made a bold surprise attack on a large Spanish fleet assembled in the Bay of Gibraltar. This battle took place on April 27, 1607. The Dutch inflicted a devastating defeat on the Spanish. The Dutch feared the creation of a second Spanish armada, which, like the first armada of 1588, they assumed would be used to transport a huge Spanish army to The Netherlands with the intention of invading the Dutch Republic. In view of this fear, the Dutch continued to find means of harassing Spain and curbing its sea power wherever possible. The *Battle of Gibraltar* was the most spectacular Dutch intervention to date, and demonstrated the vulnerability of Spain to unexpected attacks of this type. The Dutch victory at *The Battle of Gibraltar* may have been a contributing factor in drawing up the Twelve Years' Truce between the Dutch Republic and the Spanish Netherlands in 1609. Nonetheless, the Dutch fear of Spain continued unabated and would culminate in the *Battle of Downs*, in 1639, in which Admiral Maarten Harpertsz. Tromp annihilated the last Spanish armada to enter the English Channel (see Cat. 33).

Jacob van Heemskerck was killed in the *Battle of Gibraltar*. He became the Dutch naval hero of the hour, as attested by the many commemorative monuments to his great victory. These include medals, stained-glass windows,[1] his celebrated funerary epitaph by Hendrick de Keyser in the choir of the Oude Kerk in Amsterdam, and this remarkable print.

The main subject of this large etching and engraving is the *Battle of Gibraltar* represented in bird's-eye view, with the city and its fortifications appearing at the right. A map of the Straits of Gibraltar localizes the scene of action in cartographical terms. The entire upper section of this print eulogizes van Heemskerck. His portrait at the center is flanked by four scenes which read from left to right: the Bay of Gibraltar with the Dutch navy approaching (A), Van Heemskerck's coffin resting in state (D), his funeral procession (C), and a second view of the Battle of Gibraltar (B).

The author of the print is not known, but in 1882 Muller proposed the attribution of this ambitious image to Claes Jansz. Visscher.[2] Moreover, he also cites the existence of a separately printed seven-column Dutch text with numbers 1–25 and letters a–k with accompanying explanatory cap-

tions. This text, lacking the print, is in the print room of the University of Leiden and bears the publisher's address of Willem Jansz. Blaeu. The origins of Visscher's style remain obscure, but collaboration with Willem Jansz. Blaeu at this point early in his career is plausible. Such a relationship would have been a logical step for the young Claes Jansz. Visscher, who was extremely ambitious and who, within a few years, became one of the most notable and active print publishers in Amsterdam.

NOTES

1. The most remarkable of these is a large but extensively restored lancet window in the north transept of the Oosterkerk in Hoorn. The Admiralty of the North Quarter presented this stained-glass window to the church in 1620. At the bottom center is a representation of the *Battle of Gibraltar*. Above this are the attributes of navigation and cartography stacked up on a ledge to either side of a cartouche. At the very top, above the pierced lunette, Neptune appears on his chariot drawn by tritons.

2. F. Muller, *historie platen*, Supplement, p. 130, no. 1241.

126

ANONYMOUS
Battle of La Hogue

Etching, 299 × 414 mm, overall measurements with text, 556 × 414 mm
Caption in banderole at top center: *DE FRANSE VLOOT VERDELGT
 DOOR / DE VEREENIGDE ENGELSE EN STAATSE / VLOOTEN
 onder de Admiralen Russel en Allemonde*
Lettered throughout
With separately printed 3-column Dutch text below image headed by 7-line caption: *Op
 de Alder-gedenk waardigste Zee-slag...tussen Fecamp en Barfleur, op den 29/30 en
 31 May 1691, en vervolgt in Juny 1692*
Rotterdam, Stichting Atlas van Stolk, inv. suppl. (F. M. 2856b, text F. M. 2856a)

LITERATURE: F. Muller, *historie platen*, 2856a

The combined Anglo-Dutch navy inflicted a devastating defeat on the French navy of Louis XIV. Louis supported James II, who fled to France in exile in 1688 but entertained ambitions to invade England and reestablish himself on the English throne. The allied victory at La Hogue quashed these hopes forever and demonstrated the limits of French sea power.[1]

This anonymous print, executed in a style reminiscent of Romeyn de Hooghe, exists in more than one edition. The impression on view is in the first state before having the lettering throughout the scene reinforced with the burin. In a later edition the accompanying text in four columns bears the address *TOT LEYDEN. / By de Weduwe van Johannes Tangena... Met Previlegie.*[2]

NOTES

1. For further discussion of this event, see Cat. 58.

2. F. Muller, *historie platen*, 2856c. In this edition the text is supplemented by the letters A–T with accompanying explanatory captions. Impressions in this edition are in Amsterdam, Rijksmuseum "Nederlands Scheepvaart Museum," inv. A 1656 (11); Amsterdam, Rijksprentenkabinet, Atlas Muller; Dordrecht, Atlas Simon van Gijn, inv. 10.891; and Rotterdam, Atlas van Stolk, no. 2882.

Op de Alder-gedenkwaardigfte Zee-flag tuffen de Admiraals

RUSSEL EN ALEMONDE,

Tegen den Franfen Admiraal

DE TOURVILLE,

Met verdelging der Franfe Vlooten, door die van Groot-Brittanjen en het Ver-eenigde Neder-
land; voorgevallen in 't Canaal, tuffen Fecamp en Barfleur, op den 29,
30 en 31 May 1691, en vervolgt in Juny 1692.

CARTOGRAPHICAL MATERIAL

127

PIETER VAN DEN KEERE

Wall Map in Two Hemispheres and Picture of the World (1611)

NOVA TOTIUS ORBIS MAPPA, EX OPTIMIS AUCTORIBUS DESUMTA, / *studio*
 Petri K(a)erI
Scale [ca. 1:17,500,000 to ca. 1:30,000,000], equatorial stereographic projection
Amsterdam: Pieter van den Keere and Dirck Pietersz Pers, 1611
Twelve sheets: copper engraving and etching; 126 x 197 cm

The imprint of the map is in the eastern hemisphere below the equator; on a shield in the
 center of an allegorical scene filled with vanitas symbols, is the inscription:
 Amstelredami apud Petru(m) Kaerium et Theodorum Petri sub signo praeli albi (By
 Pieter van den Keere and Dirck Pietersz. Pers at the sign of the White Press in
 Amsterdam).
 Another two large scenes adorn the map. In the South Pacific are the
 personifications of Peace (*PAX*), crowned by Victory (*Victoria*), with *Mars*, the god of
 war, kneeling at her feet. The scene recalls the brief interval of peace in the struggle
 against Spain, while the Twelve Years' Truce (1609–1621) was in effect. In the lower
 part of the eastern hemisphere is the *ACADEMIA Veterum et Recentiorum
 Astronomorum Geographorum et Mathematicorum* under the direction of
 Astronomia. Around the celestial globe supported by Atlas, Mercator, Ortelius, and
 Brahe are depicted in the company of Euclid, Ptolemy, and many other eminent
 scholars and men of science.
 There are five inscriptions in cartouches: (1) on the discovery of America; (2) on
 Daniel Chappus, an explorer of *Nova Francia* (Canada); (3) on the voyages made by
 Dutch explorers to Nova Zembla; (4) on New Guinea; and (5) on the
 circumnavigators Magellan, Drake, Cavendish, and van Noort.
 The triangular spandrels around the two hemispheres are filled with six allegorical
 representations of the four continents. Besides the three of the Old World of Europe,
 Asia, and Africa, there are three of the New World, which is represented by
 Mexiacana, Peruviana, and Magallanica.
 The wide decorative border is composed of rectangular cartouches depicting
 various rulers of the world, costumed figures and views of towns.

San Francisco, Sutro Library

LITERATURE: Schilder and Welu 1980

NOVA TOTIUS ORBIS MAPPA, EX OPTIMIS AUCTORIBUS DESUMTA, studio Petri Kærl.

The splendid multi-sheet wall maps of the world are the most beautiful examples of Dutch cartography. This magnificent specimen by the distinguished engraver Pieter van den Keere (1571–ca. 1646) of Ghent exemplifies the ability of wall charts to provide a pictorial encyclopedia of geographical knowledge in cartographic form. The lavish decoration complements rather than conflicts with the restrained idiom of cartographic draftsmanship. The map as a whole celebrates the bounty of the earth in all its diversity of countries, places, and people. This is how the Dutch saw the world opening up around the turn of the seventeenth century, and how the great cartographers of the day – Plancius, Blaeu, and Hondius – rep-

Zembla in 1610, which does not appear on any other map. It is nevertheless interesting to study the map for signs of the emergent expansion of Dutch trade over the world's oceans. In the far north are the west coast of Spitsbergen, Bear Island, and the western and northern coasts of Nova Zembla; *Vlais Bay*, *Vis Bay*, and *Mossel Bay* to the east of the Cape of Good Hope recall the first voyage to the Indonesian archipelago under Cornelis Houtman (1595–1597), while the name of Mauritius for the Do Cirne island is a reminder of Wybrant Warwijk's voyage of 1598. Three names near Java and Sumatra bear witness to the first Dutch expeditions to the region – *Gebroken Hoeck*, *Vlacke Hoek*, and *3 Eylanden*. Finally, a large cartouche near the Straits of Magellan refers to Olivier van Noort's voyage around the world (1598–1601). The yield is small, but the map nevertheless shows how vessels flying the Dutch flag were sailing back and forth over the oceans, and how they had come to be an intrinsic part of the world landscape.

resented it in a number of large wall maps, as I indicate in my introductory essay on marine cartography.

Van den Keere himself acknowledges in the title that the map is not original. The information it contains was taken from *optimi auctoribus* (the best sources), and comparisons have shown that he relied heavily on the double hemisphere map by Petrus Plancius (1607). The decoration, in particular, shows a striking resemblance. Plancius's map, which is only known in a much later edition by Cornelis Danckertsz. (1651), was in turn influenced by Willem Jansz. Blaeu's map of 1605. So as far as the geography is concerned, van den Keere's map contains little new information other than a reference to a voyage made by two ships from Amsterdam to Nova

128

WILLEM JANSZ. BLAEU
The World Map on Mercator Projection
(1604, republished ca. 1666)

*NOVA ORBIS TERRARUM GEOGRAPHICA AC HYDROGRAPHICA
DESCRIPTIO, Ex optimis quibusq(ue), optimorum in hoc opere Auctorum, Tabulis
desumpta.* / [Willem Jansz. Blaeu] *a Franciscus Hoeius*
Scale [ca. 1:12,000,000 to ca. 1:50,000,000], Mercator projection
Amsterdam: Hugo Allard [ca. 1665]
Two sheets: copper engraving; 53 x 81 cm

With four inset maps: two celestial hemispheres in the upper corners and two polar maps
from 50°N and 50°S in the lower corners; numerous inscriptions, three of them in
cartouches: (1) at upper left, with portraits of Vespucci and Columbus, a ten-line
annotation on the discovery of America, *Americae (quae merito Novus Orbis)
detectio*; (2) at upper right, a five-line explanatory note on the Dutch voyages of
discovery to Nova Zembla in 1594, 1595, and 1596; (3) at lower right, an eleven-line
address to the reader, *Lectori S.*, flanked by the figures of *Astronomia* and
Geographia and crowned with the emblem of the sundial with the motto *Ut Vita, sic
fugit hora*. At lower left, a cartouche with the imprint *Ghedruct 't Amsterdam Bij
Hugo Allardt woonende in de Kalverstraet in de Werelt Kaerdt*, crowned with a crest
containing three garlands of roses.
 The chart has two networks of compass points with several artistically rendered
compass roses. The oceans are lavishly decorated with vignettes of ships, sea gods,
and ferocious monsters. The chart indicates the route taken by Olivier van Noort on
his voyage of circumnavigation (1600), and a ten-line annotation entitled *Orbis
Periplus* at lower center contains information about the expedition.

Leiden, University Library, Bodel Nijenhuis Collection, inv. 004–08–039, 040

LITERATURE: Muller 1894, nos. 7 and 8
Welu 1977, nos. 17 and 18
Schilder 1979a
Schilder 1981
Shirley 1983, nos. 258 and 265

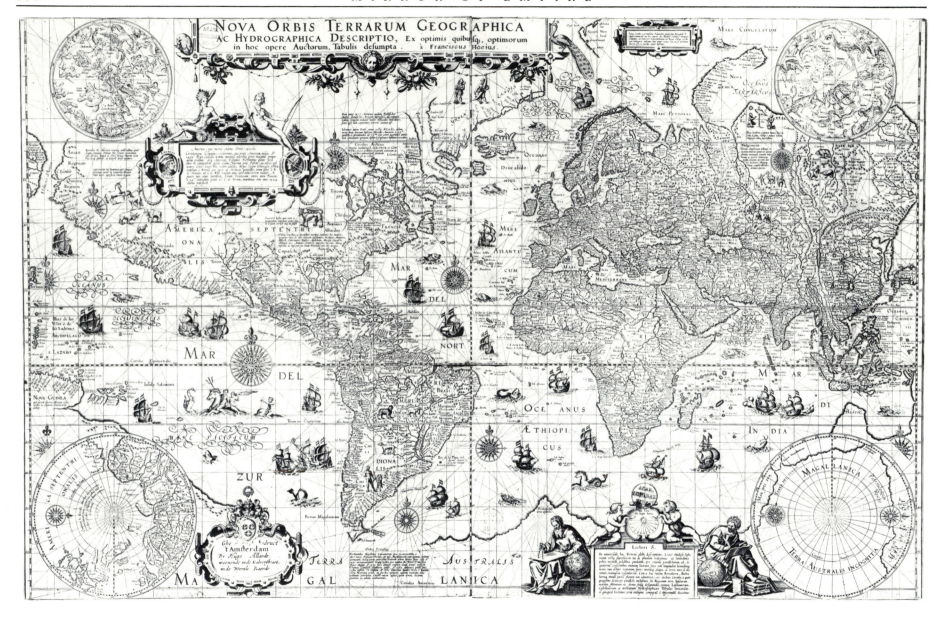

In my essay I refer to the publication by Willem Jansz. Blaeu (1571–1638) of three large wall maps of the world in three different projections – in 1604, 1605, and 1607. This unprecedented accomplishment represented a milestone in his career as a cartographer and publisher. Of the last in this series, for which he used the Mercator projection of increasing degrees, there are two smaller versions, one in a single folio sheet, and the other in two sheets reproduced here. Until a short time ago, only three specimens of Hugo Allard's much later edition of this last map were known. Professor Schilder of Utrecht University, however, was kind enough to inform me of his recent discovery of the left sheet from the first edition, which came to light during one of his frequent forays into the university library in Erlangen. He found to his amazement that the sheet was dated 1604, which meant that the two-sheet edition was three years older than the four-sheet edition of 1607, whereas reduced versions of wall maps are generally of a later date. The opposite is therefore true in this case: The two-sheet edition predates the other. Not only has this enhanced its importance in chronological terms, but it now claims precedence over the four-sheet edition that was hitherto deemed a turning point in the evolution of cartography.

Although Blaeu's name no longer appears on this edition by Allard, the traces left after it had been deleted – the emblem of the sundial with the motto *Ut vita sic fugit hora*, and the map's close resemblance to the larger wall map of 1607 – are ample evidence that Blaeu must indeed have been the author. The sharply defined engraving can be attributed with a fair degree of certainty to Josua van den Ende, who produced much work for Blaeu during his early years as a publisher. The fact that the name of the engraver and printseller François van den Hoeye (ca. 1590–1636) appears in the title suggests that he too must have worked from the copper plates before they were acquired by Hugo Allard (died 1691). This is borne out by the coat of arms with three garlands of roses, the *Drie Roosenhoeye*,

depicted on the signboard outside van den Hoeye's firm on Kalverstraat in Amsterdam. It is not known whether Schouten and Le Maire's discoveries near Tierra del Fuego in 1616 (*Fretum le Maire, Statem landt, Maurit.d.Nassau, C. Hoorn* and *I.de Barnevelt*) were incorporated by Blaeu in an unknown second edition, or whether they were added by van den Hoeye.

Blaeu's integrity as a scholar and a scientist is apparent from his address to the reader, in which he quotes his sources: *In Regionum vero, Insularum, marium, fluminum etc. forma situq(ue) designandis, optimas Lusitanorum, Castellanorum ac nostralium Hydrographicas Tabulas imitandas [. . .] duxiums* (For the shape and location of regions, islands, seas and rivers we considered it best to copy the most reliable sea charts by the Portuguese, the Spaniards and our own compatriots). Blaeu presents his Portuguese and Spanish sources almost as a guarantee of quality, and indeed he was not the only one to use them.

For their voyages to Southeast Asia, which began a little before 1600, Dutch navigators at first relied entirely on information they had gained from the Portuguese. On the basis of Portuguese examples, Petrus Plancius had compiled a set of ocean charts in 1592, and Jan Huyghen van Linschoten, a Dutchman in Portuguese colonial service, had described the Portuguese realm in Asia in his *Itinerario, Voyage ofte Schipvaert* (1596). Not only Plancius, however, but Cornelis Doedsz. and Jodocus Hondius too had managed to procure Portuguese charts (Cat. 133).

This map of the world is probably not complete in two sheets, as three paintings are known – by Anthonie Palamedeszoon and Pieter Codde – in which it is depicted with an upper border containing a series of figures of horsemen or rulers of the world, and with annotations on the left, right, and lower sides. Our quest for a complete specimen of the first edition of this monument of Dutch cartography must therefore continue.

129

WILLEM JANSZ. BLAEU
His First "Book of Seacardes" (1608)

[*Het Licht der Zee-vaert daerinne claerlijck beschreven ende afghebeeldt werde(n) alle de
Custen ende Havenen vande Westersche, Noordsche, Oostersche ende Middelandsche
Zee'en. Oock van vele Landen, Eylanden ende plaetsen van Guinea, Brasilien, Oost
ende West-Indien* [...] / *DOOR WILLEM IANS ZOON*]
Amsterdam: Willem Janszoon [Blaeu], 1608
One pilot guide with thirty-six colored charts; 26.3 x 30.5 cm, oblong

Incomplete specimen: title page, frontispiece, dedication by Blaeu to the States General,
 address to the reader, the first four quires, five maps (nos. 26, 28, 39, 40, and 41) and
 the last two quires are missing.
Six charts are exhibited in the following order:
No. 1 *Caerte vande Zuyder-Zee en van de vermaerde Stromen ende Gaten van 't Vlie
 ende Texel* [...]
 Scale [ca. 1:300,000], 25 x 55 cm
No. 2 *Pascaarte van Hollandt Zeelandt ende Vlaenderen, van Texel af tot deur de
 Hoofden* [...]
 Scale [ca. 1:600,000], 24.5 x 55 cm
No. 11 *Afbeeldinghe der Zeecusten, tusschen de C. de S. Vincente en(de) de Strate van
 Gibraltar* [...]
 Scale [ca. 1:750,000], 25 x 54.5 cm
No. 19 *Vertooninghe nae't leven vande Zeecuste(n) van Engelant tusschen Poortlant
 en(de) Doveren* [...]
 Scale [ca. 1:600,000], 25 x 54 cm
No. 27 *Beschrijvinghe vande wonderlijcke gebroocken custe van Oost-Vinlant* [...]
 Scale [ca. 1:1,000,000], 25 x 55 cm
No. 29 *Pascaarte van 't Schagher rack, vertoonende van Schagen en(de) Maesterlandt af
 door de Sondt* [...]
 Scale [ca. 1:500,000], 25 x 55 cm

Rotterdam, Maritiem Museum "Prins Hendrik", inv. WAE 119b

LITERATURE: Baudet 1871, pp. 53–76
 Burger 1908
 Skelton 1964, pp. V–XIII
 Koeman, *Atlantes Neerlandici*, vol. 4, pp. 27–62
 Keuning 1973, pp. 76–86

No. 1

No. 2

No. 19

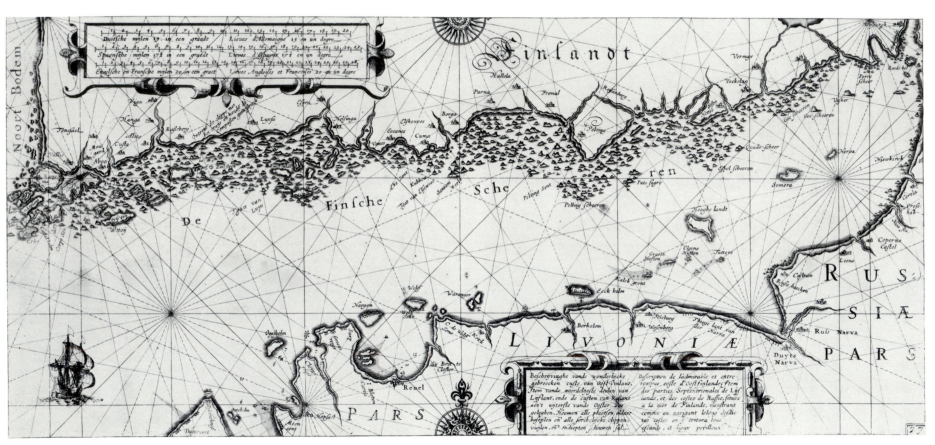

No. 27

Besides compass charts of *paskaerten*, on which distances could be measured with the aid of compasses, navigators also made use of *leeskaerten*, or "reading charts," which contained descriptions of coastlines, channels, harbors, and shallows, as well as details of distances, directions, and courses. Compendia of this type were built up during the fifteenth century and appeared in print from about 1525 on. The oldest example of *Die caerte van die Oosterse See*, by Cornelis Anthonisz. of Amsterdam, dates from 1558. It was the first sea guide to contain land surveys or coastal profiles printed from wood engravings. Lucas Jansz. Waghenaer's pilot guide (1584), which first combined sailing directions, coastal profiles, and compass charts, marked the following step in the development of guides.

Willem Jansz. Blaeu (1571–1638) opens the preface to *Het Licht der Zee-vaert* with a eulogy on three well-known pilot guides dating from the last quarter of the sixteenth century. Waghenaer's was among them. "What great good and profit (gentle Reader) is procured unto all Seafaring men by Books of Seacardes, which heeretofore have bin made and composed by Lucas Johnson Waghenaer, Albert Heyen, William Barents and others [...]," he says in the English edition of 1612. A little farther on, Blaeu mentions that he intends to improve and supplement these pilots, as rapid changes in the seabed meant that the information they contained was no longer accurate. To this end, he had secured "the aide and furtherance of manie expert and skillfull Sailers, Pilots and Masters." Even Waghenaer,

shortly before his death, had drawn his attention to errors in his own atlas. The improvements on Waghenaer's charts resulted in an increase in number to forty-one charts in all — nineteen in the First Book of the Western Navigation and twenty-two in the Second Book of the Eastern and Northern Navigation — and an enlargement of scale, which made for greater accuracy. Hydrographic data on depths, fairways, sandbanks, buoys, beacons, and the like were corrected. The network of rhumbs was denser, directions and distances were substantially more accurate, and the places on the charts in the First Book were drawn in at the appropriate latitude.

In short, the importance of Blaeu's pilot guide lay in the high quality of the information contained in its charts and sailing directions. The book enjoyed tremendous popularity and was to remain unrivaled for more than two decades. It was reprinted many times virtually unchanged, and was translated into English and French. Blaeu's promise on the title page — that he would also publish volumes on the Mediterranean Sea and the navigation to West Africa, Brazil, Guyana, and the West Indies — was only partially fulfilled. The third volume, on the Mediterranean, appeared in 1618 but was published only in Dutch. Not until 1675 was there a separate pilot guide for the West Indies (see Cat. 130). As colored specimens of Blaeu's ocean guide are extremely rare, the drawback of having only an incomplete example on exhibition here is more than offset by the beauty of the coloring.

130

ARENT ROGGEVEEN
The First Pilot Guide of the West Indies (1675)

Het Eerste Deel Van het BRANDENDE VEEN, Verlichtende geheel WEST-INDIEN, De vaste Kust en de Eylanden,
Beginnende van RIO AMASONES, En eyndigende Benoorde Terranova. / Beschreven DOOR ARENT
ROGGEVEEN
Amsterdam: Pieter Goos [1675]
One pilot guide with thirty-three charts; 54 x 35 cm

Six charts are exhibited in the following order:
No. 23 *Pascaerte van de Eijlanden Cuba en Jamaica*
 Scale [ca. 1:2,500,000], 41.5 x 53 cm
No. 26 *Pascaerte vande Virginies*
 Scale [ca. 1:1,000,000], 41.5 x 51 cm
No. 27 *Pascaerte van Nieu Nederland Streckende vande Zuydt Revier tot de Noordt Revier*
 Scale [ca. 1:1,400,000], 42 x 51 cm
No. 28 *Pascaerte van Nieu Nederland Streckende van de Noordt Revier tot Henrick Christiaens Eylandt*
 Scale [ca. 1:700,000], 41.5 x 51.5 cm
No. 29 *Pascaerte van Nieu Nederland van Hendrik Christiaens Eijland tot Statenhoeck of Cabo Cod*
 Scale [ca. 1:700,000], 41.5 x 51 cm
No. 31 *Pascaerte van Terra Nova, Nova Francia, Nieuw Engeland En de Groote Revier van Canada*
 Scale [ca. 1:5,000,000], 44 x 54 cm

Milwaukee, American Geographical Society, inv. AT. 712.1

LITERATURE: Koeman, *Atlantes Neerlandici*, vol. 4, pp. 450–458
 Koeman 1971
 Leiden 1987, p. 89

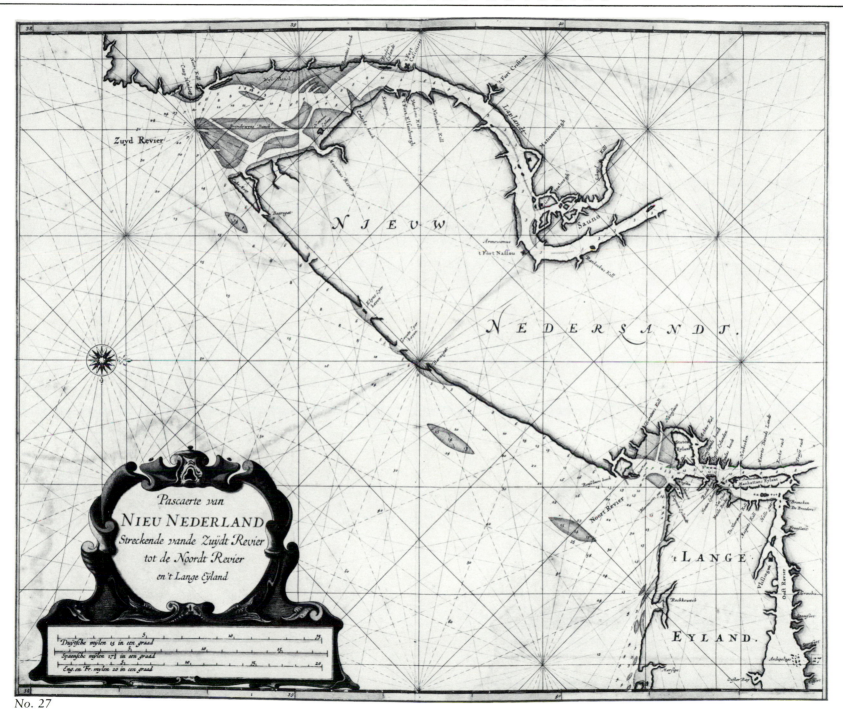

No. 27

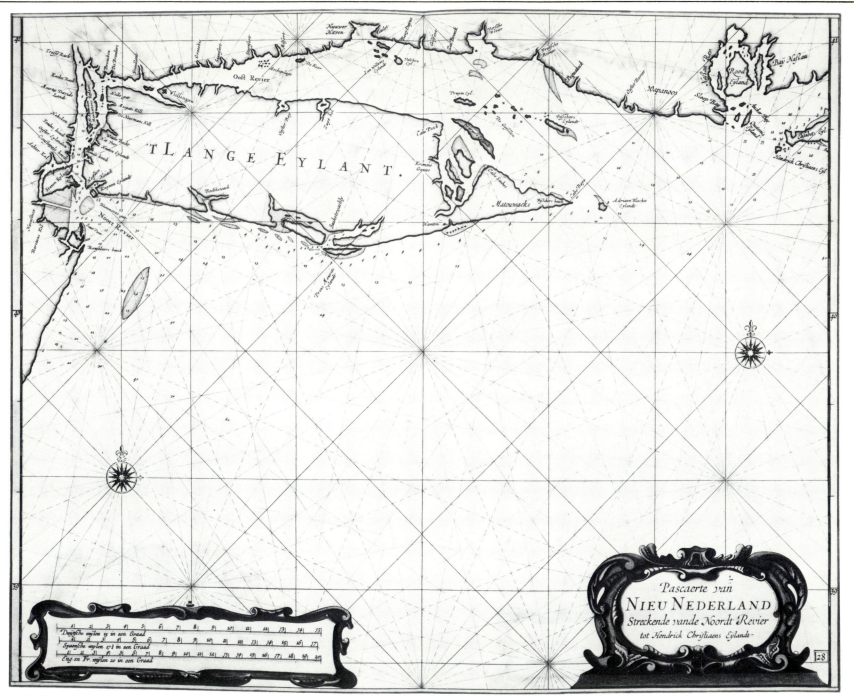

No. 28

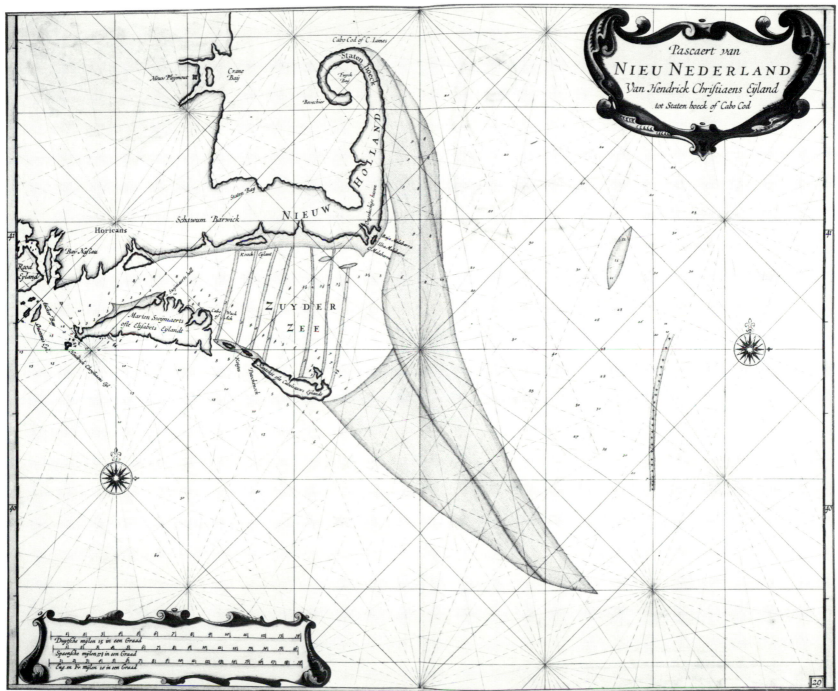

Cabo Cod of C. Iames

Staten hoeck

Crane Bay

Nieuw Pleymout

Fuyck Bay

Bevechier

NIEUW HOLLAND

Staten Bay

Schawum Barwick

NIEUW

Horicans

Bai Naſſau

Koock Eyland

Rood Eyland

Swymaerts hil

ZUYDER

Cabo Wiack Ach

ZEE

Marten Swymaerts oſte Elſabets Eylandt

Hendrick Chriſtiaens Eyl.

Krigen

Duvetſche olto Catsbaeuws Eylandt

'Pascaert van
NIEU NEDERLAND
Van Hendrick Chriſtiaens Eyland
tot Staten hoeck of Cabo Cod

Duytſche mijlen 15 in een Graad
Spaenſche mijlen 17½ in een Graad
Eng. en Fr. mijlen 20 in een Graad

No. 29

The large number of Spanish names on the charts in this first printed pilot guide of non-European coasts suggests that they may have been based not only on surveys conducted by Dutch mariners but also on Spanish and Portuguese cartographic sources. Arent Roggeveen, who taught navigation at Middelburg to seamen in both the East and West India Companies, was presumably able to use the charts and *rotarios* in the companies' hydrographic archives. Although the rough and sketchy manner in which the coasts and islands have been drawn means these charts would rarely have been used for actual navigation, the printed sailing directions, by contrast, provide fairly detailed information on navigating the coasts and entering bays and harbors. The title of Roggeveen's pilot guide, *Het Brandende Veen* (The Burning Fen), is both a pun on the author's name and an allusion to the frontispiece illustration of a mound of burning fen that illuminates the coasts of West Africa and America like a beacon.

Although Roggeveen and Goos were granted the license to publish both volumes when the book was completed in 1660, the first volume did not appear until 1675. Pieter Goos, who also printed English, French, and Spanish versions of the first volume, died that year, and it was only in about 1685, some considerable time after Roggeveen's death (1679), that Jacobus Robijn posthumously published the second volume, covering the coasts of West Africa.

131

JODOCUS HONDIUS THE ELDER
A Pair of Celestial and Terrestrial Globes (1600 and 1627)

a. [Celestial globe:] *Globus Coelestis In quo stellae fixae omnes quae a N. viro Tychone Brahae sum(m)a industria ac cura observatae sunt, accuratissime designantur; nec non, circa Polum Aust. eae quae a Peritiss. nauclero Petro Theodori Matheseos studioso annotatae sunt*
[Amsterdam]: Jodocus Hondius, 1600
Two sets of twelve gores, with two polar calottes: copper engraving, colored; diameter 35.5 cm
With a brass meridian, and placed in a wooden base with a horizon ring

The axis passes through the celestial poles. A ten-line dedication between the Ursa Major and Auriga constellations reads as follows: *Clarissimis Belgii lumini(bus) sapientiae doctrinae & verae pietatis officinis Academiae Lugdunensi Batavorum & Franekeriensi Hos globos ad Mathematicas artes promovendas, manu propria a se caelatos lubentissime dedicat consecratq. Jodocus Hondius ann. 1600*

b. [Terrestrial globe:] No title
Scale [ca. 1:36,000,000]
[Amsterdam]: Jodocus and Hendricus Hondius, 1627
Twelve gores with two polar calottes: copper engraving, colored; diameter 35.5 cm
With a brass meridian, and placed in a wooden base with a horizon ring

The imprint is in the South Pacific: *Iod. et Hendricus Hondii fratres. Cum privilegio decem annorum 1627*, with a nineteen-line address to the reader to the left: *Lectori S.P. Quoniam crebriores in omnes mundi partes quotidie navigationes* [...].

San Francisco, Fine Arts Museum of San Francisco, inv. 1938.5a-b and 1938.6a-b

LITERATURE: Stevenson 1921, vol. 2, pp. 2–19
Welu 1975
Welu 1977, pp. 52–60, 112–118
van der Krogt 1984, pp. 151–154
van der Krogt 1989, pp. 140–149, 171, 193–228

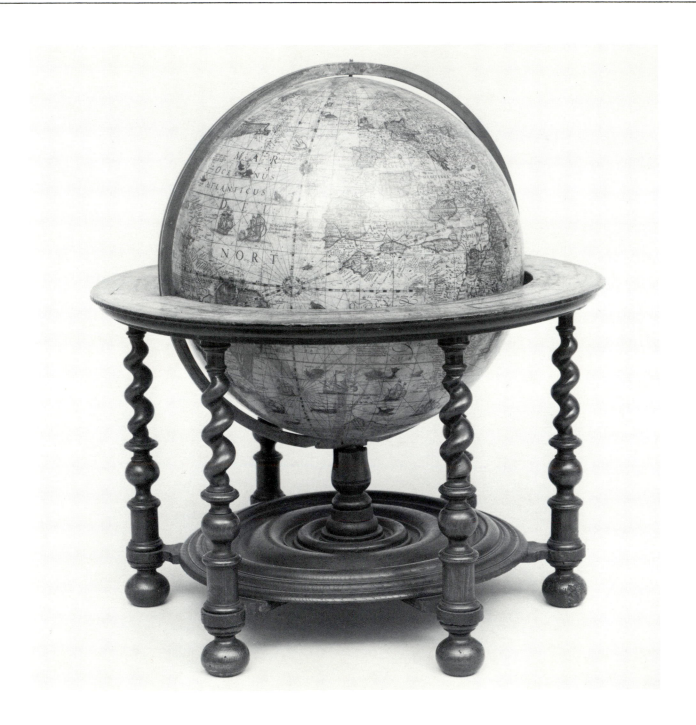

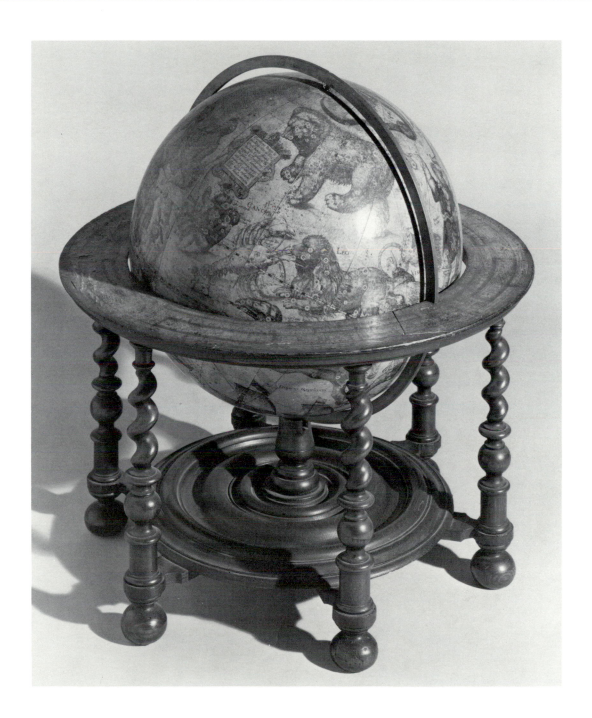

From about 1600, the production of globes in Amsterdam suddenly began to flourish. In 1586, when Jacob Floris van Langren brought the first pair of globes onto the market there, his initiative met with little response in seafaring circles. Fifteen years later, however, the situation had changed dramatically, as we can see from the number of different globes – seventeen in all – that appeared in the six years from 1597 to 1603. Most were produced by Jodocus Hondius and Willem Jansz. Blaeu, who were constantly trying to outdo each other with new versions and different formats (8, 10, 21, 23, 24, and 35.5 centimeters in diameter). The rapid increase in shipping to areas outside Europe provided the main impetus, as vessels from Holland and Zeeland sailed to the East and West Indies and returned with the prospect of lucrative trade. But for the general public, too, the geographical horizon had expanded from one moment to the next. The University of Leiden, recently founded in 1575, was not slow in acquiring pairs of globes to illustrate the basic principles of cosmography to professors and students alike.

The growth of trade created a tremendous thirst for knowledge of geography and astronomy for navigational purposes. Globes were used for teaching, having proved to be an ideal means of demonstrating the implications of the earth's convexity for navigational techniques, and innumerable pamphlets describing their use found a ready market. However, because globes were easily damaged, small in scale, and cumbersome they were impractical for navigational use at sea. The large number produced in Amsterdam was therefore apparently not in response to a demand from nautical circles.

Representations of globes in paintings, such as Hondius's terrestrial globe in Vermeer's *Geographer* and *Allegory of Faith*, and his celestial globe in the *Astronomer*, not only show that they were common objects in many homes but also illustrate the allegorical and symbolic meanings ascribed to them. For merchants they may have symbolized the wide world, their areas of trade, and the source of the nation's prosperity. Among well-to-do burghers, globes acquired an increasing value as objects of general cultural interest.

Jodocus Hondius (1563–1612) scored a major victory over his rival Blaeu by being the first to depict twelve new constellations around the South Pole of his celestial globe. He had managed to obtain the information from Petrus Plancius, who had instructed Pieter Dircksz. Keyzer to observe these stars on the first Dutch expedition to the East in 1597. The later edition of the terrestrial globe reproduced here, which dates from 1627, merits special attention as it incorporates the new discoveries made by Schouten and Le Maire (fig. a) to the south of the Magellan Straits (1616–1617). Hondius dedicated this pair of globes to the universities of Leiden and Franeker.

Cat. 131, fig. a Terrestrial Globe, *detail of the Straits of Magellan.*

132

JOHANNES JANSSONIUS
Gores of a Small Terrestrial Globe (1621)

No title. [Address to the reader, twelve lines:] *Hac iterata delineatione Globi hijdrographica, et geographica* [...] *Anno 1621*
Scale [ca. 1:83,000,000]
Amsterdam: Johannes Janssonius, 1621
One sheet (26.5 x 41 cm) with twelve gores: copper engraving; diameter 15.3 cm

Imprint: *Iohannes Ianssonius excudit, et Abrahamus Goos Amstelodamensis sculpsit*

Leiden, University Library, Bodel Nijenhuis Collection, inv. Port 143 N 21

LITERATURE: Muller 1894, no. 9
Stevenson 1921, vol. 2, p. 265
van der Krogt 1984, p. 162
van der Krogt 1989, pp. 174–179, 184–186

The oldest extant printed globe segments are those by Waldseemüller (1507). The invention that enabled copper or wood engravings of the globe to be printed on paper brought this quite faithful representation of the earth within the reach of a wide public, and thus played an important role in disseminating the new geographical information acquired during the two golden centuries of discovery. The cartographic image of the world was usually drawn in twelve segments, each of thirty degrees longitude, and for globes with only a small diameter, such as this, one copper plate and a single sheet of paper were sufficient.

Johannes Janssonius (1588–1664), not to be outdone by his neighbor Willem Jansz. Blaeu, published a small number of globes. None, however, contained any original work. This small globe, engraved by Abraham Goos, is a copy of Pieter van den Keere's globe of 1614, which in turn was a reduced version of a 26.5 cm–diameter globe compiled by Petrus Plancius and published by van den Keere himself not long before.

Three interesting points should be noted about the geographic representation. An opening in the west coast of America, above the California peninsula, should probably be related to the idea of a passage from Hudson

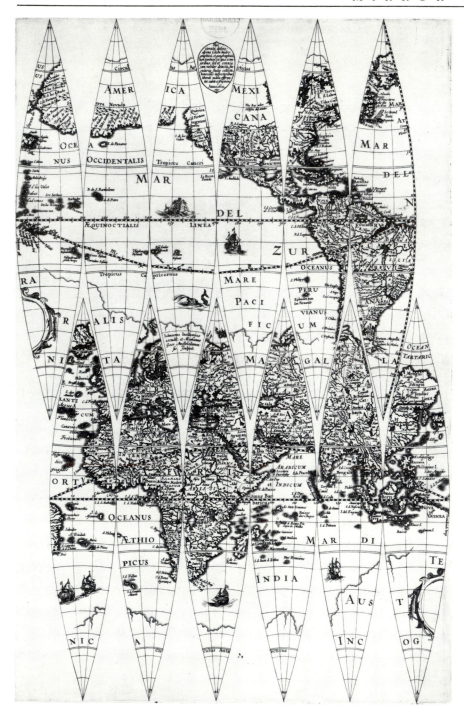

Bay to the Pacific. The inclusion of the name *Germania Inferior* (The Netherlands) in Guyana attests to the substantial mercantile interests the Republic had already established along the coast. The discoveries of Schouten and Le Maire to the south of Tierra del Fuego (1616–1617) are the only new items of information that distinguish this globe from van den Keere's original.

133

CORNELIS DOEDSZ.
A Dutch Portolan of the Atlantic Ocean (1600)

No title / *Bij mij Cornelis Doedts woonende Tot Eedam Inde Vierheemskinderen Anno*
 1600
Scale [ca. 1:14,000,000]
1600
Manuscript on vellum, colored; 82 x 103 cm

Three scaleyards [of fifteen German miles to one degree of latitude], two of which are in
 cartouches; four artistic compass roses with fleurs-de-lys; in North Africa the vignette
 of the castle of Mina (modern Elmina in Ghana), the symbol of Portuguese maritime
 power on the west coast of Africa; the chart covers the ocean area extending from
 62°N to 40°S; latitude is indicated on two bars in the middle of the ocean.

Leiden, University Library, Bodel Nijenhuis Collection, inv. 003–13–001

LITERATURE: Skelton 1958, pp. 85–90, 94
 Cortesao and Teixeira de Mota 1960, pls. 237, 360, 378, 387, 390, 407, and 408
 Smith 1978
 Zandvliet 1982
 Schilder 1984b

Toward the end of the sixteenth century, traders from Holland and Zeeland started to venture beyond the coastal waters of Europe and took to the open sea, attracted not only by the riches of the East but by the Caribbean as well, which had likewise proved to be a potential source of wealth. Around 1590, Dutch vessels were calling at ports in the region to purchase salt, a commodity of vital importance to the Dutch economy with its heavy dependence on the herring fishery.

At the same time, a group of chartmakers in the north of Holland were producing copies of Portuguese portolans of oceans or continental coastlines. Their style of cartographic draftsmanship and decoration are in the same Lusitanian tradition as the earliest charts made by a comparable group of chartmakers in London known as the "Thames school." Cornelis Doedsz. of Edam is the main representative of the North Holland school of cartographers.

A comparison of this Dutch portolan of the navigation to the West Indies with the no less magnificently illuminated Portuguese charts by Luis Teixeira, Bartholomeo Lasso, Vilavicensio and Sebastiao Lopes, all dating from the second half of the sixteenth century, leaves us in no doubt that Dutch mariners relied predominantly on material of Portuguese origin for the journey west. That Luis Teixeira's work was known in Holland has been confirmed by Jodocus Hondius the Elder, who, on his own admission, used them for his terrestrial globe of 35.5 cm (Cat. 131), and notably for the geography of North America to the west of Newfoundland (fig. a). Would Doedsz. also have borrowed from Teixeira the unusual figuration

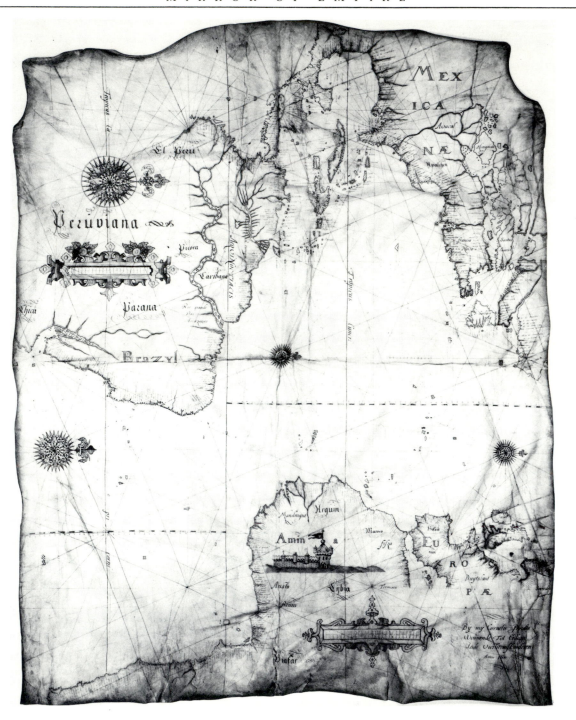

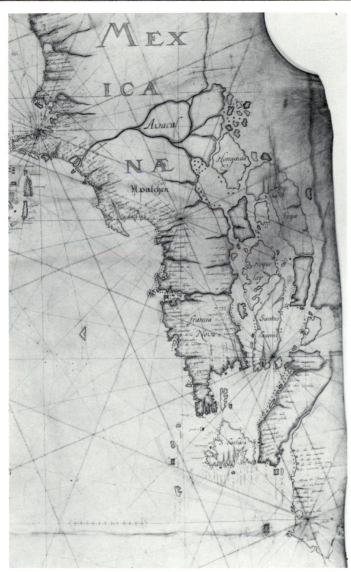

Cat. 133, fig. a Detail, east coast of North America from the Gulf of Mexico to the St. Lawrence River and New Foundland.

of the St. Lawrence River – which we again encounter several years later in two wall maps of the world (Cat. 128) by Blaeu (1604 and 1605)? The river is as wide as a sea and contains a number of large islands. It gives the impression of continuing to the west, thus offering the desperately longed for passage to the East Indies. To the south is Rio S. Pago, which runs to the Atlantic. By enlarging the St. Lawrence to the size of a sea, the cartographer may have been trying to account for the legendary inland sea of Verrazano.

The drawing of the Orinoco River with a network of tributaries is very recent and was probably added by Doedsz. himself. In 1595, Sir Walter Raleigh had sailed the river as far as the Caroni tributary; the information obtained on this voyage, which first appeared in a map of America by Hondius (1598), was later incorporated in de Bry's map of Guyana in Part 8 of his *America* (Cologne 1599).

There is no trace as yet of any Dutch commercial activity on the east coast of America. Before long, however, and much to the satisfaction of Dutch fur traders, Doedsz. (died 1613) was to chart an area between 40° and 45°N, where the colony of New Netherland was subsequently established. Years later, Willem Jansz. Blaeu was to publish his *Nova Belgica et Anglia Nova* (1635), which he based on this map.

134

ADRIAEN GERRITSEN
A Chart of the Coasts of Europe (1591)

Die Generale Pascaerte vanden vermaerden Adriaen Gerritsen van Haerlem Stierman,
ende een leermeester aller Stierluijden. Seer gebetert omt verloopen der sanden ende
gaten [...] Met previlegie voor 10 Jaren a° 1591. Op nieus oversien ende door vele
stierluijden hulpe gebetert. Men vintse te coop bij Cornelis Claess tot Amsterdam;
Joannes a Doetecum Fe
Scale [ca. 1:7,500,000]
Amsterdam: Cornelis Claesz., 1591
Copper engraving on vellum, colored; 45 x 59 cm
West at the top

The chart extends from 27° to 68°N; with two scaleyards and degrees latitude and
longitude in the border; eight artistic compass roses; seven crowned crests of various
national states.

Leiden, University Library, Bodel Nijenhuis Collection, inv. 003–13–001

LITERATURE: Burger 1913
 Moes and Burger 1900–1915, pp. 402–404, no. 722
 Amsterdam 1989d, pp. 58–59, no. 76

The earliest known *Generaele Paschaerte van Europa* to depict the area of the eastern (Baltic) and northern navigation, as well as that of the western navigation, was compiled in 1583 by Lucas Jansz. Waghenaer (1533–1606) and appended to his *Spieghel der Zeevaerdt* of 1584, which was the first fully fledged pilot guide ever produced. The maker of the chart reproduced here, Adriaen Gerritsen of Haarlem (ca. 1525–1577), was a slightly older contemporary of his, and like Waghenaer had gained a formidable reputation as a navigator and pilot through years of experience at sea. His chart was published a few years after his death by Cornelis Claesz. in Amsterdam, first appearing in 1587.

Both charts were engraved by Johannes van Deutecum. They closely resembled each other, but there were also striking discrepancies. Waghenaer's chart extended much farther north, to 71° 30', and the figuration in the north of Scotland and Ireland was entirely different. A year later,

Cornelis Claesz. published another work by Gerritsen, *De Zeevaert ende onderwijsinge der gantscher Oostersche ende Westersche Zee-vaerwater*, a small ocean pilot with declination tables, information about currents, courses, and coastal profiles. Waghenaer was later to heap criticism on the book for its inaccurate information.

A third chart of the eastern and western navigation, by Cornelis Doedsz. of Edam – another expert in the field of navigation – was published by Cornelis Claesz. in 1589, to be followed in 1591 by a revised version of Gerritsen's chart from the same publishing house. The corrections related mainly to Iceland, Scotland, and Ireland and the Baltic coasts. Besides Waghenaer, Gerritsen, and Doedsz., it was due mainly to Blaeu's publishing house that this type of sea chart of the coasts of Europe was adopted as a standard navigational aid for Dutch shipping.

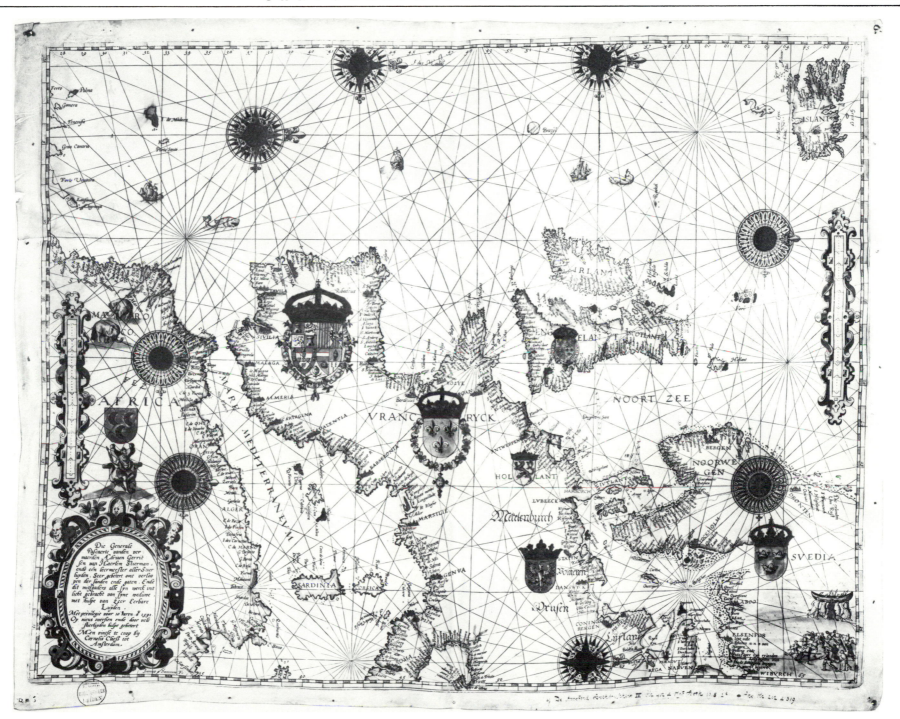

135

HUGO ALLARD AND ROMEYN DE HOOGHE
De Oost Indische Paskaart (ca. 1668)

OOST INDIEN / Anonymous; *Romano de Hooghe inv: des. et. sculpta; Romijn de Hooghe des. et sc.*
Scale [ca. 1:15,000,000]
Amsterdam: Hugo Allard [ca. 1668]
Four sheets: copper engraving; 70 x 90.5 cm

This chart, the only one of its kind known, is decorated with five lavishly engraved illustrations by Romeyn de Hooghe (1645–1708). At the upper left is an allegorical depiction of Egypt with the Nile, the Sphinx, a pyramid and the Pharos lighthouse of ancient Alexandria. Beneath it is a representation of the idea that with the expansion of trade to all corners of the earth, and with the benefits of scientific knowledge, man had transcended the frontiers of the "old" world – the Pillars of Hercules bearing the inscription *PLUS ULTRA* [!]; the motto *Nec terris erit Ultima Thule* underlines the notion of a world without boundaries (fig. a). The two large decorations along the upper and lower edges depict the mercantile activities of the East India Company in various parts of Asia.

 The title panel, lower center, is crowned with the French coat-of-arms flanked by Wisdom and Prudence with a shield bearing a portrait of the young Sun King, Louis XIV. The cartouche above, which has been left blank, may have been intended for a dedication.

 Latitude and longitude are marked. At upper left are three scaleyards, including 180 *Duytsche mylen 15 in een graadt* (= 8.9 cm).

 A narrow strip has been cut from the top of the sheet at lower left.

Leiden, University Library, Bodel Nijenhuis Collection, inv. 004–08–003/006

LITERATURE: Keuning 1949, pp. 56–61
 Brussels 1971b, pp. 57–58, no. 38
 Schilder 1976a, pp. 300, 326, 328
 de la Roncière and du Jourdin 1984, pp. 260–261, no. 87

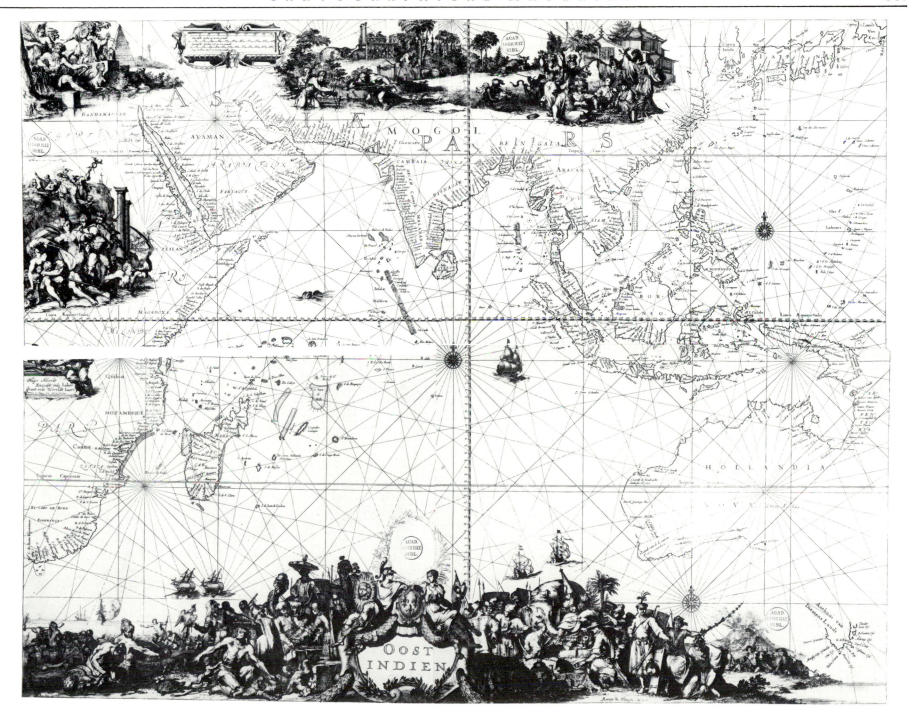

Cat. 135, fig. a Detail, vignette with the Pillars of Hercules.

Among the set of basic charts compiled in the 1620s by Hessel Gerritsz. (1580/1–1632), official cartographer for the East India Company, were charts of East and Southeast Asia and the Indian Ocean, which were regularly updated by his successors in the seventeenth and eighteenth centuries. Amsterdam publishers were soon selling a printed ocean chart of the entire area comprising the mercantile empire of the East India Company, compiled on the basis of this "secret" material. The principal differences between the early editions of this *Oost Indische Paskaart* by Colom and Jacobsz. and the later editions by Goos and Doncker are the additions of Tasman's discoveries in Australia (1642–1644) and Vries's in north Japan (1643). This publication by Hugo Allard is one of the later editions.

The dating of the chart is based on the fact that the engraver, Romeyn de Hooghe, who spent a brief period in Paris as engraver for Beaulieu in 1687, had obviously intended to dedicate it to Louis XIV. So when the Sun King launched a series of wars against the Republic a short while later, a dedication to him would clearly have been inappropriate.

136

HESSEL GERRITSZ.
The Dutch Standard Chart of the Caribbean (ca. 1631)

DE EYLANDEN ENDE VASTELANDEN VAN WESTINDIEN OP DE
NOORDZEE; curiooslijk betrocken, met Octroy van de Hoogh Moghende Heeren de
Staten Generael der vereenighde Nederlanden: ende den E.E. Heeren Bewindhebberen
der Geoctroyeerde westIndische Compagnie ghedienstigh opghedraghen. / door Hessel
Gerrits
Scale [ca. 1:7,200,000]
Amsterdam: Hessel Gerritsz. [ca. 1631]
Copper engraving on vellum, colored; 51 x 71.5 cm

Indicating latitude: 6° 50′ to 38° 40′
At lower left, an inset map of *Het Canael tusschen Havana aen Cuba, en(de) Tortugas*
en(de) Martyres aen Cabo de la Florida, in groot bestek, scale ca. 1:250,000. At lower
right, three scaleyards, including 100 *Duytsche mijlen 15 op een graedt* (= 10.5 cm).

Leiden, University Library, Bodel Nijenhuis Collection, inv. 003–12–002

LITERATURE: Keuning 1949
 Zandvliet 1985, pp. 123–133

DE EYLANDEN ENDE VASTELANDEN VAN WESTINDIEN OP DE NOORDZEE:

COSTA DE LA FLORIDA.

NVEVA ESPAÑA.

HONDVVRAS.

ESPAÑOLA

VENEZVELA

CVBA

NVEVO REYNO.

GVAIANA.

The establishment of the West India Company in 1621 was closely linked to the resumption of hostilities against Spain when the Twelve Years' Truce came to an end. To a far greater extent than the company's counterpart trading with the East Indies, its aim was to inflict damage on its rivals, both at sea and in the colonies, not only through trade but also through acts of military aggression, by pillaging and looting settlements, and by committing acts of piracy.

Hessel Gerritsz., the company's cartographer, was involved in its activities from the start. He laid the basis for the Dutch cartography of the regions under the company's trade monopoly, which covered the west coast of Africa and the Atlantic coasts of America. He was the author of the ten charts in the *Nieuwe Wereldt ofte Beschrijvinghe van West-Indien* (1625), a geography manual for the West India Company compiled by one of its directors, Johannes de Laet. Under Gerritsz.'s supervision, an archive was built up of charts, surveys, and sailing directions, which he used as a basis for making new *rotarios* and survey charts. Several of them have survived, including this chart of the Caribbean, which was specifically designed to highlight the two passages affording egress from the area. The annotation concerning the siting of Bermuda on the upper right of the chart refers in that connection to the *Canael van Bahama* and the more southeasterly passage past the islands of Caicos, Mona, or Anguilla.

In 1628 Gerritsz. himself sailed to the west aboard the *Zutphen*, which took him past the coasts of Brazil and Guyana, via the Lesser Antilles to the northeastern coast of Cuba. The vessel spent two and a half months anchored on the grounds of the Tortugas before hoisting sail to return home. It was almost certainly Gerritsz.'s prolonged stay there that enabled him to produce the insert map on this chart.

137

DIRK VAN DER VELDEN
Chart and View of the Bay of Muscat (1696)

No title / *Op den 20 augustus A°. 1682 is dese kaart te samen gestelt door Dirk van der Velden [. . .] A° 1696*
Scale [ca. 1:24,000]
1696
Manuscript, colored; 55.5 x 83 cm
South-southwest at the top

At upper right, below the caption *Aanwijsingh: legenda* (A-L), the name of the author, and notes on entering the bay. At lower center, a scaleyard of *Een duijtsche mijlen 15 voor een graad* (= 30.5 cm). The lower right corner has been torn off.

Leiden, University Library, Bodel Nijenhuis Collection, inv. 006–14–007

LITERATURE: Meilink-Roelofsz 1967
 Floor 1982
 Vermeulen 1988, pp. 84–88

The network of trade routes plied by the East India Company fleet extended as far west as the Persian Gulf, where ships laden with pepper from the coast of Malabar and sugar from Bengal exchanged their cargoes for silk and precious metals. The company had two main trading posts in the region – Basra, the port of Baghdad, which was part of the Turkish empire, and Bander Abbasi, the Persian port founded by Abbas the Great. The Arab

port of Muscat at the entrance to the Gulf occupied an important strategic position from which access to the Gulf could be controlled. As a port, however, it was less favorable than Bander Abbasi, as it had no hinterland to provide an outlet for the products the ships brought with them. It was more suitable as a transit port for the Persian realm on the opposite side of the Gulf.

In 1650 the local potentate forced the Portuguese to abandon the two forts they had established in Muscat. Relations between the East India Company and Muscat were governed by two factors: Muscat was not to usurp too large a share of the trade with India, although on the other hand it could offer a convenient alternative to Bander Abbasi should the prospects for lucrative trade be threatened by increasing import duties. This

had been the case some twenty years before the drawing shown here was made, and had prompted the company to explore the coast of Oman, including the bay of Muscat. Ultimately, however, the governor-general and the East India Company boards nevertheless opted for Bander Abbasi.

Shortly afterward, the company established a trading post there as well for a time, although it was soon abandoned. Dutch ships continued to call at Muscat at regular intervals. In August 1682, for example, *De Hoop*, a vessel belonging to the merchant Pieter Willemsz. van den Bergh, and under the command of Dirck van der Velden, took advantage of the opportunity to conduct the surveys charted here. The result was a superbly drawn and colored ocean chart, incorporating coastal profiles and a view of the town, from which the specimen exhibited was copied in 1696.

138

JOHANNES VAN LOON
Map of the Katte-Gadt and Schager-Rack
(One of Six Maps for the "Eastern Navigation," 1675)

Pascaerte van't KATTE-GADT en't SCHAGER-RACK / by Johannes van Loon
Scale [ca. 1:680,000]
Amsterdam: Johannes Janssonius van Waesberge [1675]
Copper engraving, colored; 43 x 54.5 cm
East at the top

At upper right, a cartouche with three scaleyards, including 14 *Duytsche mylen 15 in een graet* (= 15.3 cm). At lower left, a dedication to *De Hr. Henrick Brouwer, Oudt Burgemeester en Raedt der Stadt Leyden* [...], with his family crest, signed by Janssonius van Waesberge.

Leiden, University Library, Bodel Nijenhuis Collection, inv. Port 201 N 20

LITERATURE: Kleerkoper and van Stockum 1914–1916, pp. 1343 and 1344
Koeman, *Atlantes Neerlandici*, vol. 4, pp. 206, 403–408

Although the *plaetsnijder en zeekaertmaker* (engraver and chartmaker) Johannes van Loon does not in fact rank among the key figures in Dutch marine cartography, his skills must nevertheless have achieved some recognition, as his name crops up several times as a contributor to atlases produced by others, notably the publishing house of Janssonius. He is described in Theunis Jacobsz.'s atlas (1649) as a "practitioner in the sciences of astronomy, geometry and the mathematiques." Before publishing his own *Klaer Lichtende Noort-Ster Ofte Zee Atlas* in 1661 – which I refer to in my essay – he had contributed to the pilot guide by Johannes Janssonius (1588–1664) and made engravings for Janssonius's celestial atlas, the *Harmonia Macrocosmica* (1660). After 1666, Janssonius's successor, Janssonius van Waesberge, became one of the copublishers of the atlas that van Loon himself compiled.

In 1675 the States of Holland granted van Waesberge a fifteen-year license to publish six navigation charts for the German Bight and the Baltic, which he had commissioned van Loon to compile and engrave, as can be seen at lower right on this chart: *Johan van Loon fecit*. The small atlas of the Eastern Navigation for which these charts were intended, according to the publishing license, has either been lost or may never have been published. Nevertheless, the charts are original in terms of figuration and content. All those I have been able to trace from this series bear dedications and elaborate family coats of arms. This one was dedicated to Hendrik Brouwer (1624–1683), who served the town of Leiden in numerous capacities – as a member of the council, as magistrate and sheriff, and, in 1672–1673, as burgomaster. In addition to the offices he held in Leiden, he was a director of the Dutch East India Company for several years in succession, and of the Amsterdam Board of Admiralty.

<div align="center">

139

MAERTEN AERTSE BLAC AND
MICHIEL HERMANSE VAN MIDDELHOVEN
The Mouth of the River Maas (1618)

</div>

Waere afbeeldinge. vande Mase en(de) t'goereesche-gat. hoe de selve gelegen zyn. met haere diepte(n) ende drooghten. Streckingen en(de) mercken. aldus met Neersticheijt afgepeylt. Inden Jare 1618. / Door Maerten Aertse blac. en(de) Michiel Hermanse van Middelhoven. Beijde liefhebbers. vande Navigatie
Scale [ca. 1:60,000]
1618
Manuscript on vellum, colored; 46 x 59.5 cm
North-northeast at the top

The title is followed by a twenty-four-line annotation with sailing directions for the two charted approaches. The following five lines, written by a different hand, refer to an inspection survey conducted by others.

Leiden, University Library, Bodel Nijenhuis Collection, inv. Port 292 N 43

LITERATURE: The Hague 1989, p. 98, no. 71

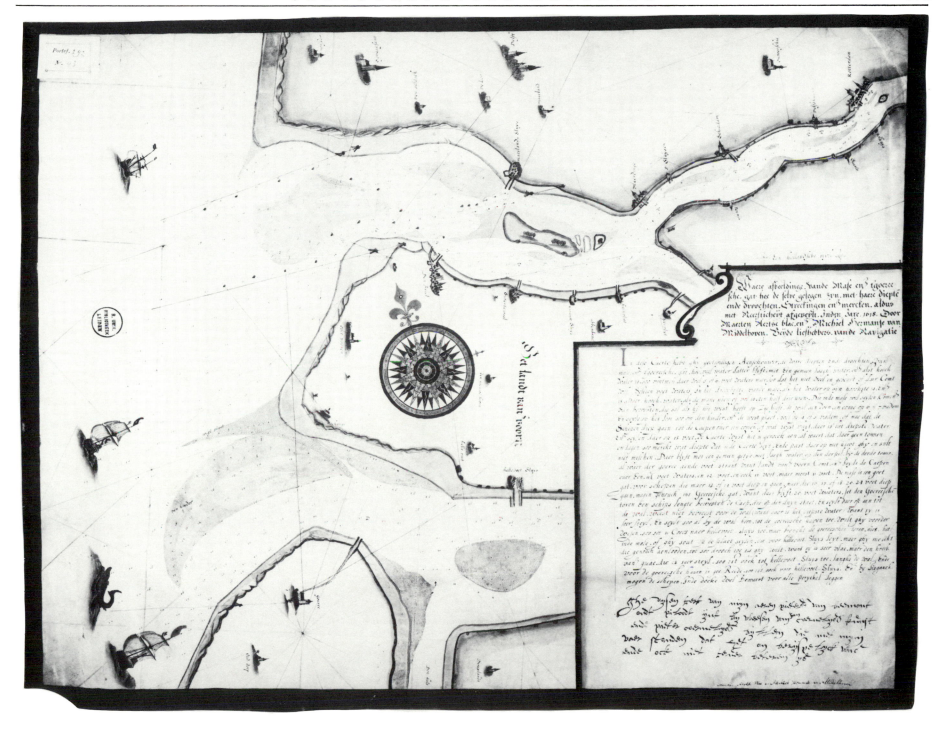

As the seabeds of the inlets along the Dutch coast constantly change under the action of strong tidal currents, soundings had to be taken periodically, beacons and buoys moved, and sailing directions revised and updated to provide accurate information. The sea chart, which offered an ideal means of presenting many of these data in relation to one another, therefore also had to be checked for reliability at regular intervals – which has just been done here, according to the annotation at lower right – and improved if necessary. One of these tidal inlets was the mouth of the Maas, which had of old given access to the harbors in the south of Holland. The process of silting, which can be seen clearly on the chart, presented a serious problem. The annotation here contains a warning to deep-drafted vessels and advises them to use the Goereesche Gat to the south and to sail as close to the coast of Goeree as possible, "want dear is het diepste water" (for it is there that the water is deepest). Prominent objects in the landscape along the banks or in the low-lying hinterland, such as beacons or church towers, are the only topographic features included for the purpose of taking bearings. Together with the carefully marked soundings and the buoys set out to demarcate the fairways, they were intended to guide the helmsman safely to land. A survey conducted some years later concluded that this meticulously drawn and aesthetically pleasing chart was *on berijspelyck ende ock niet tever beteren* (impeccable and incapable of improvement).

140

JODOCUS HONDIUS THE ELDER
Wall Map of the Seventeen Provinces (1602)

GEO-GRAPHICA. XVII. INFERIORIS GERMANIAE REGIONUM TABULA, DE INTEGRO MULTIS IN LOCIS emendata. 1602. / a I. Hondio
Scale [ca. 1:550,000]
[Amsterdam]: Pieter van den Keere, 1602

Four sheets: copper engraving; 72.5 x 95.5 cm
West at the top

Inset map at upper left of the area around the border between Flanders and Zeeland during the reign of Count Guy de Dampierre (ca. 1300): *Facies huius tractus sub Guidone Dampetra Flandriae Comite qui obiit anno M.CCC.IIII.* At center left, a cartouche in three parts with (1) a list of the number of towns and villages in the various provinces; (2) the *Scala Milliarium Germanicorum* with three scaleyards; and (3) the signature of the engraver and publisher Pieter van den Keere: *Petrus Kaerius caelavit et excudebat.*

The title, at upper right, and the fourteen lines of geographical annotation following it are framed by the crests of the Seventeen Provinces together with thirteen portrait medallions of King Philip of Spain and the governors of The Netherlands, whom he and the States General appointed. This frame is in turn set within a cartouche depicting the caryatid figures of Urania with the armillary sphere as the muse of astronomy on the left, and Mercury as the god of commerce on the right. In a medallion below the cartouche is a dedication to the States General.

Twenty-six different types of sailing vessel are shown in the North Sea, the *Oceanus Germanicus.*

Leiden, University Library, Bodel Nijenhuis Collection, inv. 009–11–028/031

LITERATURE: Rotterdam 1973, p. 24, no. 24
Welu 1977, pp. 11–13
Schilder 1979b, esp. pp. 26, 27
Schilder 1986, pp. 38–75, esp. 52–56
van der Heijden 1987
Amsterdam 1989a, pp. 59–62

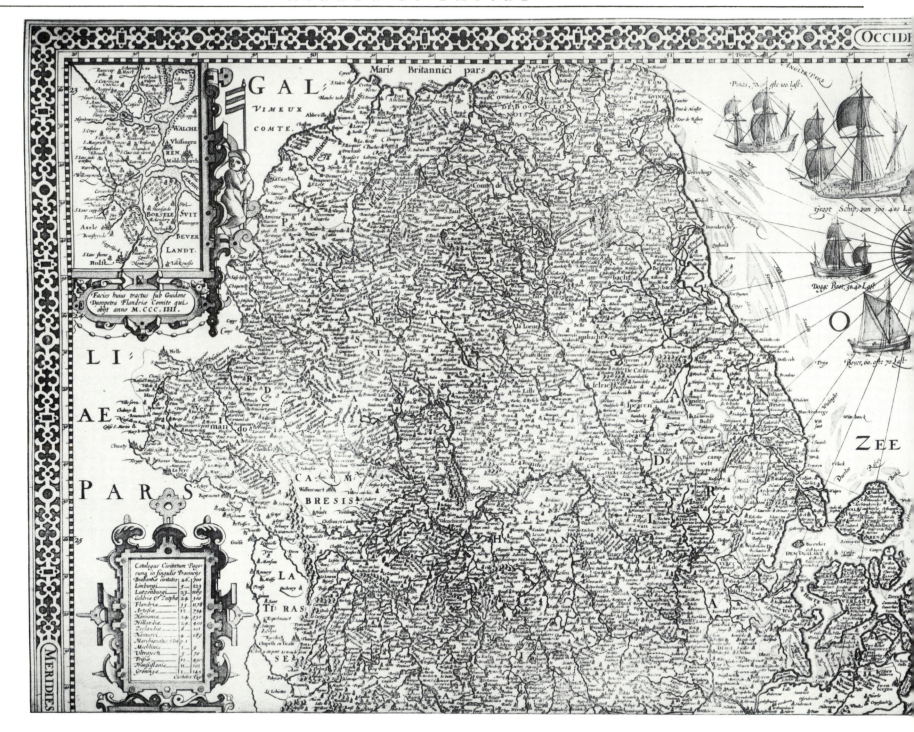

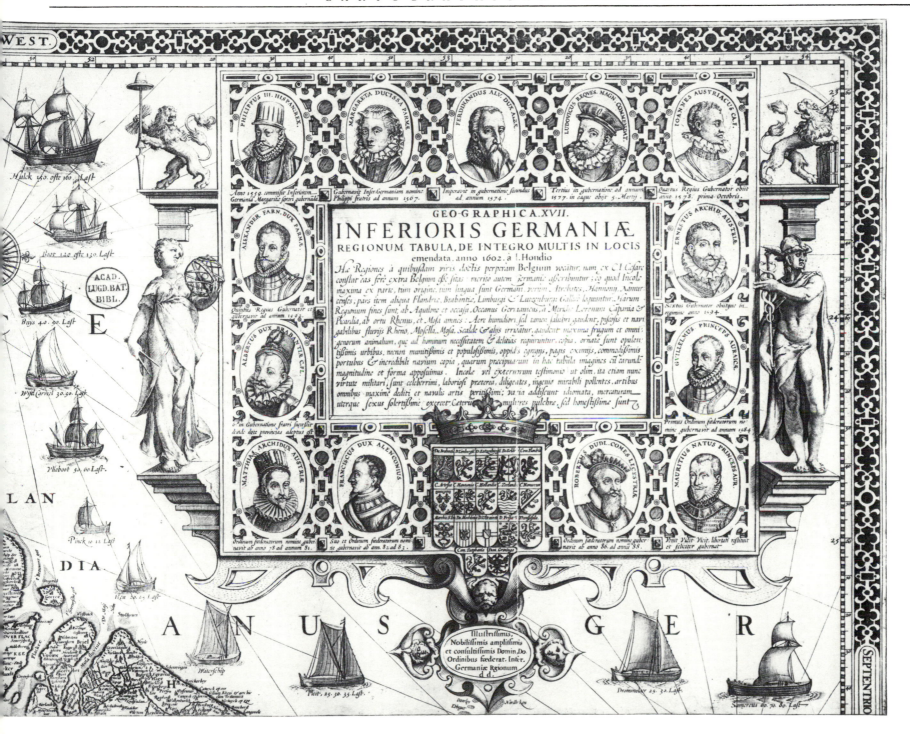

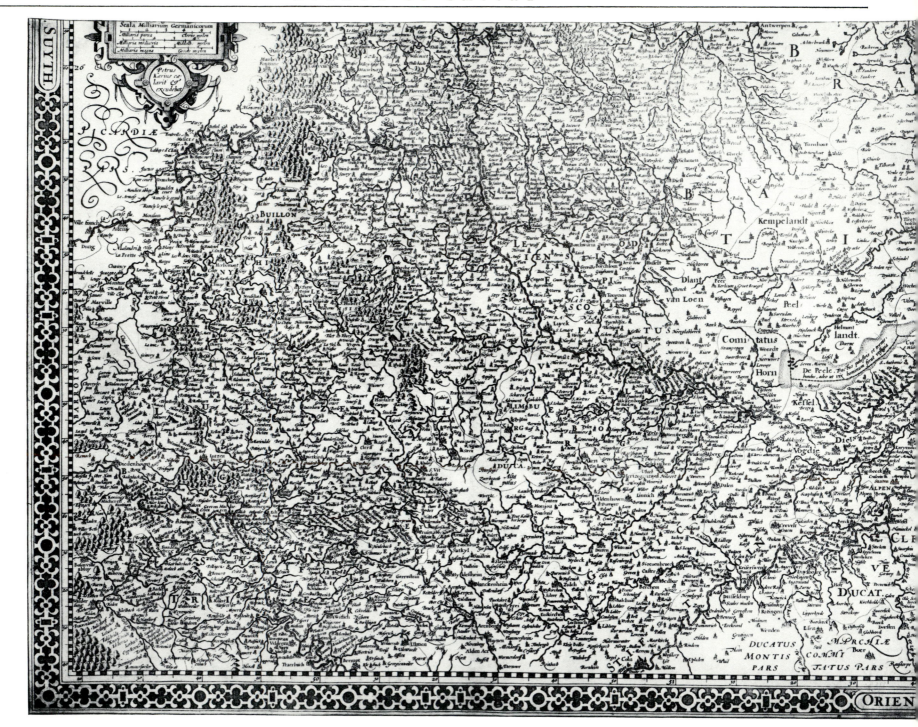

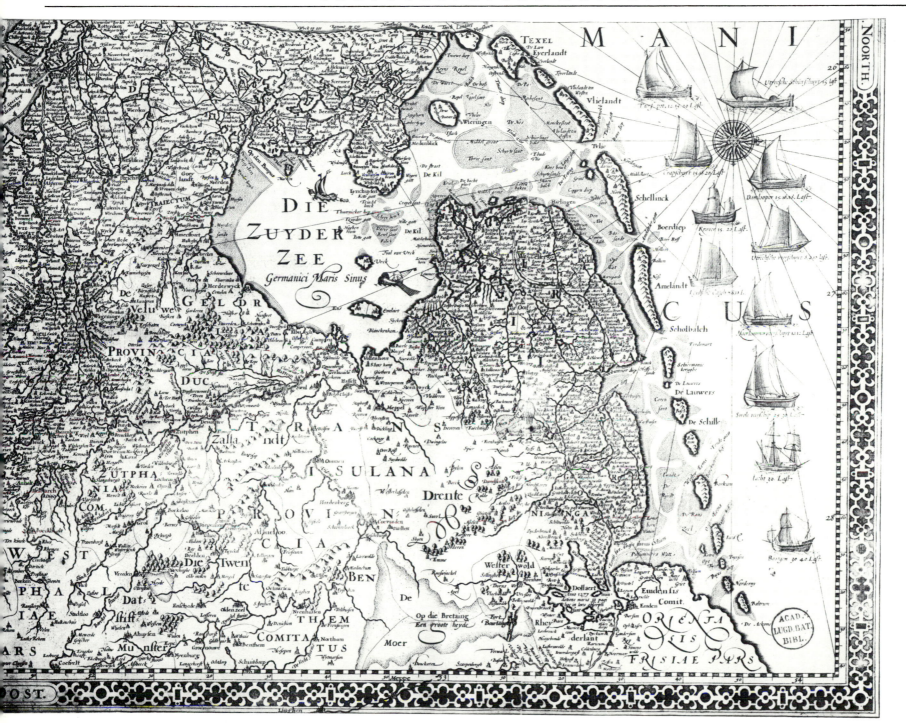

In the first half of the sixteenth century, the Low Countries were in the process of unification, fostered to a large extent by the administrative measures introduced by Charles V. The prevailing spirit of political unity was reflected in the charts of *Germania Inferior*, covering The Netherlands as a whole, which in turn – whether intentionally or not – nurtured this burgeoning political awareness. Multi-sheet wall maps, the oldest extant example being the one published in Antwerp by Gerard de Jode in 1566, occupy a singular position. Philips Galle, Hondius himself, Johannes van Doetecum, and Frans Hogenberg followed the precedent set by de Jode, and in 1602 a number of exquisite examples were available that Hondius could use as a basis for the general figuration. The decorative details in this unique map were also clearly inspired by the work of others: the idea of including portraits of the governors had a precedent four years earlier, on a map of The Netherlands in the form of a lion – known as a "Leo Belgicus map" – by van Doetecum. The "caryatids" of Urania and Mercury were borrowed from a portrait of Scaliger by Goltzius, and the cartouche of the inset map was copied directly from Plancius's map of Europe (1592). The enumeration of towns and the addition of a brief annotation concerning the country and people were by then also relatively common features.

Nonetheless, a scientific cartographer of the caliber of Hondius the Elder may also be expected to reveal a certain degree of originality. And, indeed, the geographic representation is so entirely different from that of his predecessors that we can regard this as his own distinctive work. He has not simply copied others but has combined various regional maps to create something quite new. Also without precedent is his inclusion of latitude and longitude, while another unique feature, which adds an important dimension to the work, is the pageant of twenty-six different ships with their names and tonnage clearly marked, ranging from the "Groot Schip van 300, 400 Last" (= 600, 800 tons) to the "Leydsche Caegh 7, 8, 10 Last" (14, 16, 20 tons). This overview provides a unique source of information, particularly concerning the small vessels that plied the inland waterways. It would have enhanced the map's popular appeal and probably accounts for its inclusion as a background attribute in two of Dirck Hals's "merry company" paintings of ca. 1630. In one of them the map is shown beside a painting of a ship at sea.

141

HESSEL GERRITSZ.
Wall Map of Spain (1612, reprinted 1615)

[*CARTA DEL MUY PODEROSO REYNO D'ESPANA. Con diligenca anotado y
escripta / por Hessel Gerritssen. M.D.C.XII.*]
Scale [ca. 1:1,350,000]
Amsterdam: Pieter van den Keere, 1615
Four sheets: copper engraving; 86.5 x 115 cm

At upper right is an eleven-line dedication in a cartouche to Andrea d'Almada, professor
of theology at the University of Coimbra: *ILLUSTRISSIMO DOMINO D.
ANDREAE DALMADA [. . .] Hanc Tabulam Hispaniae, animo devotissimo in
memoriam accepti beneficii DEDICAT, CONSECRATQUE HESSELUS GERARDUS
ASSUMMENSIS.* At lower right is a cartouche with the crests of the Spanish
provinces, the *INSIGNIS REGNORUM HISPANIAE*, crowned by a lion salient,
which is holding both the sword and the escutcheons of Castile and Aragon. To the
left is a ten-line annotation in Latin on the adoption of the prime meridian, *De primi
Meridiani constitutione.* At upper left and right, respectively, a legend on the spelling
of place names, and four scaleyards.

Leiden, University Library, Bodel Nijenhuis Collection, inv. Port 133 N 93

LITERATURE: Jöcher 1750, col. 285
 Keuning 1949, pp. 51–52
 Schilder 1986, pp. 119 (note 4), 162–168
 Schilder 1987, pp. 85–110, 125–129
 Amsterdam 1989c, p. 94, no. 4.41

Eight sixteenth-century multi-sheet maps of the Iberian peninsula are
known today. In 1571, Abraham Ortelius published one in six sheets, using
topographical data that the eminent botanist Carolus Clusius (1526–1609)
had collected on a field trip through Spain.

Some forty years later the cartographer Hessel Gerritsz., a master at
collecting and collating original source material, compiled a map that con-
tains little to recall these predecessors. Not only is it more accurate, but
the figuration is entirely different, notably because of the addition of a
completely updated drawing of the coast, based to some extent on the six
charts of the Spanish west coast, probably engraved by Gerritsz. himself,
in *Het Licht der Zee-vaert* (1608) by W. J. Blaeu (Cat. 129). The most
striking feature, however, is that the topography of many of the provinces

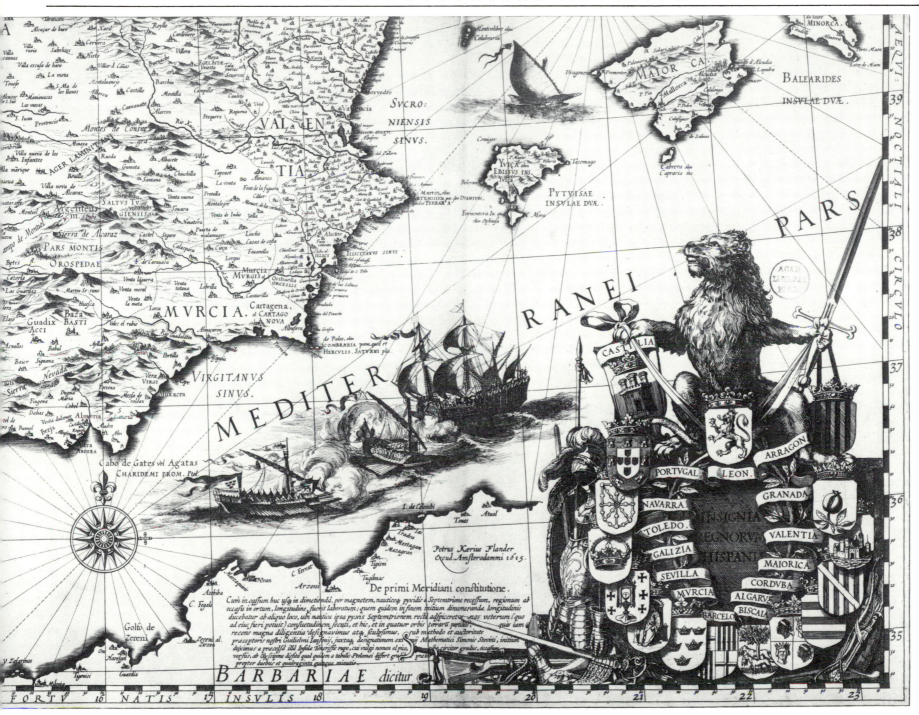

has been substantially increased, including that of Catalonia, Galicia, Portugal, Andalusia, and Valencia. For this purpose, Gerritsz. had gained access to recent regional maps that were first included in Hondius's atlases of 1606 and 1607 and in Ortelius's of 1603. J. B. Vrients of Antwerp had even produced a wall map of Catalonia in four sheets. Gerritsz.'s interest in hydrography is reflected in the four compass roses he has added and the exquisitely engraved vignettes of ships at sea. (fig. a).

The Latin annotation at lower right, concerning the adoption of the prime meridian, merits special attention, as Gerritsz. discloses that he was in fact the author of the wall maps of the four continents that Blaeu published in 1608 and that until now have been attributed to Blaeu as author. He mentions that he chose the Peak of Tenerife in the Canary Islands as the prime meridian, as he had done *in quatuor orbis terrarum partibus, quas iam recens magna diligentia designavimus atque sculpsimus* (four parts of the world which we recently drew and engraved with great care).

He dedicated the map to Andrea d'Almada (died 1642), professor of theology at the University of Coimbra, who is said to have been *magister artium* and a mathematics scholar. What the *acceptum beneficium* — assistance received — refers to, is uncertain. The map reproduced here is one of the two known examples of the second edition published by Pieter van den Keere in 1615. A unique specimen of the first printing is at the University Library in Göttingen, from which the title, which does not appear on the Leiden example, has been taken.

Cat. 141, fig. a Detail, vignette of naval battle.

142

ANDREAS VAN LUCHTENBURGH
Celestial Sphere (ca. 1695)

*Nieuwe Hemels Spiegel waer door den hemel, aerde en zee dadelik kan afgemeten
 werden. Noyt gesien en dat op alle Polus hooghten seer nodig voor Stierlieden / Alles
 door Mr. A. van Luchtenburgh Rotterdam*
From the North equatorial pole to 40°S.
[Amsterdam]: Jacobus Robijn [ca. 1695]
Copper engraving on vellum, colored; 49 cm diameter, 60.5 x 52 cm

With two inset maps: (1) at upper left, the universe according to the Copernican system;
 and (2) at upper right, the earth's orbit around the sun. This celestial chart is based
 on the equatorial coordinates system; in addition, it shows the ecliptic north pole and
 the ecliptic itself, divided into twelve segments of thirty degrees each, with each
 segment representing one of the twelve signs of the zodiac. The zenith for 52°N is
 drawn in above the *Polus Eclipticus*. A striking feature is the addition around the
 north pole of the orbits of the planets Mercury, Jupiter, Venus, Earth, Saturn, and
 Mars. At the bottom of the chart is a legend for the star magnitudes and a ten-line
 dedication, signed by J. Robijn, to the Elector Frederick III of Brandenburg:
 FREDERICO TERTIO DEO GRATIO MARCII BRANDENBURGI [. . .] *nec non
 S.R. DELECTORI ET ARCHICAMERARIO D D J. Robijn.* In the four corners are
 faces of winds.

Leiden, University Library, Bodel Nijenhuis Collection, inv. Port 169 N 1

LITERATURE: Koeman, *Atlantes Neerlandici*, vol. 4, pp. 5, 436–449
 Warner 1979, pp. 165–167
 Shirley 1983, pp. 531 (no. 534), 577–579 (no. 582)
 Davids, 1986, pp. 133–135
 Muller and Zandvliet 1987, p. 171, no. 263

Charts such as this were used for teaching students of navigation about the celestial bodies. An elementary knowledge of astronomy was essential for determining a ship's position at sea, out of sight of land, since not only the sun and the polestar but also planets and other stars were used to take sights. It was also thought that the position of the moon might be the key to a reliable solution of the age-old problem of calculating longitude – or

finding east and west. One of the independent instructors of navigation, best known for his publications, was van Luchtenburgh of Rotterdam. After the Court of Holland granted him a license to practice as a surveyor on July 1, 1664, he had continued to study mathematics and its numerous applications. Besides a world map drawn in 1706, with the path of an eclipse of the sun, and the chart of *De Loop vande Rhijn ende Maas* (1691), a number of planispheres of the earth and of the stars are known by him, many accompanied by a printed explanatory appendix. His publisher in most cases was Jacobus Robijn, whose firm in the Nieuwbrugsteeg in Amsterdam sold sea atlases, nautical almanacs, and, according to his 1688 catalogue, "gilded [!] land and sea-charts, great and small." Robijn, who began his career as a chart colorist, therefore presumably colored these printed vellum charts himself, using gold to heighten them.

EXHIBITION CHECKLIST

PAINTINGS

HENDRICK VAN ANTHONISSEN

1. *Shipping Scene*
 Oil on panel
 35 × 48 cm
 Private collection, courtesy Trafalgar Galleries, London

LUDOLPH BACKHUYSEN

2. *Fishing Vessels Offshore in a Heavy Sea*
 Oil on canvas
 64.6 × 97.7 cm
 Minneapolis, Minneapolis Institute of Arts

3. *Shipping*
 Pen painting on panel
 60 × 83.5 cm (grisaille)
 Amsterdam, Rijksmuseum "Nederlands Scheepvaart Museum"

4. *Ships in Distress off a Rocky Coast*
 Oil on canvas
 114 × 168 cm
 Washington, D.C., National Gallery of Art

5. *Shipping Before Amsterdam*
 Oil on canvas
 128 × 221 cm
 Paris, Louvre

6. *The "Eendracht" and a Dutch Fleet of Men-of-War Before the Wind*
 Oil on canvas
 75.5 × 105 cm
 London, the Trustees, National Gallery

7. *Four Days' Battle*
 Oil on canvas
 141 × 234.5 cm
 Copenhagen, Statens Museum for Kunst

JAN ABRAHAMSZ. BEERSTRAATEN

8. *The Battle of Terheide*
 Oil on canvas
 176 × 281.5 cm
 Amsterdam, Rijksmuseum

ABRAHAM VAN BEYEREN

9. *Sailboats on a Choppy Sea*
 Oil on panel
 33 × 43 cm
 Bahamas, private collection

JAN VAN DE CAPPELLE

10. *Ships off the Coast*
 Oil on canvas
 72.5 × 87 cm
 The Hague, Mauritshuis, Koninklijke Kabinet van Schilderijen
 (Exhibited in Minneapolis and Toledo)

11. *Shipping off the Coast*
 Oil on canvas
 61.9 × 84 cm
 Toledo, Toledo Museum of Art

12. *Ships on a Calm Sea*
 Oil on panel
 62.2 × 83.2 cm
 New York City, private collection

WILLEM HERMANSZ. VAN DIEST

13. *Shipwreck on a Beach*
 Oil on panel
 48.9 × 71.5 cm
 Baltimore, Walters Art Gallery

HENDRICK DUBBELS

14. *Ships Beyond a Beach*
Oil on canvas
136 × 193 cm
Copenhagen, Statens Museum for Kunst

15. *Sailboats in a Breeze*
Oil on canvas
49.9 × 49.5 cm
Schwerin, Staatliches Museum

JAN VAN GOYEN

16. *Sailboats in a Thunderstorm*
Oil on panel
40 × 60.5 cm
The Hague, Rijksdienst beeldende Kunst

17. *A Calm*
Oil on panel
36.1 × 32.1 cm
Budapest, Szépmüvészeti Múzeum

PIETER MULIER THE ELDER

18. *Sailboats in a Stiff Breeze*
Oil on panel
38 × 59.3 cm
Baltimore, private collection

REINIER NOOMS ("ZEEMAN")

19. *Ships at Anchor*
Oil on canvas
47.5 × 56.8 cm
Vienna, Gemäldegalerie der Akademie der bildenden Künste

20. *Battle of Leghorn*
Oil on canvas
66 × 117 cm
Greenwich, National Maritime Museum

21. *Battle of Leghorn*
Oil on canvas
142 × 225 cm
Amsterdam, Rijksmuseum

JAN PORCELLIS

22. *Sailboats in a Tossing Sea*
Oil on panel, tondo
39.5 cm ⌀
Antwerp Museum Ridder Smidt van Gelder
(Withdrawn from the exhibition)

23. *Shipwreck on a Beach*
Oil on panel
36.5 × 66.5 cm
The Hague, Mauritshuis, Koninklijke Kabinet van Schilderijen

24. *Sailboats in a Breeze*
Oil on panel
28 × 35.7 cm
Leiden, Stedelijk Museum De Lakenhal

JACOB VAN RUISDAEL

25. *A Rough Sea*
Oil on canvas
107 × 124.5 cm
Boston, Museum of Fine Arts

26. *A Storm off the Dutch Coast*
Oil on canvas
86.4 × 101.6 cm
Manchester, City Art Gallery

SALOMON VAN RUYSDAEL

27. *Sailboats on an Inland Sea*
Oil on panel
36 × 31.7 cm
Rotterdam, Museum Boymans–van Beuningen

ABRAHAM VAN SALM

28. *Whaling in a Northern Ice Sea*
Oil on canvas
60 × 76 cm
Sharon, Massachusetts, Kendall Whaling Museum

ABRAHAM STORCK

29. *Four Days' Battle*
Oil on canvas

76.2 × 107.8 cm
Greenwich, National Maritime Museum

30. *A Dutch Ship Passing a Mediterranean Port*
Oil on canvas
83.8 × 66.1 cm
Greenwich, National Maritime Museum

31. *The Four Days' Battle*
Oil on canvas
94.6 × 127 cm
Minneapolis, Minneapolis Institute of Arts

WILLEM VAN DE VELDE THE ELDER

32. *The Dutch Fleet Under Sail*
Oil on canvas
112 × 203 cm
Florence, Palazzo Pitti
(Exhibited in Minneapolis)

33. *Battle of the Downs*
Oil on canvas
124 × 190 cm
Amsterdam, Rijksmuseum

WILLEM VAN DE VELDE THE YOUNGER

34. *Fishing Boats Offshore in a Calm*
Oil on canvas
65.8 × 78.5 cm
Springfield, Massachusetts, Springfield Museum of Fine Arts

35. *Calm: A Prince's Yacht Surrounded by Other Vessels*
Oil on canvas
66.6 × 77.2 cm
The Hague, Mauritshuis, Koninklijke Kabinet van Schilderijen
(Exhibited in Minneapolis)

36. *A States Yacht Running Down to Some Dutch Ships in a Breeze*
Oil on canvas
75 × 108 cm
Greenwich, National Maritime Museum

37. *A Dutch Man-of-War and Small Vessels off a Coast in a Strong Breeze*
Oil on canvas
55 × 70 cm
London, the Trustees, National Gallery

38. *A Kaag Close-hauled in a Fresh Breeze*
Oil on canvas
129.5 × 189 cm
Toledo, Toledo Museum of Art

39. *Calm: A Dutch Flagship Coming to Anchor with a States Yacht Before a Light Air*
Oil on canvas
85 × 104 cm
Greenwich, National Maritime Museum

40. *The Surrender of the "Royal Prince"*
Oil on canvas
75.5 × 106 cm
West Germany, private collection

CORNELIS VERBEECK

41. *Four Ships in High Seas*
Oil on panel
35 × 55.5 cm
United States, private collection

42. *The Capture of Damiate*
Oil on panel
52.7 × 84.45 cm
Huntington, New York, Heckscher Museum

LIEVE PIETERSZ. VERSCHUIER

43. *Ships in a Bay at Sunset*
Oil on canvas
48.3 × 64.3 cm
Paris, Institut Néerlandais, Fondation Custodia (Collection Frits Lugt)

44. *The Whaler, "Prince William," on the River Maas, near Rotterdam*
Oil on canvas
95 × 140 cm
United States, private collection

SIMON DE VLIEGER

45. *Admiral van Tromp's Flagship Before Den Brielle*
Oil on canvas
82 × 125 cm
Delft, Stedelijk Museum "Het Prinsenhof"

46. *Ship in Distress off a Rocky Coast*
Oil on panel
55.2 × 78.7 cm
Milwaukee, Collection of Dr. and Mrs. Alfred Bader

47. *Sailboats in a Stiff Breeze*
Oil on panel
45.8 × 61 cm
Montreal, Collection of Mr. and Mrs. Michael Hornstein

CORNELIS VROOM

48. *Battle Between Spanish Galleons and Barbary Corsairs*
Oil on canvas
61 × 103 cm
Greenwich, National Maritime Museum

HENDRICK AND CORNELIS VROOM

49. *Battle Between Dutch Ships and Spanish Galleys off
the Flemish Coast*
Oil on canvas
117.5 × 146 cm
Amsterdam, Rijksmuseum

HENDRICK CORNELISZ. VROOM

50. *Return of the Second Dutch Expedition to the East Indies*
Oil on canvas

110 × 220 cm
Amsterdam, Rijksmuseum, on loan to Amsterdam Historisch Museum

51. *Skirmish Between Dutch and English Warships*
Oil on canvas
155 × 240 cm
Amsterdam, Rijksmuseum "Nederlands Scheepvaart Museum"

52. *View of Hoorn*
Oil on canvas
105 × 202.5 cm
Hoorn, Westfries Museum

CORNELIS CLAESZ. VAN WIERINGEN

53. *The Arrival of Frederick V of the Palatinate in Vlissingen on May 5,
1613*
Oil on canvas
110 × 215 cm
Haarlem, Frans Hals Museum

ADAM WILLAERTS

54. *The Arrival of Frederick V, Elector of the Palatinate, in Vlissingen on
May 5, 1613*
Oil on canvas
123.5 × 236.5 cm
Europe, private collection

55. *Christ Preaching from the Boat*
Oil on panel
57 × 87.5 cm
Turin, Italy, private collection

DRAWINGS

LUDOLPH BACKHUYSEN

56. *The "Amsterdam" Under Sail by a Harbor*
Brush, black ink, and gray washes over faint indications in graphite
268 × 362 mm
New York, The Pierpont Morgan Library

57. *Ships Before a Hilly Coast*
Brush, brown ink, and wash over graphite
150 × 273 mm

Berlin-Dahlem, Kupferstichkabinett, Staatliche Museen, Preussischer
Kulturbesitz
(Exhibited in Minneapolis)

58. *Battle of La Hogue, May 29, 1692*
Pen, black ink, and gray washes
204 × 296 mm
Brussels, Koninklijke Musea voor Schone Kunsten van België,
Collection de Grez

59. *Amsterdam Harbor: Calm*
Pen, brown ink, and wash over graphite
116 × 188 mm
Haarlem, Teylers Museum
(Exhibited in Minneapolis and Toledo)

60. *Warehouses of the Dutch East India Company, Amsterdam*
Brush, black ink, and gray washes
117 × 192 mm
Cambridge, Fitzwilliam Museum

61. *Ships in a Storm*
Brush, black ink, and gray washes
306 × 425 mm
Haarlem, Teylers Museum
(Exhibited in Toledo and Los Angeles)

62. *Ship in Distress in a Thunderstorm*
Pen, brown ink, brown and gray washes
245 × 184 mm
Rotterdam, Museum Boymans–van Beuningen

PIETER COOPSE

63. *Ships in a Strong Breeze*
Brush, black ink, and gray washes
170 × 279 mm
Haarlem, Teylers Museum
(Exhibited in Minneapolis and Toledo)

64. *Yacht and Other Ships Beyond a Beach*
Pen, brush, black ink, and washes over traces of black chalk
177 × 277 mm
Cambridge, Fitzwilliam Museum

ALLAERT VAN EVERDINGEN

65. *Sailboat in a Stiff Breeze Before a Harbor*
Brush, brown ink, and washes over traces of black chalk
123 × 190 mm
Brussels, Koninklijke Musea voor Schone Kunsten van België

66. *A Rocky Coast in Rough Weather*
Brush, black ink, gray and brown washes, and white highlights
 on gray-tinted paper
225 × 416 mm

Vienna, Graphische Sammlung Albertina
(Exhibited in Los Angeles)

PIETER MULIER THE ELDER

67. *Ships off a Rocky Coast*
Pen, brown ink, and gray wash over black chalk
123 × 196 mm
Leiden, Prentenkabinet der Rijksuniversiteit

REINIER NOOMS ("ZEEMAN")

68. *Dutch Fleet After a Battle with Captured English Warships*
Brush, black ink, and gray washes
203 × 331 mm
Berlin-Dahlem, Kupferstichkabinett, Staatliche Museen, Preussischer
 Kulturbesitz
(Exhibited in Minneapolis)

69. *Fishing Fleet Before Mountains*
Brush, black ink, and gray washes with white highlights
126 × 244 mm
Darmstadt, Hessisches Landesmuseum
(Exhibited in Minneapolis)

70. *A Naval Engagement Between a Dutch and an English Ship*
Brush, black ink, and gray washes
226 × 353 mm
Edinburgh, National Gallery of Scotland

71. *Calm: Ship Being Careened*
Brush, black ink, and gray washes
162 × 266 mm
Haarlem, Teylers Museum
(Exhibited in Toledo and Los Angeles)

72. *Ships Anchored*
Brush, black ink, and gray washes
149 × 278 mm
Rotterdam, Museum Boymans–van Beuningen

JAN PORCELLIS

73. *A Zeeland Koch*
Brush, gray ink, and wash
165 × 275 mm

Vienna, Graphische Sammlung Albertina
(Exhibited in Los Angeles)

HENDRICK RIETSCHOEFF

74. *Dutch Warship, Yacht and Other Ships in a Breeze*
Pen, brush, black ink, and gray wash over graphite
203 × 307 mm
Cambridge, Fitzwilliam Museum

75. *Estuary at Sunset*
Brush, gray ink, and washes
149 × 189 mm
Brussels, Koninklijke Musea voor Schone Kunsten van België

ABRAHAM STORCK

76. *A Mediterranean Harbor*
Pen, brown ink, and gray washes
195 × 159 mm
Berlin-Dahlem, Kupferstichkabinett, Staatliche Museen,
 Preussischer Kulturbesitz
(Exhibited in Minneapolis)

WILLEM VAN DE VELDE THE ELDER

77. *Dutch Ships at Anchor off Land*
Pencil
232 × 391 mm
Rotterdam, Museum Boymans–van Beuningen

78. *Ships at Anchor with a States Yacht Approaching*
Pencil and gray washes
230 × 540 mm
Rotterdam, Museum Boymans–van Beuningen

79. *The English Fleet at Anchor off Den Helder*
Pencil and gray washes
205 × 905 mm
Rotterdam, Museum Boymans–van Beuningen

80. *The "Jupiter" at Anchor and the Yacht of the States of Holland in
 the Fleet*
Pencil and gray washes
405 × 935 mm
Rotterdam, Museum Boymans–van Beuningen

81. *Four Days' Battle: The English Ships Close-hauled on the Starboard
 Tack and Tromp Tacking Back*
Pencil and gray washes
Overall measurements: 315 × 1,618 mm
Rotterdam, Museum Boymans–van Beuningen

82. *Four Days' Battle: Damaged English Ships; "Het Hof van Zeeland"
 and the "Duivenvoorde" Burning; the "Swiftsure," "Loyal
 George," and "Seven Oaks" Captured*
Pencil and gray washes
Overall measurements: ca. 355 × 2,348 mm
Rotterdam, Museum Boymans–van Beuningen

83. *The Dutch Fleet in Light Airs Before the Battle of Lowestoft*
Pencil and gray washes
Overall measurements: 348 × 1,868 mm
Rotterdam, Museum Boymans–van Beuningen

84. *The English Ship "Providence"*
Pencil and gray washes
287 × 455 mm
Rotterdam, Museum Boymans–van Beuningen

85. *The Dutch Ship "Ster" (Star)*
Pencil and gray wash
355 × 500 mm
Rotterdam, Museum Boymans–van Beuningen

86. *The Dutch Ship "Vrijheid" (Freedom)*
Pencil
392 × 515 mm
Rotterdam, Museum Boymans–van Beuningen

87. *A Dutch Ship of About Eighty Guns*
Pencil and gray washes
377 × 907 mm
Rotterdam, Museum Boymans–van Beuningen

88. *The English Ship, the "Royal Prince"*
Pencil, pen, and gray washes
449 × 739 mm
Rotterdam, Museum Boymans–van Beuningen

SIMON DE VLIEGER

89. *Ships in a Calm*
 Black chalk and gray wash
 156 × 273 mm
 Amsterdam, Rijksprentenkabinet
 (Exhibited in Minneapolis)

HENDRICK VROOM

90. *Ships in a Storm*
 Pen and brown ink
 147 × 195 mm
 Rotterdam, Museum Boymans–van Beuningen

91. *A Dutch Warship*
 Pen and brown ink
 411 × 570 mm
 Düsseldorf, Kunstmuseum

92. *Ships in a Storm*
 Pen and brown ink

LUDOLPH BACKHUYSEN

96. *The Personification of Amsterdam Riding Neptune's Chariot*
 Etching, state III
 198 × 259 mm
 Minneapolis, Minneapolis Institute of Arts

97. *Shipping on the Ij Before Amsterdam*
 Etching, state III
 177 × 238 mm
 Minneapolis, Minneapolis Institute of Arts

98. *Yacht and Other Ships by a Mole*
 Etching, state III
 176 × 236 mm
 Minneapolis, Minneapolis Institute of Arts

PIETER BAST

99. *Amsterdam: Groundplan Seen from the North*
 Engraving in four plates
 929 × 819 mm
 Leiden, University Library (Bodel Nijenhuis Coll.)

258 × 424 mm
New Haven, Yale University Art Gallery

CORNELIS CLAESZ. VAN WIERINGEN

93. *A Ship Saluting*
 Pen, brown ink, gray washes, and white highlights
 120 × 180 mm
 Amsterdam, Rijksprentenkabinet
 (Exhibited in Minneapolis)

94. *Sailboats by a Wooded Shore*
 Pen, brown ink, and gray wash
 75 × 118 mm
 Leiden, Prentenkabinet der Rijksuniversiteit

95. *Sailboats by a Pier*
 Pen, brown ink, and gray wash
 160 × 227 mm
 Cambridge, Fitzwilliam Museum

PRINTS

100. *Profile View of Amsterdam Seen from the River Ij*
 Engraving in two plates
 260 × 753 mm
 Leiden, University Library (Bodel Nijenhuis Coll.)

PIETER BAST/CLAES JANSZ. VISSCHER

101. *Profile View of Amsterdam Seen from the River Ij,*
 reworked by Claes Jansz. Visscher
 Etching and engraving in four plates
 255 × 1,120 mm overall
 Amsterdam, Municipal Archives (Dreesmann Coll.)

BALTHASAR FLORISZ. VAN BERCKENRODE

102. *Groundplan of Amsterdam*
 Etching and engraving in ten plates
 144 × 160 cm overall
 Amsterdam, Municipal Archives (Atlas Splitgerber)

HENDRICK HONDIUS II

103. *French Man-of-War in Port Profile*
 Etching

370 × 530 mm
Dordrecht, Museum Mr. Simon van Gijn

ROMEYN DE HOOGHE AND JOHANNES DE VOU

104. *Groundplan and Profile View of Rotterdam*
Etching and engraving in 43 plates
166 × 194 cm
Rotterdam, Municipal Archives

ROMEYN DE HOOGHE

105. *Reception of Mary as Queen of England*
Etching
481 × 583 mm
Dordrecht, Museum Mr. Simon van Gijn

106. *Allied Victory over the Swedes, June 11, 1676*
Etching
476 × 706 mm
Amsterdam, Rijksmuseum "Nederlands Scheepvaart Museum"

MEYNERT JELISSEN AFTER HENDRICK VROOM

107. *Ships in a Rough Sea by a Rocky Coast*
Engraving
265 × 438 mm
Vienna, Graphische Sammlung Albertina
(Exhibited in Los Angeles)

REINIER NOOMS ("ZEEMAN")

108. *Struggle Between Dutch and English Fishing Vessels*
Etching, state II
188 × 282 mm
Rotterdam, Museum Boymans–van Beuningen

109. *Ravaged Ships by a Foreign Coast*
Etching, state II
122 × 208 mm
Amsterdam, Rijksmuseum "Nederlands Scheepvaart Museum"

110. *The "Geele Fortuin," a Baltic Merchantman, and the "Liefde," a Norwegian Merchantman*
Etching, state II
137 × 247 mm
Minneapolis, Minneapolis Institute of Arts

111. *A Boeier and a Galliot*
Etching, state II
122 × 243 mm
Minneapolis, Minneapolis Institute of Arts

112. *Bicker's Island*
Etching, state II
136 × 247 mm
Minneapolis, Minneapolis Institute of Arts

113. *The "Pearl," a Dutch East Indiaman, and the "Spread Eagle," a Dutch West Indiaman*
Etching, state II
136 × 248 mm
Minneapolis, Minneapolis Institute of Arts

114. *Fishing Pinks*
Etching, state I
129 × 233 mm
Amsterdam, Rijksmuseum "Nederlands Scheepvaart Museum"

115. *Naval Battle*
Etching, state II
180 × 260 mm
Saint Louis, Saint Louis Art Museum

JAN PORCELLIS, ANONYMOUS AFTER

116. *Damloopers in a Procession*
Engraving from *Icones Variarum Navium Hollandicarum*
176 × 250 mm
Amsterdam, Rijksmuseum "Nederlands Scheepvaart Museum"

117. *Herring Busses*
Engraving from *Icones Variarum Navium Hollandicarum*
178 × 251 mm
Amsterdam, Rijksmuseum "Nederlands Scheepvaart Museum"

HANS REM, ANONYMOUS AFTER

118. *Battle of Sluis*
Engraving in two plates
520 × 933 mm
Rotterdam, Stichting Atlas van Stolk

SALOMON SAVERY

119. *A Flute Ship in Starboard Profile*
Etching
387 × 516 mm
Amsterdam, Rijksmuseum "Nederlands Scheepvaart Museum"

120. *Festive Procession of Ships Before Amsterdam*
Etching, state I
297 × 649 mm
Amsterdam, Rijksmuseum "Nederlands Scheepvaart Museum"

WILLEM VAN DE VELDE THE ELDER, ANONYMOUS AFTER

121. *The "Aemilia," Admiralty Ship of Holland*
Etching
396 × 539 mm
Dordrecht, Museum Mr. Simon van Gijn

HENDRICK CORNELISZ. VROOM, ANONYMOUS AFTER

122. *The Landing at Philippine*
Engraving in two plates
380 × 965 mm
Leiden, University Library (Bodel Nijenhuis Collection)

ANTHONY VAN ZYLVELT, AFTER MICHIEL COMANS

123. *Four Days' Battle*
Etching
330 × 437 mm
Rotterdam, Stichting Atlas van Stolk

ANONYMOUS

124. *Battle of Bantam*
Engraving in three plates, hand-colored
414 × 846 mm
Rotterdam, Stichting Atlas van Stolk

125. *Battle of Gibraltar*
Etching and engraving in three plates
437 × 844 mm
Amsterdam, Rijksmuseum "Nederlands Scheepvaart Museum"

126. *Battle of La Hogue*
Etching
299 × 414 mm (overall with text, 556 × 414 mm)
Rotterdam, Stichting Atlas van Stolk

CARTOGRAPHICAL MATERIALS

WORLD MAPS

127. P. van den Keere
World Map in Two Hemispheres
126 × 197 cm
San Francisco, San Francisco State College, Sutro Library

128. W. J. Blaeu
World Map
Engraving on paper, 2 sheets
Sheet: 53 × 81 cm
Leiden, University Library (Bodel Nijenhuis Coll.)

ATLASES

129. W. J. Blaeu
Het Licht der zeevaert
Printed book, hand-colored
26.3 × 30.5 cm closed
Rotterdam, Maritiem Museum "Prins Hendrik"

130. A. Roggeveen
Het Eerst Deel van het Brandende Veen
Printed book, 54 × 35 cm closed
Milwaukee, American Geographical Society Collection, University of Wisconsin–Milwaukee

GLOBES

131. J. Hondius the Elder
A Pair of Celestial and Terrestrial Globes
Metal, walnut, paper
Each 35.5 cm ∅
San Francisco, Fine Arts Museums of San Francisco

132. J. Janssonius
Gores of a Small Terrestrial Globe
26.5 × 41 cm (image)
Leiden, University Library (Bodel Nijenhuis Coll.)

CHARTS

133. C. Doedsz.
Atlantic Ocean
Vellum, hand-colored
82 × 103 cm
Leiden, University Library (Bodel Nijenhuis Coll.)

134. A. Gerritsen
Coasts of Europe
Printed on vellum, hand-colored
45 × 59 cm (image)
Leiden, University Library (Bodel Nijenhuis Coll.)

135. H. Allard and R. de Hooghe
Oost Indien
Engraving on vellum, 4 sheets
78 × 101 cm overall; 70 × 90.5 cm (image)
Leiden, University Library (Bodel Nijenhuis Coll.)

136. H. Gerritsz.
The Dutch Standard Chart of the Caribbean
Engraving on vellum
51 × 71.5 cm (image)
Leiden, University Library (Bodel Nijenhuis Coll.)

137. D. van der Velde
Chart and View of the Bay of Muscate
Pen drawing on paper, hand-colored
55.5 × 83 cm
Leiden, University Library (Bodel Nijenhuis Coll.)

138. J. van Loon
Het Katte-gadt
Engraving on paper, hand-colored
43 × 54.5 cm (image)
Leiden, University Library (Bodel Nijenhuis Coll.)

139. M. A. Blac and M. H. van Middelhoven
Vlac, Mase en het Goereesche Gat
Pen drawing on vellum, hand-colored
46 × 59.5 cm
Leiden, University Library (Bodel Nijenhuis Coll.)

MAPS

140. J. Hondius The Elder
Wall Map of the Seventeen Provinces
Engraving on paper, 4 sheets
72.5 × 95.5 cm overall
Leiden, University Library (Bodel Nijenhuis Coll.)

141. H. Gerritsz.
Wall Map of Spain
Engraving on paper, 4 sheets
86.5 × 115 cm overall
Leiden, University Library (Bodel Nijenhuis Coll.)

142. A. van Luchtenburgh
Nieuwe Hemelsspiegel
Engraving on vellum, hand-colored
60.5 × 52 cm
Leiden, University Library (Bodel Nijenhuis Coll.)

BIOGRAPHIES OF THE ARTISTS

HENDRICK VAN ANTHONISSEN

Amsterdam (?) 1605 – ca. 1655 Amsterdam

Hendrick van Anthonissen was the son of the Amsterdam marine painter Aert Anthonisz. Presumably Hendrick first trained under his father, but early on he allied himself with Jan Porcellis, whose pupil and assistant he became in 1626. In 1630, Hendrick van Anthonissen married Judith Flessiers, a younger sister of Porcellis's wife. Hendrick moved frequently and is documented in Amsterdam in the years 1629–1630. In 1632 he lived in Leiden, but by 1635 he had moved to the nearby village of Leiderdorp. He returned to Amsterdam, where van Anthonissen is documented in 1640, 1642, and 1643. As a witness in a legal dispute in Rotterdam in 1645, van Anthonissen declared that he was about thirty-nine years old and residing in Amsterdam.[1] At some point in 1647 he lost ownership of his house there and was forced to have an inventory of its contents drawn up. As Bredius notes, the inventory is that of a poor household.[2] By 1651, van Anthonissen is recorded as living in Rijnsburg, a village near Leiden, but by 1654 he had returned once again to Amsterdam.[3] In a document of 1660, Judith Flessiers, the widow of Hendrick van Anthonissen, is cited as living by the Pieterskerk in Leiden.[4]

Hendrick van Anthonissen's surviving paintings show no influence from his father. Conversely, his finest pictures, which date from the 1630s, reveal his great debt to Jan Porcellis. Anthonissen's marines contain a similar repertory of ship types, and he usually represents them sailing on the estuaries of the Dutch Republic. Certain of these were painted in Zeeland.[5] Virtually all of these paintings contain distant spits of low-lying land with church spires piercing the horizon. Hendrick also painted beach scenes. His signed *Beach at Scheveningen* in Cambridge and his *Shipwreck on a Beach* in Schwerin[6] are among his finest paintings and demonstrate great sensitivity to atmospheric effects. Like Porcellis, Anthonissen is a practitioner of the monochrome marine, but his more silvery light may reveal the influence of Simon de Vlieger.

Occasionally, Hendrick van Anthonissen painted naval battles, the finest of which is *The Battle of Duins,* signed and dated 1639, in the Scheepvaart Museum in Amsterdam.[7] His *Storm at Sea* in the Hermitage[8] is also exceptional in his oeuvre but demonstrates this art-ist's wish to broaden his repertory while maintaining high standards of quality.

NOTES

1. Haverkorn van Rijsewijk, 1890, pp. 203–204.

2. A. Bredius, *Künstler Inventare,* vol. 2, pp. 627–628.

3. These many domiciles are cited by Bredius, *Künstler Inventare,* vol. 2, pp. 629–632.

4. Ibid., p. 633.

5. Bol, 1973, pl. 110, illustrates one picture that represents the harbor of Veere and refers to a second painting, auctioned in Amsterdam (Roos and de Vries), February 20/21, 1906, lot 2, repr., that depicts Fort Rammekens at the mouth of the River Scheldt with Middelburg and Vlissingen in the distance; Bol, 1973, fn. 257.

6. Ibid., pl. 108, 109.

7. Ibid., pl. 112.

8. Ibid., p. 107.

LITERATURE

Haverkorn van Rijsewijk, 1890, pp. 203–214; Thieme Becker, *Allgemeines Künstler-Lexikon,* vol. 1, Leipzig, 1907, p. 553 (entry by E. W. Moes); A. Bredius, *Künstler Inventare,* 1917, vol. 2, pp. 626–635; L. J. Bol, 1973, pp. 105–111.

LUDOLPH BACKHUYSEN

Emden 1631 – 1708 Amsterdam

Ludolf Backhuysen was born in Emden in Friesland in 1631 and moved in 1650 to Amsterdam, where he remained for the rest of his life. He died there on November 7 or 8, 1708, and was buried in the Westerkerk on November 12.[1] In Emden he trained as a clerk and accountant, continuing in this capacity when he moved to Amsterdam, where he was first employed by the prominent merchant Guglielmo II Bartolotti van den Heuvel, whose family also traced its roots back to Emden.[2]

Soon after his move to Amsterdam, Backhuysen began to pursue artistic interests, first as a calligrapher, then as a draftsman of pen paintings in a style strongly reminiscent of Willem van de Velde the Elder. Subsequently he began painting; his earliest dated picture is from 1658.[3] His works reveal an interest in such painters as Allaert van

Everdingen, Hendrick Dubbels, and Willem van de Velde the Younger. Despite Arnold Houbraken's assertion that Backhuysen was Allaert van Everdingen's pupil,[4] Backhuysen's assured draftsmanship and vibrant sense of color suggest that this traditional assumption may be erroneous, or at least warrants qualification. Although Backhuysen could have drawn inspiration from Everdingen, Dubbels, and the Willem van de Veldes, father and son, he may have been largely self-taught as a painter.[5] In his marriage vows of 1657 and 1660, Backhuysen cites his profession as draftsman, etc.[6]

However, by the early 1660s Backhuysen had become an established painter. In the year 1663, he entered the Amsterdam Guild of Saint Luke. Two years later he received the significant commission from the city magistrates of Amsterdam to represent the large *Shipping Before Amsterdam* (Cat. 5), which they presented as a gift to Hughes de Lionne, Marquis de Berny, minister to Louis XIV. Backhuysen received 400 ducats, or 1,275 guilders, for this important commission.[7] From this period well into the 1680s Backhuysen produced a formidable array of fine paintings, for which there was considerable demand. His clients included the Archduke of Tuscany, Czar Peter the Great, and many German princes, such as the Duke of Saxony and the Elector of Brandenburg. After the departure of the Willem van de Veldes for England in 1672, Backhuysen became the undisputed leading marine artist in Amsterdam. His several pupils included Pieter Coopse, Michiel Maddersteeg, and Jan Claes Rietschoeff.[8]

Backhuysen's subjects often verge on the bombastic. This histrionic quality became more pronounced in his later pictures, in which his palette becomes harsher and more metallic and his compositions more repetitive. Art historians readily linked these attributes to what they associated with a general decline in Dutch art during the last decades of the seventeenth century. As a result, Backhuysen fell out of favor until recently. As W. van de Watering correctly points out, these qualities in Backhuysen's art that were so criticized conformed to the dictates of taste during the period.[9] Backhuysen's activities as a draftsman indicated with even greater consistency the high standards that he set for himself as a marine artist. Many of these marines are highly finished pen-and-wash studies that functioned as finished works in their own right, in contrast to the impetuously executed pen sketches that conform more closely to his melodramatic streak. Backhuysen produced a handful of etchings, including the suite of ten published in 1701, that assure his reputation in that medium. He also painted portraits and religious subjects, which until recently had largely fallen into obscurity.

NOTES

1. W. L. van de Watering, in Amsterdam, *Ludolf Backhuizen*, 1985, p. 3.

2. Ibid., p. 4.

3. Leipzig, Museum der bildenden Künste, inv. 781.

4. For discussion of this issue, see van de Watering, in Amsterdam, 1985, pp. 6–7. A. Houbraken, 1753, vol. 2, p. 237.

5. W. van de Watering, 1985, pp. 6–7.

6. Ibid., p. 7.

7. Ibid., p. 8; L. J. Bol, 1973, p. 301.

8. Bol, pp. 308–309.

9. van de Watering, in Amsterdam, 1985, p. 9.

LITERATURE

A. Houbraken, vol. 2, pp. 236–244; A. von Bartsch, 1803–1821, *Le Peintre-graveur*, vol. 14, 1805, pp. 269–283; J. Smith, vol. 6, 1835, pp. 401–458; A. D. de Vries, "Biografische Aantekeningen betreffende voornamelijk Amsterdamsche Schilders, Plaatsnijders enz.," *Oud Holland* 3 (1895), pp. 59–60; F. C. Willis, 1911, pp. 107–111; Bredius, *Künstler Inventare*, vol. 1, 1915, pp. 100–101; Hofstede de Groot, 1907–1928, vol. 7, pp. 237–356; Martin, 1936, vol. 2, pp. 382–384; Preston, 1937, pp. 48–49, 66; L. J. Bol, 1973, pp. 301–307; Preston, 1974, pp. 3–6; Amsterdam, 1985; Nannen, 1985; Paris, 1989, pp. 133–134.

PIETER BAST

Antwerp, ca. 1575/80 – 1605 Leiden

Pieter Bast came from a well-established family of artisans in Antwerp. His grandfather, Pieter Bast, and his uncle, Joris Bast, were reputed silversmiths in Antwerp, where Bast's maternal grandfather, Jacques Plattijn, was a merchant. Pieter Bast, the engraver, presumably received his initial training in Antwerp. His engraving style shows close affinities with the Wiericx brothers and with Adriaen Collaert, three of the leading printmakers active in Antwerp. At some point, possibly in the late

1580s or early 1590s, Pieter Bast, either alone or accompanying his family, moved to the Dutch Republic, probably settling in the province of Zeeland. There he produced his first surviving topographical prints, his *Groundplan* and *Profile View of Middelburg*. In 1595, Pieter Bast received the substantial sum of 120 pounds flemish from the magistrates of Dordrecht for his *Profile View of Dordrecht*.

In 1598, Bast resided temporarily in Emden, but in 1601 settled in Leiden, where he married Aeryaentgen Geret in August of that year. On November 15, 1602, he acquired a house on the Lockhorststraat in Leiden. He also drew up a will that same year. Bast died at a young age and was buried in the Pieterskerk in Leiden on November 13, 1605. In a more curious twist of fate his unmarried uncle, Joris Bast, died in Antwerp at almost the same time. Joris left his sizable estate in equal one-third shares to his niece, Margriete, and to the progeny of his two deceased nephews, Pieter and Joost, who also died in 1605. The complex legal issues entailed in settling this estate provide us with most of the archival information on the Bast family, its origins in Antwerp, and its diaspora.[1]

Although his career was cut short, Bast contributed notably to Dutch topographical and cartographical printmaking. His profile views of cities were an important precursor to a theme that particularly attracted Dutch landscape artists throughout the seventeenth century. His masterpieces are his *Groundplan* (Cat. 99) and two *Profile Views of Amsterdam* (Cat. 100), which represent the city at the dawn of its spectacular expansion to become the leading trading emporium of northwest Europe.

NOTE

1. Keyes, 1981, pp. 1–2, fn. 4.

LITERATURE

Bodel Nijenhuis, 1872, pp. 89–110; E. W. Moes, "Pieter Bast," *Nieuw Nederlandsch Biografisch Woordenboek*, vol. 2, 1912; Hofman, 1978; Keyes, 1981.

JAN ABRAHAMSZ. BEERSTRATEN
Amsterdam 1622 – 1666 Amsterdam

Jan Abrahamsz. Beerstraten was the most gifted and versatile member of a family of artists active in Amsterdam during the mid-seventeenth century. Son of a cooper, Abraham Jansz., Jan was baptized May 31, 1622.[1] Jan married Magdalena van Bronckhorst on January 30, 1642, and they had five children.[2] Beerstraten bought a house on the Rozengracht across from the Doolhof from the painter Johannes Collaert for 3,000 guilders.[3] Jan remarried shortly after the death of his wife Magdalena in 1665, but died during the next summer. He was buried in the Westerkerk in Amsterdam on July 1, 1666.[4] An inventory of his estate was drawn up, and a notarial act of December 15, 1667, settled the priorities of two claimants for unsettled debts owed by the deceased artist.[5]

Jan was a prolific artist who specialized in depicting Dutch topographical views, beach scenes, and imaginary Mediterranean harbor views. Only occasionally did he represent naval battles, of which *The Battle of Terheide* (Cat. 8) is the most famous. He was a prolific draftsman whose views of Dutch towns, cities, and castles conform to the high standards of the Dutch tradition of topographical representation. His large black chalk-and-wash drawings reveal a distinctive personality whose interests form a significant and intriguing overlap with Jacob van Ruisdael, Simon de Vlieger, Anthonie Waterloo, and Reinier Nooms.[6] Thematically and stylistically, Beerstraten's large topographical drawings and atmospherically conceived beach scenes demonstrate close affinity to Simon de Vlieger, whose impact on younger artists active in Amsterdam still requires proper elucidation.[7]

At least three other artists with the name Beerstraten are known: Anthonie, Abraham,[8] and the elusive Johannis, for whom no documentary record exists.[9]

NOTES

1. L. J. Bol, 1973, p. 289.

2. Ibid.

3. Bredius, *Künstler Inventare*, 1917, vol. 3, p. 817.

4. Maclaren, 1960, p. 13.

5. Bredius, vol. 3, pp. 817–819.

6. Beerstraten's beach scenes, particularly certain views of Egmond aan Zee, and his snow scenes are an important parallel to Jacob van Ruisdael's contributions to these subjects, whereas his imaginary Mediterranean harbor views are similar to those by Nooms.

7. The recently discovered *View of Weesp* further confirms de Vlieger's importance as a topographical draftsman: see Cambridge, Sackler Museum – Montreal, Montreal Museum of Fine Arts, *Landscape in Perspective Drawings by Rembrandt and his Contemporaries*, 1988, cat. 99, repr.

8. It remains unclear whether Abraham was Jan's son, born in 1644, as Maclaren suggests (p. 13), or whether more than one artist of this name was active, as Bol queries (p. 288).

9. Maclaren, p. 13; Bol, p. 288.

LITERATURE

Havard, 1880, vol. 3; Willis, 1911, pp. 99–102; Bredius, *Künstler Inventare*, 1917, vol. 3, pp. 814–820; 1921, vol. 7, p. 13; Preston, 1937, p. 54; W.F.H. Oldevelt, *Jaarboek van het Genootschap Amstelodamum*, 1938, vol. 35, pp. 81–87; Maclaren, 1960, pp. 12–16; Bol, 1973, pp. 286–289; Preston, 1974, pp. 8–9.

BALTHASAR FLORISZ. VAN BERCKENRODE

Delft 1591/92 – after 1644 The Hague

Balthasar Florisz. van Berckenrode, the son of the reputed surveyor and engraver Floris Balthasar van Berckenrode, was born in Delft in 1591 or 1592. He trained under his father, assisting him on the important Schieland and Rijnland maps in which Floris Balthasar charted the lakes, rivers, canals, cities, towns, and villages of these two regions in the Province of Holland.

By 1611, Balthasar Florisz. had already produced his first independent print, a map for the Admiralty of Rotterdam. From 1619 he resided in Amsterdam, first on the Reestraat. He married Adriaentgen Cornelisdr. van Schagen in Amsterdam on July 23, 1622. In 1626 and 1631 he is recorded as living on the Egelantiersgracht in Amsterdam.

The States General of the Dutch Republic appointed Balthasar Florisz. as an official surveyor to the government. He moved to The Hague in 1641; there he lived on the Spui in a house called the Gulden Grutmolen (the Golden Gristmill). He paid his guild membership dues on

October 3, 1643, but must have died shortly thereafter, because no prints from his hand appear after 1644.

Balthasar Florisz. was not a prolific engraver (Hollstein lists only twenty-one items).[1] He is most noted for his celebrated *Groundplan of Amsterdam* of 1625 (Cat. 102) and a smaller *Groundplan of Rotterdam* from 1626. The artist produced this smaller work in honor of the College of Delfland, which paid his wife, Adriana Cornelisdr. Schagen, 12 pounds and 40 grooten on November 20, 1626.[2]

Balthasar Florisz. is also noted for several large history prints representing the *Sieges of Den Bosch* (1629), *Breda* (1637), *Gennep* (1641), and the *Sas van Ghent* (1644), as well as for a *Bird's Eye View of Honselaersdijk Palace*. Such subjects demonstrate his close affiliation with the Stadholder, Frederick Henry, whose military exploits on behalf of the Dutch Republic were the themes of what are arguably the finest military prints produced in Holland during the seventeenth century.

NOTES

1. Hollstein, 1949–, vol. 2, pp. 24–35.

2. M. G. W., 1917, vol. 35, p. 192.

LITERATURE

Bodel-Nijenhuis, 1845, vol. 5, p. 316ff.; Wurzbach, 1974 (rpt. of the 1906 ed.), vol. 1, p. 91; Thieme Becker, *Künstler Lexikon*, 1909, vol. 3, p. 375 (entry by E. W. Moes citing previous literature); M. G. W., 1917, vol. 35, p. 192; d'Ailly, 1932, pp. 103–130.

ABRAHAM VAN BEYEREN

The Hague, 1620/21 – 1690 Overschie

Abraham van Beyeren, the son of Hendrick Gillisz. van Beyeren, was born in The Hague in 1620 or 1621. In 1639 he lived in Leiden, where, aged eighteen, he married Emerentia Staecken. Abraham moved back to The Hague in 1640, joining the Guild of St. Luke there. In February 1647, several months after the death of his first wife, he remarried. His second wife, Anna van den Queborn, was the daughter of the respected portrait painter Daniel van den Queborn. Her aunt was the wife of

Pieter de Putter, a painter of fish still lifes whose influence on van Beyeren is detectable. In 1656, Abraham was one of the founding members of the confraternity Pictura. Despite his productivity as a painter, van Beyeren incurred mounting debts with various tradesmen in The Hague, and, possibly in an attempt to escape this burden, he moved to Delft, joining the artists' guild there on October 15, 1657. Records of unpaid debts indicate his presence in Delft through 1661, but by 1663 he had returned to The Hague. During the years 1669–1674 the artist is recorded in Amsterdam but had registered in the artists' guild in Alkmaar in 1674. He moved to Gouda the following year and remained there until 1677.[1] That year Abraham van Beyeren moved to Overschie near Rotterdam, where he died in 1690. His entire estate including ninety-nine paintings was sold to cover debts.

Abraham van Beyeren is principally known as a still life painter whose subjects range from breakfast themes to ostentatious and sumptuous *pronk* still lifes. He was an important transitional figure from the monochrome tradition to the more brightly colored palette of the *pronk* tradition of midcentury. He also developed a separate category of fish still lifes that resemble the rarer works of his uncle, Pieter de Putter.

Van Beyeren's marines are rare and distinguished. These show a certain affinity with the tonal marines of Jan van Goyen. To some degree, they also anticipate the mature marines of Jacob van Ruisdael in terms of van Beyeren's brighter palette and his focus on the broad expanses of cloud-filled sky and strongly illuminated patches of choppy water. His most remarkable surviving undertaking is the *Visserij-bord* still in situ in the Groote Kerk in Maassluis.[2]

NOTES

1. Helbers, 1947, vol. 62, p. 164.

2. Sullivan, 1987, vol. 101, pp. 115–125.

LITERATURE

Thieme Becker, *Algemeines Künstler Lexikon*, 1909, vol. 3 (entry by E. W. Moes citing previous literature); Willis, 1911, pp. 52–54; Bredius, *Künstler Inventare*, 1917, vol. 4, pp. 1165–1172; 1921, vol. 7, pp. 13–14; Helbers, 1928, vol. 45, pp. 27–28; A.P.A. Vorenkamp, *Bijdrage tot de geschiedenis van het Hollandsch stilleven in de zeventiende eeuw*, Leiden, 1933, p. 24; Martin, 1936, vol. 1, p. 267; Preston, 1937, p. 52; H. E. van Gelder, 1941 (Palet Serie); Helbers, 1947, vol. 62, p. 164; Bernstrom and Rapp, 1957; L. J. Bol, 1973, pp. 159–161; Preston, 1974, p. 10; Sullivan, 1987, vol. 101, pp. 115–125; Meijer, 1988, vol. 102, pp. 243–245.

JAN VAN DE CAPPELLE
Amsterdam 1625/26 – 1679 Amsterdam

Jan van de Cappelle was baptized in Amsterdam on January 25, 1626. Although it was customary to baptize infants a few days after their birth, certain confusion exists in van de Cappelle's case because in a document of November 19, 1666, he declared that he was about forty-two years old.[1] His father, Franchoys van de Cappelle, was the owner of a prosperous dyeworks, the Crowned Hand (*de gecroonde handt*) on the Raamsgracht in Amsterdam. Jan was trained in this profession and was variously cited throughout his career as a carmosin dyer (*carmosynverwer*), merchant, and painter. His father, who died in 1674, only five years before Jan, presumably remained active into his old age running his dyeworks, thereby providing Jan with the income and leisure time to pursue painting.

Jan married Anna Grootingh on February 2, 1653, entering the register of painters who had become citizens of Amsterdam by marrying the daughter of an Amsterdam citizen. Anna was from a wealthy family, and at her mother's death Jan inherited three properties in the city of Amsterdam. Until 1663, he and his family lived on the Keizersgracht, where many of the wealthiest patrician families of the city had built palatial residences. We may assume that van de Cappelle moved easily among Amsterdam's elite. One memento of his social stature is the drawing he contributed to the *Album Amicorum* of Jacob Heyblocq, the rector of the Amsterdam gymnasium. The drawing is accompanied by a verse written by the artist Gerbrandt van den Eeckhout, dated June 29, 1654. (Govaert Flinck, Jan de Bray, Aert van der Neer, and Rembrandt were among the other artists who contributed to Heyblocq's *Album Amicorum*, which also included an impressive roster of distinguished local literary and theological talents.)[2] Eeckhout's verse is of particular interest because he prefaces it with the statement that Jan van de Cappelle was self-taught: "In praise of the art of Johannes van de Cappelle who taught himself to paint out of his own desire."[3] Jan

van de Cappelle had his portrait painted by Rembrandt, Frans Hals, and Gerbrandt van den Eeckhout, but, alas, all three portraits appear to have been lost. In 1663 van de Cappelle moved to the Koestraat in Amsterdam. He and his wife drew up a will on June 10, 1666, but the artist, having recovered from a serious illness, lived until 1679 and died a wealthy man. He was buried in the Nieuwe Kerk in Amsterdam on December 22, 1679.

The inventory of his estate, which took more than seven months to draw up, indicates that Jan van de Cappelle not only possessed valuable commercial chattel and residential properties but had assembled an immense art collection comprising two hundred paintings and no fewer than six thousand drawings. Among its contents were more than seven hundred drawings from his own hand; five landscape paintings by Hercules Seghers; sixteen pictures by Jan Porcellis; ten paintings and four hundred drawings by Jan van Goyen; nine hundred drawings by Hendrick Avercamp; nine paintings and more than thirteen hundred drawings by Simon de Vlieger; and ten paintings and roughly five hundred drawings by Rembrandt.[4]

Simon de Vlieger is the most likely source of inspiration for Jan van de Cappelle's interest in marine art. That van de Cappelle possessed so many of de Vlieger's works supports this supposition. Moreover, de Vlieger resided in Weesp, a town close to Amsterdam, from 1649 until his death in 1653.

Van de Cappelle is best known for his marines, although he also painted winter landscapes. Most of his marines are calms and stately in mood, partly because of the extraordinary painterly effects of the reflecting sailboats and other vessels in the still water. Occasionally, van de Cappelle represents breezy weather conditions. One tantalizing listing in his estate inventory reads: "*A Storm* by the deceased." In fact, only six paintings by the artist appear in his estate, proving that he was able to find collectors for his output. This would not have prohibited a reputable dealer or established painter in the guild from marketing Jan van de Cappelle's pictures.[5]

NOTES

1. Russell, 1975, p. 9.
2. See Russell, 1975, p. 10.

3. Ibid., pp. 10, 48., "Aan Dom Jacobus Heyblocq op de schilderconst van Johannes van de Cappelle, bij hem selfs uijt eygen lust geleert Ao. 1654 29 Junius."

4. Abraham Bredius discovered this inventory and published it in its entirety in 1892 – Bredius, 1892, vol. 10, pp. 133–137. M. Russell republished it, translated into English, in *Jan van de Cappelle*, 1975, pp. 49–57.

5. For further discussion of this issue, see Russell, p. 13, and L. J. Bol, 1973, p. 222.

LITERATURE

Bredius, 1892, vol. 10, pp. 26–40, 133–137; Willis, 1911, pp. 76–79; Hofstede de Groot, 1918, vol. 7, pp. 177–232; Martin, 1936, vol. 2, pp. 386, 388; Preston, 1937, pp. 42–44; Valentiner, 1941, pp. 272–296; Maclaren, 1960, pp. 762–773; Stechow, 1966, pp. 95–98, 106–108; L. J. Bol, 1973, pp. 218–228; Preston, 1974, pp. 12–13; Russell, 1975; P. Sutton et al., in Amsterdam–Boston–Philadelphia, 1987/1988, pp. 285–286; Paris, 1989, pp. 136–137.

PIETER COOPSE

Active in Amsterdam 1668–1677

Virtually no biographical data exists on this marine artist. Pieter Coopse is cited in his brother William's marriage documents in Amsterdam on December 12, 1668. Pieter was married at least twice; he is listed as a widower in his marriage vows to Anna Oldenvliedt on July 4, 1677.

Coopse was putatively the pupil of Ludolf Backhuysen. A painting dated 1657 and a drawing from the following year[1] demonstrate that he was active at the time Backhuysen was developing into a serious marine artist. Nonetheless, Coopse's style conforms closely to Backhuysen's idiom, suggesting that he was influenced by the work of this exuberant master. Coopse's art parallels that of Backhuysen closely in its refinement but lacks the other's dynamism.

Signed paintings by Coopse are in Stockholm and in the Bavarian state collections. Coopse is more spirited as a draftsman and manifests a greater degree of individuality in his brush-and-wash drawings.

NOTE

1. Cited by L. J. Bol, 1973, p. 308.

LITERATURE

Willis, 1911, p. 112; Thieme Becker, *Künstler Lexikon*, 1912, vol. 7, p. 366 (entry by E. W. Moes citing previous literature); Wurzbach, 1974 (rpt. of 1906 ed.) vol. 1,

p. 330; Preston, 1937, p. 69; Bernt, *Zeichner*, 1957, vol. 1, nos. 155–156, repr.; Bernt, *Maler*, 1962, vol. 4, pl. 252; L. J. Bol., 1973, p. 308; Preston, 1974, p. 14; Paris, 1989, p. 137.

WILLEM HERMANSZ. VAN DIEST

The Hague before 1610 – after 1663 The Hague (?)

Willem van Diest was one of the leading marine painters in The Hague during the second third of the seventeenth century. He was first cited in 1631 at the baptism of his child, who, although unnamed in the records, may have been his son Hieronymus, the future marine painter.[1] Van Diest was noted as a specialist in marine painting by the Guild of St. Luke in The Hague, which cited him as "Master Willem, ship painter residing on the Veerkay."[2] Earlier evidence confirming his specialization exists: In 1634 the city magistrates of The Hague paid Willem van Diest 72 pounds flemish for a picture representing a ship from Lubeck, which the residents of The Hague rescued after it had been chased and run aground by a Dunkirk corsair.[3]

In 1656, Willem van Diest – along with other artists active in The Hague including Abraham van Beyeren and Anthonie van der Croos – withdrew from the Guild of St. Luke and organized a separate artists' brotherhood, Pictura. Van Diest painted a marine to adorn its chamber of directors in 1657. This painting later came under dispute because the artist removed it in 1660 without replacing it, and members of Pictura felt obligated to retrieve it from him.[4] Van Diest is last recorded in The Hague on September 10, 1663, in a notarial document declaring that he would not be required to appear as a witness.[5]

Van Diest was not the only distinguished marine painter active in The Hague. Jan van Goyen and Abraham van Beyeren were both resident there at the time. Despite their potential influence on van Diest, he developed a personal style that embraced a wide repertory of marine themes. This included calms, beach scenes, storms, and his preferred subject: small craft in breezy weather. His paintings tend to be monochrome, and his interest in representing gray, lowering weather suggests that he particularly admired the art of Simon de Vlieger. Van Diest's economic, almost spare sense of design may also stem from Jan Porcellis.

NOTES

1. L. J. Bol, p. 163.

2. Ibid., p. 163.

3. Ibid.

4. *Obreens Archief*, vol. 4, pp. 126, 79.

5. L. J. Bol, 1973, p. 163. On July 29, 1666, the three children of Willem van Diest, painter, and his wife, Swaentie Coymans, were cited as beneficiaries in the will of Abraham van der Vougen – A. Bredius, *Künstler Inventare*, 1918, vol. 5, p. 1507.

LITERATURE

Willis, 1911, pp. 54–55; Bredius, *Künstler Inventare*, 1918, vol. 5, p. 1507; Preston, 1937, p. 35; L. J. Bol, 1973, pp. 162–166; Preston, 1974, p. 17.

HENDRICK DUBBELS

Amsterdam 1620/21 – 1676(?) Amsterdam

Hendrick Dubbels remains an enigmatic master despite a reasonable number of surviving signed paintings, many of which have only recently come to light. Little is known about his life, but in a document of March 1641, Dubbels is cited as being age nineteen, and a second document, of September 1651, cites his age as thirty. Dubbels is recorded as living in Amsterdam in these two documents and in others of 1663, 1664, and 1665. He is listed as a member of the Amsterdam artists' guild in 1650. Dubbels married in 1651 and, after the death of his first wife, remarried in 1656. He was cited as a shopkeeper in 1663, and in 1665 declared bankruptcy. Whether the "Henricus Dubbels" who was buried in Amsterdam on June 9, 1676, is the same as the marine artist remains conjectural.

Stylistically, Dubbels shows close affinity with Simon de Vlieger and Jan van de Cappelle. De Vlieger was possibly his teacher and exerted the greatest influence on Dubbels, most evident in terms of the latter's interest in a silvery, atmospheric tonality but especially in his representation of clouds. In his paintings Dubbels creates a vast canopy of overlapping clouds that ultimately lacks the diaphanous quality of Jan van de Cappelle's skies. Dubbels followed de Vlieger's repertory of marine subjects closely, representing beach scenes, fleets offshore in unsettled weather, and shipwrecks off imaginary rocky coasts in stormy

weather. In his *parade* subjects and calms Dubbels shows an equal affinity to van de Cappelle. He frequently includes surprisingly prominent foreground staffage – often single fishermen going about their business on beaches or figures in skiffs silhouetted against the still water. Jan van de Cappelle also depicts such figures, but they tend to be less conspicuous.

Dubbels's earliest dated painting is from 1653 (Kassel, Gemäldegalerie), but he must have been active several years earlier. Regrettably, many of his pictures have lost their original Dubbels signature in the process of being "upgraded" into spurious Jan van de Cappelles, thereby hastening Dubbels's fall into obscurity. Only recently, through the efforts of Laurens Bol and others, has Dubbels begun to secure the stature he deserves.

LITERATURE

Willis, 1911, pp. 72–76; Bredius, *Künstler Inventare*, 1919, vol. 6, pp. 1879–1885; Martin, 1936, vol. 2, p. 373; Preston, 1937, pp. 53–54; Maclaren, 1960, p. 109; L. J. Bol, 1973, pp. 211–218; Preston, 1974, pp. 18–19; Russell, 1975, pp. 43–47.

ALLAERT VAN EVERDINGEN

Alkmaar 1621 – 1675 Amsterdam

Allaert van Everdingen, younger brother of the history painter Caesar van Everdingen, was baptized in Alkmaar on June 18, 1621. Arnold Houbraken states that Allaert studied with Roelandt Savery in Utrecht and subsequently with Pieter Molyn in Haarlem. Allaert traveled to the southern coast of Norway and the region of Sweden around Göteborg, where he produced annotated, topographical pen drawings. He was back in Holland by 1645 and married Janneke Cornelisdr. Brouwers in Haarlem on February 21 of that year. He became a member of the Dutch Reformed Church in Haarlem on October 13, 1645, and entered the artists' guild the following year. Between 1646 and 1651 four of his children were baptized in Haarlem. In 1652, Allaert van Everdingen moved to Amsterdam, where he became a citizen in 1657. In 1661 the artists Allaert van Everdingen, Willem Kalf, Barend Kleeneknecht, and Jacob van Ruisdael were asked to judge the authenticity of a marine painting purportedly by Jan Porcellis, which they, by consensus, felt was not correctly attributed to that master.[1] Several works by Everdingen indicate that he made an otherwise undocumented journey to the Ardennes in the Spanish Netherlands at some point after he moved to Amsterdam.[2] Allaert van Everdingen died in Amsterdam and was buried in the Oude Kerk on November 8, 1675. A portion of his estate was sold on March 3, 1676; and the sale of his widow's estate on April 16, 1709, which included pictures by many notable sixteenth- and seventeenth-century masters, suggests that the artist may have supplemented his career by being an art dealer.

Everdingen's earliest dated painting from 1640 is a marine. His contribution to marine painting was notable, although his oeuvre was small (Davies lists twenty marines).[3] He transformed the monochrome subjects of Porcellis into more august visions of the restless, even tempestuous sea in which the interplay between tossing waves and cloudy sky becomes a dramatic visual counterpoint. This stately concept of marine painting appealed enormously to Jacob van Ruisdael, whose debt to Allaert van Everdingen was significant.[4]

Everdingen was a prolific printmaker, a draftsman of the first rank, and an ambitious painter. One measure of his success was the important commission to produce several landscapes to decorate the interior of the Trip mansion in Amsterdam. His only known pupil was Ludolph Backhuysen, although Everdingen had many followers and emulators, of whom Jacob van Ruisdael and Jan van Kessel are the best known.

NOTES

1. For a full discussion of this adjudication, see S. Slive in The Hague, Mauritshuis – Cambridge, Fogg Art Museum, *Jacob van Ruisdael*, 1981/1982, p. 22.
2. Whereas Davies (1978, p. 39) postulates that this trip occurred about 1660, F. Duparc argues that a date shortly before 1654 is more likely – Mauritshuis, 1980, pp. 30–31.
3. Davies, 1978, pp. 320–324, cat. 1–20.
4. Ruisdael's emulation of Everdingen's Scandinavian waterfall subjects has received far more attention in the critical literature.

LITERATURE

Houbraken, 1718–1721, vol. 2, pp. 95–96; Willis, 1911, pp. 65–67; Bredius, *Künstler Inventare*, 1915, vol. 1, pp. 17–18; Preston, 1937, pp. 54–55; L. J. Bol, 1973, pp. 203, 205; Davies, 1978; Preston, 1974, p. 20; Mauritshuis, 1980, pp. 29–31; P. Sutton et al., in Amsterdam–Boston–Philadelphia, 1987/1988, p. 307 (with bibliography); Paris, 1989, pp. 139–140.

JAN VAN GOYEN
Leiden 1596 – 1656 The Hague

Jan van Goyen, son of the cobbler Joseph Jansz. van Goyen, was born in Leiden on January 13, 1596. According to the Leiden chronicler, J. J. Orlers,[1] from a young age Jan was determined to excel in art and was apprenticed successively to four Leiden artists, including the glass designer Hendrik Clock. Because none of his Leiden teachers apparently fulfilled van Goyen's aspirations, his father arranged for him to study with the landscape painter Willem Gerritsz. in Hoorn, where the young man remained for two years.[2] Gerritsz. also seems to have had no noticeable impact on the aspiring painter. Van Goyen returned to Leiden and at age nineteen, according to Orlers, journeyed throughout France for a year, returning to study with Esaias van de Velde in Haarlem. This critical contact occurred just before van de Velde moved permanently to The Hague during the summer of 1618 (Beck dates this apprenticeship at about 1617).[3] Following his period of study with Esaias, van Goyen returned to Leiden, where he married Annetje Willemsdr. van Raelst on August 5, 1618. Even during his Leiden years, van Goyen tried to supplement his income through speculation in real estate. On May 14, 1629, he sold a house on the St. Pieterskerkstraat in Leiden to the noted marine painter Jan Porcellis. Possibly during the summer of 1632, van Goyen moved to The Hague, the residence of the Stadholders and center of government of the Dutch States General. On March 13, 1634, he acquired citizenship in The Hague, and in 1638 and 1640 he served as *hoofdman* in the artists' guild. He continued his speculative instincts in The Hague both in residential property and as an unlucky participant in the Tulip Mania that swept the Dutch Republic in 1636–1637. In 1649, van Goyen's two daughters married artists, Maria to Jacques de Claeuw and Margaretha to Jan Steen. Each bore her respective husband eight children.

Despite his prodigious output and considerable investment in property, Jan van Goyen left a heavily encumbered estate at his death in The Hague on April 27, 1656.

His earliest paintings reveal a great debt to Esaias van de Velde. During the later 1620s, in all likelihood inspired by the example of Jan Porcellis, van Goyen transformed his style to become the leading practitioner of monochrome landscape painting. He traveled widely throughout the Dutch Republic eastward along the Rhine into the region of Cleves, Emmerich, and Elten. In about 1648 he also visited many of the great cities of Brabant and Flanders in the Spanish Netherlands.[4] Numerous chalk sketches, many of which still survive in their original format as leaves in pocket-size sketchbooks, immortalize these journeys. Van Goyen was an avid sailor who plied the rivers, estuaries, and inland seas of his native land. Like Salomon van Ruysdael, his marines are confined to the rivers, lakes, and coastline of the Dutch Republic, and, as Laurens Bol points out, a van Goyen marine always includes some patch of land, whether a riverbank or an island in the vast deltas of the Rhine, Maas, or Scheldt or the coastal dunes of Holland.[5] Unlike Salomon van Ruysdael, van Goyen in his later marines occasionally represents oceangoing vessels, although he clearly feels more at home depicting the type of open sailboat that he handled so deftly. The focus of his marines is the inexhaustibly varied interplay of water, land, and sky in ever changing weather conditions. Occasionally van Goyen depicted stormy weather that, in rare instances, includes lightning bolts. He also represented calms, but his preferred subject was blustery weather in which a stiff breeze sets the world in motion.

NOTES

1. Orlers, 1641, vol. 1, pp. 373–374.
2. Renckens, 1951, vol. 66, pp. 23–34.
3. Beck, 1972–1973, vol. 1, p. 16.
4. Beck, vol. 1, cat. no. 846, pp. 271–283.
5. L. J. Bol, 1973, p. 128.

LITERATURE

Orlers, 1641, vol. 1, pp. 373–374; Willis, 1911, pp. 51–52; Hofstede de Groot, 1923, vol. 8, pp. 3–350; Preston, 1937, pp. 26–28, 31; Waal, 1941 (Palet Serie); Stechow, 1966, pp. 22–23, 26–27, 39, 41, 54–56, 87–90, 102–103, 114–115; Beck, 1972–1973; L. J. Bol, 1973, pp. 119–132; Preston, 1974, pp. 22–23; P. Sutton et al., in Amsterdam–Boston–Philadelphia, 1987/1988, pp. 317–318; Paris, 1989, p. 142.

HENDRICK HONDIUS II

Amsterdam ca. 1597 – 1651 Amsterdam(?)

Hendrick Hondius II was the son of the famous cartographical publisher Jodocus Hondius the Elder, whose publishing house in Amsterdam, "de Wackeren Hont" (the watchful dog), was the great rival to Willem Jansz. Blaeu's at the beginning of the seventeenth century. Hendrick's mother, Colette van den Keere, was the sister of Pieter van den Keere (see Cat. 127), another important publisher of cartographical material. Hendrick Hondius II, aged twenty-eight, married Janneken Verspreet on November 7, 1625. Their son, Jodocus III, was baptized in Amsterdam on September 8, 1626. Hendrick followed his father's footsteps as a publisher in Amsterdam and was particularly active in the years 1624–1640, concerning himself principally with cartographical material. Initially he was an independent publisher with his brother, Jodocus II, and together they oversaw the reissue in 1627 of Jodocus Hondius the Elder's *World Map* of 1611, and produced a *Map of Brabant* in 1629. From 1623 onward Hendrick was involved in publishing revised editions of the *Mercator Atlas*.[1] From 1636 and possibly earlier Hendrick Hondius II worked in partnership with his brother-in-law, Johannes Janssonius. Hendrick was a friend of Constantijn Huygens, as surviving letters of 1637, 1640, and 1644 attest.

In 1924, W. Stechow reassessed the complex and confused definition of the printed oeuvre of Hendrick Hondius I, a publisher and printmaker active in The Hague, and Hendrick Hondius II.[2] The relationship of these two artists has not been established.

Hendrick Hondius I stems from a late Mannerist tradition and undertook several notable publications including military treatises, manuals of instruction at arms and artillery, as well as history prints representing sieges and maps of land battles. He also published the well-known series of portraits of religious reformers and a new edition of the portraits of the artists of the Low Countries after Hieronymus Cock's *Pictorum Aliquot Celebrium Praecipuae Germaniae Inferioris Effigies*, published in The Hague in 1610.

By contrast, there is no evidence that Hendrick Hondius II produced prints: He restricted his activities to publishing. A broadsheet such as the *Navire Royale* (Cat. 103) would have appealed to a publisher of

maritime atlases and maps as an appropriate sideline to his main activities.

NOTES

1. For these and other notable publications issued by Hendrick Hondius II, see Koeman, *Atlantes Neerlandici*, 1967–1971, vol. 2, pp. 136–146.

2. Thieme Becker, *Künstler Lexikon*, 1924, vol. 17, pp. 435–436.

LITERATURE

Wurzbach, 1974 (rept. of 1906 ed.), vol. 1, p. 707; Thieme Becker, *Künstler Lexikon*, 1924, vol. 17, pp. 435–436 (entry by W. Stechow); Waller, 1974 (rept. of 1938 ed.), p. 147; Koeman, *Atlantes Neerlandici*, 1967–1971, vol. 2, pp. 136–146.

ROMEYN DE HOOGHE

1645 Amsterdam – Haarlem 1708

Romeyn de Hooghe was a prolific printmaker who produced more than 3,500 etchings, most of which are book illustrations. He also produced frontispieces for many books published in Amsterdam, Leiden, and elsewhere in the Dutch Republic. De Hooghe was also a painter, sculptor, and designer of medals and stained-glass windows. He was an erudite man who held a law degree and served on the Haarlem court of justice in 1687 and 1688.

The son of a button maker, Romeyn de Hooghe was baptized in Amsterdam on September 10, 1645. In 1662 he was a member of Pictura, the artists' confraternity in The Hague. After a visit to Paris in 1668, de Hooghe established himself in Amsterdam, where he married Maria Lansman in 1673. He worked closely with many of the celebrated publishers of Amsterdam, the chief book-publishing center of Europe at the time.

The artist was a great admirer of the stadholder, William III, and became a staunch supporter of the Orangist party. His many illustrated political treatises and broadsheets champion William's cause. In recognition of this support, the stadholder appointed Romeyn de Hooghe commissioner of mines for the region of Lingen. De Hooghe became virulently anti-French following the invasion of the Dutch Republic by the armies of Louis XIV in 1672. The artist became one of the first

great political satirists of the seventeenth century, a unique chronicler of the epoch of Louis XIV. His satires and allegorical and history prints provide an unequaled picture of political events in Holland during the period 1670–1700.

De Hooghe inherited a house in Haarlem from an uncle and moved there about 1680–1682. He became active in local affairs and enriched Haarlem's cultural life when, in 1688, with a subsidy from the city, he set up a drawing academy.

In 1690, Romeyn de Hooghe became embroiled in a libel case initiated by the city of Amsterdam. He was accused of atheism, incest with his daughter, and the production of pornography. The mayor of Haarlem agreed to hear the case, but the artist was never prosecuted.

Although best known as a political satirist, Romeyn de Hooghe also produced notable cartographical and topographical prints. His *Groundplans of Delft* (1675–1678), *Haarlem* (1689), and *Rotterdam* (1694) (Cat. 104) are among the most important works of their type produced in Holland during the seventeenth century. He also designed and etched the frontispiece to Nicolaes Witsen's *Aeloude en Hedendaegsche Scheeps-Bouw en Bestier*, first published in Amsterdam in 1671. Witsen was the leading Dutch authority on shipbuilding and ship design of the later seventeenth century, and his profusely illustrated maritime publications were internationally renowned.

Romeyn de Hooghe died in Haarlem on June 10, 1708, and was buried in the Church of St. Bavo five days later.

LITERATURE

Thieme Becker, *Künstler-Lexikon*, 1924, vol. 17, pp. 458–461 (entry by M. D. Henkel, who cites previous literature); Landwehr, 1970; W. H. Wilson, 1974; Boston–Saint Louis, 1980/1981, p. 257.

MEYNERT JELISSEN
Active in Amsterdam ca. 1612

This artist is known only through a handful of engravings after other masters. Waller indicates he was a publisher and draftsman as well as an engraver. Wurzbach lists two prints, one of which, *Abraham and Melchisedech,* bears the address of the publisher, Kornelis Jansen.

LITERATURE

Wurzbach, 1974 (reprint of edition of 1906), vol. 1, pp. 754—755; Thieme Becker, *Künstler Lexikon*, 1925, vol. 18, p. 500 (entry by M. D. Henkel); Waller, 1974 (rept. of 1938 edition), p. 164.

PIETER MULIER THE ELDER
Haarlem ca. 1610/15 – 1670 Haarlem

Little is known about Pieter Mulier the Elder, who was first recorded as a member of the Haarlem Guild of St. Luke in 1640. He was buried in Haarlem on April 22, 1670. Traditionally he is cited as a pupil of Salomon van Ruysdael, although Mulier's art betrays only modest stylistic affinities with Ruysdael's. Mulier's interest in beach scenes and his adoption of the upright format in certain of his marines indicate his awareness of the mature art of Salomon van Ruysdael, but his sustained dedication to the monochrome marine indicates a much closer affinity to Jan Porcellis and the Leiden school of marine painting than to developments in Haarlem.

Mulier was a reasonably prolific artist, frequently signing his paintings with the monogram PML. He was a capable painter of modest ambitions, whose activities as a draftsman are becoming better known. Until recently his drawings were ascribed to other, more illustrious, artists, including Hendrick and Cornelis Vroom, Cornelis Claesz. van Wieringen, Jan Porcellis, and Bonaventura Peeters. In certain respects Mulier's drawings demonstrate closer links to his Haarlem origins and associate him with the greatest marine artists of the preceding generation.

Mulier's son, Pieter Mulier II (1637–1701), left Holland at a young age and established himself in Italy, where he became better known as "Cavaliere Tempesta." His early drawings reveal a greater debt to Pieter Molyn and Nicholas Berchem than to his father, whose art failed to ignite his imagination to the same degree.

LITERATURE

Willis, 1911, pp. 60–61; Preston, 1937, p. 35; Röthlisberger, 1970; Müllenmeister, 1973; L. J. Bol., 1973, pp. 142–147; Preston, 1974, p. 29; Keyes, 1976, vol. 90, pp. 230–261.

REINIER NOOMS ("ZEEMAN")

Amsterdam ca. 1623 – 1664 Amsterdam

Virtually nothing is known about the life of this significant master. He appeared as a witness before various notaries in Amsterdam in 1653 and 1663. On March 8, 1658, Nooms declared that he was about thirty-five years old.[1] He died in 1664.[2] In May of that year the Utrecht painter Nicolas Outhuys deeded an income to Maria Mousien (Moosijn), wife of Reinier Nooms, the better to feed and provide for herself.[3] This document implies that by May 1664, Nooms was incapable of supporting his family. He must have died shortly afterward. On December 9, 1667, his widow, Maria Jans (Moosijn), drew up an inventory of her possessions as part of her marriage contract to Dirck van den Helm.[4] This inventory cites several pictures by Nooms plus his library, which included several nautical treatises.

Nooms is best known as an etcher whose output numbers more than 170 plates. With few exceptions he produced these in series, which fall into four basic categories: topographical views of Amsterdam including one suite representing its gates; topographical views of Paris and its environs; maritime scenes; and depictions of various types of ships. Two dated sets of etchings were published in Paris in 1650 and 1652.[5] Many posthumous editions of Nooms's prints attest to the sustained popularity of his etchings.

Nooms was also a prolific draftsman whose vivacious yet finished brush and gray wash sketches are among the most felicitous of all Dutch seventeenth-century marine drawings. Although many of these drawings were preparatory studies for his etchings, they were also treated as finished works in their own right and considered a desirable staple in any great drawings cabinet.

Nooms's nickname, "the Seaman," and the itemized navigational treatises in his widow's estate imply that Nooms was an experienced sailor who traveled far beyond the confines of his native land. He frequently painted Mediterranean harbor views and coastal landscapes that seem to derive from firsthand experience of this region. Moreover, Nooms painted two if not three surviving versions of *The Battle of Livorno* of March 12, 1653 (Cat. 20 and 21), an action of the First Anglo-Dutch War.[6] Nooms's interest in topography ranges from surviving views of Paris to the four representations of the North African seaports, Salee, Tripoli, Tunis, and Algiers, preserved in the Rijksmuseum in Amsterdam.[7] Despite his wide-ranging topographical interests, Nooms's most interesting subjects are his views of Amsterdam and his close examination of ships, their maintenance and operation.

L. J. Bol stresses the subtle atmospheric effects of Nooms's pictures and rightly believes that Zeeman remains underestimated as a painter. In this reappraisal Bol sees a close connection between Nooms's cool, silvery-gray palette and the tonalism of Simon de Vlieger. He even postulates that Nooms may have worked in de Vlieger's atelier for a time.[8] This hypothesis further confirms my belief that de Vlieger's role in influencing younger artists active in Amsterdam at midcentury was central to the further development of Dutch marine art.

NOTES

1. Bredius, *Künstler Inventare,* vol. 7, p. 201.

2. *Illustrated Bartsch,* 1986, vol. 6 (commentary), p. 109, citing an unpublished document in the Amsterdam municipal archives discovered by S. Hart.

3. Bredius, *Künstler Inventare,* p. 201.

4. Ibid., p. 199.

5. C. Ackley, in Boston–Saint Louis, 1980/1981, p. 221. This production of etchings printed in Paris finds an interesting parallel in analogous material by Herman Swanevelt, who was also active for periods of time in Paris. Stylistically the prints by these two artists contain similarities, and the possibility that they knew each other should not be excluded.

6. Amsterdam, Rijksmuseum; Amsterdam, Rijksmuseum "Nederlands Scheepvaart Museum" (Livorno?); and Greenwich, National Maritime Museum.

7. Amsterdam, *All the Paintings,* 1976, pp. 418–419, inv. nos. A 1396–A1399, repr.

8. L. J. Bol, 1973, p. 291.

LITERATURE

Bartsch, 1805, vol. 5, pp. 127–146; Willis, 1911, pp. 103–105; Bredius, *Künstler Inventare,* 1921, vol. 7, pp. 199–201; Martin, 1936, vol. 2, pp. 381–382; Preston, 1937, p. 53; L. J. Bol, 1973, pp. 289–296; Preston, 1974, pp. 30–32; *Illustrated Bartsch,* 1980, vol. 6, pp. 113–237, and 1986, vol. 6 (commentary, ed. C. Levesque), pp. 109–197; Boston–Saint Louis, 1980/1981, pp. 221–224; Paris, 1989, p. 155.

JAN PORCELLIS
Ghent 1580/84 – 1632 Zouterwoude

Jan Porcellis was born in Ghent, in the Spanish Netherlands, of parents who emigrated in 1584 with so many other Protestants seeking refuge in the northern Netherlands. Porcellis is first documented in 1605 when he married Jacquemijntje Jans in Rotterdam. He probably received his first training in Rotterdam, but Houbraken's assertion that Porcellis was a pupil of Hendrick Vroom in Haarlem warrants consideration, even though the oeuvre of the two artists seems, at first sight, so antithetical.[1] Two paintings at Hampton Court Palace, now attributed to Porcellis, may be dated no later than 1612 and possibly even to 1610 because they were presented by Dutch emissaries to Henry, Prince of Wales (died 1612), whose royal brand is found on the back of each panel. These works show a certain affinity to Hendrick Vroom in terms of their melodramatic subject matter, but, as John Walsh, Jr., points out, they are also a premonition of Porcellis's radical rethinking of Dutch marine art.[2] By 1615, Porcellis had gone bankrupt in Rotterdam and subsequently moved with his wife and three children to Antwerp, where he remained for about nine years. Soon after his arrival there in 1615, Porcellis signed a contract with Adriaen Delen, a cooper in Antwerp, to deliver two panel paintings a week for twenty weeks, for which the artist received an advance of 32 guilders, a weekly payment of 15 guilders, plus an equal share of the profits generated from the sale of these pictures in the Antwerp market.[3] Porcellis was listed as a free master in the Antwerp artists' guild in September 1617. He settled in Haarlem in 1622 and remained there until 1624. His first wife having died in Antwerp, on August 30, 1622, Porcellis married Janneke Flessiers, the daughter of the painter and print publisher, Balthasar Flessiers, in Haarlem. Although Samuel Ampzing, in his *Beschryvinghe ende Lof der Stad Haerlem* of 1628, claimed that Porcellis was the greatest living marine painter of Haarlem, in fact the artist had already moved to Amsterdam in 1624, but by 1626 he was residing in Voorburg, outside The Hague. By 1626, Porcellis was also acquiring property in Zouterwoude, a village on the Rhine near Leiden. Through the substantial inheritance of his wife in 1627, Porcellis was able to pay the large sum of 4,000 guilders for a house owned by the Flessiers in The Hague,

which he never occupied but acquired as an investment. He also bought three more properties in Zouterwoude and purchased a house on the Sint Pieterskerkstraat in Leiden from Jan van Goyen on May 14, 1629, for 1,200 guilders.[4] These real estate transactions indicate that Porcellis enjoyed great prosperity during his last years, cut short by his early death on January 29, 1632. Jan Porcellis bequeathed all those works by his own hand, still in his possession, to his only son, Julius, who continued to paint marines in his father's manner.

Jan Porcellis was the leading marine painter of the generation succeeding Hendrick Vroom and his contemporaries. He played a seminal role in redefining Dutch marine art from the depiction of graphically detailed historical events to evocations of the sea. Porcellis stressed the interplay of cloudy sky, wind, and restless sea in atmospheric conditions. In his art he supplanted strong local color with a predominant gray tonality. Porcellis developed this monochrome palette in the course of the 1620s. He owned a sailboat (a *jachtschuit*), in which he must have plied the inland seas of Holland and estuaries of Zeeland. His marine paintings immortalize these subjects and focus on the broad estuaries, sand dunes, and islands that define the Dutch coast. Two series of prints, twenty etchings by Gillis van Scheyndel entitled *Verscheyden Stranden en Water Gesichten* published by Jan Pietersz. Beerendrecht in Haarlem, and a suite of twelve engravings entitled *Variarum navium hollandicarum*, published in 1627 by Claes Jansz. Visscher in Amsterdam, further attest to Porcellis's growing recognition during the 1620s. In one sense this culminated in a passage in Constantijn Huygens's unpublished youthful autobiography, in which he places Porcellis at the forefront of Dutch marine art: "On account of the year of his birth there finally comes a place for Hendrick Vroom, a famous sea painter, but now so much inferior to Porcellis and others even less well known that I feel he can hardly be mentioned in the same breath with them."[5]

Porcellis's paintings were sought after by discerning seventeenth-century collectors, including artists. Rubens owned one; Rembrandt, six; Allaert van Everdingen, thirteen; and Jan van de Cappelle, sixteen. During the artist's lifetime his work was copied – a single collection, auctioned in Haarlem on November 17, 1631, contained twelve copies after Porcellis.[6] The artist had a number of followers and emulators including his son, Julius, his brother-in-law, Hendrick van Anthonissen,

Hendrick Staets, Cornelis Leonardsz. Stooter, and Pieter Mulier the Elder.

NOTES

1. Houbraken, 1718/1721, vol. 1, p. 213.

2. Walsh, 1974a, pp. 654, 657.

3. Ibid., p. 657.

4. Beck, 1973, vol. 1, pp. 17, 29. In 1632, Porcellis's widow, Janneke Flessiers, sold this house to her brother-in-law, Hendrick van Anthonissen.

5. Walsh, 1974a, p. 653, fn. 3.

6. L. J. Bol, 1973, p. 92.

LITERATURE

Ampzing, 1628; Schrevelius, 1648; Hoogstraeten, 1678, pp. 237–238; A. Bredius, "Johannes Porcellis, zijn leven, zijn werk," *Oud Holland*, 23 (1905), pp. 69–73, and 25, (1906), pp. 129–138; Haverkorn van Rijsewijk, 1906a, vol. 9, pp. 189–206, and 1906b, vol. 10, pp. 64–74; Willis, 1911, pp. 35–40; Bredius, *Künstler Inventare*, 1916, vol. 2, pp. 614–618; 1921, vol. 7, pp. 173–179; Martin, 1936, vol. 1, pp. 261–264; Preston, 1937, pp. 22–25; Stechow, 1966, pp. 111–114; Walsh, 1974a, vol. 116, pp. 653–662, and Walsh, 1974b, pp. 734–745; L. J. Bol, 1973, pp. 91–102; Preston, 1974, pp. 36–38; Duverger, 1976, pp. 269–279; Los Angeles–Boston–New York, 1981/1982, pp. 73–75; Paris, 1989, pp. 144–145.

HANS REM

Antwerp, ca. 1567 – 1620 Amsterdam

Hans Rem, born about 1567 in Antwerp, was the son of Joris Rem, a painter who died in Kampen. On April 22, 1594, Hans became a citizen of Amsterdam. He drew up a will on April 29, 1620, and that is the last we hear of this still obscure artist. The surviving history prints after Rem's designs are important and indicate a master whose art catered to the highest echelon of society. The nature of his work would suggest that Rem must have been acquainted with the leading mapmakers and publishers of cartographical material in Amsterdam. On November 8, 1602, Rem, cited as a resident of Amsterdam, received a five-year extension on his copyright from the States General of the Dutch Republic for his large print *The Battle of Sluis* (Cat. 118).[1]

NOTE

1. *Resolutiën*, 1950 (R.G.P. 92), (vol. 12: 1602–1603), p. 323.

LITERATURE

Thieme Becker, *Künstler Lexikon*, 1934, vol. 28, p. 145 (entry by M. D. Henkel). Waller, 1974 (rept. of 1938 ed.), p. 268. *Resolutiën*, 1950 (R.G.P. 92), (vol. 12: 1602–1603).

HENDRICK RIETSCHOEFF

1678(?) – 1746 Hoorn

According to Houbraken, Hendrick Rietschoeff was born in 1678.[1] The artist died in Hoorn in 1746. Initially, Hendrick was the pupil of his father, Jan Claesz. Rietschoeff (1652–1719), who trained under Ludolph Backhuysen. Subsequently, Hendrick also studied with Backhuysen and, like Pieter Coopse, was a capable emulator of Backhuysen's style and perpetuated his concept of marine art well into the eighteenth century. A modest number of Hendrick Rietschoeff's paintings exist,[2] but he is better represented by his drawings, which survive in greater numbers.

NOTES

1. Houbraken, 1976, vol. 3, p. 323.

2. Thieme Becker, *Künstler Lexikon*, vol. 28, p. 346, lists a handful of paintings by Rietschoeff.

LITERATURE

Houbraken, 1976 (rept. of 1753 ed.), vol. 3, p. 323; Wurzbach, 1974 (rept. of 1911 ed.), vol. 2, p. 458; Thieme Becker, 1934, vol. 28, p. 346.

JACOB VAN RUISDAEL

Haarlem 1628/29 – 1682 Amsterdam

Jacob van Ruisdael, son of the framemaker and picture dealer Isaack van Ruisdael, was born in Haarlem in either 1628 or 1629. This ambiguity is based on Jacob's declaration in a notary's deed dated June

9, 1661, that he was thirty-two years old.[1] Isaack moved with his brother, Salomon van Ruysdael, the noted landscape painter, to Haarlem about 1616. At the time of his marriage to Maycken Cornelisdr. on November 12, 1628, Isaack is described as a "widower from Naarden." Whether Jacob was the child of this second marriage or of the first remains uncertain.[2]

Little is known about Isaack except his pecuniary difficulties, but occasional references in old inventories suggest he may have been a painter as well as framemaker and picture dealer. He may have taught his son certain rudiments of painting, but Jacob was precocious and must have sought more stimulating tutelage from other artists, including his uncle Salomon. Subsequently he derived significant inspiration from the mature landscapes of his older Haarlem compatriot, Cornelis Vroom.

By 1646, aged seventeen or eighteen, Jacob van Ruisdael signed paintings and etchings, indicating that the Haarlem painters' guild – which normally prohibited artists younger than twenty from signing their works – must have recognized the young Ruisdael's extraordinary talents and made an exception in his case. Even as a youth he must have assisted his father financially, because after 1646 all legal disputes concerning Isaack's inability to pay his debts ceased.[3]

As a young man Jacob traveled to Naarden, Alkmaar, and Egmond. Subsequently, around 1650, he accompanied Nicolas Berchem to the eastern regions of the Dutch Republic and into Westphalia. The two artists visited Bentheim and Burgsteinfurt but also must have stopped at Singraven in Overijssel, where Ruisdael studied the watermills that made such a lasting impression on him.

Probably in 1656 or 1657, Ruisdael moved to Amsterdam, where he remained for the rest of his life.[4] He lived on the Kalverstraat at the time he drew up his two wills of 1667, but by about 1670 he had moved to a house on the south side of the Dam, which afforded him a unique view of the bustle of the city across its greatest public space, and toward the Damrak and harbor beyond.

Ruisdael died, presumably in Amsterdam, about March 10, 1682; on March 14,[5] his body was transported to Haarlem for burial in the Church of St. Bavo.

Ruisdael is principally known as a landscape artist whose repertory included dune landscapes, forest subjects, watermills, vast panoramas including his famed "*Haarlempjes*," imaginary "Scandinavian" scenes containing waterfalls and cascading water, beach scenes, and city views. His marines are rare and, with few exceptions, capture nature at its most brooding and turbulent.

NOTES

1. S. Slive, in The Hague–Cambridge, 1981/1982, p. 16.

2. Ibid., p. 17.

3. Ibid., p. 18. Moreover, in two wills that Jacob drew up on May 23 and May 27, 1667, he made ample provision for his aged father – ibid., p. 25.

4. In a document of June 14, 1657, Ruisdael indicated his desire to be baptized into the Dutch Reformed Church in Amsterdam – Slive, in The Hague–Cambridge, 1981/1982, p. 21.

5. Ibid., p. 25. Ruisdael's worldly estate was far removed from that of his first cousin, Jacob Salomonsz. van Ruysdael, who died insane in the Haarlem almshouse on November 13, 1681. Until the archival discoveries of Wijnman in 1932, it was assumed that Jacob Isaacksz. van Ruisdael was the unfortunate pauper who died under these abject circumstances.

LITERATURE

Willis, 1911, pp. 62–64; Hofstede de Groot, 1912, vol. 4, pp. 1–349; K. E. Simon, 1927; Rosenberg, 1928a; Preston, 1937, pp. 46–47; Maclaren, 1960, pp. 353–355; L. J. Bol, 1973, pp. 276–282; The Hague–Cambridge, 1981/1982; Amsterdam–Boston–Philadelphia, 1987/1988, pp. 437–438 (with bibliography).

SALOMON VAN RUYSDAEL
Naarden 1600/1603 – 1670 Haarlem

Salomon van Ruysdael was born in Naarden, a small fortified city southeast of Amsterdam in the region known as Gooiland. He originally called himself Salomon de Goyer, but changed his name to Ruysdael in reference to Castle Ruisdael (or Ruisschendael) near Blaricum, where his grandfather resided. After his father's death in 1618, Salomon and his older brother, Isaack, father of Jacob van Ruisdael, moved to Haarlem. Salomon entered the Haarlem painters' guild in 1623, inscribed as Salomon de Gooyer, and remained an active member of it up until his death in 1670. He was an overseer (*vinder*) of the guild in 1647

and 1669 and served as deacon in 1648.[1] As a Mennonite, Salomon was not allowed to bear arms but contributed financially to the Haarlem militia. He was an astute businessman, with interests in the cloth industry for which Haarlem was famous. Salomon also owned valuable properties in Haarlem and died a wealthy man. He was buried in the Church of St. Bavo in Haarlem on November 3, 1670.[2]

Although principally active as a landscape painter, Salomon van Ruysdael began producing marines shortly after 1640. As Laurens Bol indicates, these evolve from his river landscapes of the 1630s. Sailboats play a progressively greater role in the composition, to the point that they become the prime pictorial element set against a vast expanse of sky.[3] Around 1650 Salomon developed small, usually square or upright marine compositions that are among his most spirited paintings.[4]

Salomon's marines offer a parallel to the art of Jan van Goyen, who journeyed throughout the Dutch Republic in his own sailboat. As an indefatigable observer, van Goyen produced several chalk sketchbooks in which he records the landscape and topography of his native land.[5] Salomon also represented the river towns, inland seas, estuaries, and beaches of the Dutch Republic. His marines remain landlocked, and his interest in river topography stamps Ruysdael's marine subjects, which immortalize the unique character of Holland.

NOTES

1. Amsterdam–Boston–Philadelphia, 1987/1988, p. 466.

2. His funeral costs, 24 florins, were considerable for the period and indicated his prominent social position.

3. L. J. Bol, 1973, pp. 148–149.

4. Stechow, 1938, lists roughly two dozen upright marines plus an even larger number of horizontal oblongs that are similar in effect.

5. Whether Salomon followed a similar practice is impossible to ascertain, but the vivacity of his marines may suggest that he, like van Goyen, plied the rivers of the Dutch Republic. His representations of Alkmaar, Dordrecht, Leiden, Egmond, Amersfoort, Utrecht, Rhenen, Arnhem, and Nijmegen indicate that he must have traveled widely.

LITERATURE

Willis, 1911, p. 59; Preston, 1937, p. 28; Stechow, 1938; Maclaren, 1960, p. 377; L. J. Bol, 1973, pp. 148–156; Mauritshuis, 1980, p. 94; Amsterdam–Boston–Philadelphia, 1987/1988, p. 466.

ABRAHAM VAN SALM
Delfshaven, ca. 1660 – 1720 Delfshaven

Virtually nothing is known about this master, who until recently was listed either as Adriaen or Abraham van Salm. He was married in the village of Charlois near Rotterdam in 1686, and was a schoolteacher initially in Schoonderloo, the town where his wife was born. By 1693 he was back in Delfshaven, where he may also have been a schoolteacher. In 1706, van Salm is cited in the painters' guild of Delft as a draftsman residing in Delfshaven. He died there in 1720.

The exhibited picture *Whaling in a Northern Ice Sea* (Cat. 28) is the sole known surviving work that the artist signed *Abram Salm* rather than the more usual *A. Salm.*

Salm specialized in grisaille pen paintings in the style of Willem van de Velde the Elder. Included in his repertory are views of Delfshaven and winter scenes containing frozen rivers and canals, but whaling was his most popular subject. Invariably, van Salm depicts whaling in arctic waters. The Kendall Whaling Museum picture is a rare, fully colored variant on this theme, which van Salm, to a unique degree, popularized in Holland at the end of the seventeenth century.

LITERATURE

Wurzbach, 1974 (rept of the 1906 ed.), vol. 2, p. 553 (with previous literature); Thieme Becker, *Künstler Lexikon*, 1935, vol. 29, p. 351; van Overeem, 1958; Brewington, 1965, p. 3; L. J. Bol, 1973, p. 231; Preston, 1974, pp. 39–40; Frank, 1988, p. 1; Eggink, 1989, vol. 12, pp. 70–71.

SALOMON SAVERY
Amsterdam 1594 – after February 21, 1678, Amsterdam

Salomon Savery, the son of Jacob Savery, was born in Amsterdam in 1594. His uncle Roelandt Savery was the well-known court artist to Rudolph II whose rare etchings and landscape drawings had such impact in Holland during the seventeenth century. Roelandt was a witness at Salomon's marriage vows on January 2, 1616. Salomon was active as a printmaker, book illustrator, and publisher in Amsterdam from as

early as 1616. In 1632 he may have resided in England, because certain portraits of English sitters, signed by Savery, were used in books issued by English publishers. He drew up a will in 1652 and a second one on November 6, 1665. Salomon was listed as a member of the publishers' guild in Amsterdam in 1664.

Salomon Savery is best known as a portraitist and as a book illustrator. He worked closely with the prolific author J. H. Krul, whose many moralizing treatises are profusely illustrated. Savery's finest emblem prints grace Jan van der Veen's *Zinne Beelden* (H.181) of 1642. He also contributed to Caspar Barlaeus, *Medicea Hospes* (Cat. 120), and *Rerum per Octennium in Brasilia*, both published by Joan Blaeu in Amsterdam. Savery produced history prints, complex allegorical subjects, and ships' portraits, and also created several series of etchings representing subjects ranging from costume prints and various ships to soldiers demonstrating the proper handling of weapons.

LITERATURE

Wurzbach, *Niederländisches Künstler Lexicon*, 1974 (reprint of 1911 ed.), vol. 2, p. 564 (with previous literature); Bredius, *Künstler Inventare*, 1918, vol. 5, p. 1495; Thieme Becker, *Künstler Lexikon*, 1935, vol. 29, pp. 507–508 (entry by M. D. Henkel); Waller, 1974 (rept. of 1938 ed.), p. 284; Hollstein, 1980, vol. 24.

ABRAHAM STORCK

Amsterdam 1644 – 1708 Amsterdam

Abraham Storck was baptized on April, 17, 1644, in Amsterdam. His father, the marine painter Jan Jansz. Sturck, or Sturckenburg, moved to Amsterdam from Wesel, becoming a citizen of Amsterdam in 1628. Jan had three sons, Johannes, Jacob, and Abraham, all three of whom became marine painters. No works by the father survive, and Johannes also remains an obscure figure. By contrast, Jacob Storck produced a sizable oeuvre of paintings.[1] Abraham is the most illustrious member of the family although, except for his artistic output, his life is virtually undocumented. He married Neeltje Pieters van Meijservelt on November 14, 1694. Their marriage was childless, although she had two children by a previous marriage who became part of the Storck household.[2] Abraham is recorded in Amsterdam in 1695, and Houbraken states

that he represented the reception of the Duke of Marlborough in Amsterdam in December, 1704.[3] Based on recently discovered archival documents, Dudok van Heel demonstrates that Storck died in 1708.[4]

Despite the pervasive influence of Ludolph Backhuysen on marine painting in Amsterdam after 1665, Abraham Storck developed a personal style that owed much to his elder brothers. An *Imaginary Harbor View* in Helsinki, signed by both Johannes and Abraham, and dated 1673, offers a clear link to Abraham Beerstraten, with whom Johannes was acquainted.[5] Beerstraten exploited the imaginary Mediterranean harbor theme that Jacob Storck developed into a distinct specialty. Abraham, emulating his brother, produced a sizable number of finished pen drawings depicting this subject. Two other themes that Abraham represented were first developed by Jacob: views of the Amstel River within the city of Amsterdam and representations of recreational boating activities at Overtoom, a popular spot near Amsterdam dotted with tea houses frequented by the burghers of the city who had country residences in the vicinity.

Early in his career Abraham represented naval battles (see Cat. 29 and 31), but shifted to less ambitious subjects. Views of Amsterdam, Overtoom, and imaginary Mediterranean seaports figure prominently in his repertory. Abraham also represented mock battles on the River Ij in honor of Czar Peter the Great, who resided in the Dutch Republic from August 1697 until January 7, 1698, with the intention of mastering the art of shipbuilding.

Abraham Storck was a prolific painter and a draftsman of considerable repute. He also produced six etchings. As a perfect exponent of late-seventeenth-century Dutch civilization, he captures the period of denouement following the extraordinary growth of Dutch maritime power and represents an affluent society basking in the afterglow of its earlier rise to power and wealth.

NOTES

1. For Jacob Storck, see J. Vuyk, 1935, vol. 52, pp. 121–126.

2. Dudok van Heel, 1982, vol. 9, p. 76.

3. Houbraken, 1753, vol. 3, pp. 320–321.

4. Dudok van Heel, 1982, vol. 9, pp. 76–77.

5. L. J. Bol, 1973 p. 315. Johannes was a witness at the baptism of Beerstraten's daughter, Annetge.

LITERATURE

Willis, 1911, pp. 112–113; Martin, 1936, vol. 2, pp. 384, 386; Preston, 1937, pp. 67–68; van Eeghen, 1953, vol. 68, pp. 216–222; L. J. Bol, 1973, pp. 315–323; Preston, 1974, pp. 46–48; Mauritshuis, 1980, pp. 104–105; Dudok van Heel, 1982, vol. 9, pp. 76–77.

WILLEM VAN DE VELDE THE ELDER

Leiden 1611 – 1693 London

Willem van de Velde the Elder was born in 1611 in Leiden, where he married Judith van Leeuwen in 1631. Their marriage records make no mention of his occupation. His first two children, a daughter, Magdalena, and Willem van de Velde the Younger, were also born in Leiden. Willem II was baptized there on December 18, 1633, but their third child, Adriaen, the future celebrated landscape artist, was baptized in the Oude Kerk in Amsterdam on November 30, 1636. Exactly when Willem van de Velde moved with his family to Amsterdam is not known, nor is their first address there. From 1646 until 1672 the van de Veldes lived in the Nieuwe Waelseiland near the waterfront by the Montelbaanstoren.

Willem van de Velde the Elder was a noted and prolific draftsman whose talent for sketching naval actions on the spot commanded attention and assured him a busy career, largely under the employ of the Dutch admiralty. His earliest dated drawing is from 1638,[1] but he must have been active as an artist considerably earlier.[2]

During the 1640s, Willem van de Velde the Elder sketched the Dutch fleet in the Texel, at Den Helder, and near Terschelling, and in 1646 he sketched the English fleet off the Dutch coast at Hellevoetsluis. During the First Anglo-Dutch War of 1652–1654 the artist sailed in a galliot bearing letters for Admiral Marten Tromp on August 8, 1653, and was still present on this vessel two days later at the outset of the Battle of Scheveningen.[3] Admiral Tromp was killed early in this battle, and the Dutch were eventually forced to withdraw, although the English fleet was so badly battered that despite their nominal victory, they had to return to England for refitting.

In 1658, van de Velde accompanied the Dutch navy under Admiral van Wassenaer to Copenhagen to defend the Sound from the aggressions of Charles X of Sweden. Joining forces with the Danes, the Dutch inflicted defeat on the Swedish navy on November 8. The artist produced sketches of this battle, which Admiral van Wassenaer showed to the Danish king, who admired them greatly.[4]

Willem van de Velde the Elder was present at the major naval battles of the Second Anglo-Dutch War. He produced sketches of the *Battle of Lowestoft* (June 13, 1665), a decisive English victory over the Dutch. As a result, the artist was never called upon to utilize these sketches for finished pen paintings. This situation was reversed the following year when, on June 11–14, 1666, the Dutch had their revenge at the Four Days' Battle. The Dutch admiral, Michiel de Ruyter, expressly commanded that van de Velde be escorted by Captain Govert Pietersz. in his galliot to record the battle. The artist immortalized this victory in his greatest series of friezelike chalk and wash sketches, which rank among the greatest drawings of the Dutch school (Cat. 81 and 82).

At the outbreak of the Third Anglo-Dutch War in 1672 the artist once again joined the Dutch fleet commanded by de Ruyter, and was present at the Battle of Solebay on June 7. At the same time, the armies of Louis XIV of France invaded the Dutch Republic and occupied the province of Utrecht, threatening Amsterdam. During this period of hardship, art languished and the Willem van de Veldes chose to move to England, either at the end of 1672 or early the following year. Willem van de Velde the Elder's domestic life had been turbulent at least since 1653. In 1662 he and his wife agreed to a legal separation, but apparently remained together because on September 14, 1672, the artist demanded that his wife produce evidence to support her accusations of his marital infidelity. England – with its attractions of glowing professional prospects and as a new environment without the burden of a complaining, aggrieved wife – offered him an irresistible haven.

In Holland, Willem van de Velde developed a specialized art form, pen paintings (*pinceel schilderijen*) on a white ground, in which he utilized his rapid sketches as points of reference for his highly finished, precisely detailed compositions. He was not alone in developing pen painting, but perfected it to a degree far beyond the ambitions or capabilities of its other practitioners. In the years before his move to England, the Elder cultivated distinguished patrons including Pieter Blaeu, the son of the great publisher Johannes Blaeu, and Cardinal

Leopold de Medici, who visited van de Velde's studio in Pieter Blaeu's company. In his correspondence with Cardinal Leopold, Blaeu makes repeated references to Willem van de Velde the Elder. In a letter of July 20, 1674, Blaeu states that van de Velde the Elder was briefly back in Amsterdam fetching his wife in order to settle permanently in London, where he was receiving a salary of £100 per annum from the king of England plus a promised annual stipend of £50 from the king's brother, the Duke of York.[5] In fact, the Willem van de Veldes established a studio together in the Queen's House in Greenwich, where they carried out, among other royal commissions, a series of designs for a suite of tapestries representing *The Battle of Solebay*. With the Third Anglo-Dutch War still in progress, Willem van de Velde the Elder accompanied the English fleet at the first and second battles of Schooneveld in May and June, 1673, but he was forbidden, because of potential risk to his life, to witness the Battle of the Texel on August 11, 1673. During the remainder of his career in England, Willem the Elder principally represented royal arrivals and embarkations, often involving much pageantry. He remained active up to his death in December 1693.

Unlike his sons, Willem and Adriaen, Willem van de Velde the Elder was not of a poetic bent. He was an assiduous recorder of events, and formulated a tremendously flexible drawing style to represent individual ships and the unfolding of complex events. His chalk, pen, and wash drawings exhibit an astonishing range and versatility not reflected in his pen paintings. He may well have believed that his art was immortalized most effectively in his pen paintings, but in many respects his spirited drawings reveal his energy and brilliance to a much greater degree. Fortunately, many hundreds of these drawings survive, most of them divided between two repositories, the National Maritime Museum in Greenwich (Caird and Ingram Collections, totaling more than one thousand sheets) and the Museum Boymans–van Beuningen in Rotterdam (Collection Boymans, numbering almost seven hundred sheets).

NOTES

1. Robinson, 1958, p. 3, note 4.

2. Ibid., pp. 3–4, cites prints datable to this same period that reproduce designs by the Elder, including *The Battle of Duins*.

3. D. Cordingly, in Greenwich, 1982, p. 11.

4. Ibid., p. 12. Moreover, Robinson indicates that upon his return to Holland from Scandinavia, van de Velde produced a number of pen paintings in grisaille for distinguished Italian patrons including the Duke of Tuscany, Cardinal Leopold de Medici, and collectors in Genoa and Venice.

5. Cordingly, in Greenwich, 1982, p. 14.

LITERATURE

Haverkorn van Rijsewijk, 1898, vol. 16, pp. 65–78; ibid., 1899, vol. 17, pp. 33–46; ibid., 1900, vol. 18, pp. 21–44; ibid., 1902, vol. 20, pp. 171–192, 225–247; Willis, 1911, pp. 29–33; Bredius, *Künstler Inventare*, 1915, vol. 1, pp. 356–358; Zoege von Manteuffel, 1927; Voorbijtel Cannenburg, vol. 36, pp. 185–204; Martin, 1936, vol. 2, pp. 373–376; Preston, 1937, pp. 29–30, 31, 55–59; Baard, 1942 (Palet Serie); Robinson, 1958–1974; Preston, 1974, pp. 50–52; Weber and Robinson, 1979; Greenwich, 1982; Paris, 1989, p. 148.

WILLEM VAN DE VELDE THE YOUNGER

Leiden 1633 – 1707 London

Willem van de Velde the Younger, the second child of Willem van de Velde the Elder, was baptized in Leiden on December 18, 1633. By the time his younger brother, Adriaen, the future noted landscape artist, was born, the family had moved to Amsterdam, where Adriaen was baptized on November 30, 1636.

Willem was first a pupil of his father, who produced a prodigious number of marine drawings later utilized to execute pen paintings extraordinary for their detail. Such a grounding instilled in his son an understanding of ships, their construction and displacement on the water, which served him admirably throughout his life. In temperament Willem van de Velde the Younger differed markedly from his father, whose almost clinical precision precluded the poetic conception of marine painting that was the very essence of his son's achievement. In order to master the art of marine painting Willem the Younger studied with Simon de Vlieger, who was acquainted with Willem van de Velde the Elder by the 1640s. De Vlieger, who had moved to Weesp near Amsterdam in about 1648, was one of the chief practitioners of tonal painting at midcentury. His refined representation of cloudy weather, generally executed with rather silvery atmospheric effects, appealed enormously to his talented pupil.

Willem van de Velde the Younger, aged eighteen, married Petronella le Maire of Weesp in Amsterdam on March 13, 1652. Their marriage proved unhappy, lasting all of fifteen months. On June 20, 1653, Willem the Younger initiated proceedings against his wife, and Simon de Vlieger testified on his behalf. In 1666 Willem married his second wife, Magdalena Walravens, who bore him six children. According to tradition his three sons – Willem, Cornelis, and Peter – also became painters, although their activities remain obscure.

Willem van de Velde's period of study with Simon de Vlieger probably lasted about two years. On completing this training Willem rejoined his father's studio, and the two worked in a close partnership until the Elder's death in 1693.[1] The invasion of the Dutch Republic by Louis XIV's armies caused widespread upheaval and deep uncertainty about the future of Holland. Although Willem van de Velde the Younger was still living in Amsterdam in August 1672, later that year he moved to London with his family. His father also moved to London at about the same time, and the two artists reconstituted their atelier. By the summer of 1674, when Willem the Elder was temporarily back in Amsterdam to collect his wife, he and his son were already receiving royal patronage from Charles II, king of England and his brother, James, Duke of York. On January 12, 1674, the van de Veldes received an official appointment as painters to the king, each receiving an annual income of £100.[2] The same year they were also provided with a studio in the Queen's House at Greenwich. After his father's death in 1693 Willem van de Velde the Younger continued to oversee the studio, which appears to have generated a progressively larger number of versions, replicas, and copies of well-known van de Velde compositions. The shop included his sons, Willem and Cornelis, plus Isaac Sailmaker, Jacob Knyff, and Peter Monamy among others.[3] C. Hofstede de Groot listed more than six hundred paintings by Willem van de Velde the Younger, but Laurens Bol cautions against this number because the sustained desirability of van de Velde paintings in England during the eighteenth century spawned emulators and copyists whose works still masquerade as originals to the unsuspecting eye. Willem van de Velde the Younger died on April 7, 1707, and was buried next to his father in St. James's Church, Piccadilly.

Willem van de Velde the Younger's earliest dated paintings of 1651 and 1653 in Greenwich, Budapest, and Kassel[4] reveal close affinities to the silvery tonality of Simon de Vlieger. By the mid-1650s and early 1660s, Willem produced his loveliest calms, in which he often depicts sailboats by jetties and beach scenes or ships becalmed. In all these calms light becomes more limpid, although the artist does not dispense with atmospheric effects altogether but develops them to a new level of subtlety. Partly because of the Dutch victory in the Four Days' Battle of June 11–14, 1666, a turning point in the Second Anglo-Dutch War, demand rose for representations of this celebrated engagement. Van de Velde, who painted several versions of the event, set a standard for this subject. This shift away from nonhistorical marines to vivid representations of recent glorious naval events changed the tenor of his art. This change quickened after van de Velde's move to London, because his two royal patrons commissioned such subjects largely to the exclusion of nonhistorical maritime themes.

Following the conclusion of the Third Anglo-Dutch War in 1673, Willem van de Velde the Younger turned progressively more to royal British ceremonial subjects. Some of these include William III, Prince of Orange, and his consort, Mary Stuart, sister of Charles II. At the time of the Glorious Revolution in 1688 the artist continued representing the same types of subjects for his new royal patrons, William and Mary.

Willem van de Velde's activities following his move to London relate less directly to Dutch marine painting, except in those instances when he returned to Amsterdam on visits and accepted commissions from Dutch clients. Such commissions include his great *View of Amsterdam from the River Ij*, signed and dated 1686, probably painted for the Amsterdam Harbor Commission,[5] and his exhilarating representations of the celebrated duel between Admirals Cornelis Tromp and Sir Edward Spragge in the *Battle of the Texel*.[6] The prime version of this subject, signed and dated 1687 (now in Greenwich), was probably commissioned by Cornelis Tromp for his country house, Trompenburg, in s'Gravesande, east of Amsterdam.

Willem van de Velde the Younger was the greatest Dutch marine painter of the seventeenth century. His move to London coincided with a general shift in power from the militarily exhausted Dutch Republic to the rising mercantile state of England and the expansionary territorial

goals of absolutist Bourbon France. Willem van de Velde the Younger spawned a host of pupils, followers, and emulators, but his true greatness found its first assessment in the great marines of his most celebrated admirer, J.M.W. Turner.

NOTES

1. D. Cordingly, in Greenwich, 1982, p. 19.

2. Document quoted in full by Cordingly, p. 15.

3. Ibid., p. 20.

4. For the painting in Greenwich, see Greenwich, 1982, cat. 18, repr. The *Calms* in Budapest and Kassel are Hofstede de Groot, nos. 83 and 186 respectively. The Kassel picture is reproduced in Stechow, 1966, ill. 238.

5. L. J. Bol, 1973, pp. 240–242, pls. 246–248.

6. In this battle the Dutch inflicted such great damage to the Anglo-French fleet that it was forced to withdraw from the Dutch coast, and de Ruyter could claim a strategic victory.

LITERATURE

J. Smith, 1835, vol. 6, pp. 313–400; Haverkorn van Rijsewijk, 1901, vol. 19, pp. 61–63; Willis, 1911, pp. 79–89; Hofstede de Groot, 1918, vol. 7, pp. 1–173; Zoege von Manteuffel, 1927; Martin, 1936, vol. 2, pp. 378–381; Preston, 1937, pp. 40–42, 55–59; Baard, 1942 (Palet-Serie); Maclaren, 1960, pp. 420–421; Robinson, 1958–1974; L. J. Bol, 1973, pp. 231–243; Preston, 1974, pp. 52–57; Mauritshuis, 1980, pp. 110–111; Greenwich, 1982; Paris, 1989, p. 149.

CORNELIS VERBEECK

Amsterdam, ca. 1590/91 – ca. 1637 Haarlem (?)

In his marriage records of December 6, 1609, Cornelis Verbeeck is cited as from Amsterdam. After their marriage, he and Anna Pietersdr. of Haarlem lived near the Cruys, or Sint Janspoort, just outside the city ramparts of Haarlem. Verbeeck already lived at this address before his marriage, as attested by a document of April 2, 1609, in which he had to testify before a notary concerning his role in a brawl at a public house. In this declaration Verbeeck stated that he was about eighteen years old. By 1610, Verbeeck was a member of the Guild of St. Luke in Haarlem. He had two daughters: Elsgen, born on October 20, 1613,

and Janneke, born on April 7, 1619. In the baptismal and other archival records the artist's name appears with several different spellings: Verbeek, Verbeecke, and Verbeecq.[1]

Evidently Verbeeck was a rowdy and potentially dangerous fellow. In 1610 he wounded a certain Pieter Bossu, a bleacher from Haarlem, in another squabble. Even before this affair had been settled Verbeeck was prosecuted in 1612 because of his involvement in another brawl involving knifing. This pattern of violence is recorded with depressing regularity in the Haarlem archives throughout the 1620s and early 1630s.[2]

L. J. Bol has dispelled the entrenched misnomer that the marine artist Cornelis Verbeeck was the father of the well-known Haarlem horse painter Pieter Cornelisz. Verbeeck.[3]

Although as a young man Cornelis Verbeeck was attracted to Haarlem and its celebrated marine artists, his style does not slavishly imitate that of Hendrick Vroom or Cornelis Claesz. van Wieringen. Verbeeck works on a smaller scale and prefers to represent single ships pitted against the elements, often struggling against seemingly overwhelming odds. In these representations of sea storms Verbeeck shows a strong affinity with Jan Porcellis, as his strong metallic yet monochrome palette indicates. His origins remain obscure, yet Verbeeck is an important pioneer in the shift in Dutch marine painting from the representations of the history piece to subjects more intimate in character and with a greater focus on the elemental forces of nature. Occasionally he represented history subjects, which presumably reflect a degree of official recognition of his talent, but no surviving work of this type is recorded in documents.

NOTES

1. The artist's preferred signature on his paintings is equally idiosyncratic: *Kornelio VB.*

2. Bol, 1973, p. 48.

3. Ibid., pp. 45–48.

LITERATURE

Preston, 1937, p. 15; L. J. Bol, 1973, pp. 45–52; Preston, 1974, pp. 57–58.

LIEVE PIETERSZ. VERSCHUIER

Rotterdam, ca. 1630 – 1686 Rotterdam

Lieve Verschuier, born in Rotterdam about 1630, was the son of Pieter Verschuier, a sculptor and carver who worked for the Admiralty of Rotterdam. Before 1652, Lieve Verschuier resided in Amsterdam for about a year and may have studied with Simon de Vlieger at this time. Following this interlude he traveled to Italy in the company of Johan van der Meer, a portraitist from Utrecht. Verschuier returned to Rotterdam, where he married Catharina Akershoek on September 24, 1656. On October 25, 1674, he was appointed sculptor and painter to the Admiralty of the Maas in Rotterdam, and in 1678 he became the dean of the Guild of St. Luke. He was buried in Rotterdam on December 17, 1686.

Verschuier's oeuvre falls into three distinct groups. He occasionally represented historical events such as the *Arrival of Charles II of England in Rotterdam* (Amsterdam, Rijksmuseum). More generally his large, finished marines represent shipping, usually with cargo ships moored at piers or jetties. In two notable instances Verschuier depicted the whaling industry. In these paintings ships bearing partially processed blubber unload their cargo by the factories that refined the blubber into whale oil (Cat. 44). These are perhaps the most graphic documents of an important trade, which did not become a popular subject for Dutch artists until late in the seventeenth century. Moreover, they preferred representing the whale fisheries in the northern seas rather than the processing, which occurred in Holland.

In addition to these detailed subjects, Verschuier painted smaller pictures representing seacoasts at sunset or in moonlight. The dramatic light playing across the cloudy sky contrasts to the stillness of the scene below. Such poetic and visionary subjects are Verschuier's most popular paintings, but they represent only one aspect of this versatile artist's activities.

Verschuier remains an obscure artist: His oeuvre is small and only one picture bears a date.[1] He must have devoted much of his energy to his responsibilities as a sculptor for the Rotterdam admiralty. Yet such work was destined to perish, with the result that the artist's surviving oeuvre gives only a truncated impression of Verschuier's activity.

NOTE

1. *Ships at a Pier*, signed and dated 1661, Munich, Bayerische Staatsgemälde-sammlungen – L. J. Bol, 1973, pl. 277.

LITERATURE

Bredius, 1890, vol. 8, pp. 297–313; Willis, 1911, pp. 105–107; Martin, 1936, vol. 2, pp. 388–389; Thieme Becker, *Künstler Lexikon*, 1940, vol. 34, p. 301; Preston, 1937, p. 62; Stechow, 1966, p. 182; L. J. Bol, 1973, pp. 273–275; Preston, 1974, pp. 58–59; Paris, 1983, pp. 149–150; Paris, 1989, p. 150.

CLAES JANSZ. VISSCHER

Amsterdam 1587 – 1652 Amsterdam

Claes Jansz. Visscher was born in Amsterdam in 1587. He was the son of a ship's carpenter but became involved in the world of publishing and cartography at a young age. Although traditionally cited as a pupil of Jodocus Hondius the Elder as an engraver of maps, no proof confirms this putative relationship. Visscher did work for Willem Jansz. Blaeu, but, as Simon notes, he specialized in contributing ornamental detail to Blaeu's maps.[1] He also worked with David Vinckboons, another artist closely associated with the world of cartographical publishers in Amsterdam.[2] Visscher finished his training by 1605, but until 1608 principally worked for Amsterdam publishers, including Willem Jansz. Blaeu, Pieter van den Keere, Herman Allard (Coster), and Cornelis Claesz. On May 26, 1611, Visscher bought a house on the Kalverstraat and set up his own publishing operations, which soon became famous. From 1611 until 1619 he produced and published many suites of landscape and topographical prints, and after 1618 began producing political broadsheets. After 1620, Visscher seems to have abandoned etching because of his all-engrossing involvement with his publishing activities. Nonetheless, he successfully established a house style that remained strongly reminiscent of his own etching manner. At the same time he acquired innumerable copperplates from other publishers and reissued well-known prints bearing his address.

Visscher's global activity as a publisher played a major role in disseminating Dutch prints throughout Europe. He was buried in the Nieuwe Zijds Kapel in Amsterdam on June 21, 1652. His son, Nicolas

(1618–1709), inherited Claes Jansz. Visscher's publishing house, which he continued to operate until late in the seventeenth century.

NOTES

1. M. Simon, 1958, p. 11.

2. For this relationship, see the recent exhibition, Amsterdam, 1989a, pp. 51–54.

LITERATURE

Wurzbach, 1910, vol. 2, pp. 795–796; Burchard, 1912, pp. 42–43; Simon, 1958; Boston–Saint Louis, 1980/1981, p. 61; Paris, 1989, p. 151.

SIMON DE VLIEGER

Rotterdam 1600/1601 – 1653 Weesp

Simon de Vlieger married Anna Gerridts van Willige in Rotterdam on January 10, 1627, and was repeatedly recorded in that city through 1633. Early in 1634, de Vlieger moved to Delft, where he became a member of the artists' guild there on October 18. He bought a house in Rotterdam on December 1637 from the painter Cryn Hendricksz. Volmaryn for 900 guilders. As part of this transaction, de Vlieger agreed to deliver for a stipulated period paintings totaling a value of 31 guilders per month.[1] De Vlieger was still living in Delft on March 12, 1638, but by July 19 he was cited as residing in Amsterdam, where he became a citizen on January 5, 1643. He may have been attracted to Amsterdam by the commission to provide two designs for the festivities associated with Marie de Medici's entry into the city on August 31, 1638.[2] During the years 1638–1643, de Vlieger fulfilled commissions for tapestry designs from the city magistrates of Delft (1640 and 1641) and received the commission to paint the organ shutters for the Laurentius Kerk in Rotterdam in 1642, for which he was paid the substantial amount of 2,000 guilders on January 7, 1645.[3] Presumably he lived in Rotterdam at least sporadically during these years, but in September 1644, he sold his house there. Early in 1648, de Vlieger received the prestigious commission to design the stained-glass windows for the south side of the Nieuwe Kerk in Amsterdam, for which he received 6,000 guilders from the city.[4] On May 16, 1648, Simon de Vlieger appeared as a witness before the Amsterdam notary, J. van Oli, on behalf of Willem van de Velde the Elder concerning two drawings by van de Velde. During these proceedings de Vlieger declared that he was about forty-seven years old.[5] On January 13, 1649, de Vlieger bought a house in Weesp, a small town about ten miles southeast of Amsterdam, where he died in 1653.

Although de Vlieger's early training remains undocumented, the influence of Jan Porcellis, who resided in Rotterdam from about 1605 until 1615, is strongly evident in de Vlieger's paintings of the 1620s and 1630s. De Vlieger also appears to have been familiar with Adam Willaerts's pictures of the 1620s in which Willaerts represents purely imaginary savage, rocky coasts. De Vlieger developed this motif in his depictions of such subjects in calm and stormy weather. What de Vlieger borrowed from Porcellis in terms of monochrome atmospheric effects, he transformed into an almost transparent silvery tonality in his mature marines of the 1640s, which in turn were tremendously influential. De Vlieger has been associated with a number of younger marine painters, the most prominent of whom are Jan van de Cappelle, Hendrick Dubbels, and Willem van de Velde the Younger. Laurens Bol justly enlarges this list to include Hendrick van Anthonissen, Willem van Diest, Claes Claesz. Wou, Pieter Mulier the Elder, Abraham van Beyeren, and two marine painters active in Rotterdam, Hendrick Martensz. Sorgh and Jacob Bellevois.[6] Arnold Houbraken asserts that Willem van de Velde was de Vlieger's pupil.[7] Although de Vlieger's exact relationship to Jan van de Cappelle remains uncertain, the fact that van de Cappelle possessed so many paintings and more than 1,300 drawings by de Vlieger may suggest that he was able to acquire much en bloc from de Vlieger's estate.

Simon de Vlieger was a versatile artist with wide-ranging interests. Although he was a gifted and prolific draftsman, depressingly little survives to this day. He was also an experimental etcher whose landscapes and studies of animals were a significant contribution, paralleled by his rare landscape paintings in which large trees at the edge of a forest dominate the subject. Bol stresses the range of de Vlieger's innovations in marine painting, focusing on his notable contribution to the beach theme, his development of views with ships moored at jetties before estuaries, and his representations of *parade* subjects.[8] De Vlieger's experimental investigation into perspective, his refined representations of atmospheric effects, and his superb sense of pictorial design

are qualities that command admiration and assure him an influential role in the transition of Dutch marine art from its tonal phase to the formal and august idiom of the painters Jan van de Cappelle and Willem van de Velde the Younger.

NOTES

1. L. J. Bol, 1973, p. 178. Interestingly, a single large painting was deemed worth 31 guilders, but if the artist so chose, he had the option to produce pictures on a smaller scale, which were priced according to size. This transaction must have been protracted, because on July 19, 1638, Volmaryn authorized his wife to sell the house on the north side of the Schilderstraat in Rotterdam to Symon de Vlieger, also a painter living in Amsterdam – Bredius, *Künstler Inventare*, 1918, vol. 5, p. 1643.

2. These are immortalized in Caspar Barlaeus, *Medicea Hospes*, published by Joan Blaeu in Latin, French, and Dutch editions.

3. Amsterdam–Boston–Philadelphia, 1987/1988, p. 511.

4. Haverkorn van Rijsewijk, 1891, vol. 9, p. 224.

5. Bredius, *Künstler Inventare*, 1915, vol. 1, pp. 356–358.

6. L. J. Bol, 1973, p. 181.

7. Houbraken, 1718–1721, vol. 2, p. 325.

8. L. J. Bol, 1973, pp. 182–190.

LITERATURE

Houbraken, 1718–1721, vol. 2, p. 325; Haverkorn van Rijsewijk, 1891, vol. 9, pp. 221–224; and 1893, vol. 11, pp. 229–235; Willis, 1911, pp. 44–50; Bredius, *Künstler Inventare*, 1915, vol. 1, pp. 356–358; 1916, vol. 5, p. 1643; Martin, 1936, vol. 1, pp. 264–266; Preston, 1937, pp. 25–27, 31; Maclaren, 1960, pp. 442–443; Kelch, 1971; L. J. Bol, 1973, pp. 176–190; Preston, 1974, pp. 60–63; Mauritshuis, 1980, pp. 119–121; Ruurs, 1983, vol. 13, pp. 189–200; Amsterdam–Boston–Philadelphia, 1987/1988, pp. 511–512; Paris, 1989, pp. 152–153.

CORNELIS VROOM

Haarlem, ca. 1591 – 1661 Haarlem

Cornelis Vroom was born in Haarlem, the son of the celebrated marine painter Hendrick Vroom. In a notarial document of February 1649, Cornelis declared that he was about fifty-eight years of age. Although he initially trained with his father and became his trusted assistant, Cornelis by the 1620s was pursuing an independent career as a land-scape painter. Samuel Ampzing first cites Cornelis Vroom in his *Het Lof der Stadt Haerlem in Hollandt,* of 1621, and expands his praise considerably in his far better known *Beschryvinge ende Lof der Stad Haerlem in Holland,* of 1628, in which the chronicler places the son on equal terms with his father.[1] Hendrick Vroom's grating and mercurial personality led to family dissension, which resulted in a serious breach between the parents and Cornelis and his sister, Cornelia, who left their parents' house never to return. In 1628, Cornelis received a stipend of 80 pounds from King Charles I of England and probably resided in London at some point in the mid-1620s. In 1635, Vroom was tardy in paying his annual dues to the artists' guild in Haarlem. The guild was evidently a source of frustration to him because Cornelis formally resigned from it well before 1642. He also freed himself from the obligation to serve city militia duty by presenting a substantial percentage (200 guilders) of the value of a picture which he painted for the city magistrates of Haarlem in 1639, for which he received the sum of 125 guilders.

Cornelis Vroom was well connected. This may partly have been due to his father's prestige and wealth. Cornelis seems to have inherited Hendrick's business acumen and was a successful real estate entrepreneur. His independent income, his association with the leading families of Haarlem, and his contact with architects and artists such as Jacob van Campen, Paulus Bor, Caesar van Everdingen, and Pieter Saenredam provided him with patrons beyond the confines of his native city. Vroom contributed paintings to the decoration of Honselaersdijk Palace in 1638, for which he received 450 guilders. Cornelis died in September 1661 and was buried in the Church of St. Bavo on September 16. He left a substantial estate, which was divided between his brother, Frederick, and his nephew and niece, Adriaen and Josina Backer, with the balance going to his natural son, Jacobus, who was still in his minority.

Cornelis Vroom is best known as a landscape painter. His earlier landscapes of the 1620s and 1630s manifest a classicizing strain largely uninfluenced by the predominant tonal phase of Dutch landscape. Subsequently he represented forest subjects that appealed to several younger Haarlem artists, including Jacob van Ruisdael.

Vroom's career as a marine painter was short. His earliest surviving painting, dated 1615, reveals a personality quite different from Hen-

drick's. Even during their collaboration, father and son struck different paths. The acute perception of light and atmospheric effects which he first developed in his marines continued to serve Cornelis admirably in his landscapes.

<div align="center">NOTE</div>

1. S. Ampzing, 1628, p. 368.

<div align="center">LITERATURE</div>

Ampzing, 1621; Ampzing, 1628, p. 368; Schrevelius, 1648; Bredius, *Künstler Inventare*, 1916, vol. 2, pp. 658–667, and 1921, vol. 7, pp. 281–284; Rosenberg, 1928b, vol. 49, pp. 102–110; Haverkamp Begemann, 1967, vol. 82, pp. 65–67; L. J. Bol, 1969, pp. 144–148; L. J. Bol, 1973, pp. 28–29; Preston, 1974, p. 64; Keyes, 1975; Russell, 1983; Amsterdam–Boston–Philadelphia, 1987/1988, p. 516.

HENDRICK CORNELISZ. VROOM

<div align="center">Haarlem 1566 – 1640 Haarlem</div>

Carel van Mander describes Hendrick Vroom's early career in considerable detail up to 1604, the year his *Het Schilder-Boeck* appeared.[1] Vroom had an adventurous youth, born in Haarlem in 1566, the son of a sculptor and ceramicist who died when Hendrick was still a boy. His stepfather, also a ceramicist, demanded that Hendrick assist him as a pottery decorator. However, his stepfather's harshness forced Hendrick to leave home. Initially he set out to find another master, but after a time Hendrick took the momentous step of joining a ship bound for San Lucar in Spain.

After a sojourn in Seville, Vroom journeyed to Italy, where he traveled from Livorno to Florence and Rome. He came to the attention of Cardinal Ferdinand de Medici, who became his patron for a period of roughly two years. While in Rome, Hendrick painted histories, portraits, and landscapes on copper, and copied prints. He came into contact with Paul Bril, who offered him instruction. After Vroom left Rome, he journeyed to Venice, Milan, Genoa, and Turin. He crossed the Alps and settled for a time in Lyon, where he executed battle subjects for a local patron named Bottoin. Vroom next sojourned in Paris, but returned to Haarlem by 1590, where he married and bought a house on April 28. Shortly after his marriage Vroom and his wife visited Danzig,

where he assisted his uncle, Frederick Vroom, the city architect, who instructed Hendrick in the art of perspective. In Danzig, Vroom painted an altarpiece for the Jesuits.

Hendrick returned to Haarlem, but soon thereafter set forth once again for Spain. En route he was shipwrecked on an island off the coast of Portugal, but miraculously survived. Based on this harrowing experience, Vroom was able to execute a marine painting evoking his recent ordeals. This work established his reputation in Lisbon and enabled the artist to earn enough money to return in 1592 to Haarlem, where he remained for the rest of his life. Much about the circumstances of his early career remains obscure, further complicated by the fact that in 1634 Hendrick presented a *Panoramic View of Delft* to that city's magistrates, stating that he wished to honor the city where his mother was buried and where he had learned his art.[2]

In 1592, Vroom received his first important commission, to provide designs for a suite of ten tapestries commissioned by Lord Howard of Effingham depicting the defeat of the Spanish Armada. Lord Howard, the British admiral who had commanded the English fleet defending England against threatened Spanish invasion, wished to commemorate this great victory and approached the Delft weaver François Spierincx. Spierincx asked Carel van Mander to produce the designs, but van Mander, in turn, recommended Hendrick Vroom, whose specialized knowledge of maritime matters made him uniquely qualified for this task. In 1616, Lord Howard sold this great suite of tapestries to King James I, who used them as decorations in the Tower of London. Later Oliver Cromwell transferred them to the House of Lords, where they were consumed by fire in 1834.[3]

At about the same time, Vroom became involved as the designer of a second notable series of tapestries. These were commissioned by the States General of Zeeland to immortalize the earliest Dutch naval exploits against the Spanish during the early stages of the Dutch revolt. These hangings, the first of which was woven by Francois Spierincx and the remainder by Jan de Maeght in Middelburg, decorated the chambers of the States General of Zeeland.[4]

Even while preparing the tapestries' designs, Vroom preferred painting, because, as he stated in a letter of November 27, 1599, to Hendrick de Maecht, it was more lucrative and came easily to him.[5] Earlier, on

February 7, 1594, the magistrates of Haarlem had exempted Hendrick Vroom from civic militia duty because of his unique skill as a marine painter. A picture putatively from this year, formerly in Schwerin and now destroyed, reveals his mature talents as a painter.[6] Van Mander describes two more works, the artist's design for *The Landing at Philippine* of 1600 (Cat. 122), commissioned by the States General of the Dutch Republic, and a representation of the *Seventh Day of the Battle of the Armada,* probably identifiable as the picture in Innsbruck.[7] In its metallic coloring this painting reveals Vroom's debt to contemporary Flemish artists such as Jan Bruegel the Elder.

In the ensuing years Vroom perfected his talents as a marine painter. As a result of his focus on ships, he developed a repertory whose themes included naval battles, the departure or return of commercial fleets, and important dignitaries arriving at Dutch seaports. His reputation as an unrivaled observer and portrayer of ships is justly deserved and set a standard unequaled by his emulators. Vroom also directed great attention to the profile views of cities that appear in the background of so many of his marines. His topographical exactitude in representing these city skylines is also notable.

Vroom produced his masterpiece, *The Arrival of Frederick V, Elector of the Palatinate in Vlissingen* (Cat. 52, fig. a), in 1623, ten years after the actual event. This grandiose subject represents the high-water mark of Vroom's career. Two years earlier, in 1621, Vroom suffered his first serious professional setback, partly as a result of his own arrogance. The Admiralty of Amsterdam wished to commission a *Battle of Gibraltar* to present to Prince Maurice, but Vroom's asking price of 6,000 guilders proved too steep, even for such a wealthy patron. His subsequent inflexibility and defiant behavior cost him the commission, which went to his former pupil and fellow townsman Cornelis Claesz. van Wieringen for the still considerable sum of 2,400 guilders.[8]

Vroom's interest in city profile views led him to develop a specialty for which he became famous: the portrayal of Dutch seaports with shipping in the foreground. Views of Amsterdam, Veere, Hoorn, and closely related works of the more landlocked cities of Haarlem and Delft provided Vroom with an added source of income, and remain fascinating documents of the prosperity of the great cities of Holland and Zeeland during the early years of the new century.

Hendrick Vroom's reputation rests with his large-scale, detailed history pieces – public commissions that were among the costliest pictures ever produced in the Dutch Republic. Yet it is evident from several surviving beach scenes, and from a number of spirited pen sketches in which the artist depicts small sailboats and fishing vessels as well as beach subjects, that his interests ranged beyond the formal history piece.[9] This shift to more unassuming themes demonstrates Vroom's interest in exploring directions that younger artists were pursuing to a greater degree, with tremendous implications for the future course of Dutch marine art. In fact, by about 1630, Hendrick Vroom's art was deemed old-fashioned in certain circles. For example, the young Constantine Huygens in his unpublished autobiography showed his lack of regard for Vroom in his praise for Jan Porcellis: "On account of the year of his birth there finally comes a place for Hendrik Vroom, a famous sea-painter, but now so much inferior to Porcellis and others even less well known that I feel he can hardly be mentioned in the same breath with them."[10]

Only recently have scholars resuscitated Vroom's reputation as the founder of Dutch marine art. Bol's sensitive reassessment of Vroom's place as the Nestor of this genre was the first serious recent attempt to recognize Vroom on his own terms – as the chronicler of significant maritime events. Hendrick Vroom's greatest talent rests with his ability to portray ships and capture the dramatic import of his subjects, whether the ships be participants in significant historic events or protagonists pitted against the elemental forces of nature.

NOTES

1. Folios 287r–288v.

2. Russell, 1983, p. 94.

3. For further discussion of these tapestries, see Russell, pp. 116–137.

4. For further discussion of these so-called Zeeuws tapestries, see Keyes, 1975, pp. 20–24, and Russell, pp. 137–138.

5. Russell, p. 152.

6. Ibid., p. 141, fig. 122.

7. L. J. Bol, 1973, p. 13, fig. 6; Russell, pp. 146, 149.

8. Bol, p. 19. In 1610, Vroom received 1,800 guilders from the States General for another version of the same subject.

9. Keyes, 1975, vol. 1, pls. XXV, XXVI, XXXIII, XXXVII; Russell, 1983, figs. 137, 138a, 138b.

10. Quoted from Walsh, 1974a, p. 653.

LITERATURE

Van Mander, 1604, fols. 287r–288v; Waard, 1897, vol. 15, pp. 65–93; Willis, 1911, pp. 15–20; Bredius, *Künstler Inventare*, 1916, vol. 2, pp. 667–679; 1921, vol. 7, pp. 273–281; Martin, 1936, vol. 1, pp. 258–259; Preston, 1937, pp. 11–12; van Ysselstein, 1936; L. J. Bol, 1973, pp. 11–28; Preston, 1974, pp. 65–66; Keyes, 1975, pp. 8–13, 20–30; Russell, 1983; Paris, 1989, pp. 153–154.

CORNELIS CLAESZ. VAN WIERINGEN

Haarlem, ca. 1580 – 1633 Haarlem

Cornelis Claesz. van Wieringen was born in Haarlem about 1580. His father, Claes Cornelisz. van Wieringen, was a skipper and shipbuilder, and his son thus had firsthand experience of the sea – a point confirmed by Carel van Mander, who, in his *Het Schilder-Boeck* of 1604, praised van Wieringen's ability to draw and paint ships with great accuracy.[1] Alas, nothing by van Wieringen before 1604 survives.

Van Wieringen may have initially trained with Hendrick Vroom, but no archival evidence confirms this traditionally held hypothesis. Nonetheless, his art is indelibly influenced by the example of his more illustrious townsman. His earliest dated picture, *A Battle Between an English Ship and a Dutch Privateer Before La Rochelle* of 1616 in Greenwich, is a marine of the first rank. Three years earlier Claes Jansz. Visscher, the Amsterdam etcher and publisher, issued a series of fourteen prints after drawings by van Wieringen.[2] These are principally landscapes in a style that recalls the idiom of Hendrick Goltzius, the paradigm of international Mannerism active in Haarlem. This possible contact and source of inspiration may be corroborated by van Wieringen's being a trusted friend of Goltzius's respected colleague Cornelis Cornelisz. van Haarlem. Van Wieringen witnessed the drawing up of several of Cornelis Cornelisz. van Haarlem's last wills and testaments.[3]

In terms of surviving material, van Wieringen was most productive during the 1620s, a period from which several major commissions survive. The first of these is the celebrated commission from the Admiralty of Amsterdam in 1621 for his huge version of *The Battle of Gibraltar,* dated 1622. He executed this painting for a total sum of 2,450 guilders (after Hendrick Vroom, having asked the astronomical price of 6,000 guilders, lost the commission). The admiralty monitored the project closely and initially required the painter to produce a trial piece to show to Prince Maurice for his approval. It further required van Wieringen to produce a worked-up sketch for the composition before authorizing him to proceed on the final version. The finished painting, which measures 1.82 × 4.9 meters, is one of the great monuments of Dutch marine painting in the Rijksmuseum "Nederlands Scheepvaart Museum."[4]

Two paintings datable to 1628 were important civic commissions. *The Capture of Damiate* in the Frans Hals Museum can probably be identified with a picture described by Samuel Ampzing in 1628, which van Wieringen painted as the overmantel in the Oude Doelen, the musketeers' militia company headquarters.[5] At about the same time he painted *The Arrival of Frederick V, Elector of the Palatinate, in Vlissingen* (Cat. 53), which was acquired for the old persons' almshouse in Haarlem.[6] Van Wieringen recast this subject in his grandiose design for a tapestry commissioned by the city fathers of Haarlem to decorate the magistrates' chamber of the town hall, where it still hangs. For his design van Wieringen received 300 pounds flemish on April 12, 1629. The tapestry was woven by Joseph Thienpont (Thibauts), who received the huge sum of 2,000 pounds flemish for his work.[7]

In many respects van Wieringen's concept of Dutch marine painting closely follows that of Hendrick Vroom. Like Vroom, he focused on the large-scale representation of significant maritime events. Moreover, van Wieringen was prepared to match Vroom in tackling ambitious projects. He also occasionally represented nonhistorical marine subjects, such as beach scenes. Van Wieringen's willingness to explore this range of marine subjects nonhistorical in character is readily apparent in his ample surviving oeuvre of pen drawings, certain of which were etched by Claes Jansz. Visscher and Jan van de Velde the Younger.[8] Their early interest in his drawings document the great appeal van Wieringen held for his contemporaries.

NOTES

1. L. J. Bol, 1973, p. 30, citing C. van Mander, *Het Schilder-Boeck*, 1604, fol. 300.

2. Discussed by Keyes, 1979, pp. 8–15.

3. Bredius, *Künstler Inventare*, 1922, vol. 7, pp. 89–92.

4. L. J. Bol, 1973, pp. 30–31. The early history of this picture has been confused with another version of the same subject by Abraham de Verwer, commissioned by the Amsterdam admiralty for 2,400 guilders – see van Gelder, 1947, vol. 62, pp. 211ff.

5. L. J. Bol, 1973, p. 31, citing S. Ampzing, 1628, p. 371.

6. A. van der Willigen, *Les Artistes de Haarlem*, 1870, p. 334.

7. For further discussion of this tapestry, see van Ysselstein, 1936, vol. 1, p. 129; vol. 2, pp. 211–212; van de Waal, 1952, vol. 1, p. 247; Keyes, 1979, pp. 6–7; Biesboer, 1983, pp. 43–45.

8. This aspect of van Wieringen's art deserves greater emphasis. For example, Jan van de Velde's prints after van Wieringen's drawings can be interpreted as a series focusing on ship types. Such suites play a significant role in the output of marine paintings, and van Wieringen's contribution to this tradition should not be underestimated.

LITERATURE

Van Mander, 1604; Ampzing, 1628, p. 371; Willis, 1911, pp. 20–21; Bredius, *Künstler Inventare*, 1916, vol. 2, pp. 673–679; 1921, vol. 7, pp. 88–93; Martin, 1936, vol. 1, pp. 259–260; Preston, 1937, p. 13; L. J. Bol, 1973, pp. 29–35; Preston, 1974, p. 66; Keyes, 1979, pp. 1–46; Paris, 1989, p. 154.

ADAM WILLAERTS

Antwerp 1577 – 1664 Utrecht

Although Adam Willaerts was born in Antwerp, he settled at a relatively young age in Utrecht, where he remained active for the rest of his life. When he was married in Utrecht in 1605, Willaerts stated that he was from London.[1] He was one of the founders of the Utrecht Guild of St. Luke in 1611 and frequently served as its deacon between the years 1611 and 1637. The artist presented a picture, *A Storm at Sea,* to the Hospital of Job (Hiobsgasthuis) in Utrecht in 1628, and served as a regent of this institution from 1639 until 1660.

Three of his sons, Abraham (ca. 1603–1669), Cornelis (ca. 1600–1660), and Isaac (1620–1693), also became painters. They not only assisted Adam but, in the case of Abraham and Isaac, perpetuated his style, which they emulated so closely that they largely sacrificed their own artistic individualities.

Adam Willaerts worked in the same general idiom as Hendrick Vroom and Cornelis Claesz. van Wieringen of Haarlem, and like them, focused his activity on representing history subjects including naval battles, the arrivals of dignitaries at Dutch seaports, and the Dutch East India Company fleets en route. Willaerts evidently had access to Savery's drawings of Prague and the Tyrolean Alps, because his own representations often include architectural motifs and rugged rocky landscapes that adapt Savery's ideas. Savery was not the only Rudolfiner artist from whom Willaerts borrowed, but remained his chief source for such exotic motifs.[2]

One of Willaerts's most important pictures is the large *Profile View of Dordrecht Seen from the River Maas,* signed and dated 1629, with many types of river vessels that the artist characterizes with great care. He also produced at least two large marines that contain group portraits painted by another artist.[3] These figures are gathered prominently in the foreground and await the ships from which other people are disembarking.

Willaerts occasionally painted marines containing religious subjects that demonstrate a link between purely secular marine painting and its sixteenth-century Netherlandish origins. This repertory includes such subjects as *Jonah Cast to the Whale* (Greenwich, National Maritime Museum), *The Miraculous Draught of Fishes* (Bruges, Commissie voor Openbare Onderstand – Bol, 1973, pl. 73), *Christ Preaching from the Boat* (Cat. 55), and *The Apostle Paul on Malta* (Utrecht, Centraal Museum).

Adam Willaerts developed certain subjects such as the beach scene and seastorm, which he often treats on a relatively modest scale. This suggests that he cultivated a sizable clientele for cabinet-size paintings. His beach scenes painted in collaboration with the fish still life artist Willem Ormea are his most unusual contribution to this development. In these works Ormea fills the foreground with an opulent array of fish, shellfish, and crustaceans.

The few drawings surviving from Willaerts's hand indicate that he

was a talented draftsman. His finest surviving drawings are two that he contributed to the *Album Amicorum Arnold van Buchel,* now in the University Library in Leiden.[4] Similar, equally finished drawings must have served as the designs for the two reproductive engravings *Fishermen on a Beach Cutting Up a Whale* and *A Ship in Distress by a Rocky Coast,* by Magdalena de Passe, who was active in Utrecht from 1612 until at least 1636.[5]

NOTES

1. J. Spicer, "Conventions of the Extra-ordinary: Savery, the Willaerts and the Attractions of *Variety,*" forthcoming.

2. See J. Spicer's forthcoming article on Willaerts citing his borrowing from other artists, particularly the landscapists associated with Rudolph II.

3. The first is *The Estuary of the Maas near den Brielle,* signed and dated 1633, in the Museum Boymans–van Beuningen in Rotterdam – Museum Boymans–van Beuningen, *Old Paintings 1400–1900,* 1972, p. 45, inv. 1982, repr. The second picture represents *The Arrival of the Elector Palatinate and Princess Elizabeth in the "Prince Royal" in Heidelberg,* signed and dated 162(?), currently on the London art market – London, Rafael Valls Gallery, *1989 Recent Acquisitions,* cat. 38, repr. Anthonie Palamedesz. may have painted the prominent staffage in the left foreground.

4. Letterkunde 902, folios 94v, 95r.

5. Hollstein, 1974, vol. 16, M. de Passe, nos. 20, 21.

LITERATURE

Sandrart, 1675, p. 306; Willis, 1911, pp. 25–26; Martin, 1936, vol. 1, pp. 267–268; Preston, 1937, p. 14; van Luttervelt, 1947, pp. 225ff; L. J. Bol, 1973, pp. 63–77; Preston, 1974, pp. 67–70; Paris, 1989, pp. 154–155.

ANTHONY VAN ZYLVELT

Ca. 1640 Amsterdam, active 1665–1695

Little is known about Zylvelt, who was a printmaker and draftsman active in The Hague, Amsterdam, and Leiden. He principally produced portrait likenesses, most of which are after other artists. Zylvelt also produced a suite of four Genoese harbor views after the designs of Johannes Lingelbach. From 1690 onward Zyvelt was active in Leiden, where he drew studies of plants in the famous Hortus Botanicus of the University of Leiden. No recent compilation of his oeuvre exists, but Muller and Wurzbach provide provisional lists of his prints.

LITERATURE

Muller, 1853 (pt. Soest, 1972); Wurzbach, 1910, vol. 2, p. 687; Thieme Becker, *Künstler Lexikon,* 1947, vol. 36, p. 616 (entry by K. G. Boon citing previous literature).

BIBLIOGRAPHY

SELECTED REFERENCES

d'Ailly 1932
d'Ailly, A. E. "Balthazar Florisz.' Plattegrond van Amsterdam." *Jaarboek Amstelodamus* 29 (1932), pp. 103–130.

d'Ailly 1934
d'Ailly, A. E. *Catalogus van Amsterdamsche Plattegronden.* Amsterdam, 1934.

d'Ailly 1953
d'Ailly, A. E. *Repertorium van de Profielen der stad Amsterdam en van de plattegronden der Schutterwijen.* Amsterdam, 1953.

Ampzing 1621
Ampzing, S. *Het Lof der Stadt Haerlem in Hollandt.* Haarlem, 1621.

Ampzing 1628
Ampzing, S. *Beschryvinge ende Lof der Stad Haerlem in Holland.* Haarlem, 1628.

Amsterdam, Rijksmuseum, *All the Paintings* 1976
Amsterdam, Rijksmuseum, *All the Paintings in the Rijksmuseum,* Amsterdam, 1976.

Anderson and Anderson 1963
Anderson, R., and Anderson, R. C. *The Sailing Ship: Six Thousand Years of History.* New York, 1963.

Andrews 1977
Andrews, K. *Adam Elsheimer.* Oxford, 1977.

Andrews 1985
Andrews, K. *Catalogue of Netherlandish Drawings in the National Gallery of Scotland.* Edinburgh, 1985.

Antwerp, Museum Ridder Smidt van Gelder 1980
Antwerp, Museum Ridder Smidt van Gelder. *Catalogus I Schilderijen tot 1800.* Antwerp, 1980.

Archibald 1957
Archibald, T. *Sea Fights, Oil Paintings in the National Maritime Museum.* London, 1957.

Ausserer 1929
Ausserer, K. "Der Atlas Blaeu der Wiener National-Bibliothek," *Beiträge zur historischen Geographie, Kulturgeographie, Ethnographie und Kartographie.* Vienna, 1929, pp. 1–40. Reprinted in *Acta Cartographica,* vol. 27, Amsterdam, 1981, pp. 15–59.

Baard 1942
Baard, H. P. *Willem van de Velde de Oude Willem van de Velde de Jonge.* Amsterdam, Palet Serie, 1942.

de Balbian Verster 1914
Balbian Verster, J.F.L. de. "De Slag bij Livorno (14 Maart 1653)," *Elsevier's Geillustreerd Maandschrift* 24, no. 48 (1914), pp. 340–354.

Barbour 1963
Barbour, V. *Capitalism in Amsterdam in the 17th Century.* Ann Arbor, Mich., 1963.

Bartsch
Bartsch, A. von. *Le Peintre Graveur.* 21 vols. Vienna, 1803–1821 (2nd ed., Leipzig, 1818–1876).

van Bastelaer 1908
Bastelaer, R. van. *Les estampes de Peter Bruegel l'ancien.* Brussels, 1908.

Baudet 1871
Baudet, P.J.H. *Leven en werken van Willem Jansz Blaeu.* Utrecht, 1871.

Beck 1972–1973
Beck, H.-U. *Jan van Goyen. Leben und Werk.* 2 vols. Amsterdam, 1972–1973 (Supplement, 1987).

Beets 1939
Beets, N. "Cornelis Anthonisz.," *Oud Holland* 56 (1939), pp. 160–184.

Bernstrom and Rapp 1957
Bernstrom, J., and Rapp, B. *Iconographica II Abraham van Beyeren.* Stockholm, 1957.

Bernt, *Maler*
Bernt, W. *Die niederländischen Maler des 17. Jahrhunderts.* 4 vols. Munich, 1962.

Bernt, *Zeichner*
Bernt, W. *Die niederländischen Zeichner des 17. Jahrhunderts.* 2 vols. Munich, 1957–1958.

Beylen 1961
Beylen, J. van. "De uitbeelding en documentaire waarde van schepen van enkele oude meesters," *Bulletin van de Koninklijke Musea voor Schone Kunsten van België* 10 (1961), pp. 123–150.

Beylen 1970
Beylen, J. van. *Schepen van de Nederlanden: Van de late Middeleeuwen tot het einde van de 17de eeuw.* Amsterdam, 1970.

de Bie 1661
Bie, Cornelis de. *Het gulden cabinet vande edele en vry schilder-const.* Antwerp, 1661.

Biesboer 1983
Biesboer, P. *Schilderijen voor het Stadhuis Haarlem.* Haarlem, 1983.

Blankert 1975/1979
Blankert, A. *Amsterdams Historisch Museum, Schilderijen daterend van voor 1800.* Amsterdam, 1975/1979.

Blankert 1978
Blankert, A. *Nederlandse 17e Eeuwse Italianiserende Landschapschilders*. Soest, 1978.

Blok 1933
Blok, P. J. *Life of de Ruyter*. London, 1933.

Bock and Rosenberg 1930
Bock, E., and Rosenberg, J. *Staatliche Museen zu Berlin, Die Zeichnungen alter Meister im Kupferstichkabinett. Die niederländischen Meister*. 2 vols. Berlin, 1930.

Bode 1891
Bode, W. *Die Grossherzogliche Gemälde-Galerie zu Schwerin*. Vienna, 1891.

Bodel Nijenhuis 1845
Bodel Nijenhuis, J. T. "Over de Nederlandsche Landmeters en Kaartgraveurs Floris Balthasar en sijne drie zonen," in *Verhandelingen van het Koninklijk Nederlandsche Instituut*, vol. 5 (1845), pp. 1–52.

Bodel Nijenhuis 1872
Bodel Nijenhuis, J. T. "De Leidse graveur Pieter Bast," in *Handelingen en mededelingen van de Maatschappij der Nederlandsche Letterkunde te Leiden over het jaar 1872*. Leiden 1872, pp. 89–110.

Bol 1969
Bol, L. J. *Holländische Maler des 17. Jahrhunderts nahe den grossen Meistern: Landschaften und Stilleben*. Braunschweig, 1969.

Bol 1973
Bol. L. J. *Die Holländische Marinemalerei des 17. Jahrhunderts*. Braunschweig, 1973.

Bom 1885
Bom, G. D. *Bijdragen tot eene geschiedenis van het geslacht "Van Keulen." Eene biblio-cartographische studie*. Amsterdam, 1885.

Boon 1978
Boon, K. G. *Catalogue of Dutch and Flemish Drawings in the Rijksmuseum. II, Netherlandish Drawings of the Fifteenth and Sixteenth Centuries*, 2 vols. Amsterdam, 1978.

Bontekoe 1646
Bontekoe, W. I. *Journael ofte gedenckwaerdige beschrijvinghe van de Oost-Indische reijse*. Hoorn, 1646. Reprinted in *De Linschoten Vereeniging*, no. 54, The Hague, 1952 (ed. G. J. Hoogewerff).

Bos-Rietdijk 1984
Bos-Rietdijk, E. "Het werk van Lucas Jansz. Waghenaer," in Enkhuizen, Zuiderzeemuseum, *Lucas Jansz. Waghenaer van Enckhuysen. De maritieme cartografie in de Nederlanden in de zestiende en het begin van de zeventiende eeuw*, 1984, pp. 21–46.

Boxer 1930
Boxer, C. R., ed. and trans. *The Journal of Maarten Harpertszoon Tromp Anno 1639*. Cambridge, 1930.

Boxer 1965
Boxer, C. R. *The Dutch Seaborne Empire*. London, 1965.

van Bragt 1982
Bragt, J.T.W. van. *Ten geleide Atlas van kaarten en aanzichten van de VOC en WIC, genoemd Vingboons-Atlas*. Haarlem, 1982.

Bredius 1890
Bredius, A. "Het Schildersregister van Jan Sysmus Stads-Doctor van Amsterdam." *Oud Holland* 8 (1890), pp. 297–313.

Bredius 1892
Bredius, A. "De Schilder Johannes van de Cappelle." *Oud Holland* 10 (1892), pp. 26–40; 133–137.

Bredius 1905
Bredius, A. "Johannes Porcellis, zijn leven, zijn werk." *Oud Holland* 23 (1905), pp. 69–73.

Bredius 1906
Bredius, A. "Johannes Porcellis, zijn leven, zijn werk." *Oud Holland* 24 (1906), pp. 129–138.

Bredius, *Künstler Inventare*
Bredius, A. *Künstler Inventare: Urkunden zur Geschichte der Holländischen Kunst des XVIten, XVIIten und XVIIIten Jahrhunderts*. 7 vols. The Hague, 1915–1922.

Brewington 1965
Brewington, M. V., and Brewington, D. *Kendall Whaling Museum Paintings*. Sharon, Mass., 1965.

Briels 1976
Briels, J.G.C.A. "De Zuidnederlandse immigratie in Amsterdam en Haarlem omstreeks 1572–1630." Diss., Utrecht, 1976.

Broos 1987
Broos, B.P.J. *Meesterwerken in het Mauritshuis*. The Hague, 1987.

Bruijn 1979
Bruijn, J. R. et al. *Dutch Asiatic Shipping in the 17th and 18th Centuries*, vols. 2–3. The Hague, 1979.

Burchard 1912
Burchard, L. *Die Holländischen Radierer vor Rembrandt*. Halle, 1912.

Burchard 1949
Burchard, L. "Bruegel's Parable of the Whale and the Tub." *Burlington Magazine* 91 (1949), p. 224.

Burger 1908
Burger, C. P., Jr. "Oude Hollandsche zeevaert-uitgaven. I. De oudste uitgaven van het *Licht der Zeevaert*." *Tijdschrift voor Boek- en Bibliotheekwezen* 6 (1908), pp. 119–137.

Burger 1913
Burger, C. P., Jr. "Oude Hollandsche Zeevaert-uitgaven. De Zeevaert van Adriaen Gerritsz." *Het Boek* 2 (1913), pp. 113–128.

Burger 1917
Burger, C. P., Jr. *Amsterdam in het einde der Zestiende Eeuw door Pieter Bast*. Facsimile edition. Amsterdam, 1917 (2nd ed., 1925).

Butlin and Joll 1984
Butlin, M., and Joll, E. *The Paintings of J.M.W. Turner*. 2 vols. New York, 1984.

Cambridge, Fitzwilliam Museum 1960
Cambridge, Fitzwilliam Museum. *Catalogue of Paintings*. Vol. 1, 1960.

Campbell 1985
Campbell, T. "One Map, Two Purposes: Willem Blaeu's Second *West Indische paskaart* of 1630." *The Map Collector* 30 (1985), pp. 36–38.

Christensen 1941
Christensen, A. E. *Dutch Trade to the Baltic About 1600.* Copenhagen, 1941.

Copenhagen, Royal Museum of Fine Arts 1951
Copenhagen, Royal Museum of Fine Arts. *Catalogue of Old Foreign Paintings,* 1951.

Cortesao and Teixeira da Mota 1960
Cortesao, A., and Teixeira da Mota, A. *Portugaliae Monumenta Cartographica,* vol. 3. Lisbon, 1960.

Davids 1986
Davids, C. A. *Zeewezen en wetenschap. De wetenschap en de ontwikkeling van de navigatietechniek in Nederland tussen 1585 en 1815.* Amsterdam, 1986.

Davies 1978
Davies, A. T. *Allart van Everdingen.* New York, 1978.

Debergh 1983
Debergh, M. "A Comparative Study of Two Dutch Maps, Preserved in the Tokyo National Museum. Joan Blaeu's Wall Map of the World in Two Hemispheres, 1648 and Its Revision ca. 1678 by N. Visscher." *Imago Mundi* 35 (1983), pp. 20–36.

Dekker and Eggink 1989
Dekker, P., and Eggink, R. *De walvisvaarder Prins Willem op de Nieuwe Maas by Rotterdam.* Amsterdam, 1989.

de la Roncière and du Jourdin 1984
de la Ronciere, M., and du Jourdin, M. M. *Les portulans. Cartes marines du XIIIe au XVIIe siècle.* Freibourg, 1984.

Destombes 1944
Destombes, M. *La mappe-monde de Petrus Plancius gravée par Josua van den Ende, 1604 d'après l'unique exemplaire de la Bibliothèque Nationale Paris.* Facsimile edition. Hanoi, 1944.

Destombes 1978
Destombes, M. "Quelques rares cartes nautiques néerlandaises du XVIIe siècle." *Imago Mundi* 30 (1978), pp. 56–70.

Destombes and Gernez 1949
Destombes, M., and Gernez, D. "La *West Indische Paskaart de Willem Jansz Blaeu* de la Bibliothèque Royale," in *Communications de l'Académie de Marine de Belgique,* vol 4. Antwerp, 1947–1949, pp. 35–50. Reprinted in M. Destombes, *Contributions sélectionnées à l'histoire de la cartographie et des instruments scientifiques,* ed. G. Schilder. Utrecht, 1987, pp. 23–40.

van Deursen 1978–1980
Deursen, A. Th. van. *Het Dagelijks Brood. Het Kopergeld van de Gouden Eeuw.* 4 vols. Amsterdam, 1978–1980.

Diekerhoff 1967
Diekerhoff, F. L. *De oorlogsvloot in de zeventiende eeuw.* Bussum, 1967.

Diekerhoff 1970
Diekerhoff, F. L. "Egbert Meeuszoon Cortenaer." *Spiegel Historiael* 5 (1970), pp. 22–30.

Dreesmann 1942
Verzameling Amsterdam W.J.R. Dreesmann. Amsterdam, 1942.

Dudok van Heel 1982
Dudok van Heel, S.A.C. "Het Sterfjaar van de Schilder Abraham Storck (1644– . . .)." *Maandblad Amstelodamum* 9 (1982), pp. 76–77.

Dutuit 1881–1885
Dutuit, E. *Manuel de l'amateur d'estampes,* vols. 4–6, *Ecoles flamande et hollandaise.* Paris, 1881–1885.

Duverger 1976
Duverger, E. "Nadere gegevens over de Antwerpse periode van Jan Porcellis." *Jaarboek van het Koninklijk Museum voor Schone Kunsten Antwerpen* 16 (1976), pp. 269–279.

van Eeghen 1953
Eeghen, I. H. van. "De Schildersfamilie Sturck, Storck of Sturckenburch." *Oud Holland* 68 (1953), pp. 216–222.

Eggink 1989
Eggink, R. A. "Walvisjacht in het Hoge Noorden." *Tableau,* 12 (1989), pp. 70–71.

Ertz 1979
Ertz, K. *Jan Bruegel der Altere Die Gemälde.* Cologne, 1979.

Fairfax Murray 1905–1912
Fairfax Murray, C. J. *Pierpont Morgan Collection of Drawings by the Old Masters Formed by C. Fairfax Murray.* 4 vols. London, 1905–1912.

Floor 1982
Floor, W. "First contacts between the Netherlands and Masqat or, a report on the discovery of the Coast of Oman in 1666: translation and introduction." *Zeitschrift der Deutschen Morgenländischen Gesellschaft* 132 (1982), pp. 289–297, 306–307.

Fontaine Verwey 1981a
Fontaine Verwey, H. de la. "Dr. Johan Blaeu and His Sons." *Quaerendo* 9 (1981), pp. 2–23.

Fontaine Verwey 1981b
Fontaine Verwey, H. de la. "The Glory of the Blaeu Atlas and the *Master Colourist.*" *Quaerendo* 9 (1981), pp. 197–229.

van Forest, Webber, et al. 1984
Foreest, H. A. van, Webber, R.E.J., et al. *De Vierdagse Zeeslag.* Amsterdam, 1984.

Frank 1988
Frank, S. M. *Corrections to "Brewington" Notes and Revisions to M. V. and Dorothy Brewington's Kendall Whaling Museum Paintings, 1965.* Kendall Whaling Museum, Sharon, Mass., 1988.

Fulton 1911
Fulton, T. W. *The Sovereignty of the Sea.* Edinburgh, 1911.

Geisenheimer 1911
Geisenheimer, H. "Beiträge zur Geschichte des nieder-ländischen Kunsthandels in der zweiten Hälfte des XVII Jahrhunderts." *Jahrbuch der Preuszischen Kunst-sammlungen* 32 (1911), pp. 34–61.

van Gelder, H. E. 1941
Gelder, H. E. van. *W. C. Heda, A. van Beyeren, W. Kalf.* Amsterdam, Palet Serie, 1941.

van Gelder, H. E. 1947
Gelder, H. E. van. "Abraham de Verwer levert een schilderij van de Slag by Gibraltar." *Oud Holland* 62 (1947), pp. 211–213.

van Gelder, J. G. 1953
Gelder, J. G. van. "Rembrandt and his Circle." *Burlington Magazine* 95 (1953), p. 34.

van Gelder, J. G. 1963
Gelder, J. G. van. "Notes on the Royal Collection IV: The Dutch Gift of 1610 to Henry Prince of *Whalis* and some other Presents." *Burlington Magazine* 105 (1963), pp. 541–544.

Geyl 1958
Geyl, P. *The Revolt of the Netherlands.* London, 1958.

Geyl 1961
Geyl, P. *The Netherlands in the Seventeenth Century.* Part One, *1609–1648,* trans. S. T. Bindoff. London, 1961.

Goedde 1984
Goedde, L. O. "Tempest and Shipwreck in the Art of the Sixteenth and Seventeenth Centuries: Dramas of Peril, Disaster and Salvation." Diss., Columbia University, 1984.

Goedde 1986
Goedde, L. O. "Convention, Realism and the Interpretation of Dutch and Flemish Tempest Painting," *Simiolus* 16 (1986), pp. 139–149.

Goedde 1989
Goedde, L. O. *Tempest and Shipwreck in Dutch and*

Flemish Art Convention, Rhetoric, and Interpretation. University Park, Pa., 1989.

Gordijn and Ratsma 1984
Gordijn, A., and Ratsma, P. *Catalogus van de kaartenverzameling van de Gemeentelijke Archiefdienst Rotterdam. Stadsplattegronden van Rotterdam tot 1940.* Rotterdam, 1984.

Greenwich, National Maritime Museum 1958
Greenwich, National Maritime Museum. *Concise Catalogue of Paintings.* London, 1958.

de Grez 1913
Inventaire des dessins et aquarelles donnés à l'Etat Belge par Mme la douairière de Grez, 1913.

de Groot and Vorstman 1980
Groot, I. de, and Vorstman, R. *Zeilschepen.* Maarssen, 1980. (English ed.: *Sailing Ships: Prints by Dutch Masters from the Sixteenth to the Nineteenth Century.* Trans. M. Hoyle. New York, 1980).

Haak 1984
Haak, B. *The Golden Age: Dutch Painters of the Seventeenth Century.* New York, 1984.

Harwood 1988
Harwood, L. B. *Adam Pynacker.* Doornspijk, 1988.

Havard 1880
Havard, H. *L'art et les artistes hollandais,* 1880.

Haverkamp Begemann 1959
Haverkamp Begemann, E. *Willem Buytewech.* Amsterdam, 1959.

Haverkamp Begemann 1967
Haverkamp Begemann, E. "Cornelis Vroom aan het Meer van Como." *Oud Holland* 82 (1967), pp. 65–67.

Haverkamp Begemann and Logan 1970
Haverkamp Begemann, E., and Logan, A.-M. *European Drawings and Watercolors in the Yale University Art Gallery 1500–1900.* 2 vols. New Haven, 1970.

Haverkorn van Rijswijk 1890
Haverkorn van Rijswijk, P. "Eenige Aanteekeningen betreffende Schilders, wonende buiten Rotterdam," *Oud Holland* 8 (1890), pp. 203–214.

Haverkorn van Rijswijk 1891
Haverkorn van Rijswijk, P. "Simon Jacobsz de Vlieger." *Oud Holland* 9 (1891), pp. 221–224.

Haverkorn van Rijswijk 1893
Haverkorn van Rijswijk, P. "Simon Jacobsz de Vlieger." *Oud Holland* 11 (1893), pp. 229–235.

Haverkorn van Rijswijk 1898
Haverkorn van Rijswijk, P. "Willem van de Velde de Oude zijn leven en zijn werk." *Oud Holland* 16 (1898), pp. 65–78.

Haverkorn van Rijswijk 1899
Haverkorn van Rijswijk, P. "De Eerste Oorlog met Engeland en W. van de Velde de Oude." *Oud Holland* 17 (1899), pp. 33–46.

Haverkorn van Rijswijk 1900
Haverkorn van Rijswijk, P. "Willem van de Velde de Oude te zee en te Land (1657–Juni 1666)." *Oud Holland* 18 (1900), pp. 21–44.

Haverkorn van Rijswijk 1901
Haverkorn van Rijswijk, P. "Willem van de Velde de Jonge." *Oud Holland* 19 (1901), pp. 61–63.

Haverkorn van Rijswijk 1902
Haverkorn van Rijswijk, P. "Willem van de Velde de Oude." *Oud Holland* 20 (1902), pp. 171–192; 225–247.

Haverkorn van Rijswijk 1906a
Haverkorn van Rijswijk, P. "Jan Porcellis." *Onze Kunst* 9 (1906), pp. 189–206.

Haverkorn van Rijswijk 1906b
Haverkorn van Rijswijk, P. "Werken van Jan Porcellis." *Onze Kunst* 10 (1906), pp. 64–74.

Hazelhoff Roelfzema 1971–1972
Hazelhoff Roelfzema, H. "Plattegrond van Amsterdam." *Vereeniging Nederlandsch Historisch Scheepvaart Museum,* 1971–1972, pp. 76ff.

Heawood 1927
Heawood, E. *The Map of the World on Mercator's Projection by Jodocus Hondius, Amsterdam 1608 from the Unique Copy in the Collection of the Royal Geographical Society.* Facsimile edition. London, 1927.

van der Heijden 1987
Heijden, H. A. M. van der. *The oldest maps of the Netherlands. An illustrated and annotated carto-bibliography of the 16th century maps of the XVII Provinces.* Utrecht, 1987.

Helbers 1928
Helbers, G. C. "Abraham van Beyeren Mr. Schilder tot Overschie." *Oud Holland* 45 (1928), pp. 27–28.

Helbers 1947
Helbers, G. C. "Abraham van Beyeren to Gouda." *Oud Holland* 62 (1947), p. 164.

Hoet 1752
Hoet, G. *Catalogus of naamlyst van schilderyen, met derzelver pryzen zedert een lange reeks van jaaren....* 2 vols. The Hague, 1752.

Hoetink 1985
Hoetink, H., ed. *The Royal Picture Gallery Mauritshuis.* Amsterdam, 1985.

Hofman 1978
Hofman, W. *Historische Plattegronden van Nederlandse Steden Deel I. Amsterdam.* Alphen aan den Rijn, 1978.

Hofstede de Groot
Hofstede de Groot, C. *Beschreibendes und Kritisches Verzeichnis der Werke der hervorragendsten Holländischen Maler des XVII. Jahrhunderts.* 10 vols. Esslingen, 1907–1928.

Hollstein
Hollstein, F.W.H. *Dutch and Flemish Etchings, Engravings and Woodcuts 1450–1700.* Amsterdam, 1949– .

van 't Hoff 1941–1942
van 't Hoff, B. "Bijdrage tot de dateering van de ou-dere Nederlandsche stadsplattegronden." *Nederlands Archievenblad* 2 (1941–1942), pp. 29–68; 97–150.

van 't Hoff 1949
van 't Hoff, B. "De plattegronden van de stad Rotterdam in de 16de en 17de eeuw." *Het Boek* 30 (1949), pp. 43–65.

van 't Hoff 1966
van 't Hoff, B. "Oude kaarten van Rotterdam en omgeving." *Rotterdams Jaarboekje,* 1966.

't Hooft 1915
't Hooft, C. G. "Onze Vloot in de Schilderkunst," in *Feest-Bundel Dr. Abraham Bredius.* Amsterdam, 1915, pp. 97–108.

't Hooft and de Balbian Verster 1916/1917a
't Hooft, C. G. and de Balbian Verster, J.F.L. "Een fraaie grisaille van Backhuysen." *Jaarverslag Vereeniging Nederlandsch Historisch Scheepvaart Museum* 1 (1916/1917), p. 36.

't Hooft and de Balbian Verster 1916/1917b
't Hooft, C. G., and de Balbian Verster, J.F.L. "Een merkwaardige zeeslag van Vroom." *Jaarverslag Vereeniging Nederlandsch Historisch Scheepvaart Museum* 1 (1916/1917), p. 36.

't Hooft and de Balbian Verster 1919
't Hooft, C. G., and de Balbian Verster, J.F.L. "De merkwaardige zeeslag van Vroom." *Jaarverslag Vereeniging Nederlandsch Historisch Scheepvaart Museum* 3 (1919), p. 61.

Hoogsteder 1986
Hoogsteder, W. J. "De Schilderijen van Frederik en Elizabeth, Koning en Koningen van Bohemen." Master's thesis, 3 vols., Utrecht, 1986.

Hoogstraeten 1678
Hoogstraeten, S. van, *Inleyding tot de hooge schoole der schilderkunst, anders de zichtbare werelt,* Rotterdam, 1678. Reprinted Utrecht, 1969.

Horn 1989
Horn, H. J. *Jan Vermeyen.* Doornspijk, 1989.

Houbraken
Houbraken, A. *De Groote Schouburgh der Nederlantsche Konstschilders en Schilderessen.* 3 vols. Amsterdam, 1718–1721 (2nd ed., 1753).

Huygens
P. Leendertz, ed. *Volledige Dichtwerken van Constantijn Huygens.* Amsterdam–Rotterdam, Hollandsche Maatschappij van Fraaije Kunsten en Wetenschappen.

Illustrated Bartsch
The Illustrated Bartsch. New York, 1975– .

Jöcher 1750
Jöcher, C. G. *Allgemeines Gelehrten Lexicon,* vol. 1, Leipzig 1750.

de Jongh 1967
Jongh, E. de. *Zinne-en minnebeelden in de schilderkunst van de zeventiende eeuw.* Amsterdam, 1967.

Judson 1964
Judson, J. Richard. "Marine Symbols of Salvation in the Sixteenth Century," in *Essays in Memory of Karl Lehman.* New York, 1964.

Kattenburg 1989
Kattenburg, R. *Two Centuries of Dutch Marine Paintings and Drawings from the Collection of Rob Kattenburg.* Amsterdam, 1989.

Kelch 1971
Kelch, J. "Studien zu Simon de Vlieger als Marinemaler." Diss., Berlin, 1971.

Keuning 1946
Keuning, J. *Petrus Plancius, theoloog en geograaf 1550–1622.* Amsterdam, 1946.

Keuning 1949
Keuning, J. "Hessel Gerritsz." *Imago Mundi* 6 (1949), pp. 49–66.

Keuning 1973
Keuning, J. *Willem Jansz. Blaeu. A biography and history of his work as a cartographer and publisher,* re-

vised and edited by M. Donkersloot-de Vrij. Amsterdam 1973.

Keyes 1975
Keyes, G. S. *Cornelis Vroom: Marine and Landscape Artist.* Alphen aan den Rijn, 1975.

Keyes 1976
Keyes, G. S. "Pieter Mulier the Elder." *Oud Holland* 90 (1976), pp. 230–261.

Keyes 1979
Keyes, G. S. "Cornelis Claesz. van Wieringen." *Oud Holland* 93 (1979), pp. 1–46.

Keyes 1981
Keyes, G. S. *Pieter Bast.* Alphen aan den Rijn, 1981.

Keyes 1982
Keyes, G. S. "Hendrick and Cornelis Vroom: Addenda," *Master Drawings* 20 (1982), pp. 115–124.

Kleerkoper and van Stockum 1914–1916
Kleerkoper, M. M., and Stockem, W. P. van. *De boekhandel te Amsterdam voornamelijk in de 17de eeuw* 2 vols. The Hague, 1914–1916.

Koeman 1964
Koeman, C. *The History of Lucas Jansz Waghenaer and His "Spieghel der Zeevaerdt."* Lausanne, 1964.

Koeman, *Atlantes Neerlandici*
Koeman, K. *Atlantes Neerlandici: Bibliography of terrestrial, maritime and celestial atlases and pilot books, published in the Netherlands up to 1880.* 5 vols. Amsterdam, 1967–1971.

Koeman 1970
Koeman, C. *Joan Blaeu and His Grand Atlas.* London, 1970.

Koeman 1971
Koeman, C. Introduction to *Arent Roggeveen and Pieter Goos, The Burning Fen, First and Second Part, Amsterdam 1675.* Amsterdam, 1971.

Koeman 1972
Koeman, C. *The Sea on Paper. The Story of the Van Keulens and Their "Sea-torch."* Amsterdam, 1972.

Koeman 1980
Koeman, C. "The Chart Trade in Europe from Its Origin to Modern Times." *Terrae incognitae* 12 (1980), pp. 49–64.

Koeman 1982
Koeman, C. "17e eeuwse Hollandse bijdragen in de kartering van de Amerikaanse kusten." *Caert-Thresoor* 1 (1982), pp. 50–53.

Koeman 1983
Koeman, C. *Geschiedenis van de kartografie van Nederland. Zes eeuwen land- en zeekaarten en stadsplattegronden.* Alphen aan den Rijn, 1983.

Koeman and Schilder 1977
Koeman, C., and Schilder, G. "Ein neuer Beitrag zur Kenntnis der niederländischen Seekartografie im 18. Jahrhundert." *Festschrift für Erik Arnberger. Beiträge zur theoretischen Kartographie.* Vienna, 1977, pp. 267–290.

Kok 1989
Kok, M. "Cartografie van de firma Van Keulen 1674–1880," in Amsterdam, Rijksmuseum "Nederlands Scheepvaart Museum," *In de Gekroonde Lootsman. Het kaarten-, boekuitgevers- en instrumentenmakershuis Van Keulen te Amsterdam 1680–1885.* Utrecht, 1989, pp. 15–43.

Krielaart 1974
Krielaart, T. "Symboliek in zeegezichten." *Antiek* 7 (1974), pp. 568–569.

van der Krogt 1984
Krogt, P.C.J. van der. *Old globes in the Netherlands. A catalogue of terrestrial and celestial globes made prior to 1850 and preserved in Dutch collections.* Utrecht, 1984.

van der Krogt 1989
Krogt, P. C. J. van der, *Globi Neerlandici. De globeproduktie in de Nederlanden.* Utrecht, 1989.

Krul 1640
Krul, J. H. *Minnenbilden: Toe-gepast de lievende jonckheyt.* Amsterdam, 1640.

Kuretsky 1979
Kuretsky, S. D. *The Paintings of Jacob Ochtervelt (1634–1682).* Oxford, 1979.

Landwehr 1970
Landwehr, J. *Romeyn de Hooghe (1645–1708) as Book Illustrator.* Amsterdam, 1970.

Linschoten 1957
Linschoten, Jan Huygen van. *Itinerario Voyage ofte Schipvaert van Jan Huygen van Linschoten naer Oost ofte Portugaels Indien.* 3 vols. The Hague, 1957.

Lugt 1921
Lugt, F. *Les marques de collections de dessins et d'estampes.* Amsterdam, 1921 (Supplement, The Hague, 1956).

Lugt 1927
Lugt, F. *Les dessins des ecoles du Nord de la collection Dutuit.* Paris, 1927.

Lugt 1931
Lugt, F. "Beiträge zu dem Katalog der niederländischen Handzeichnungen in Berlin." *Jahrbuch der Preussischen Kunstsammlungen* 52 (1931), pp. 36–80.

van Luttervelt 1947
Luttervelt, R. van. "Een zeegezicht met een historische voorstelling van Adam Willaerts." *Historia* 12 (1947), pp. 225ff.

Maclaren 1960
Maclaren, N. *National Gallery Catalogues: The Dutch School.* London, 1960.

van Mander 1604
Mander, C. van. *Het Schilder-Boeck.* Haarlem, 1604.

Maritieme Geschiedenis der Nederlanden 1977
Maritieme Geschiedenis der Nederlanden, vol. 2, ed. L. M. Akveld, S. Hart, and W. J. van Hoboken. Bussum, 1977.

Martin 1936
Martin, W. *De Hollandsche Schilderkunst in de Ze-ventiende Eeuw.* 2 vols. Amsterdam, 1935–1936 (2nd ed., 1942).

Mauritshuis 1980
The Hague, Mauritshuis. *Hollandse Schilderkunst Landschappen 17de Eeuw*, 1980.

Meijer 1988
Meijer, F. G. "Een aantekening bij Scott A. Sullivans Abraham van Beijerens Visserij-bord in de Groote Kerk Maassluis." *Oud Holland* 102 (1988), pp. 243–245.

Meilink-Roelofsz 1967
Meilink-Roelofsz, M. A. P. "Een Nederlandse vestiging in de Perzische Golf." *Spiegel Historiael* 2 (1967), pp. 480–488.

M.G.W. 1917
M.G.W. "Korte Mededelingen IV. De Vrouw van Balthasar Florisz. van Berckenrode." *Oud Holland* 35 (1917), p. 192.

Moes 1893
Moes, E. W. "Een Geschenk van de Stad Amsterdam aan den Marquis de Lionne." *Oud Holland* 11 (1893), pp. 30–33.

Moes 1904–1906
Moes, E. W. *Oude Teekeningen van de Hollandsche en Vlaamsche Shool in het Rijksprentenkabinet.* 2 vols. The Hague, 1904–1906.

Moes and Burger 1900–1915
Moes, E. W., and Burger, C. P., Jr. *De Amsterdamsche boekdrukkers en uitgevers in de zestiende eeuw.* 4 vols. Amsterdam, 1900–1915.

Müllenmeister 1973
Müllenmeister, K. *Meer und Land im Licht des 17. Jahrhunderts.* Bremen, 1973.

Muller 1853
Muller, F. *Beschrijvende Catalogus van 7000 Portretten, van Nederlanders.* Amsterdam, 1853. Reprinted Soest, 1972.

Muller 1863–1870 (F. M. historie platen)
Muller, F. *Beredeneerde Beschrijving van Nederlandsche Historieplaten, Zinneprenten en Historische Kaarten.* 4 vols. Amsterdam, 1863–1870. Reprinted in 3 vols., Amsterdam, 1970.

Muller 1894
Muller, F., ed. *Remarkable maps of the XVth, XVIth and XVIIth centuries reproduced in their original size. I. The Bodel Nijenhuis Collection at Leyden.* Amsterdam, 1894.

Muller and Zandvliet 1987
Muller, E., and Zandvliet K., eds. *Admissies als landmeter in Nederland voor 1811. Bronnen voor de geschiedenis van de landmeetkunde.* Alphen aan den Rijn, 1987.

Nannen 1985
Nannen, H. *Ludolf Backhuysen.* Emden, 1985.

Newton 1933
Newton, A. P. *The European Nations in the West Indies.* London, 1933.

Orlers 1641
Orlers, J. J. *Beschryvinge der Stadt Leyden.* Leiden, 1641.

van Overeem 1958
Overeem, J. B. van. "De schilders A. en R. van der Salm." *Rotterdams Jaarboekje*, 1958.

Palmer 1961
Palmer, E. C. "*The Battle of the Armada* and *The Great North Sea Storm.*" *Connoisseur* 149 (1962), pp. 154–155.

Pastoureau 1984
Pastoureau, M. *Les atlas français, XVIe–XVIIe siècles: repertoire bibliographique et étude.* Paris, 1984.

Preston 1937
Preston, L. R. *Sea and River Painters of the Netherlands in the Seventeenth Century.* London, 1937.

Preston 1974
Preston. L. R. *The Seventeenth Century Marine Painters of the Netherlands.* Leigh-on-Sea, 1974.

Ratsma 1984
Ratsma, P. *Historische plattegronden van Nederlandse steden, II, Rotterdam.* Alphen aan den Rijn, 1984.

Reiss 1975
Reiss, S. *Aelbert Cuyp.* London, 1975.

Renckens 1951
Renckens, B.J.A., "Jan van Goyen en zijn Noordhollandse leermeester." *Oud Holland* 66 (1951), pp. 23–34.

Resolutiën
Resolutiën der Staten-Generaal, vol. 11 (1941), ed. N. Japikse (R.G.P. Grote Serie 85); vol. 12 (1950), ed. H.H.P. Rijperman (R.G.P. Grote Serie 92); vol. 13 (1957), ed. H.H.P. Rijperman (R.G.P. Grote Serie 101); vol. 14 (1970), ed. H.H.P. Rijperman (R.G.P. Grote Serie 131); Nieuwe Reeks, vol. 1 (1971), ed. A. T. van Deursen (R.G.P. Grote Serie 135); Nieuwe Reeks, vol. 2 (1984), ed. A. T. van Deursen (R.G.P. Grote Serie 151); Nieuwe Reeks, vol. 3 (1975), ed. J. G. Smit (R.G.P. Grote Serie 152). The Hague.

Reznicek 1961
Reznicek, E.K.J. *Die Zeichnungen von Hendrick Goltzius.* Utrecht, 1961.

Ritter von Engerth 1889
Ritter von Engerth, E. "Nachtrag zu der Abhandlung über die im Kaiserlichen Besitze befindlichen Cartone darstellend Kaiser Karls V Kriegzug nach Tunis von Jan Vermeyen." *Jahrbuch der Kunsthistorischen Sammlungen des allerhöchsten Kaiserhauses* 9 (1889), p. 419ff.

Robinson 1958–1974
Robinson, M. S. *Van de Velde Drawings: A Catalogue of drawings in the National Maritime Museum Made by the Elder and the Younger Willem van de Velde.* 2 vols. Cambridge, 1958–1974.

Rosenberg 1928a
Rosenberg, J. *Jacob van Ruisdael.* Berlin, 1928.

Rosenberg 1928b
Rosenberg, J. "Cornelis Hendricksz. Vroom." *Jahrbuch der Preussischen Kunstsammlungen* 49 (1928), pp. 102–110.

Rosenberg 1958
Rosenberg, J. "A Seascape by Jacob van Ruisdael." *Bulletin Museum of Fine Arts,* Boston, vol. 56 (1958), pp. 144–146.

Röthlisberger 1970
Röthlisberger, M. *Cavalier Pietro Tempesta and His Time.* Newark, Del., 1970.

Ruurs 1983
Ruurs, R. "*Even if it is not architecture,* Perspective Drawings by Simon de Vlieger and Willem van de Velde the Younger." *Simiolus* 13 (1983), pp. 189–200.

Russell 1975
Russell, M. *Jan van de Cappelle.* Leigh-on-Sea, 1975.

Russell 1983
Russell, M. *Visions of the Sea: Hendrick C. Vroom and the Origins of Dutch Marine Painting.* Leiden, 1983.

Russell 1986
Russell, M. "Seascape into Landscape," in London, National Gallery, *Dutch Landscape: The Early Years, Haarlem and Amsterdam 1590–1650,* 1986, pp. 63–71.

Sandrart 1675
Sandrart, Joachim von. *Teutsche Academie der Edlen Bau-, Bild- und Malerey-Künste.* Nuremberg, 1675.

Schaffran 1957
Schaffran, E. "Das Dr. v. Wurzbach Legat an die Galerie der Akademie der bildenden Künste in Wien." *Oud Holland* 72, pp. 41–50.

Schama 1987
Schama, S. *The Embarrassment of Riches: An Interpretation of Dutch Culture in the Golden Age.* New York, 1987.

Scheffer 1868–1880
Scheffer, J. H. *Roterodamum Illustratum.* 4 vols. Rotterdam, 1868–1880.

Scheurleer 1912–1914
Scheurleer, D. F., ed. *Onze Mannen ter zee in dicht en beeld.* 3 vols. The Hague, 1912–1914.

Schilder 1976a
Schilder, G. *Australia Unveiled: The Share of the Dutch Navigators in the Discovery of Australia.* Amsterdam, 1976.

Schilder 1976b
Schilder, G. "Organization and Evolution of the Dutch East India Company's Hydrographic Office of the Seventeenth Century." *Imago Mundi* 28 (1976), pp. 61–78.

Schilder 1976c
Schilder, G. "Willem Janszoon Blaeu's Map of Europe (1606), a Recent Discovery in England." *Imago Mundi* 28 (1976), pp. 9–20.

Schilder 1977
Schilder, G. *The World Map of 1624 by Willem Jansz. Blaeu and Jodocus Hondius.* Facsimile edition. Amsterdam, 1977.

Schilder 1978
Schilder, G. *The World Map of 1669 by Jodocus Hondius the Elder and Nicolaas Visscher.* Facsimile edition. Amsterdam, 1978.

Schilder 1979a
Schilder, G. "Willem Jansz. Blaeu's Wallmap of the World on Mercator's Projection, 1606–07 and Its Influence." *Imago Mundi* 31 (1979), pp. 36–54.

Schilder 1979b
Schilder, G. "Wandkaarten der Nederlanden uit de 16e en 17e eeuw Een verkenning." *Kartografisch Tijdschrift* 5 (1979), pp. 23–32.

Schilder 1981
Schilder, G. *Three World Maps by François van den Hoeve of 1661, Willem Janszoon (Blaeu) of 1607 (and) Claes Janszoon Visscher of 1650.* Facsimile edition. Amsterdam, 1981.

Schilder 1983
Schilder, G. "The *Van der Hem Atlas,* a monument of Dutch Culture in Vienna." *The Map Collector,* no. 25 (1983), pp. 22–26.

Schilder 1984a
Schilder, G. *The Netherland Nautical Cartography from 1550 to 1650.* Lisbon, 1984.

Schilder 1984b
Schilder, G. "De Noordhollandse Cartografenschool," in Enkhuizen, Zuiderzeemuseum, *Lucas Jansz. Waghenaer van Enckhuysen. De maritieme cartografie in de Nederlanden in de zestiende en het begin van de zeventiende eeuw,* 1984, pp. 47–72.

Schilder 1986
Schilder, G. *Monumenta cartographica Neerlandica I.* Alphen aan den Rijn, 1986.

Schilder 1987
Schilder, G. *Monumenta Cartographica Neerlandica II.* Alphen aan den Rijn, 1987.

Schilder 1988
Schilder, G. "Het cartografisch bedrijf van de VOC," in Enkhuizen, Zuiderzeemuseum, *De VOC in de kaart gekeken. Cartografie en navigatie van de Verenigde Oostindische Compagnie 1602–1799.* The Hague, 1988, pp. 17–46.

Schilder 1989
Schilder, G. *Monumenta Cartographica Neerlandica III,* Alphen aan den Rijn, 1989.

Schilder and Welu 1980
Schilder, G., and Welu, J. A. *The World Map of 1611 by Pieter van den Keere.* Facsimile edition. Amsterdam, 1980.

Schlie 1882
Schlie, W. *Beschreibendes Verzeichnis der Werke älterer Meister in der Grossherzoglichen Gemälde Gallerie.* Schwerin, 1882.

Scholten 1904
Scholten, H. J. *Musée Teyler à Haarlem, Catalogue raisonné des dessins des Ecoles Française et Hollandaise.* Haarlem, 1904.

Schrevelius 1648
Schrevelius, P. *Harlemias.* Haarlem, 1648.

Schulz 1971
Schulz, W. "Doomer and Savery." *Master Drawings* 9 (1971), pp. 253–259.

Schwerin 1951
Katalog *Holländische Maler des XVII. Jahrhunderts im Mechlenburgischen Landesmuseum.* Schwerin, 1951.

van Selm 1987
Selm, R. van. *Een menighte treffelijcke Boecken: Nederlandse boekhandelscatalogi in het begin van de zeventiende eeuw.* Utrecht, 1987.

Shirley 1983
Shirley, R. W. *The Mapping of the World. Early Printed World Maps 1472–1700.* London, 1983.

Simon 1927
Simon, K. E. "Jacob van Ruisdael." Diss., Berlin, 1927.

Simon 1930
Simon, K. E. *Jacob van Ruisdael: Eine Darstellung seiner Entwicklung.* Berlin, 1930.

Simon 1958
Simon, M. "Claes Jansz. Visscher." Diss., Freiburg, 1958.

Skeeles-Schloss 1982
Skeeles-Schloss, C. *Travel, Trade and Temptation. The Dutch Italianate Harbor Scene 1640–1680.* Ann Arbor, Mich. 1982.

Skelton 1958
Skelton, R. A. *Explorers' Maps. Chapters in the Cartographic Record of Geographical Discovery.* London, 1958.

Skelton 1964
Skelton, R. A. Introduction to *Willem Jansz. Blaeu (William Johnson), The Light of Navigation, Amsterdam 1612.* Facsimile edition. Amsterdam, 1964.

Smith 1829–1837
Smith, J. *A Catalogue Raisonné of the works of the Most Eminent Dutch, Flemish and French Painters.* 9 vols. London, 1829–1837 (Supplement, 1842).

Smith 1978
Smith, T. R. "Manuscript and Printed Sea Charts in Seventeenth Century London: The Case of the Thames School," in *The Compleat Plattmaker. Essays on Chart, Map and Globemaking in England in the Seventeenth and Eighteenth Centuries.* Berkeley and Los Angeles, 1978, pp. 45–100.

Smith 1982
Smith, D. R. *Masks of Wedlock: Seventeenth-Century Dutch Marriage Portraiture.* Ann Arbor, Mich. 1982.

Spicer 1979
Spicer, J. "The Drawings of Roelandt Savery." Diss., Yale University, 1979.

Stechow 1938
Stechow, W. *Salomon van Ruysdael Eine Einführung in seine Kunst.* Berlin, 1938 (rev. ed., Berlin, 1975).

Stechow 1960
Stechow, W. "Landscape Paintings in Dutch Seventeenth Century Interiors." *Nederlands Kunsthistorisch Jaarboek* 2 (1960), pp. 165–184.

Stechow 1965
Stechow, W. "Uber das Verhältnis zwischen Signatur und Chronologie bei einigen holländischen Kunstlern des 17. Jahrhunderts." *Festschrift für Dr. H. C. Trautscholdt.* Hamburg, 1965.

Stechow 1966
Stechow, W. *Dutch Landscape Painting of the Seventeenth Century.* London, 1966.

Stechow 1969
Stechow, W. *Pieter Bruegel the Elder.* New York, 1969.

Stevenson 1914
Stevenson, E. L. *Willem Janszoon Blaeu 1571–1638. A Sketch of His Life and Work with a Special Reference to His Large World Map of 1605.* Facsimile of the unique copy belonging to the Hispanic Society of America. New York, 1914.

Stevenson 1921
Stevenson, E. L. *Terrestrial and Celestial Globes. Their History and Construction, Including a Consideration of their Value as Aids in the Study of Geography and Astronomy,* 2. vols. New Haven, 1921.

Stevenson and Fischer 1907
Stevenson, E. L., and Fischer, J. *Map of the World by Jodocus Hondius, 1611.* Facsimile edition. New York, 1907.

van Stolk
Atlas van Stolk. Katalogus der historie-, spot en zinnenpranten betrekkelijk de geschiedenis van Nederland. 10 vols. Amsterdam, 1895–1933.

Sullivan 1987
Sullivan, Scott A. "Abraham van Beyeren's *Visserijbord* in the Groote Kerk, Maassluis." *Oud Holland* 101 (1987), pp. 115–125.

Teensma 1968
Teensma, B. N. "Don Francesco Manuel de Melo en de Nederlanden." *Spiegel Historiael* 3 (1968), pp. 219–224.

Tervarent 1949
Tervarent, G. de. "Bruegel's Parable of the Whale and the Tub." *Burlington Magazine* 91 (1949), p. 293.

Thieme and Becker *Künstler Lexikon*
Thieme, U., and Becker, F. *Allgemeines Lexikon der bildenden Künstler von der Antike bis zur Gegenwart.* 37 vols. Leipzig, 1907–1950.

Timm 1961
Timm, W. "Der gestrandete Wal. Eine motivkundige Studie," in Staatliche Museen zu Berlin, *Forschungen und Berichte,* vols. 3–4 (1961), pp. 76–93.

Timm 1976
Timm, W. *Schiffe und ihre Schicksale: Maritime Ereignisbilder.* Rostock, 1976.

Valentiner 1941
Valentiner, W. R. "Jan van de Cappelle." *Art Quarterly* 4 (1941), pp. 272–296.

Vermeulen 1988
Vermeulen, T. "Onvermoeid in actie: verkenningen in de Oost," in Enkhuizen, Zuiderzeemuseum, *De VOC in de kaart gekeken. Cartografie en navigatie van de Verenigde Oostindische Compagnie 1602–1799.* The Hague, 1988, pp. 75–106.

Verner 1967
Verner, C. Introduction to *The English Pilot: The Fourth Book, London, 1689.* Facsimile edition. Amsterdam, 1967.

Verner and Skelton 1970
Verner, C., and Skelton R. A. Introduction to *John Thornton, The English Pilot: The Third Book, London, 1703.* Facsimile edition. Amsterdam, 1970.

Vlekke 1945
Vlekke, B.H.M. *Nusantara. A History of the East Indian Archipelego.* Cambridge, Mass., 1945.

Voorbijtel Cannenburg 1950
Voorbijtel Cannenburg, W. "The Van de Veldes." *Mariners Mirror* 36 (1950), pp. 185–204.

de Vries 1885
Vries, A. D. de. "Biografische Aanteekeningen betreffende voornamelijk Amsterdamsche Schilders, Plaatsnijders enz. en hunne verwanten." *Oud Holland* 3 (1885), pp. 55–80.

de Vries 1968a
Vries, A. B. de. "Schipbreuk bij het strand Jan Porcellis." *Openbaar Kunstbezit* 12 (1968), pp. 5a–5b.

de Vries 1968b
Vries, L. de. "Een paneel van Jan Porcellis in het Mauritshuis." *Antiek* 3 (1968), pp. 14–15.

de Vries 1981
Vries, Jan de. *Barges and Capitalism. Passenger Transportation in the Dutch Economy 1632–1839.* Utrecht, 1981.

de Vries 1989
Vries, D. de. "Dutch Cartography," in Williamsburg, Colonial Williamsburg, *The Age of William & Mary II; Power, Politics and Patronage 1688–1702,* 1989, pp. 105–111.

Vuyk 1935
Vuyk, J. "Johannes of Jacobus Storck of Sturch." *Oud Holland* 52 (1935), pp. 121–126.

Waagen 1854
Waagen, G. F. *Treasures of Art in Great Britain.* 3 vols. London, 1854 (Supplement, 1857).

van de Waal 1941
Waal, H. van de. *Jan van Goyen.* Amsterdam, Palet Serie, 1941.

van de Waal 1952
Waal, H. van de. *Drie Eeuwen Vaderlandsche Geschied-Uitbeelding 1500–1800 Een Iconologische Studie.* 2 vols. The Hague, 1952.

de Waard 1897
Waard, C. de. "De Middelburgsche Tapijten." *Oud Holland* 15 (1897), pp. 65–93.

Waller 1974
Waller, F. G. *Biographisch Woordenboek van Noord Nederlandsche Graveurs.* Amsterdam, 1974. Reprint of 1938 edition.

Walsh 1974a
Walsh, J., Jr. "The Dutch Marine Painters Jan and Julius Porcellis I: Jan's Early Career." *Burlington Magazine* 116 (1974), pp. 653–662.

Walsh 1974b
Walsh, J., Jr. "The Dutch Marine Painters Jan and Julius Porcellis II: Jan's Maturity and *de jonge Porcellis.*" *Burlington Magazine* 116 (1974), pp. 734–745.

Warner 1979
Warner, D. J. *The Sky Explored. Celestial Cartography 1500–1800.* New York, 1979.

Wawrik 1982
Wawrik, F. *Berühmte Atlanten. Kartographische Künst aus fünf Jahrhunderten.* Dortmund, 1982.

Weber and Robinson 1979
Weber, R. E. J., and Robinson, M. S. *The Willem van de Velde Drawings in the Boymans–van Beuningen Museum, Rotterdam.* 3 vols. Rotterdam, 1979.

Welu 1975
Welu, J. A. "Vermeer: his cartographic sources," *Art Bulletin* 57 (1975), pp. 529–547.

Welu 1977
Welu, J. A. "Vermeer and Cartography" Diss., Boston University, 1977.

Welu 1987
Welu, J. A. "The Sources and Development of Cartographic Ornamentation in the Netherlands," in *Art and Cartography. Six Historical Essays.* Chicago, 1987, pp. 147–173, 233–238.

Wheelock 1981
Wheelock, A. K., Jr. *Vermeer.* New York, 1981.

Wieder, 1925–1933
Wieder, F. C. *Monumenta Cartographica.* 5 vols. The Hague, 1925–1933.

Willis 1911
Willis, F. C. *Die Niederländischen Marinemalerei.* Leipzig, 1911.

Wilson 1957
Wilson, C. *Profit and Power. A Study of England and the Dutch Wars.* London, 1957 (2nd ed., The Hague, 1978).

Wilson 1968
Wilson, C. *The Dutch Republic and the Civilization of the Seventeenth Century.* London, 1968.

Wilson 1974
Wilson, W. H. "The Art of Romeyn de Hooghe: An Atlas of European Late Baroque Culture." Diss., Harvard University, 1974.

Wurzbach
Wurzbach, A. von. *Niederländisches Künstler Lexikon.* 3 vols. Vienna, 1906–1911. Reprinted Amsterdam, 1974.

van Ysselstein 1936
Ysselstein, G. T. van. *Geschiedenis der Tapijtweverijen in de Noordelijke Nederlanden.* Leiden, 1936.

Zandvliet 1979a
Zandvliet, K. "Johan Maurits and the Cartography of Dutch Brazil," in *Johan Maurits van Nassau-Siegen, a Humanist Prince in Europe and Brazil.* The Hague, 1979, pp. 494–518.

Zandvliet 1979b
Zandvliet, K. "De cartografie van Nederlands Brazilië," in The Hague, Mauritshuis, *Zo wijd de wereld strekt,* 1979, pp. 151–167.

Zandvliet 1982
Zandvliet, K. "Een ouderwetse kaart van Nieuw Nederland door Cornelis Doetsz en Willem Jansz. Blaeu." *Caert-Thresoor* 1 (1982), pp. 57–60.

Zandvliet 1985
Zandvliet, K. *De groote wereld in 't kleen geschildert. Nederlandse kartografie tussen de middeleeuwen en de industriële revolutie.* Alphen aan den Rijn, 1985.

Zandvliet 1989
Zandvliet, K. "Joan Blaeu's Boeck vol kaerten en beschrijvingen van de Oostindische Compagnie," in Amsterdam, Koninklijk Paleis, *Het kunstbedrijf van de familie Vingboons. Schilders, architecten en kaartmakers in de Gouden Eeuw.*" Amsterdam, 1989, pp. 58–95.

Zoege von Manteuffel 1927
Zoege von Manteuffel, K. *Die Künstlerfamilie van de Velde.* Bieleveld-Leipzig, 1927.

Zwollo 1983
Zwollo, A. "Ein Beitrag zur Niederländischen Landschaftsmalerei um 1600." *Umeni* 31 (1983), pp. 399–412.

EXHIBITIONS

Amsterdam and Vlissingen 1957
Amsterdam, Rijksmuseum – Vlissingen, Nieuw Tehuis voor Bejaarden. *Michiel de Ruyter,* 1957.

Amsterdam 1976
Amsterdam, Rijksmuseum. *Tot Lering en Vermaak,* 1976 (exhibition organized by E. de Jongh et al.).

Amsterdam 1985
Amsterdam, Rijksmuseum "Nederlands Scheepvaart Museum." *Ludolf Backhuizen 1631–1708,* 1985 (catalogue by B. Broos, R. Vorstman, and W. L. van de Watering).

Amsterdam 1987
Amsterdam, Rijksprentenkabinet. *Land and Water Dutch Drawings from the 17th Century,* 1987.

Amsterdam, Boston, and Philadelphia 1987/1988
Amsterdam, Rijksmuseum – Boston, Museum of Fine Arts – Philadelphia, Philadelphia Museum of Art. *Masters of 17th-Century Dutch Landscape Painting,* 1987/1988 (exhibition organized by P. C. Sutton).

Amsterdam 1989a
Amsterdam, Rijksprentenkabinet. *Kunst in kaart.* Utrecht, 1989.

Amsterdam 1989b
Amsterdam, Rijksmuseum. *Russen en Nederlanders,* 1989.

Amsterdam 1989c
Amsterdam, Amsterdams Historisch Museum. *Gesneden en gedrukt in de Kalverstraat. De kaarten- en atlassendrukkerij in Amsterdam tot in de 19e eeuw* (ed. P. van den Brink and J. Werner). Utrecht, 1989.

Amsterdam 1989d
Amsterdam, Nico Israel. *Catalogue Twenty-five. 250 fine and interesting old books in many fields, maps and atlases. A selection from our stock arranged in chronological order,* 1989.

Berlin 1974
Berlin, Staatliche Museen Preussischer Kulturbesitz, Kupferstichkabinett. *Die Holländische Landschaftszeichnung 1600–1740,* 1974 (catalogue by W. Shultz).

Berlin 1975
Berlin, Staatliche Museen Preussischer Kulturbesitz, Kupferstichkabinett. *Pieter Bruegel der Alterer als Zeichner: Herkunft und Nachfolge,* 1975.

Boston and Saint Louis 1980/1981
Boston, Museum of Fine Arts – Saint Louis, The Saint Louis Art Museum. *Printmaking in the Age of Rembrandt,* 1981/1982 (catalogue by C. S. Ackley).

Braunschweig 1978
Braunschweig, Herzog Anton Ulrich Museum. *Die Sprache der Bilder,* 1978.

Brussels 1961
Brussels, Royal Library of Belgium. *Hollandse Tekeningen uit de Gouden Eeuw,* 1961.

Brussels 1967
Brussels, Koninklijke Musea voor Schone Kunsten van België. *Honderd Twintig Tekeningen,* 1967.

Brussels 1971a
Brussels, Koninklijke Musea voor Schone Kunsten van België. *De Rembrandt à Van Gogh*, 1971.

Brussels 1971b
Brussels, Koninklijke Bibliotheek. *De Hollandse kartografie*, 1971 (catalogue by A. de Smet).

Cambridge and Montreal 1988
Cambridge, Sackler Museum – Montreal, Montreal Museum of Fine Arts. "*Landscape in Perspective Drawings by Rembrandt and His Contemporaries*," 1988 (catalogue by F. Duparc).

Cologne 1975
Cologne, Historische Archiv. *Rotterdam. Stadtgeschichte in Dokumenten und Bildern*, 1975.

Dordrecht 1964
Dordrecht, Dordrechts Museum. *Zee-, rivier-, en oevergezichten: Nederlandse schilderijen uit de 17de eeuw*, 1964.

Dordrecht 1977/1978
Dordrecht, Dordrechts Museum. *Aelbert Cuyp en zijn familie schilders te Dordrecht*, 1987/1988 (catalogue by J. Giltay).

Dordrecht 1989
Dordrecht, Dordrechts Museum. *Een onsterfelijk zeeschilder J. C. Schotel 1787–1838*, 1989.

Göteborg 1954
Göteborg, Göteborgs Kunstmuseum. *Rotterdam och Havet*, 1954.

Greenwich 1982
Greenwich, National Maritime Museum. *The Art of the Van de Veldes*, 1982 (catalogue by D. Cordingly).

The Hague 1966
The Hague, Mauritshuis, *In the Light of Vermeer – Five Centuries of Paintings*, 1966.

The Hague and Cambridge 1981/1982
The Hague, Mauritshuis – Cambridge, Fogg Art Museum. *Jacob van Ruisdael*, 1981/1982 (catalogue by S. Slive).

The Hague 1989
The Hague, Museon, *Kaarten met geschiedenis 1550–1800. Een selectie van oude getekende kaarten van Nederland uit de Collectie Bodel Nijenhuis* (ed. D. de Vries), 1989.

Kingston 1984
Kingston, Ontario, Agnes Etherington Art Center. *Pictures from the Age of Rembrandt*, 1984 (catalogue by D. McTavish).

Leiden 1976/1977
Leiden, Stedelijk Museum De Lakenhal. *Geschildert tot Leyden Anno 1626*, 1976/1977.

Leiden 1987
Leiden, Rijksmuseum van Oudheden. *Goed gezien. Tien eeuwen wetenschap in handschrift en druk*, 1987.

London 1986
London, The National Gallery. *Dutch Landscape: The Early Years, Haarlem and Amsterdam 1590–1650*, 1986 (catalogue by C. Brown).

Los Angeles, Boston, and New York 1981/1982
Los Angeles, Los Angeles County Museum of Art – Boston, Museum of Fine Arts – New York, Metropolitan Museum of Art. *A Mirror of Nature: Dutch Paintings from the Collection of Mr. and Mrs. Edward William Carter*, 1981/1982 (catalogue by J. Walsh, Jr., and C. Schneider).

Minneapolis, Houston, and San Diego 1985
Minneapolis, Minneapolis Institute of Arts – Houston, Museum of Fine Arts – San Diego, San Diego Museum of Art. *Dutch and Flemish Masters*, 1985.

New York, Toledo, and Toronto 1954/1955
New York, Metropolitan Museum of Art – Toledo, Toledo Museum of Art – Toronto, Art Gallery of Ontario. *Dutch Painting of the Golden Age*, 1954/1955.

New York 1988
New York, American Academy of Design. *Dutch and Flemish Paintings from New York Collections*, 1988 (catalogue by A. J. Adams).

Paris 1967
Paris, Musée des Arts Decoratifs. *La Vie en Hollande au XVIIe Siècle*, 1967.

Paris 1970/1971
Paris, Petit Palais. *Le Siècle de Rembrandt*, 1970/1971.

Paris, Antwerp, London, and New York 1979/1980
Paris, Institut Néerlandais – Antwerp, Koninklijk Museum van Schone Kunsten – London, British Museum – New York, Pierpont Morgan Library. *The Age of Rubens and Rembrandt*, 1979/1980 (catalogue by F. Stampfle).

Paris 1983
Paris, Institut Néerlandais, Fondation Custodia. *Réflets du Siècle d'Or Tableaux Hollandais du Dix-Septième Siècle*, 1983 (catalogue by S. Nihom-Nystad).

Paris 1989
Paris, Institut Néerlandais, Fondation Custodia. *Eloge de la Navigation Hollandaise au XVIIe Siècle*, 1989 (catalogue by M. Berge-Gerbaud).

Philadelphia, Berlin, and London 1984
Philadelphia, Philadelphia Museum of Art – Berlin, Gemäldegalerie, Staatliche Museen Preussischer Kulturbesitz – London, Royal Academy of Arts. *Masters of Seventeenth-Century Dutch Genre Painting*, 1984 (exhibition organized by P. C. Sutton).

Rotterdam 1950
Rotterdam, Maritiem Museum "Prins Hendrik." *Van Vroom tot Van de Velde*, 1950.

Rotterdam 1954/1955
Rotterdam, *Rotterdam en de zee*, 1954/1955.

Rotterdam and Amsterdam 1961/1962
Rotterdam, Museum Boymans–van Beuningen – Amsterdam, Rijksprentenkabinet. *150 Tekeningen uit Vier Eeuwen uit de verzameling van Sir Bruce en Lady Ingram*, 1961/1962 (catalogue by C. van Hasselt).

Rotterdam 1973
Rotterdam, Maritiem Museum "Prins Hendrik." *Plancius 1552–1622,* 1973.

Rotterdam 1984
Rotterdam, Gemeente Archief. *Kaarten en kaartmakers van Rotterdam,* 1984.

Rotterdam 1986
Rotterdam, Maritiem Museum. *"Prins Hendrik," De wereld volgens Blaeu, Blaeu's wereldkaart op groot formaat uit 1646,* 1986.

Salzburg and Vienna 1987
Salzburg, Residenz – Vienna, Akademie der bildenden Künste. *Niederländer in Italien,* 1987 (catalogue by R. Trnek).

Toledo, Boston, and San Francisco 1966/1967
Toledo, Toledo Museum of Art – Boston, Museum of Fine Arts – San Francisco, California Palace of the Legion of Honor. *The Age of Rembrandt,* 1966/1967.

Washington, Detroit, and Amsterdam 1980/1981
Washington, National Gallery of Art – Detroit, Detroit Institute of Arts – Amsterdam, Rijksmuseum. *Gods, Saints and Heroes,* 1980/1981.

Washington and New York 1986/1987
Washington, National Gallery of Art – New York, Morgan Library. *The Age of Bruegel. Netherlandish Drawings in the Sixteenth Century,* 1986/1987.

Worcester 1983
Worcester, Worcester Art Museum. *The Collector's Cabinet: Flemish Paintings from New England Private Collections,* 1983 (catalogue by J. Welu).